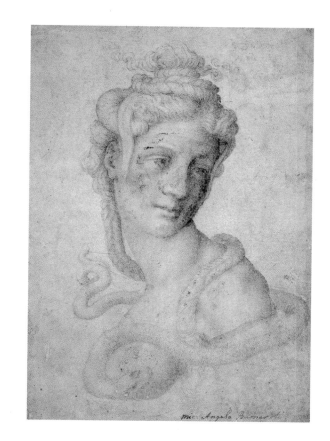

CLEOPATRA
of EGYPT

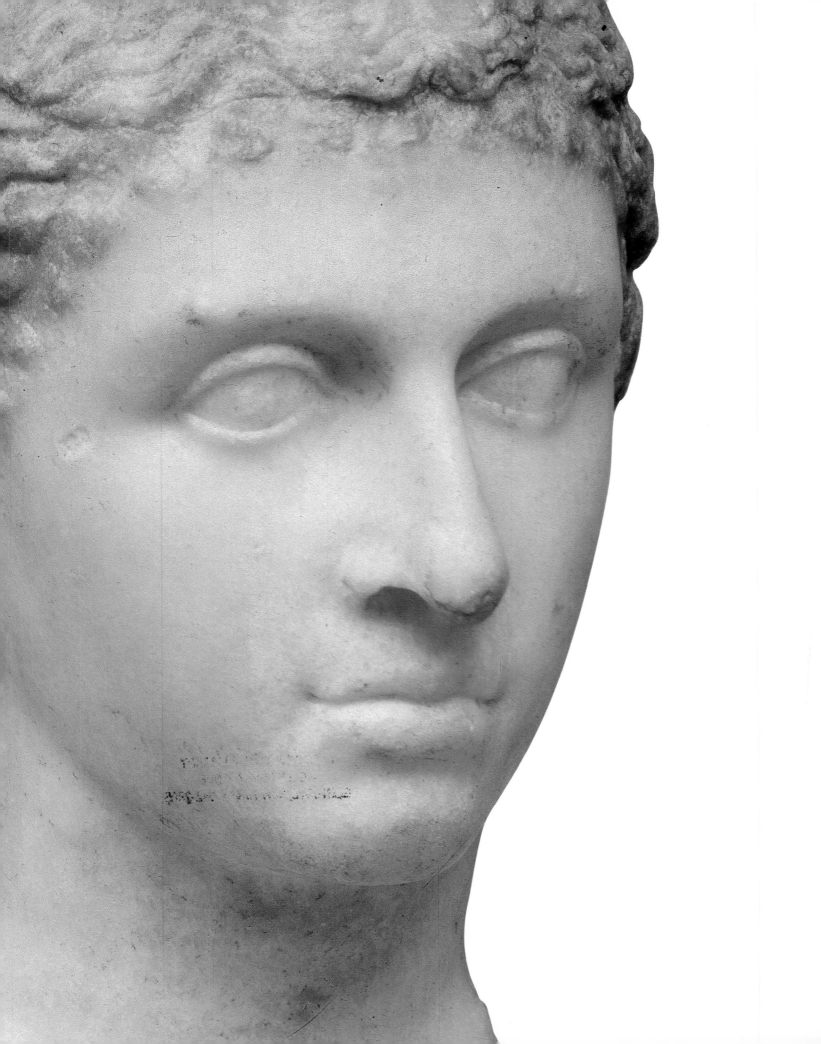

Edited by

SUSAN WALKER *and* PETER HIGGS

CLEOPATRA *of* EGYPT

FROM HISTORY TO MYTH

Princeton University Press

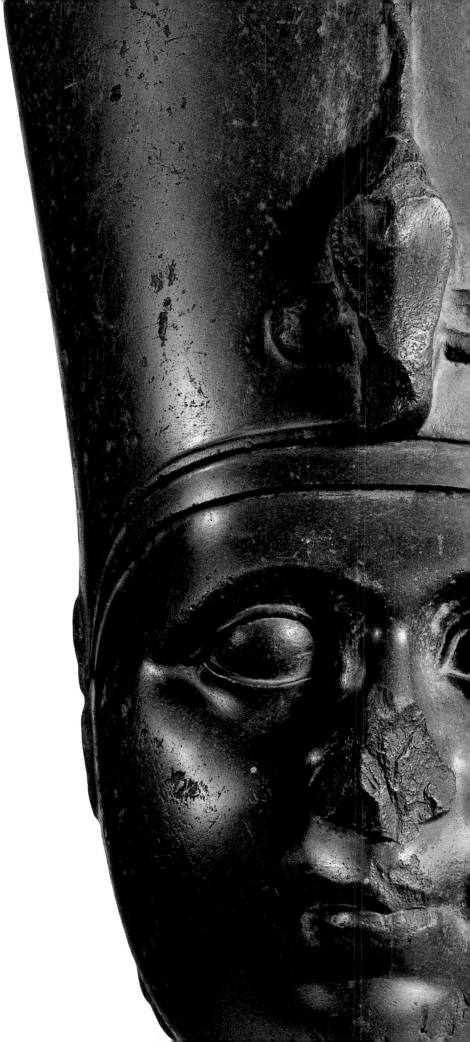

THE TRUSTEES OF THE BRITISH MUSEUM AND
THE FIELD MUSEUM GRATEFULLY ACKNOWLEDGE
BP AS THE INTERNATIONAL SPONSOR OF THIS
EXHIBITION.

Text on pp. 128–41, 210–15 and cat. nos 270, 352
© Guy Weill Goudchaux, 2001

First published in 2001 by The British Museum Press
A division of The British Museum Company Ltd
46 Bloomsbury Street, London WC1B 3QQ

Published in North America by Princeton University Press
41 William Street, Princeton, New Jersey 08540
www.pup.princeton.edu

Library of Congress Control Number: 00-111971

ISBN 0-691-08835-7 (cased)

Designed by Harry Green
Edited by Barbara Horn
Index by Suzanne Atkin
Printed in Spain by Grafos S.A. Barcelona

HALF-TITLE PAGE: Head of Cleopatra,
after Michelangelo (cat. 378).

FRONTISPIECE: Marble portrait of Cleopatra VII (cat. 198).

CONTENTS PAGE: Basalt head of a Ptolemaic king (cat. 22).

Contents

BP is delighted to support
'Cleopatra – From History to Myth'
at these two great institutions,
The British Museum, London
and The Field Museum, Chicago.
As one of the world's leading
energy companies, BP is committed
to supporting arts and culture as
part of its broader social investment
programme. Ancient Egyptian
culture has provoked popular
interest for centuries.
We hope you enjoy this exhibition
on the subject of one of history's
most fascinating characters.

SIR JOHN BROWNE
Group Chief Executive
BP Amoco plc

Foreword

It is always very pleasing when a project as ambitious as this arises from the success of a previous international collaboration. *Cleopatra of Egypt: from History to Myth* was born of another British Museum exhibition with an Egyptian theme: *Ancient Faces* (1997). It was a pleasure to make a positive response to Roberto Memmo's suggestion of further collaboration, and I thank him for supporting the research that has brought to the present exhibition eight previously unrecognized images of the last queen of Egypt, and a galaxy of her remarkable forebears.

Exhibiting Cleopatra is a challenge. Evidence of our own reactions to this exceptional woman may be seen almost anywhere, but relics of Cleopatra from her own lifetime are pitifully few, and the curators have searched collections on three continents to find them. I am very grateful indeed to all our lenders, and notably to the Supreme Council of Antiquities of Egypt, who have been most generous with loans from the Egyptian Museum, Cairo and the Greco-Roman Museum, Alexandria, including a range of exciting objects from recent excavations that give a flavour of the good life in that most glittering city of the ancient Mediterranean.

Within the British Museum, the outstanding collection of coins of Cleopatra, her forebears and contemporaries is well represented in the exhibition. In the Greek and Roman department, a remarkable gem the size of a little fingernail (cat. no. 153) has provided the clinching evidence for the newly recognized Egyptian images of the last queen of Egypt. The Egyptian department contains fascinating documents concerning the family of a priest of the god Ptah, appointed by Cleopatra's father, whose desperate pleas for a son were answered during her reign, which preserved the family interest in the priesthood through the Roman conquest of Egypt (cat. nos. 192–193). A search on the Museum's database produced the unexpected (to classicists, at least) find of watches bearing images of Cleopatra, not Hollywood products but seventeenth- and eighteenth-century works made for the aspiring gentleman (cat. nos 381–383). The Museum also holds some exceptional drawings, for Cleopatra inspired Michelangelo and contemporary copyists (cat. no. 378), Guercino (cat. no. 369) and elegant theatrical sets in the style of Tiepolo (cat. nos 375–376). For these discoveries we must thank the curator of the exhibition, Dr Susan Walker of the Department of Greek and Roman Antiquities of the British Museum, and her curatorial colleagues.

This exhibition has seen a collaboration between five departments of the British Museum and a galaxy of lenders in Africa, Europe and North America. The hosting institutions span two continents: having begun with a very successful run at the Palazzo Ruspoli (Fondazione Memmo) in Rome, the exhibition continues at the British Museum, London, moving for a third showing to the Field Museum, Chicago. I hope it will prove an inspiration to its visitors, who will emerge with some questions answered, but, one hopes, with many more left to ask.

R.G.W. ANDERSON
Director
The British Museum

Preface

Who was Cleopatra? The question may be answered easily enough by locating Cleopatra VII (70/69–30 BC) in the historic context of the relationship between the wealthy but mismanaged empire of the Ptolemies and the irresistible might and greed of Rome. A more challenging question is 'Who's *my* Cleopatra?', for it is abundantly clear that there are many Cleopatras (an ambivalence encouraged in her lifetime by the queen), and our perceptions of her are shaded by centuries of absorption with the romantic tragedy of her last moments. The last section of the exhibition is concerned with Renaissance and later visions of Cleopatra as martyr and Cleopatra as player, the latter both in the sense of a major actor on the world stage and as a highly privileged woman who enjoyed the finer things in life. Here, responses to Cleopatra from the Renaissance to our day are discussed by Mary Hamer (pp. 302–11), and the Romans' perceptions of the queen, formative for later Western cultures, by Christopher Pelling (pp. 290–301). Peter Higgs (pp. 200–209) shows how, from the Renaissance to the twentieth century, persistent obsession with the drama of Cleopatra's suicide hindered the discovery and understanding of her historical portraits.

In telling the story of the historical Cleopatra, it is difficult to avoid the temptation of making an exhibition of Ptolemaic Egypt, or indeed of Alexandria, both of which have received attention in recent years. Though we hope that the exhibition will bring the exceptional quality and vivacity of Ptolemaic art to a wider audience, we have concentrated on the way in which the Ptolemies represented themselves to Egyptian and to Greek audiences, as a means of explaining Cleopatra's needs and priorities as ruler of Egypt at a particularly difficult moment in that country's history. A detailed historical account is provided by Andrew Meadows (pp. 14–31), while Cleopatra's religious policy, a matter of key importance in securing the loyalty of the Egyptian people, is explored by Guy Weill Goudchaux (pp. 128–41). We hope that the magnificent objects generously loaned by the Supreme Council of Antiquities of Egypt, and the essay contributed by John Ray (pp. 32–7) will help to give an impression of the nature of Cleopatra's capital city, particularly evoking the festive climate that prevailed during Cleopatra's rule in Antony's presence from 37 to 32 BC. In that year hostilities between Cleopatra, Antony and their sober rival Octavian came to a head; an account of the uneasy relationship is given by Jonathan Williams (pp. 190–99).

It is clear from the historical record, despite the efforts of Octavian to suppress it, that many Romans supported Antony, and Cleopatra herself aroused considerable interest, even notoriety, during her two years (46–44 BC) in Rome as the guest of Caesar. Her impact upon the Roman taste for Egyptian culture and religion has been somewhat underrated, and the exhibition goes some way to redress the balance: the context is set out by Carla Alfano (pp. 276–89).

One of the most exciting elements of the research programme has been the recognition of a number of Egyptian-style images of Cleopatra by Sally-Ann Ashton (pp. 148–55). The identification of such images of individual Ptolemaic monarchs is a matter of considerable schol-

arly controversy, and this exhibition has provided a unique opportunity to bring together those candidates we were able to locate, and to set out the arguments for their identification. We are enormously grateful to the lending museums (the Hermitage, St Petersburg; the Egyptian Museum, Turin; the Musei Capitolini, Centro Montemartini, Rome; the Museo Egizio, Turin; the Louvre, Paris; the Metropolitan Museum of Art, New York; the Brooklyn Museum of Art, and the Rosicrucian Museum, San Jose), and we hope that, even if their curators disagree with this interpretation, public interest in their collections will be strengthened by the display of these remarkable images as a group.

And yet Cleopatra's image was nothing if not inconsistent, a reflection of contemporary political instability (Susan Walker, pp. 142–7). What did she really look like? Was she beautiful, as generations of writers have led us to believe? The first question is now unanswerable; the second considered by Guy Weill Goudchaux (pp. 210–16).

In an exhibition such as this we cannot hope to do more than present a vision of Cleopatra that will inevitably be but a partial record of an exceptional woman, an able ruler who happened to live at a crux of history. We have been fortunate in the generosity of others, and in recent moments of discovery and creation, for Cleopatra continues to inspire artists. It is, then a particular pleasure to include the newly recognized papyrus bearing Cleopatra's personal authorization (cat. no. 188); a portrait bust perhaps representing her son Caesarion, raised for the first time to public view from Alexandria harbour (cat. no. 172), and Barbara Chase-Riboud's *Cleopatra's Marriage Contract III* (cat. no. 385), made especially for the exhibition.

SUSAN WALKER *and* PETER HIGGS

ACKNOWLEDGEMENTS

The organizers would like to thank the numerous friends and colleagues who assisted with the preparation of this exhibition and the catalogue.

In Rome, Avvocato Roberto Memmo (Presidente), Dr Roberta d'Amelio and Daniela, Contessa d'Amelio, Patrizia Memmo Ruspoli, Allegra Getzel and Dr Carla Alfano, all of the Fondazione Memmo; Professor Eugenio la Rocca, Director of the Musei Comunali di Roma; Dr Claudio Parisi Presicce of the Musei Capitolini; Dr Leila Nista of the Museo Nazionale Romano; Dr Francesco Buranelli and Dr Paolo Liverani, Musei Vaticani.

In Chicago, we thank John W. McCarter Jr, President of the Field Museum, and Judy McCarter; Cathleen A. Costello, Vice President for Museum Affairs; Anne C. Haskel, Director of Corporate Affairs; Sophia Shaw, Director of Exhibitions; Abigail Sinwell, former Manager, Temporary Exhibitions; Robin Groesbeck, Manager, Exhibit Coordination; David Foster, Project Administrator; and Barbara Ciega, John Dalton, Eric Frazer, Amanda Reeves and Dick Urban, all of the Department of Exhibitions, the Field Museum.

In Egypt, Dr Gaballa Ali Gaballa, Secretary-General and Ibrahim Abd el Galil, Head of the Exhibitions Abroad department, Supreme Council of Antiquities; Soheir el-Samy (Director), Dr el Shimy (former Director) and Dr May Trad (Senior Curator), the Egyptian Museum, Cairo; H.M. Ambassador Graham Boyce; Geoffrey Adams, British Embassy, Cairo; David Marler, Director, British Council; and Azza Hamed. Ahmed Abd el-Fatah (Director), Amira Bakr el-Kusht (Head of Conservation), Dr Mervat Seif-el Din (Senior Curator), The Greco-Roman Museum, Alexandria; Dr Jean-Yves Empereur and his colleagues at the Centre d'Etudes Alexandrine; Franck Goddio, Institut d'Archéologie Sous-Marine, Paris; Georg Rosenbauer, Hilti Company.

In addition to the lenders from Egypt and Rome, we thank Professor Wolf-Dieter Heilmeyer, Antikensammlung, Berlin; Professor Dietrich Wildung, Ägyptisches Museum, Berlin; Professor Francis Van Noten and Dr Luc Limme, Musées Royaux d'Art et d'Histoire, Brussels; Dr Árpád Nagy, Museum of Fine Arts, Budapest; Barbara Chase-Riboud; Abdul Haman Khalifa, Patrimonie Culturel, Ministère de la Communication et de la Culture, Algiers; Imona Rebahin, Cherchel Museum; Dr William H. Peck, The Detroit Institute of Art; Dr Stefano de Caro, Museo Nazionale Archeologico, Naples; Dr Richard Fazzini, The Brooklyn Museum of Art; Dr Dorothea Arnold and Marsha Hill (Department of Egyptian Art), Dr Carlos Picón, Dr Christopher Lightfoot (Department of Greek and Roman Art), The Metropolitan Museum of Art, New York; Dr W. Metcalf, American Numismatic Society, New York; Jean-Pierre Angremy and Dr Michel Amandry, Bibliothèque Nationale de France, Paris; Christiane Ziegler and Dr Marc Etienne (Département des antiquités egyptiennes), Dr Alain Pasquier (Département des antiquités grècques, étrusques et romaines), Musée du Louvre, Paris; Dr Mikhail Pietrowsky, Dr Vladimir Medveyev, and Dr Andrey Bolshakov, The Hermitage Museum, St Petersburg; Jill Freeman, The Rosicrucian Museum, San Jose; Dr Margret Honroth, Württemburgisches Landesmuseum, Stuttgart; Dr Alison Easton, Royal Ontario Museum, Toronto; Dr Anna Maria Donadoni Roveri, Museo Egizio, Turin; William Zewadski; Janet Moat, British Film Institute; Dr Scot McKendrick, Dr Barry Taylor, Pamela Porter, Anne Rose, The British Library; Jon Culverhouse, Burghley House; Hélène Alexander, The Fan Museum, Greenwich; Dr Eleni Vassilika, Fitzwilliam Museum, Cambridge; Dr J.D. Bateson, Hunterian Museum,

Glasgow; Dr David Jaffé and Dr Sally Korner, National Gallery, London; Simon Jervis, Alistair Laing, The National Trust; Sally Macdonald and Dr Stephen Quirke, Petrie Museum of Egyptology, University College, London; Dr Paul Williamson, Victoria and Albert Museum; the Hon. Jane Roberts and Theresa Mary Morton, The Print Room, Royal Library, Windsor Castle; Jonathan Marsden and Caroline de Guitaut, The Royal Collection Trust; Geoffrey Sharpe; Claude Hankes-Drielsma.

We thank all our contributors. We are grateful to the Caryatids, the international supporters group of the Department of Greek and Roman Antiquities, for a grant supporting the involvement of international scholars in the writing of this catalogue. We owe a special debt to those who worked extensively on the development of the exhibition: Dr Sally-Ann Ashton, Special Assistant to the Cleopatra project, now of the Petrie Museum of Egyptology, University College, London; Guy Weill Goudchaux, London; Dr Mary Hamer, Cambridge and Harvard University; Dr Andrew Oliver Jr and Dr Diana Buitron Oliver; our warmest thanks to Carol Andrews and Michelle Lovric.

At the British Museum, Graham C. Greene, Chairman of the Trustees; Suzanna Taverne, Managing Director and Dr Robert Anderson, Director; Sir Claus Moser, Sukie Hemming, and Temple Perham, Development Trust; Vivian Davies, Keeper of Egyptian Antiquities; and Dr Dyfri Williams, Keeper of Greek and Roman Antiquities. For curatorial support, we thank Dr Paul Roberts and Dr Donald Bailey, Department of Greek and Roman Antiquities; Dr Andrew Burnett, Dr Andrew Meadows, Dr Jonathan Williams, and Dr Luke Syson, Department of Coins and Medals; John Cherry, Aileen Dawson, Judy Rudoe and Dr Dora Thornton, Department of Medieval and Modern Europe; Antony Griffiths, Frances Carey, Dr Hugo Chapman and Dr Kim Sloan, Department of Prints and Drawings.

Our sincere thanks to the members of the British Museum Stone Conservation team: J. Kenneth Uprichard, Nicholas Lee, Jane Foley and Karen Birkhölzer. For administrative and technical support, we thank Evelyn Wood, Marian Vian, Keith Lowe, Kate Morton, Clare Pickersgill, Ken Evans, Kate Cooper, Andrew Lane and Mattias Engdahl, Greek and Roman Antiquities; Brendan Moore, Coins and Medals; Ben Green and Evan York, Egyptian Antiquities; Ivor Kerslake, John Williams, Claudio Mari and Jerome Perkins, Photography and Imaging; Geoffrey House (Head of Exhibitions), Margaret Hall (Head of Design), Ann Jones and Dinah Pyatt, Department of Exhibitions; at Pentagram UK, Lorenzo Apicella, Johanna Molineus, Angus Hyland and Kelsey Finlayson.

At The British Museum Press, Emma Way, Coralie Hepburn, Sarah Levesley, Penelope Vogler, Harry Green, Elisabeth Ingles and Barbara Horn.

We thank Ferdinand Mount and the *Times Literary Supplement* for permission to use, with alterations, 'Alexandria' by John Ray.

Guy Weill Goudchaux dedicates the chapter 'Cleopatra's subtle religious policy' to Gunilla, Gräfin Douglas. He also thanks Valentina Bocchia and the European Academy of Arts of London. Peter Higgs thanks Mette Moltesen for help information on the Despuig Collection and Magdalena Rosselló Pons of the Castell de Bellver, Palma. Susan Walker thanks Dr Hans Ruprecht Goette and Dr P. Hadjimichalis for assistance with the portrait of the woman from Delos (p.144).

The editors apologise for any inadvertent omissions in this list.

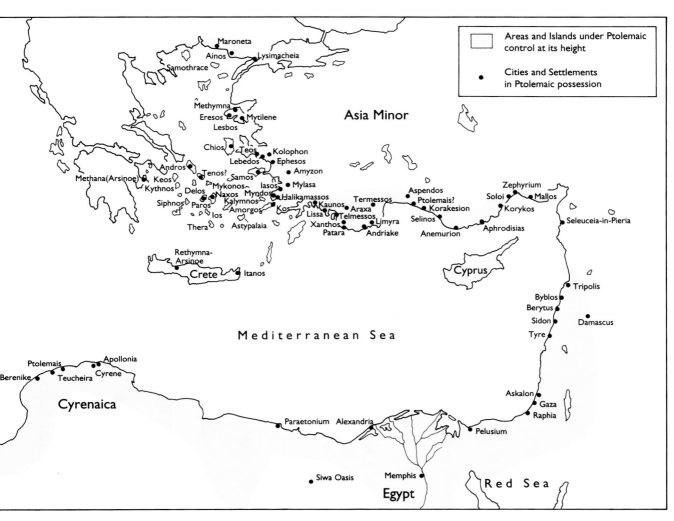

Ptolemaic Empire

visited by Cleopatra VII

11

The Ptolemies and Alexandria

Sins of the fathers:

the inheritance of Cleopatra, last queen of Egypt

ANDREW MEADOWS

Two years after his defeat of Antony and Cleopatra's forces at Actium, and a year after the end of the Ptolemaic dynasty had been declared, the Greek historian Dio Cassius described the third day of Octavian's celebrations in the autumn of 29 BC thus:

> The other processions were remarkable…, but the most extravagant and stunning was that commemorating Egypt. Among other items was carried a statue of Cleopatra lying in a representation of her death on a couch, so that in a way she too could be seen in procession with the other prisoners and with her children, Alexander Helios and Cleopatra Selene….
> After he had finished these celebrations, Octavian dedicated the temple of Minerva (also known as the Chalcidicum), and the Curia Iulia, built in honour of his father. In this he set up the statue of Victory which is still there, claiming, so it seems, that it was from her that he received the Empire. The statue had belonged to the people of Tarentum, and was brought from there to Rome, set up in the Senate house and decorated with the spoils of Egypt. (Book 51, chs 21–2)

That Octavian should have celebrated the final defeat of the wealthy land of Egypt in such sumptuous style comes as no great surprise. But the last detail mentioned by him is unexpected: why did Octavian set up the statue of Victory from Tarentum in the new Senate House? The reason is not immediately clear. Perhaps this was the only statue available at short notice; or perhaps the Tarentines stood in Octavian's mind for the moral weakness of the East (see page 195); or maybe, just maybe, Octavian did in fact know some history that he had not himself (re)written, for Tarentum and Victory stand, like bookends, at both beginning and end of the relations between Rome and the Ptolemaic house. These relations had begun in 273 BC with the dispatch of an embassy by Ptolemy II Philadelphus to the Roman people. Our source is again Dio: 'Ptolemy Philadelphus, the king of Egypt, learnt of Pyrrhus' reverse and the growing power of the Romans and sent them gifts and made an agreement with them. The Romans, pleased that one so far away should have thought so highly of them, sent ambassadors to him' (Book 10, frag. 43).

In the following year the Romans completed their conquest of the Italian peninsula to their south, as Tarentum, the last great Greek city of Italy, deserted by its temporary champion Pyrrhus, fell to the besieging Roman army. By its fall, the geopolitical map of the western Mediterranean was redrawn for good. Ptolemy had been the first of the successors of

Alexander the Great to realize this, just as his line would be the last to succumb to the ineluctable consequence in the East.

Initially, relations between the two powers were cordial. The ambassadors sent by Rome in response to Philadelphus' overtures returned laden with such embarrassingly extravagant gifts that they felt obliged to donate them to the public treasury, while the Senate was so pleased with their performance that they declined the offer and allowed the men to keep the gifts for themselves. It is possible too that a more practical outcome of the first contacts with Egypt is visible in the coinage of Rome shortly thereafter. At around the time of the conquest of Tarentum the Romans began to strike a new type of coin, with a portrait of the goddess Roma on one side and, interestingly, the figure of Victory on the other. The idiosyncratic control marks on these coins find parallels only in the contemporary coinage of the Ptolemies (cf. cat. no. 79), perhaps suggesting technical help offered by Egypt to the fledgling Roman mint.

At this period, from the 270s to the 240s BC, the Ptolemaic empire under Ptolemy II Philadelphus (285–246 BC) and Ptolemy III Euergetes (246–222 BC) was at its apogee. Apart from the core Ptolemaic kingdom, consisting of areas of modern Egypt, Libya, Israel, Jordan, Lebanon, Syria and Cyprus, there were the overseas provinces of Cilicia, Pamphylia, Lycia, Caria and parts of Ionia in modern Turkey, parts of Thrace and the Peloponnese in modern Greece, as well as a protectorate over a league of islands in the Aegean. At its heart lay the imperial city of Alexandria, the city founded by Alexander at the westernmost debouchment of the Nile into the sea. Here the Ptolemies created for themselves a glittering ceremonial centre, to draw the eye from all quarters of their realm (pp. 32–7). Under Euergetes the empire stretched briefly as far east as the Euphrates, and under both kings its western boundary sat on the same line of longitude as the toe of Italy. The Ptolemaic kings thus had stronger interests – political and economic – in events in the West than any of their royal rivals.

Thus we can explain their apparently contradictory behaviour towards Rome throughout the third century BC. After the warm, generous handshake of 273 BC, the Ptolemies remained coolly aloof throughout most of Rome's struggle with the other great power in the West, Carthage; for if the Roman state was now one of Ptolemy's neighbours to the north, the Carthaginians were nonetheless his neighbours to the west, and there was little point in upsetting either neighbour unnecessarily. Thus, when the Carthaginians sought help from Philadelphus during the course of their first war with Rome (264–241 BC), Ptolemy made his neutrality quite clear:

> The Carthaginians sent an embassy to Ptolemy, son of Ptolemy, son of Lagos, asking him
> for two thousand talents. But he had friendly relations with both the Romans and the Carthaginians,
> and offered to negotiate a settlement between them. Unable to do this, he replied that while
> he was willing to help friends who were fighting against enemies, he could not if it were against
> friends. (Appian, *Sic.* 1)

In reality, the Ptolemies were waiting, as in 273 BC, to see the likely outcome before committing themselves to one side or the other. In the Romano-Carthaginian conflict the moment came in 212 BC, during the second war, with the Roman capture of another crucial Greek city, Syracuse in Sicily. At around this time an embassy was sent from Rome to Ptolemy IV Philopator (222–205 BC) requesting aid. No literary source relates the response, but again an issue of Roman coinage is perhaps suggestive. In around 211 BC three Roman mints – one at Rome, the others in Sicily – began to produce a remarkable series of gold coins. On the obverse was the head of Mars, appropriate to the wartime circumstances of the issue; on the reverse appeared an eagle on a thunderbolt, a symbol recognizable the world over as the badge of the Ptolemaic house.

If this coinage was an acknowledgement of Ptolemaic aid, then Philopator had supported

THE PTOLEMIES

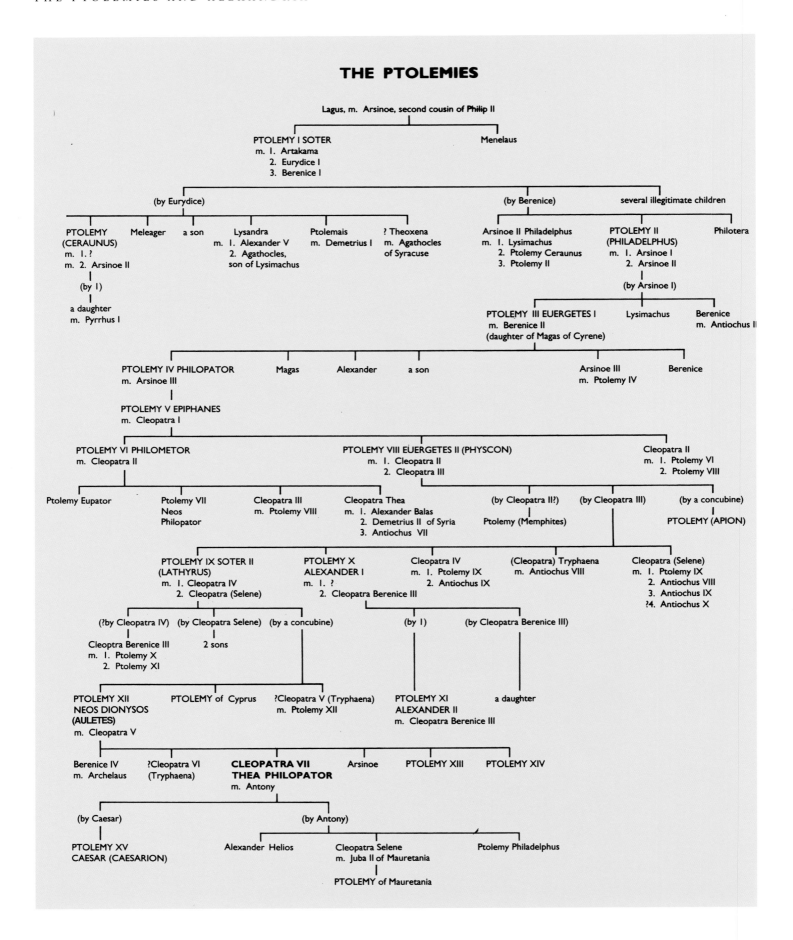

Lagus, m. Arsinoe, second cousin of Philip II

PTOLEMY I SOTER
m. 1. Artakama
2. Eurydice I
3. Berenice I

Menelaus

(by Eurydice)

(by Berenice)

several illegitimate children

PTOLEMY
(CERAUNUS)
m. 1. ?
m. 2. Arsinoe II

Meleager

a son

Lysandra
m. 1. Alexander V
2. Agathocles,
son of Lysimachus

Ptolemais
m. Demetrius I

? Theoxena
m. Agathocles
of Syracuse

Arsinoe II Philadelphus
m. 1. Lysimachus
2. Ptolemy Ceraunus
3. Ptolemy II

PTOLEMY II
(PHILADELPHUS)
m. 1. Arsinoe I
2. Arsinoe II

Philotera

(by 1)

a daughter
m. Pyrrhus I

(by Arsinoe I)

PTOLEMY III EUERGETES I
m. Berenice II
(daughter of Magas of Cyrene)

Lysimachus

Berenice
m. Antiochus II

PTOLEMY IV PHILOPATOR
m. Arsinoe III

Magas

Alexander

a son

Arsinoe III
m. Ptolemy IV

Berenice

PTOLEMY V EPIPHANES
m. Cleopatra I

PTOLEMY VI PHILOMETOR
m. Cleopatra II

PTOLEMY VIII EUERGETES II (PHYSCON)
m. 1. Cleopatra II
2. Cleopatra III

Cleopatra II
m. 1. Ptolemy VI
2. Ptolemy VIII

Ptolemy Eupator

Ptolemy VII
Neos
Philopator

Cleopatra III
m. Ptolemy VIII

Cleopatra Thea
m. 1. Alexander Balas
2. Demetrius II of Syria
3. Antiochus VII

(by Cleopatra II?)

Ptolemy (Memphites)

(by Cleopatra III)

(by a concubine)

PTOLEMY (APION)

PTOLEMY IX SOTER II
(LATHYRUS)
m. 1. Cleopatra IV
2. Cleopatra (Selene)

PTOLEMY X
ALEXANDER I
m. 1. ?
2. Cleopatra Berenice III

Cleopatra IV
m. 1. Ptolemy IX
2. Antiochus IX

(Cleopatra) Tryphaena
m. Antiochus VIII

Cleopatra (Selene)
m. 1. Ptolemy IX
2. Antiochus VIII
3. Antiochus IX
?4. Antiochus X

(?by Cleopatra IV)

Cleoptra Berenice III
m. 1. Ptolemy X
2. Ptolemy XI

(by Cleopatra Selene)

2 sons

(by a concubine)

(by 1)

(by Cleopatra Berenice III)

PTOLEMY XII
NEOS DIONYSOS
(AULETES)
m. Cleopatra V

PTOLEMY of Cyprus

?Cleopatra V (Tryphaena)
m. Ptolemy XII

PTOLEMY XI
ALEXANDER II
m. Cleopatra Berenice III

a daughter

Berenice IV
m. Archelaus

?Cleopatra VI
(Tryphaena)

**CLEOPATRA VII
THEA PHILOPATOR**
m. Antony

Arsinoe

PTOLEMY XIII

PTOLEMY XIV

(by Caesar)

(by Antony)

PTOLEMY XV
CAESAR (CAESARION)

Alexander Helios

Cleopatra Selene
m. Juba II of Mauretania

Ptolemy Philadelphus

PTOLEMY of Mauretania

the right side. The Romans appreciated the act of faith: among the gifts they sent to the King in an embassy of 210 BC was a toga. Within ten years the Carthaginians had been dealt a crushing defeat from which they would never fully recover. The Romans sent another embassy in 201 BC to Ptolemy V Epiphanes (205–180 BC) to thank the King 'because in difficult times, when even their closest allies had deserted the Romans, he had kept faith', but this time they went to ask 'if, forced by wrongs they had suffered, they were to declare war on Philip of Macedon, Ptolemy would maintain his old friendly attitude towards the Roman people?' (Livy 31.2.3–4). The reply that came from the Ptolemaic court reveals yet another shift in relations between the two powers: 'Ambassadors arrived from King Ptolemy who reported that the Athenians had sought his help against Philip: however, even though they were his allies, the king would not send a fleet or an army for defensive or offensive purposes into Greece, unless it was the Roman people's will' (Livy 31.9.1).

What a change just fifty years had made! From aloof and neutral, the tone of Ptolemaic diplomacy towards the Romans had become politely deferential. Once more the Ptolemaic court was showing itself to be keenly aware of the strength of Rome and again, as in 273 BC and 212 BC, it deliberately ceded its right of independent action to Rome rather than be trapped by Rome's advance. To intelligent Greeks the speed of Rome's rise had been impressive. 'For what man is so stupid or lazy that he does not want to know how and by what system of government practically the whole world has been conquered and in less than fifty-three years has fallen under the rule of the Romans, a phenomenon previously unknown?' (Polybius 1.1.5). These words were written by one of the leading politicians in Greece in the second century BC, and the forty-book history that they preface is the principal surviving account of the Roman conquest of Greece between 220 BC and the Roman sack of Corinth in 146 BC. Polybius had a privileged viewpoint. Over twenty years of his life were spent at Rome in the company of the foremost Romans of his day, but prior to his enforced absence from Greece, he and his family had enjoyed a close relationship with the Ptolemaic house in Egypt. Polybius himself was close to Ptolemy Epiphanes, and this closeness to charismatic figures in Rome and Egypt led to inevitable problems in his explanation of their not always worthy motivations. While Polybius was eager to explain the process of Roman world conquest, he had somehow to deal with the problem that part of this world conquest came at the expense of his friend Epiphanes.

In fact, the process of Ptolemaic decline had begun well before 200 BC. While the deferential Ptolemaic embassy of that year concerning Philip was in part a response to growing Roman power, it was also necessitated by increasing erosion of the Ptolemaic dominions by the two other major Hellenistic royal houses of the period, the Antigonids of Macedon and the Seleucids of Syria. The former, under Antigonus Doson (229–221 BC) and then his successor, Philip V (221–179 BC), had struck at the province of Caria, the heart of the Ptolemaic provinces in Asia Minor. The latter, under Antiochus III (223–187 BC) had deprived the Ptolemies of their possessions in the area of Phoenicia in 201 BC. Moreover, in 205 BC Ptolemy Philopator had died, leaving as his heir the six-year-old Ptolemy Epiphanes. The sudden Roman desire to put Philip V in his place provided the opportunity for the courtiers of the young Ptolemy to invite in their Western allies as protectors of the King and his possessions. One of the Roman ambassadors to Alexandria, the young Marcus Aemilius Lepidus, was invited to become a guardian of the King. So began an interference by influential Romans in the affairs of the Ptolemaic royal house that would become a leitmotiv of future relations: Lepidus' position was an honour that a descendant, Lepidus the triumvir, could commemorate 140 years later (cat. nos 279–280). For their part, the Romans could now enter Greece under the righteous banner of the protectors of the young King's territories. Now they would repay the debt to their loyal friends in Egypt.

For all Rome's claims to be acting on Ptolemy's behalf, collapse occurred. By the time of Epiphanes' death in 180 BC, the Ptolemaic empire overseas was essentially lost. What went wrong? Polybius' explanation was simply that the damage had already been done, and that it had been done by Epiphanes' father, Philopator.

> He revealed himself to his courtiers and those who administered matters in Egypt to be inattentive and unpleasant to deal with and proved himself negligent and lazy to those conducting foreign affairs – the aspect to which the previous kings had devoted more attention than to the kingdom of Egypt itself…. But Philopator, neglecting all these things due to his shameful philanderings and incoherent and continuous bouts of drunkenness, not surprisingly found in a very short space of time both himself and his kingdom to be the object of a number of conspiracies. (Pol. 5. 34.4–10)

Polybius took the easy way out. Evidence that survives from the period of Philopator's reign belies the picture of indolence and carelessness of empire that the historian portrays. In reality Rome failed its young ward in the first instance through contrived negligence of its own; in the second, through active connivance.

In 200 BC an embassy was sent to Philip V bidding him 'not to make war on any of the Greeks and not to lay his hands on the possessions of Ptolemy'. The message was delivered by the young king's guardian, Lepidus. In truth, however, the two facets of Roman policy in the East – the protectorate of the freedom of the Greeks and the guardianship of Ptolemy's interests – were incompatible. For seventy years one of the cornerstones of Ptolemaic influence in Greece had been the role the kings claimed as champions of Greek freedom, particularly against the Antigonids of Macedon. That position was now being usurped by Rome, and reached its logical conclusion in 197 BC, after the defeat of Philip V, in the proclamation by the Roman general Flamininus of the freedom of the Greeks of Europe. The premise on which all Ptolemaic diplomacy in Greece had been based was destroyed at a stroke. For the time being, however, the Romans maintained their stance as guardians of Egypt's interests. Philip was ordered to remove his garrisons from all towns that had belonged to Ptolemy. In that and the following year Roman ambassadors would make a similar demand of the great king of Syria, Antiochus III.

Meanwhile, Antiochus had taken advantage of the weakness of the young Ptolemy Epiphanes and the Roman preoccupation with Philip. In 197 BC he had begun a massive campaign with the ultimate aim, as he saw it, of reclaiming Asia Minor for the Seleucid throne. Concerted army and naval efforts along the south and western coasts had resulted in the conquests of the Ptolemaic provinces of Cilicia, Pamphylia, Lycia, Caria and Ionia. While Flamininus was eliminating Epiphanes from Greece, Antiochus replaced him in Asia. However, as Antiochus entered European Greece, Rome was drawn inevitably into conflict with him, and in 190 BC the Romans won a clear victory at Magnesia, in western Asia Minor. The resulting peace settlement finalized at Apamea in 188 BC was in many ways a defining moment in the history of the eastern Mediterranean, and not least for the Ptolemaic house. Here was the opportunity for Rome to enforce the demands it had been making for the withdrawal of Seleucid forces from Ptolemaic towns. The withdrawal from all cities to the west of the Taurus mountains duly came, but nowhere in the settlement of Apamea was there mention of Ptolemaic interests. Rome now had new friends in the East and, with the claims of Ptolemy Epiphanes quietly forgotten, the former Ptolemaic provinces of Ionia, Caria, Lycia and Pamphylia were parcelled out to Rome's new allies, Attalus I of the kingdom of Pergamum, and the state of Rhodes.

Within the remarkably short space of a decade or so the formerly proud Ptolemaic empire was thus reduced from close to its widest extent to just the core areas of Egypt, Cyprus and Cyrenaica, which were all that was left to the fifth Ptolemy after the Peace of Apamea. The voracity of Philip and Antiochus, followed by the betrayal by Rome and combined with the

youth of Epiphanes, had contributed much to the empire's demise. But this is not quite the whole story, for the end of the reign of Philopator and the beginning of that of Epiphanes saw the rise of internal dissent, a problem that would haunt the Ptolemaic house for the rest of the dynasty. Our knowledge of the difficulties that Epiphanes faced is limited, and must largely be extrapolated from the solutions he appears to have adopted. There had been a revolt in the Thebaid, beginning in 207/206 BC, and rival pharaohs had appeared. To a certain extent the Ptolemaic administration was weak at the time of Epiphanes' accession in 197 BC. From the Rosetta Stone it is clear that the fifth Ptolemy, unlike his predecessors, was crowned at Memphis, the ancient Egyptian capital, not Alexandria, the new Greek one. The same text preserves clear royal attempts to win over the native Egyptian priesthood. Epiphanes' measures seem to have met some success, however, since the next threat to the empire would come from an external source.

A result of the diminution of the Ptolemaic empire in Europe and Asia Minor was an increased focus on the neighbouring Syrian kingdom of the Seleucids. The Seleucids too, with their ambitions stalled by the Peace of Apamea, were left only with Egyptian territory to covet. Upon the death of Ptolemy V, a minor was again heir to the Egyptian throne. Ptolemy VI Philometor (180–145 BC) was probably only six years old when he inherited in 180 BC, ten when crowned in 176 BC, and sixteen when his kingdom was invaded by Antiochus IV of Syria in 170 BC. But Antiochus, apparently wary of catching the eye of Rome by an alarming new conquest, left the young king in place, merely conferring his blessing on him and withdrawing with his army for the winter. To the proud citizens of Alexandria, however, the idea of rule by a Seleucid puppet was intolerable, and by popular acclaim Philometor's younger brother, Ptolemy Physkon ('pot-belly') was placed on the throne in the city. Within a year the two brothers had reached an uneasy settlement and a joint rule (170–164 BC) was established, but this was to prove intolerable to Antiochus. In the spring of 168 BC he invaded Egypt again, taking first Memphis and then advancing to Alexandria. For the Romans this was clearly a city too far: while they may have felt ambivalent towards the fortunes of the Ptolemaic kings, the prospect of Antiochus capturing Alexandria itself now goaded them into action. The Roman Senate resolved that Antiochus must withdraw from Egypt. A former consul, Gaius Popilius Laenas, was sent to communicate the resolution and met the King at Eleusis, a suburb of Alexandria:

> On Antiochus calling a greeting to him from a distance and holding out his hand, Laenas, who had in his hand the tablet on which the Senate's resolution was written, handed it to Antiochus and told him to read it, deeming it inappropriate to make any sign of friendship before gauging the king's intentions – hostile or friendly. But when Antiochus had read it and asked if he could consult his friends about its contents, Laenas did something which inevitably looks harsh and highly arrogant. For holding in his hand a staff made from a vine, he drew a circle around Antiochus and told him that he must give a reply from within that circle. The king was outraged at the high-handedness of this act but, recovering his wits after a moment's pause, said that he would do everything that the Romans ordered. (Pol. 29.27.2-6)

Laenas set matters in order in Alexandria and then proceeded to Cyprus, where he supervised the withdrawal of Antiochus' occupying forces there. From this point on the Ptolemaic kings owed not only the loss of their empire but also the continued existence of the kingdom to the Roman Senate.

Continued squabbling between the two brothers served only to strengthen the debt. After five years of shaky joint rule Physkon gained the upper hand and forced his brother into exile. Philometor fled to Rome, arriving there destitute and throwing himself upon the mercy of the Senate. Now, in 163 BC, the Roman Senate took the opportunity to weaken the Ptolemaic kingdom still further by dividing it in two. They imposed a settlement whereby Philometor was to rule in Egypt and Cyprus, while Physkon was to have Cyrenaica. Relations between the

two brothers remained strained, with Physkon attempting to use the influence of Rome to lever himself into a stronger position. In 155 BC he went to the extraordinary length of making the Roman people the guardians of his kingdom in the event of his untimely death. A copy of this will has been found at the site of Cyrene:

> In the fifteenth year, in the month of Loos. With good luck. This is the testament of King Ptolemy, son of King Ptolemy and of Queen Cleopatra, gods Epiphanes, the younger son. Of this another copy has been sent to Rome. May it be mine with the good will of the gods to take vengeance worthily upon those who have organized against me the unholy plot and have deliberately chosen to deprive me not only of my kingdom but also of my life. But if anything happens to me, in accordance with human destiny, before successors are left by me for my kingdom, I bequeath to the Romans the kingdom belonging to me, for whom from the beginning friendship and alliance have been preserved by me with all sincerity. And to the same I entrust my possessions for them to protect, appealing to them by all the gods and by their own good reputation that, if any persons attack either my cities or my territory, they may help, in accordance with the friendship and alliance which toward each other we now have, and in accordance with justice, with all their power. And I make witness to these dispositions Zeus Capitolinus and the Great Gods and Helios and the Founder Apollo, to whose custody the text of these things is also consecrated. With good luck. (*SEG* 9 [1938]: 7)

Crucially, a copy of this will was sent to Rome. Physkon himself appeared there in the following year to give the Senate a private viewing of some particularly nasty scars he had acquired. The Senate gave Physkon Cyprus. His brother was less understanding, however, and refused to let him keep it. Physkon was captured by Philometor during his invasion of the island, and sent back to Cyrenaica. The Senate had offered Physkon indecisive diplomatic support but no practical help, though it was perhaps the fear of the latter materializing that caused Philometor to show such leniency. There was some reaction in Rome, including a speech against one of the ineffectual Roman ambassadors by the great Marcus Porcius Cato, but Physkon's cause evaporated for the time being.

Philometor was soon engaged with the old enemy, Seleucid Syria. By giving his support to a pretender to the Seleucid throne by the name of Alexander Balas he sought to unseat the current Seleucid king, Demetrius I. The policy was successful and when Alexander ascended the throne in 150 BC, he took as a bride Philometor's daughter Cleopatra, soon to be known as Cleopatra Thea. Through this remarkable queen would be forged a link between the Seleucid and Ptolemaic kingdoms that would be recalled and consciously evoked by her equally illustrious namesake over a century later (cat. nos 221–222). However, Philometor's death in 145 BC on campaign in Syria ('protecting' his son-in-law's kingdom) threw the Ptolemaic house into bloody internal strife again.

Prior to his death Philometor had installed his young son, Ptolemy VII Neos Philopator (145–144 BC) as co-regent. Physkon now entered Alexandria, took the title Euergetes ('benefactor'), and married his brother's wife, their sister Cleopatra II. His gift to his bride was to have her son, the young Ptolemy VII, murdered in her arms at the wedding feast. Ptolemy VIII Euergetes II (145–116 BC) had now united the remnants of the Ptolemaic empire – Egypt, Cyprus and Cyrenaica – under one crown again. The Roman Senate does not seem to have reacted to this. There was in any case little they could do about it, and Euergetes was – not surprisingly in the circumstances – preoccupied with placating his powerful and aggrieved sister. Nonetheless, a Roman eye was kept on Egypt. In about 140 BC Publius Cornelius Scipio Africanus Aemilianus was sent as head of a fact-finding mission to the East. A report of the legates' visit to Egypt concludes, ominously, 'Astonished at the number of inhabitants of Egypt and the natural advantages of the countryside, they perceived that a mighty power could be sustained there if this kingdom ever found capable leaders' (Diodorus Siculus 28b. 3).

Capable leaders were precisely what the kingdom lacked at this point in its history. Euergetes, having successfully reunited the kingdom, undid his work by dying in 116 BC and splitting the kingdom again by the terms of his will. Cyrenaica was once more detached from Egypt and now became the kingdom of his illegitimate son, Ptolemy Apion (116–96 BC). The throne of Egypt and Cyprus fell to Ptolemy IX Soter II (first reign, 116–107 BC), Euergetes' elder son by his second wife (and niece), Cleopatra III. Further dislocation followed thanks to the machinations of Cleopatra in her attempts to install on the throne her favourite, younger son, Ptolemy X Alexander. The latter was given Cyprus to rule as viceroy, and then, following a partially successful coup, the island became the refuge of his older brother, while Ptolemy X became king in Egypt (107–89 BC). After the death of Cleopatra III in 101 BC, her younger son's popularity waned to the point where he was driven from the kingdom in 89 BC. In an attempt to regain control over his kingdom Ptolemy X appears to have sold his patrimony to the Romans for the money to equip a fleet. The instrument was a will leaving his kingdom to the Roman people. Ptolemy X died in the attempt to regain Cyprus, and the Romans seem to have been reluctant for the time being to pursue anything other than their lost money. The older son, Ptolemy IX Soter II (second reign, 89–80 BC), was thus able to reunify Egypt and Cyprus.

In the meantime Cyrenaica had been lost for good. In 96 BC Ptolemy Apion had died, and in his will had left his kingdom to the Roman people. Although Rome did not move immediately to annex the territory, Cyrenaica was now detached from the Ptolemaic realm after some two hundred years of close connection. Nevertheless, within a year of his return to Egypt Ptolemy IX found himself in a position of power that no Ptolemaic king had known since the third century BC. A Roman envoy arrived in Alexandria asking for military aid. Just as Philadelphus and Euergetes had been embarrassed by the requests two centuries earlier, so now was Ptolemy IX, for the envoy was from Sulla, a rogue general currently besieging the city of Athens without the full approval of the Roman Senate. Soter's response, like that of his forebears torn between Rome and Carthage, was to remain uncommitted. The refusal to help had no subsequent repercussions for the Ptolemaic state, but served nonetheless as a warning of the perils that Eastern powers would soon face when new Roman generals began to pursue their own ends.

Upon the death of Ptolemy IX Soter in 80 BC, the new king arrived from Rome, and with the Senate's blessing. Ptolemy XI Alexander II, the son of Soter, had been in Rome since he had been rescued by Sulla from Mithridates VI, the king of Pontus. By the time Ptolemy arrived in Alexandria, the widowed queen, Berenike III, had been ruling alone for six months and was popular in the city. Ptolemy had her murdered. It was a misjudgement: within a day Ptolemy had, in turn, been killed by the mob. This was also unfortunate: Ptolemy XI had been the Roman Senate's choice and, moreover, was the last legitimate male heir to the throne. Those in power at court had to look abroad for royal alternatives and found it in two illegitimate sons of Ptolemy IX, apparently in Syria at the time of Ptolemy XI's death. The elder was given the throne of Egypt and took the titles Ptolemy Theos Philopator ('the father-loving god') and later Neos Dionysos ('the new Dionysos'), though he was more popularly known as Nothos ('the bastard') or Auletes ('the flute-player'). The younger son became the king of Cyprus, and was also known as Ptolemy.

Matters were no longer simple. The gift of the Alexandrian throne lay (in many Romans' eyes) no longer with the court of Alexandria but at Rome, and the Senate refused to recognize the new kings. For the next twenty-two years Auletes undertook a delicate balancing act, while there were several attempts from within and outside his kingdom to displace him. Upon his accession a copy of the supposed will of Ptolemy X Alexander I leaving the kingdom to Rome was produced. During the 70s BC two legitimate sons of Ptolemy IX by his second wife

appeared at Rome to claim the throne, as did two of this queen's sons by her fourth husband, Antiochus X of Syria. But the claims of none were upheld. Then, in 65 BC the matter of the will was raised at Rome again, this time by the censor Marcus Licinius Crassus. His aim was to collect tribute at Rome: seventy years after Scipio Aemilianus' mission had pointed out to Rome the wealth that existed there, ambitious Romans were beginning to focus on the Egyptian kingdom as a source of personal enrichment. The attempt by Crassus, though thwarted at Rome, signalled the loss of independence for the Ptolemaic kings. From this point onwards Egypt became a tool for Roman politicians to wield, and the future of the kingdom would be decided at Rome. In the following year this point was enforced by the Roman general Pompey as he put an end to the Seleucid dynasty by the creation of the Roman province of Syria. However, as so often one move ahead of the other kings in reading Rome's intentions, Auletes astutely sent Pompey 8,000 cavalry to help in the conquest of Palestine.

The crisis arrived nonetheless for Auletes in 59–58 BC. In 59 BC one of the Roman consuls for the year, Gaius Julius Caesar, again threatened to raise the Egyptian question. Ptolemy is said to have dispatched 6,000 talents of silver, perhaps half of his annual revenue, to Caesar to secure his official recognition as king of Egypt by Rome. It did him little good, for while Egypt was temporarily removed from the agenda of Roman politics, there remained Cyprus. In 58 BC the Roman tribune Publius Clodius, a supporter of Caesar, proposed the formal annexation of Cyprus. The matter was dressed up once more in the rhetoric of inheritance, with the will of Ptolemy X Alexander I being invoked as justification, but this could not disguise what was essentially a Roman political act. More honourable Romans, like the famous orator Cicero, were thoroughly disgusted. So too were the people of Alexandria. Upon hearing of the annexation and the suicide of the king of Cyprus they responded by ousting their own king. On his way to Rome Auletes suffered the additional indignity of meeting on Rhodes the magistrate who had carried out the Cypriot annexation, Marcus Porcius Cato (the great grandson of Physkon's supporter). In a scene vividly recorded by the Greek writer Plutarch, Cato, who had just taken a laxative and was forced to receive the King mid-defecation, advised him to return home and even offered to mediate with the people of Alexandria. Uncertain how to take advice given in such circumstances, Auletes chose to continue his journey to Rome and was once more able to buy his way out of trouble, this time by promising the governor of Syria, Aulus Gabinius, 10,000 talents. In exile, however, he was forced to raise the money through the Roman banker Gaius Rabirius Postumus. Gabinius invaded Egypt in 55 BC, taking with him the exiled King, an occupying army (amongst whom, a young cavalry officer by the name of Mark Antony), and Rabirius as the King's new finance minister.

Auletes survived a further four years on the throne before he died in early 51 BC. His eldest surviving daughter, Cleopatra VII (51–30 BC) ascended the throne with her brother Ptolemy XIII (51–c.47 BC). The kingdom she found was now but a pale shadow of that her ancestors had ruled. Gone were the overseas provinces; gone were the lands of Phoenicia and Palestine; gone was Cyrenaica, a Roman province since 75 BC; gone too for the moment was Cyprus, absorbed into the Roman province of Cilicia. Most seriously of all, Roman troops were now stationed within Egypt itself. The price for Auletes' return had been not just 10,000 talents but, in effect, the kingdom itself. In a gesture that recalled that of Ptolemy VIII before him, Auletes sent a copy of his will to Rome to be deposited with the public record office; the Roman people were to be its guarantors.

Thus, by the time of Cleopatra's birth in 69 BC the drama of the Ptolemaic empire had been largely played out, the main parts in the final act reserved for the great men of Rome, with only bit parts for the last members of the Ptolemaic royal house. Anything Cleopatra could salvage could come only by the will of the Roman Senate, whether in the person of Caesar or Antony. And for these two men, no less than for their rapacious contemporaries like Rabirius,

the kingdom of Egypt was dead in all but name; what remained was merely the administrative shell to facilitate the dunning of the country for its vast wealth.

While Cleopatra's father was certainly Ptolemy XII Auletes, the identity of her mother is uncertain. She was most probably Auletes' full sister, Cleopatra V. The blood relationship of her parents may have left the young Cleopatra with the curious circumstance of possessing only one set of grandparents. Her grandfather was Ptolemy IX Soter II, but the identity of her grandmother, who was said to have been a concubine, is unknown. It is this last fact that has given rise to speculation of a mixed race ancestry. For the rest, she was descended from a long line of Macedonian rulers of Egypt stretching back to the conquest of the land by Alexander the Great. On the whole, this Macedonian dynasty had taken an inward approach to the preservation of the line: Cleopatra's great-grandparents, Ptolemy VIII and Cleopatra III, had been uncle and niece; her great-great-grandfather (who was thus also her great-grand-mother's grandfather) had also been the child of a brother–sister marriage [fig. 1.1]).

When Cleopatra's father had been ousted from his kingdom in 58 BC by the angry Alexandrian populace, they had replaced him on the throne with either his wife and eldest daughter or his two elder daughters: Cleopatra V or VI and Berenike IV (the sources are unclear). Cleopatra soon died, however, and Auletes had Berenike put to death on his return from exile in 55 BC. So it was that on Auletes' death in 51 BC his next daughter, Cleopatra VII, inherited the throne, along with the older of her two younger brothers, Ptolemy XIII, whom custom dictated she married. She was about seventeen years of age, he only ten. By this stage of the dynasty, surviving as a Ptolemaic monarch was a matter of performing a delicate juggling act between various influential Romans outside the kingdom, the Egyptians, the Alexandrian mob and ambitious courtiers within. Cleopatra did not so much ascend a throne as descend into a snake-pit.

As far as Rome was concerned, matters were further complicated by the enormous debts that Cleopatra's father had incurred in purchasing military support to regain his kingdom in 55 BC. In theory these were private debts, but in these turbulent years at the end of the Roman Republic few Romans wealthy enough to lend money to foreign kings were without political connections. An obligation had been created and would return to haunt the Ptolemaic house. At the same time, the shrewd Egyptian monarch would need to wed herself to the individual with most power in the East.

Matters at home were complicated too. Unrest among the native Egyptian population had long been a serious problem. The fact that Cleopatra was said to have been the first of her line to take the trouble to learn to speak the Egyptian language is perhaps indicative as much of her concern for internal stability within the kingdom as of linguistic ability. More immediately troublesome to the young queen on her accession were the court and the populace of Alexandria. The ousting of Auletes in 58 BC had been the product of Alexandrian wrath at the King's failure to stand up to the power of Rome. As far as foreign policy was concerned, this left Cleopatra in a dilemna. Failure to accede to the requests of Roman *imperatores* might lead to armed intervention; overzealous response brought with it the threat of an urban uprising. Finally, there was the court. The accession of at least one minor to the Ptolemaic throne in 51 BC brought considerable scope for machination on the part of guardians and other creatures of the palace.

Cleopatra's response seems to have been to strike out for a position of strength within the court. The few documents that survive from the first years of her reign show no sign of the existence of her brother and co-ruler; the impression is rather of the Queen taking sole control. As far as we can tell from the documents, her rule was characterized by concern for the smooth running of the Egyptian economy. It was during this period, in 49 BC, that she seems to have received her first proposition from a Roman commander, Gnaeus Pompey 'the Great'

(a nickname recalling Alexander's), who had largely forged his reputation in the East, and was embroiled in civil war with Julius Caesar, fresh from his conquests in the West. Pompey sent his son to Alexandria to request troops, ships and supplies. Cleopatra acceded to the request. There were rumours (preserved by Plutarch) of a liaison between herself and the young Pompey but, whether true or not, the fact was she had little choice in the matter of military support. Gabinius, the Roman general who had restored Auletes, had been a lieutenant of the elder Pompey, and the Ptolemaic house was thus in his debt. Indeed, some of Gabinius' troops were still in Egypt, and a contingent of these, together with fifty ships and a supply of grain, were dispatched to Pompey.

There were, however, immediate repercussions to her actions. The untraditional pose of sole queen was not to the liking of everyone in Alexandria, and her positive response to a Roman request for help, combined in 51 BC with her deportation to the Roman province of Syria of the murderers of its governor's sons, may not have helped her cause. At any event, by the middle of 48 BC Cleopatra had been driven into exile by her younger brother and his supporters. She took up residence in Arabia and Palestine, where she undertook the task of raising an army. The city of Ascalon (in modern Israel) certainly seems to have remained faithful to her at this period, minting coins in 50/49 BC and (probably) 49/48 BC with the queen's portrait (cat. no. 220). At Alexandria the young Ptolemy seems to have claimed sole rulership. By late summer of 48 BC the opposing armies of Cleopatra and her young brother were facing each other at the eastern end of the Delta, when events elsewhere overtook them.

On 9 August 48 BC Caesar had comprehensively defeated Pompey in battle at Pharsalus in Greece. Pompey fled to Alexandria with Caesar in hot pursuit, and it was time once more for the Ptolemaic court to take sides in a Roman dispute. A throne was set up for the fifteen-year-old king at the harbour's edge, whence he watched as Pompey was ferried ashore and stabbed by one of his former officers, now in Ptolemaic service. Four days later Julius Caesar sailed into the harbour with a force of just 4,000 men and was presented with the severed, pickled head of his defeated rival. The attempt to placate him failed; he marched into the royal palace in Alexandria, set up residence there and summoned Ptolemy to meet him. For Ptolemy attendance was a simple matter, since he controlled the city. Cleopatra, famously, was reduced to subterfuge to gain entrance to the palace.

> Taking just one of her courtiers, Apollodorus the Sicilian, she boarded a small boat and landed near the palace at dusk. Unable to think of any other way to enter unnoticed, she lay down full length in a bed-linen sack, and Apollodorus tied the sack up with a strap and carried it through the gates to Caesar. Caesar, it is said, was immediately taken with this trick of Cleopatra, and the coquettish impression it made and, becoming more so through further getting to know her and her charm, resolved to re-establish her on the throne with her brother. (Plutarch, *Caesar*, ch. 49)

Caesar's espousal of Cleopatra's cause did not endear him to her brother, his army or an increasingly hostile Alexandrian mob. By November 48 BC the great dictator found himself besieged with Cleopatra in the palace while the mob outside proclaimed a new queen, Arsinoe, Cleopatra's younger sister. An indecisive war ensued, which was not ended until the arrival of Caesar's reinforcements in March of the following year. Ptolemy XIII fled and was drowned in the Nile, while Arsinoe was to return captive with Caesar to Rome, where she would be paraded in a triumph in 46 BC. Cleopatra, who still, according to custom, needed a male co-regent, now married another younger brother, Ptolemy XIV. Only eleven at the time of the marriage, the new king was presumably in no position to complain about the state in which he received his bride; for the long winter nights within the besieged palace had not been without their amusement, and on 23 June 47 BC Cleopatra bore Caesar a son, Ptolemy Caesarion. On the island of Cyprus, which Caesar now restored to the Ptolemaic kingdom,

the event was commemorated, though how long after we cannot say, on a bronze coin bearing the portrait of the queen holding her young son (cat. no. 186).

Caesar was now faced with a dilemma. There was a strong ideological principle that had run through Roman imperial policy for centuries favouring devolution rather than central-ization. It was far more efficient to leave local rulers in control of an area and encourage them to exploit it than to impose a central Roman-run bureaucracy. Caesar was clearly of the impression that Cleopatra was at once cautious and unambitious enough not to cause any long-term problems for himself in the area, while at the same time shrewd enough to run the country with the efficiency required to produce a strong revenue for Rome. The problem was how to establish her firmly in power. Caesar had two answers. First he took Cleopatra on a Nile cruise, though not of the conventional kind: they were accompanied by an army carried, it was said, by 400 ships. This was a deliberate display of Roman military might to all the people of Egypt. Secondly, he resolved to leave behind three of the four legions he now had in Egypt as an occupying army. We are fortunate to possess the words of one of Caesar's officers on his motives for leaving these troops:

> … so that the power of the monarchs might be stronger, since they had neither the love of their own people (because they remained faithful to Caesar), nor the authority that derived from length of rule, having been established as rulers for only a few days. At the same time, Caesar thought it beneficial to the smooth running and renown of our empire, that the king and queen should be protected by our troops, as long they remained faithful to us; but if they were ungrateful, they could be brought back into line by those same troops. (Caesar, *The Alexandrian War*, ch. 33)

Inveterate womanizer Caesar may have been; blinded by infatuation he was not. For the time being he moved on. Further military campaigns led him via Syria to Asia Minor and then to Africa, where, it was said, he indulged himself in another royal affair with Queen Eunoe, wife of Bogudes the Moor. Finally, in 46 BC he returned to Rome, where, at last, he held his triumphs. And Cleopatra, with her brother, followed. Quite whose initiative the Queen's excursion to Rome was remains unclear. A later source implies that Caesar summoned her, though his reasons for doing so if this were the case, and for including her husband in the invitation, remain unknown. It is not impossible, however, that the trip was her own idea, for diplomatic reasons. If so, it was a bold move to leave her kingdom for so long, so soon after her restoration to the throne. Beyond dispute, though, are the facts that she stayed as the guest of Caesar on his estate across the Tiber, and that this did not meet with everyone's approval: Caesar was married to Calpurnia at the time. However, the Queen succeeded in obtaining the formal friendship and alliance of the Roman people for herself and her husband. Most remarkable was Caesar's decision to dedicate a gold statue of Cleopatra in his new temple of Venus. The precise import of this act is lost to us, although it is clear that Venus, as the mythi-cal ancestor of Caesar's family, held a particular place in the dictator's world view.

Ultimately, however, Caesar's divine origins were of little use to him, or to Cleopatra. Following his assassination on the Ides of March 44 BC, Cleopatra and her retinue soon departed the capital and returned to Egypt. In the struggle for pre-eminence that would ensue Cleopatra now held a trump card: the son of Caesar. To Caesar's legal heir, his eighteen-year-old great-nephew Caius Octavius (Octavian), this would prove an embarrassment. To Octavian's opponents, in particular Mark Antony, his significance would not be lost. Cleopatra was quick to seize the opportunity thus offered: within a month or so of their return to Egypt, her husband was (conveniently) dead, and Caesarion was elevated to the throne in his place as Ptolemy XV Theos Philopator Philometor ('the father and mother-loving god'). He was three years old.

There will have been more pressing concerns that forced Cleopatra into her elevation of Caesar's son. She was now alone, her protector dead, with only the three legions he had left

behind to guarantee her safety. Their loyalty had now to be won, and marriage to their general's son was an obvious gambit. Indeed, the fragility of Cleopatra's position in Egypt was soon exposed in the conflict that followed Caesar's death. Caesar's assassins Brutus and Cassius fled to the East; they were opposed in the West by an uneasy alliance of Mark Antony, Octavian and Caesar's former lieutenant, Marcus Lepidus. This triumvirate moved to crush the assassins' armies in the east, and as Cassius sought help against them from Egypt, Cleopatra found herself playing a delicate diplomatic game. Matters were complicated by the defection of her governor of Cyprus to the cause of Cassius, probably in the hope of deposing Cleopatra and replacing her with her sister, Arsinoe, who had been freed after Caesar's triumph and was now residing in Ephesus. Faced with the threat of invasion from Cassius, the only hope of salvation lay with the triumvirs in the West. Cleopatra set about the construction of a fleet, and in 42 BC she sailed it westwards to meet Antony and Octavian, only to be hit by a storm off the coast of Africa. The fleet was all but destroyed and Cleopatra was forced to turn back to Alexandria to begin again.

Cleopatra's instincts had been right. The potency of Cassius and Brutus in the East could only be short term, and to have allied herself with them would have led to her downfall. While she was engaged in the construction of her second fleet, news arrived that the assassins had been defeated and killed by Mark Antony in battle at Philippi in northern Greece. Now, in the autumn of 42 BC, the world was divided between two men: to Octavian fell the West; to Antony the East.

Few things went down as well with the Senate and People of Rome as a resounding military victory. Antony now set his sights on the conquest of Rome's major enemy in the East, the Parthian empire, whose heartland lay in the territory covered by modern Iran and Iraq. To launch such an assault, he would require a base in the East and a secure source of supplies for his army. Egypt was the obvious choice, and Antony summoned its queen to meet him at Tarsus in southern Asia Minor. To believe the ancient sources, where Julius Caesar had preyed upon women, Mark Antony was himself the prey. Certainly the story of how Cleopatra turned what might have been a diplomatically tricky summons into the seduction of the ruler of the Roman East has captured minds ancient and modern alike. She seems to have arrived at the meeting in considerable style, and set out to create an impression, although we should not forget that Antony and Cleopatra had met before, probably when Antony served as a junior officer under Caesar in Alexandria, as well as during the queen's stay in Rome. He will already have been well aware of the queen's nature and lifestyle. The meeting at Tarsus was thus foremost an event of showy though transparent diplomacy, and for Cleopatra the act paid off. She retained her kingdom and she secured the support of the new commander of the East.

Antony returned to Egypt with Cleopatra and over the winter of 41/40 BC twins (to be named Alexander and Cleopatra) were conceived. By the time of their birth in the autumn of 40 BC, however, Antony was back in Italy and about to marry his second Roman wife. In October a deal was brokered between Antony and Octavian, and secured by the marriage of the former to the latter's sister, Octavia. For the time being Cleopatra was forgotten. We hear nothing of her activities for three years. In part she was undoubtedly concentrating on the running of her kingdom. At the same time she will have kept a close eye on the rise of Parthia, whose armies were rapidly advancing towards the borders of Egypt.

For a brief period Antony's marriage to Octavia seems to have worked in keeping the peace between him and Octavian. All the outward signs are of Antony taking the relationship seriously, notably in issues of his coinage bearing Octavia's portrait (cat. no. 259). By the autumn of 37 BC Octavia was pregnant with their second child, but relations between her husband and brother were worsening and it seems probable from Antony's actions that he had given up

hope of any military help from Octavian and the western part of the empire towards the great Parthian campaign that was still at the heart of his plans in the East. In a sense he was back to the situation of 41 BC, and he repeated his actions of that year. Leaving his wife behind in Italy, he sailed east to Antioch in Syria, whither he again summoned Cleopatra to meet him. She remained with him there through the winter of 37/36 BC as Antony completed his settlement of the East.

In concept, there was a certain element of innovation to Antony's scheme: there would henceforth be two systems of administration in the East. On the one hand the existing system of provinces would be retained in the key areas of Macedonia, Achaea, Asia, Bithynia and Syria. On the other, a system was set up of client kings or tyrants who were to be responsible for administering territories not directly under Roman rule: Polemo in Pontus, Amyntas in Galatia, Archelaus in Cappadocia, Herod in Judaea and Cleopatra in Egypt. In itself there was nothing new in the policy of client kingdoms. Antony's innovation was, in all but one of these cases, to appoint client kings from outside the dynasties he found already in place. Far from maintaining old political structures and loyalties, Antony created new ones.

From these kingdoms Egypt stood out as the plentiful treasury and abundant granary out of which Antony would build and feed his campaign in the East, and it was with this in mind that he set about adding to its resources. It was no doubt to Cleopatra's delight – though we cannot tell how far it was at her instigation – that new territories were added to her domain. Principal among these were the areas of southern Syria and Ituraea. These, together with areas of Cilicia also given to Egypt by Antony, and Cyprus, which had been restored by Caesar, turned the eastern end of the Mediterranean into a Ptolemaic lake, albeit a lake circumscribed by Roman owned provinces and Roman supported kingdoms.

Nonetheless, Cleopatra clearly revelled in her new territories, and cities within them responded to her. Some of them began to adopt her portrait for their coinages. It is perhaps to 37/36 BC and Antioch that the remarkable silver coinage belongs, with Cleopatra on the obverse and Antony on the reverse, giving the former the title Cleopatra Thea Neotera (cat. nos 221–222 and cf. 232–234). This title, which a document from Egypt confirms was current there by 36 BC, is a deliberate allusion to Cleopatra's great great aunt, Cleopatra Thea, the daughter of Ptolemy VI Philometor; wife of the Seleucid kings Alexander I Balas, Demetrius II and Antiochus VII; and mother of Seleucus V (whom she murdered), Antiochus VIII and Antiochus IX. The allusion was not just to an awesome namesake, but also to a queen of Ptolemaic blood who had previously ruled in Syria. Cleopatra was proud of the extent to which she had increased her inheritance.

Having thus disposed the lands that would lie in his rear, and dispatched Cleopatra back to Egypt, Antony set off in 36 BC on his first great Parthian expedition. It was an unmitigated disaster: a combination of poor tactics and treachery led to a rout of the expeditionary force. By the time Antony had brought his bedraggled army back to Syria, he had lost one third of the 60,000 legionaries he had set out with and approaching half of the 10,000 cavalry. In place of a message announcing victory he was compelled to write to Cleopatra instructing her to sail to Syria with fresh clothes for his troops. Cleopatra, who just given birth to her third child by Antony, Ptolemy Philadelphus, finally arrived in Syria with the spare clothes in January of 35 BC. The couple then retired to Alexandria for the winter.

Antony, desperate to resume his Parthian offensive in 35 BC as a means to recover lost face, was in a vulnerable position. His army needed reinforcement, and Octavian, via his sister Octavia, offered Antony a mere 2,000 troops. It was an offer easily declined, and Antony sent his wife back to Octavian for the last time. For the level of support he needed there was now only one possible source – Egypt. But Antony clearly felt it necessary in the short term to bolster Cleopatra's possessions with a further grant of land, this time at the

expense of the Jewish king, Herod. Cleopatra, in fact, had a long-standing grudge against Herod, and dispossessing him of his last remaining Mediterranean harbour at Gaza may have been at her suggestion.

The campaign of 35 BC was not to be, however, as trouble with the Republican rebel Sextus Pompeius (son of Pompey the Great), who had been flushed out of the western Mediterranean by Octavian, diverted Antony to Asia Minor for the best part of the campaigning season. Thus it was in 34 BC that Antony next set off for Parthia. He took Cleopatra with him this time as far as the River Euphrates, before sending her back to Egypt. Cleopatra seems to have been in no hurry to return: she spent the summer progressing through her Syrian domains before finally inflicting her company on her old enemy Herod. An account of her behaviour while staying in the palace at Jerusalem is preserved by the later Jewish writer Josephus, probably ultimately deriving from Herod's own written account:

> While she was there, being frequently in Herod's company, she sought to have sex with the king, and she made no secret of her indulgence of such pleasures. Perhaps she did indeed feel lust towards him or, more probably, was plotting that any violence that was done should be the beginning of an ambush for him. In any event, she gave a fair impression of being overcome with desire. Herod, who had for a long time borne the queen no goodwill, knowing her to be vicious to all, thought her now even more despicable if she proceeded out of lust, and weighed up the possibility of having her killed, if such were her intentions. (Josephus, *Jewish Antiquities* Book 15, chs 97–8)

Given his personal feelings towards the Queen, Herod is perhaps not the most trustworthy of sources. But the mere fact of the Queen's visit to the neighbour at whose expense she had recently increased her domains was provocative in itself.

Cleopatra's star was now in its brief moment of ascendance. Antony returned in triumphant mood at the end of 34 BC, having achieved a limited victory in Armenia. A grand procession took place in Alexandria after which Antony,

> having filled the gymnasium with a crowd and set up two thrones on a silver platform, one for himself and one for Cleopatra, and other lower ones for their children, in the first place declared Cleopatra queen of Egypt, Cyprus, Libya and Coele Syria. Co-regent with her was Caesarion, who was regarded as the son of the former Caesar who had left Cleopatra pregnant. Secondly, he proclaimed his sons by Cleopatra as Kings of Kings: to Alexander he assigned Armenia, Media and the lands of the Parthians (when they had been conquered); to Ptolemy, Phoenicia, Syria and Cilicia. At the same time he brought forward Alexander in Median dress, including a tiara and upright Persian head-dress and Ptolemy in boots, a cloak and a kausia bearing a diadem: the latter was the dress of the successor kings of Alexander, the former that of the Medes and Armenians. When the two children had embraced their parents, an Armenian guard encircled one, a Macedonian the other. Cleopatra both then and at other times when she appeared in public, took the holy dress of Isis, and was treated as the New Isis. (Plutarch, *Life of Antony*, ch. 54)

Antony himself, of course, had no place in this partition of kingdoms. He stood outside and above the new realms he had created, as Roman triumvir for the establishment of the state. Once again there was nothing shockingly new in the system of organization that Antony imposed on the East: he was placing the lands at the eastern boundaries of the Roman Empire in the hands of client monarchs whom he knew he could trust. The unconventionality lay in the fact that some of these kings were also his children. But at the same time he was ensuring the loyalty of the land that was rapidly becoming the guarantor of his future eastern campaigns, Egypt.

To the other triumvir, Octavian, Antony's close relations with Cleopatra gave him the opportunity to show his anger in public: Antony was, after all, married to his sister. The text of part of a letter, written by Antony in response to criticism by Octavian at this time, survives in the later account of Suetonius.

What has changed your mind: that I am screwing the queen? Is she my wife? Have I just begun, or have I been doing it nine years already? And do you only screw Drusilla? You're doing well if, by the time you read this letter, you have not screwed Tertulla or Terentilla or Rufilla or Salvia Titisenia or all the rest. Does it really matter where and in whom you get it up? (Suetonius, *Life of the Deified Augustus*, ch. 69)

If genuine, the letter provides evidence not just of the breakdown of relations between the two men, but also, perhaps, of the low value that Antony placed on his liaison with the Queen. The real bones of contention between the two triumvirs were not women but territories, and throughout late 34 BC and early 33 BC the Senate was beset by claim and counterclaim on the part of the two generals. Antony was back on campaign in Media when a letter arrived from Octavian demanding a share of Armenia in return for a part of Sicily. To Antony it was now clear that matters would have to be resolved in the West. He instructed Canidius, one of his officers, to embark sixteen legions, summoned Cleopatra to join him, and set off to Ephesus for the winter.

The decision to summon Cleopatra to Ephesus was understandable. For over 150 years Hellenistic monarchs had been fighting alongside Roman generals, and for them to attend if their forces were present was the rule rather than the exception. For her part, Cleopatra probably had little choice but to answer the call, although it will have been apparent to her that by so doing she was destroying any possibility of a subsequent rapprochement with Octavian. To have refused Antony would have left her, her kingdom and, crucially, her children vulnerable to those of Antony's legions still in the East. And, in reality, Antony probably looked the surer option at the end of 33 BC. Two of his staunch supporters had been elected to the consulship at Rome; a large number of the Senate were firmly on Antony's side (see p. 191); Antony was the more experienced commander; and with her support he would have the more powerful army.

Antony's cause began to collapse in February of 32 BC, when Octavian arrived in the Senate with a bodyguard and made a case against him. Some two to three hundred Senators responded to his intimidation by departing Rome for Antony's camp. Antony did not hasten to defend his reputation at home. In April he and Cleopatra sailed from Ephesus to Samos where they held a large dramatic festival. In May they sailed on to Athens and here, in the city where he had once lived with Octavia, he repudiated her: now that relations with Octavian had irretrievably broken down, he had no need of a marriage to his sister. The Athenians seem to have admired Cleopatra: a statue of her in the guise of Isis was erected on the Acropolis (Dio Cassius, 50, 15, 2), and Athenian coinage of this period bears consciously Egyptian references. By the autumn of 32 BC, however, Antony and Cleopatra had moved on to their winter quarters at Patras in the north-western Peloponnese. They were now situated at the mid-point of a line of Antonian bases running up the west coast of Greece from Methone in the south to Actium in the north. There they awaited Octavian.

In the spring of 32 BC hostilities commenced, as Octavian's great lieutenant Agrippa captured the base at Methone by surprise and began to capture the remaining Antonian bases from the south. Within weeks Antony and Cleopatra had been forced to move north to Actium, which was now under threat from Octavian himself. The Antonian forces became blockaded in the large bay at Actium. Attempts to break the blockade failed through the summer until by September the only options open to Antony were either to abandon Cleopatra's navy and withdraw with his legions by land, or to split his forces by withdrawing partly by land and making one final naval breakout. In the event, he opted for the latter. Later speculation was that Cleopatra would not let him abandon her precious navy; but, equally, the naval breakout may have looked a safer option than a forced march under pursuit. It certainly offered the possibility of saving some of the fleet. And so it was that on 2 September 31 BC Antony and Cleopatra boarded their ships and headed for Octavian and Agrippa's naval lines. The plan succeeded, in that both Antony and Cleopatra escaped with their

lives and 60 of the 230 ships that sailed. But the battle would for ever after be remembered as the great victory of Octavian.

Antony and Cleopatra fled to Africa: Antony to Paraetonium in Libya to guard against an attack by his former officer in Cyrenaica, Lucius Pinarius Scarpus who quickly switched sides after Actium,

> while Cleopatra hurried to Egypt in case the people, hearing of the disaster that had befallen her and Antony, should rise up in revolt. To ensure that she made a safe approach, she garlanded her prows as if she had been victorious, and had victory odes played by flute-players. But when she had reached safety, she murdered many of the foremost men because they had always hated her and were now openly enjoying her downfall. And she collected together huge treasure from her own possessions and those of others, holy and sacred, sparing not even the holiest of temples. She prepared her forces and began to look around for allies. (Dio 51. 3–5)

After a few weeks Antony went to join Cleopatra in Alexandria, where the two began to plan for the future: now, for the first time, Antony's destiny lay entirely in the hands of the Queen.

They did their best at first to create a semblance of normality within Alexandria. A huge festival took place to celebrate the coming of age of Caesarion and Antyllus (Antony's elder son by Fulvia), the former in Greek style, the latter in Roman. There was still a clear division in Antony's mind between his eastern and western lives. With Antony's military might now gone, however, Cleopatra needed once more to find a strong protector. About the only option left to her was the kingdom of Media, but direct access to the East was now blocked to her by the defection of Antony's forces in Syria and of Herod the Great to Octavian. She attempted to send Caesarion to India, and hauled her Mediterranean fleet overland to the Red Sea, supposedly with the intention of following him. But the ships were burnt by the Nabataean Arabs, who had once supported her.

Cleopatra and Antony were now trapped in Alexandria. In the summer of 30 BC Octavian began to close in with his army from Syria, while his lieutenant Cornelius Gallus moved in from Cyrenaica in the West. Cleopatra sent an embassy to Octavian offering to abdicate in favour of her children; there was no reply. Antyllus was dispatched to offer Antony's retirement to private life; there was no reply. Cleopatra offered again to abdicate; again no reply. As Gallus and Octavian closed on Alexandria, Antony prepared himself for one last battle. On 1 August 30 BC he set out by land and sea and was comprehensively defeated. As Octavian entered the city Cleopatra fled to the treasure-house she had created out of her mausoleum. When news reached Antony that the Queen had killed herself, he fell on his sword. The news proved false however, and the dying Antony was carried back to the mausoleum and hauled through a window to expire in Cleopatra's presence. Upon the arrival of Roman forces Cleopatra refused to leave the building but was easily tricked and overcome by Gallus and another of Octavian's lieutenants, Proculeius. Removed to the palace, she was kept for several days under guard, while Octavian hinted to her that suicide would be the simplest exit for all concerned. Accepting the inevitable, she asked to visit Antony's grave to pour a libation.

> Having finished her lamentation, and wreathed and embraced Antony's urn, she ordered that a bath be prepared. Having bathed she reclined and ate a sumptuous meal…. After her meal, Cleopatra took a writing tablet which had already been written on, added her seal to it and sent it to Octavian. Then, sending away all but her two woman-servants, she closed the doors. Octavian opened the tablet and, reading her passionate plea that he should bury her with Antony, immediately knew that the deed had been done. At first he got up to go to her himself, but then sent men quickly to see what had happened. But her end had been short and swift. For the men ran to her apartment and, finding the guards aware of nothing, threw open the doors. There they found her lying dead upon her golden couch, laid out in royal state. Of her two servants, the one called Eiras lay dead at her feet, while Charmion was staggering and clumsily trying to arrange the diadem around the queen's head. When

one of the guards exclaimed in anger, 'This is a fine thing, Charmion!' the woman replied, 'The finest indeed and fitting for one descended from so many kings.' (Plutarch, *Life of Antony*, ch. 85)

'The truth about the manner of her death no one knows', Plutarch was forced to admit.

Cleopatra was survived by all her children. Caesarion was subsequently caught in flight from Egypt and, like Antyllus, executed by Octavian. The three children by Antony were spared. Cleopatra Selene was taken to Rome to be paraded before the Roman people in Octavian's triumph. She was subsequently married to King Juba II of Numidia, to whom she bore a son, Ptolemy (cat. nos 271–275). Her brothers, the grandly named kings Alexander Helios and Ptolemy Philadelphus, were sent with their sister to live out their lives in complete obscurity.

Alexandria

JOHN RAY

J-P. Golvin, watercolour
showing the Canopic street
looking west from its
intersection with the main
north-south axis (crossing of
R1 and L1), after *Alexandria
Rediscovered* (London 1998)
47.

I n the early days of July, 168 BC an Egyptian named Hor of Sebennytos had a dream. The times were dangerous: Antiochus, king of Seleucid Syria, had invaded Egypt and was encamped on the coast near the capital. The ramshackle army of the Ptolemies had been no match for the invader, and the only way out was to appeal to Rome. Two years earlier the king of Egypt, Ptolemy VI Philometor, had been reduced to going to Rome and taking up lodgings in the house of a painter and decorator. The idea was to move the Roman Senate to take pity on a garret-dweller down on his luck, who had been thrown out of his kingdom by an over-ambitious brother. We know this from the pages of the historian Polybius, who met the Egyptian king while he was in these poor lodgings. Ptolemy's pathetic appearance won him support on that occasion, but anyone in Egypt with political insight knew that another appeal to Rome would come at a high price. The dynasty was in acute trouble. In his dream Hor, an Egyptian priest who doubled as the committee secretary to a sacred ibis-shrine, saw the goddess Isis walking upon the waters of the Syrian sea until she reached the harbour at Alexandria. There she announced that the city was safe and that an heir to the throne was about to be born, and Hor concluded from this that all would be well. He even persuaded one of the Greek officers in the Ptolemaic army, who by now must have been a very worried man, that the gods of Egypt could predict the future with authority. Hor's dream won for this humble Egyptian an interview with the Ptolemaic king, his queen and his troublesome brother in the great temple of the god Serapis, which stood at the south-western end of Alexandria near the native quarter. We know this interview took place on 29 August 168 BC. We know this, because we have Hor's account of it, unearthed twenty-two centuries later, in the 1960s, from the sand of Saqqara, some three hundred kilometres from Alexandria. One of Hor's draft letters had his inky thumbprint on it, where he had made one of his frequent alterations.

About the time of Hor's interview a neighbour of his also had a dream. This was a Macedonian named Ptolemy, son of Glaukias, a recluse who seems to have suffered a prolonged identity crisis. Ptolemy's dream was more personal than Hor's. He, too, dreamt that he was in Alexandria, but standing on top of a high tower. In this dream he discovered that he had a beautiful face, which was one of the attributes of divinities, but he did not want to show

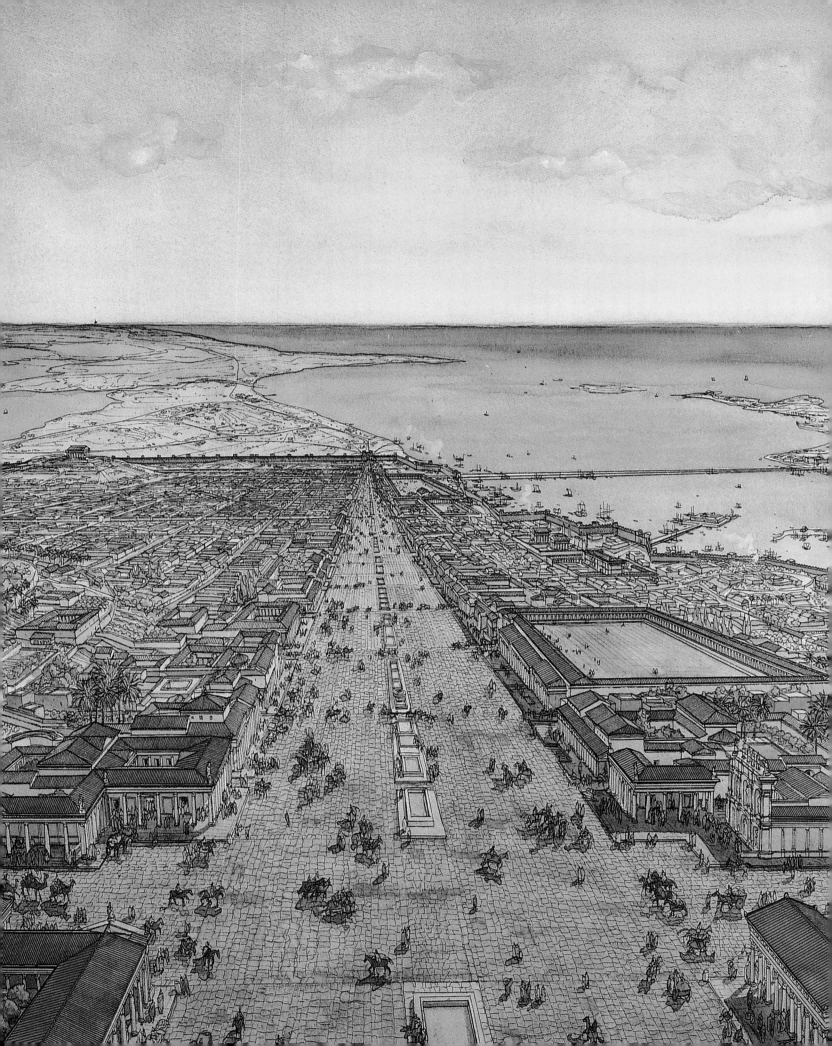

it to anyone, because it was beautiful. We have no idea what Ptolemy looked like in reality, but it does not take too much imagination to see his dream as the recluse's own commentary on the paradox that he spent his life hiding himself away from the people he knew while expressing constant concern for them. Standing on a tower in Alexandria is not a bad way of attracting attention, especially if you do not have to do it in reality. But the point is that Ptolemy, too, dreamt of Alexandria.

The city seems to have had a similar effect on the Arab poet known to E. M. Forster as el-Deraoui (Forster, 1974: 147–50), although he could not possibly have known of Ptolemy the recluse's correspondence. In one of his poems, the writer imagines himself at the top of the Pharos lighthouse itself, mingling with the clouds:

> A lofty platform guides the voyager by night, guides
> him with its light when the darkness of evening falls.
> Thither have I borne a garment of perfect pleasure
> among my friends, a garment adorned with the memory
> of beloved companions.
> On its height a dome enshadowed me, and thence I
> saw my friends like stars.
> I thought that the sea below me was a cloud, and that
> I had set up my tent in the midst of the heavens.

The poem appears to be genuine, although details about the poet are hard to find. Forster's version may owe something to his translator, but it fits the image of our city well enough. Perhaps it is right to think of Alexandria as a city of dreams. Many of its inhabitants have a contemplative quality to them, and undisputed men of action, like Octavian, Napoleon and Nelson, have a habit of appearing briefly in the place and moving on swiftly. Mark Antony, who had certainly been a man of action in his youth, is transformed by the place – or by the seductions of alcohol and Cleopatra – into a languid loser. One of the acts of Antony and his femme fatale is to set up a dining club known as the Synapothanoumenoi, 'those who are about to die together', perhaps alternatively rendered as 'We'll all go together when we go.' According to Plutarch (75, 4–5), almost the last act of Antony before losing to Octavian is to go to the window and look down into the dark street, where a party of revellers is being piped on its way home. Constantine Cavafy, in his poem 'The God Abandons Antony', turned this moment into a piece of wistful stoicism, a farewell to the greatest but most capricious of cities:

> When suddenly there is heard at midnight
> A company passing invisible
> With wonderful music, with voices,–
> Your fortune giving way now, your works
> Which have failed, the plans of a lifetime
> All turned illusions, do not mourn uselessly.
> As one prepared long since, courageously,
> Say farewell to her, to Alexandria who is leaving.
> Above all do not be tricked, never say it was
> All a dream, and that your hearing was deceived;
> Do not stoop to such vain hopes as these.
> As one prepared long since, courageously,
> As becomes one worthy as you were of such a city,

Firmly draw near the window,
And listen with emotion, but not
With the complainings and entreaties of cowards,
Listen, your last enjoyment, to the sounds,
The wonderful instruments of the mystic company,
And say farewell, farewell to the Alexandria you are losing.

(J. Mavrogordato (tr.), *Poems by C.P. Cavafy*, Hogarth Press, London 1971)

Even for Alexander, whose claim to be a man of action is a good one, the city was a place in which to be admired as a corpse. His body was hijacked by one of his generals, who became Ptolemy I, and re-routed to the new foundation by the sea. For centuries the conqueror of the world lay in his golden sarcophagus (later said to have been pawned by a bankrupt Ptolemaic king). His tomb was at the centre, where the Canopic way, with its green awnings, intersected the Street of the Monument, and he may still be there to this day, since no one seems ever to have found him. Later, with the growth of Christianity, Alexander was replaced as the city's most illustrious corpse by St Mark, who was given a basilica of his own. But he too fell into disrepair, and in 828 he was smuggled out of his city by ruthlessly ambitious Venetian merchants, who, at the customs, declared the saint to be a barrel of pickled pork. It is amusing to toy with the idea that the officers were deceived with the wrong body, in which case Alexander the Great is now sleeping under St Mark's in Venice. There would be something very Alexandrian about the irony of this, but historians will conclude that it is a bit too romantic to be true. The finest example of the dreamy loser in Alexandria is probably Cavafy's Levkios, whose death at the age of twenty-seven is recorded in a poignant and fragmentary Greek inscription, which appears to have been made up by the poet:

IN THE MONTH OF ATHYR
I read with difficulty
 upon the ancient stone
'O LO(RD) JESUS CHRIST'
 I can make out a 'SO(U)L'.
'IN THE MO(NTH) OF ATHYR
 LEVKI(OS) FELL AS(LEE)P.'
At the mention of his age
 'He LI(VE)D' so many 'YEARS'
The Kappa Zeta means
 quite young he fell asleep.
In the damaged part I see'
 'HI(M)….ALEXANDRIAN'.
Then there are three more lines
 very much mutilated;
But I make out some words
 like "OVR T(E)ARS", and "SORROW",
Afterwards 'TEARS' again,
 and 'OF H(IS) GRIEVING (FR)IENDS'.
I see that Levkios
 had friends whose love was deep.
In the month of Athyr
 Levkios fell asleep.

(J. Mavrogordato (tr.), *Poems by C.P. Cavafy*, Hogarth Press, London 1971)

Mavrogordato notes that the kappa and zeta refer to the youth's age at death – twenty-seven – and the month of Athyr is the ancient Egyptian November. Unreal perhaps, but Levkios achieved immortality in his way.

The languidness of Alexandria, at least in the imagination, is unmistakable, but it contrasts with another aspect of the city, its restlessness. Analogies are half-truths, but it is not too fanciful to call Alexandria the New York of the ancient world. It was laid out in a grid pattern by the sea, to take advantage of the prevailing winds. Its colonnades were gleaming white, at least when new, and dark clothes were advisable if you wanted to be seen. There were passenger terminals, world-class libraries, and financial houses. Automatic doors were designed for some of the buildings, and there were rudimentary coin machines. Its quarters were named after the letters of the alphabet, and it may have been the first place in history to have addresses in the modern sense. If a man told you he lived in Delta, he was probably Jewish, and there were more Jews in Alexandria than anywhere else, except presumably Palestine. The city drew immigrants from most of the Greek world, and most of everywhere else, and race riots were frequent, as, one suspects, were fast food and street crime. The place was a magnet for soothsayers, charmers, storytellers, people offering an easy route to personal salvation, people come from somewhere that they were not in a hurry to go back to, and cranks. In the Christian era even the porters at the docks were famous for arguing about philosophy and the latest heresy. The Ptolemaic rulers and Roman emperors were popular only fitfully, and the Alexandrians had some witty derogatory nicknames. As the emperor Hadrian put it in retaliation, 'I wish this body of men were better behaved.'

The soul of the place must have been quite superficial, yet it was also a university that attracted the best minds of the Mediterranean and North Africa. Perhaps this contrast is not a true one: there are other times and places where the intellect and the shallow-minded find a strange attraction for each other. Alexandrians wrote Euclid and Ptolemy's *Almagest*, peopled the first museum, transformed astronomy and the calendar, discovered how the monsoons worked and how to trade with India and the Far East. They dissected corpses, and set up a form of universal health service; the first of these practices extended to Egyptians, though it is doubtful whether the second did. There were models powered by steam, and in the temple of Arsinoe Zephyritis overlooking the sea there was said to be an iron statue that floated in mid-air. This has never been explained and it may just be part of the gossip that filled the place. But it feels as if it ought to be right, since it is a fine example of the intellect and the superficial showman working closely together.

Alexandria may have been a home of scholarship, but until recently it has been one of the 'black holes' of Mediterranean archaeology. Egyptologists have tended to ignore the place, being busy with the monuments of earlier dynasties. All of ancient Alexandria lies underneath a crowded modern city, and there are few monuments surviving above ground to kindle curiosity about what lies beneath. The Pharos collapsed into the sea in the Middle Ages, and Cleopatra's Needles are now on the Embankment in London and in Central Park, New York. True, there is Pompey's Pillar, which is nothing to do with Pompey, but not bad as pillars go. The site of Alexander's tomb may or may not correspond to the mosque of the Prophet Daniel on the street of the same name, but there is little else one can say about it, and tiny pictures on the back of half-decayed coins are no substitute. The British governed the city for a while, along with the rest of Egypt, but with a few exceptions British archaeologists have ignored the place, and until recently most of the systematic work on the site has been conducted by a Polish team.

The land aspect of Alexandria may be a disappointment, but what has come to its rescue is the sea. This is appropriate, since some of ancient Alexandria must have been built on land reclaimed from the water or built artificially over it. The rediscovery of Napoleon's flagship,

L'Orient, at the bottom of Abukir Bay to the east of the city gave an impetus to the development of underwater archaeology and, once the place had ceased to be a Soviet naval base and military sensitivities had cooled, divers were ready to explore the waters of the two ancient harbours. During the past few years most of this work has been done by two Franco-Egyptian teams. One is dredging the sea below the remains of the Pharos (Empereur, 1999), the other has concentrated on the area to the eastern end of the main ancient harbour, north of where the royal palaces were believed to be (Goddio, 1998). It is now clear that the palaces have been misunderstood. Since 1992 the work of the Institut Européen d'Archéologie Sous-Marine has shown that, thanks to subsidence of the coastline and the effects of earthquakes and tidal waves, the seabed in this area is covered with a large part of the royal quarters themselves, together with a submerged island, the ancient Antirrhodos – part of a peninsula, the ancient name for which is Lochias – and a sunken harbour, whose monumental stone blocks may be Ptolemaic rather than Roman. The harbour was found complete with a shipwreck. It was on Lochias and Antirrhodos that Antony and Cleopatra played out the last act of the Synapothanoumenoi, and Antony turned disillusionment into architecture by building a shrine called the Timoneum, after the misanthrope of Athens. Shortly afterwards, they were buried not far from it.

It was no surprise to find that discoveries of the underwater archaeologists at the site attracted immediate attention in the press, which did little to undo the impression that Cleopatra's palace was intact down there, with the calendars stopped at the moment the asp took its bite, and, if Shakespeare was a reliable guide, the billiard tables still laid out for the next game. In truth, the palace area must have been used in one capacity or another for three or four centuries after the death of Cleopatra, and there is little reason to think that the Roman governors who succeeded her were nostalgic about her memory. In fact, we do not need her, since the site is unique in its own right. Thanks to the work of both French teams, and their Egyptian collaborators, another feature of Alexandria is becoming clear. The place, at least in the Roman period if not earlier, was littered with Egyptian monuments: statues, sphinxes, obelisks and other paraphernalia, liberated from native cities in the Delta such as Sais and Heliopolis. The sea beneath the area of the Pharos has produced stacks of these, reused as ballast to prevent further subsidence into the water. The same applies to the site of the submerged palace, which must have had Egyptian statues as decoration, although some of them appear to have been recycled into walls and other structures. There are Greek themes, to be sure, including a charming statue of Roman date, representing a priest in a full robe holding the sacred water-jar of the god Osiris Canopus, and a remarkable coiled statue of the protective serpent of the city, the Agathos Daemon. These must have come from a chapel. But even these would have seemed hybrid to an inhabitant of Athens or Rome, and in reality the Egyptian influence extended far beyond this.

There is a sacred ibis in limestone, and the head of a gigantic falcon in granite, which originally decorated a sphinx. There are blocks from the excavations of the Pharos area that have clearly made their way by canal or mouth of the Nile from the ancient cities of the Delta, such as Sais, Sebennytos, and in particular Heliopolis, north-east of present-day Cairo. The dilapidated state of the latter site was confirmed by Strabo, when he visited the area in the first century BC. Let us hope that there are more discoveries to come, although the diving conditions will be difficult. Hollywood film-makers have always known that Alexandria had an Egyptian look to it, but archaeologists and epigraphers have tended to emphasize its Greekness. This may be true of the greater public buildings, which may well have resembled those in other Hellenistic cities, such as Ephesus and Antioch. But the Hollywood moguls were not so far from the truth as some have imagined. Perhaps showmanship can recognize its own, even after two millennia. The paradox is that Alexandria is also the capital of men's minds, and there has never been a more fascinating city.

1

1 Fragment of a black granite clepsydra

332–323 BC

From Tell el-Yahudiya, Egypt

Height 37 cm, maximum width 38 cm, maximum thickness 6 cm

London, British Museum EA 933

This substantial fragment comprises most of the height of a clepsydra, or water clock, a deep vessel with a circular base used to measure time during the hours of darkness. On the outer face the figured frieze contains parts of two scenes. In both the pharaoh depicted making offerings is unnamed in the accompanying cartouches, but his identity is supplied in the first of the two rows of hieroglyphs below as Alexander the Great. In the right-facing scene he offers a water pot to Khonsu, the Theban moon god, who is named in the hieroglyphs and wears a full moon and crescent moon on his head. The god holds a *was* sceptre and offers the ankh sign of life to the King, to whom the text says he is giving all lands and foreign countries. A male deity behind Alexander can no longer be identifed. In the left-facing scene the King is attended by a female deity whom the text names as the local Theban goddess Ipet, who is more usually represented as a female hippopotamus. On this occasion Alexander offers burning incense to a deity, who, again, can no longer be identified. Apart from the line of text below, wishing all life and health to the king, the remaining incomplete two lines of hieroglyphs concern the passage of the heavenly bodies through the heavens.

On the inner face of the fragment are three hieroglyphic signs, a *was*, a *djed* and an ankh. They alone survive of the twelve markings that each stood at the base of a column, enabling the night hours to be reckoned when water that filled the vessel was allowed to drain away through a small hole in the base. A different line of the markings was used for each month.

Although both the deities named are Theban, the find-place of this piece suggests it was used in a temple in the Delta, where their cult was also located.

BIBLIOGRAPHY: E.A.W. Budge, *A Guide to the Egyptian Galleries (Sculpture), British Museum* (London 1909), cat. no. 948.

C.A.

2 Marble portrait of Alexander the Great (356–323 BC)

Second to first century BC

Said to be from Alexandria

Height 37 cm

London, British Museum GR1872.5-15.1 (Sculpture 1857)

The head was cut to fit into a separately made body. The surface is in good condition with only minor abrasions. The back of the head has been worked to receive the remainder of the hair, which was probably made of another material, such as stucco or plaster.

Literary sources claim that Alexander selected only a few artists to produce his image. Famous names, such as the sculptor Lysippos and the painter Apelles, were associated with Alexander's portraiture. None of the famous images have been identified, but a vast array of sculptures in different materials, portraits on gemstones and coins survive. These were produced mostly long after Alexander's death, and while the portraits follow similar general characteristics, they also vary in style. A relatively large number of portraits of Alexander have been found in Egypt, ranging in date from Hellenistic to Roman.

Alexander was always shown clean-shaven, which was an innovation: all previous portraits of Greek statesmen or rulers had beards. This royal fashion lasted for almost five hundred years and almost all of the Hellenistic kings and Roman emperors until Hadrian were portrayed beardless. Alexander was the first king to wear the royal diadem, a band of cloth tied around the hair that was to become the symbol of Hellenistic kingship. His portrait types were utilized and adapted for images of later rulers. Earlier portraits of Alexander tend to appear more heroic and mature, while posthumous portraits, like this example, portray Alexander as a more youthful, god-like character. He has longer hair, a more dynamic twist of the head and an upward gaze; in fact, more like the description of Alexander in literary sources.

This head was acquired in Alexandria, the city that Alexander had founded after he conquered Egypt in 332 BC. Ptolemy had been one of Alexander's Macedonian generals and he was given Egypt in the division of Alexander's lands after his death. Alexandria was also the location of Alexander's tomb. From the time Ptolemy I Soter declared himself king in 305/304 BC, Alexander was worshipped as a god and as the forefather of the Ptolemaic dynasty.

BIBLIOGRAPHY: A.H. Smith, *A Catalogue of Sculpture in the Department of Greek and Roman Antiquities, British Museum*, Volume III (London1904), cat. no. 1857; J.J. Pollitt, *Art in the Hellenistic Age* (Cambridge 1986), fig.18; R.R.R. Smith, *Hellenistic Sculpture* (London 1991), fig. 9.

P.H.

2 ▶

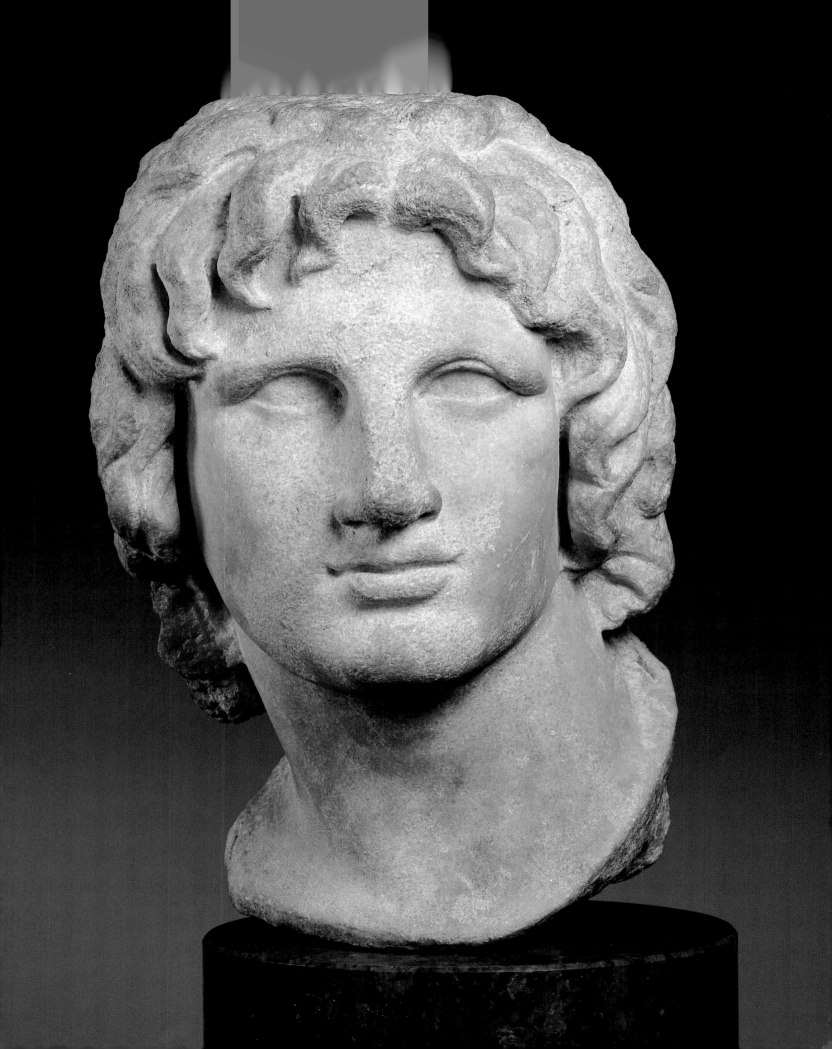

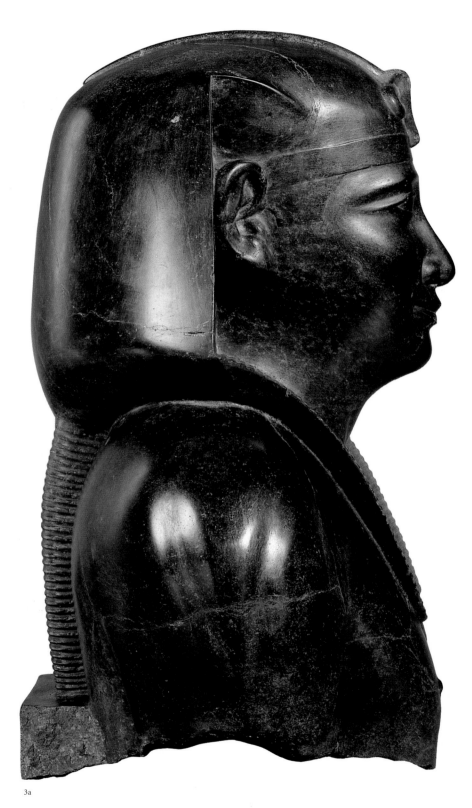

3a

3 Fragment of a basalt Egyptian-style statue of Ptolemy I

305–283 BC
Provenance unknown,
Height 64 cm, width 66 cm
London, British Museum EA 1641

The statue is preserved to below the chest; the left shoulder and the head of the uraeus are missing. The *nemes* headdress and back pillar are damaged and there are further superficial marks on the surface. Only the top of the back pillar, which ends at the middle of the shoulder, survives and is uninscribed.

The *nemes* headdress, plain at the top but ribbed on the lappets, and the uraeus identify the subject as a ruler. The mouth has drill holes in the corners, forcing the lips into a wide smile of a type that was characteristic of Thirtieth Dynasty and early Ptolemaic portraits. The wide, fleshy nose, cheeks and chin are also representative of portraits of this period, but the slightly raised eyebrows are carved in a more naturalistic manner than those on Late Period sculpture, which would support the dating of this piece to the Ptolemaic period. The large, fleshy ears are also characteristic of Ptolemaic portraiture. Because this particular piece does not bare a strong resemblance to the inscribed statues of Ptolemy II, it is, therefore, likely to represent the ruler's father, Ptolemy I.

Although the exact provenance of the statue is unknown, it is said to have been found in the lining of a well in the Delta. It was acquired with a number of other objects, but, unfortunately, the site was not named and it has been suggested that the story of its discovery was fabricated to increase interest in the piece.

BIBLIOGRAPHY: E.A.W. Budge *Egyptian Sculpture in the British Museum* (London 1914), 23, pl. 52.

S-A.A.

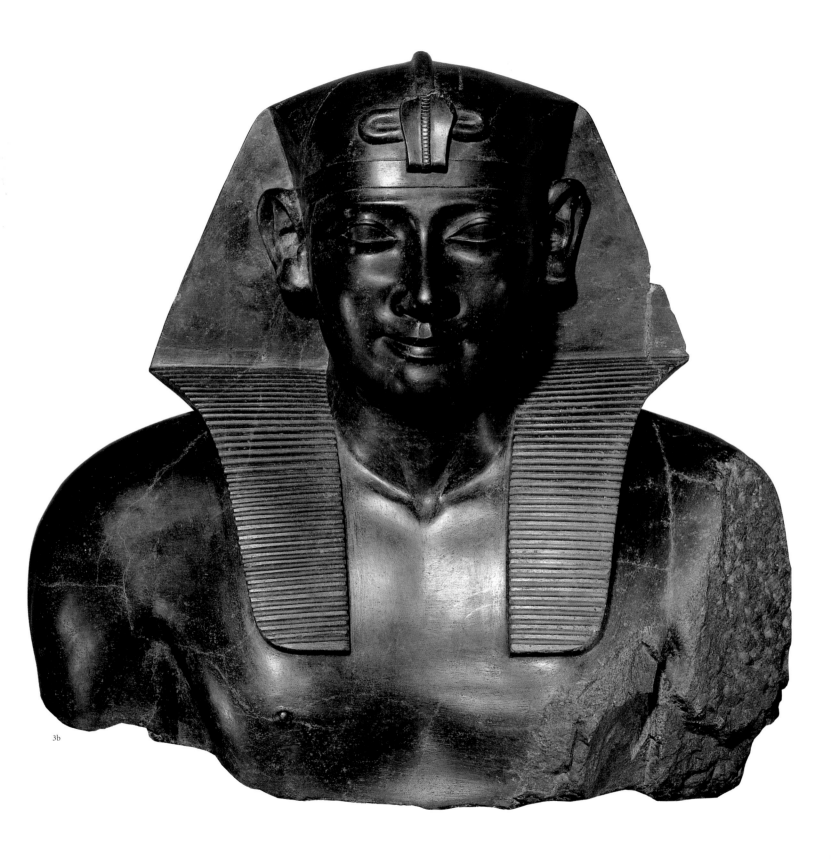

3b

4 Plaster impression of a repoussée relief with Ptolemaic royal portraits

250–200 BC

Probably from the Fayum

Maximum diameter 15 cm

Alexandria, Greco-Roman Museum 24345 (Gift of King Fouad I of Egypt)

The plaster is damaged and worn in places, but is otherwise in good condition.

This is one of the largest surviving ancient plaster casts of a Greek-style Ptolemaic relief bearing royal portraits. Similar, but much smaller, examples were found during excavations at Memphis, but none are of this quality. The subjects are identified as either Ptolemy I and Berenike I or their successors, Ptolemy II and Arsinoe II. If the former identification is correct, the cast is an invaluable document, for Berenike I's portrait type has yet to be successfully identified in sculptures or other objects; coin portraits are more numerous. Details of the faces were altered after the cast was produced, and this is evident on the nose of the king, which has been reduced in size, but left a ghost on the cheek of the queen. The king wears a diadem, tied at the back with the loose ends visible behind his head. Above this the hair is arranged in short curls, but below the diadem, the hair hangs freely in longer, more dishevelled locks. He wears a Macedonian *chlamys*. The queen wears a veil, just visible under the king's chin. She has a long, slender nose, large eyes, thin lips and a pointed chin. The king's features are heavier and his face squarer than his consort's. His eyes are large and deep set, his nose short (but has been remodelled) and his chin strong and heavy. His neck is particularly thick.

If the subjects are the first Ptolemy and his wife, then it is likely that the cast was made after their deaths, like the series of similar posthumous coins issued with their portraits. The faces of both sovereigns do appear more like the portraits of Berenike I and Ptolemy I, but any attempt at identification must take into account the modification of the cast.

The object is often published as a cast of a cameo, but is more likely to have been cast from a metal relief, which could then have been reused to produce another copy. Alternatively, it could be a sculptor's model or a votive offering.

BIBLIOGRAPHY: D. Plantzos, 'Hellenistic Cameos: Problems of Classification and Chronology', *Bulletin of the Institute of Classical Studies, University of London 41* (1996), 122–3, pl. 22c; F. Queyrel in M. Rausch (ed.), *La Gloire d'Alexandrie. Cat. Exh. Petit Palais* (Paris 1998), 79, no. 37; G. Grimm, *Alexandria: Die erste Königsstadt der hellenistischen Welt* (Mainz 1998), 74.

P.H.

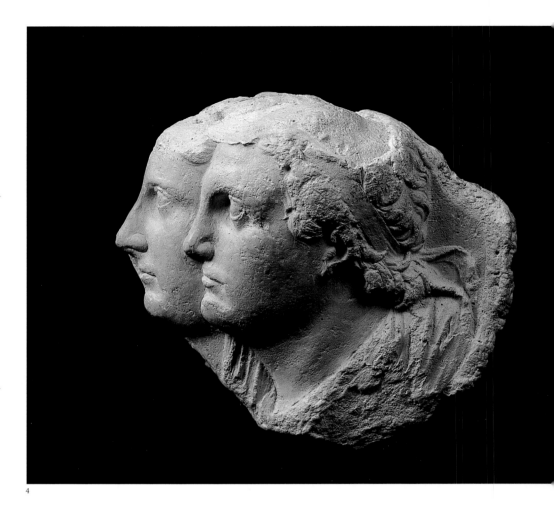

4

5 Calcite Egyptian-style bust of Ptolemy II

286–246 BC

Provenance unknown.

Height 61 cm, width 43 cm, depth 25 cm

London, British Museum EA 941 (Received as a gift from the British consul in Egypt and donated by Queen Victoria in 1854)

The statue is preserved to the elbows but a section of the right shoulder and upper right arm are missing, and the front of the beard and chin are damaged.

A single uraeus and plain *nemes* headdress, which appears to be unusually placed over a wig, identify the subject as a ruler, even though the low relief dorsal support that reaches the middle of the back is uninscribed. The right arm is placed across the chest, with the thumb resting on the index finger, but, unusually, there is nothing in the clenched hand. The same positioning of the arm can be seen on the statue of Arsinoe II (see p. 150, fig. 5.3). The left arm was probably held by the King's side, although the lower section is now missing.

The face is rounded and the nose is broad with a slightly bulbous end. The mouth is wide and the lips are fleshy, with indented corners, but the *filtrum*, the fold or channel of skin above the upper lip, is hardly visible. The eyes are almond shaped, with slightly downturned tear ducts, and the modelled eyebrows are straight across the brow. The portrait also has a stylized beard. These features are typical of the inscribed portraits of Ptolemy II.

The ears, however, are unfinished and there is a channel of stone behind the lobes. This observation may explain the unusual lappets and low relief of the tail of the headdress and the back pillar. However, the peculiarities of the double headdress, position of the right hand and beard have led some scholars to suggest that the statue is a modern forgery.

BIBLIOGRAPHY: E.A.W. Budge, *Egyptian Sculpture in the British Museum* (London 1914), pl. 53 [Ptolemaic]; J.A. Josephson, *Egyptian Royal Sculpture of the Late Period 400–246 BC* (Mainz 1997), 30–31 [Nectanebo II?]; S-A. Ashton, 'Ptolemaic royal sculpture from Egypt: the interaction between Greek and Egyptian traditions', *BAR* (Oxford, forthcoming), no. 4 [Ptolemy II].

S-A.A.

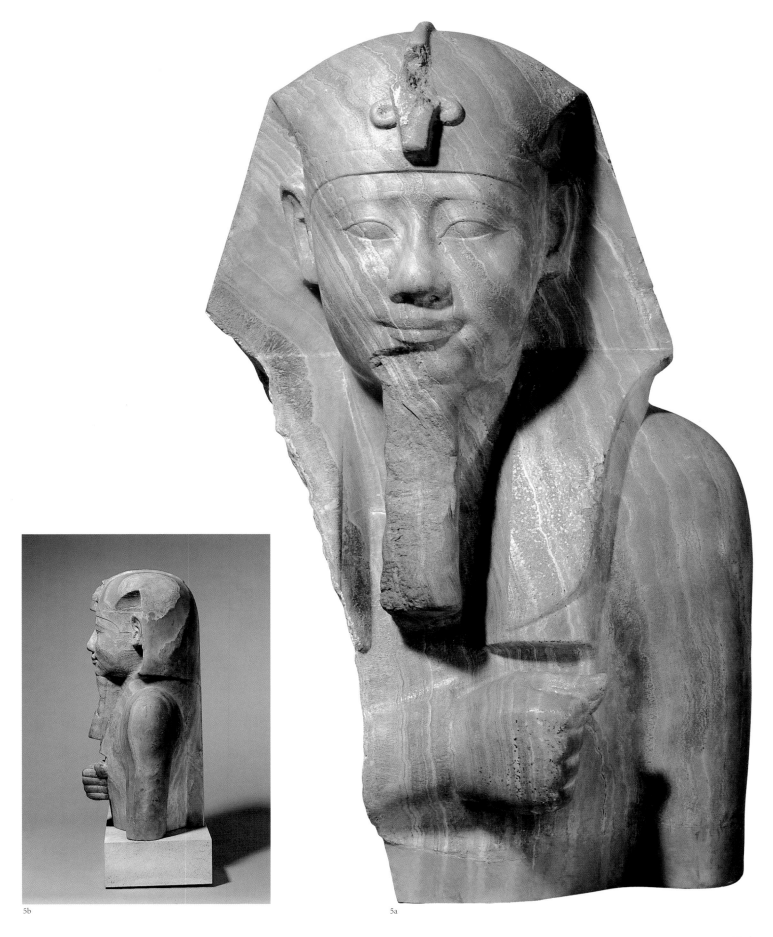

5b

5a

7 Marble portrait of Ptolemy II

c. 285–246 BC

From Hermopolis

Height 23.5 cm

Paris, Musée du Louvre Ma 3261

The back of the head is missing and there are four dowel holes in a central line from the top of the head to the neck at the rear.

The front of this Greek-style portrait of Ptolemy II is well preserved and was originally inserted in a statue. The ruler wears a diadem over his short hair, the locks of which fall just short of curls. The head rests on a strong, thick neck and has distinctive portrait features. The chin is rather pointed in appearance and the mouth is downturned, the nose is very angular and straight, and the brow follows its line, accentuating the rather flat profile. The eyes are set deeply with the eyebrows obscuring the lids. The ears are not level and are slightly different in shape.

BIBLIOGRAPHY: J. Charbonneaux, 'Portraits ptolémaiques au Musée du Louvre', *Mon. Piot* 47 (1953), 99–129; G.M.A. Richter, *Portraits of the Greeks*, 2 vols (London 1965) 261, n. 1; V.M. Strocka, 'Aphrodite Kopf in Brescia', *JDI 82* (1967) 110–56, no. 40; H. Kyrieleis , *Bildnisse der Ptolemäer*, AF 2 (Berlin 1975), 21–4, 36, B10 [Ptolemy II]; R.R.R. Smith, *Hellenistic Royal Portraits* (Oxford 1988), appendix 5 [third-century BC sovereign].

S-A.A.

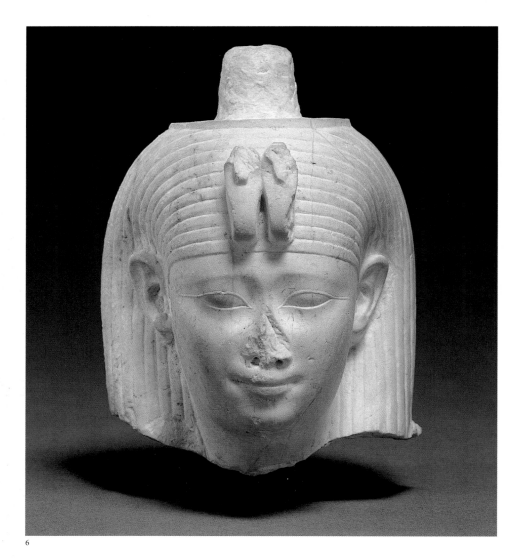

6

6 Limestone head of Arsinoe II

275–270 BC

From Abu Roasch, Lower Egypt

Height 12 cm

New York, The Metropolitan Museum of Art, 38.10; gift of Abby Aldrich Rockefeller, 1938

The crown is missing and the wig survives only to below the jaw line. The face is well preserved apart from the end of the nose, which is damaged, and the heads of the cobras on the wig are lost. The base of the crown is egg-shaped.

This Egyptian-style head of a queen wears a striated, tripartite wig with a double uraeus, a feature that identifies the subject as Arsinoe II. The eyes are almond shaped and are outlined by the gentle curve of the eyebrows. The mouth is fleshy, with drill holes at the upturned corners that form a smile. The overall appearance is one of a youthful, rounded face and the features are typical of early Ptolemaic Egyptian-style portraits.

BIBLIOGRAPHY: B.V. Bothmer, *Egyptian Sculpture of the Late Period* (New York 1960), 125–6, no. 98 [Arsinoe II]; K. Michalowski, *L'art de l'ancienne Egypte* (Paris, 1968) 421; J. Frel, 'A Ptolemaic Queen in New York', *AA* 86 (1971): 211-214; E.K. Lillesø, 'Two Wooden Uraei', *JEA* 61 (1975), 143–46; R.S. Bianchi (ed.), *Cleopatra's Egypt: Age of the Ptolemies* (New York 1988), 166; S-A. Ashton, 'Ptolemaic royal sculpture from Egypt: the interaction between Greek and Egyptian traditions', *BAR* (Oxford, forthcoming), no. 36.

S-A.A.

7 ▶

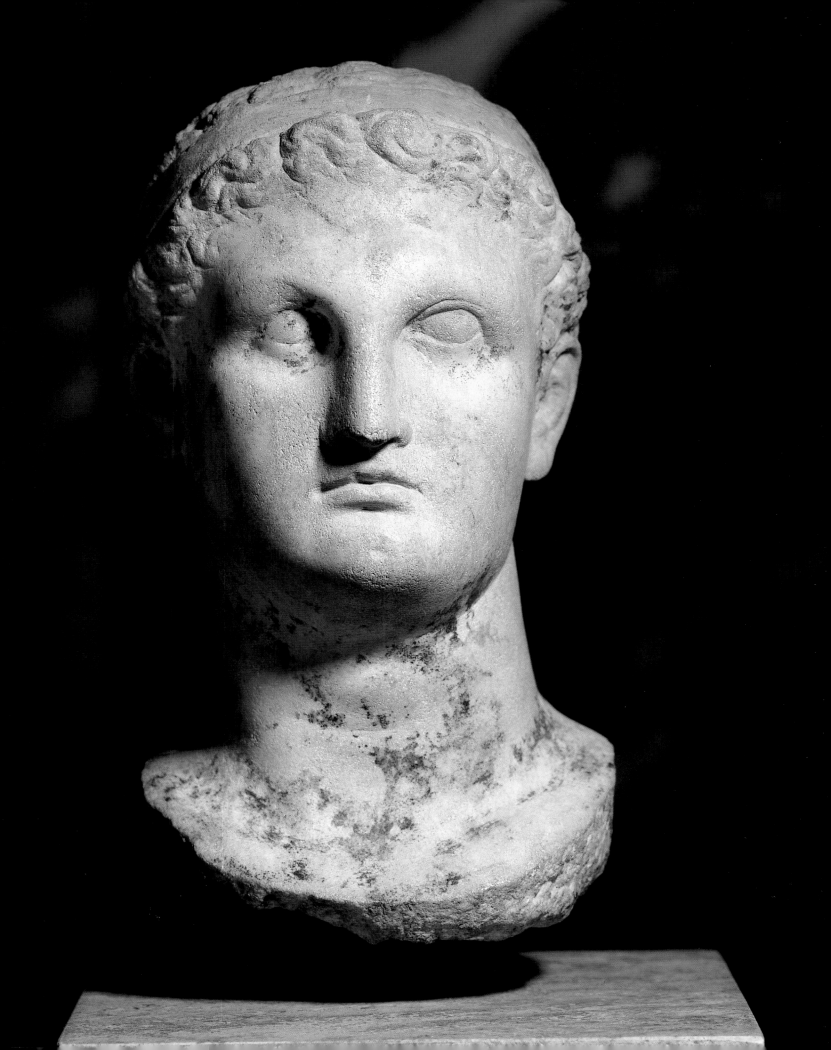

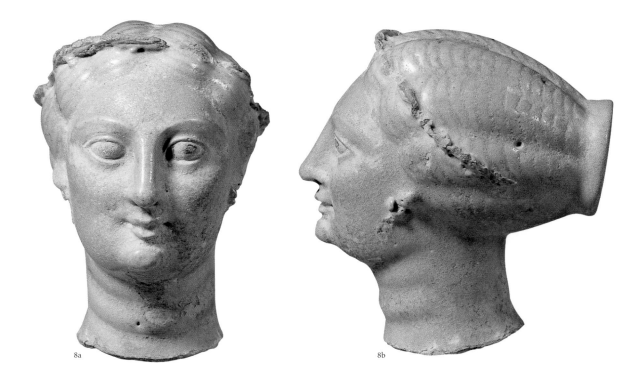

8a 8b

8 Faience head of a Ptolemaic queen

Third century BC

From Naukratis, Egypt

Height 5.8 cm

London, British Museum, GR 1888.6-1.38 (Vase K7),
(Given by the Egypt Exploration Society)

This beautifully modelled head has large eyes, a long, aquiline nose and prominent Venus rings around the neck. The hair is arranged in a melon coiffure, over which is worn a floral wreath, pendants and earrings. The facial features are so closely parallelled with portraits on faience *oinochoai* (jugs) and coins showing Arsinoe II (reigned 278–270 BC) as to make identification with that queen likely. The head probably came from a full-length statuette of the queen, either completely made from faience, or combined with another material. The original context for such a figure is uncertain, but the high quality of this piece suggests that it was a fairly important dedication, perhaps for the cult of Arsinoe II.

The aquamarine colour of the faience was enhanced by the addition of other coloured decoration. The eyebrows, and perhaps even the hair, were painted yellow or gold; the wreath may also have been gilded. There is a dark colour on the eyeballs, and a line over the lids. The lips were probably also painted, although no pigment survives.

BIBLIOGRAPHY: E. Gardner, *Naukratis II* (London 1888) 86; H.B.Walters, *Catalogue of the Roman Pottery in the Department of Antiquities, British Museum* (London 1908), cat. no. K7; D.B.Thompson, *Ptolemaic Oinochoai and Portraits in Faience* (Oxford 1973), cat. no. 270.

P.H.

9 Bronze statuette of a Ptolemaic king, perhaps Ptolemy III Euergetes

Of uncertain date, either Hellenistic or Roman

Provenance unknown, but from the Payne Knight Bequest, so perhaps acquired in Italy

Height 29.9 cm

London, British Museum GR 1824.4-46.13
(Bronze 1247)

The stauette is virtually intact apart from the left ankle and foot, which has been restored, and the greater part of the sword. The surface has been heavily over-cleaned (when it formed part of the Richard Payne Knight's collection) and may have been coated with a false dark patina.

Formerly considered to be a figure of Herakles wearing his characteristic lion-skin, a recent study has proposed that this statuette is in fact a portrait of a Ptolemaic king. The heroic stance, the facial features, which evoke a specific individual, and the royal diadem suggest that a royal portrait was intended. Furthermore, it would not be surprising to find a Ptolemaic king represented in the guise of Herakles: Ptolemy I, like Alexander the Great, traced his ancestry back to Herakles.

The presence of a cornucopia and the comparison of the facial features with portraits of Ptolemies on coins point towards the figure's identification as Ptolemy III (reigned 246–222 BC). Cornucopias did not appear as the reverse devices on coins of the Ptolemaic kings until after the death of Ptolemy III, when they were used on posthumous coins bearing his image. The way in which the King is offering his cornucopia may have alluded to his title of 'Benefactor'. The figure also wears a baldric and originally had a sword clutched in his left hand, which is covered with the lion-skin. Herakles is rarely, if ever, shown with a sword.

Few full-length, Greek-style portraits of Ptolemaic rulers survive and most of these are small in scale. Furthermore, evidence would suggest that statues of Hellenistic dynasts were not a popular subject for Roman patrons, and only a handful of copies survive, few of which can be identified with certainty. The series of portraits from the Villa of the Papyri at Herculaneum, which included some of the Ptolemies, is a rare exception.

BIBLIOGRAPHY: H.B. Walters, *Catalogue of the Bronzes, Greek, Etruscan and Roman in the Department of Greek and Roman Antiquities, British Museum* (London 1899), no.1247; D.M. Bailey, 'Not Herakles, a Ptolemy', *Antike Kunst* 33 (1990), 107-10.

P.H.

9 ▶

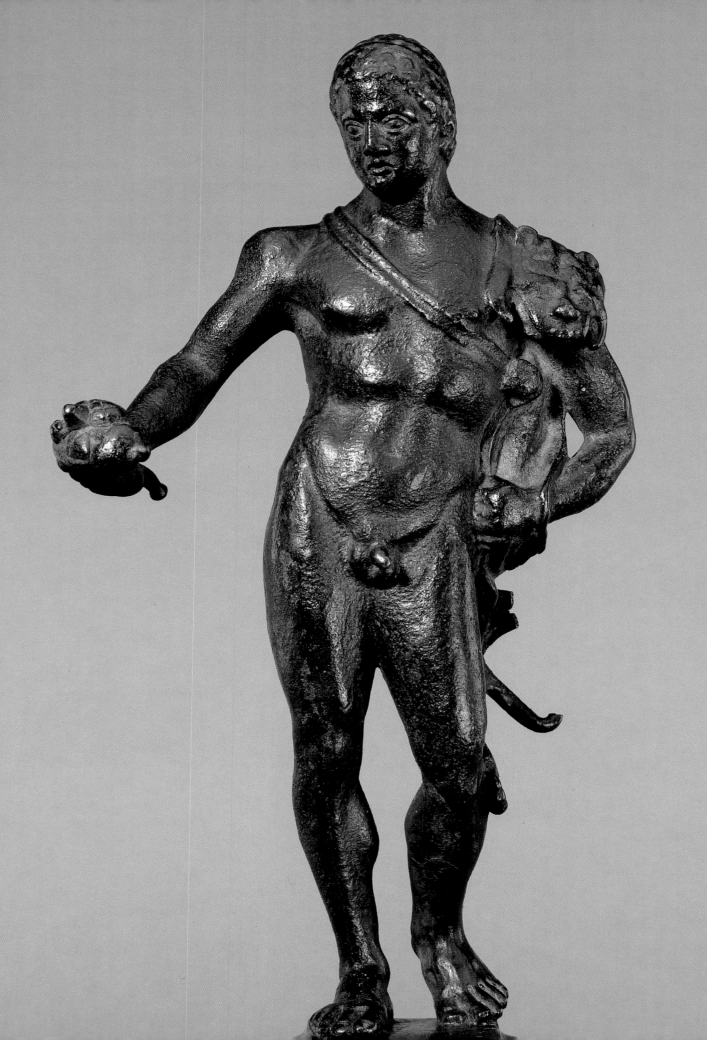

10–11 Tell Timai group

These two portraits form part of a group of third-century-BC portraits that were found at Tell Timai in the Delta and are now in the Egyptian Museum, Cairo.

10 Marble head of Ptolemy III

246–222 BC

Excavated at Tell Timai

Height 20 cm

Cairo, Egyptian Museum JE 39520

There is some damage to the rear of the head, with superficial scratches to the surface of the marble. This Greek-style portrait of Ptolemy III, one of a pair with cat. no. 11, was originally inserted in a statue. The ruler wears the *mitra* band across the forehead, worn by the god Dionysos, unlike the representations on coin portraits (see cat. no. 72), where he was associated with Helios, Zeus and Poseidon. This portrait is idealized with a heavy brow, but the roundness of the cheeks seems to have sagged and the mouth is not as full as on other representations of this ruler. The neck is particularly fleshy.

BIBLIOGRAPHY: C.C. Edgar, 'Greek Sculpture from Tell Timai.' in G. Maspero (ed.), *Le musée égyptien: Recueil de monuments et de notices sur les fouilles d'Égypte*, 3. (Cairo 1915) 3, no. 2; D. Wildung *et al.*, *Götter und Pharaonen*. Exh. cat. Römer- und Pelizäus Museum (Mainz 1979), no. 91; F. Queyrel, 'Petits autels et culte royal, petits autels et brûle-parfums', *Bulletin de Liaison de la Société des amis de la Bibliothèque Salomon Reinach*, Nouvelle Serie, 6 (1988), 15, 22, no. 20 [Ptolemy III]; M. Rausch (ed.), *La gloire d'Alexandrie* (Paris 1998), 205, no. 150 [Ptolemy III].

S-A.A.

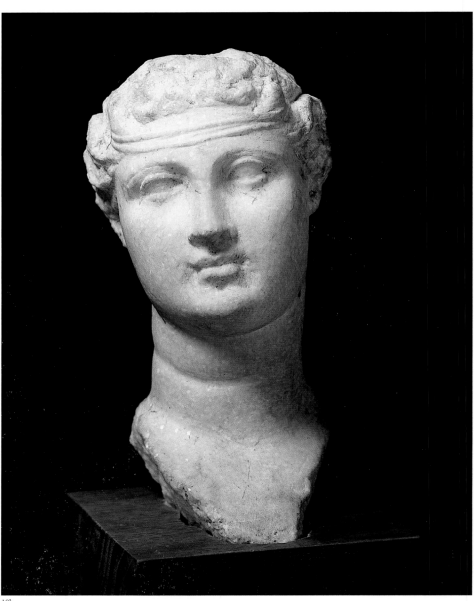

10b

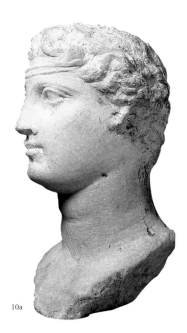

10a

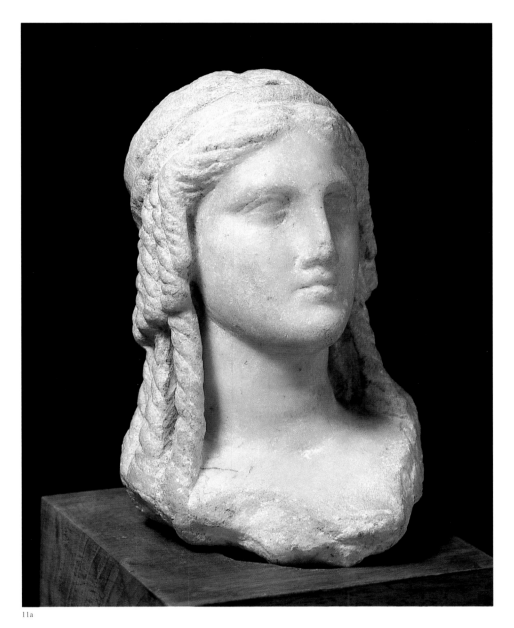

11a

11 Marble head of Berenike II

246–222 BC

Excavated at Tell Timai

Height 19 cm

Cairo, Egyptian Museum JE 39517

The tip of the nose is damaged and the back of the hair is roughly carved. There is a small hole at the front of the head, which may have supported a crown, now missing.

This Greek-style portrait of Berenike II has the hair styled in corkscrew curls, as on her early portraits from Cyrenaica in Libya, where the princess was raised. The Queen wears a diadem and there is a hole at the top of her head, presumably for the insertion of a crown. Her features are very similar to those of Ptolemy III on an associated portrait from the same site (see cat. no. 10): she has a strong chin and heavy brow. Her mouth is slightly downturned and her nose is well modelled. The neck is also slightly fleshy, but not to the extent of the related portrait of Ptolemy III.

BIBLIOGRAPHY: C.C. Edgar, 'Greek Sculpture from Tell Timai.' in G. Maspero (ed.) *Le musée égyptien: Recueil de monuments et de notices sur les fouilles d'Égypte*, 3. (Cairo 1915), 4, no. 4 [Isis]; F. Queyrel, 'Petits autels et culte royal, petits autels et brûle-parfums', *Bulletin de Liaison de la Société des amis de la Bibliothèque Salomon Reinach*, Nouvelle Serie, 6 (1988), 15, 22 [Berenike II]; M. Rausch (ed.), *La gloire d'Alexandrie* (Paris 1998), 200, no. 145 [Berenike II].

S-A.A.

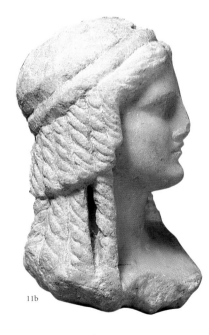

11b

12 Marble herm with a portrait of a Ptolemy

Third century BC

Found on the site of the temple of Apollo, Kalymnos, Greece

Height 39 cm

London, British Museum GR 1856.8-26.160
(Sculpture 1741)

Intact, but weathered, the herm was left unfinished and bears many traces of tool marks, mostly that of the rasp. The back of the head is flat and roughly worked. Two rectangular slots were cut into either side of the figure. It may have formed part of a balustrade of herms.

The male head has a full head of hair, swept up over the brow and behind the ears. A slight depression in the hair probably indicates that a diadem was added, perhaps made of metal. The face is long, with a high furrowed brow and a fleshy bar above the eyes. The cheekbones are strongly marked and prominent, and the chin is broad and square. The long nose is slightly pointed and has an upturned tip. The short mouth has tightly closed lips. The rather pinched features, with the heavily lidded, mean eyes imbue the portrait with a marked sense of severity, but this may have been unintentional: the sculptor has not finished his work, and the facial features are only roughly worked.

The presence of a diadem suggests that a royal personage is intended. It was formerly thought to be a representation of Herakles (see also cat. no. 9), but Gisela Richter claimed that the small mouth and heavy chin resembled the coin portraits of Ptolemy IV. If this is the correct identification, it is difficult to determine the exact context of the portrait in this unusual herm form. It may have been a dedication in the sanctuary of Apollo on Kalymnos, an island under Ptolemaic control during the reign of Ptolemy IV.

BIBLIOGRAPHY: A.H. Smith, *A Catalogue of Sculpture in the Department of Greek and Roman Antiquities in the British Museum*, Volume III (London 1904), cat.no 1741; G.M.A. Richter, *The Portraits of the Greeks* (London 1965), 264, figs.1824-6.

P.H.

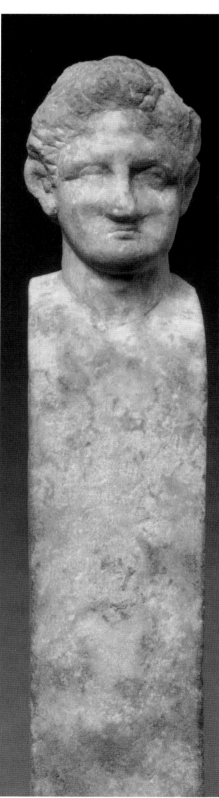

12

13 Marble portrait of Arsinoe III

222–204 BC

Excavated at Bubastis

Height 30 cm

Cairo, Egyptian Museum JE 35334

The front edges are damaged, the bun is missing and there are further superficial marks to the face and neck.

This Greek-style portrait of Arsinoe III was originally inserted in a statue. The queen has a long neck, marked with Venus rings. Her face is oval and rounded, with a long nose and a small, slightly downturned mouth, a portrait that compares well to the queen's image on coins and offers a marked contrast to the youthful appearance of her consort, Ptolemy IV, and of earlier queens. Although it is idealized, the facial expression is somewhat disdainful in appearance, recalling the queen's character as described in Athenaeus' *Deipnosophistai* (276 A-C, quoting Eratosthenes' biography of the queen), where Arsinoe refers to one of her husband's many festivals as squalid.

The eyes are large with a heavy upper lid; the eyebrows are curved and follow the line of the

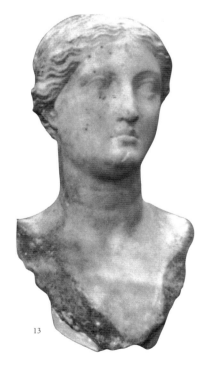

13

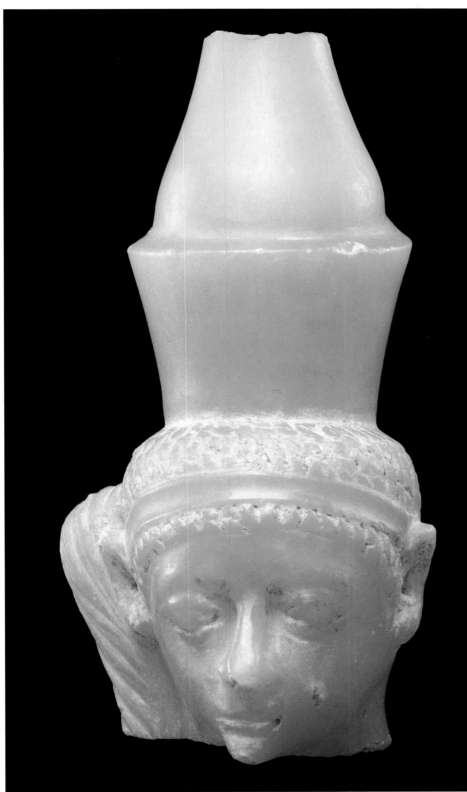

eyes closely. The queen wears a narrow diadem over her centrally parted hair, which was loosely drawn back in a high bun (now missing).

BIBLIOGRAPHY: A. Adriani, 'Nuovi ritratti di Arsinoe III', *Arti Figurative* (1975), 351–2; H. Kyrieleis, *Bildnisse der Ptolemäer*. AF 2 (Berlin 1975), 104–5 and 182, L2 [Arsinoe III]; D. Wildung *et al.*, *Götter und Pharaonen*. Exh. cat. Römer- und Pelizäus Museum (Mainz 1979), no. 95 [Arsinoe III].

S-A.A.

14 Calcite head of Ptolemy V

204–181 BC

Height 10 cm

Provenance unknown

Berlin, Ägyptisches Museum, 14568

This portrait of Ptolemy V has no trace of a back pillar. The head is preserved to below the chin and there is superficial damage to the surface and the top of the crown.

The subject wears a diadem across the front of his head and then tied in a bow at the back of the head, and also wears the crowns of Upper and Lower Egypt, unusually without a *nemes* head-dress. The face is triangular in shape, with a narrow, straight nose. The wide, downward slop-ing, slightly bulging eyes, narrow nose and pointed chin are all typical of the coin portraits of Ptolemy V (see cat. no. 76). The hair has been carved in very low relief to form curls, but there is also an additional lock of hair falling from the right side of the subject's head and down towards the shoulder. Kyrieleis has interpreted this as the Egyptian convention of showing the eldest child in a family with a lock of hair, but, as Bianchi points out, the priesthood at Memphis, where Ptolemy V moved the royal court, also appear with a lock of hair; see the stela (cat. no. 192) for a later example. However, Parlasca suggested that the head dates to the first century BC and repre-sents either one of Cleopatra VII's brothers or Caesarion.

BIBLIOGRAPHY: H. Kyrieleis, *Bildnisse der Ptolemäer*, AF 2 (Berlin 1975), 54–6, 134–6, 172, E1 [Ptolemy V]; K. Parlasca, 'Probleme der späten Ptolemäerbildnisse', in H. Maehler and V.M. Strocka (eds), *Das Ptolemäische Ägypten* (Mainz 1978), 25–39, no. 30 [Ptolemy XIII]; R.S. Bianchi (ed.), *Cleopatra's Egypt* (New York 1988),129, 152–3, 242, no. 55 [Ptolemy V]; S-A. Ashton, 'Ptolemaic royal sculpture from Egypt: the interaction between Greek and Egyptian traditions', *BAR* (Oxford, forthcoming), no. 13 [Ptolemy V].

S-A.A.

14

15a

15b

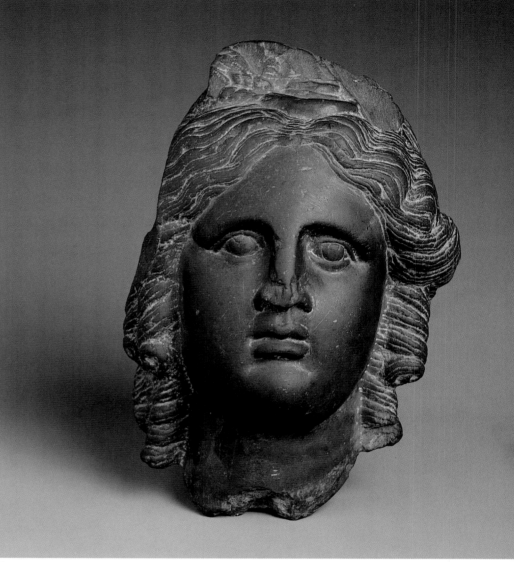

16

15 Limestone head of a Ptolemaic king

Third century BC

From Naukratis

Height 5.9 cm

London, British Museum EA 68860

The sculpture is preserved as a mask-like fragment: at the back, the outer edges are finished, but a rough recessed strip protrudes from the flat surface and is damaged, and the top is worked smooth and flat. Both the top and the back appear to have been worked to receive a large, separately made wig, perhaps of another material such as glass, faience or another coloured stone. The neck surface was carved with a small tenon to be inserted into a separately made body. The limestone is extremely hard and finely polished.

This Egyptian style head is of a king, wearing a band beneath what was presumably a headdress or wig. He has large, almond-shaped eyes, placed beneath a carefully delineated brow, a long, pointed and slightly hooked nose. The broad mouth and thin lips, with their outer corners upturned, form a subtle smile. The cheeks are finely modelled and the pointed chin has a pronounced dimple in the centre. The ears are very large. The creamy colour of the stone was perhaps contrasted with a darker material for the wig and the body.

The facial features compare well with Egyptian style portraits of Ptolemy V.

BIBLIOGRAPHY: E.A. Gardner, *Naukratis Part II* (London 1888), 87, no.13, pl. XVII.

S-A.A., P.H.

16 Greywacke (?) head from a statue of a Ptolemaic queen

First half of the second century BC

Said to have been found in Egypt

Height 17.5 cm

London, British Museum GR 1926.4-15.15

The right side of the hair and the top of the head, including most of the crown, are damaged. The back of the sculpture has been destroyed, although the angle at which the stone has been cut suggests that it originally had a back pillar and was therefore Egyptian in style.

The portrait is likely to represent a Ptolemaic queen or princess, who has a round face, short nose and a small mouth with fleshy lips. The eyes are deep set, with lines at their corners. The subject has two rows of locks of hair at the side of

her head, parted down the centre and then pulled to the back of the head to form a bun. Comparisons with other examples of this type of image indicate that the queen once wore an Egyptian crown. The styling of the hair and portrait features suggest a date of around the time of Ptolemy VI and the head may, therefore, represent either Cleopatra I or II.

BIBLIOGRAPHY: E.A. Arslan (ed.), *Iside: il mito, il mistero, la magia.* (Milan 1997), 96, no. III.2 [Isis]; S-A. Ashton, 'Ptolemaic royal sculpture from Egypt: the interaction between Greek and Egyptian traditions', *BAR* (Oxford, forthcoming), Appendix 3.4 [Cleopatra I or II].

S-A.A.

17 Limestone head of Cleopatra I or II

181–164 BC

From Mazarita district, Alexandria (exact date and place of discovery unknown)

Height 80 cm

Alexandria, Greco-Roman Museum 21992

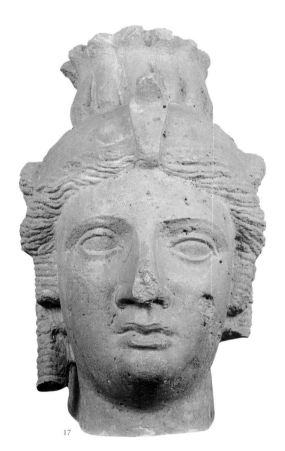

17

Only the head of this Egyptian-style statue is preserved. There is superficial damage to the face, and the locks on the right side and the crown are missing. The uninscribed back pillar is preserved to the upper part of the head.

The queen wears her hair in a hybrid Greek style, with two thick ringlets at the sides of her face and a central parting. Pleats of hair are then drawn to the back of the head and curled up the sides of the back pillar. Over her hair she wears a diadem and a single uraeus; the base of a crown, in the form of a circle of cobras, is also preserved. The face is rounded, with a straight mouth and fleshy lips. The nose is slightly hooked in the profile view. The eyes are large and oval in shape, and the brows are well defined and accentuate the shape of the upper lids. Stylistically, the head compares well to images from the reigns of Ptolemy VI and Ptolemy VIII, and therefore probably represents either Cleopatra I or II.

BIBLIOGRAPHY: E. Breccia, 'Sculture inedite del Museo Greco-Romano', *BSAA* 26 (1931), 258–70, 264–5; H. Kyrieleis, *Bildnisse der Ptolemäer*, AF 2 (Berlin 1975), 119, 184–6, M 10 [a Cleopatra]; B. Tkaczow, *Topography of Ancient Alexandria (An Archaeological Map)*, TCAMAPS 32 (Warsaw 1993), 194, cat. no. 22; S-A. Ashton, 'Ptolemaic royal sculpture from Egypt: the interaction between Greek and Egyptian traditions', *BAR* (Oxford, forthcoming), no. 44.

S-A.A.

18 Marble portrait of Ptolemy VI

176–145 BC

Exact provenance unknown, said to be from Alexandria

Height 37 cm

Alexandria, Greco-Roman Museum 24092

The lips, the nose and right eyebrow are damaged. The top of the head is roughly carved and was probably finished in stucco.

This Greek-style portrait of Ptolemy VI was originally carved to be inserted in a statue. The head tilts slightly to the right and the ruler appears supercilious, though this effect may not have been intended by the sculptor, who was perhaps making an idealized image, developed from those devised by Ptolemies III and IV and found on other Hellenistic rulers in the second century BC. After the reign of Ptolemy VI, the Egyptian rulers adopted the so-called Physcon portrait type, as illustrated by cat. nos 21–22. In this portrait, the eyes are almond shaped, with the eyebrows following the line of the upper lid; the brow is flat. The hair falls on the forehead in soft waves, with the outer strands combed inwards to the centre of the brow. The mouth is straight, with well-proportioned lips. The chin is strong, particularly in profile, and the nose appears to have been wide, straight and relatively long. The long neck has a well-defined musculature.

BIBLIOGRAPHY: A. Adriani, 'Sculture del Museo Greco-Romano di Alessandria, V: Contributi all' iconografia dei Tolomei', *BSAA* 32 (1938), 77–111, 97f.; H. Kyrieleis, *Bildnisse der Ptolemäer*, AF 2 (Berlin 1975), 59–61, 120–1, 127, F3; R.R.R. Smith, *Hellenistic Royal Portraits* (Oxford 1988), 28, 93–4, 166, no. 55 [Ptolemy VI]; R.R.R. Smith, 'Ptolemaic Portraits: Alexandrian Types, Egyptian Versions' in *Alexandria and Alexandrianism* (Malibu, Calif. 1996), 203–14, no. 205 [Ptolemy VI].

S-A.A.

19 Part of a granite statue of Ptolemy VI

176–145 BC

From Canopus

Height 61 cm

Alexandria, Greco-Roman Museum 3357

The nose, lips and chin and parts of the ears are damaged; the inlaid eyes are missing.

This Egyptian-style portrait of Ptolemy VI has an uninscribed back pillar that ends halfway up the headdress. The subject is represented as Pharaoh, wearing a *nemes* headdress; he originally also wore a crown, now missing. The portrait features are carved according to the ruler's Greek portrait type and, although the eyes were originally inset, their outline is typical of the heavy appearance on other Greek portraits of Philometor. The hair emerging from under the

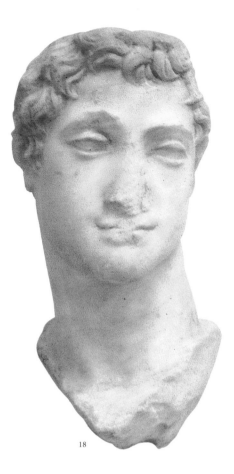

18

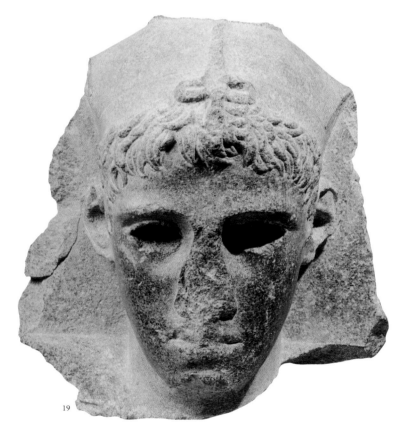

19

headdress is a non-Egyptian feature, and rendered in an extremely naturalistic manner. Its treatment is very similar to that on the other Alexandrian Philometor (cat. no. 18), as indeed is the overall appearance of the piece. It was only during the reigns of Ptolemies V and VI that Egyptian sculptors closely copied models of a Greek portrait type. From the time of Ptolemy VIII onwards Egyptian versions, rather than accurate copies of Hellenistic portraits, were produced, as seen on the Brussels Physcon (cat. no. 22), followed by more stylized images.

BIBLIOGRAPHY: E.D.I. Dutilh, 'A travers les collections du Musée Gréco-Romain d'Alexandrie', *BSAA* 7 (1905), 38–47, 49 [Alexander IV]; A. Adriani, 'Sculture del Museo Greco-Romano di Alessandria, V: Contributi all' iconografia dei Tolomei', *BSAA* 32 (1938), 77–111, 103, figs. 13–14; W. Needler, 'Some Ptolemaic Sculptures in the Yale University Art Gallery', *Berytus 9* (1949), 129–41 [Ptolemy IV]; H. Kyrieleis, *Bildnisse der Ptolemäer* (Berlin 1975), 59–62, F2 [Ptolemy VI]; R.R.R. Smith, *Hellenistic Royal Portraits* (Oxford 1988), 170, no. 72 [Ptolemy VI]; R.R.R. Smith, 'Ptolemaic Portraits: Alexandrian Types, Egyptian Versions' in *Alexandria and Alexandrianism* (Malibu, Calif. 1996), 203–14, no.206 [Ptolemy VI]; S-A. Ashton, 'Ptolemaic royal sculpture from Egypt: the interaction between Greek and Egyptian traditions', *BAR* (Oxford, forthcoming), no. 27 [Ptolemy VI].

S-A.A.

20 Black basalt statue of a Ptolemaic Ruler

Mid- to late second century BC

Provenance unknown

Height 82 cm, width 39 cm, height of back pillar 25 cm

Paris, Museé du Louvre A28

This Egyptian-style statue of a Ptolemaic ruler is preserved from the thighs upwards. The right arm and most of the left arm are missing. There is also weathering on the surface of the statue and the uraeus, which is in the form of a single cobra. The nose is damaged.

The subject strides forwards, wearing a plain *nemes* headdress with single uraeus and a plain kilt with an uneven waistband. He stands with the left leg in front, in a striding stance with the arms held straight down. The face is rounded, with a small chin and large ears, which are unevenly proportioned and positioned. The eyes are large and the eyebrows trace the oval shape of the upper lid. The mouth is small in proportion to the face and the corners of the mouth curl upwards. The torso is softly modelled rather than muscular, betraying the youthful age of the subject.

Bianchi suggested that the piece dates to the first century BC on account of the uneven execution of the waistband and the placement of the back pillar, which rises above the lower line of the headdress and is pyramidal in shape. The statue is clearly later than the third century BC in date, but is also different from the late Ptolemaic images, where there is a preference for corpulent portraits and later, in the first century BC, a distinctive downturned mouth. The youthful appearance might suggest that the figure represents Ptolemy V, although stylistically the wide appearance of the eyes and the small mouth would suggest a mid- to late second century BC date of the period around the time of Ptolemy VIII. It is possible that this purely Egyptian-style statue was manufactured alongside the Physcon type of portrait (cf. cat. nos 21 and 22) and therefore dates to the late second or early first century BC.

BIBLIOGRAPHY: B.V. Bothmer *Egyptian Sculpture of the Late Period* (New York 1960), 162; R.S. Bianchi (ed.), *Cleopatra's Egypt* (New York 1988), 157 cat. no. 59 [first century BC]; L.M. Berman and B. Letellier, *Pharaohs: Treasures of Egyptian Art from the Louvre* (Cleveland, Ohio 1996), 88–9 [first century BC].

S-A.A.

21 Marble head of Ptolemy VIII?

Mid- to late second century BC

Provenance unknown.

Height 25 cm

Collection of W. Kelly Simpson, currently on loan to The Metropolitan Museum of Art L1992.27 (Formerly in the collection of Constance and Edgar P. Richardson)

The right side, ear and back of the head are missing. The nose, top of the head and lower chin are

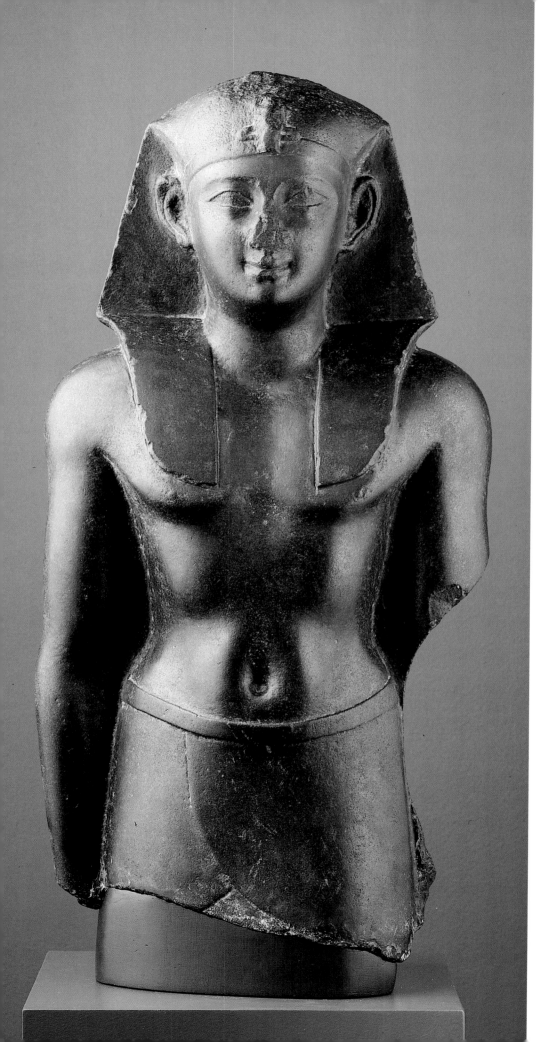

damaged. There are traces of red paint in the hair and on the eyes.

This is a Greek-style portrait of one of the late Ptolemies, of which only the head is preserved. The ruler is shown with a corpulent face, fleshy, pouting lips and a strong, hooked nose. The nostrils are large and deeply hollowed out. The eyes are round and set deep and close together, the well-defined eyebrows following the curve of the upper eyelids. The left ear is very large, and the marble between the back of the ear and the hair has been carved rather crudely, and been finished roughly. The hair is combed forward on to a strong and prominent brow, with a curl falling on to the cheek, but recedes at the temples. This characteristic is commonly found on Egyptian-style portraits dating from the late second to first centuries BC, such as the statue of Hor (cat. no. 190) and the representation of a priest (cat. no. 206). The back and top of the hair is carved in a rough manner and a channel for a thin diadem is just visible between the fringe and the main body of the hair.

The identity is clearly one of the later, corpulent rulers. The lack of beard would suggest that it is more likely to be Ptolemy VIII or X, and the narrow channel for a diadem is more typical of second-century-BC rulers. This head, in frontal view, compares well with the Egyptian version of this portrait type representing Ptolemy VIII (cat. no. 22).

BIBLIOGRAPHY: Sotheby's New York Sale 30 May 1986, no. 35 [Ptolemy XII]; R.R.R. Smith, *Hellenistic Royal Portraits* (Oxford 1988), 96–7, 124, 167, no. 58 [Ptolemy IX or X?]; R.R.R. Smith, 'Ptolemaic Portraits: Alexandrian Types, Egyptian Versions' in *Alexandria and Alexandrianism* (Malibu, Calif. 1996), 207–8 [Ptolemy VIII]; S-A. Ashton, 'Ptolemaic royal sculpture from Egypt: the interaction between Greek and Egyptian traditions', *BAR* (Oxford, forthcoming), Appendix 1.4 [Ptolemy VIII].

S-A.A.

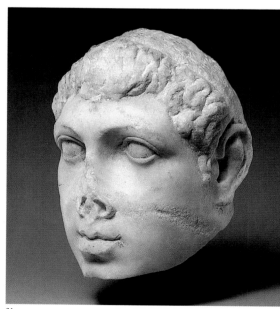

21

◀ 20

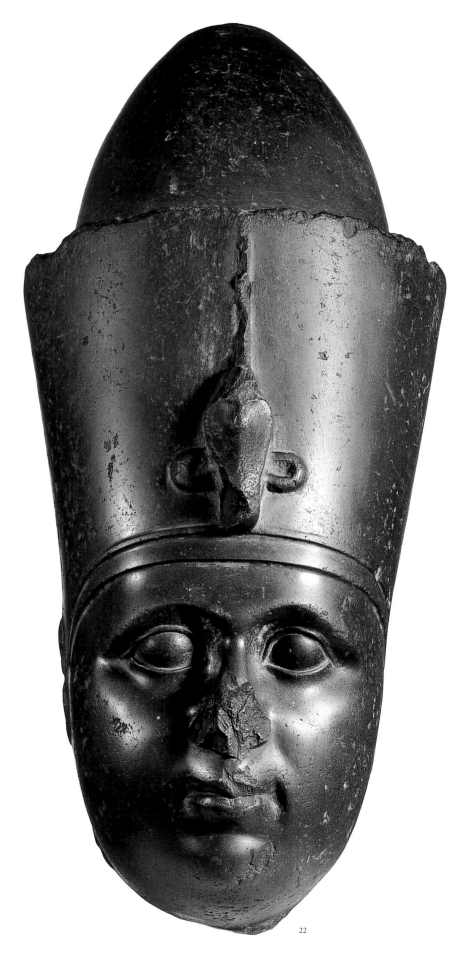

22 Basalt head of a Ptolemaic king

170–116 BC

Provenance unknown

Height 47 cm

Brussels, Musées Royaux d'Art et d' Histoire E.1839

The statue is broken at the neck and the lower section of the nose is missing. There is further minor damage to the surface, although it is generally well preserved.

This remarkable head shows, at natural scale, a pharaoh wearing a double crown with the uraeus. The head comes from a figure set against a back pillar, of which the top is partially preserved. The delicate manner in which the face is modelled in the stone gives the portrait a unique charm. It also gives the impression that the crown is a little too tight in relation to the round, inflated face, which sites the work among the sculptures classed as Ptolemy Physkon ('fatty') and gives it a realistic or, at least, an unidealized character.

The work has given rise to commentaries by art historians that are often contradictory. Certain authors have sought a Greek influence, but for some time this view has been increasingly abandoned in favour of a purely Egyptian interpretation, as the Physkon type is already attested in the reign of the last Egyptian pharaohs. A large number of specialists continue to identify the subject as Ptolemy VIII Euergetes, nicknamed Physkon. However, this identification (resting solely on the physiognomical similarities between the Brussels head and the coins struck for Ptolemy VIII in 138/137 BC) is not really certain, for, in theory, the facial characteristics of this head could also fit other Ptolemaic kings. The iconographic characteristics of these kings are, in reality, poorly understood. L.J.H.L.

The portrait has a corpulent face with close-set eyes, features traditionally associated with Ptolemy VIII Euergetes II. This ruler was also called 'Physkon', or fatty, by the Alexandrians on account of his physical appearance. The eyes are round, with thin, arched eyebrows forming a narrow bridge over the short nose. The mouth is small with fleshy lips, a feature that, along with the plump cheeks, is accentuated by the double chin. Unusually, the ruler does not have a *nemes* headdress beneath the crowns.

Although scholars generally accept that the portrait represents Ptolemy VIII, their opinions differ over the Egyptian and Hellenistic components of the piece. Because of its similarity to the Greek coin portraits of the ruler, Vandersleyen suggests that many of the features were Hellenistic in origin, not least of all the non-ideal appearance, which is usually reserved for private individuals in Egyptian art. Kyrieleis, Kiss, Smith

and Bianchi, however, all conclude that the head is essentially Egyptian in character. In his summary, Bianchi suggests that since the head is independent from the Greek tradition, it is not possible to associate it with a particular ruler and it cannot be identified as Ptolemy VIII because of its similarity to the coin portraits (see L.J.H.L. comments above). It is, however, possible to categorize the portrait as an Egyptian interpretation of a Hellenistic type without denying the Egyptian nature of the piece.

BIBLIOGRAPHY: B.V. Bothmer, *Egyptian Sculpture of t he Late Period* (New York 1960), 177; H. Kyrieleis, *Bildnisse der Ptolemäer* AF 2(Berlin 1975), 64, 174, 187, G2; C. Vandersleyen, 'Rundplastik der Spätzeit', in C. Vandersleyen *et al.*, *Das alte Ägypten*. PpK 15. (Berlin, 1975), 255–73; Z. Kiss, *Études sur le portrait impérial Romain en Egypte*. TCAMAPS 23 (Warsaw, 1984); R.R.R. Smith, 'Three Hellenistic Rulers at the Getty' *Getty Museum Journal* 14 (1986), 70; R.R.R. Smith, *Hellenistic Royal Portraits* (Oxford 1988), 87, 93–4, no. 73; R. Tefnin, *Statues et statuettes de l'ancienne Égypte*, Musée Royaux d'Art et d'Histoire, Guides du Département Égyptien 6 (Brussels 1988), 54–5; R.S. Bianchi (ed.), *Cleopatra's Egypt* (New York 1988), 62, 106, 143, 145, 148–9, 154, 176, 184, 249, 251, no. 53; S-A. Ashton, 'Ptolemaic royal sculpture from Egypt: the interaction between Greek and Egyptian traditions', *BAR* (Oxford, forthcoming), no. 8.

S-A.A.

23 Marble portrait of a diademed Hellenistic king, perhaps Ptolemy Apion (d. 94 BC), the last king of Cyrene

Late second to early first century BC

Found on the east side of the naos of the Temple of Apollo at Cyrene, Libya (the head was found in the same context as a similar portrait, also identified as Ptolemy Apion and now in the British Museum, Sculpture 1383)

Height 23 cm

London, British Museum GR 1861.11-27.55 (Sculpture 1394)

The nose, chin and lips are damaged, the locks of hair are weathered, and the separately made upper section of the head is missing. There are patches of surface incrustation. The neck has been broken from the body at an angle.

This portrait represents a young man with a tightly curled hairstyle consisting of deeply drilled locks. The almond-shaped, deeply set eyes are placed beneath fleshy brow muscles, and give the impression that the subject is looking upwards slightly. The lips are damaged, but the lower one is short and fleshy. The head turns sharply on its neck to the right, giving a dramatic twist, typical of Hellenistic ruler portraits. The damage caused to the nose and mouth, presumably when the statue to which it belonged fell from its base, furnish the facial features with a pronounced pathos that may not have been so apparent when the head was complete.

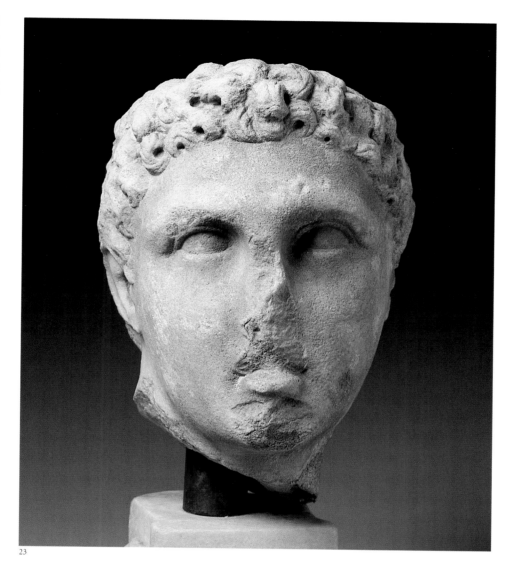

23

Even though the facial features seem less harsh than those of the so-called Ptolemy Apion from the same context (BM Sculpture 1383), the tightly curled locks of hair, and the extensive use of the drill to create them, are very similar on both portraits. Also closely comparable are the rounded shapes of the face. A diadem has not been carved on the surviving portion of this head, and ought not perhaps to be restored on the missing upper section, as then the subject would have worn the band very high on his head. Instead, the diadem may have actually been rendered in metal or perhaps even cloth and placed over a shallow depression behind the three tiers of curls.

The style suggests a date in the later second century BC, and the prime candidate for a royal subject from Cyrene at this time is Ptolemy Apion. Unlike the other Apion from Cyrene, which is carved as a rather stiff, formal and frontal portrait, this portrait is of the dynamic and heroic type, typified by nude Hellenistic ruler portraits. The two portraits may have stood side by side within the Hellenistic temple of Apollo, one showing the king in an almost uncompromising fashion, the other, this head, more as a heroic ruler, almost raised to the ranks of the gods.

Ptolemy Apion was the illegitimate son of Ptolemy VIII Physkon (reigned 170–164 BC; 145–116 BC). Apion's mother was reportedly his father's mistress Eirene, who had a Greek name but may have been a native North African. Apion was given Cyrenaica to rule, and when he died he bequeathed his kingdom to Rome.

BIBLIOGRAPHY: A.H. Smith, *A Catalogue of Sculpture in the Department of Greek and Roman Antiquities in the British Museum*, Volume II (London 1900), no. 1394; E. Rosenbaum, *A Catalogue of Cyrenaican Portrait Sculpture* (London 1960), cat. no. 9, pl. X; for the other Apion (Sculpture 1383), see J. Huskinson, *Roman Sculpture from Cyrenaica in the British Museum* (Corpus Signorum Imperii Romani GB, Vol II, I (London 1975), cat. no. 63.

P.H.

24a Colossal granite statue of a late Ptolemy

Found at Fort Qait Bey, Alexandria

116–87 BC?

Height 4.55 m

Alexandria, Greco-Roman Museum, 1001

The statue is preserved to the knees. The crown, the inlays for the eyes, and the sides of the head-dress are missing, and the facial features have been eroded.

The ruler wears a ribbed *nemes* headdress, his hair clearly visible beneath it, suggesting that the statue dates from after the reign of Ptolemy V (204–181 BC), when this phenomenon first occurs. The mouth seems to have been fleshy and is distinctly downturned in the frontal and pro-file views, a characteristic feature of statues dating from the late second to early first cen-turies BC. The appearance compares well with the portraits of Ptolemy IX and X, but on this piece the back pillar is uninscribed.

This colossal statue is part of a group of repre-sentations of five rulers, two females and three males, which stood in front of the Pharos light-house in Alexandria and was recently recovered from the sea by a team of archaeologists under the direction of Jean-Yves Empereur.

BIBLIOGRAPHY: W. La Richie, *Alexandria the Sunken City* (London 1996), 84–94; M.Rausch (ed.), *La gloire d'Alexandrie.* (Paris 1998), 103 cat. no. 64; J-Y. Empereur, *Alexandrie redécouverte* (Paris 1998), *Alexandria Rediscovered* (London 1999), 76–7; S-A. Ashton,

'Ptolemaic royal sculpture from Egypt: the interaction between Greek and Egyptian traditions', *BAR* (Oxford, forthcoming), no. 20.

S-A.A.

24b Colossal granite statue of a late Ptolemaic queen

116–101 BC?

Recovered from Alexandria harbour, 1960

Height 9.80 m (including crown)

Alexandria, Greco-Roman Museum, 106

The statue has been reconstructed from three separate pieces: upper torso and head, the lower torso, and the crown. The right arm is missing and there is considerable damage to the left arm and cornucopia. The inlays from the eyes are also now missing and the entire surface is badly eroded. The back pillar is uninscribed and extends to the top of the crown.

The garment, drawn over the right shoulder and tied in a knot between the breasts, identifies the subject as a Ptolemaic queen, although the statue is sometimes erroneously associated with images of the goddess Isis, because of the later adoption of this type of costume for the goddess made in the Roman period. The hair consists of stylized locks, and the queen seems to have worn a single uraeus. The crown, which consists of two plumes and the characteristic sun disk, is set within cow horns on a base formed of a circle of cobras. Ptolemaic queens often wear this crown, but it is unlikely that the queen represents Arsinoe II, as has been suggested (Empereur, 1998), because that particular queen wears a spe-cific version rather than the more general type shown here (see p. 149, fig. 5.1). The face is rounded, although most of the features are badly weathered. The queen appears to have held a cor-nucopia in her right arm.

This particular statue was the first of the group to be salvaged from the sea in 1960; the crown was recovered during the more recent explorations.

BIBLIOGRAPHY: B. Tkaczow, *Topography of Ancient Alexandria (An Archaeological Map)*, TCAMAPS 32 (Warsaw 1993), 183, no. 1; J-Y. Empereur, *Alexandrie redécouverte* (Paris 1998), *Alexandria Rediscovered* (London 1999), 65; S-A. Ashton, 'Ptolemaic royal sculpture from Egypt: the interaction between Greek and Egyptian traditions', *BAR* (Oxford, forthcoming), no. 56.

S-A.A.

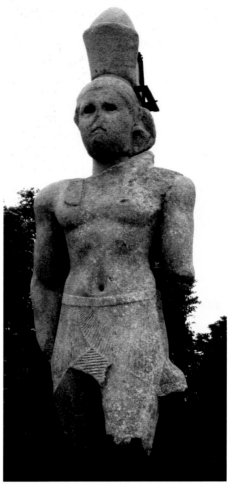

24a

24b

25 Marble portrait of Cleopatra II or III

c. 176–101 BC

Provenance unknown

Height 37 cm, height of head 22 cm

Paris, Musée du Louvre MA 3546

The nose is restored. There is considerable weathering to the surface, and damage to the chin, eyebrows, lips and coiffure. The top and back of the head are roughly worked.

This Greek-style portrait of Cleopatra III was originally carved to be inserted into a statue. The queen wears her hair in corkscrew locks, short on the fringe but longer at the sides, where the locks fall on to the left shoulder. Her head twists upwards and to the left. The nose, as Smith suggests, would have originally been larger and fleshier in appearance. The mouth is down-turned, a characteristic of the mid- to late-second century BC, and the eyes are set deeply, with sharply sculpted eyebrows. The neck has Venus rings and its surface indicates how the statue was once finished. This strong, masculine image is paralleled in the Egyptian-style images (see cat. no. 26) and may be indicative of the increasingly powerful political and religious roles of living queens.

BIBLIOGRAPHY: G.M.A. Richter, *Portraits of the Greeks* (London 1965), 267 [Cleopatra II–III]; J. Charbonneaux *et al.*, *Hellenistic Art* (London 1973), 311 [Cleopatra II]; H. Kyrieleis, *Bildnisse der Ptolemäer* AF2 (Berlin 1975) 120–21, M12; E. Brunelle, *Die Bildnisse der Ptolemäerinnen* (Frankfurt 1976), 80–1 [Cleopatra III]; R.R.R. Smith, *Hellenistic Royal Portraits* (Oxford 1988), 94–4, 166–7, no. 56 [Cleopatra I–III]; M. Hamiaux, *Les Sculptures Greques II: La période hellenistique IIIe–Ie siècles avant J.C.* (Paris 1998), 87–7, no. 89 [Cleopatra II–III].

S-A.A.

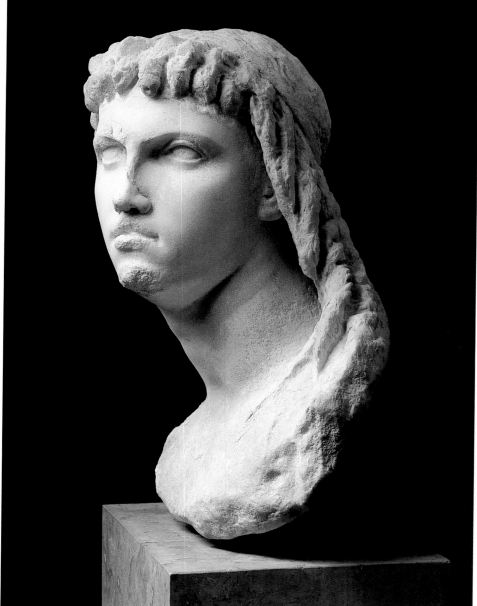

25a

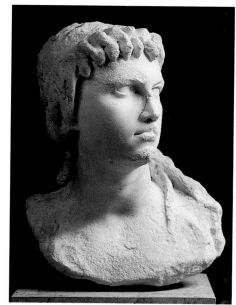

25b

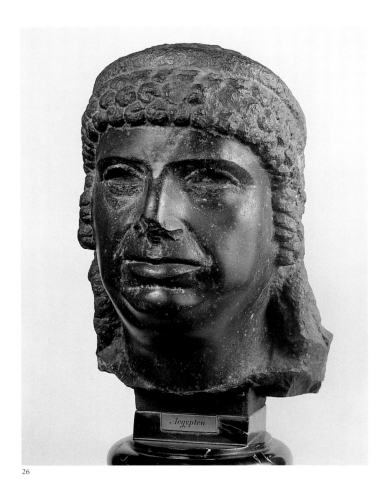

26

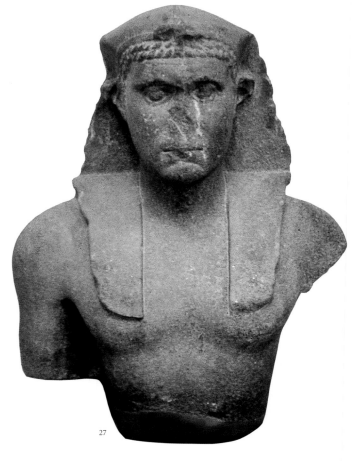

27

26 Basalt Egyptian-style portrait of a queen

145–101 BC

Provenance unknown

Height 31 cm

Vienna, Kunsthistorisches Museum 406

The inlaid eyes are now missing and the tip of the nose is damaged. Although the head is broken at the neck and there is no trace of a back pillar, it is carved with emphasis on the frontal position and was probably Egyptian in style.

The head shows an energetic face of an elderly woman with a double chin, long ringlets and a bun tied with a band. On the expressive face, two deep furrows run from the nose to the mouth; the eyes must have been inserted, fashioned from another material. This, the Egyptian version of an official portrait, comes from a frontally posed figure with a supporting back pillar. The head, unusually worked in hard stone, must, despite its masculine features, represent a princess, as is clear from the hairstyle and the diadem. In contrast to the 'beautiful' images of third-century-BC princesses, a type of portrait based upon images of men was created for the powerful queens Cleopatra II and Cleopatra III

from the middle of the second century BC. We should then be concerned here, on the basis of comparisons with a female profile on a seal impression from Edfu, with a mature portrait of Cleopatra III (cat. no. 61).

The use of basalt is rooted in the artistic tradition of pharaonic Egypt, but there is very little of Egypt in this head. Indigenous influences are restricted to the frontal pose and the setting of the eyes and mouth, with the lips slightly open. The hairstyle corresponds to that of the goddess Isis in her Greek form.

A.B-W.

Recent research on the hairstyle of this figure supports the identification as Cleopatra III.

S-A.A.

BIBLIOGRAPHY: *5000 Jahre Ägyptische Kunst, Katalog Wien 1961/2* no. 213; *Kunsthistorisches Museum Wien. Führer durch die Sammlungen* (Vienna 1988), 70; R.R.R. Smith, *Hellenistic Royal Portraits* (Oxford 1988), 87, 94–5, no. 74 [Cleopatra I–III]; W. Seipel, *Gott, Mensch, Pharao: Viertausend Jahre Menschenbild in der Skulptur des alten Ägypten* (Vienna 1992), no. 6; 440–41, no. 180 [second century BC]; R.R.R. Smith, 'Ptolemaic Portraits: Alexandrian Types, Egyptian Versions', *Alexandria and Alexandrianism*: 203–14 (1996), 208; S-A. Ashton,

'Ptolemaic royal sculpture from Egypt: the interaction between Greek and Egyptian traditions', *BAR* (Oxford, forthcoming), no. 46 [Cleopatra III].

27 Fragment of a granite statue of Ptolemy IX or X

c. 116–81 BC

Height 65 cm

Excavated from the eastern limit of Alexandria in the region of Miami

Alexandria, Greco-Roman Museum 12072

The bust was found during the digging of foundations for a house close to the intersection of Eskander Ibrahin Street and Hefney Nasef Street. The statue was found with several Hellenistic common-ware clay vessels. The head and upper torso of the statue are preserved; the nose and edges of the headdress are damaged.

Although this Egyptian-style statue has an uninscribed pillar to the mid-back, the stylized features reveal it as a late Ptolemaic ruler. The king wears a plain *nemes* head cloth with a single uraeus in the centre, and there are two rows of stylized curls along the forehead, a non-Egyptian feature. The portrait is similar to the Brussels

head of Ptolemy VIII (cat. no. 22), with a rounded face and closely set eyes. However, the stylized nature of the hair beneath the headdress and the straight mouth with a well-defined chin suggest that the statue dates to the reign of Ptolemy IX or X, when a variation of the Physcon portrait type was still commonly used.

BIBLIOGRAPHY: P. Stanwick, 'A Royal Ptolemaic Bust in Alexandria.' *JARCE* 29 (1992), 131–41; B.V. Bothmer, 'Hellenistic elements in Egyptian sculpture of the Ptolemaic Period' in *Alexandria and Alexandrianism* (Malibu, Calif.,1996), 215–29; 228, n. 19; S-A. Ashton, 'Ptolemaic royal sculpture from Egypt: the interaction between Greek and Egyptian traditions', *BAR* (Oxford, forthcoming), no. 24 [Ptolemy IX or X].

S-A.A., M.A. el-F.

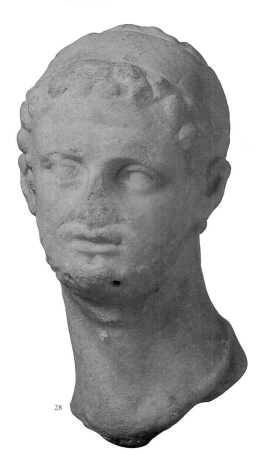

28

28 Marble portrait of Ptolemy IX

116–80 BC (Ptolemy IX?)
Found at Athribis
Height 23.3 cm
Stuttgart, Württembergisches Landesmuseum SS.17

The nose is damaged and there is further superficial damage, particularly to the beard and hair.

This Greek-style head of a late Ptolemy was originally inserted into a statue. The ruler wears a broad diadem over his hair, which, along with the locks of the beard, is rendered in large clumps of locks instead of individual strands. The face is oval in shape and the chin is square, with an indentation below the bottom lip. The mouth is straight and the lower lip is fuller than the upper, There are creases running from the nostrils to the lower cheeks. The eyes are deep-set and the brow is prominent, and the head appears to be turning around and upwards. Parallels for this type of portrait can be found on the Edfu sealings and also in the Egyptian-style royal portraits, where the hair forms stylized blobs.

BIBLIOGRAPHY: C. Watzinger, *Expedition Ernst von Sieglin 2: Die griechisch-ägyptische Sammlung Ernst von Sieglin 1. Malerei und Plastik.* 2 teil. (Leipzig 1927), 14 f [Ptolemy XI=X]; E. Pfuhl, 'Ikonographische Beiträge zur Stilgeschichte der hellenistischen Kunst.' *JDI* 45 (1930), 1-61, no. 38; K. Parlasca, 'Ein verkanntes hellenistisches Herrscherbildnis: Ein Kolossalkopf Ptolemaios IX in Boston', *JDI* 82 (1967), 167–94, no. 188 f [Ptolemy IX]; H. Kyrieleis (1975) 72–3, 176, H8 [Ptolemy IX].

S-A.A.

29 Bronze portrait of Ptolemy IX or X

116–80 BC or 107–87 BC
Provenance unknown
Height 2.1 cm
Stuttgart, Württembergisches Landesmuseum SS. 176

This small bronze portrait is similar to the other Stuttgart head (cat. no. 28), with the ruler wearing a broad diadem over small blobs of hair. This style of hair is used on the head and to form a beard beneath the chin and at the sides of the face. The face is fleshy in appearance, with a wide mouth, strong brow and a large, hooked nose, resembling the representations on the Edfu sealings (cat. nos 63–64). The portrait, with its exaggerated features, may represent Ptolemy IX or X.

BIBLIOGRAPHY: C. Watzinger, *Expedition Ernst von Sieglin 2: Die griechisch-ägyptische Sammlung Ernst von Sieglin 1. Malerei und Plastik.* 2 teil. (Leipzig 1930), 64 [Ptolemy XI=X]; E. Pfuhl, 'Ikonographische Beiträge zur Stilgeschichte der hellenistischen Kunst.' *JDI* 45 (1930), 1–61, no. 38; K. Parlasca, 'Ein verkanntes hellenistisches Herrscherbildnis: Ein Kolossalkopf Ptolemaios IX in Boston', *JDI* 82 (1967), 167–94 [Ptolemy IX]; H. Kyrieleis, *Bildnisse der Ptolemäer* (Berlin 1975), 72–3, 176, H8 [Ptolemy IX].

S-A.A.

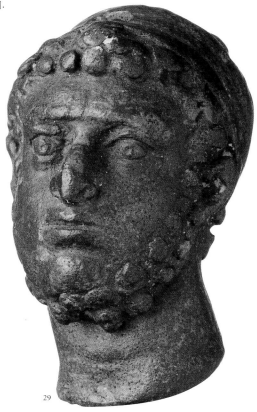

29

30 Greywacke head of a king, perhaps Ptolemy X

107–87 BC

Provenance unknown

Height 6.5 cm

Paris, Musée du Louvre E8061

The head survives to the top of the neck; although there is some surface pitting, it is otherwise in excellent condition.

Some Egyptologists believe this head to be a unusual type of face of King Nectanebo I, the first ruler of the Thirtieth Dynasty (380–362 BC). This attribution has been made by comparison of the features of a king on a slab bearing the cartouches of Nectanebo, which is in the British Museum (BM EA 22). That pharaoh has a swollen face and also wears the *khepresh*, or blue, crown. These slabs are believed by some scholars to have been engraved again during the Ptolemaic period, thus explaining the similarity with the well-known Ptolemy Physkon type. Another element can also be taken into account: the tapered back pillar is adorned with a Horus figure and a sun disc of a type similar to some of the Thirtieth Dynasty examples.

Bianchi suggests that this head represents Nectanebo I because the crown worn does not appear on Ptolemaic statuary. The blue crown does, however, appear on temple relief representations of Ptolemaic rulers, and, indeed, the form of the uraeus, with tight single twists of the cobra's body and a straight tail, is of a type more commonly found on representations of this period. Unfortunately, only the initial and more general part of the inscription survives, with a sun disc supporting two cobras and two ankh signs. There seems to be a return to inscribing statuary at the end of the Ptolemaic period and there are several inscribed back pillars from statues of Ptolemy XII.

The evidence for the portrait being Ptolemaic stems from the iconography and style of the piece. This small Egyptian-style head wears a blue crown with a single uraeus. The face is fleshy, with a square jaw with jowls and a prominent chin. The nose is slightly bulbous in appearance and the lips are very thin. The portrait closest to this type appears on the Edfu sealings, and is most frequently identified as Ptolemy X (cat. no. 66). A similar profile can be found on the stela of a Memphite priest (cat. no. 192).

BIBLIOGRAPHY: H.W. Müller, 'Ein Königsbildnis der 26. Dynastie mit der blauen Krone', *ZÄS* 80 (1955), 46–8; B.V. Bothmer, *Egyptian Sculpture of the Late Period* (New York 1960), 90–2, 134, 177, no. 73 [Nectanebo I]; H.W. Müller, 'Bildnisse König Nektanebos I (380–362 BC)', *Pantheon* 28 (1970), 89–99 [Nectanebo I]; K. Parlasca, 'Probleme der späten Ptolemäerbildnisse' in H.G.T. Maehler and V.M. Strocka (eds), *Das ptolemäische Ägypten: Akten des internationalen Symposions 27–29. 1976 in Berlin* (Mainz 1978) 25–39; R.S. Bianchi (ed.), *Cleopatra's Egypt* (New York 1988), 130, 143, 194, 228, 249, no. 48 [Nectanebo I]; J.A. Josephson, *Egyptian Royal Sculpture of the Late Period 400–246 BC* (Mainz 1997), 15 [Late Ptolemy, Ptolemy X?]; S-A. Ashton, 'Ptolemaic royal sculpture from Egypt: the interaction between Greek and Egyptian traditions', *BAR* (Oxford, forthcoming), no. 9 [Ptolemy X].

S-A.A., M.É.

30a

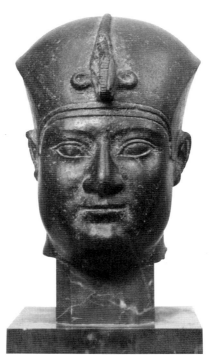

30b

31 Bone ring with a portrait bust of a woman in relief

Third to first centuries BC

Probably made in Alexandria

London, British Museum GR 1917.5-1.1619 (Ring 1619)

Length of bezel 2.8 cm

The hoop has broken away and there are minor abrasions on the surface.

This ring belongs to a series of similar bone finger rings found mostly on Cyprus and in Alexandria. They all show a portrait bust of a woman in relief. The woman on this ring has an elaborate hairstyle, with locks of hair framing the face in front of a narrow diadem, behind which the hair is arranged in the so-called melon coiffure. At the back the hair is secured in a bun. The woman has a rather severe expression with a long pointed nose, deeply set eyes and a small mouth, the lips of which curl downwards, almost forming a sneer. Her long neck has three prominent Venus rings scored into the surface beneath the pointed chin. Many of these facial features have been compared to the coin portraits and heads on faience *oinochoai* showing Arsinoe II (reigned 278–270 BC). This and the other similar rings may represent this particular queen; the diadem certainly suggests that the woman is royal. The rings may have served a commemorative function, or were perhaps made during the festival of Arsinoe, the Arsinoeia which was inaugurated

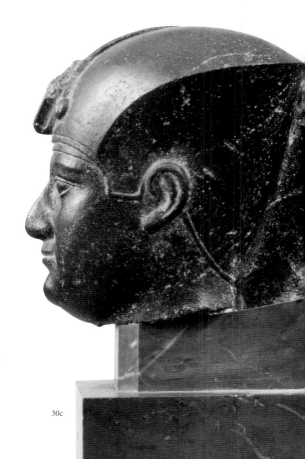

30c

after her death and became one of the most celebrated festivals in Egypt. Though she ruled for such a short time, Arsinoe II fast became a most popular queen, and Cleopatra VII herself adopted many of Arsinoe's traits in her Egyptian royal iconography (cat. no. 160); even Augustus' empress, Livia, modelled her early portraits on Greek-style images of Arsinoe II.

The date of these rings, which all follow similar forms and details of representation, is disputed, but if they do show Arsinoe II, they could date to any time from her death in 270 BC until late in the Hellenistic period. The bone rings show great similarities to a series of bone gaming counters, most of which have been found either in Alexandria or in sites around the Bay of Naples (cat. nos 327–333). These counters, some of which show portraits of Ptolemaic rulers, private individuals and Roman emperors, are thought to date to the late Hellenistic or early Roman period. It has been proposed that the portraits on the rings and the associated counters were inspired by a sense of nostalgia that was prevalent in the first century BC to the first century AD, as the Ptolemaic empire fell increasingly under Roman political control.

BIBLIOGRAPHY: F.H. Marshall, *Catalogue of Finger Rings, Greek, Etruscan and Roman in the Department of Antiquities, British Museum* (London 1907), cat.no 1619; L. Marangou, 'Ptolemäische Fingerringe aus Bein', *AM* 86 (1971), 164–71; E. Alföldi-Rosenbaum, 'Ruler Portraits on Roman Game Counters from Alexandria', in R. Stucky and I. Jucker (eds), *Eikones: Studien zum Griechischen und Römischen Bildnis, Festschrift Hans Jucker*, AntK Beiheft 12 (Bern 1980), 29–39, pl. 11.4.

P.H.

32 Bone finger-ring with a portrait of a Ptolemaic queen

Third to first century BC

Height 3.3 cm, width 3.4 cm, diameter 2 cm

Provenance unknown

London, Petrie Museum of Egyptian Archaeology UC 2382

The hoop of the ring is missing at the back and there is superficial damage to the surface and cracks at the top and side.

This round ring bears an image of a Ptolemaic queen, identified as such by the narrow diadem that is worn over her hair. The hair is secured in a bun, which is bound with a fillet, the loose ends of which hang down. The face is fleshy with a small chin, straight nose and a heavy eyelid. The creases carved around her neck are known as Venus rings. At the back of the neck the shallow incised lines indicate the folds of the queen's garments.

The suggested subject is Arsinoe II, although the hairstyle has been compared with that worn by Berenike II, and the small chin with jowls and the rounded cheeks are more typical of the some of the coin portraits of the latter queen (see cat. no. 71). The portrait compares well with that on cat. no. 31.

BIBLIOGRAPHY: W.F. Petrie, *Objects of Daily Use* (2nd edn, Warminster, Wilts. and Encino, Calif. 1974), 20, pl. xvi no. 322.

S-A.A., P.H.

31

32

33

34

33–34 Two bronze rings with portraits in relief

Third century BC

Provenance of ring 1267, unknown; ring 1930.7-15.3 said to be from Rhodes

Lengths 3 cm

London, British Museum GR 1917.5-1.1267 (Ring 1267) and GR 1930.7-15.3

The surface of 1267 is corroded and the hoop is missing. The other ring has lost its hoop and has a chunk missing from the lower left side.

Portraits of both royal and private individuals survive on finger rings made in a variety of materials, ranging from gold to glass. They were not exclusively manufactured in Egypt and some may represent rulers of other Hellenistic kingdoms, and members of their courts. The royal images may be positively identified by the presence of a diadem, and perhaps by the use of more expensive raw materials like gold. The aesthetic quality of the portraits varies greatly with the poorer images perhaps belonging to members of the lower social classes who still wished to honour a particular dynast. The rings were used to seal documents. The portraits were either carved in relief or cut in intaglio producing a raised image in clay.

Clay sealings survive from many parts of the eastern Mediterranean, particularly those areas controlled at one time or another by the Ptolemies. On Cyprus a large cache of clay sealings was found at New Paphos, and from the island of Delos come a large number of sealings showing possible Ptolemaic ruler portraits. From Egypt, excavations at the site of Edfu have yielded vast quantities of portraits of Ptolemaic rulers on clay sealings (cat. nos 59–66).

These two rings have busts of women in profile. One woman wears a diadem and may be a Ptolemaic queen, perhaps Berenike II, whereas the other more delicately worked image has no diadem and may represent a private individual. Both women have their hair arranged in the so-called melon coiffure, a hairstyle often associated with the Ptolemaic dynasty and members of their court. Tests of the metal content of the two rings have shown that there is an abnormally high tin content. This may have been added to give an extra shine to the bronze, which, when first made, would have almost imitated gold.

BIBLIOGRAPHY: F.H. Marshall, *Catalogue of Finger Rings, Greek, Etruscan and Roman in the Department of Antiquities, British Museum* (London 1907), cat. no. 1267; E. Boehringer, 'Ein Ring des Philetairos', in Corolla Ludwig Curtius, *Zum Sechzigsten Geburtstag Dargebracht* (Stuttgart 1937), fig.35a (1267); ring 1930.7-15.3 is unpublished.

P.H.

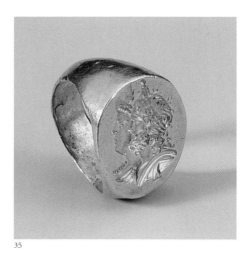

35

36

35 Gold ring engraved with the head of a Ptolemaic queen with Sarapis

Third century BC

Provenance unknown

Length of bezel 2.4 cm

London, British Museum GR 1865.7-12.55 (Ring 95)

The ring is intact, with only a few minor abrasions, and dents in the surface.

A male and female bust are shown in profile. The male wears a feather and disc crown, and is heavily bearded, and so is probably to be identified as Sarapis. He also has an unusual plait of hair, or even a wreath tied around his head. The woman has heavy features, a double chin, thick lips, large eyes with fleshy lids, and carefully rendered eyebrows. She has prominent Venus rings around her neck. Her hair is ornamented with a wreath, perhaps in the form of a sheath of corn, and she wears the disc, horn and feather crown associated with both the goddess Isis and representations of Ptolemaic queens. The identity of the woman is therefore uncertain, but the non-idealized facial features suggest that a portrait was intended.

BIBLIOGRAPHY: F.H. Marshall, *Catalogue of the Finger Rings, Greek, Etruscan and Roman in the British Museum* (London 1907), no. 95; D. Plantzos, *Hellenistic Engraved Gems* (Oxford 1999), pl. 91.4.

P.H.

36 Gold ring with a cartouche of a Ptolemaic king

Perhaps 246–221/220 BC

Provenance unknown

Length of bezel 3.8 cm

London, British Museum EA 36468

The bezel is inscribed with rather poorly formed hieroglyphs reading 'Son of Re, Ptolemy, living forever, beloved of Ptah'. The name is contained within a cartouche. From the Fifth Dynasty the *nomen,* the birth name of a pharaoh, was prefaced by the title 'Son of Re'. Ptolemy is spelled out as usual in alphabetic hieroglyphs as P-t-o-l-m-y-s. The epithets 'living forever' (*ankh djet*) and 'beloved of the god Ptah' (*mer Ptah*) were contained in the *nomen* cartouches of four of the Ptolemaic rulers: Ptolemy II, V, VIII and IX. However, in the light of the fact that there are no further titles to distinguish the owner from those with the same epithet, the ring presumably dates to the reign of Ptolemy III.

UNPUBLISHED.

C.A.

37 Terracotta with a nozzle in the form of a caricature

170–116 BC

From Memphis

Height 9.4 cm

London, Petrie Museum of Egyptology UC 47632

The nozzle and the surface of one of the chariot wheels are damaged. There are traces of plaster on the face, although the paint is missing. The form cannot function as a lamp, and on a copy of the terracotta, also in the Petrie Museum of Egyptology, the nozzle has been covered in plaster.

The terracotta figure is in the form of a corpulent male sitting in a chariot with his legs splayed, resting his hands on the sides of the high-backed

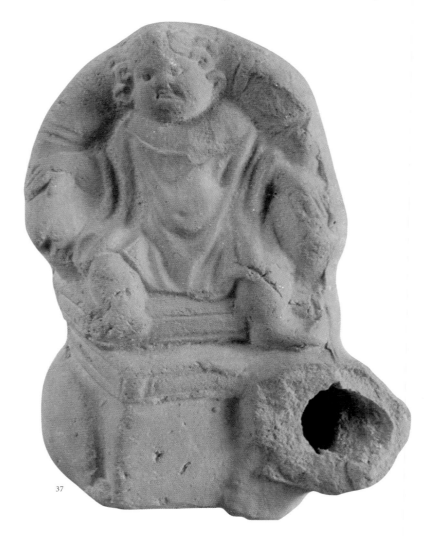

37

and cushioned seat. The chariot is embellished with a row of heart-shaped mouldings at the back. The subject's face is round, with a double chin, and the hair is unkempt, with waves falling on to his shoulders. He wears a transparent dress, which falls off his left shoulder, through which his rounded form is clearly visible. This image is similar to a description of Ptolemy VIII in Athenaeus' *Deipnosophistai* (XII. 549e): 'Through indulgence in luxury his body had become corrupted with fat and with a belly of such a size that it would have been hard to measure it with one's arms…' Athenaeus (IV. 184 b–c) and Diodoros Siculus (38.28b) also record the visit to Egypt by Scipio Aemilianus in the role of Roman envoy, and that the ruler was forced to walk with the general to the harbour, sweating and panting in his semi-transparent robes. Later, Scipio commented 'The Alexandrians owe me one thing, they have seen their king walk.' The terracotta may, therefore, be a caricature of the ruler.

UNPUBLISHED

S-A.A.

38 Bronze finger-ring with an engraved portrait of Ptolemy VIII or X

Second century BC

Height 2.4 cm, width 1.4 cm, diameter 2.3 cm

Provenance unknown

London, Petrie Museum of Egyptian Archaeology UC 2457

The hoop of the ring does not appear to be the original and has been soldered on to the bezel.

The ring is functional as a seal, in that it would have created an impression of the ruler, whose head and bust appear on the surface of the oval bezel. In the original publication by Petrie the subject portrayed is described as wearing a helmet, although this may be a crown. At the top of the headdress is a sun disc and what appear to be horns, with a uraeus at the front of the head

38

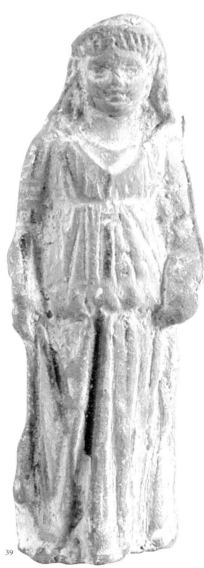

39

and possibly the tail of a snake at the rear. The ruler wears an Egyptian aegis. The face is bloated, with a large fleshy nose; the king may therefore be either Ptolemy VIII (cf. cat. no. 91) or Ptolemy X, who wears an elaborate helmet on the seal impression now in the Royal Ontario Museum, Toronto (cat. no. 66).

BIBLIOGRAPHY: W.F. Petrie, *Objects of Daily Use* (2nd edn, Warminster, Wilts. and Encino, Calif. 1974), 17, pl. xiii no. 159.

S-A.A.

39 Terracotta figure of a Ptolemaic queen

Mid-second to mid-first century BC

Height 8.7 cm, width 3 cm, depth 2 cm

Memphis

London, Petrie Museum of Egyptology UC 47952

There are traces of white plaster on the surface and black paint on the dress and cornucopia, which was roughly modelled with the details painted on. This terracotta figure represents a Ptolemaic queen, as illustrated by the *stephane* (diadem) that she wears on her shoulder-length corkscrew locks. The face is rounded and typical of the royal portraits from the second century BC, this particular figure may have been associated with the royal cult, and compares well to the images of queens found on faience *oinochoai*, such as cat. no. 48. Like the images on the cult vases, this queen holds a single cornucopia in her left hand, the horn resting against her inner arm; unlike the images on the vases, the right hand clutches the drapery and pulls the dress away from her thigh. The queen wears typically Hellenistic dress, consisting of a chiton and himation, with narrow folds of cloth emanating from a waistband and the undergarment clearly visible at the collar. The right leg is bent and the left leg supports her weight.

UNPUBLISHED.

S-A.A.

40

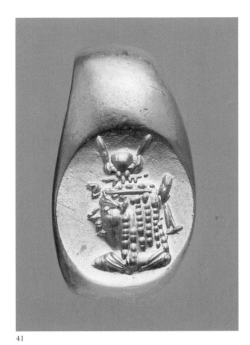

41

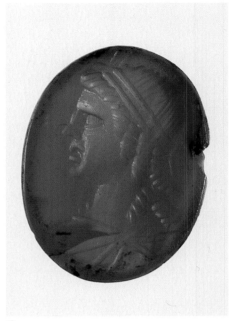

42

40 Bronze finger-ring with a portrait of Ptolemy IX

116–107 BC

Height 1.7 cm, width 1 cm, diameter 1.2 cm

Provenance unknown

London, Petrie Museum of Egyptian Archaeology
2462

The band is missing and there is a small section lost from the lower right edge of the impression, where the metal is thin.

The bezel bears a portrait of a late Ptolemaic ruler, identified by the broad diadem worn over the hair and the himation (mantle) around the shoulders. The features are similar to those on the Toronto seal impression (cat. no. 63) and the Stuttgart marble portrait of Ptolemy IX (cat. no. 28), with well-proportioned features and a short beard under the chin. This portrait, therefore, represents the same ruler.

BIBLIOGRAPHY: W.F. Petrie, *Objects of Daily Use* (2nd edn, Warminster, Wilts. and Encino, Calif. 1974),17, pl. xiii, no. 158 [portrait of a man].

S-A.A.

41 Gold ring with a portrait of a Ptolemaic queen

First half of the second century BC

Provenance unknown

London, British Museum GR 1917.5-1.97 (Ring 97)

Length of bezel 2.1 cm

The portrait is of a woman wearing a headdress in the Egyptian style in the form of a solar disc and cow's horns resting on ears of corn. The hair is arranged in thick, corkscrew locks, a style worn by queens of the late third to early second century BC (Berenike II and Cleopatra I). She wears a plain necklace of beads. The facial features have been slightly disfigured because the bezel has been squashed, but the subject has a long, straight nose, quite thick lips and a small, pointed chin. These characteristics compare well with coin portraits of Cleopatra I (193–176 BC).

BIBLIOGRAPHY: F.H. Marshall, *Catalogue of the Finger Rings, Greek, Etruscan and Roman, in the Department of Antiquities, British Museum* (London 1907), cat. no. 97.

P.H., S-A.A.

42 Sardonyx intaglio with a bust of a woman in profile

First half of the second century BC

Said to be from Cyrenaica

London, British Museum GR 1877.8-25.1 (Gem 1196)

Length 2 cm

The engraved design is of a draped, female bust, the hair bound by a double diadem formed by two strips worn close together but revealing the strands of hair in between. The hair is pulled back from the brow, and two rows of corkscrew locks frame the face, and then fall on to the shoulders. The eye that is shown is large. The downturned mouth and the short nose with flared nostrils compare with the marble portrait of a Ptolemaic queen in the Louvre (cat. no. 25), which may represent Cleopatra II or III. The woman wears a garment that is pinned on her shoulder.

The workmanship is fairly crude, but the composition is lively.

BIBLIOGRAPHY: H.B. Walters, *Catalogue of the Engraved Gems and Cameos, Greek, Etruscan and Roman, in the British Museum* (London 1926), cat. no. 1196.

P.H., S-A.A.

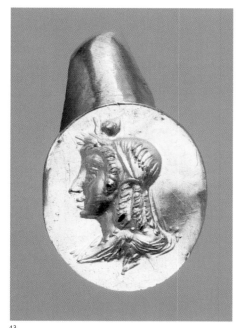

43

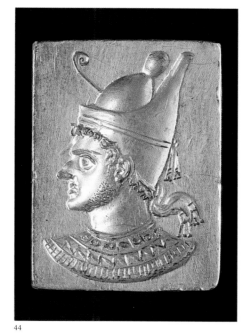

44

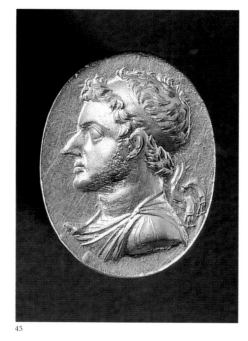

45

43 Gold ring with a portrait of a Ptolemaic queen

c. 150–100 BC

Provenance unknown

British Museum, Greek and Roman Antiquities, GR 1917.5-1.96 (Ring 96)

Length of bezel: 9.5 mm

This portrait in Egyptian style shows the profile of a woman with sharp, masculine features. The vulture headdress, which is held in place by a diadem, identifies the subject as either a queen or a goddess; the head, tail and legs of the vulture are clearly visible (cf. cat. no. 67). The hair is arranged in corkscrew locks, possibly an Egyptian wig. On top of the head is the base of a crown, composed of a circlet-of-cobras supporting a sun disc and cows' horns, as worn by the goddess Isis. The woman wears the knotted garment found on statues of Ptolemaic queens (see cat. no. 56).

The portrait features compare closely with the basalt head of a Ptolemaic queen (cat. no. 26) here identified as Cleopatra III (reigned 142–101 BC). Because of the similarity between this portrait and those of Ptolemies IX and X, the sons of Cleopatra III, this ring is most likely to date from the period when she was ruling with them (116–101 BC)

BIBLIOGRAPHY: F.H. Marshall, *Catalogue of the Finger Rings, Greek, Etruscan and Roman, in the department of Antiquities, British Museum* (London 1907), cat. no. 96.

P.H./S-A.A.

44 Gold sealing-ring with an Egyptian-style portrait, perhaps representing a late Ptolemy

116–80 BC (?)

Height 3.4 cm, width 2.5 cm

Bought in Egypt, 1863

Paris, Musée du Louvre Bj 1092

There are some scratches to the surface, otherwise the plaque is well preserved.

The image engraved on the rectangular bezel of this ring shows a ruler wearing the dual crowns of Upper and Lower Egypt and a fillet or diadem. The portrait type follows that typical of representations of Ptolemy IX or XII (cf. cat. no. 157). The subject on this ring has been identified as a Ptolemy VI through comparisons with coins and marble portraits, but, as on the other ring (cat. no. 45), the ruler wears a short beard under his chin. The nose is long and aquiline in appearance and the fleshy lips are downturned, another feature of late Ptolemaic portraits. The ruler wears an Egyptian collar to accompany the crowns, but the portrait features are more typical of those originally found on Greek-style images, thus dating the piece at the earliest to the second century BC. The portrait features may, however, suggest that the ring dates to the later part of this century or indeed the first century BC.

BIBLIOGRAPHY: G.Richter, *Engraved Gems of the Greeks and the Etruscans* (London 1968), cat. no. 626; H. Kyrieleis, *Bildnisse der Ptolemäer* (Berlin 1975), 63, pl. 46, 6; M-L. Vollenweider, *Camées et intailles.* Vol. 1 (Paris 1995), 113; C. Metzger in A. Rausch (ed.), *La gloire d'Alexandrie, Catalogue de l'exposition du Petit Palais* (Paris 1998), 203, no. 148 [second century BC, Ptolemy VI].

P.H., S-A.A.

45 Gold sealing-ring with a Greek-style portrait of a Ptolemaic king, perhaps Ptolemy IX

116–80 BC (?)

Diameter 2.5 cm

Bought in Egypt, 1863

Paris, Musée du Louvre Bj 1093

Apart from some superficial marks to the surface, this gold plaque is perfectly preserved.

The oval bezel contains an engraved portrait of a male ruler, whose royal status is indicated by the broad filet or diadem that is tied around the head, the loose ends of which hang loosely at the back The locks of hair are short and unkempt particularly at the front. This hairstyle has been compared to the portraits of Ptolemy VI on coins and sculptured images of the king (cat. nos 18, 19 and 90), although the short beard and the large aquiline nose are closer to the features found on portraits identified as Ptolemy IX such as the marble head from Stuttgart (cat. no. 28). This broader type of diadem is also more commonly found on images dating from the late second century BC. Furthermore, the king has a large eye and a heavy, downturned mouth, all of which are typical of late Ptolemaic royal portraits.

BIBLIOGRAPHY: G. Richter, *Engraved Gems of the Greeks and the Etruscans* (London 1968), cat. no. 625; H. Kyrieleis, *Bildnisse der Ptolemäer* (Berlin 1975), 63, pl. 46, 5; H.P. Laubscher, 'Zur Bildtradition in ptolemäisch-römischer Zeit', *JDI* 111 (1996), 242–4; C. Metzger in A. Rausch (ed.), *La gloire d'Alexandrie, Catalogue de l'exposition du Petit Palais* (1998), 203, no. 147 [second century BC, Ptolemy VI].

P.H., S-A.A.

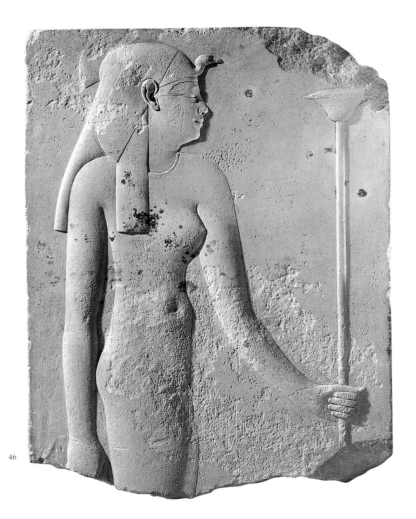

46

46 Limestone trial piece of a goddess or queen

Third century BC

Provenance unknown

Height 23.5 cm, width 17.8 cm

London, British Museum EA 14371

The lower section of the plaque is missing, including the right hand and ankh, and the top right hand side is damaged. There are further marks on the surface of the limestone. Such plaques may have been used as votives or as practice pieces for Egyptian sculptors working on temple reliefs or stelae.

This particular example features a woman wearing a plain tripartite wig and vulture headdress, identifying her as a goddess. She wears a plain sheath-like costume and only the left breast is indicated, which was the convention. The stomach is doughnut shaped, also a common feature on images of Ptolemaic women. The right hand rests by the female's side, and would originally have held an ankh sign. The left hand is stretched outwards and holds a lily sceptre. The portrait features show a rounded face, small chin, a narrow eye with incised pupil and a forced smile, all of which are typical of the third century BC, as seen on the posthumous representation of Arsinoe II now in the Metropolitan Museum of Art, New York (cat. no. 166).

UNPUBLISHED.

S-A.A.

47 Limestone trial piece with two royal portraits

Late second century BC

Provenance unknown

Length 14 cm, width 19.1 cm

London, British Museum EA 57348

The left side is damaged and the edges are rough. The block is worked on the top and right side. There is a substantial hole at the back of the plaque, possibly for hanging. This feature on many of these so-called trial pieces has led some scholars to suggest that the images were ex-votos, and that they were dedicated at temples on behalf of the royal family. Some of the examples are unfinished or, like this piece, show evidence of errors and reworking, as seen clearly on the male portrait, where the original lines of the face have been re-cut but are still visible. It is, therefore, possible that as royal and divine images such practice pieces were dedicated at sanctuaries.

This particular example shows two heads facing each other; on the left is a young royal male, identified by the lock of Horus and uraeus, and around his neck is an aegis. The same hair-

47

style can be found on a small head of Ptolemy V, now in Berlin, (cat. no. 14). The accompanying female wears a circle of cobras crown, an echeloned tripartite wig and vulture headdress and body over the wig. Because the female has no uraeus it is possible that she was intended to represent a goddess, or a queen fulfilling this role. Both have exceptionally large ears, a common Ptolemaic trait; the female has a small chin, bulging cheeks and fleshy nose, and the ruler has large eyes, a straight, upturned mouth and hooked nose with large nostrils. These portrait features are typical of representations of rulers from the mid to late second century BC, and it is possible that this plaque shows a queen with a young son, possibly Cleopatra I with her son Ptolemy VI or Cleopatra III with one of her sons, Ptolemy IX or X, with whom she ruled as regent.

UNPUBLISHED.

S-A.A.

48 Faience *oinochoe* (jug) showing Arsinoe II, sister and wife of Ptolemy II Philadelphos

Made in Egypt *c.* 270–240 BC

Said to have been found at Canosa, Italy

Height 32.4 cm

London, British Museum GR 1873.8-20.389 (Vase K 77)

Restored from many fragments, and the surface of the vessel has faded and worn considerably. Traces of gilding, which survive on the Silenus masks and on the base, suggest that the vessel was intended as an imitation of similar jugs in precious metals. The figure of the queen and the masks were moulded separately and applied to the vessel.

Few full-length, Greek-style statues of the Ptolemaic rulers survive, and so portraits in relief on faience 'queen jugs' constitute a rare record. Draped in garments that were worn by fashionable Greek women of the third century BC, Arsinoe II stands with her right arm outstretched and holding a *phiale* from which she pours a libation over an altar. Behind her is a *baitulos*, round which are placed garlands. Her other hand supports a double cornucopia (a feature common in representations of this queen) filled with pyramidal cakes and bunches of grapes.

The jug is inscribed with a dedication wishing great fortune upon the queen. These *oinochoai* were no doubt used in rituals associated with the ruler cults established during the reign of Ptolemy II (285–246 BC). Arsinoe II was the first Ptolemaic ruler to be deified during her lifetime, as Arsinoe Philadelphos ('she who loves her brother'). Such was the queen's great influence

48

that a festival, the Arsinoeia, was established in 267 BC after her death, and altars inscribed with her name have been found throughout the Greek world. The faience jugs may have been used to pour libations in honour of the dead queen over such altars during her festival. This vessel was made in Egypt and was probably found in southern Italy, which suggests that a cult of Arsinoe II

existed there. Alternatively, the jug may have been considered a valuable luxury item by its owner, and buried in his or her grave.

BIBLIOGRAPHY: D.B. Thompson, *Ptolemaic Oinochoai and Portraits in Faience* (Oxford 1973), cat. no. 1; L. Burn, *Greek and Roman Art* (London 1991), 139–40; S. Walker, *Greek and Roman Portraits* (London 1995), 58.

P.H.

49

49 Pair of gold earrings in the form of double cornucopia

Third century BC

Provenance unknown

Length 2.5 cm

London, British Museum GR 1999.3-29.1

These, a rare form of earring, are in the shape of a *dikaras* (double cornucopia), a symbol of the fecundity of Egypt, and associated with both Arsinoe II and Cleopatra VII. The two horns rise from a single lotus, which is attached to the clasp of the earring and at the top by a collar of small tongues formed from twisted wires, above which are three rows of wire that, at the back, are attached to the hoop of the earring. Below this band are two bunches of grapes formed from small granules of gold, and above it four globular fruits and two stylized pyramidal cakes (*pyramidia*) emerge from the top of the horns. A rosette surrounded by plain and twisted wires is joined to the twisted hoop of the earring and decorates the top of the cornucopia. A star-shaped floral motif with two granules at the bottom decorates the central part of the cornucopia. These earrings would have been worn with the cornucopia inverted.

An elaborate pair of earrings connected by a chain, and now in Hamburg, have a double cornucopia suspended from a disc and hoop earring.

UNPUBLISHED. For the Hamburg earrings see, H.Hoffmann and V. von Claer, *Antiker Gold und Silberschmuck: Museum für Kunst und Gewerbe Hamburg* (Mainz 1968), 106–9, cat. no. 68.

P.H.

50 Limestone statue of Heresankh

Mid-second century BC

From the Serapeion at Saqqara

Height 38.8 cm

Paris, Musée du Louvre 2456

The statue of the lady Heresankh stands out as a landmark in Ptolemaic statuary. It is indeed one of the scarce well-dated feminine statues of non-royal persons whose provenance is sure. This is not surprising, considering the fact that Heresankh belonged to the family of a high priest of the god Ptah, whose sacred animal, the Apis bull, was buried at Saqqara. The back pillar bears an inscription which gives the beginning of the titles of Heresankh and ends on the left side of the statue. Heresankh was a priestess of the cult of the royal princess Philotaira, sister of the deified queen Arsinoe II, and therefore her statue can be dated to about the middle of the second century BC.

This statue also gives us important and rare information concerning certain characteristics of private female statues of that time. Her posture, with the hands resting against the hips without holding anything, seems to be typical of private statuary. The thin waist and the full, rounded breasts echo some features already existing in the rendition of female bodies on the reliefs dating to the Thirtieth Dynasty. The tripartite wig with tubular locks which merge into the back pillar is not a typical feature of statues representing queens and goddesses in the Ptolemaic period.

BIBLIOGRAPHY: J. Quaegebeur, 'Trois statues de femme d'époque ptolemaique' in H. Demeulenave and L. Limme (eds), *Artibus Aegypti, Mélanges Bothmer* (Brussels 1983), 109–14, figs 5–8.

M.É.

50 ▶

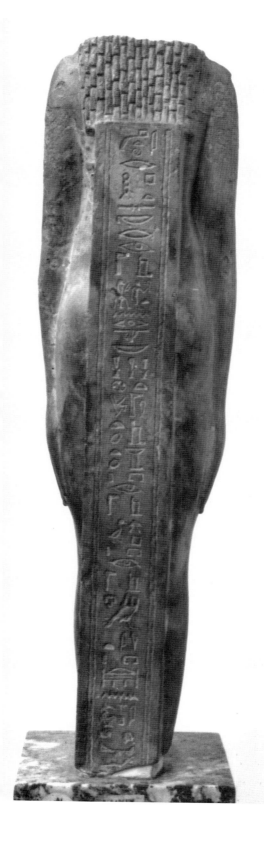
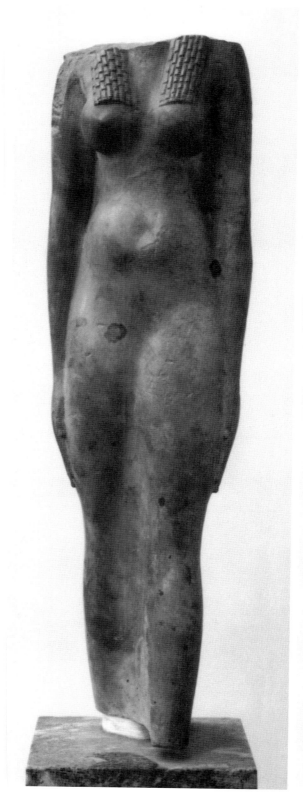
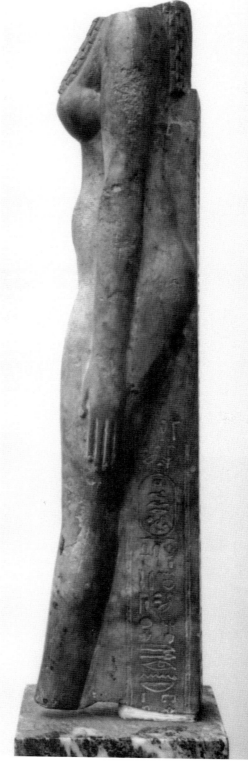

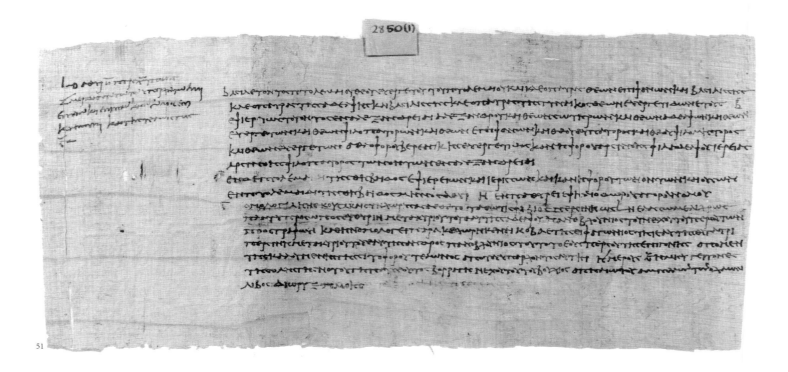

51

51 A Greek will from Pathyris

27 November 116 BC

Height 16 cm, width 33.7 cm

London, British Library 2850, cat. no. 2191

This fragment is the first part of a papyrus containing the testament of a Persian woman, Tathotis, bequeathing her land to her daughter, Kobahetesis. The testator is described in the usual manner: 'a Persian woman, about 50 years old, rather small, honey-coloured, broad-faced and straight nosed…'. The first fifteen lines, which are illustrated here, provide important information for the dynastic cult:

> In the second year of the reign of Ptolemy (VIII),
> god Euergetes, son of Ptolemy (V) and Cleopatra
> (I), gods Epiphanies, and (of the reign) of queen
> Cleopatra (II), the sister, and of Cleopatra (III), the

wife, goddesses Euergetides; during the priesthood of he who is priest, in Alexandria, of Alexander and the gods Soteres and the gods Adelphoi and the gods Euergetai and the gods Philopatores and the gods Epiphaneis and the god Eupator and the god Philometor and the gods Euergetai (and during the priesthood) of the priestesses who are the *athlophoros* of Berenike Euergetis, and the *kanephoros* of Arsinoe Philadelphos, and the priestess of Arsinoe Philopator in Alexandria, and in Ptolemais of the Thebaid, during the priesthood of them that are the priests and the priestesses and the *kanephoros* in Ptolemais of the Thebaid, on the 8th month of Hathyr, in Pathyris, before Heliodoros, the *agoranomos.* (tr. PW Pestman, 1969)

The current rulers are named, and the two consorts of Ptolemy VIII are distinguished as

sister and wife. The fact that the current priest of the dynastic cult also served that of earlier rulers is also explicit since they are listed. It is also clear that the queens who were deified posthumously were allocated a separate priestess, but, interestingly, following the reforms of Ptolemy IV, his mother, Berenike, is listed before the earlier queen, Arsinoe II, thus confusing the chronological sequence. As part of these reforms an eponymous priesthood was established at Ptolemais in the Thebaid as well as Alexandria, which is also noted in the text of this papyrus.

BIBLIOGRAPHY: P.W. Pestman, 'A Greek testament from Pathyris', *JEA* 55 (1969), 129-57; A. Kränzlein, 'P.Lond.Inv.Nr 1850–Ein Testament?', *Zeitschrift für Papyrologie und Epigraphik* 9 (1972), 289-92.

S-A.A.

52–55 The Sarapieion group

Sarapis is the Hellenized version of an Egyptian deity, Osiris-Apis, worshipped in the cult of the dead Apis bull. Although the bulls were housed and buried at Memphis, a new sanctuary and cult were established in the early Ptolemaic period at Alexandria, and were closely associated with the royal house. The chronographer Eusebius places the foundation of the cult of Sarapis between the reigns of Ptolemy I and II, when the two jointly ruled Egypt between 285 and 282 BC. This dating accords with the archaeological evidence from the Alexandrian Sarapieion, where the earliest dedication at the site dates to the reign of Ptolemy II, with the formal sanctuary being dedicated under Ptolemy III Euergetes. Tacitus (*Histories* 4.84) states that Ptolemy III was responsible for the dedication of the cult statue in Alexandria, since he financed the building stages of the main *temenos* and temple. The only evidence of dedications from the site prior to Euergetes' building works were to Isis and Osiris, and this fact is echoed in the ancient literary sources, suggesting that the worship of Sarapis was instigated under Euergetes, and that any earlier worship was concerned with Osiris. The date suggested by Eusebius could, therefore, refer to the cult of Osiris, which was so closely associated with Sarapis in his chthonic role, especially at Memphis.

In 1975 Kyrieleis suggested that a head of a Ptolemaic ruler in Paris (cat. no. 53) was associated with two other heads representing a queen and the god Sarapis, which were found at the Sarapieion in Alexandria (cat. nos 52 and 54). The two Alexandrian heads are stylistically similar and both have considerable traces of paint surviving on the surface of the marble. The group was most probably dedicated at the Sarapieion during the building of the temple of Sarapis by Ptolemy III or as part of the building works completed by Ptolemy IV, which included a temple to Harpokrates. The most commonly suggested identification is that the rulers represent Ptolemy IV and Arsinoe III. The portrait features, however, are not consistent with either ruler and the idealized images fit more closely the type used by Ptolemy III and Berenike II. It is, however, possible that the group was dedicated posthumously as part of the building programme of their successor, Ptolemy IV. They have been assembled for this exhibition and their presence at the Sarapieion demonstrates the close association between the deified rulers and existing gods. All three sculptures date to the third century BC, but the identifications and their homogeneity have been disputed.

A close inspection of the three heads reveals several technical similarities in the execution, which supports their original association. The broad, flat brow and cheeks are present on all three heads, along with the arched eyebrows framing deeply set eyes. Furthermore, the rendering of the hair on the two rulers and Sarapis are extremely similar in execution, with thick curls falling towards the sides of the head. Finally, the compact mouths with full, fleshy lips are similar on all three images and unusual on Ptolemaic portraits.

Unfortunately, the bodies, which were probably manufactured in metal or wood, are now missing. Athenodorus in Clement of Alexandria's *Protrepticus* (4.48) describes a bejewelled cult statue at the site and it is generally accepted that the type of cult image showed a seated Sarapis, as seen on several Roman copies. The rulers may have appeared in a similar guise to the figures on a relief from Athens (cat. no. 123). S-A.A., M. A el-F.

52 Marble head of Sarapis

Mid- to late third century BC

Sarapieion, Alexandria, excavated 1905–6

Height 50 cm

Alexandria, Greco-Roman Museum 3912

The hair, beard and nose are damaged. The back of the head is missing. Traces of polychromy remain on the hair, beard and eyes. This head of the Greek god Sarapis has a full beard, and the remains of thick, wavy locks of hair are visible on the forehead. The eyes are deeply set and the lips are very fleshy, with the teeth visible. The nose is badly damaged, but appears to have been straight.

The attributes associated with Sarapis in the Ptolemaic period are a lotus crown, beard and carefully divided fringe. It is only later in the Roman period that the god is shown with a *modius* and is accompanied by the dog Cerberus. Although the statue was originally dated to the second century AD, the stucco and modelling suggest that the head is a Hellenistic original, like the queen with which it was found.

BIBLIOGRAPHY: D. Wildung *et al.*, *Götter und Pharaoenen*. Edh. cat. Römer- und Pelizäus Museum (Mainz 1979), no. 113; B. Tkaczow, *Topography of Ancient Alexandria (An Archaeological Map)*, TCAMAPS 32 (Warsaw 1993) 244, no. 160; R.R.R. Smith, *Hellenistic Royal Portraits* (Oxford 1988), pl. 36, fig. 2.

S-A.A., M.A el-F.

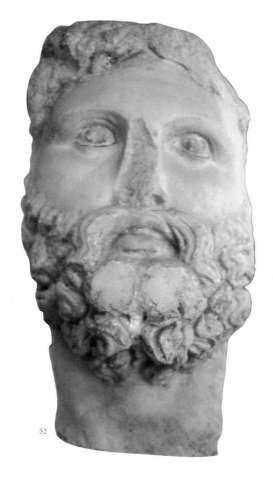

52

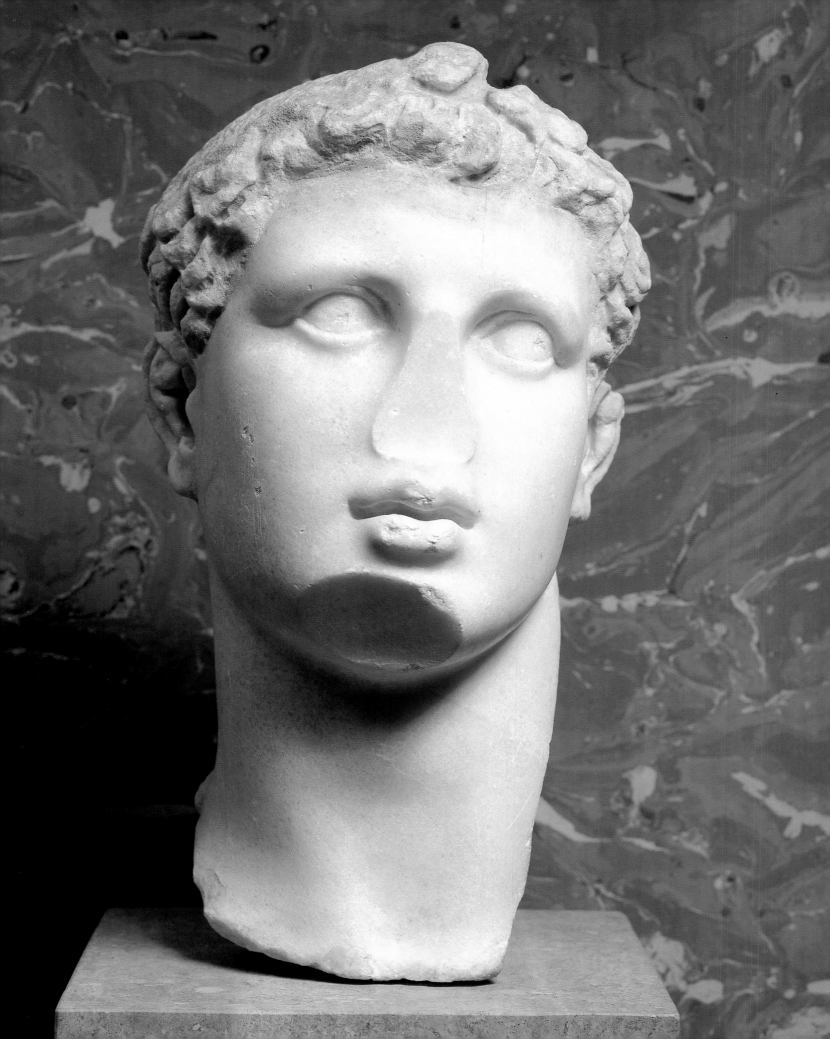

53 Marble head of a Ptolemaic ruler, Ptolemy III?

246–222 BC

Probably Sarapieion, Alexandria

Height 45 cm

Paris, Musée du Louvre Ma 3168

The nose, chin and the inlay for the eyes are missing.

This Greek-style portrait of a Ptolemaic ruler was originally inserted into a statue. It shows an idealized image of a ruler, probably a cult statue because of its size. The face is rounded, with full lips. The forehead is strong and accentuates the deeply set eyes, and the hair is wavy and unkempt. The head has been identified as Ptolemy III and Ptolemy IV, although it is possible that the statue was dedicated in honour of Ptolemy III by his successor and son, Ptolemy IV; this would explain the heroic appearance of the head and the softly modelled features. It has been identified here as Ptolemy III because of its association with the portrait of a queen representing Berenike II (cat. no. 54).

BIBLIOGRAPHY: A.W. Lawrence, 'Greek Sculptures in Ptolemaic Egypt', *JEA* 11 (1925), 179–80, no. 183; J. Charbonneaux, 'Portraits ptolémaïques au Musée du Louvre', *Mon.Piot.* 47 (1953), 99–129, no. 106 f. [Ptolemy III]; H. Kyrieleis, *Bildnisse der Ptolemäer* AF 2 (Berlin 1975), 46–51, D3 [Ptolemy IV]; Z. Kiss, *Études sur le portrait impérial Romain en Egypte*, TCAMAPS 23, 88 (Warsaw 1984), 23–24 [Ptolemy IV]; R.R.R. Smith, *Hellenistic Royal Portraits* (Oxford 1988), 92, 165–6, no. 51 [late third to early second century BC]; F. Queyrel, 'Portraits princiers hellénistiques', *Chronique Bibliographique* 1 (1990), 97–172 [Ptolemy IV]; A. Pasquier, catalogue entry in M. Rausch (ed.), *La gloire d'Alexandrie* (Paris 1998) 97, no. 54. cat. 77 no. 79 [Ptolemy IV]; M. Hamiaux, *Les Sculptures Greques II: La période hellenistique IIIe–Ie siècles avant J.C.* (Paris 1998), 77, no. 79 [Ptolemy IV?].

S-A.A.

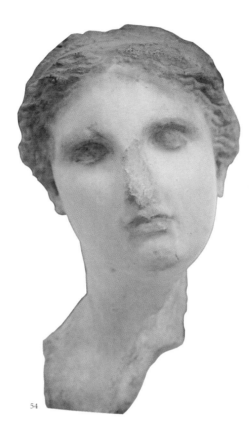

54

54 Marble head of a Ptolemaic queen, Berenike II?

246–222 BC

Excavated Sarapieion, Alexandria, 1905–6

Height 46 cm

Alexandria, Greco-Roman Museum 3908

This Greek-style portrait of a Ptolemaic queen was originally inserted in a statue. The nose is missing and part of the head at the back is damaged. Colour is still visible on the face and hair. The queen wears a narrow diadem; her hair is parted down the centre and pulled back. The image is idealized; the subject's head looks upwards and the left side is held higher than the right. The lips are very full and the mouth is fleshy in appearance. The eyes are deep-set and the painted pupils are just visible. The overall appearance is rounded and youthful.

The identity of the queen has been disputed: Berenike II, Arsinoe III and Cleopatra I have been suggested. Berenike II seems to be the most logical choice on stylistic grounds by comparison with other accepted portraits of the queen and also because of her association with the foundation of the sanctuary.

BIBLIOGRAPHY: E. Breccia, *Alexandria ad Aegyptum* (Bergamo 1922),115 [Berenike II]; C. Watzinger, Expedition Ernst von Sieglin 2: *Die griechisch-ägyptische Sammlung Ernst von Sieglin 1. Malerei und Plastik* 2 Teil (Leipzig 1927) [Berenike II]; I. Noshy, *The Arts of Ptolemaic Egypt: A Study of Greek and Egyptian Influences on Ptolemaic Architecture and Sculpture* (London 1937), 91 [goddess]; A. Adriani, *Documenti e ricerche d'arte Alessandrina. Sculture monumentali del Museo Greco-Romano di Alessandria* (Rome 1946), 34; H. Kyrieleis, *Bildnisse der Ptolemäer* (Berlin 1975),105–6, L5 [Arsinoe III]; D. Wildung *et al.*, *Götter und Pharaönen*. Exh. cat. Römer- und Pelizäus Museum (Mainz 1979), no. 114 [217 BC?]; R.R.R. Smith, *Hellenistic Royal Portraits* (Oxford 1988), 89, 92, no.52 [late third to early second century BC]; F. Queyrel, catalogue entry in M. Rausch (ed.), *La gloire d'Alexandrie* (Paris 1998), 96, no. 53 [Cleopatra I].

S-A.A., M.A el-F.

55

55 Gold foundation plaque from the Sarapieion

246–222 BC

Sarapieion, Alexandria

Length 17.3 cm

Alexandria, Greco-Roman Museum P8357

This thin sheet of gold commemorated the foundation of the temple of Sarapis by Ptolemy III. The Greek text reads: 'Ptolemy, son of Ptolemy and Arsinoe, the Theoi Adelphoi, [dedicated] the temple and precinct to Sarapis. '

BIBLIOGRAPHY: A. Rowe, *Discovery of the Famous Temple Enclosure of Serapis at Alexandria* (London 1946), 8, fig. 2; G. Grimm, *Alexandria. Der erste Königsstadt der hellenistischen Welt* (Mainz 1998), 84, fig. 840.

S-A.A.

56 Round-topped limestone stela of Ptolemaic rulers before deities

222–204 BC

From San el-Hagar (Tanis), Egypt

Height 70.5 cm, width 48.8 cm

London, British Museum EA 1054; gift of the Egypt Exploration Society

Above the figured scene is the usual winged sun disc with Nekhbet and Wadjyt as pendant cobras wearing the crowns of Upper and Lower Egypt respectively, for which they were the protective goddesses. Between them are the hieroglyphs for 'giving life' and, on either side in mirror image, the hieroglyphs name with epithets Horus of Edfu, whose wings protect the disc.

The sign for heaven forms the top of the frame to the figured scene, in which a king and queen stand before three deities; they do not make offerings, but are in the company of the divine triad because they are considered divine in their own right. This is a scene found on temple walls throughout the dynastic period when a pharaoh wished to stress his divine nature through his kinship with the gods. The king and queen depicted were identified by the excavator as Ptolemy II and his sister–wife Arsinoe II. The signs in the cartouches are still barely legible, but enough survives to suggest that it is rather Ptolemy IV and Arsinoe III who are shown. The fringed garment worn by the king is counterpart to that worn by his queen.

It is an unusual form of dress, particularly for a male ruler, and its special significance has not been identified with certainty. The royal women are often represented with this costume (see cat. no. 168), which is possibly associated with their individual cult rather than the dynastic cults that link husband and wife, often brother and sister. In this instance the ruler may wear the knotted garment in connection with the celebration of the *heb sed,* or jubilee, originally in dynastic times held after thirty years of reign but subsequently after shorter periods. Both royal figures carry an ankh, symbol of life, and the king holds a staff, which apparently ends in an anthropomorphic figure. He wears the double crown of united Egypt, she the tall plumes, cow's horns and disc of a goddess, often worn by Ptolemaic queens. The queen's hairstyle appears to comprise corkscrew locks, since the usual lappets of a tripartite wig are not present. The stela is therefore important for our knowledge of the adoption of Greek features on Egyptian royal representations, and is the earliest securely datable example to survive.

The divine triad comprises ithyphallic Min with characteristic tall plumes and flail floating over his upraised arm; the child-form Horus son of Isis, who stands on a block to bring his head to the level of his co-deities; and Wadjyt, protectress of Lower Egypt, represented in completely human form but wearing the Lower Egyptian crown.

The hieroglyphs with the deities provide their names with epithets. When excavated the stela was found set into the recess at one end of a mudbrick chapel acting as the focal point for worship. Another stela depicting Min and Horus son of Isis in the company of a deified Ptolemaic queen found at the same site is further evidence of the importance of this cult at San el-Hagar and the desire of the Ptolemaic rulers to be associated with it.

There are still traces of gilding on this piece.

BIBLIOGRAPHY: R.S. Bianchi in R.S. Bianchi (ed.), *Cleopatra's Egypt, Age of the Ptolemies* (New York 1988), cat. no. 15.

C.A., S-A.A.

56 ▶

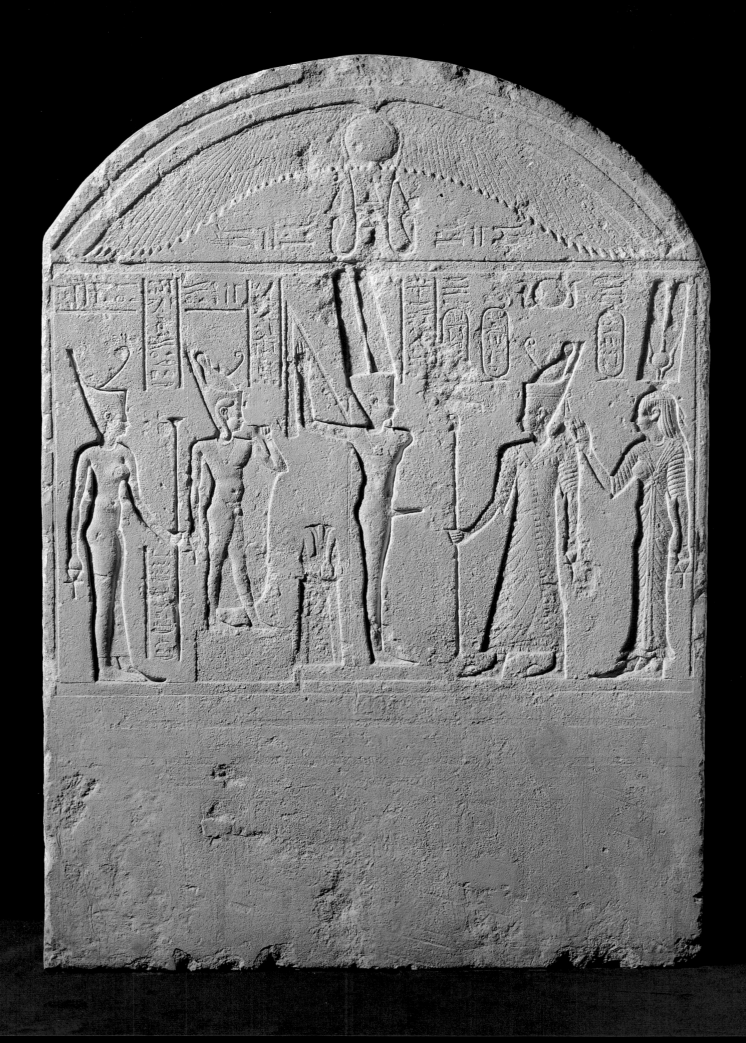

57 Painted and gilded limestone stela dedicated to the Buchis bull by Ptolemy V

180 BC

From the cemetery of Buchis at Armant; excavated by the Egypt Exploration Society, 1929–30

Height 72 cm, width 50 cm

Cairo, Egyptian Museum JE 54313

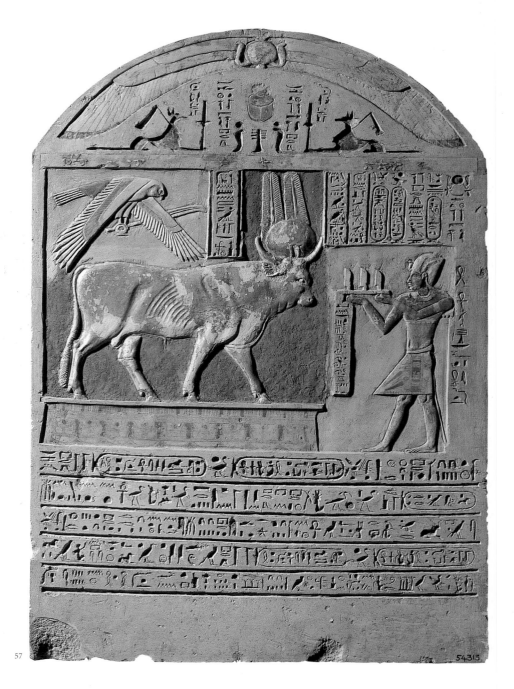

57

54313

At the top of the stela, below the usual protective winged sun disc, is a mirror image scene, separated by the scarab beetle, of the sun god over a *djed* pillar, symbolizing stability, flanked by two upreared cobras wearing sun discs. The reduplicated scene shows a crouched black jackal, a flail over his shoulder and the *wekh-* fetish of Cusae before him, who is named in the hieroglyphs as Anubis, son of Osiris.

In the main scene beneath the blue-coloured sign for heaven the Buchis bull, earthly animal manifestation of the Theban war god Monthu, wearing his characteristic headdress of sun disc, two plumes and double uraei, stands on an elaborately decorated plinth. The hieroglyphs name him and provide the epithets 'living spirit of Re' and 'herald of Re', thus linking him with the sun god. Over his shoulder flies a falcon, another of Monthu's manifestations, carrying a protective *shen* ring and ostrich feather fan in its talons. The hieroglyphs name the falcon form as Monthu-Re-Horakhty, thus linking him again with the sun god, and call him 'Lord of Southern Heliopolis', that is, Armant, one of Monthu's four cult sites in the Theban area.

Before the bull stands a pharaoh offering the emblem of a field symbolizing the produce of Egypt. He wears the blue war crown, a corselet and kilt with triangular apron; the bull's tail hanging from his belt and the uraeus on his forehead are age-old symbols of kingship. The cartouches identify him as Ptolemy V: in Egyptian this king is designated 'heir of the two father-loving gods', that is, 'son of the Ptolemies Philopatores'. To his epithet 'the god who manifests himself' (Epiphanes) has been added in this instance the words 'beloved of Monthu-Re-Horakhty'. The cartouche of Ptolemy's queen, Cleopatra I, is also present, although she is not depicted.

The text is dated to Ptolemy's twenty-fifth regnal year, in the Gregorian calendar precisely 14 February 180 BC, the day on which the Buchis represented died. It provides the further information that the bull was thirteen years, ten months and twenty-four days old (actually twenty-eight days) at death, having been born in year 11 of Ptolemy's reign, in March 194 BC in the town of Taareq, but was only installed as Buchis the year before its death.

The Buchis bulls were interred in their own burial place, called the Bucheum, at Armant, just as the Apis bulls, earthly animal manifestations of the god Ptah, had their own burial vaults, called the Serapeum, at Saqqara. But whereas the first burials in the latter catacombs were instituted during the earliest dynasties, those in the Bucheum do not predate the Thirtieth Dynasty only two centuries earlier. In both cemeteries stelae like this one, recording the salient facts about a sacred bull's life, would have been set up next to the burial place of the bull in question. By supporting the cult of the Buchis at Armant the Ptolemies provided a geographical counterbalance in Upper Egypt to their adherence to the cult of Ptah and the Apis at Memphis.

BIBLIOGRAPHY: H. Fairman in R. Mond and O. H. Myers, *The Bucheum II, The Inscriptions* (London 1934), 4–5, pl. XL; J-C. Grenier, 'La stèle funéraire du dernier taureau Buchis', *Bulletin de l'Institut français d'archéologie orientale* 83 (1983), 197–208, pl. XLI; A. Charron in M. Rausch (ed.), *La Gloire d'Alexandrie*. Cat. Exh. Petit Palais (Paris 1998), 198, no. 143.

C.A.

58 Round-topped limestone stela with Ptolemy VIII before Egyptian deities

c. 142–116 BC

From the temple of Karnak, Thebes, Egypt

Height 63 cm, width 51 cm

London, British Museum EA 612

The stela is framed at the top by a winged sun-disc with pendant snake-form Wadjyt and Nekhbet, respectively protective goddesses of the kingdoms of Lower and Upper Egypt, whose crowns they wear. Each holds a *flabellum* (feather-fan) that passes through a *shen* ring, which symbolizes eternity.

Below is a typical scene of a pharaoh making an offering before deities. On the left, holding *was* sceptre and ankh, and wearing characteristic double plumes, stands Amen-Re, king of the gods and state god of Egypt since the New Kingdom 1,500 years before. Two columns of hieroglyphs give his name with the epithets 'Lord of Karnak, self-created one, youthful god, lord of heaven, earth, the waters and mountains'. He is accompanied by his wife, the goddess Mut, carrying papyrus sceptre and ankh, whose vulture headdress is a reminder of her earlier bird manifestation; on top of it she wears the double crown of united Egypt. The hieroglyphs name her 'Great Mut, Lady of Karnak, Lady of heaven and Mistress of all the gods'. Behind stands their child, the moon god Khonsu, with full moon and crescent moon on his head. As usual, he is wrapped in an all-enveloping garment, wears a sidelock signifying his youth and carries a multiple sceptre of ankh, *was* and *djed* pillar. The accompanying hieroglyphs provide his name with epithets. Together the three formed the holy family of Karnak (modern Luxor). As the central column of hieroglyphs explains, the ritual is the presentation of Maat, goddess of cosmic order, without whom it was believed the world would be unable to function. She is shown as a small squatting figure with characteristic ostrich feather on her head. This scene was depicted in temples throughout Egypt during the pharaonic period as part of the daily temple ritual.

The king, wearing *atef* crown and short kilt with triangular apron, and offering Maat, is named in the two cartouches before him as Ptolemy VIII; in hieroglyphs Euergetes is rendered 'Heir of the two gods who appear', that is, of the gods Epiphaneis. The king is accompanied by two royal women wearing cow's horns, sun-disc and double plumes, each termed 'Lady of the Two Lands' and named in a cartouche as Cleopatra. Both exhibit the distinctive physique with large, full single breast and well-muscled stomach characteristic of depictions of women during the Ptolemaic period.

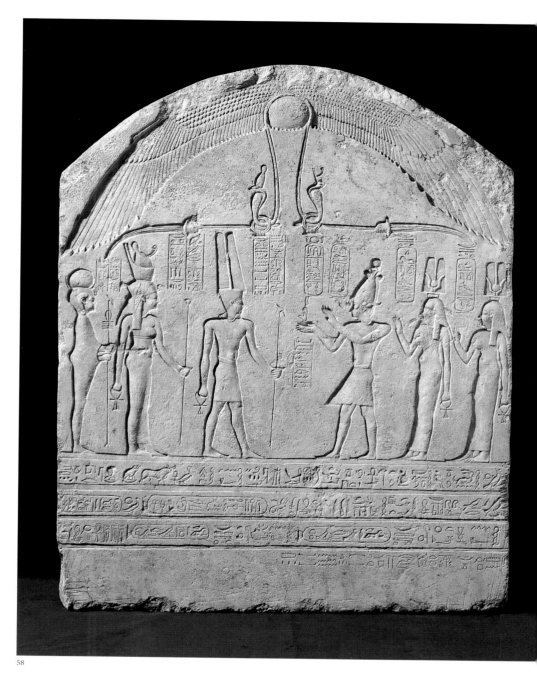

58

The four rows of hieroglyphic text below begin with Ptolemy's full royal titulary of five names and continue by distinguishing between the first-named Queen Cleopatra, who is called 'his sister' and the second, who is designated 'his wife', in other words the second and third respectively to bear the name. The last line repeats the epithets of Amen-Re from the main scene.

Ptolemy VIII first married his sister Cleopatra II. From demotic documentation his subsequent marriage to her daughter Cleopatra III took place in 142 BC; the stela cannot precede that date since both wives are depicted. At first the marriage led to open warfare with Cleopatra II; reconciliation came later in the reign, which suggests the stela should be dated nearer 116 BC. The depiction of these three Ptolemaic rulers together may well be unique for a stela; thus far, the grouping has only been noted on temple walls.

BIBLIOGRAPHY: E.A. W. Budge, *A Guide to the Egyptian Galleries (Sculpture), British Museum* (London 1909), cat. no. 961.

C.A.

59

60

61

62

59 Clay seal impression with a portrait of a ruler wearing a kausia

Second to first century BC

Height 1.9 cm, width 1.7 cm

Said to have been found at Edfu

Toronto, Royal Ontario Museum 906.12.66

The lower section of this clay seal impression is damaged. The portrait shows a male, with wavy, unkempt hair protruding from beneath a *kausia* (a Macedonian cap). The portrait features – a strong nose and well-proportioned face – are similar to the profile found on posthumous coin images of Ptolemy I, and it is possible that this impression was intended to represent the founder of the dynasty.

BIBLIOGRAPHY: J.G. Milne, 'Ptolemaic seal impressions', *JHS* 36 (1916), 87–101, pl. IV, no. 63

S-A.A.

60 Clay seal impression with a portrait of Ptolemy VIII?

170–116 BC(?)

Said to have been found at Edfu

Height 1.8 cm, width 1.8 cm

Toronto, Royal Ontario Museum 906.12.83

The portrait on this clay sealing impression shows a clean-shaven male ruler, identified by the wide diadem, which is tied at the back of the head. The face is rounded with slightly bloated cheeks and a hooked nose. The profile is similar to that on the coins of Ptolemy VIII, particularly with regard to the slightly flared nostrils (cf. cat. no. 91).

BIBLIOGRAPHY: K. Parlasca, 'Ein Verkanntes Hellenistisches Herrscherbildnis', *JDI* 80 (1967), 180, 183, 185, 187 [Ptolemy X]; H. Kyrieleis, *Bildnisse der Ptolemäer* (Berlin 1975), pl. 54.15 [Ptolemy IX].

S-A.A.

61 Clay seal impression with a portrait of Ptolemy VIII, Cleopatra II and Cleopatra III.

Second century BC

Said to have been found at Edfu

Height 2 cm, width 2 cm

Toronto, Royal Ontario Museum 906.12.207

The lower section of this clay seal impression is damaged but the impression is still very clear.

The portrait features are bland, probably because of the number of faces portrayed, but each of the three figures wears a specific crown. The first two crowns appear to be the crown of Upper Egypt, and the third subject wears a more general plumed headdress. This triad probably represents Ptolemy VIII, his sister and wife Cleopatra II and her daughter, his niece, Cleopatra III. The three also appear on a stela (cat. no. 58). It is, however, also possible that the images represent Ptolemy VI, Ptolemy VIII and Cleopatra II during their early years when the three ruled together. The portrait features are not rendered well enough to distinguish the sex of the three subjects.

BIBLIOGRAPHY: J.G. Milne, 'Ptolemaic seal impressions', *JHS* 36 (1916), 87–101; A. Krug, 'Die Bildnisse Ptolemaios IX, X und XI' in H. Maehler and V.M. Strocka (eds), *Das Ptolemäische Ägypten* (Mainz 1978), 9–24; H. Maehler 'Egypt Under the Last Ptolemies', *BICS* (1983a), 30: 1–16; D. Plantzos, 'Female portrait types from the Edfu hoard of clay seal impressions', *Bulletin de Correspondance Hellénique,* suppl. 29 (1993), 307–31.

S-A.A.

62 Clay seal impression with portraits of late Ptolemaic rulers

Second century BC

Height 2.1 cm, width 2.0 cm

London, The British Museum GR 1956.5-19.2

The top section is cracked and there are further hairline cracks at the sides of the impression.

The images are well preserved and show a strong portrait of a male ruler with fleshy jowls and a large hooked nose, a type associated with Ptolemies VIII and X. The second head shows a similar, although less exaggerated, portrait of a female ruler. There is a ghost of a third female head, which may have been where the seal slipped or may actually represent a third head, in which case the triad can be identified as Ptolemy VIII, Cleopatra II and Cleopatra III. The exaggerated portrait of the male is, however, closer to the images of Ptolemy X as seem on cat. no. 66. On the back are impressions of horizontal lines, from where the sealing was originally attached to a papyrus document.

UNPUBLISHED.

S-A.A.

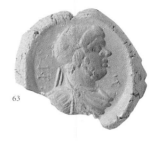

63

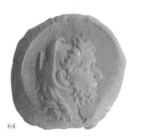

64

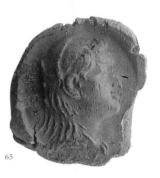

65

66

63 Clay seal impression with a portrait of Ptolemy IX (?)

116–107 BC?

Said to have been found at Edfu

Toronto, Royal Ontario Museum 906 .12.113

The lower, right section of this seal impression is missing. The impression is clear and shows the profile of a Ptolemaic ruler wearing Hellenistic costume. The portrait features a fleshy, hooked nose, full lips and a rounded face; there are sideburns on the cheek.

BIBLIOGRAPHY: J.G. Milne, 'Ptolemaic seal impressions', *JHS* 36 (1916), pl. V, no. 113.

S-A.A.

64 Clay seal impression with a portrait of Ptolemy IX (?)

88–80 BC(?)

Said to have been found at Edfu

Height 2 cm, width 2 cm

Toronto, Royal Ontario Museum 906 .12.125

The portrait on this seal impression shows a Ptolemaic ruler with a fleshy face, hooked nose and beard covering the sides of the cheeks and below the chin. The ruler wears a lion's head as a headdress, under which unkempt hair protrudes. Amongst the sealings, this portrait type has been identified as Ptolemy IX because the lion headdress is distinct from the other portrait type (cat. no. 66), which is associated with a plumed headdress and represents Ptolemy X.

BIBLIOGRAPHY: J.G. Milne, 'Ptolemaic seal impressions', *JHS* 36 (1916), pl. IV.

S-A.A.

65 Clay seal impression with a portrait of Ptolemy IX or XII (?)

First century BC(?)

Said to have been found at Edfu

Height 2 cm, width 2 cm

Toronto, Royal Ontario Museum 906.12.140

The right edge of this sealing is damaged. The portrait clearly shows an idealized image of a Ptolemaic ruler wearing a lion's cap. The portrait features show a straight nose with flared nostrils, and a pointed chin. It is possible that this more idealized image is a slimmer version of the Ptolemy VIII portrait type (cat. no. 60) and represents Ptolemy IX, as proposed for the more

corpulent image (cat. no. 64), or an idealized image of Ptolemy Auletes, as seen on some of the marble images of this ruler (cat. no. 155).

BIBLIOGRAPHY: H. Kyrieleis, *Bildnisse der Ptolemäer* (Berlin 1975), pl. 55, 10 [Ptolemy X]; J.G. Milne, 'Ptolemaic seal impressions', *JHS* 36 (1916), pl. V, no. 160.

S-A.A.

66 Clay seal impression with a portrait of Ptolemy X (?)

107–88 BC

Said to have been found at Edfu

Height 2.3 cm, width 2 cm

Toronto, Royal Ontario Museum 906.12.97

Clay seal impression with a portrait of a Ptolemaic ruler wearing a plumed headdress with cheek protectors. The ruler, unusually, is shown facing forwards rather than in profile and has a corpulent face with large, hooked nose and full lips. In his right hand he holds a sword, and the top of a shield can be seen in the right corner of the impression, thus being held in his left hand. The headdress is particularly important for the identification of this portrait type and has been associated with the plumed headdress known to have been worn by Alexander the Great. The ruler is therefore identified as Ptolemy X Alexander II.

BIBLIOGRAPHY: J.G. Milne, 'Ptolemaic seal impressions', *JHS* 36 (1916), pl. IV, no. 95.

S-A.A.

Ptolemaic silver coinage

In the autumn of 332 BC Alexander the Great, encouraged by his victories over the Persian Great King Darius at the Granicus and Issus, invaded Egypt. Mazaces, the Persian governor (*satrap*) of the province offered no resistance. As if symbolic of the new Macedonian rule over the ancient land of Egypt, Alexander founded his new city of Alexandria at the western end of the Nile Delta in January 331. Before long, the new city had usurped the position of the traditional old Egyptian capital of Memphis. Upon his departure for the east, Alexander left Egypt in the care of a Satrap based in Alexandria.

On Alexander's death in 323 BC a new *satrap* by the name of Ptolemaios (Ptolemy) arrived in Egypt. Macedonian by birth, he had been one of Alexander's most trusted generals and a chronicler of his campaigns. He claimed to have been appointed by Alexander's half-brother, Philip III Arrhidaeus, but in reality the boy king was a puppet, and it is likely that Ptolemy chose the appointment for himself. By 305 BC the unity of the empire that Alexander had created had largely broken down, and several of his former generals took the royal title. Among these was Ptolemy: Egypt became his kingdom and was to remain in the hands of the dynasty he founded until the death of Cleopatra 275 years later. Ptolemy I's coinage policy was radical, and yet for all its novel and isolationist tendencies it would in spirit survive his dynasty by a further 300 years.

The Ptolemaic closed currency system

Egypt's position as one of the principal grain-producing areas of the ancient Greek world brought its rulers phenomenal wealth. Crucially, the sale of grain abroad provided a much-needed influx of precious metal into Egypt, which did not otherwise have a ready source of silver. The Ptolemaic kings were able to exploit the position of economic strength they derived from agriculture to maximize precious metal revenues by the establishment of a closed currency system. This imposed the use of Ptolemaic currency, and only Ptolemaic currency, within the borders of the kingdom. Traders from outside were forced to exchange their foreign coins for Ptolemaic issues. By setting the weight of their silver coinage 17 per cent lower than that of the most common standard outside Egypt, the Ptolemies were thus able to reap a considerable benefit from the system.

A famous papyrus now in Cairo preserves a letter from a mint official called Demetrius to his superior. Dated 258 BC, it describes the difficulties he is having keeping up with the need to exchange foreign coins at the same time as having to introduce a new gold denomination in place of an old one:

> I am undertaking the work as you instructed me and have received 57,000 pieces of gold, which I have reminted and returned. We might have received a great deal more, but, as I have written to you before, the foreigners arriving by sea and the merchants and importers and others bring both their good local currencies as well as the *trichrysa*, so that it can be turned into new coin according to the decree which requires us to accept it and remint it… (*P.Cairo.Zen.* 59021)

67 Gold pentadrachm (*trichryson*) in the name of Ptolemy I

c. 280s BC

Mint of Alexandria

London, British Museum CM 1987-6-49-131
(Presented by the National Art Collections Fund)

The gold pentadrachm, or *trichryson* (so named because it was worth three gold staters, equal to sixty silver drachms) was the standard gold denomination under Ptolemy I, but was replaced, as the papyrus shows, in the reign of Ptolemy II.

BIBLIOGRAPHY: G.K. Jenkins, 'The monetary systems in the early Hellenistic time with special regard to the economic policy of the Ptolemaic kings', in A. Kindler (ed.), *Proceedings of the International Numismatic Convention, Jerusalem, 27–31 December 1963* (Jerusalem 1967), 53–72.

A.M.

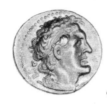

67

68 Gold octadrachm (*mnaeion*) of Ptolemy II

285–246 BC

Mint of Alexandria

London, British Museum CM 1964-13-3-3
(Sir A. Clark Bequest)

The new denomination, the *mnaeion*, with a value of 100 silver drachms, became the standard gold denomination in the Ptolemaic empire after the late 260s BC. These were the coins that Demetrius would have been producing at his mint.

On this coin, the king has more prominent sideburns and the chin is closer to the portrait type of Ptolemy I. The shield behind his head may refer to a specific victory. The figure shown in profile beside him is his sister–queen, Arsinoe II (278–270 BC).

A.M.

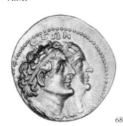
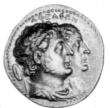

68

Ptolemaic gold

With two important exceptions, gold coinage was never a regular element in ancient Greek currency systems. The first exception was the kingdom of Macedon under the rule of Philip II (359–336 BC) and his son, Alexander the Great (336–323 BC), where the combination of gold mines in Thrace and the conquest of the Persian empire ensured a steady flow of the metal into the Macedonian treasury. The second exception was Egypt under the early Ptolemaic kings. These kings too had access to sources of gold in the southern extremities of their kingdom. According to the historian Diodorus of Sicily, writing in the first century BC, but probably reflecting conditions in the second,

> At the end of Egypt, and in the bordering territory of Arabia and Ethiopia lies an area with many large gold-mines, where a great deal of gold is extracted at much suffering and expense … For the kings of Egypt gather together and sentence to gold-mining those who have been convicted of crimes, prisoners of war, and even those convicted on trumped up charges or locked up because of their beliefs (and not just the men themselves, but sometimes their entire families too). In this way they inflict punishment on the convicted and at the same time reap the great rewards of their labours.

The existence of a royal monopoly on gold-mining in the third century BC is confirmed by documentary evidence from papyri. Production of gold coinage began under Ptolemy I (cat. no. 67), and continued probably until the reign of Ptolemy VIII Euergetes II (145–116 BC). Certainly no gold coins were produced by Cleopatra.

69 Gold octadrachm of Ptolemy II Philadelphus (285–246 BC) in the name of his wife and sister, Arsinoe II Philadelphus

285–246 BC

Mint of Tyre

London, British Museum BMC Arsinoe II 3

At around the time of her death in 268 BC, or perhaps slightly before, Philadelphus began to issue coins in gold and silver in the name of his sister and wife, Arsinoe. These were produced in Alexandria and at mints in Phoenicia.

The coin bears a portrait of Arsinoe II. The queen wears a *stephane* (diadem), with her hair pulled back and secured in a bun, which is visible beneath her veil. The portrait is youthful, with a long, slender nose, pointed chin, and two Venus rings on the neck. Below the ear is a small horn, thought to associate the queen with either Amun or Khnum, the Egyptian ram-headed deity. It has also been suggested that the sceptre behind the queen's head is Egyptian. On the reverse of the coin is a double cornucopia, or *dikeras*, filled with the fruits of Egypt and referring to the queen's role as provider. The double form is always associated with Arsinoe II and may refer to her close relationship with her brother and consort, Ptolemy II. Alternatively, it could refer to the unification of Upper and Lower Egypt.

This particular gold coin shows a less stylized version of the queen's portrait type: the nose and chin, although prominent, are less angular than on some coins The horn beneath the ear, the sceptre and the double cornucopia are consistent features of the queen's iconography.

BIBLIOGRAPHY: H.A. Troxell, 'Arsinoe's Non-Era', *ANSMN* 28 (1983), 35–70.

A. M., S-A.A.

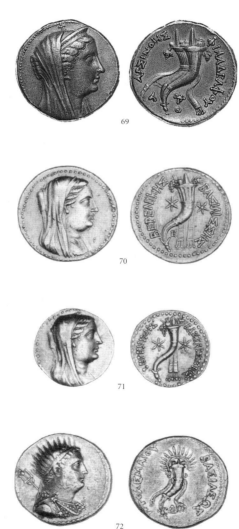

69

70

71

72

70–71 Gold decadrachm and pentadrachm of Ptolemy III Euergetes in the name of Berenike

246–222 BC

London, British Museum CM 1923-11-8-1; BMC Berenike II 3

The tradition of issuing gold coins in the name of the queen was continued by Ptolemy III Euergetes, who produced a series of gold decadrachms and pentadrachms in the name of Berenike II. Remarkably, these were issued on the Attic weight standard rather than the Ptolemaic.

The coins bear a portrait of Berenike II. The queen wears a diadem and veil. Her hair is pulled back in a bun, with a single curl falling on to her face. She is distinguished from other queens by her rounded face, fleshy cheeks and jowls, prominent chin and well-proportioned, straight nose.

A.M., S-A.A.

72 Gold octadrachm of Ptolemy IV Philopator in the name of Ptolemy Euergetes

225–205 BC

London, British Museum BMC Ptolemy III 104

Gold coins of such high denominations were clearly not produced for everyday payments. They were showy coins, perhaps originally handed out on special occasions or as particular favours. Their designs reflect their special place in royal munificence, often drawing attention to the dynasty itself or members (living or dead) within it. Gold coins were issued by Ptolemy IV with the portrait of his deified father, bearing the attributes of both Zeus (the aegis) and Poseidon (the trident).

The coin bears a portrait of Ptolemy III. The ruler wears a radiate diadem, associating him with the Greek sun god, Helios. The face is broad and fleshy, with a weak chin and straight, well-proportioned nose. The neck is also fleshy rather than muscular, in contrast to the portraits of his predecessors. This is the earliest example of a Ptolemaic ruler directly associating himself with deities. On the reverse is a cornucopia, more typically associated with Ptolemaic queens, which is also surrounded by sun rays and overflowing with the usual fruits, referring to the ruler's role as provider.

A.M., S-A.A.

73–76 Gold octadrachms from the reign of Ptolemy V Epiphanes

205–180 BC

London, British Museum BMC Ptolemy V 51; BMC
Ptolemy IV 34; BMC Arsinoe III 1; BMC Ptolemy V 62

The accession to the throne of Ptolemy V at the
age of five or six was a troubled time for the
dynasty. The young boy's claim to the throne is
evident in this series of coins produced early in
his reign. On one (cat. no. 73) comes the portrait
of the young king himself, wearing a radiate
crown, symbol of his manifest (*Epiphanes*) divin-
ity. On two others occur portraits of the King's
parents, Ptolemy IV (cat. no. 74) and Arsinoe III
Philopator (cat. no. 75). Coins with a portrait of
Ptolemy V, although without radiate crown (cat.
no. 76), were also produced in Phoenicia, until its
loss to the Seleucids in 199 BC.

On cat. no. 74 Ptolemy IV has a full, youthful
face with fleshy cheeks, small mouth and slightly
upturned nose. His hair is rendered in light curls,
which continue to form a sideburn on his right
cheek. He wears a diadem, which is tied loosely at
the back of the head. On the reverse is the eagle
holding a thunderbolt, which frequently
appeared on Ptolemaic coins throughout the
dynasty's rule.

On cat. no. 75 Arsinoe III appears in profile.
The queen wears a *stephane* and fillet, and has
her hair rolled upwards and tied, rather than in
the usual tight bun. Also, unusually, the queen
does not wear a veil. The image shows the queen's
distinctive profile with downturned mouth,
small pointed chin and chiselled nose. She wears
a necklace, presumably of precious stones, and
her chiton and himation are visible on the shoul-
ders. The earrings are made of a straight bar and
three hanging pendants. Although the sceptre
behind her head is difficult to distinguish, it has
been suggested that, like that of Arsinoe II, it is
Egyptian in origin, and it possibly shows a sun
disc with cow's horns, a common Hellenization
of the Egyptian crown worn by the goddess Isis.

No. 76 shows a youthful portrait of Ptolemy V.
The ruler has the usual large eye and a large
ear. The nose is slightly hooked, the chin pointed
and the neck fleshy rather than muscled. The
ruler wears his hair short with a knotted fillet
tied behind the head and with an ear of corn

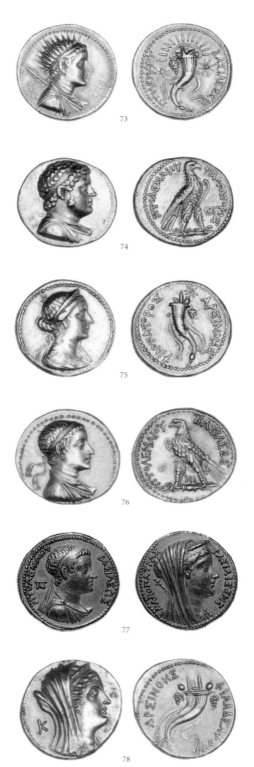

attached to it. On the reverse is the usual eagle
and thunderbolt.

BIBLIOGRAPHY: O. Mørkholm, 'The Portrait Coinage of
Ptolemy V. The Main Series' in O. Mørkholm and N.
Waggoner (eds), *Greek Numismatics and Archaeology.*
Essays in Honor of Margaret Thompson (Wetteren 1979),
203–14.

A.M., S-A.A.

77 Gold octadrachm in the names of Ptolemy VI Philometor and Cleopatra I

c. 180–176 BC

London, British Museum CM 1978-10-21-1

The last Ptolemaic rulers to place their portraits
on gold coinage were the young Ptolemy VI and
his mother, Cleopatra I, acting as regent.
Cleopatra's depiction closely resembles the coin
portrait of her predecessor, the powerful queen
Arsinoe II (cat. no. 69), and is perhaps a con-
scious echo. The portrait of the young Ptolemy
VI strikingly resembles that of his father (cat. no.
75). The ruler is youthful in appearance, and has
a pointed chin and straight, long nose. His hair is
short and he wears a diadem, tied behind his
head with two straight ends. Cleopatra I wears a
stephane (diadem) and veil.

A.M., S-A.A.

78 Gold octadrachm of the reign of Ptolemy VIII Euergetes II

145–116 BC

London, British Museum BMC Arsinoe II 36

During the reign of Ptolemy VIII, references to
the former glory of the dynasty became even
more overt on the gold coinage. In place of
immediate family members Ptolemy returned to
the issue of gold coins in the name of his illustri-
ous ancestor Arsinoe II, wife of Philadelphus.
With this rather unimaginative series the pro-
duction of Ptolemaic gold ended.

A.M.

Portrait coins of the Ptolemaic house

It was by no means the norm for Ptolemaic kings after Ptolemy I to place their portraits on their coins. The portrait of Ptolemy I remained the standard design for silver issues until the end of the dynasty, while bronze coinage was more often decorated with the heads of divinities. Nonetheless, certain kings did choose to place their own or family portraits on their coins. Often this was on gold coins, probably produced for specific celebratory occasions (cat. nos 69–78), but silver and bronze was dignified with portraiture too, presumably often with specific occasions or purposes in mind.

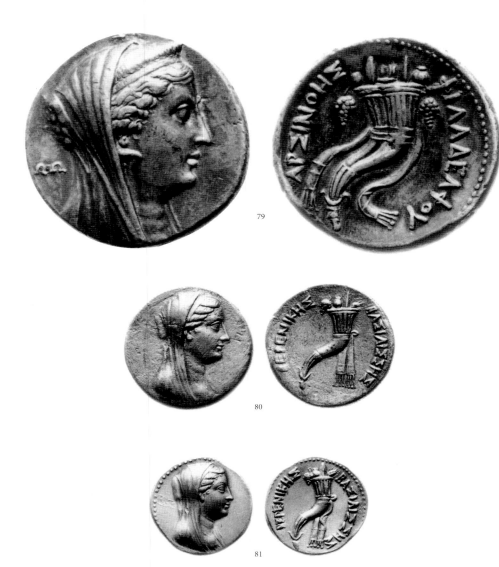

79

80

81

79 Silver decadrachm in the name of Arsinoe II Philadelphus

c. 240s BC

Mint of Alexandria

London, British Museum CM 1897-2-1-4

The most substantial group of portrait issues in Ptolemaic coinage are those in the name of Arsinoe II Philadelphus, queen and sister of Ptolemy II. Both gold octadrachms (cat. no. 69) and silver decadrachms were produced. The precise circumstance of their introduction is not known, although it has been suggested that they are connected with the diversion of the ἀπόμοιρα (a one-sixth tax on agricultural produce) from the cults of Egyptian gods to the cult of the deified Arsinoe. Certainly the bulk of the coinage belongs to the period after Arsinoe's death in 268 BC, and production probably continued into the reign of Ptolemy III (246–222 BC).

BIBLIOGRAPHY: H.A. Troxell, 'Arsinoe's Non-Era', *ANSMN* 28 (1983), 35–70.

A.M.

80–81 Silver decadrachm and tetradrachm in the name of Berenike II, reign of Ptolemy III Euergetes

246–222 BC

London, British Museum CM 1987-6-49-281; 1987-6-49-514 (Presented by the National Art Collections Fund)

Berenike II, Arsinoe's successor as queen of Egypt, was also honoured with several series of portrait coinage. The issues were not as large as those of Arsinoe, but were distinctive for their production on two different weight standards. Some gold and silver was produced, like these two examples, on the local Ptolemaic standard for use within the closed currency system of the kingdom. Others (cat. nos 70–71) were produced on the Attic standard, evidently with a view to use abroad.

A.M.

82–83 Bronze coins from the reign of Ptolemy III Euergetes

246–222 BC

London, British Museum BMC Ptolemy III 101;
BMC Berenike II and Ptolemy III 16

Unusually, under Ptolemy III bronze coins were also produced with the portraits of the ruling couple, Ptolemy and Berenike II. The former, it has been suggested, may have been produced *c.* 227–33 BC to pay a donative to the city of Sparta in the Peloponnese.

BIBLIOGRAPHY: T. Hackens, 'A propos de la circulation monétaire dans le Peloponnèse au IIIe siècle av. J.-C.', *Antidorum Peremans, Studia Hellenistica* 16 (1968), 69–95.

A.M.

84 Bronze coin of Ptolemy III Euergetes

246–222 BC

Mint of Cyrene

London, British Museum BMC Cyrenaica Regal Issues 39

The personification of Libya portrayed on the reverse of this coin has been seen by some scholars to have the features of Euergetes' wife, Berenike II, herself of Cyrenaican origin.

UNPUBLISHED.

A.M.

85–86 Silver didrachm and drachm from the reign of Ptolemy IV Philopator or Ptolemy V Epiphanes

Late third century BC

London, British Museum BMC Ptolemy IV 16
(Payne Knight Bequest); BMC Ptolemy IV 20

Either late in the reign of Ptolemy IV (222–205 BC) or early in that of his son (205–180 BC) silver coins were issued on Cyprus with a depiction of Dionysos wearing an ivy wreath on the obverse. The features of Ptolemy IV have been seen by some in the portrait. Literary sources describe attempts by Philopator to identify himself as Dionysos, and it is possible that these coins reflect an official policy of assimilation. Coins of these types continued to be produced on the island until the early first century BC. This identification of the ruler with Dionysos was later taken up by Antony.

BIBLIOGRAPHY: R.A. Hazzard, 'A Review of the Cyprus Hoard, 1982', *NC* 158 (1998), 25–36.

A.M.

87 Silver tetradrachm of Ptolemy V Epiphanes

205–208 BC

London, British Museum BMC Ptolemy V 66
(Payne Knight Bequest)

Ptolemy V broke with tradition by producing a large number of issues with his own portrait, rather than that of Ptolemy I, at a wide variety of mints. This substantial group of issues appears to be linked to the Fifth Syrian War fought between the Ptolemaic and Seleucid kingdoms (202–195 BC).

BIBLIOGRAPHY: O. Mørkholm, 'The Ptolemaic coinage in Phoenicia and fifth war with Syria', *Egypt and the Hellenistic World. Proceedings of the International Colloquium, Leuven 24–26 May 1982. Studia Hellenistica* 27 (Louvain,1983), 241–51.

A.M.

88–89 Bronze coins of the reign of Ptolemy VI Philometor

180–145 BC

London, British Museum BMC Ptolemy VIII 11;
CM 1926-1-16-951 (Seager Bequest)

Like his father before him, Ptolemy VI was a minor at the time of his inheritance of the

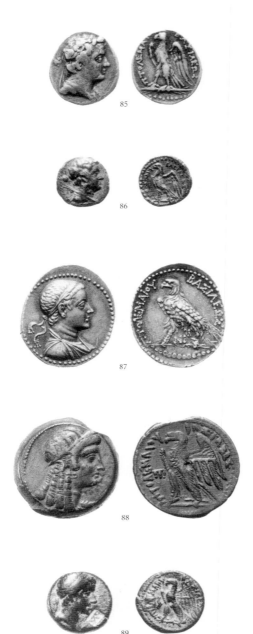

Egyptian throne. During his early years his mother, Cleopatra I, served as his regent, and her portrait has been discerned by some scholars in the representation of Isis on a series of bronze coins produced at Alexandria (cat. no. 88). The portrait of the young king was placed on some bronze issues (cat. no. 89), as well as spectacular gold coinage (cat. no. 77).

UNPUBLISHED.

A.M.

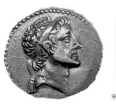

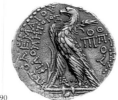

90

90 Silver tetradrachm
of Ptolemy VI Philometor

180–1445 BC

Paris, Bibliothèque Nationale Fonds Gen. 368

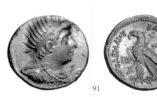

91

91 Silver didrachm
of Ptolemy VIII Euergetes II

145–116 BC

New York, The American Numismatic Society,
1944-100-75452

The last two monarchs to place their portraits on
large silver coins were the brothers Ptolemy VI
and VIII. At one time joint rulers (170–164 BC),
the two were for the most part bitter rivals for the
Egyptian throne. Their reigns saw the end of
impressive silver portrait coinage, as well as the
end of issues of gold (cat. no. 78).

A.M.

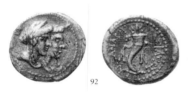

92

92 Bronze coin of Alexander
Balas with Cleopatra Thea

150–145 BC

London, British Museum BMC Alexander I and
Cleopatra 1

Cleopatra Thea, the daughter of Ptolemy VI
Philometor and Cleopatra II, was Cleopatra VII's
most tenacious and powerful ancestor. Having
been briefly betrothed to her uncle Ptolemy
Physkon (the future Ptolemy VIII), in 150 BC she
was married to Alexander Balas, the usurper of
the Seleucid throne (150–145 BC). Upon his death
she was then married to Demetrius II (first reign
145–140 BC), the son of the previous Seleucid
king. When Demetrius was taken hostage by the
Parthians in 140 BC, Cleopatra turned to his
younger brother, Antiochus VII (138–129 BC) for
support against a pretender to the throne, and
duly married him. Antiochus proceeded to
march east against the Parthians, who responded
by freeing his brother Demetrius. Antiochus
having been killed in battle, Demetrius (second
reign 129–126/125 BC) returned to Syria with a
new, Parthian wife, and no intention of wooing
Cleopatra back. She fled with her son by
Antiochus, also called Antiochus, to raise a rebel-
lion against her former husband. In 126/125 BC,
the rebellion having succeeded, Demetrius was
captured by Cleopatra, tortured and put to death.
He was succeeded, briefly, by his son by
Cleopatra, Seleucus V (126/125 BC), who was so

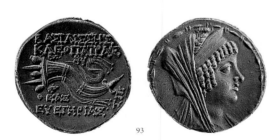

93

unsatisfactory a ruler that his mother killed him
by using him for archery practice. Next in line
was Seleucus' brother Antiochus VIII (126/
125–96 BC). When he, like his brother, proved
reluctant to accept his mother as co-ruler,
Cleopatra resolved in 121 BC to murder him too.
She greeted him with a glass of wine one day as
he came into the palace. Suspicious of this
unwonted kindness on the part of his mother,
Antiochus VIII insisted that she drink it instead.
The poison she had put in the wine killed her.

Cleopatra Thea's portrait graced a number of
coins throughout her lifetime. The appearance
on some of these of a cornucopia suggests that
the queen remained proud of her Egyptian
ancestry. It was no doubt this aspect of her
memory – the Egyptian queen who had ruled in
Syria – as much as her colourful family back-
ground that led Cleopatra VII to announce her-
self as the second Cleopatra Thea.

A.M.

93 Silver tetradrachm
of Cleopatra Thea

c. 125 BC

London, British Museum BMC Cleopatra Thea 1

A.M.

94 Silver tetradrachm
of Cleopatra Thea and
Antiochus VIII

125–121 BC

London, British Museum BMC Cleopatra Thea and
Antiochus VIII 6 (Payne Knight Bequest)

UNPUBLISHED.

A.M.

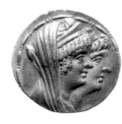

94

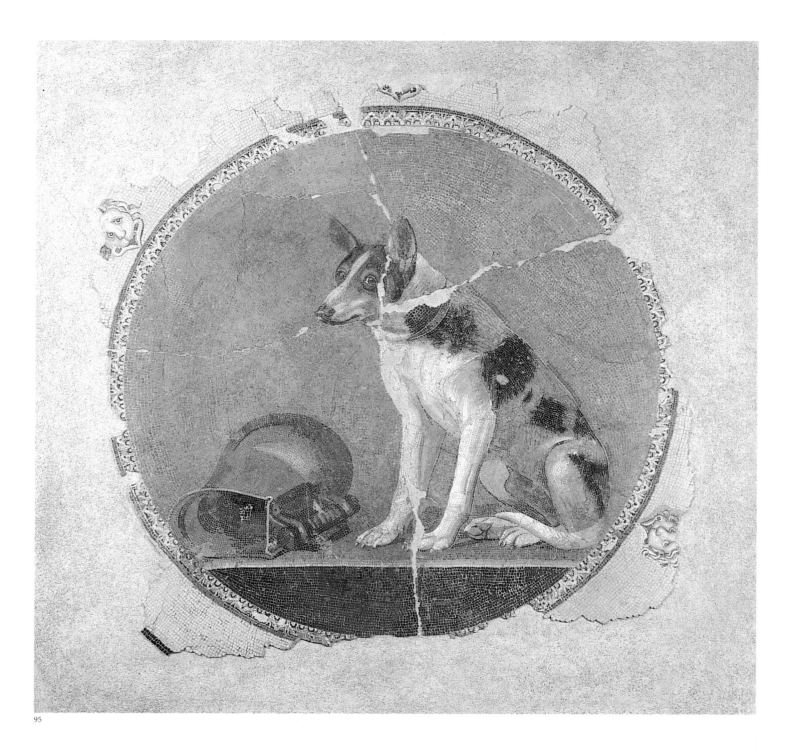

95

95 Roundel from a mosaic floor decorated with a dog and a gilded *askos*

c. 200–150 BC

Excavated on the site of the new Alexandria Library, 1993

Maximum diameter 69 cm

Alexandria, Greco-Roman Museum 32044

The roundel has two large cracks running through it, and the border is damaged. The outer

part of the mosaic (not exhibited here) is more fragmentary.

This roundel, from the centre of a large floor mosaic (about 3.5 m wide), was enclosed by a larger concentric circle decorated with a guilloche design of interlinked chains (not exhibited). The roundel itself has an unusual border of lions' heads shaded with only greys and blacks, whereas the details of the central dog are picked out in a variety of coloured tesserae. Lion heads of this sort are usually associated with architec-

tural ornament, used as water spouts. Below these are two rows of red tesserae, and then a band of Lesbian kymation design, again echoing architectural forms.

The centre is occupied by a large, male dog, perhaps a hunting dog, sitting next to a metal *askos* lying on its side, of which actual examples survive, some from Pompeii, dating from the late second to early first century BC. It has two horizontal handles, with the rivets connecting them to the body of the vessel clearly visible, and these

support a vertical handle. The material that the handle is intended to represent is unclear: it may be ribbed metal or wood, or even the latter bound with strips of leather to ensure a firm grip.

The whole mosaic is composed of tiny tesserae, and imitates painting in its fine detail. The significance of the scene is not easy to determine. Dogs of this type are often associated with hunting, and the theme may have represented the aristocratic aspirations of the owner of the building in which the mosaic was placed. It could simply be a reference to the owner's faithful pet. Dogs are often shown in banquet scenes in Greek contexts, sometimes lying asleep under couches. Here the *askos* would be one of the vessels used at the feast, now empty, but once containing water or wine.

BIBLIOGRAPHY: D. Saïd, 'Deux mosaïques hellénistiques récemment découvertes à Alexandrie', *Bulletin de l'Institut français d'archéologie orientale* 94 (1995), 377–80, figs A–D, 487, 489; A.M. Guimier-Sorbets in M. Rausch (ed.), *La Gloire d'Alexandrie. Cat. Exh. Petit Palais* (Paris 1998), 230–1; A.M. Guimier-Sorbets, 'Alexandrie: les mosaïques hellénistiques découvertes sur le terrain de la nouvelle Bibliotheca Alexandrina', *Revue Archéologique* (1998), 2, 227–62, esp. 265–72, no.1; G. Grimm, *Alexandria: Die erste Königsstadt der hellenistischen Welt* (Mainz 1998), 102–105.

P.H.

96 Ceramic *askos*

Third century BC
Height 11.4 cm, width 7.5 cm
Provenance unknown
London, Petrie Museum of Egyptology UC 47634

The foot is damaged and half of the rim is missing. There is a white slip on the lower section of the vessel. This ceramic, mould-made *askos* (wine jug) has an angular mouth and a square handle, of

97

a type more commonly associated with metal vessels (cat. no. 95). The body is decorated with two moulded figures. One is a bald-headed dwarf wearing a short garment over his left shoulder, with the right shoulder exposed. He carries a vessel in his left hand and an unidentifiable object in his right, possibly a horn or *rhyton*. The second figure is a bearded old man wearing a yoke over his shoulder, which supports two vessels attached by three strings. The man wears a heavy, folded, long-sleeved garment and stands on a floral motif, which covers the lower section of the vessel.

UNPUBLISHED.

S-A.A.

97 Terracotta figure of a satyr offering a wineskin

Third or second century BC
From the Delta, near Rosetta
Height 8.5 cm
Cairo, Egyptian Museum CG 26752 (JE 6102)

This well preserved terracotta shows the figure of a young satyr kneeling on the ground and clutching a large skin. The colour is extremely well preserved and the tanned skin of the satyr is easily distinguished from the red skin that he holds and the ochre cloak, which flares behind him. The hair is unkempt and the head thrown backwards, giving the impression that the satyr is looking upwards as he holds out the skin, presumably to receive its contents. The slovenly way in which he is seated might suggest drunkenness, and it has been suggested that the subject shown is part of a Dionysiac festival and that the skin is held out to catch wine. This scene is reminiscent of the Pompe of Ptolemy Philadelphos, as described in Athenaeus' *Deinosophistae*. During the elaborate parade through Alexandria, fountains of wine poured from artificial caves for distribution to the crowds.

BIBLIOGRAPHY: D. Kassar, 'Le satyre du Caire à son retour des Indes', *Bulletin des correspondance hellénique* 110 (1986), 309–15; M.-F. Boussac in M. Rausch (ed.), *La Gloire d'Alexandrie. Cat. Exh. Petit Palais* (Paris 1998), 268 no. 211.

S-A.A.

96a

96b

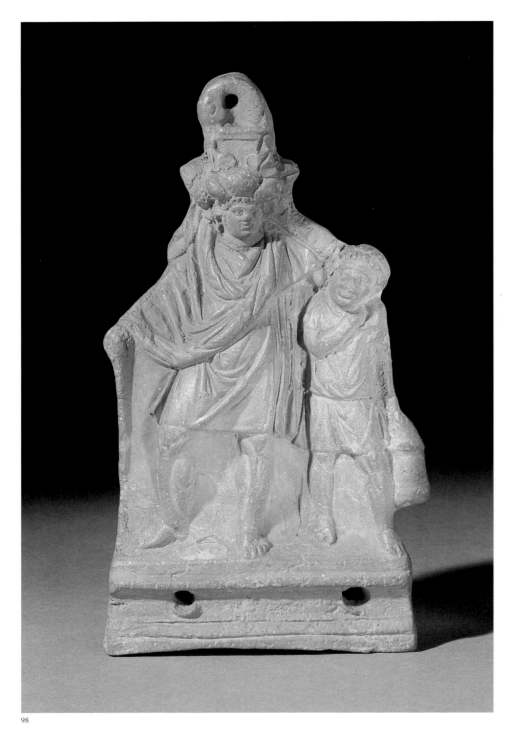

98

98 Terracotta group (hanging lamp): a reveller and his slave boy

Second to first century BC

An ink mark underneath the group preserves two letters 'T[]s'(?), so perhaps from Thebes.

Height 16 cm

London, British Museum EA 37561

The lamp is intact. The back is plain except for a small 'filling hole' with a semicircular ledge beneath. It was made in a two-piece mould, with an inset floor for the oil chamber. The fabric is an orangey-brown clay with a darker surface, with no mica but some dark grit.

This lively group shows a young man wearing a slightly disordered short tunic and himation, leaning on a small African boy with his left hand, and on a walking stick with his right. His widely spaced legs appear to stagger: he is perhaps returning home after a wild night of drinking. On his head he wears a large and elaborate wreath consisting of ivy leaves and large fruits(?), which is secured by a strip of cloth, the ends of which fall on to his shoulders.

The boy leans to his left side, perhaps pushed in this direction by the pressure exerted by the drunken man who leans on him: his left leg is extended to steady himself further. The boy wears a short, belted tunic and carries a lantern to light the way home.

The suspension loop is in the form of a curving duck's head, but the wick hole is not very functional, and this lamp may not ever have been lit.

Genre scenes became particularly popular all over the Mediterranean during the Hellenistic period, but many examples are found on small-scale objects from Egypt. They are vignettes, often dramatic or comic, of everyday life, and represent the ordinary populace of the Ptolemaic cities. Some of the scenes may be specific, and relate to literature in some way, but most are probably general, like this example, where the man's wreath suggests that he has participated in some form of ceremony associated with the wine-god Dionysos.

UNPUBLISHED.

P.H.

99 Gilded silver goblet

First century AD

From Ashmunein (Hermopolis)

Height 12 cm

Alexandria, Greco-Roman Museum 24201
(Gift of King Fouad I, 1936)

The goblet is intact. The gilding has disappeared in various places, removing details from some of the figures and motifs. The vessel has a lightly moulded rim, from which the sides taper to a plain foot. It appears to have been cast from a mould; there is no trace of repousée work on the interior surface, nor of a separate inner sleeve.

This vessel is decorated with gilded figures of vintaging Cupids and Dionysos, reclining to drink the fruit of their labours. On one side three cupids pluck grapes from the vine while trampling the fallen fruit in a vat. The resulting liquid flows from a spout (now lost, but probably a lion's head) into a *krater* (mixing bowl) held by two other cupids. Beneath is a large vine-leaf.

On the opposite side, the wine-god Dionysos reclines, his *thyrsos* (staff) in his left hand, a *kantharos* (two-handled drinking cup) held aloft in his right. Before him stands a satyr serenading the god with double-pipes while two cupids approach with more wine. The rest of the surface is taken up with scenes of preparation of the wine by cupids, who appear amidst a riot of tendrils of vine. Though Roman in date and decorated with motifs that were to become a very familiar in the succeeding century, especially on marble sarcophagi, the scenes perfectly evoke the carefree and exuberant atmosphere of late Ptolemaic Alexandria, recalling the symposium scene on the Palestrina mosaic (cat. no. 352).

BIBLIOGRAPHY: F. Baratte, 'Dionysos en Chine: remarques à propos de la coupe en argent de Beitan', *Arts Asiatiques* 51 (1996), 142–7; M-F. Boussac in M. Rausch (ed.), *La Gloire d'Alexandrie. Cat. Exh. Petit Palais* (Paris 1998), 162, no.104.

S.W.

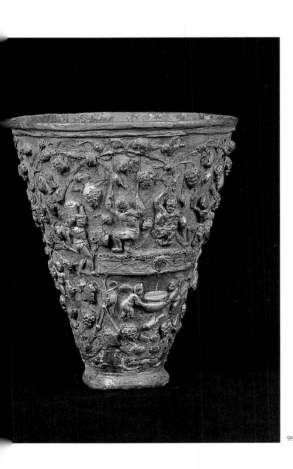

99a

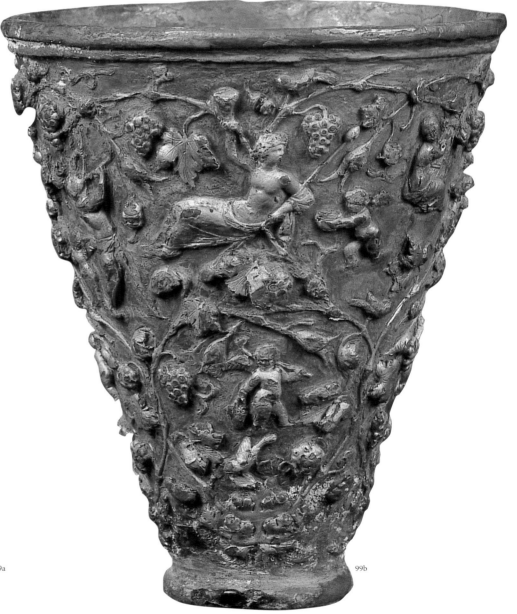

99b

100–102 Three agate vessels

Second century BC

Said to have been discovered near Coptos

Height of goblet 7.7 cm, diameter of bowl 8.4 cm,
length of rhyton 9 cm

Cairo, Egyptian Museum 55034 (goblet), 55035 (bowl),
55038 (rhtyon)

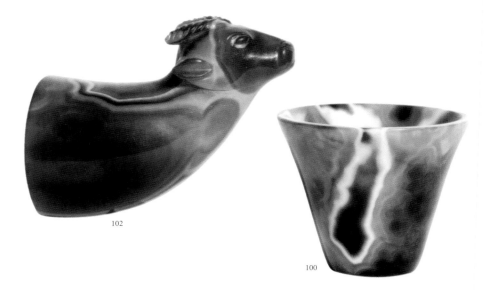

102

100

These three agate vessels form part of a group of
eight that were discovered near Coptos, Upper
Egypt in 1931 along an old caravan route. Most
of the vessels went to Cairo Museum, but a
couple ended up in private collections. The
goblet and bowl are forms that were found in
vessels of other materials, such as silver and,
more commonly, glass. The rhyton in the form of
a calf is a less common form, suggesting influ-
ences from Acheamanid Persia, but mixing Greek
elements too.

Agate was used for gemstones, cameos and
vessels, particularly during the Greek Bronze Age,
Classical and Hellenistic periods, but became less
frequently used thereafter. Banded agate does not
naturally occur in Egypt, but the stone may have
been imported into the country unworked, and
then the vessels formed by craftsmen there. There
is, however, no proof that these vessels are of
Egyptian manufacture: luxury vessels of this type
often travelled a great distance from their place of
manufacture. A similar agate vessel of a gazelle-
headed rhyton of about the same date as these
was found in China amongst other objects of
precious materials but from a ninth-century-AD
context.

101

BIBLIOGRAPHY: H.P. Bühler, *Antike Gefässe aus Edelstein*
(Mainz 1973), cat. nos 4, 6, 8, pls 1, 2; G. Grimm,
Alexandria: Die erste Königsstadt der hellenistischen Welt
(Mainz 1998), 118–119; For JE 55034 see F. Queyrel ,
catalogue entry, in M. Rausch (ed.), *La Gloire d'Alexandrie.
Cat. Exh. Petit Palais* (Paris 1998), 157, cat. no. 94. (with a
reference and a photograph of the similar vessel in China).

P.H.

103 Bronze bowl decorated with lotus leaves and Egyptian crowns

Second century BC

Acquired at Qena

Height 10.4 cm, diameter 16 cm

Cairo, Egyptian Museum JE 36460

The intact hemispherical bowl is decorated with
lotus leaves, between which are twelve stylized
Egyptian crowns. Around the rim are two regis-
ters of decoration: the upper level has a version
of the guilloche design, often found bordering
mosaics; the lower level, a series of intertwined
leaves, and stylized Herakles' knots. The bottom
is decorated with a slightly inset rosette.

The crowns are an unusual feature in terms of
decorative motifs for vessels, and vary in form. It
is almost as if the whole corpus of Egyptian

103

104

alexandrinischer und grossgriechischer Toreutik frühhellenistischer Zeit (Berlin 1987), 100, 116ff, n.689, pl. 61; M-F. Boussac, catalogue entry, in M. Rausch (ed.), La Gloire d'Alexandrie. Cat. Exh. Petit Palais (Paris 1998), 165, no.111.

P.H.

104 Pair of gold disc and amphora earrings linked by a long chain

Second century BC

Said to be from Egypt, formerly in the Tyszkiewicz and Guilhou Collections

Length 7 cm

London, British Museum GR 1906.4-11.1 (Jewellery 2331)

The earrings are in good condition, missing only a few of the beads hanging from the elements attached to the main disc. There is also an emerald missing from one of the large discs.

These elaborate earrings still preserve the chain, perhaps worn over the front of the body. The upper part of the earrings consists of a large disc with a garnet setting, capped by a finial in the form of a disc and feathered crown: a smaller garnet represents the discs, one of them conical, the other rounded, and the feathers were originally inlaid with a precious stone, now missing. The larger disc has an elaborate setting for the garnet, which is surrounded by a ring of granules, and the outer edge appears like a cogged wheel, each triangle embellished with tiny gold granules. At the sides of this disc are soldered hooks, from which hang pendants with small garnets and then a gold cone, from which three small chains with pearl, emerald and garnet beads (some missing) are suspended. From the bottom centre of the large disc a complicated fixing is soldered on, and from this hangs an amphora-shaped element. A large, almost spherical garnet represents the body of the vase, while the gold handles are in the form of dolphins. Delicate granulation work decorates the setting for the garnet. The foot of the vase is in the form of a square box to which the chain is attached.

This pair of earrings forms part of a series of similar examples using stylized forms of Egyptian crowns as part of their decoration. The motif may have derived from Ptolemaic jewellery, but because it is found all over the eastern Mediterranean this Egyptianizing motif probably lacked any specific significance: the crown becomes a purely decorative element.

BIBLIOGRAPHY: F.H. Marshall, Catalogue of Jewellery, Greek, Etruscan and Roman in the Department of Antiquities, British Museum (London 1911), no. 2331; B. Deppert-Lippitz, Griechischer Goldschmuck (Mainz 1985), 261–2, colour pl. XXXI.

P.H.

crowns were included, and those recognizable are the double crown, the red crown of Lower Egypt, the Anedtj feather crown, the Atef and Hmhm crown, two king's headdresses, the white crown of Upper Egypt, and the feather crown of Horus. The decoration is inspired by Egyptian symbols and vegetation motifs, but the form of the bowl conforms to a type popular in the mid Hellenistic period all over the Mediterranean. The decorative scheme can also be found on faience vessels from Egypt.

BIBLIOGRAPHY: K. Parlasca, 'Das Verhältnis der megarischen Becher zum alexandrinischen Kunsthandwerk', Jahrbuch des Deutschen Archäologischen Instituts 70 (1955), 129–154; U. Hausmann, Hellenistischer Reliefbecher aus attischen und böotischen Werkstätten (Stuttgart 1959), 104, n. 52, 114; G. Grimm and D. Johannes, Kunst der Ptolemäer und Römerzeit in Ägyptischen Museum Kairo (Mainz 1975), 26, no.59; M. Pfrommer, Studien zu

105

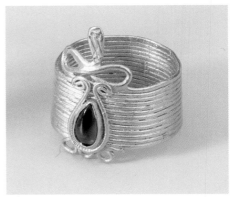

106

105 Pair of gold earrings

Second century BC
Found in a tomb at Ashmunein, Egypt
Length 6.7 cm
London, British Museum GR 1904.7-6.1 (Jewellery 2332-3)

One of the earrings has lost all of its side pendants and some of the decorative berries within the central disc. The other earring has also lost some of these, but preserves the side pendants, with only the loss of the beads.

Although missing some of their pendants, these earrings are intricately made, with careful attention to detail. They follow the common disc and amphora type of the middle and late Hellenistic period, but the use of a large emerald is unusual: emeralds became more popular during the Roman period.

These earrings have a highly decorated disc, above which is a large stylized floral motif, either a palmette or an acanthus leaf. This is soldered on to the main disc, which has a central motif in the form of a double rosette, with berries formed of tiny granules, some now missing, between each leaf. Small flowers further decorate the design, originally filled with blue-green enamel, the colour perhaps emulating the emerald, some of which survives. Below the disc hangs a large amphora, with dolphins forming its handles and an emerald for the body. The casing for the stone is decorated in a design familiar from vase painting and metal vessels. The foot of the amphora is in the form of a square box formed of sheet gold. Originally, on either side of the amphora hung pendants, and on one of the earrings the chains and two of the pearl beads survive. These pendants are similar in technique and design to those on the pair of earrings at cat. no. 104.

This pair of earrings was said to have been found in a tomb with a bracelet, also decorated with emeralds, but usually dated to the Roman period. If the dating of the bracelet is correct, this pair of earrings could perhaps have been an heirloom, with the bracelet made at a later date to match.

BIBLIOGRAPHY: F.H. Marshall, *Catalogue of Jewellery, Greek, Etruscan and Roman in the Department of Antiquities, British Museum* (London 1911), no. 2332-3. (For the bracelet, not in the exhibition, see ibid. no. 2822).

P.H.

106 Gold finger-ring

Second to first century BC
Said to be from Beirut
Length 1.6 cm
London, British Museum GR 1917.5-1.770 (Ring 770)

A single, long piece of gold wire has been coiled around to form the bezel of this ring, one end of which was formed into a simple snake's head. The other end has been coiled around three times to form the tail. The scales of the snake have been summarily rendered with a few hatched lines and dots formed by a punch. Below the snake's head a cabochon garnet has been placed into an oval setting made of sheet gold, around which gold wire has been shaped to emulate the forms of rearing snakes.

BIBLIOGRAPHY: F.H. Marshall, *Catalogue of the Finger Rings, Greek, Etruscan and Roman in the British Museum* (London 1907), no. 770.

P.H.

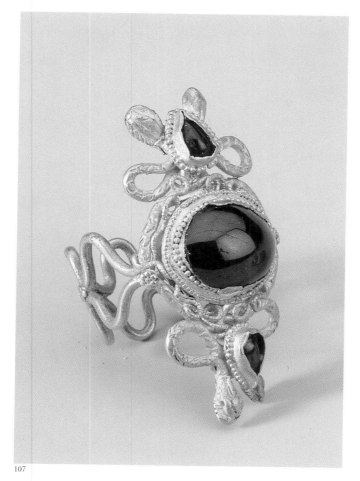

107

107 Gold openwork ring with serpents and garnet settings

First century BC

Said to be from Alexandria, Egypt

Length 3.5 cm.

London, British Museum GR 1917.5-1.771 (Ring 771)

This intricate ring is formed by two wires twisting into a hoop and around the bezel, then terminating in two pairs of serpents' heads. At the base of the hoop, the point where the loops of wire meet, is a rosette of gold granules, now rather worn. The oval bezel has a thinner twisted wire as a border, and the central garnet is embedded in an elaborate setting decorated with granulation. Two further garnets are placed in oval-shaped settings near the snakes' heads. The scales of the snakes have been lightly notched out until the point where they meet the rosettes that join the two wires.

Serpents had a specific meaning in the Egyptian cult of Isis, as symbols of fertility and the afterlife.

A similar but more elaborate ring is now in the Benaki Museum, Athens.

BIBLIOGRAPHY: F.H. Marshall, *Catalogue of the Finger Rings, Greek, Etruscan and Roman in the British Museum* (London 1907), no. 771; R. Blurton (ed.), *The Enduring Image: Treasures from the British Museum* (London 1997), cat. no. 97.

P.H.

108 Gold finger-ring in the form of a coiled snake

First century BC or first century AD

Said to be from Alexandria

Length 2 cm

London, British Museum GR 1917.5-1.950 (Ring 950)

From a series of similar rings, made of bronze, silver or gold, comes this simple example made out of one piece of gold wire, tapering from the narrowest point at the tail to the broad and flat head. The scales of the snake are engraved simply, and rendered only on the upper part of the ring, where they could be seen. The broader scales on the top of the snake's head are skilfully composed, and their overhang at the sides gives the snake a menacing look from its almost hooded eyes. The snake's mouth, with its serrated edge, enhances this sinister appearance.

BIBLIOGRAPHY: F.H. Marshall, *Catalogue of the Finger Rings, Greek, Etruscan and Roman in the British Museum* (London 1907), no. 950.

108

P.H.

109 Gold pendant showing Harpokrates

Second or first century BC

Provenance unknown, but probably from Egypt

Height 2.3 cm

London, British Museum EA 29499

The group is intact, but has lost the chain from which it was suspended. The base of the group has bent slightly, and there are minor scratches on the surface. The loop for suspension has been soldered on to the back of the figure, and then a small cap of gold placed over the solder. The figure was probably cast, but then finer details achieved by hammering when the metal was cold, best seen on the back of the legs of Harpokrates.

The boy god stands in the traditional posture, with one of the fingers of his right hand in his mouth. He wears an Egyptian feather crown, and holds an unwieldy cornucopia in his left hand, so heavy that he rests it on a tree trunk. He wears a large sash around his body. Unusually, Harpokrates is shown with wings, a feature that suggests that this is an example of conflation between the Greek god Eros and the Egyptian Harpokrates; a similar iconographic association was to be found between Aphrodite and Isis, the mothers of the two child gods.

UNPUBLISHED.

P.H.

110 Pair of gold earrings with hawk-headed terminals

Second or first century BC

Provenance unknown, but perhaps from Egypt

Height 2.7cm

London, British Museum EA 65405-6

Both earrings are intact but slightly misshapen.

These unusual earrings consist of hawk heads of lapis lazuli secured within gold, ribbed mounts. The birds' heads are finely modelled, with particular attention paid to the detailing of the feathers. There are remains of gilding on one of the hawk's heads. The hoop is secured within an attachment soldered to this gold mount, and beneath this is a ring decorated with large granules. On the gold ring itself the end closest to the bird has a sleeve of sheet gold attached to prevent a series of beads, consisting of lapis lazuli, red glass and a gold ring with granulation, from slipping around the hoop.

Earrings of this general form are common throughout the Hellenistic world, but hawk-headed versions seem purely Egyptian. If these earrings were worn with the hawk heads upright, the beaks would have faced the ear lobe.

UNPUBLISHED.

P.H.

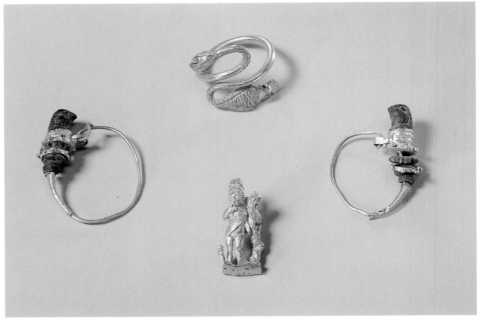

109–111

111 Gold finger-ring with a snake and a hawk

First century BC or first century AD

Provenance unknown, but likely to have come from Egypt

Internal diameter 1.7 cm

London, British Museum EA 15715

The ring is intact but slightly misshapen.

The form is that of a developed snake ring. The hoop is curved round to form a circle, and then the ends curve back from the hoop, with one end terminating in a snake's head, while the other has the body of a hawk. The bird's feathers are indicated by light cross-hatching for the wings held close to the body, and incised ripple marks for the belly. The scales of the snake are indicated with cross-hatching.

UNPUBLISHED.

P.H.

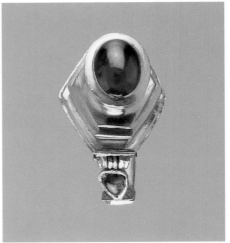

112a

112 Gold finger-ring with garnet settings

Second or first century BC

Provenance unknown

Length 2.5 cm

London, British Museum GR 1917.5-1.844 (Ring 844)

The ring is in good condition except for a few minor scratches. One of the gold pins has been replaced.

The ring is composed of two separately made parts that have been fixed together with a hinge secured by gold pins (one is a modern replacement). The hoop has three garnet settings, two of them pear shaped, the other circular. The hoop

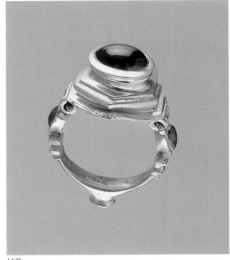

112b

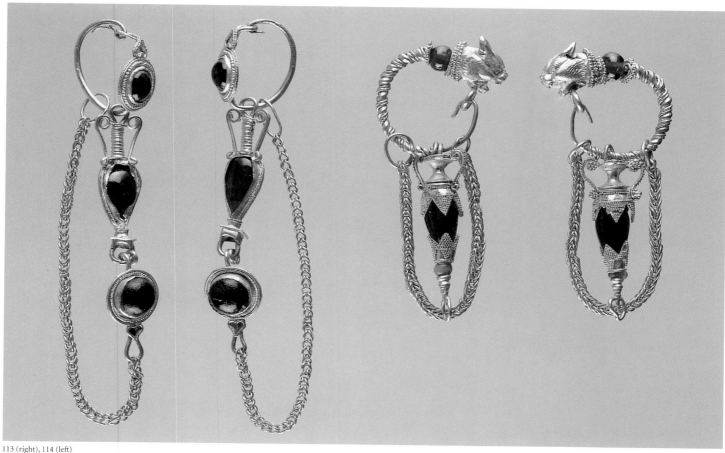

113 (right), 114 (left)

also has a projecting moulding on either side below the pear-shaped settings. The upper part of the ring has an angular, hexagonal form raised up in several steps. Above this the form is oval and contains the oval garnet.

Several others rings of this type come from archaeological contexts, from Pelinna in Thessaly, Greece, and Eretria. The example from Pelinna was found in a tomb with pottery dated to a the second half of the second century BC.

BIBLIOGRAPHY: F.H. Marshall, *Catalogue of the Finger Rings, Greek, Etruscan and Roman in the British Museum* (London 1907), no. 844; S.G. Miller, *Two Groups of Thessalian Gold* (Berkeley, Calif.1979), 41, pl. 26f–g.

P.H.

113 Pair of gold earrings in the form of lynx heads and amphoras

c. 100–50 BC

Provenance unknown

Length 4.8 cm.

London, British Museum GR 1872.6-4.1105 (Jewellery 2442-2443).

The lynx head was made in two halves. Thin sheet gold would have been pressed over two bronze for-

mers, the front and back pieces, and then the finer details added by chasing. Behind the collar there is a small garnet bead, while the hoop consists of a thin wire with additional wires twisted around it. The amphora pendant is elaborately decorated with granulation, a garnet for the body and a green glass bead at the bottom. Another pendant would originally have hung from the suspension hoop at the bottom, but is now missing on both earrings.

These earrings would have been worn with the head of the lynx inverted and facing up to the front of the ear lobe, while the chain would have been secured over the top of the ear.

This particular pair has no known provenance, but other examples of the type have been found in Syria and the eastern Mediterranean. The use of wild and exotic animals was common on hoop earrings of the mid- to later Hellenistic period.

BIBLIOGRAPHY: F.H. Marshall, *Catalogue of Jewellery, Greek, Etruscan and Roman in the Department of Antiquities, British Museum* (London 1911), nos. 2442–3; J. Ogden, *Ancient Jewellery* (London 1992), 45, fig. 28; M. Pfrommer, *Untersuchungen zur Chronologie früh und hochhellenistischen Goldschmucks* (Tübingen 1990), cat. no. OR380, pl. 24, no. 8; R. Blurton (ed.), *The Enduring Image: Treasures from the British Museum* (London 1997), 98–9, cat. no. 96.

P.H.

114 Pair of gold earrings with amphora-shaped pendants

Second century BC

Provenance unknown

Length 7 cm

London, British Museum GR 1872.6-4.532 (Jewellery 2607-8)

These elaborate earrings consist of a central amphora-shaped pendant, above and below which discs are attached. All three elements are formed from sheet gold and contain cabochon garnets. The upper disc is the most elaborate, with the garnet set into a disc formed from concentric circles. The outer circle has tiny gold granules soldered to it, the inner one is formed from a twisted wire. An inverted heart-shaped motif is cut from the same gold sheet as the disc, behind which the hoop is attached.

The amphora pendant hangs from the upper disc by means of a loop, which is attached to a hollow tube incised to appear like twisted wire. This element also forms the neck of the vessel. The looped handles of the amphora are formed from gold wire, looped at the top and bottom. The amphora is soldered on to a box fitting incorporating the foot of the vessel, but also acting as the suspension loop for the disc element

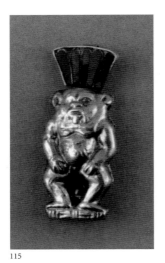

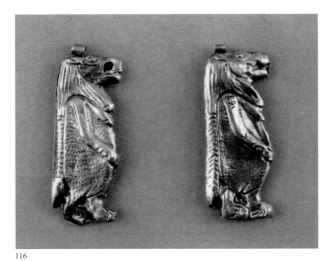

115 116 117

below. This disc, plainer than the upper one, is decorated with a twisted wire and heart-shaped element. The loop-in-loop chain connecting the two ends of the earrings would have been hooked over the top of the ear.

Disc and amphora earrings were popular throughout the Hellenistic world during the second and first centuries BC. The findspot and place of manufacture of these particular examples is, unfortunately, unknown.

BIBLIOGRAPHY: F.H. Marshall, *Catalogue of Jewellery, Greek, Etruscan and Roman in the Department of Antiquities, British Museum* (London 1911), nos 2607-8.

P.H.

115–116 Gold pendants in the form of Bes and Ta-Urt

Third to first century BC

Provenance unknown

London, Victoria and Albert Museum (115) M31-1963; (116) M32/32a-1963 (Wallis Collection)

The figure of Bes is complete, but some of the glass-paste fill is missing from the crown. The figure is slightly dented around the left side of the stomach. The two figures of Ta-urt are well preserved, although the mouths of both have been damaged, and one has been pierced. The right, rear foot of this particular figure has also been damaged.

These three pendants all have suspension loops, indicating that they probably formed part of a necklace. The relatively large size of the pieces makes the likelihood of their being attached to earrings less likely. The figures were made out of sheet gold.

The figures of Ta-urt follow the canonical type used for representations of the goddess. Ta-urt was associated with the protection of women during childbirth, and was appropriately shown

in the form of a female hippopotamus with pendulous breasts and a swollen stomach. Here she is without her usual Egyptian symbols and headdress, and is unusually clothed in what appears to be an animal skin.

The figure of Bes is modelled superbly, especially the ribs flanking and contrasting with the smooth, distended stomach, which in turn is punctured by the navel. This figure compares closely with the figures of Bes in terracotta and on the faience vase (cat. nos 119, 120 and 121).

UNPUBLISHED.

P.H., S-A.A.

117 Gold amulet in the form of an aegis or pectoral ornament

Third to first century BC

Provenance unknown

London, Victoria and Albert Museum M34-1963 (Wallis Bequest)

The amulet is intact, with only very minor abrasions to the surface.

The amulet is in the form of a gold-sheet aegis (protective cloak) with a solid-cast feline head surmounted by a solar disc. The head is flanked by two falcons' heads in profile, their outermost wings outstretched and resting on the upper surface of the aegis. In the centre of the aegis a sacred Wad-jet eye is engraved, enhancing the talismanic properties of the amulet. The aegis or pectoral ornament is a deep, broad collar surmounted by the head of a deity, and its protective quality is witnessed by the fact that it was set up on the prow and the stern of the sacred barque (boat) at the temples of the Egyptian gods. Amulets in the form of aegises, however, are connected with only a handful of gods, including Bastet (a cat-headed goddess) and possibly Tefnut in the form of a lion. The most obvious

candidate for a lion-headed deity is Sekhmet, although she is not usually associated with amulets of this type.

This type of amulet emerged during the New Kingdom but was more common in the Third Intermediate Period and later. The style and form vary so slightly that it is difficult to date such amulets.

UNPUBLISHED.

P.H.

118 Limestone ring with a glass intaglio showing a portrait of a woman

First century BC

Said to have been found at the Rosetta Gate, Alexandria

Length of ring 4.1 cm

London, British Museum GR 1917.5-1.1615 (Ring 1615)

The limestone bezel is chipped and there is iridescence on the surface of the violet-coloured glass setting.

The use of glass for the production of intaglios became popular during the Hellenistic period. Glass could, of course, be produced in a variety of colours and be used to imitate semi-precious stones. Cost and availability of gemstones may have been the determining factor when glass was selected, but the ability of the craftsman to produce a variety of colours may also have been a consideration for the customer. This ring contains a dark-blue glass setting that may have been intended to simulate lapis lazuli, although the properties of this stone made it difficult to engrave and it was seldom used for intaglios. Some paste gems may have been used to deceive the buyer, as they can be extremely convincing imitations of semi-precious stones. Many of the designs were achieved by casting the glass in ter-

118

racotta moulds, examples of which survive. This particular portrait appears to have been cast in a mould rather than engraved.

Rings with stone bezels are rare, but a few limestone rings of this type have been discovered in Alexandria. The shape imitates glass and metal examples, but the limestone versions tend to be larger than their prototypes, of which only a few survive with the setting intact. Their relatively large size would have rendered the stone rings impractical for everyday use, and their production and the rare survivals may represent a short-lived fashion. It is difficult to determine the date of this form of ring, but glass imitations of gemstones were rarely used as finger rings until the later Hellenistic period.

The portrait is in the form of a draped bust in profile, facing left. The subject is a rather full-cheeked woman, with a heavy chin and a long neck. Her hair, partly covering her none too detailed ear, is tied back in a neat bun. Her eye is large, but the nose has not been successfully cast from the mould. Portraits of women on jewellery, especially rings, are all too often identified as queens, irrespective of their attributes or lack of them. To be absolutely certain that the subject of the portrait is royal there ought to be a diadem. This woman has no diadem and may therefore represent a private individual.

BIBLIOGRAPHY: F.H. Marshall, *Catalogue of Finger Rings, Greek, Etruscan and Roman in the Department of Antiquities, British Museum* (London 1907), cat. no. 1619; J. Boardman and M. Vollenweider, *Ashmolean Museum: Catalogue of the Engraved Gems and Finger Rings 1 Greek and Etruscan* (Oxford 1978), 87, where Arsinoe III is proposed as the subject.

P.H.

119 Terracotta figure of Bes

Third to first century BC

Provenance unknown

Height 43.2 cm

London, British Museum EA 22378

The lower section of the figure has been broken and reattached, and there is some surface damage at the back of the crack. There are traces of white and pink paint on the left ear, and green paint on the base and the plumes of the crown. The terracotta was moulded in separate halves; the back, as with many Ptolemaic and Roman terracottas, is shaped but unmodelled. The fabric is a Nile silt clay.

This terracotta figure represents the Egyptian deity Bes, who was seen as a protector of the family and was associated with childbirth and sexuality, the latter particularly during the Ptolemaic period. The dwarf god stands naked, with his hands resting on his thighs. He wears a leonine mask with a snub nose, stylized mane-like beard and furrowed brow; his tongue is stuck out. The paws of the lion-skin cape are visible on his shoulders and around his neck is an amulet in the form of an animal head. The god was a popular subject for amulets because of his protective properties. On his head Bes wears his usual plumed crown, but one of the feathers is moulded and the others are plain: details may have been added with paint.

UNPUBLISHED.

S-A.A.

119

120

This particular vase is a fine example of its type and the applied Bes figures remain intact. The glaze is a pale green and there are traces of added ochre pigment on the figures and on the remaining globular applications on the neck and body of the vase. The decoration is composed of a series of friezes: lotus leaves emanate from the foot of the vessel, followed by wave-like foliage decorated with applied dots. The main frieze features metopes of Orientalizing griffins, above which there is a wave-like pattern with blobs of applied yellow mouldings and floral rosettes. There is a second animal frieze on the neck of the vase and a wave pattern below the plain lip of the vessel. A full Bes figure breaks up the frieze, and heads of the god interrupt the floral rosettes.

Faience vessels were often used for cult activity (see cat. no. 48) and numerous examples have been found in burial contexts. The kilns for manufacturing Ptolemaic faience have been found at Memphis, but it is also possible that the material was manufactured in Alexandria itself. Many scholars see faience as an alternative to the more costly gold and silver vessels that were manufactured for a similar purpose, although this idea has recently been challenged.

BIBLIOGRAPHY: E. Breccia, *Municipalité d'Alexandrie: Rapport sur la marche du service du musée en 1912* (Alexandria 1912), 30, pls 20, 20a; M-D. Nenna and M. Seif el-Din, 'La vaisselle en faïence du Musée Gréco-Romain d'Alexandrie', *Bulletin de correspondance hellénique* 117 (1993), 565–602; M-D. Nenna and M. Seif el-Din in M. Rausch (ed.), *La Gloire d'Alexandrie. Cat. Exh. Petit Palais* (Paris 1998), 150, no. 84; G. Grimm, *Alexandria: Die erste Königsstadt der hellenistischen Welt* (Mainz 1998), 88.

S-A.A.

120 Terracotta *kantharos* with scenes of the god Bes

Second half of the second century BC to first century BC
Provenance unknown
Height 14.3 cm
London, British Museum GR 1997.10-5.1 (Bequeathed by Ronald Bullock, through the good offices of Peter Clayton)

The vessel has lost its foot, and the rim may be a clever restoration, or perhaps ancient and repaired. The fabric is a light brown clay, possibly a Nile silt, but maybe mixed with marl.

This relief-ware vessel was made in two halves, but from slightly different moulds. On each side three acanthus leaves rise from the base with rosette-headed flowers emerging from them. To conceal the join between the two halves, a large acanthus-like leaf covers the side. The upper part of the scene is decorated with hanging garlands from which ribbons fall, and between them a figure of Bes dancing. He is semi-naked, with only a himation draped around his hips, one leg

and arm raised. On his head he wears a three-feathered crown.

BIBLIOGRAPHY: Christies, South Kensington, Sale Catalogue, 8 May 1989, lot 240.

P.H.

121 Faience jug with appliqué heads of Bes

Third century BC
Hadra, Alexandria
Height 18.5 cm
Alexandria, Greco-Roman Museum 19462

There is superficial damage to the glaze and cracks at the neck and on the applied figures, but the overall condition of the jug is excellent. This faience vessel was found in a tomb in the Hadra region of Alexandria, which is well known for its cemetery and the vases that take their name from the area (cat. nos 142–146). According to the museum records, the vase was found with a group of coins dating to the reign of Ptolemy I.

122 Green schist head of the god Dionysos

Third to first century BC
Acquired in Cairo
Height 22.5 cm
Alexandria, Greco-Roman Museum 25066

The head comes from a high relief, and the entire left side was unworked. The nose and right cheek are damaged, and there are abrasions over much of the surface. The neck has broken away from the rest of the body (if it was a full figure rather than just a bust).

Here the god Dionysos can be recognized by his *mitra*, a band worn around the head, and beneath the hairline. Below this emerge two small bull's horns, betraying the subject's exact identity as Dionysos Tauros, but an attribute also adopted by some of the Hellenistic kings. Dionysos often appeared in myths as a bull, and in Euripides' *Bacchae* (610-20, 922) the god manifests himself in the form of a bull to Pentheus

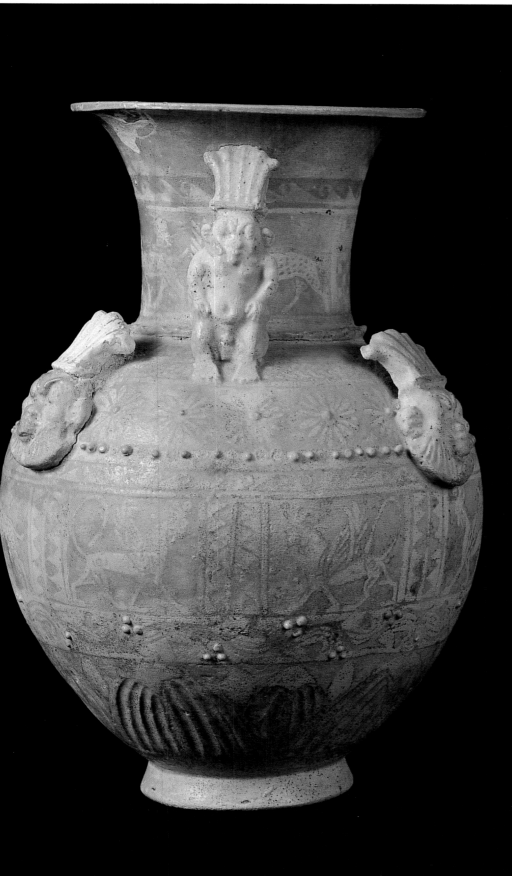

and then again in human form but with bull's horns. When dynasts adopted the horns in their public images, they were making a clear reference to the god: they were representing themselves as descendants of Dionysos, and therefore god-like (see cat. no. 10).

This type of Dionysos follows that formulated during the fourth century BC, when images of the god became more youthful and effeminate. Here Dionysos wears his hair long at the back, partly concealing the unfinished ear. The wreath of ivy leaves was commonly worn by Dionysos and his wild, female followers, the Maenads. The carving of the eyes and lips is hard and crisp, a technique commonly found on sculptures carved in relatively hard stones. The use of the green stone emulates bronze images. The style has been considered classicizing and Augustan, but the exact date of this piece is difficult to determine.

BIBLIOGRAPHY: A. Adriani, *Repertorio d'arte dell 'Egitto greco-romano* I–II (Palermo 1961–2), 39, no. 53; R.B. Pasqua, *Sculture di età Romana in basalto* (Xenia Antiqua Monographie 2 Rome 1995), 87, no. 33; F. Queyrel, catalogue entry, in M. Rausch (ed.), *La Gloire d'Alexandrie. Cat. Exh. Petit Palais* (Paris 1998), 244, no. 182.

P.H.

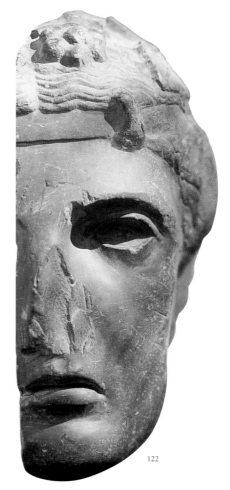

122

121

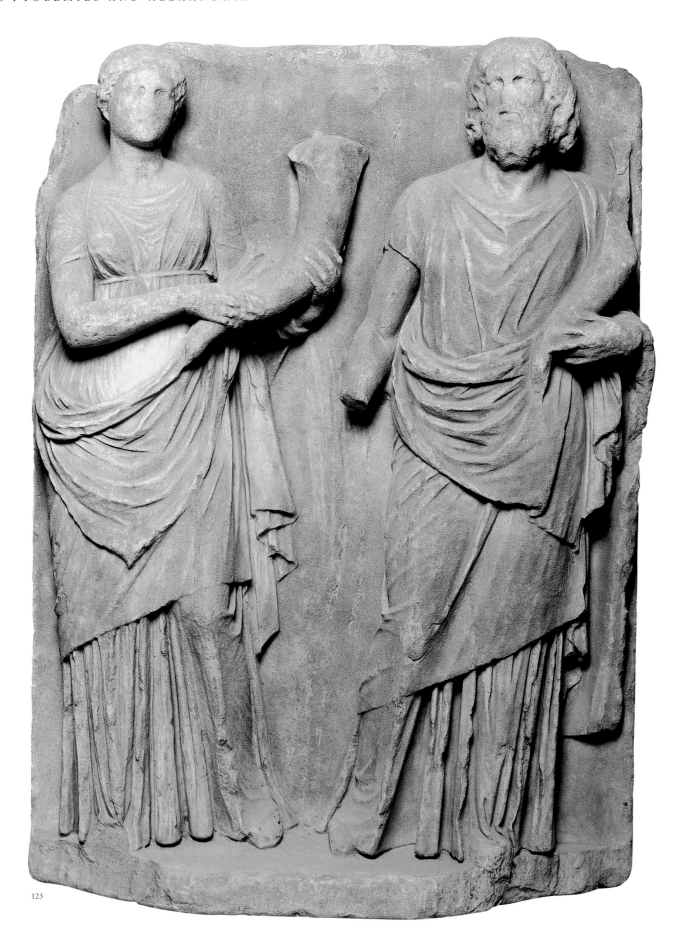

123

123 Marble relief showing the god Sarapis and a woman, perhaps a Ptolemaic queen

Second or first century BC

Said to be from Athens

Height 84 cm, width 60 cm

London, British Museum GR 1809.11-11.1 (Sculpture 2163) (Given by Sir Joseph Banks)

The relief is damaged around the edges of the frame and the upper part of Sarapis' cornucopia has broken away, along with his right wrist and hand. The woman's right foot is missing. The facial features of both figures are weathered, and the surface of the Pentelic marble has been damaged by weathering and perhaps fire.

Sarapis may have been created as the embodiment of several deities, and it has been thought that his function merged those of Osiris and Apis (whence his name). Popular outside Egypt, his cult did not appeal to native Egyptians, but he did have a large and important sanctuary in Alexandria (cat. nos 52–55) and a no less significant cult at Memphis. Sanctuaries of Sarapis existed all over the Hellenistic world outside Egypt, where he was usually worshipped alongside Isis. His image was completely Greek: he was represented as a mature, bearded man, fully draped. It has been suggested that the statue in Alexandria showed the god seated whereas the Memphite cult statue showed a standing figure. Sarapis became a god of death and on the Roman images he is sometimes accompanied by the dog Cerberus, who guarded the entrance to Hades. The cornucopia that he holds on this sculpture symbolizes fertility; on Roman images this is further specified by the addition of a *modius* (corn measure), representing the importance of Egyptian corn, now under Roman control, to the feeding of the people of Rome.

Here Sarapis is shown with a woman, also holding a cornucopia and dressed in a chiton with buttoned sleeves and belted beneath the breasts, over which is draped a mantle. Her hair is pulled back over her ears, and then hangs loose down her back. The arrangement of her drapery is not unlike that of Ptolemaic queens on faience jugs (cat. no. 48) but she wears no diadem to denote that she is royal. Scholars have previously identified this woman as Isis, but Hellenistic images of this goddess invariably showed her with archaizing drapery and an Egyptian crown.

The relief may have formed part of a votive offering accompanied by an inscription, now lost. Its date is difficult to determine. The style of the figures, however, with their elongated proportions and small heads, display later Hellenistic characteristics.

BIBLIOGRAPHY: A.H. Smith, *A Catalogue of Sculpture in the Department of Greek and Roman Antiquities in the British Museum*, Vol. III (london 1904), cat. no. 2163; F. Dunand, *Le culte d'Isis dans le bassin Oriental de la Méditerranée* Vol. II (Leiden 1973), pl. 44; T-T. Tinh, *Sérapis Debout* (Leiden 1983), cat. no. III 5, fig. 94; G. Clerc and J. Leclant, 'Isis', *LIMC* VII/1 (1994), no.1256.

P.H.

124 Terracotta figure of Sarapis

Third to second century BC

Provenance unknown

Height 17 cm

London, British Museum EA 37562

There is some superficial damage but the figure is well preserved. Like most of the Hellenistic mould-made terracottas from Egypt, this piece was manufactured in two separate halves, the back unmodelled.

The subject is a seated, bearded male holding a cornucopia in his left arm and clutching the arm of the throne with his right arm. On his head is an Egyptianizing lotus crown. These attributes are commonly associated with the god Sarapis, of whom there was a seated cult statue in his sanctuary in Alexandria (see cat. no. 52). The body is well modelled, the torso exposed, with drapery covering the legs.

The iconography on this particular terracotta is typically Hellenistic and not dissimilar to the river-god Nilus.

UNPUBLISHED.

S-A.A.

124

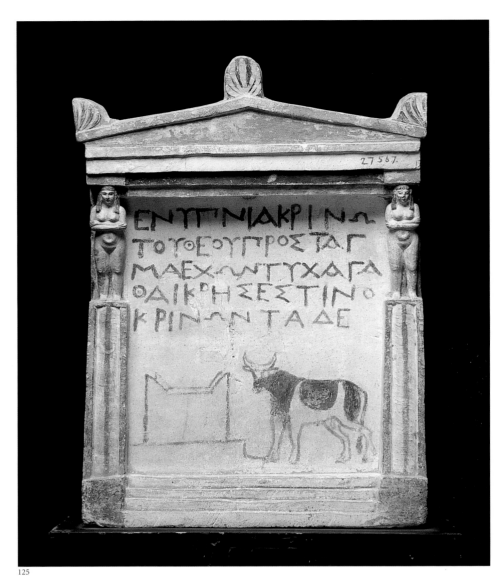

125

Apis gave rise to the two major temples in the city, but other Egyptian gods had their priests too. Moreover, during the Ptolemaic period a Greek influence came to bear on the religious life of the city, in terms of the new hybrid cult of Sarapis, with its visible manifestation in the form of the Serapieion complex, and the personnel serving in the temples.

This stele, found in the region of the temple of Anubis, is equipped with holes on the rear to facilitate its hanging, and seems to have served as an advertisement for a Cretan immigrant now working, perhaps with official blessing, as an interpreter of dreams in or near the sanctuary. Dreams and their interpretation were an important part of both Egyptian and Greek religious life, with people travelling considerable distances to sleep in sacred areas in the hope of receiving a message from a god in the form of a dream.

BIBLIOGRAPHY: M.I. Rostovtzeff, *Social and Economic History of the Hellenistic World* (Oxford 1941), II. 900, pl. CI; D.J. Thompson, *Memphis under the Ptolemies* (Princeton, 1988); A. Charron catalogue entry, in M. Rausch (ed.), *La Gloire d'Alexandrie. Cat. Exh. Petit Palais* (Paris 1998), 195, no. 141.

A.M.

125 Limestone stele: advertisement for an interpreter of dreams

Third century BC

From the area of the Anoubieion at Memphis

Height 35 cm, width 25 cm

Cairo Egyptian Museum CG 27567

I interpret dreams
having a commission from
god. With good fortune!
A Cretan is he who
interprets these things

Aside from being one of the ancient capitals of Egypt, Memphis was also an important religious centre, and continued to be so in the Ptolemaic period. The native Egyptian cults of Ptah and

126 Fragment of a faience statuette of Isis

Third century BC

Provenance unknown

Height 18 cm

London, British Museum EA 20549

Only the top half of the statuette is preserved, and the arms, vulture head, crown and the inlays for the eyes and eyelines are missing. The colour and modelling of this statuette are well preserved. The green glaze is typical of Ptolemaic faience, and the added blue highlights the detailed modelling of the piece.

The rounded face, forced smile and inlayed eyelines date the piece to the third century BC, and the gesture of the hand to the large, left breast identify the subject as Isis nursing Harpocrates (now missing). The goddess would have sat on a throne with her son on her knee. The ornate vulture headdress, decorated with blue paint on the traditional echeloned, tripartite wig, confirms that the female is divine. She wears a sheath-like plain garment with an elaborate collar decorated with floral, triangular and teardrop-shaped beads.

UNPUBLISHED.

S-A.A.

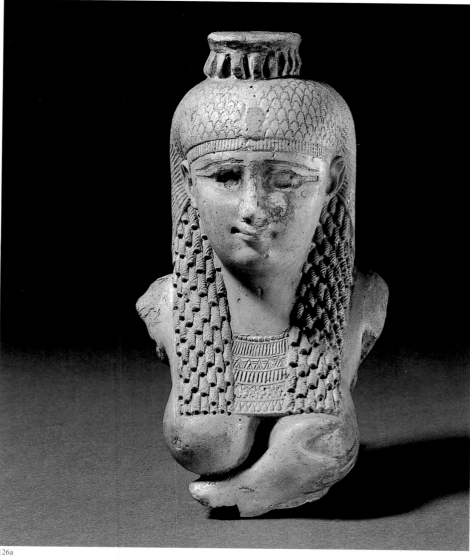

126a

126b

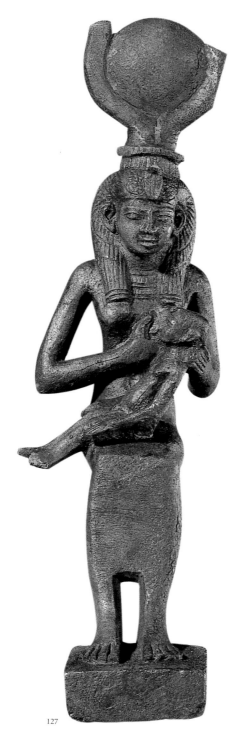

127

mother's left hand. The young god is naked and is identified by the single lock of hair, denoting his youth, on the right side of his head.

The goddess and her son were an important parallel for Cleopatra and Caesarion, and a similar scene can be seen on the Cypriot coins minted by the queen (cat. no. 186).

UNPUBLISHED.

S-A.A.

127 Bronze statuette of Isis nursing Horus

Fourth or third century BC

Provenance unknown

Height 21 cm

London, British Museum EA 60756

There are some cracks in the metal and the tops of the horns are missing on the crown of this stauette.

The sun disc and cow's horns identify the subject as Isis, who is accompanied by her son, the young Horus, who sits on her knees. The goddess wears a tripartite wig with vulture headdress, decorated with a cobra rather than the usual vulture head. On top of her head, supporting the crown is a *modius* of cobras. Her dress is Egyptian in style and sheath-like in appearance, and around her neck she wears a collar of beads. She holds her left breast with her right hand for her son, who leans back, supported by his

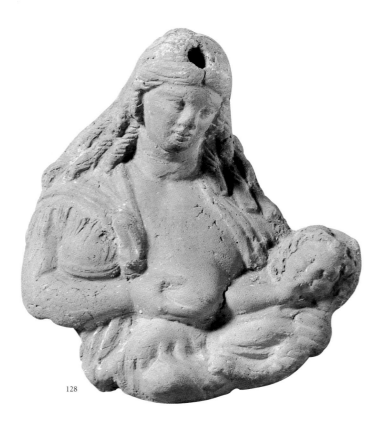

128

129

130

128 Terracotta group of Isis nursing Harpokrates

First century BC

Provenance unknown

Height 7.4 cm

London, British Museum GR 1938.3-14.1

This group is intact apart from the loss of a small chip from the lower left side. A hole bored into the upper part of Isis' head is perhaps for a separately made crown, now missing. The fabric is a micaceous orange-brown Nile silt. There are minute traces of a white coating on the front. The back is unworked.

The group shows Isis offering her breast to her son, Harpokrates, who seems uninterested. Isis wears her usual knotted costume, which has been unbuttoned to expose the breast. Her long, corkscrew locks fall on to her shoulders. Harpokrates has a full head of hair and is wrapped in a cloak.

It seems likely that the group was made to be an emblem for a terracotta bowl, rather than being broken from a larger figure in relief. This group follows a series of similar compositions popular during the Ptolemaic and Roman periods.

BIBLIOGRAPHY: R.P. Hinks, 'Isis suckling Horus', *BMQ* 12 (1937–8), 74–5, pl. XXVIIb; V. Tan Tam Tinh, *Isis Lactans* (Leiden 1973), pl.XXXIV, cat. no.A26, fig. 53; E.A. Arslan (ed.), *Iside, il mito, il mistero, la magica* (Milan 1997), cat. no. III.12.

P.H.

129 Terracotta figure of Isis or a devotee of her cult

First century BC

Provenance unknown

Height 22 cm

London, British Museum GR 1936.9-3.3

The figure is almost intact, with only the left elbow damaged. There are traces of applied white gypsum plaster. The back is plain, with a circular vent. The hollow figure was made from a two-piece mould. The clay is a micaceous red-brown Nile silt.

This figure may represent either Isis herself or a devotee of her cult. The object that she holds in her raised left hand is hard to distinguish, but may be either a sistrum or a cobra (only the head of which is shown), an attribute of Isis-Thermouthis. Her other hand holds a *situla* (bucket). The garment, corkscrew locks, and sun disc with cow's horns are also found in representations of Isis from the late Ptolemaic and Roman periods. The crown was probably completed with feathers, now broken away.

The figure also wears a plain garland on her head and a second, floral garland thrown over her left shoulder and around her waist.

UNPUBLISHED.

P.H., S-A.A.

130 Terracotta flask in the form of Isis riding a goose

Second or first century BC

Provenance unknown

Height 10.5 cm

London, British Museum EA 30458

The flask is in good condition, except for the nose of Isis and the base ring, which are damaged. The vessel was made in a two-piece mould; the fabric is micaceous brown Nile silt, covered with a black slip (Memphite Black Ware).

This vessel shows Isis riding side-saddle on a goose, wrapping her arms around the neck of the bird, whose head turns back and leans on her right arm. Isis has a row of short corkscrew locks around her forehead, and then longer curls that fall on to her shoulders. She wears a fringed garment, knotted at her breasts, that covers her back and buttocks, but leaves her legs exposed. At the back the work is less detailed, and the goose's wing is extended.

A handle runs from the head of Isis to her back, and on top of her head is the short, flaring mouth of the vessel. Below the group is a series of long, pointed leaves rising from the base ring.

The face of Isis is distinctly unflattering and she may be intended to be a caricature of Aphrodite, who was commonly shown with geese; the semi-nudity and erotic nature of the group amplifies the parody. The vessel is of an unusual type, but the workmanship is excellent, with the feathers of the goose and the garment of Isis being finely textured and detailed.

UNPUBLISHED.

P.H.

131 Bronze statuette of the god Harpokrates

Third to first century BC

Unknown provenance in Egypt

Height 29 cm, maximum width of base 4.6 cm

London, British Museum EA 35417

The youthful son of Isis and Osiris, depicted with pronounced Ptolemaic features, wears the striped *nemes* wig cover with two lappets down the front of his shoulders and a queue at the back. There is a uraeus, emblem of royalty, over his forehead, and a plaited sidelock is attached to the right side of the *nemes*, symbolizing his youthfulness and that he is heir to the throne of his father, Osiris. On top of the *nemes* is a *hemhemet* crown com-

prising three central *mw*-crowns surmounted by sun discs and flanked by ostrich feathers, the whole perched on ram's horns with a cobra wearing a sun disc at each end and two rings below for further attachments, now lost.

In characteristic iconography Harpokrates has his right index finger to his lips, a convention in Egyptian art to signify youthfulness, since child-like proportions were rarely reproduced. A further conventional indication that he is a child is his chubby nakedness. As usual, his thighs are in a strongly sloping position relative to the seat on which he would once have sat.

On the underside of the extremely thin base on which the figure rests its feet are three columns of incised hieroglyphs providing the name of the donor: 'May Horus-the-Child give life to Paw son of Ankhbadjedet begotten on the Mistress of the House Tiemkhered (?)'.

The piece is solid cast.

UNPUBLISHED.

C.A.

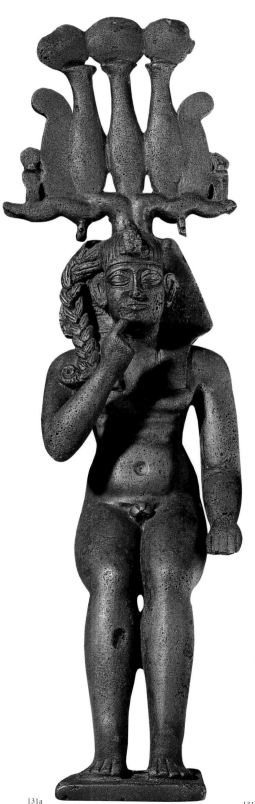

131a

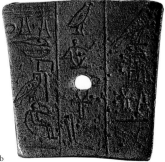

131b

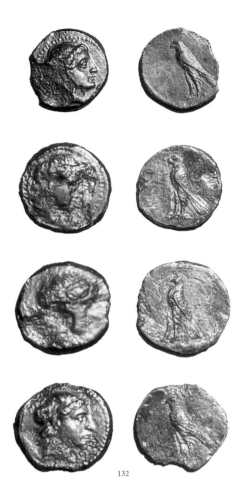

132

132 Bronze tokens from Alexandria

Second century BC

Found in excavation in the Brucheion region of Alexandria in 1996

Alexandria, Greco-Roman Museum, cri 96.2088.1.2, 31, 32, 38,39,43; cri 96.2127.56

During the course of excavations in Alexandria in 1996 a hoard of thirty-four bronze tokens of types hitherto unknown was unearthed. The tokens divide by diameter, weight and types into four denominations. The three largest share the same types of a laureate head of Apollo on the obverse and a falcon facing to the left on the reverse. The smallest denomination has the same obverse design, but a thunderbolt on the reverse.

None of the specimens bears any legend, monogram or other form of symbol such as characterize the coinage of the Ptolemaic kingdom. It thus seems clear that they must instead represent some form of semi- or unofficial token coinage. From the appearance of Apollo on one side and a falcon, symbol of the Egyptian god Horus, on the other it is tempting to suggest a

religious context for the production of the tokens. They may have been issued for use at a particular festival or sanctuary.

Whatever their exact pupose, the combination of Greek and Egyptian religious symbolism on these objects, unparalleled in the coinage of the kingdom, is striking.

BIBLIOGRAPHY: O. Picard, 'Monnaies de fouille d'Alexandrie', *RA* (1998), 203–5; id., 'Un monnayage Alexandrin énigmatique: le Trésor d'Alexandrie 1996', in M. Amandry and S. Hurter (eds), *Travaux de Numismatique Grècque Offerts à Georges Le Rider* (Paris 1999), 313–21, pl. 34.

A.M.

133 Two figures of Hathor

Second or first century BC

Made in Egypt: apparently from an uncertain site in Middle Egypt

Height 64.0 and 64.7 cm

London, British Museum EA 1895.5-11.49-50; 26265-6

Both of these very large terracotta figures of Hathor show her naked with her legs close together and her arms extended down her sides, her hands flat against the thighs. They have Isis-locks in a double layer back and front and falling on to the shoulders, and wear tightly woven wreaths bound with narrow ribbons. The jewellery consists of a plain necklace, a bracelet on the right wrist, an armlet and bracelet on the left arm and wrist, and an anklet on the right leg; a single breast-chain crossing from the right shoulder to the left waist has an oval fastening above the right breast, with two pendants. All the jewellery is modelled in relief, but a painted ribbon crosses the breast-chain from the left shoulder to the right waist. Details at the rear are well modelled.

Both figures are products of the same two-piece moulds or mould-series. EA 26265 is restored in plaster from above the knees down;the restoration was probably moulded from EA 26266. Both are of Nile silt and coated in a layer of white gypsum, but the painted decoration differs slightly in colour and detail. The better-preserved figure, EA 26266, has black hair, but the brows are brown, as are the breast-chain and other jewellery; the pubic triangle is also painted brown. The eyelids and pupils are a dull pink, the eyes and pupils are outlined in brown, and the irises are brown. The lips and nipples are painted bright pink and the bracelet on the right wrist has a pink ribbon tied above it, the loose ends hanging down the right thigh. There is pink paint between the feet and on some of the toes; some pink paint survives on the wreath.

Although figures of naked women with arms down their sides are at least as early as the

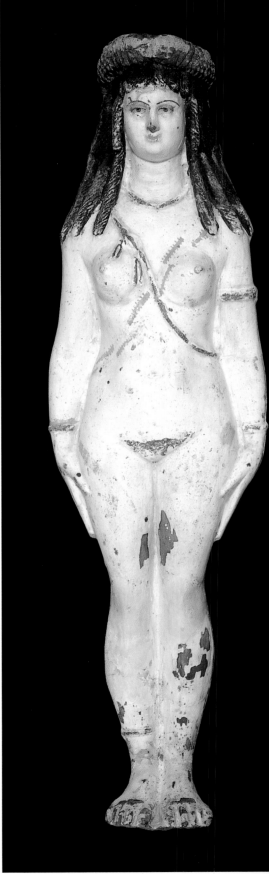

133

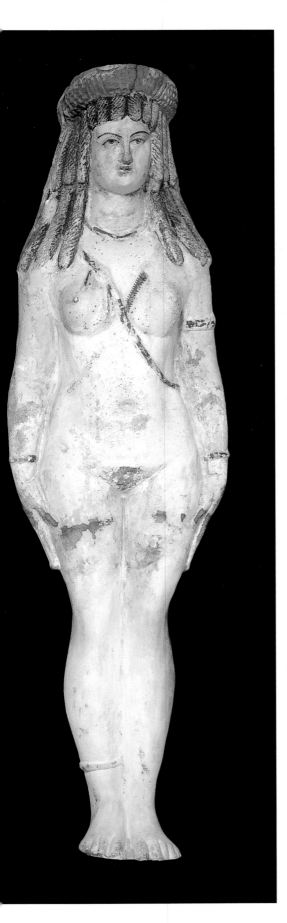

Middle Kingdom, and are thought to be 'embodiments of the human sexual urge, buried with the dead to ensure their continued sexual activity and fertility in the after life' (Reeves and Taylor, 1992, 101), these Ptolemaic figures seem likely to represent Hathor of the West, who receives the dead into her realm. Female anthropoid coffins of Ptolemaic to early Roman times, although garbed, have the same pose, for example those from a cemetery of Akhmim (Panopolis), published by M. Smith. Some of these inscriptions and a related stele describe the female deceased as 'Hathors', as distinct from 'Osiris' for a dead man.

BIBLIOGRAPHY: N. Reeves and J.H. Taylor, *Howard Carter before Tutankhamun* (London 1992), 101; E.A.W. Budge, *By Nile and Tigris*, ii (London 1920), 349, 350, said to be from Panopolis; D.M. Bailey, 'Terracotta Revetments, Figurines and Lamps', in M. Henig (ed.), *A Handbook of Roman Art* (Oxford 1983), 191–204, pl. 17 (dated too late); M. Smith, 'Budge at Akhmim, January 1896', in C. Eyre *et al.* (eds), *The Unbroken Reed, Studies in the Culture and Heritage of Ancient Egypt* (London 1994), 295–6, 299, where it is shown that Budge once claimed the figures came from Meir; M. Smith, 'Dating Anthropoid Mummy Cases from Akhmim: the Evidence of the Demotic Inscriptions', in M.L. Bierbrier (ed.), *Portraits and Masks, Burial Customs in Ancient Egypt* (London 1997), 66–71; J. Rowlandson (ed.), *Women and Society in Greek and Roman Egypt* (Cambridge 1998), pl. 28; probably from Tuna el-Gebel.

D.M.B.

134 Gold medallion pendant with Aphrodite and Eros

200–100 BC

Said to be from Egypt.

Diameter 4.4 cm.

London, British Museum GR 1884.6-14,12 (Jewellery 2883)

The medallion is complete but misshapen, and the outer edge is buckled and slightly cracked. The damage has also distorted the figures.

This medallion is made out of sheet gold worked over a bronze former (actual examples of which survive from Egypt), the finer details being tooled by hand. The disc has three loops soldered to the back, probably for the attachment of chains. This element would have been part of a larger ensemble of chains and medallion pendants that was perhaps worn over the upper body.

Aphrodite wears a *stephane* (diadem), behind which is a veil. She wears a chiton (tunic), which is pinned on the right side but slips down to reveal her shoulder. Prominent Venus rings, or wrinkles, are shown on the turning neck. The goddess is seated on a high-backed throne, while a small, winged Eros is perched on her shoulder.

BIBLIOGRAPHY: F.H. Marshall, *Catalogue of Jewellery, Greek, Etruscan and Roman in the Department of Antiquities, British Museum* (London 1911), no. 2883; U. Axmann, *Hellenistische Schmuckmedaillons* (Berlin 1986). 235–6, cat. no. 43, pl. 7.1; R. Blurton (ed.), *The Enduring Image: Treasures from the British Museum* (London 1997), cat. no. 94.

P.H.

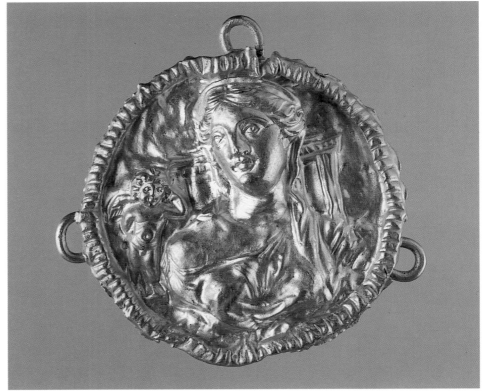

134

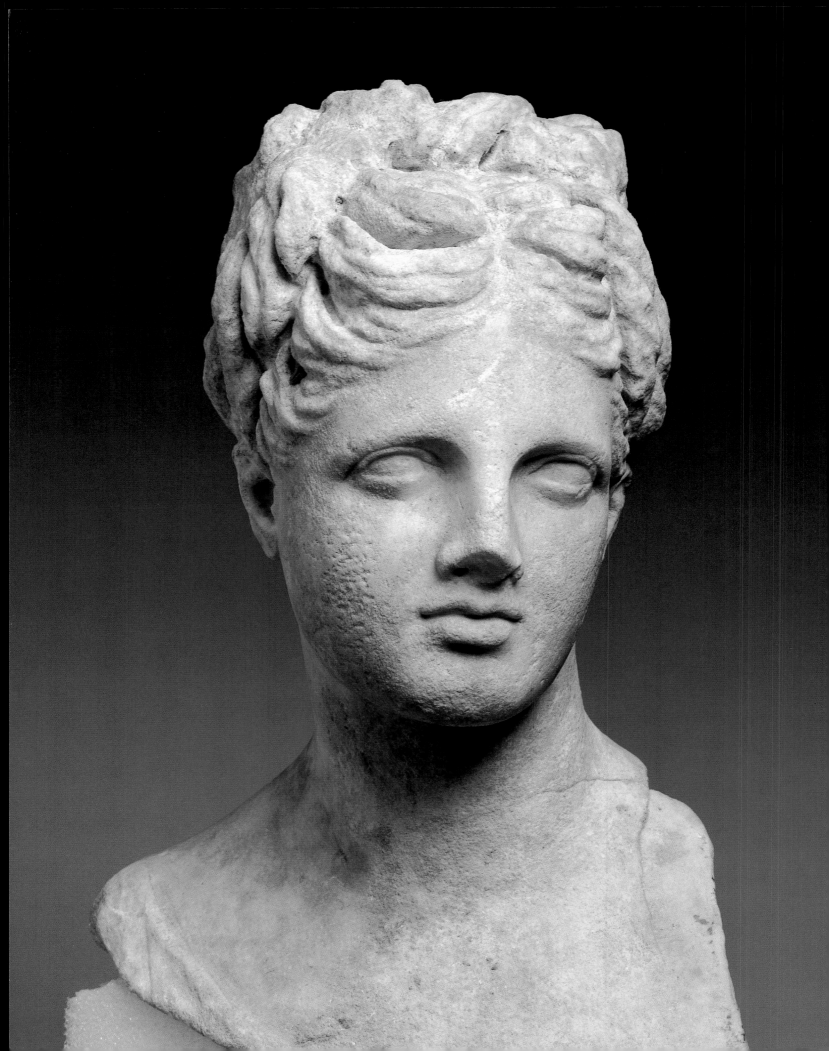

135 Marble head of a young woman, perhaps the goddess Aphrodite

Second to first century BC

Acquired in Alexandria, but said to have come from the Fayum, Egypt.

Height 32 cm

London, British Museum GR 1888.10-12.1

The head and neck are intact and part of the right shoulder and left breast are also preserved. The surface of the Pentelic marble is weathered and chipped, and the rear part is worked in less detail than the front. The lower surface has been worked to join the rest of the body.

A young woman with her hair elaborately arranged into a crowning top-knot is represented. Her head tilts slightly to her left, and the left cheek recedes somewhat more than the right, suggesting that this side was less conspicuous when the statue was displayed in its original setting. The woman is draped in a chiton, which has slipped from her left shoulder, probably exposing the left breast. The provocatively arranged drapery would suggest that the subject portrayed is Aphrodite or maybe a nymph. The benign and rather delicate facial features, with their almond-shaped eyes, delicately carved, short nose and curvilinear mouth, also support such an identification.

Aphrodite was perhaps the most widely worshipped of all of the Greek goddesses in Egypt. Many of the Ptolemaic queens associated themselves with Aphrodite (as well as with her Egyptian form, Hathor) and with Isis. An anonymous and fragmentary hymn dedicated to Arsinoe II, associating her with the marine Aphrodite, may have been written at the time when the temple of Arsinoe–Aphrodite was constructed at Zephyrion, east of Alexandria, and was dedicated by the admiral Kallikrates. Other queens also associated themselves with Aphrodite, including Berenike II, whose shrine stood at Magdala in the Fayoum, where another shrine dedicated jointly to Berenike–Isis and Arsinoe–Aphrodite is also recorded. Later queens continued the trend, and from 107/106 BC onwards we hear of a priestess of Queen Cleopatra (III), goddess Aphrodite.

Cleopatra VII was also linked with Aphrodite, albeit in a more obviously Roman context. Caesar had a golden statue of Cleopatra placed in the temple of Venus Genetrix in the Forum Julium. Furthermore, later sources tell us of the way in which Cleopatra exploited her relationship with Aphrodite. Plutarch, in his *Life of Antony*, records the first meeting of Mark Antony and Cleopatra in Cilicia, at which Cleopatra sailed up the river Kydnos in a luxurious barge, adorned like Aphrodite in a painting, with boys dressed like Erotes standing and fanning the queen.

UNPUBLISHED.

P.H.

136 Gold ring with a lapis lazuli intaglio showing a head of a priest

Third century BC

Provenance unknown

Height 2.4 cm

London, British Museum GR 1917.5-1.384 (Ring 384) (Franks Bequest)

The ring is intact, with only a few minor abrasions. This intaglio gem set into a gold ring shows a man wearing a skullcap surmounted by a disc. He also wears a short, false beard. The man has a sturdy, thick neck supporting a strong,

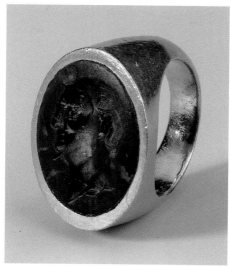

136

heavily built face. The large eye is quite low down the line of the nose beneath a heavy brow, and the lips are full. The physiognomy is distinctly un-Greek in appearance. Richter identified the subject as an Oriental ruler, and Plantzos, an Egyptian priest: the latter identification is perhaps more applicable considering the Egyptian attributes. The distinctive facial features suggest that a portrait is intended, but the sitter remains anonymous.

BIBLIOGRAPHY: F.H. Marshall, *Catalogue of the Finger Rings, Greek, Etruscan and Roman in the British Museum* (London 1907), no. 384; G.M.A. Richter, *The Engraved Gems of the Greeks, Etruscans and Romans* (London 1968), 165, no. 663; D. Plantzos, *Hellenistic Engraved Gems* (Oxford 1999), no. 141, pl. 25. P.H.

137 Black jasper gem with a portrait of a priest

First century BC

Provenance unknown

Height 1.9 cm

London, British Museum GR 1902.12-13.1 (Gem 2068)

The ancient intaglio is intact, apart from slight damage to the upper right side behind the subject's head. It is set into a modern metal mount.

This high-quality engraving shows a completely bald and clean-shaven man wearing a pectoral ornament that completely encompasses the bust. Behind him is a snake-entwined staff. The man's neck is extremely long, and the upper part of his skull appears enlarged and cut deeper into the stone than the lower part of the face. The face is intricately modelled, with a distinctly arching brow, a large deeply set eye, with sharply defined lids and incised pupils. The nose is short, and un-classical in appearance, and the nostrils

137

curl slightly. The lips are full and fleshy, and the chin rounded and strong. The ears are particularly large, almost swollen and set low on the skull.

The iconography of this subject is particularly difficult to understand. The snake-entwined staff is usually associated with the Greek healing god, Asklepios, whereas the Egyptianizing motifs, like the pectoral and the bald head, cannot be associated with that god. It may then represent a priest, perhaps a late Republican generic adaptation of a Ptolemaic type.

BIBLIOGRAPHY: H.B. Walters, *Catalogue of the Engraved Gems and Cameos, Greek, Etruscan and Roman, in the British Museum* (London 1926), cat. no. 2068. P.H.

138 Basalt standing statue of the priest Pasherbastet

First century BC

Unknown provenance in Egypt

Height 48.5 cm, width of base 13.5 cm, depth of base 15.5 cm

London, British Museum EA 34270

This figure is only one in a series whose distinctive features have led them to be termed 'pensive men'. However, it is probably one of the finest in the genre: the way in which the head is cocked to one side, the treatment of the heavily lidded eyes with incised iris, and the rather tragic expression are noteworthy. The downturned mouth and the sharp line below the lower lip are characteristic of late first-century-BC royal portraits, which the sculptor may have had in mind when manufacturing this representation of a private individual. Although it is tempting to interpret the portrait as an accurate copy of the subject's true appearance, the so-called veristic or pensive portraits still follow Egyptian artistic conventions of the first century BC and, as noted, the royal style at this time.

As with all figures of this type, the man wears a costume comprising a short-sleeved round-necked shirt, a wraparound skirt and a fringed shawl, whose mid-section he grasps in his left hand; the object in his right fist has been identified as a folded cloth, a symbol of aristocracy since early dynastic times. The figure strides on the left foot with one hand clenched, the artistic convention since the beginning of the dynastic period for representing male dynamism and capability for action. As a priest, the owner has a shaven head.

The back pillar, which is rounded at the top and reaches the back of the head, supports the figure and was an architecturally necessary support for standing statuary but with inherent symbolism. It is incised with a column of hieroglyphs providing the name, titles and filiation of the owner. As is often the case with Ptolemaic period hieroglyphic inscriptions, the individual signs, though clear, are not always easy to interpret. Pasherbastet was the son of a man whose name may be read as Khons-Hor; his mother was Bastet-iw. Her name incorporates that of the popular cat goddess, Bastet, as does that of her son, suggesting a particular devotion and a possible northern Egyptian origin. The provision of Pasherbastet's father's name is not common: if a parent's name is given, invariably it is that of the mother, on the basis that her identity alone cannot be disputed. The statue's owner held priestly offices connected with Isis, Hathor, Neith and Horus, the first three specifically in a temple of Amen-Re in the Leontopolite *nome* in the central-eastern delta, which suggests that this is the probable location from which the statue originally came.

BIBLIOGRAPHY: B.V. Bothmer, *Egyptian Sculpture of the Late Period* (New York 1960), 145, 154, 155.

C. A., S-A.A.

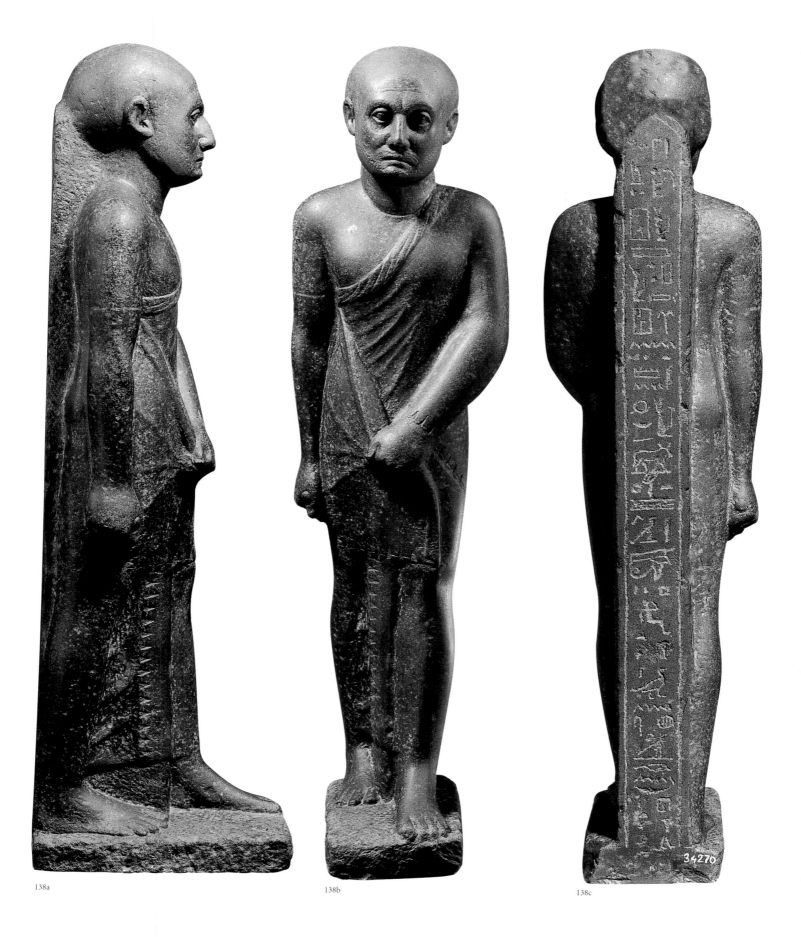

138a

138b

138c

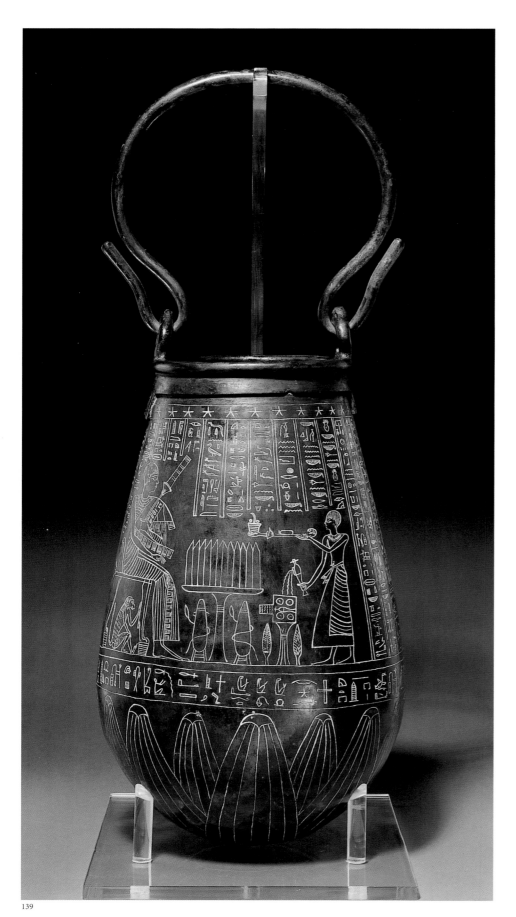

139

139 Bronze *situla* of Padiamennebnesuttawy

c. 300 BC

Found at Thebes

Height 37.3 cm, maximum diameter 22.8 cm

London, British Museum, EA 38214

The vessel is in excellent condition.

This *situla*, or bucket, would have been used during the daily offering ritual at the tomb of its owner and would have contained either water or milk. One side of the vessel shows the son of the deceased performing this very ritual for his father, named by the hieroglyphs as Padiamennebsuttawy. The text also lists the owner's numerous priestly titles held at Karnak in the service of the state god, Amen-Re, and his consort, Mut. However, the most important of his titles was held to be that of Scribe of the Oracle, since it is also inscribed in large signs on the two tongues of metal that project downwards from the rim.

One figured panel on the vessel's body depicts the deceased seated behind an offering table with slices of bread on it and jars of wine below. Beyond, his son shakes incense and pours offerings above an offering table bearing representations of loaves and a water container. Should actual offerings not be presented, these two-dimensional images could magically become three-dimensional reality and supply the deceased with basic rations. Padiamennebnesut-tawy wears an elaborate pleated and fringed garment, whose sash bears one of his titles, and he carries a *kherep* (sceptre), a sign of his rank. Beneath his lion-footed chair squats a vervet monkey, probably a pet but also symbolically a guarantee of the deceased's sexual prowess in the afterlife. The accompanying columns of text contain formulae that will provide him with sustenance in the other world.

In the other panel Osiris, god of the dead, is depicted as an animated *djed* pillar, wearing the god's *atef* crown and carrying royal accoutrements. He is flanked by his sister goddesses, Isis and Nephthys, who pour water for the deceased's human-headed *ba*-bird to drink. The *ba*, which represents the deceased's characteristics, personality or traits, was capable of assuming different forms and was the most widely ranging of the spirit forms that survived death. In the accompanying texts the goddesses offer the deceased protection and liquid refreshment wherever he might be. The petals of the lotus around the base hint at the watery contents of the *situla*.

The deceased was a member of a well-documented Theban priestly family. Other items from his burial have also survived.

BIBLIOGRAPHY: C. Andrews, catalogue entry, in *Egyptian Treasures from the British Museum*, exhibition catalogue (Hong Kong 1998), 196, cat. no. 61.

C.A.

140

140 Bronze statuette of an Egyptian priest

Late first century BC or first century AD

Said to be from Hermonthis

Height 13 cm

Paris, Louvre Br 4165

The figure is in good condition, but has lost a vessel that he held up to his chest. The bronze has a green patina, with cuprite visible on the left elbow and around the upper legs.

This figure follows a type that was popular for representing priests in the late Ptolemaic and Roman periods. The priest is shown with the typical shaven head and long robes. He also wears elaborate thonged sandals. In the space

above his hands we can assume there was a Canopic jar, through comparison with similar figures: a large, granite figure of a similar priest was recently found on the seabed on the east side of the port of Alexandria. He holds an Osiris-Canopus jar, the top of which rests between his left cheek and shoulder. The jar was human-headed, its form recalling the cult image of the god from the town of Canopus.

Despite the provenance of both this example and the granite statue just mentioned, this statue-type was more popular outside than within Egypt, and became more common in the Roman period. The canonical form of representing priests however, remained unchanged from the Ptolemaic period: compare the shaven heads, for example, of cat.nos 136–8.

BIBLIOGRAPHY: S. Descamps and P. Ballet, catalogue entry, in M. Rausch (ed.), *La Gloire d'Alexandrie. Cat. Exh. Petit Palais*, 97, cat. no. 55; for the granite statue recently found at Alexandria, see F. Dunand, 'Priest bearing an "Osiris-Canopus" in his veiled hands', in F. Goddio *et al.*, *Alexandria: The Submerged Royal Quarters* (London 1998), 189–94.

P.H.

141 Black basalt block inscribed with list of victors at the birthday festival of Ptolemy II Phildelphus, 8 March 267 BC

Third century BC

Probably found in the Fayum

Height 80 cm, width 70 cm, depth 35 cm.

Cairo, Egyptian Museum. JE 90702

The festival of Basileia, in origin probably dedicated to Zeus, the protector of kings, coincided during the reign of Ptolemy Philadelphus (285–246 BC) with the King's birthday. A major festival was held in the capital, Alexandria, and from this inscription it is clear that a smaller festival was held in at least one other area in the Egyptian countryside. The find-spot of the inscription, and thus the precise location of the festival, is unknown, but was probably in the Fayum.

The participants in the games that accompanied the festival were no doubt drawn mainly from the colonists (known as Cleruchs) who had been settled on the land by Philadelphus and his

141

βασιλεῖ Πτολεμαίωι Σωτήρων Ἡράκλειτος Λεπτίνου Ἀλεξανδρεὺς
ἀγωνοθετήσας καὶ πρῶτος ἆθλα προθεὶς χαλκώματα.
ἔτους ὀκτωκαιδεκάτου Δύστρου δωδεκάτηι γενεθλίοις
Βασίλεια τιθέντος Ἀμαδόκου, τὴν ἀναγραφὴν τῶν νικώντων· 4

σαλπικτάς		παῖδας πυγμήν	
Θεόδωρος Στράτωνος Θρᾶιξ		Χρύσερμος Ἀμαδόκου Θρᾶιξ	
κήρυκας		πτολεμαϊκούς	
Ἡφαιστίων Δημέου Ταραντῖνος	8a	Δημήτριος Ἀρτέμωνος Ναυκρατίτης	8b
λαμπάδι ἀπὸ πρώτης		ἀγενείους	
Πτολεμαῖος Ἀμαδόκου Θρᾶιξ		Στράτιππος Μενοίτου Μακεδὼν	
λαμπάδι		ἄνδρας	
Διονύσιος Στεφάνου Ἁλικαρνασσεύς	12a	Βαστακίλας Ἀμαδόκου Θρᾶιξ	12b
παῖδας δόλιχον		πτολεμαϊκοὺς παγκράτιον	
Αἰνῆσις Παταμούσου Θρᾶιξ		Ἀμάδοκος Σατόκου Θρᾶιξ	
ἄνδρας		ἀγενείους	
Πτολεμαῖος Βουβάρου Μακεδὼν	16a	Στράτιππος Μενοίτου Μακεδὼν	16b
παῖδας στάδιον		ἄνδρας	
Πτολεμαῖος Ἀμαδόκου Θρᾶιξ		Πτολεμαῖος Ἀδύμου Μακεδὼν	
πτολεμαϊκούς		ὁπλίτην	
Κινέας Ἀλκέτου Θεσσαλός	20a	Μνησίμαχος Ἀμεινοκλέους Βοιώτιος	20b
ἀγενείους		ἵππωι λαμπρῶι	
Κινέας Ἀλκέτου Θεσσαλός		Πτολεμαῖος Ἀμαδόκου Θρᾶιξ	
ἄνδρας		ἀβόλωι στάδιον	
[.] Παρμενίωνος Μακεδὼν	24a	Λυκομήδης Κτησικλέους Σάμιος	24b
[παῖδας δί]αυλον		τελείωι	
- - - - - - - - - - - - - - - - -		Α[.]. . . .[
		- - - - - - - - - - - - - - - - -	

For king Ptolemy son of the Saviours, Heracleitus son of Leptines of Alexandria,
having organized the competition and first offered bronze vessels as prizes,
in the eighteenth year on the twelfth of Dystros, at the birthday celebrations,
Amadokos having established the festival of Basileia, set up the list of victors: 4

Trumpeters		Boxing (boys)	
Theodoros son of Straton Thracian		Chrysermos son of Amadokos Thracian	
Heralds		Boxing (ptolemaikoi)	
Hephaistion son of Demeas Tarentine	8a	Demetrius son of Artemon Naucratite	8b
Torch race (first lap)		Boxing (beardless)	
Ptolemaios son of Amadokos Thracian		Stratippos son of Menoites Macedonian	
Torch race (last lap)		Boxing (men)	
Dionysios son of Stephanos Halicarnassian	12a	Bastakilas son of Amadokos Thracian	12b
Long race (boys)		Wrestling (ptolemaikoi)	
Ainesis son of Patamousos Thracian		Amadokos son of Satokos Thracian	
Long race (men)		Wrestling (beardless)	
Ptolemaios son of Boubaros Macedonian	16a	Stratippos son of Menoites Macedonian	16b
Short race (boys)		Wrestling (men)	
Ptolemaios son of Amadokos Thracian		Ptolemaios son of Adumos Macedonian	
Short race (ptolemaikoi)		Race in armour	
Kineas son of Alketes Thessalian	20a	Mnesimachos son of Ameinokles Boiotian	20b
Short race (beardless)		Dressage	
Kineas son of Alketes Thessalian		Ptolemaios son of Amadokos Thracian	
Short race (men)		Short race for yearlings	
[.] son of Parmenion Macedonian	24a	Lykomedes son of Ktesikles Samian	24b
Double length race (boys)		Short race for older horses	
- - - - - - - - - - - - - - - - -		A[.]. . . .[
		- - - - - - - - - - - - - - - - -	

father. These Cleruchs, though now subjects of the king in Egypt, clung nonetheless to their roots by maintaining as part of their names the cities or regions from which they had originally come. The names of the victors in the inscription thus give an interesting insight into the make-up of the Cleruchic communities in the Egyptian countryside. Predictably strong is the representation of Macedonians and Thracians from the area of Alexander and the Ptolemaic dynasty's homelands. But there are also men from Tarentum in southern Italy, Thessaly and Boiotia in central Greece, and Samos and Halicarnassus on the western littoral of Asia Minor.

The inscription also serves as clear evidence for the way in which Alexandria, the Ptolemaic royal house and their festivals served as focal points for the cultural and social lives of the Cleruchic settlers outside the city. Part at least of what bound these individuals together in their new land under their new kings was the image of divine monarchy that the Ptolemaic house projected to its subjects. The possession of a local festival in honour of the king's birthday no doubt brought prestige (if only in their own eyes) to the inhabitants of the area in which it was held. At the same time it helped to provide them with a sense of identity and belonging within an otherwise foreign land.

BIBLIOGRAPHY: P.M. Fraser, *Ptolemaic Alexandria* (Oxford 1972) I., 48;II., 129 n. 97; 192 n. 87; 382 n. 341. L. Koenen, *Eine agonistische Inschrift aus Ägypten und frühptolemäische Königsfeste, Beiträge zur Klassischen Philologie* 56 (Meisenheim am Glan 1977). L. Robert, 'Bulletin Epigraphique', *REG* (1977), 436–8, no. 566; J-Y. Empereur, catalogue entry, in M. Rausch (ed.), *La Gloire d'Alexandrie. Cat. Exh. Petit Palais* (Paris 1998), 267, no. 210.

A.M.

Hadra *hydriai* (water jars used for burial)

These Hadra *hydriai* form part of a distinctive group of Hellenistic vases that found use as cinerary urns. They are named for one of the main cemeteries of Alexandria, where this type of vase was first discovered during the last quarter of the nineteenth century. The vases, as well as having painted decoration, bear ink inscriptions that provide information about the identity of the deceased and the date of his death or burial. It becomes clear from this that the ashes contained in the vases (cat. nos 144–146) were those of visiting Greek dignitaries who had suffered the misfortune of dying while taking part in embassies to the Ptolemaic court. Whereas native Egyptians continued to follow the established custom of mummification, it would seem that provision was made during the third century BC for the Greco-Macedonian inhabitants of Alexandria, as well as foreign mercenaries stationed there and visiting officials from abroad, to be cremated according to Greek custom. Over time this practice fell into disuse as the Greek community adopted Egyptian ways. The latest example of a dated Hadra *hydria* belongs to the thirteenth regnal year (210/209 BC) of Ptolemy IV Philopator; other vases, however, have been assigned on stylistic grounds to the second century BC (see Callaghan 1980, 33–47).

It may be significant that the vases (cat. nos 144–146) record the deaths of three ambassadors all in the ninth year (213/212 BC) of the same king, Ptolemy IV Philopator. It certainly suggests a high mortality rate, and it underscores the fact that in antiquity the dangers of travelling were not restricted to those of the voyage – a change of climate and diet could also be detrimental to one's health.

Since the greatest concentration of such vases was found in the necropolis of Alexandria, it was long assumed that they were made in Egypt. Some *hydriai* undoubtedly were (notably the so-called White Ground *hydriai*), but those classified as belonging to the Clay Ground group are now known to have been produced in Crete. Indeed, in all likelihood the present three vessels were made in central Crete, in or near Knossos (see Callaghan and Jones 1985). It remains, however, a matter of scholarly dispute as to whether all Hadra *hydriai* were made specifically for use in a funerary context, and it has been suggested that some at least were intended as prizes at athletic contests (see Enklaar 1985, 109–10; Callaghan and Jones 1985, 2). What is clear is that the inscriptions are secondary, added to the body and sometimes to the underside of the foot by a local scribe shortly before the vase received the ashes of the deceased. The cinerary urn was then deposited in one of the local cemeteries or, in some cases, was taken home by the family or friends of the dead person for burial in his native land.

BIBLIOGRAPHY: P.J. Callaghan, 'The Trefoil Style and Second Centruy Hadra Vases' *BSAA* 75 (1980), 33–47; P.J. Callaghan and R.E. Jones, 'Hadra Hydriae and Central Crete: A Fabric Analaysis', *BSAA* 80 (1985), esp. 2–3, 9–11; A. Enklaar, 'Chronologie et Peintres des hydries de Hadra', *BABesch* 60 (1985), 109–110; Callaghan and Jones (1985), 2.

C.S.L.

142 Hadra *hydria*

c. 220 BC

Excavated at Gabbari, Alexandria, 1997

Height 31 cm

Alexandria, Graeco-Roman Museum 32047

This *hydria* is complete except for a small part of the lip. It is made of fine light-orange clay, turning to grey at some places, and decorated with black paint, which is for the most part worn off, leaving red traces.

Most Hadra *hydriai* were made in Crete and originally used as water vases. During the years 270–265 BC the Ptolemies occupied the Cretan city of Itanos and brought the whole island into the Egyptian sphere of influence. This opened excellent opportunities for Cretan potters to export their vases to the fast-growing new metropolis, Alexandria. Thousands of Hadra *hydriai* must have been shipped to Alexandria to serve there, not as water vases, but as cinerary urns.

In order to win the Alexandrian market the Cretan potters developed a more elegant *hydria* shape than they used to make. They decorated their vases in a characteristic light-on-dark technique; that is, a black paint on the light clay surface. Several workshops can be distinguished, of which the two most important must have been situated in the Mesara plain, perhaps

142

at Phaestos, and at Knossos. This vase, with a decoration of the laurel wreath around the neck, the typical division of the body in a front and rear panel by horizontal and vertical lines, and the scroll pattern under the upright handle, looks very much like the products of the Mesariote workshop. However, the shape of the vase and several particularities of the decoration recall the Knossian workshop. The vase was strongly influenced by both major workshops, but was probably made elsewhere in Crete. The scene in the front panel, an ibex (a wild goat) hunted by dogs and men, recurs on several Hadra vases. It was first used by potters at Knossos and later imitated by other workshops. The scene has no direct relationship with the funerary use of the vase, but the laurel wreath around the neck and the *kerukeion* (staff) in the vertical strips besides the horizontal handles do. The first recalls the laurel wreaths of gilded bronze that were frequently put on the head of the dead and that were also found in Alexandrian tombs. The *kerukeion* refers to Hermes, the guide of the souls to the underworld.

The Alexandrians always had a marked preference for vases of the *hydria* shape to serve as cinerary urns. At first a local Alexandrian type of urn, the White Ground *hydria* with polychrome decoration, was predominant, but soon the Hadra vases outnumbered all other types. They were even clumsily imitated by an Egyptian workshop in Alexandria.

BIBLIOGRAPHY: J-Y. Empereur and M-D. Nenna, *Necropolis 1, Etudes alexandrines 5* (Cairo 2000).

A. E.

143

143 Hadra *hydria*: burial vase of Andragoras

225–215 BC

Excavated at Gabbari, Alexandria, 1998

Height 37.5 cm

Alexandria, Greco-Roman Museum 32053

This vase is complete, but a few chips of the lip are missing. There is scale on neck and belly. The *hydria* is made of fine light-orange clay, turning to grey, owing to unequal firing. The paint turns from black to brown-red, and there are additions of white paint.

The shape of this *hydria*, with its low foot and flaring neck, clearly shows that it was made at Knossos. Another vase by the same potter and now in New York is dated to 233 BC by an inscription. The decoration of the vase exhibited here is far more developed, and points to a later date. The extensive use of additional white paint is conspicuous. Most striking, however, is the scene

in the front panel. The stock pattern of an ibex and a dog is found on several other Hadra vases, but nowhere else is the landscape setting depicted as on this vase, showing traces of the ground and a tree to the right. Does this reflect the growing interest in landscape in the Hellenistic age? In any case, we should notice that, like most Hadra vases and unlike the preceding vase, nothing in the decoration refers unequivocally to the use of the vase as a cinerary urn.

This vase contained the cremated bones of a man called Andragoras, as the small inscription on the lower part of the upright handle indicates. It is more correct to speak here of 'cremated bones' instead of the 'ashes' of contemporary cremation, since many parts of the burnt skeleton are represented, some of them even complete, and the pieces are all rather big. Most Alexandrian Greeks were inhumated after their

death, but a few of them (perhaps no more than a few per cent) were cremated. Inhumation and cremation may be found side by side in the same tomb or even in the same *loculus* (burial niche), suggesting that this difference of practice did not involve different groups of the population. For example, the Ptolemaic kings were all buried, except Ptolemy, who died in 204 BC and whose cremated bones were gathered in a silver *hydria*. For some Alexandrians there might have been something 'heroic' in being cremated, just like the ancient heroes in the *Iliad*. But perhaps it was just another way to preserve the most stable remains of the deceased, the bones.

Meticulous study of the cremated bones in a number of Alexandrian urns by G. Grevin and P. Bailet has revealed a clear difference between cremation practice in Roman times and that in the third century BC. Roman urns usually contain

tiny fragments of cremated bones. In the third century BC in Alexandria, however, the cremated bones were often carefully gathered from the remains of the pyre and put into the urn in a more or less strict order, starting with the toes and ending with pieces of the skull on top.

A considerable number of Hadra vases bear an inscription, usually indicating the name of the deceased. A small series of urns containing the remains of ambassadors and high officers (e.g. cat. nos 144–146) also gives the exact date of the burial. In combining this evidence with a thorough study of shapes and decoration of Hadra vases, it has become possible to date most Hadra vases with great precision and to trace the development of this pottery class. The beginning of the production lies in the 260s BC and can be explained by the growth of a Ptolemaic presence on the island of Crete. No Hadra vases can be dated later than the beginning of the second century BC, and it is most probable that the production then stopped. Even of the other types of urns found in the Alexandrian hellenistic cemeteries no samples can be dated with certainty to the later second or early first century BC. On the other hand, there has been found a series of cinerary urns clearly datable to the Roman imperial period. This absence of cinerary urns after the beginning of the second century BC and the marked difference between cremation practices in the early Hellenistic period and in the Roman period suggest that there was not a continuous cremation tradition in Alexandria. It cannot be excluded that the custom of cremation was abandoned in the early second century BC, reappearing only in the first century AD when Roman citizens came to Egypt as military men or administrators, bringing with them their own cremation practice.

BIBLIOGRAPHY: J-Y. Empereur and M-D. Nenna (eds), *Necropolis 2, Etudes alexandrines 7* (Cairo 2000)

A.E.

144 Terracotta Hadra *hydria*

24 March–12 April 213 BC

Made in Crete, found in Egypt; exact provenance unknown

Height 46.9 cm, diameter 24.8 cm, width with handles 29.5 cm

New York, The Metropolitan Museum of Art 90.9.13; purchased in 1890

The vase belongs to the 'Dropped Floor Class' of *hydriai* (the Clay Ground group), with two side handles and a vertical back handle. It has painted decoration, applied straight on to the surface before firing: on the neck, laurel sprays; on the shoulder, a row of buds, their leaves linked to

144

form arches; on the upper section of the body, at the front, a central panel comprising a running dog motif above a scroll of leaves surrounded by dots, flanked either side by five vertical alternating straight and wavy lines; and, at the back, a *rinceau* (foliated scroll).

Below, on the front, is painted an inscription in Greek: 'Year 9, Mecheir; Damo[...], son of Nearchos, Member of the Sacred Embassy, of Boeotia; by Theodotos, agorastes.'

BIBLIOGRAPHY: B.F. Cook, *Inscribed Hadra Vases in the Metropolitan Museum of Art* (New York 1966), 24, no. 8, pls II, XI; A. Enklaar, 'Chronologie et Peintres des hydries de Hadra', *BABesch* 60 (1985), 134.

C.L.

145

146

145 Terracotta Hadra *hydria*

19 May 213 BC

Made in Crete, found in the eastern necropolis of Hadra, Alexandria

Height 43.8 cm, diameter 24.4 cm, width with handles 29.5 cm

New York, The Metropolitan Museum of Art 90.9.29 (Purchased in 1890)

Part of the rim and neck of this *hydria* is restored.

The vase belongs to the 'Dropped Floor Class' of *hydriai* (the Clay Ground group), with two side handles and a vertical back handle. It has painted decoration, applied straight on to the surface before firing: on the neck, laurel sprays; on the shoulder, a double row of dots with a rosette at the front; on the upper section of the body, a saltire cross of cross-hatched strips with a rosette of four petals over the crossing, pairs of dot-rosettes above and below, flanked to either side by palmettes; and, at the back, a *rinceau*.

Below, on the front, is painted an inscription in Greek: 'Year 9, Hyperberetaios 30, Pharmouthi 7; Timasitheos, son of Dionysios of Rhodes, an Ambassador; by Theodotos, agorastes.' The precise date is given according to both the Macedonian and the Egyptian calendar.

BIBLIOGRAPHY: B.F. Cook, *Inscribed Hadra Vases in the Metropolitan Museum of Art* (New York 1966), 24–5, no. 9, pls III, XI; A. Enklaar, 'Chronologie et Peintres des hydries de Hadra', *BABesch* 60 (1985), 133.

C.L.

146 Terracotta Hadra *hydria*

Before 14 February 212 BC

Made in Crete, found in the eastern necropolis of Hadra, Alexandria,

Height 45.7 cm, diameter 28.3 cm

New York, The Metropolitan Museum of Art 90.9.37 (Purchased in 1890)

One of the side handles on the vase is restored.

The vase belongs to the 'Dropped Floor Class' of *hydriai* (the Clay Ground group), with two side handles and a vertical back handle. It has painted decoration, applied straight on to the surface before firing: on the neck, laurel sprays; on the shoulder, a double row of dots with a circle around a cross at the centre; on the upper section of the body, three horizontal narrow panels comprising, from top to bottom, a running dog motif, cross-hatching, and ivy tendrils together with dot-rosettes; and, at the back, a *rinceau*.

Below, on the front, is painted an inscription in Greek: 'Year 9; Sotion, son of Kleon of Delphi, Member of the Sacred Embassy announcing the Soteria; by Theodotos, agorastes.'

BIBLIOGRAPHY: B.F. Cook, *Inscribed Hadra Vases in the Metropolitan Museum of Art* (New York 1966), 8, 25, no. 10, pls III, XI.

C.L.

147 Black-glazed *hydria* surmounted by a figure of a woman

c. 270–250 BC

Probably made in Crete; found in a grave in the Hellenistic necropolis at Ibrahimieh, 1906

Height 75 cm

Alexandria, Greco-Roman Museum 7306

The *hydria* is in good condition, but the surface has worn in many places. The reddish-brown colour around the lower part of the belly of the vase and on the handles indicates a misfiring.

This elaborate vessel is of a type common throughout the Hellenistic world and the brown-black glaze was perhaps intended to emulate more expensive metal versions of the same shaped vase: the appliqué reliefs, handles and the ribbing indicate that a metal prototype was followed. The decoration consists of white-painted, large intertwined ivy leaves and berries, characteristic of the Cretan workshops, and a series of female figures, draped in sleeveless chitons, with one arm either raised in a gesture of reverence, or perhaps indicating that they are dancing. These figures were made in the same mould and applied to the vase before firing. In between them are masks of the goddess Athena.

The terracotta female figure that surmounts the lid wears a tightly wrapped himation that covers her hands, and has long locks of hair falling on to her shoulders. She follows the general principles of the Tanagran terracotta figures of women, but here she has been covered in a black glaze to blend in with the vase. The figure has been set into a plaster bung that may have sealed the ashes of the deceased within the vase.

The vessel was probably used in a domestic context before being reused as a receptacle for the ashes.

BIBLIOGRAPHY: M. Rostovtzeff, *The Social and Economic History of the Hellenistic World Vol. 1* (Oxford 1941), 368, no. 3, pl. XLI; B. Barr-Sharrar, *The Fire of Hephaistos. Large Classical Bronzes from North American Collections* (Cambridge, Mass. 1996), 105–6; P. Pelletier-Hornby in M. Rausch (ed.), *La Gloire d'Alexandrie. Cat. Exh. Petit Palais* (Paris 1998), 256 no. 196.

P.H.

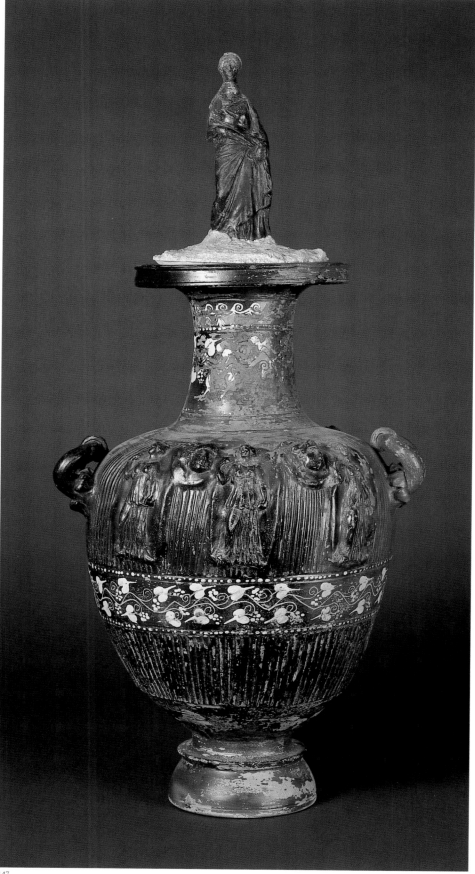

147

148 Terracotta figure of a standing woman

c. 200 BC

Made in Egypt; provenance unknown, but said to have been purchased from a resident in Alexandria

Height 20.5 cm

London, British Museum GR 1926.9-30.39

The figure has been restored from numerous fragments, but the lower part is missing. There is damage to the top of the head. A white slip, the base for polychrome decoration, survives in several areas. There are minute traces of blue and pink pigment on the chiton and blue on the himation. The figure was made in a two-piece mould, with a *petasos* (wide-brimmed hat), now missing, added separately.

The woman wears a himation, which has been pulled up over her head to form a veil. She raises her right hand, concealed beneath the garment, and pulls the material over her mouth like a muffler. Her left arm crosses her body at waist level. The vertical folds of a chiton, a garment made of heavier material than the himation, can be seen around her lower legs. The woman's hair is parted centrally, and then drawn back to form a bun, which is concealed beneath the veil. The break at the top of the head may mark where a broad, conical hat was added, a feature of such figures. The woman's eyes are relatively large, and she does not have the delicate features of the usual Tanagra types, either found in Alexandria or elsewhere. In fact, she has a rather matronly appearance. The woman is dressed in outdoor attire, and muffles her face either for reasons of modesty or to protect herself from the elements.

UNPUBLISHED.

P.H.

149 Terracotta figure of a standing woman

c. 250–200 BC

Made in Egypt; provenance unknown

Height 22 cm

London, British Museum GR 1981.2-10.9 (Transferred from the Victoria and Albert Museum, Reg.A 593-1910: Salting Bequest no. 2962)

The condition of this statuette is generally good, except for areas of the white slip and paint that have flaked off. The back of the figure has not been modelled, and has a circular vent. The piece was made in a two-piece mould, with the head made separately and attached.

This figure follows the tradition of the so-called Tanagras, made in Boeotia in central Greece from the third century BC onwards. Two-piece moulds for making the figures and finished pieces were exported to various locations in the Hellenistic world. Although the provenance of

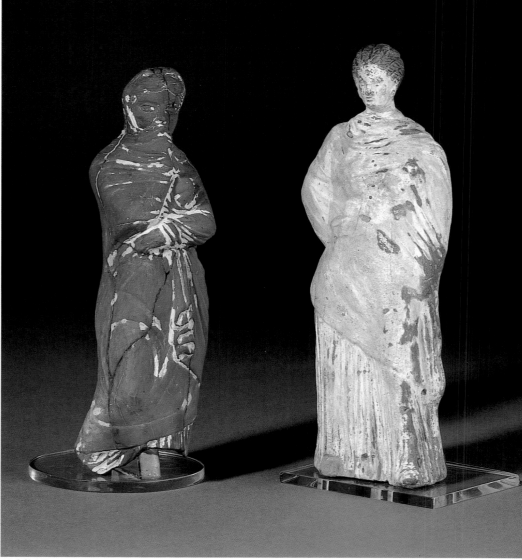

148 (left), 149

this piece is unknown, its micaceous, orangey-brown clay betrays its Egyptian origin.

The woman wears a long chiton, over which is draped a himation that covers her whole upper body and part of her legs. She has a melon hairstyle, which is drawn back and secured in a ring-shaped bun, and she wears disc-shaped earrings. A white slip covers much of the front of the figure except for the hair. Apart from the chiton around her lower legs, which remained white, the rest of the figure is richly coloured. The face and neck are pink, and the arms also, perhaps indicating that the woman is wearing a sleeveless chiton, with the flesh almost showing through the fine material of the himation worn over it. The eyes are painted blue and the earrings orange, perhaps to indicate gold. The himation was decorated with a series of yellow and blue panels that do not correspond with the lines of the drapery folds, a feature seen in several other Alexandrian, Tanagra-like terracotta figures.

Similar figures have been found in the rock-cut tombs in the necropolis of Hadra in Alexandria, and therefore come from a similar context to the Hadra *hydriai* (cat. nos 142–146). That their function was not solely funerary however, is demonstrated by the discovery of terracottas in domestic contexts too. The figures are an invaluable record of changing fashions in clothes, as well as showing activities carried out during everyday life, such as playing games or musical instruments. To have such images placed in the grave would then be a means of expressing a strong hope to continue these pleasures into the afterlife.

UNPUBLISHED.

P.H.

150 Limestone funerary slab

Third century BC

Excavated in the necropolis at Gabbari, Alexandria, 1997

Height 58 cm, width 38 cm

Alexandria, Greco-Roman Museum GAM. 97.1019.23

The surface of the slab is flaky, with most of the decoration of its lower third obliterated. The edges of the slab have also been damaged, and much of this may have occurred if the slab had been removed from its position in antiquity to add more bodies to the tomb. A large area of the painted surface, however, does survive.

During the construction of a flyover in the district of Gabbari in western Alexandria, a large subterranean necropolis was discovered. It was excavated by archaeologists under the direction of Jean-Yves Empereur. The tombs were cut into the rock, with each having a square or rectangular opening (*loculus*) sealed by a tombstone. These tombs were often reopened to place another body or cremation, probably of the same family as the original occupant.

Most of the tombstones followed an architectural format: the pediment was painted on to the actual rock wall, while the door would be painted on to the removable slab. The whole design was richly painted, and would have contained the name of the deceased in Greek, sometimes accompanied by a farewell message. The name of the deceased to whom this slab belonged has not survived. This example has a brightly painted double door, with large, presumably metal, ring handles. The handle on the proper left of the door appears to have a sash and perhaps a key hanging from it. The two upper panels are decorated with sashes and cross-shaped garlands, perhaps the paraphernalia added during a funerary ritual: they may be an accurate representation of actual Alexandrian doors. Other slabs show human figures (see cat. no. 152). Within the tombs were found terracotta figurines, small vessels, coins and Hadra *hydriai* (such as cat. nos 142–143) in the smaller *loculi* holding cremations.

BIBLIOGRAPHY: J-Y. Empereur, *Alexandria Rediscovered* (London 1999), 193.

P.H.

150

152

152 Limestone stele of a young girl and a dog

Second century BC

From the Shatby cemetery, Alexandria

Height 39 cm, width 30 cm

London, British Museum GR 1922.1-17.1

The lower surface of the stele has been sawn off, and the back is rough and uneven, with parts of the stone sawn away. The sides have a sandy-coloured wash over them with paint strokes (perhaps not ancient) still visible. The top surface is uneven, and the pediment is slightly damaged at the corners. The surface is damaged and weathered, with several chips missing from the stone. There is a crack running diagonally through the relief. Red paint is preserved on the pediment, and on the frame around the central scene. When first published, a faint painted inscription was noted, but this is now undetectable.

This scene shows a small girl dressed in a long, unbelted *peplos*, with black vertical stripes running down the outer edges of the garment. These stripes resemble *clavi*, coloured stripes on tunics worn by Romans of high rank from the late second century BC onwards, but this may just be coincidental. The garment is textured with incised grooves, similar to those used to indicate the dog's fur. The girl has extremely chubby arms and legs with grooves and wrinkles marking the folds of flesh. Her body is hardly indicated through the thick material of her garment. The hair is coloured brown, and the cheeks tinted with red, and the pupil of the left eye marked by a black dot. The bird in her left hand is painted black. The girl taunts a spirited dog with a creature, probably a bird with its wings extended, and the dog jumps up and grabs the creature, a scene common amongst Greek grave reliefs showing children.

The frame echoes architectural forms, with a pediment and architrave; the latter bears traces of a painted decorative pattern.

This stele was clearly intended to be placed in a rock cut tomb, and would have enclosed the niche in which the body was placed. The Shatby cemetery was the first to be used in the newly founded city of Alexandria; the first generations of Alexandrians would have been buried there.

BIBLIOGRAPHY: E. Breccia, 'Alcune nuove stele sepolcrali alessandrine a rilievo', *BArchAlex* 20 (1924), 253–4; M. Zlotogorska, *Darstellungen von Hunden auf griechischer Grabreliefs* (Hamburg 1997), 181, cat. no. 207, pl. 21. The author identifies the figure as a boy, but the figure clearly has Venus rings around the neck, and a hairstyle commonly associated with girls.

P.H.

151 Sandstone stele with snake-bodied figures of Isis and Dionysos

First century BC

Provenance unknown

Height 41 cm, width 37.5 cm

London, British Museum EA 1539

The stele is chipped around the edges, and roughly worked at the back. There are traces of red pigment in Dionysos' hair and diadem, and traces of reddish-pink on Isis' diadem and *polos* (high crown). A vertical crack runs through the body of Isis.

This unusual scene has the snake-bodied figure of Isis wearing an Egyptian crown with cow's horns, a sun disc, double feathers and ears of corn. She also wears a *polos*. Her hair is arranged in corkscrew locks that emerge in two layers from what is otherwise essentially a Greek hairstyle with a central parting. The male figure appears much like Sarapis, but the hairstyle and long, pointed beard compare more favourably with depictions of Dionysos, and the face and hairstyle

are almost identical with a type known as the Dionysos Sardanapallos. He wears a *hm-hm* crown with three uraeai and a *polos*. The snake bodies of the two deities intertwine: details of scales would have been added in paint.

The figures also echo representations of the mysterious Agathos Daimon, whom tradition says was closely linked with the foundation of Alexandria. The text known as the 'Alexander Romance' tells us that while building the city, the workmen were perturbed by the frequent appearance of a snake, which Alexander ordered to be killed. A sanctuary was erected at the spot where the snake was disposed of, and when it was finished many more snakes appeared and crawled into nearby houses; they were duly named the Agathoi Daimones. Subsequently, the snake deity was assimilated with Sarapis. The cult was probably related to both the household and the afterlife. This stela may then have formed the door to a tomb chamber in a rock-cut necropolis.

UNPUBLISHED

P.H.

◀ 151

Cleopatra, Lady of the Two Lands

Cleopatra's subtle religious strategy

GUY WEILL GOUDCHAUX

Censorship and misinformation

That Cleopatra should have had a religious policy ought not to surprise the reader. That it does so is due to the fact that, even today, we are still influenced by the subtle propaganda put forth by the queen's implacable enemy, Octavian, later Augustus. Given that he lived another forty-four years after her death, he had all the time he needed to reshape history to his own liking.

As if to prove the point, even the historian and future emperor Claudius, the nephew of Livia, wife of Augustus, was scolded by his aunt and ordered to leave that particular period of history alone! Claudius took heed and promptly concentrated his studies and research on the less compromising Etruscans (Suetonius, *Claudius,* 41, 2). The campaign of misinformation was so well-organized that three centuries later Dio Cassius was to write that, after Actium, the queen 'began to gather great riches … not sparing even the most sacred temples' (Dio Cassius, 51, 5, 5). But the historian forgets that the royal treasure, loaded on to Egyptian vessels, had managed to escape the trap of Actium! (Plutarch, *Life of Antony*, 55, 1,2 ; 66, 3 ; 67, 6). Most importantly, after the Queen's death, the Egyptian clergy took courage and, in the person of Archibios, offered Octavian 2,000 talents not to destroy the statues of the Princess (Plutarch, *Life of Antony*, 86, 5). Was that the reaction of a cleric who had been mistreated by his queen?

With awareness of the need to mistrust the clichés, it is easy to understand that Cleopatra had to have a religious policy, and that it formed the backbone of both her domestic policy and diplomacy. The most noticeable characteristic of this strategy, complex as a spider's web, was the extent to which it was applied by the queen in Egypt as well as in Asia and in Europe.

A most religious people

During the first century BC the centuries-old saying by Herodotus was still true, the Egyptians 'were the most religious men'. It suffices to mention Herodotus's own declaration that during a fire the Egyptians were far more worried about saving cats than actually putting out the flames (Herodotus, *History*, II, 66). It may sound amusing, but the following anecdote acquires a deeper significance when, in 59 BC (Cleopatra was ten years old at the time), Diodorus Siculus was eyewitness to an unthinkable scene: 'A Roman…member of a delegation sent from Italy … killed a cat, the crowd ran to his house, and neither the king's representatives

who came to ask for clemency for the foreigner nor the fear of Rome were sufficient to save the unfortunate man's life, even though the cat had been killed by accident' (Diodorus Siculus, 1, 83,8). This episode says a great deal about the intensity and special quality of feeling towards sacred animals on the part of the people whom Cleopatra would be called to govern eight years later.

From the time the Macedonians established themselves in the Egyptian countryside, slowly integrating with the indigenous population, the dominant social group, the one that was most structured and gave structure to others, was the circumscribed world of the temples: the priests and their numerous helpers, their artisans and their farmers controlled and sustained the economy of a country with six million inhabitants, the most populous in the Mediterranean. Without priests, nothing worked. Without them, the officials and the merchants of Alexandria were like fish out of water.

Taking control of Egypt after the death of Alexander, Ptolemy I won over the clergy, especially that of Memphis, which was still the key city. Indeed, the city was called Mekhat-tawy, or the 'scale (or balance) of the two countries' because of its position at the junction of the Delta and the Nile Valley. By that time, the capital of the north, rather than being the balance between Upper and Lower Egypt, seemed more like a centre of equilibrium and of control between the Nile and the Mediterranean. Strabo declared that 'the city is the second' in the country 'after Alexandria with a population where the races have mixed as in Alexandria' (Strabo, XVII, 1, 32). The alliance between the Macedonians and the 'dynasty' of great priests of Ptah at Memphis lasted for 275 years, primarily for social and geographical reasons. For ten generations they supported and crowned one another in turn. Was not the temple of Ptah, god of metals, the country's leading factory for the production of bronze statues, arms and objects made of metals? Did it not hold a considerable amount of land and number of titles granted by the kings? This alliance was to withstand the vicissitudes that afflicted the reigns of fifteen kings of the Lagid dynasty. From the end of the third century BC Memphis backed the power of Alexandria against the revolts under way in the Nile Valley. It was the priests of Memphis who reached an agreement in 196 BC between 'church and state' (that is to say, Ptolemy V, an adolescent boy) recorded in the Rosetta stone.

The Ptolemies are often mentioned for the role they played in constructing and decorating the walls of temples. We are grateful to them for the still-standing temples of Dendera, Edfu, Kom Ombo and Philae. But these consecrated places had another aspect: they were given land and tax benefits, and, of not insignificant importance in an extremely hierarchical world, numerous immunities that established them as places of refuge for farmers overburdened by taxes. Medieval Europe would adapt this tradition in favour of convents and churches, and the modern world has transformed it into a privilege in favour of embassies. These temples and their property foreshadowed the economic and cultural microcosm of the monasteries. Could Cleopatra possibly have ignored such a varied and potentially rich patrimony?

The cult of the sovereign

From the time of Ptolemy II, the deification of the royal family was organized by means of the cult of the sovereigns, who became Synnaoi Theoi, '(the cult of the gods who share the innermost part of the temple)' with the temple's main god. The image of the sovereign, either living or dead, was placed next to that of the god and special priests were appointed to care for it. This gives us some idea of the grip of the royal family, for the most part foreigners, who in this way ensured loyalty on the part of local elites and acceptance on the part of the people.

When Cleopatra was born at the end of 69 BC, she was seen as the daughter of a god, Ptolemy XII 'Neos Dionysos', the new Dionysos. From her earliest years she had the authority of a goddess, the same authority as her brothers and sisters, but, in contrast to the other members of the

Macedonian royal family, it seems that she was able to speak Egyptian (Plutarch, *Life of Antony*, 27, 3, 4.). Even Ptolemy VIII, her great-grandfather who had supported the indigenous population against the Greeks, had not been able to speak the language. Who taught her? A wet nurse (thus learnt by chance)? A priest from Memphis or Hermonthis (for political and religious reasons)? Such questions may not now be answered, but these were the factors that encouraged the princess to weave a web of ties with the priests and to become closer to the indigenous people.

The support of the gods

Cleopatra was born at a time when her dynasty was rocked by events both inside and outside Egypt. Her grandfather Ptolemy IX had to put down a violent rebellion in Upper Egypt. The capital of the south, Thebes, was still a very active religious centre, even if religious sites were no longer being constructed as they once had been. Backed by the clergy of Memphis, Ptolemy's mercenaries sacked the city (Pausanias, I, 9, 3) and it seems as though this act secretly pleased certain members of the population of Memphis. But Ptolemy XII had wanted to take control of the temples of the Nile Valley, at Coptus, Hermonthis, Edfu and Philae, and decorate them at great expense. Shortly after his return from exile, on 16 July 54 BC, the day of the helical rise of Sirius, which heralded the flood, Ptolemy laid at Dendera the first stone of the temple of Hathor, companion of the god Horus.

Looking out to sea from the royal library of Alexandria, Cleopatra and her mentors could not help but contemplate the decline of the empire: in less than150 years Lycia, Crete and some of the Aegean islands, Syria-Coele and, from 74 BC to the west, Cyrenaica, all, one after another, had fallen into the hands of Roman proconsuls. But without a national army, what could Ptolemy XII and his daughters, Berenike IV and then Cleopatra VII, have done? For more than a thousand years Egypt had been deprived of an army corps of prestigious repute – the old divisions of Ra, Amon, Seth and Ptah composed of Egyptians. These had carried out victorious campaigns during the reigns of the pharaohs of the Middle and New Kingdoms, conquering land up to the Euphrates and, in Africa, beyond the first cataracts.

The moment when the priests got the better of the military – with the Twenty-first Dynasty – Egypt placed its defence primarily in the hands of foreigners. After the *shardanes* (one of the Sea People) of the Nineteenth and Twentieth Dynasties, there were the Libyans of the Twenty-second, whose leaders became pharaohs. Then there were the Carians and the Greeks of the Twenty-sixth, Twenty-eighth and Twenty-ninth Dynasties. At other times Egypt fell to whomsoever wanted to take it: the Nubians of the Twenty-fifth, the Persians of the Twenty-seventh and Thirtieth Dynasties, and, finally, the Macedonians of Alexander and the first three Ptolemies. The Egyptian masses were at the mercy of the priests and could only stand by and watch this constant coming and going of rulers, punctuated by sporadic moments of resistance, and in the end they took the side of the last triumphant invader.

All things considered, the world of the temples remained the safest refuge for that living 'god' who was to become Ptolemy XII, player of the flute, the favourite instrument of the goddess Isis. Indeed, he played with such passion that some Romans nicknamed him 'Auletes' (the flute player). Thus what could his daughter Cleopatra have hoped, when, at the age of seventeen, she took the throne with her brother and husband, a boy of ten? Even the flourishing island of Cyprus had been taken from her paternal uncle by the Romans seven years earlier in 58 BC. All she could do was invoke the support of the gods.

Diffusion of Egyptian cults in the Mediterranean

Paradoxically, the cult of Isis continued to spread in the Mediterranean: from the end of the fifth century BC in the port of Piraeus with the cult of Amun, and on Delos, from 230 BC with the cult of Serapis. During the second century BC, she became the favourite goddess of Roman

merchants on their way to the Delian market, whose importance can be compared to that of Victorian Hong Kong. The brutality of Roman imperialism, with its battles, assaults on cities and plunder, increased the flow of the masses of slaves, who were trafficked on Delos. The message of salvation offered by Isis also attracted a certain number of these unfortunate souls who were scattered to the four corners of the Mediterranean. The Egyptian sailors who sailed their ships loaded with grain all the way to Puteoli (modern Pozzuoli) introduced the cult of Isis and Serapis in Campania and then in Rome itself.

The cult's diffusion would eventually modify its strictly Egyptian nature; even Plutarch, in his *Isis and Osiris* noted this phenomenon (already present in the third century BC and even more so during Cleopatra's time). The moralist wrote that he would not have found it strange 'if it were thought that Isis and Osiris were held to be divinities also for us, who are not Egyptian'. He went on to say that 'other men who do not possess either the Nile or the cities of Buto or Memphis, at least would not be deprived of these great divinities' (*Isis*, 66). By that time, sailors from different nations adored Isis and the goddess had taken on a variety of names: Isis Epikoos ('of ready help'), Isis Pelagia, Isis Euploia ('of fortunate sailing'), Isis Pharia, a name that attests to the importance of the link with the Pharos (lighthouse) of Alexandria. Thanks to the sea trade the cult of Isis spread throughout the Mediterranean. However, in the vast majority of cases this religious exportation carried no political ties to the Egyptian crown. It was a form of proselytism that foreshadowed the wanderings of the early Christians. As for Ptolemy XII, it seems that he did not realize the importance of the diffusion of such a cult, Egyptian in origin but soon to be universally accepted in the Mediterranean.

Ptolemy XII and Cleopatra in Italy

All of a sudden in 58 BC, as a result of popular nationalist pressure, Ptolemy XII left Alexandria in haste, travelling to Rhodes, then Athens and then Rome. According to a contemporary Greek inscription, brilliantly interpreted by Wilhelm (1934,1007), the King stayed there with one of his daughters. This daughter was very probably Cleopatra, who was eleven at the time, as her older sister, Berenike, had substituted for her father on the throne of Egypt. And there is all the reason in the world to believe that the daughter the King chose to bring with him was Cleopatra and not Arsinoe, who was still too young for such a journey.

If the Princess did indeed accompany her father, as both Volkmann (1958) and Grant (1972, 15–16) assert, she must have stayed in the vicinity of Italy's largest temple at that time, that of Praeneste (present-day Palestrina) in one of the villas of Pompey, protector of the interests of Ptolemy XII (Dio Cassius 39, 14, 3–4; Cicero, *Pro Rabirio* 3, 6, 8). The sanctuary of Praeneste was a giant building set against Monte Ginestro. Similar to the temple of Hatshepsut in Deir-el-Bahri, its size foreshadowed the majesty of the Vatican. 'Still today, the beauty and antiquity of the sanctuary keep alive the fame of the Praenestine oracle, at least for the vulgar [common] people', wrote one contemporary (Cicero, *De Divinatione*, II, 41). 'But what magistrate', he added cynically, in his habitually elegant manner, 'what person of importance would consult these oracles?' The temple was visited by followers of Fortuna Primigenia, the ancient Italian divinity, most of whose followers were women, although she also attracted travellers, soldiers and sailors. Fortuna was associated with Isis Navigans and her temple included a special place of worship for the Egyptian goddess (Coarelli, 1984). This allows one to suppose that, if Cleopatra stayed in the surrounding area, she must have visited the temple along with her female protectors and guardians.

Thus she had the opportunity to discover a Latin community composed of followers of Isis. Importantly, these followers were not appreciated and accepted by the majority of the

Roman Senate. In 58 BC the Senate ordered the destruction of their statues and altars on the Capitolium. However, immediately afterwards, the cult's Roman followers, who were rather influential, had them rebuilt. It seems that the Senate was split into two camps consisting of followers (a minority) and opponents of Isis. It would be wrong to think that Ptolemy XII could have triggered this series of events, as he reached Rome only towards the end of 58 BC. After the King's departure in 57 BC skirmishes between the two factions continued for another ten years. Even if Cleopatra was still too young to fully understand the importance of such things, these childhood memories had an influence on her.

The ethic of the first century BC differs from ours

When her father was forced to leave Rome, Cleopatra clearly followed him all the way to Ephesus, where she was hosted at the Temple of Artemis, another consecrated international cult, and, as chance would have it, one based on worship of a female divinity. In Egypt the goddess Artemis Eileithyia Lochia was, like Isis, the goddess who watched over births, and for some time the characteristics of the two goddesses had merged. Despite the fact that he was swamped in debt, Ptolemy XII embellished the temple at Ephesus with sumptuous ivory doors. Therein lies a paradoxical aspect of his nature that, today, we may find difficult to understand. This inexorable prince was religious. Yet he ordered the death of his daughter Berenike IV upon his return to Egypt because she had committed the unpardonable crime of usurping the throne in his absence. Indeed, Berenike herself, only three days after a forced marriage, had her husband, Seleukos Kubiosaktos (that is, seller of salted fish) strangled because his manner was offensive to her. And in 40 BC Cleopatra had her youngest sister, Arsinoe, killed. The young woman had been a guest at the Temple of Artemis at Ephesus and had been greeted with the title of queen by the head priest. But, as Plutarch wrote in his *Life of Demetrius* (3,5), was it not true that almost all the Hellenistic Greek dynasties were rife with the murders of children, mothers and wives? 'With regard to the assassination of siblings, it was a well-established habit ... as widely used as were the propositions of Euclid by mathematicians, it was legitimated by the kings, in order to guarantee their security.' Just like a Mafia boss, once in Italy, Ptolemy XII ordered the death of about one hundred delegates from Alexandria because they had contested his request to the Senate that he return to the Egyptian throne. This was the same prince who simultaneously increased the number of acts of piety. He remained faithful and observed the religious rites no matter what, and he was a sacred personage when he participated in such rites.

Due to his role and his birthright, the king was a god by divine right. Divine Ptolemy considered himself as such to the point that he was the first of the dynasty's sovereigns to incorporate within his titles 'New Dionysos', the very title of a god, Theos Neos Dionysos ! All of this seems very surprising and perhaps difficult for us to understand, but the dichotomy between faith and religion on the one hand and violence and depravity on the other is a fairly recent phenomenon, born during the age of Romanticism. An inscription dated 5 December 57 BC bears witness to continued veneration for Ptolemy: the doors of the temple of Edfu, in bronze-covered cedar wood, were offered on behalf of the King, even when he was still in exile at Ephesus. A year and a half after his flight, the clerics of Upper Egypt continued to consider him a sovereign, at least from a religious point of view.

Cleopatra's interventions in animal cults

The very year of Ptolemy XII's death, which had been announced or accompanied by a partial solar eclipse, this perfectly oiled machine continued to work. A good pupil of her father, Cleopatra celebrated the rites. Fifteen days after the terrible eclipse, the queen took part in the presentation of the new Buchis, the sacred bull of Hermonthis. 'Having reached Thebes,

the place of his coronation, he was crowned by the king himself (Ptolemy XIII) in the first year of the new reign, Pnamenoth 19 (22 March 51 BC)', as is recorded on a stele from the Bucheum, today in Copenhagen. 'The queen (Cleopatra), Lady of the Two Lands, the queen who loves her father, leads him on to the ship of Amun surrounded by the king's boats. All of the inhabitants of Thebes and Hermonthis along with the priests worshipped the divine animal. As for the queen, everyone was able to see her.' Such testimony, especially the last part, cannot be put down to rhetorical adulation, since the stele is dated from the year 29 of the Bull, in the reign of Augustus! This proves how intense was the memory of Cleopatra in the minds of local people even after many years had passed. The reader of Shakespeare will note the many similarities between this ceremony, specifically Egyptian and taking place in a river setting – elements which both Plutarch and Shakespeare were unaware of – and the meeting, also in a river setting, between Antony and Cleopatra along the Cydnus at Tarsus ten years later. We shall return to this previously unconsidered coincidence later.

The interest in zoolatry (animal worship) was not an isolated instance on Cleopatra's part. In 49 BC, the third year of her reign, upon the death of another bull, Apis, son of the cow Ta-nt-Bastet, – this time at Memphis – it was necessary to observe the rites demanded by the cult. The stele of Harmachis, now in the Louvre, describes the personal contribution made by the queen: 412 silver coins, even though the queen preferred to use bronze coins inside Egypt. These funds allowed the setting up of a banquet table filled with votive offerings and the provision of daily rations: a measure of wine, a measure of milk and twelve loaves of bread for the clergy, and twenty-seven measures of oil for the other acolytes. The donation also included 50 measures of beans and 40 measures of another type of oil as well as payment for meat. Between 51 and 49 BC the queen unquestionably made other donations and carried out other rites. It is thought that the very famous zodiac of Dendera, now in the Louvre, depicts the configuration of the stars that would have been in the sky in August 50 BC. It is thus probable that Cleopatra took part in the inauguration of the massive carved stone in the temple commissioned by her father. It is also likely that she was present at the inauguration of the chapels of Osiris on 26 Choiak (28 December) in 47 BC.

Cleopatra's geo-political vision widens

So long as Cleopatra ruled a small state restricted to traditional borders, the fulcrum of which was the Nile, her objective was to reinforce her ties with the clergy. Lucan (*Pharsalia*, 8, 475–477) tells us that a member of the queen's private group of counsellors was a priest, Acoreus, from Memphis. But the arrival of Julius Caesar in Egypt during the summer of 47 BC forced the queen to expand her spiritual and political horizons. In accordance with the tradition of the pharaohs, as sculpted on the walls of the Mammisi (the temple of birth) of Hermonthis, the queen was 'visited by the holy spirit' (as her emulator, the Madonna, would be later) or the god Amun, who appeared to her in the guise of the Roman.

Her visit to Italy, by Caesar's invitation, from 46 BC until the Dictator's assassination in 44 BC, brought about a change in her; her religious policy became linked to a strategic vision of the world. She boarded a ship in Alexandria that was headed for Pozzuoli. On the way to Rome she possibly stopped at the sanctuary of Fortuna Primigenia at Preneste, to thank the divinity linked to Isis for having given her Caesar's son.

From V. Tran Tam Tinh to Robert Turcan, there have been many who have listed the travails and changes of fortune of the Roman followers of Isis during the first century BC, but no one has considered this rather convoluted situation in the context of Cleopatra's stay in Rome. Between Ptolemy XII's visit to Italy at the end of 58 BC and the queen's arrival in 46 BC,

there was a conflict between the Roman followers of Isis, who had become quite powerful and could hold their own against a majority of members of the Senate who were hostile to them. A brief chronological list of events is provided below.

58 BC: The Senate orders that all statues and altars honouring Isis located on the Capitolium be destroyed.

The statues are replaced, the reconstruction of the altars begins.

53 BC: The Senate orders the destruction of all private chapels dedicated to Isis.

50 BC: A new decree orders the destruction of monuments dedicated to Isis.

The resistance hardens: the consul Publius Aemilius, armed with an axe, is forced to intervene and break down the door of one of the places of worship (Valerius Maximus, I, 3,4). This detail suggests that even the joiners and custodians feared Isis and that her followers had grown numerous. How many of them were there? And how many followers were there of Dionysos, the Hellenistic consort of Isis, even though in 50 BC the worshippers of Dionysos had not yet received permission to practise their faith openly?

48 BC: Orders were once again given to destroy the protective walls surrounding the rebuilt sanctuaries on the Capitolium.

46 BC: Arrival of the queen. She was probably present at the inauguration of the Temple of Venus built upon Caesar's orders. Her statue was placed inside, with the Dictator's approval. In Cleopatra's mind, this statue must have represented the establishment of her royal cult, linked to that of Venus.

During his stay in Egypt in mid-48–47 BC Caesar was inspired by the religious policy of the Lagid dynasty and decided to create a new image for himself. Although his stay with the queen along the Nile was brief, it served to show him how important was the cult of the sovereigns, dead or alive. This trip to Egypt had an enormous impact on Caesar, as it had on Alexander and as it would have on Napoleon Bonaparte.

Before meeting the queen in Egypt, Caesar already had some ideas on the subject, as can be seen from the speech he made in 68 BC during the funeral rites performed for his aunt Julia: 'My aunt, on the side of my mother, descended from kings, and, on her father's side, descended from the immortal gods... the Julii are the descendants of Venus and we are a branch of this family. Thus the sacred nature of kings is united … with the sacredness of the gods, on whom the kings also depend' (Plutarch, *Life of Caesar*, 5). The claim is clear. But how was he to become another Alexander the Great? To move from being a rebellious, though victorious general to sovereign by means of a dictatorship was not enough. The temptation offered by the assumption of divine status was not new to autocrats – from Sulla to Pompey – but none of them had dared so much. The birth of a son by Cleopatra – a future king of Egypt, but in Rome nothing but an illegitimate child – urgently required that he find a new strategy: in 44 BC Caesar was fifty-six years old, and, according to Cicero, upon his return from Egypt he had already assumed a 'divine' comportment.

The placing of a statue of Cleopatra in the new temple dedicated to Venus was the first step, part of a bold theocratic move never before witnessed by the Roman Republic, which was hostile to the idea of a monarchy and contemptuous of Eastern rulers, who were often seen more as hostages than divine beings while they were in Rome. A second step, taken at the same time, was the introduction of a statue of Caesar in the Temple of Quirinus, recently restructured upon the orders of the dictator with the inscription 'to the unvanquished god', a direct transposition in Latin of the dedication inscribed on the statue of Alexander the Great in Athens (Dio Cassius, XLIII, 45 and 45.3 and Hyperides, *Or.* I, 32.3). The official recognition of the cult of Dionysos – he too was related to Isis with the same title as Osiris and Serapis – shortly after the queen's arrival suggests that this act may have been a third step. In relation to

this last move, Cleopatra was preparing in Italy to present her future consort (Caesar) in the role of her deceased father, Ptolemy XII, Theos Neos Dionysos. The assassination of the Dictator foiled these plans.

The celebration of the Lupercalia and 'rumours'

One month before the assassination – 15 February 44 BC – the feast of Lupercalia was celebrated. It is likely that Cleopatra made her contribution, even if she was not present and was not mentioned. Everyone has heard of Plutarch's text, derived from the Philippics (Cicero, *Second Philippics*, XXXIV, 85–86 and *Third Philippics*, V, 12).

> It was the celebration of the feast of Lycaia, which the Romans called Lupercalia. Caesar was dressed as a victor and seated in the gallery in the Forum watching the runners. And it is true that there were many young noblemen and also magistrates who were covered in ointments and, as if in a game, struck the people that they met with leather whips still covered in skins. Mark Antony was one of the runners. Without pausing to observe the norms of Roman tradition, he decided to decorate a diadem with a laurel crown. Then, leaping on the tribune where he had been pushed by the other participants, he wanted to place the diadem on the Dictator's head, as if to say that royal power belonged to Caesar by right. But Caesar repeated his refusal...Pleased by the refusal, the crowd applauded. However, Antony renewed the offer and Caesar again refused. This game of to and fro continued for some time. While Antony sought to crown Caesar almost by force, he was egged on by the applause of a small group of friends. When Caesar refused the crown, all those present clapped their hands and cheered. It was truly a paradox to see men who are essentially slaves, as are the subjects of a king, reject the royal title, because it symbolized their loss of freedom. Finally, completely exasperated, Caesar got up, took off his mantle and shouted that he was ready to have his throat slit if someone wanted to do it. The crown was subsequently placed on one of his statues, but the Tribune (or people's champions) removed it and the people showed their approval by applauding the Tribunes. Caesar dismissed them. (Plutarch, *Life of Antony*, 12)

In the *Second Philippics* (XXXI, 85) Cicero asks a poisonous question: 'Where did this diadem come from?' and he adds that 'it was a premeditated crime prepared in advance'. It all seemed to be a sort of dress rehearsal ... which flopped. In the famous ceremony of the Donations, in 34 BC in Alexandria, during which Antony handed out new lands to the queen's heirs (three of whom were his own children), the same thing that had occurred during the feast of Lupercalia happened again, but this time with greater success. Certainly, at the Forum in Rome Cleopatra had not been there to follow Caesar, but at least the diadem of the Hellenistic kings had been present. Caesar's disappointment had been so great that this cold-blooded man lost control.

Having thus failed, Caesar prepared a set of bills to be placed before the Senate designed to allow him to be king outside Italy, to marry a second time outside of Italy (bigamously), to have children with a foreign woman (thus opening up the way to recognition of his son by Cleopatra), and to create a second capital for the new empire (Alexandria, thus anticipating the founding of Constantinople by 374 years). The demise of this programme came with his assassination. Octavian, upon becoming Augustus, censored all of the relevant testimonies in order to eliminate every single trace of these proposed bills, which clearly bore the queen's fingerprints.

Cleopatra and Caesarion alone in Egypt

This is not the place to dwell either on the events that followed the death of Julius Caesar and the queen's departure about a month later, or on the death throes of the Roman Republic. Between 44 and 41 BC (when Cleopatra once again met Mark Antony) the queen tried to maintain a balance in her dealings with the various factions engaged in civil war. Back in

Fig. 3.1 Hermonthis: the Mammisi
(temple of birth) dedicated to Caesarion and Cleopatra.
(Photo by Francis Frith, 1857.)

Alexandria the queen did everything she could to impose the presence of her son's assassinated father on her people. The parallel between the assassination of Caesar and that of Osiris, father of Horus, is clear. Cleopatra dedicated a huge temple to him – the Caesareum – along the coast of the present-day Eastern port. Philo of Alexandria expressed his admiration, using terms unusual for a monotheist Jew: 'No such sanctuary exists anywhere else... situated on an artificial hill ... a temple of dimensions unknown in any other place, with votive offerings, including paintings and statues in gold and silver ... embellished with porticoes, libraries, rooms, gardens, portals and large open courtyards' (Philo of Alexandria, *Legatio ad Gaium*, 15). Even if this description dates to the time of Caligula, it gives us an idea of the overall imposing architecture desired by the queen. All of this was confirmed during the excavations carried out by Neroutsos Bey in 1874, which were not concluded due to opposition of the then landowners. The archaeologist described the walls of the structure as having a thickness of 3.5 and 2.5 metres. The queen had wanted to outshine the nearby and imposing Serapeum, because nothing was too beautiful or great enough for the father of Caesarion.

In Hermonthis, Cleopatra had a temple built in a purely Egyptian style, as can be seen in the photograph taken by the Englishman Francis Frith in 1857 (fig. 3.1), four years before it was destroyed by the Khedive Ismael, who used the stones to build a sugar refinery. The engravings made by travellers such as the scholar Lepsius of this temple of birth (Mammisi), dedicated to Caesarion and his mother, give an idea of the traditional themes depicted in some of the bas-reliefs.

More than ever, Cleopatra depended on the clergy. Shortly after her return, the queen introduced a new religious female figure, the 'bride of Ptah', and she assigned the role to Tneferos, who played the *sistrum* (rattle) in the cult of Ptah and was in real life the bride of the Great Priest. The idea was inspired by the very ancient Theban role of 'the bride of Amun'. In 39 BC Cleopatra nominated the very young Petobastis-Imouthes, nephew of Tneferos, who succeeded both father and uncle as great priest and prophet, even though the boy was only seven years old!

Flavius Josephus reveals that during this two-year period (41–43 BC) in which the level of the Nile ran low (resulting in a food shortage), the queen 'refused to distribute the necessary grain to the Jews' (Flavius Josephus, *Against Apion*, II, 60). One can imagine that Cleopatra did not appreciate the neutral or passive attitude on the part of monotheistic Jews regarding her desire to be worshipped as the incarnation of Isis. Yet, considering the fact that Josephus was not particularly fond of the queen and that the Delta Jews had been very supportive of Caesar and Cleopatra during the war against the Alexandrians, this accusation needs to be confirmed.

In Thebes, Kallimachos, head of a family of high level officials, was able to find solutions to the problems arising from the famine. Thus, in addition to the donation of statues representing him, the city of Thebes and the priests of Amun Ra also honoured him with a stele: the collaboration between church and state allowed the rediscovery of 'an absolute peace' (Bernard, 1992, no. 46).

The meeting along the banks of the River Cydnus

After the Battle of Philippi in 41 BC, Mark Antony established himself as the leader of the eastern Roman Empire. Leaving Greece, he followed a route that might be described as something of a Grand Tour along the present-day coast of Turkey. His objectives were to collect money, (enrich his followers) and prepare for the expedition to be sent from Rome against Persia, a project that Caesar had previously planned in 44 BC. In the Asiatic cities Antony was greeted as a new Dionysos. He asked the queen of Egypt to met him in Tarsus and Cleopatra decided to transform what was essentially a financial and political meeting into a religious event.

If we read Plutarch's description and keep in mind Egyptian practices, we may understand that the queen arrived in a sort of vessel turned tabernacle. The River Cydnus took the place of the Nile and Tarsus that of Memphis and Thebes. The queen appeared as Aphrodite–Isis coming to meet her consort, Dionysos. Plutarch tells us that Cleopatra 'was under a canopy embroidered in gold and presented herself as painters often depicted Aphrodite'. Her most beautiful women were dressed to represent the Nereids and Graces. The influence of Augustus' propaganda is such that the reader having a traditional Judaeo-Christian background might well imagine a bordello Venus on her to meet a future client, Mark Antony. 'The ship had a golden stern, crimson sails and silver oars. Numerous perfumes were disbursed on both banks of the river...and the ship was followed by many people on both banks' (Plutarch, *Life of Antony*, 26, 1–4), as had happened many times along the Nile. In 76 BC the queen's father had visited the high priest of Ptah in Memphis and an ancient text tells us that 'he went back and forth and up and down in order to be admired on both sides of the river' (Lichtheim, 1980, 134–5). Cleopatra's ship sailed to the 'sound of a flute', which had been Ptolemy XII's favourite instrument as well as that of followers of Isis. There were numerous lights. Plutarch wrote a seven-line paragraph to describe the system of illumination, again to be ascribed to the tradition of the cult of Isis (Plutarch, *Life of Antony*, 26,7).

Plutarch comments: 'The news spread everywhere that Aphrodite, for the good and happiness of Asia, met Dionysos at a festive reception' (Plutarch, *Life of Antony,* 26, 5). Had Mark Antony been informed beforehand of this staged performance or hadn't he? At that time, the

Fig. 3.2 The south wall of the Temple of Hathor
at Dendera: on the right, Caesarion and Cleopatra
make offerings to the gods.

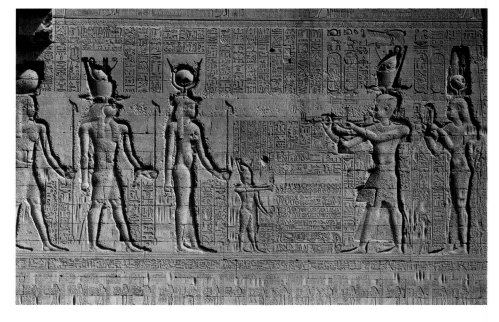

Fig. 3.3 A giant falcon protects a statue of a prince,
Caesarion, at the gate to the Temple of Horus, Edfu.
(Photo Coen / Guy Weill Goudchaux.)

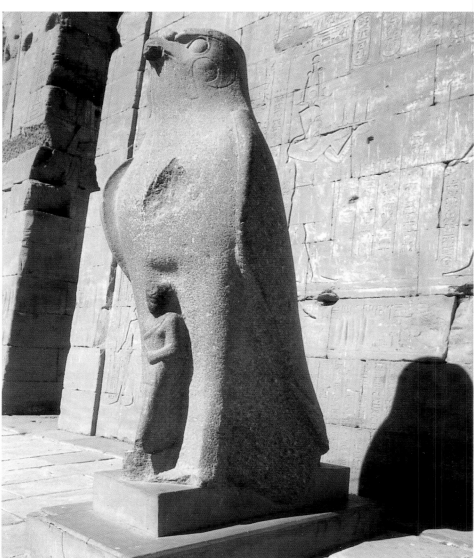

two rulers had known one another for fourteen years: it couldn't have been a complete surprise. If the two protagonists grew even closer, it was certainly not due to a staged event of this sort. The show along the river had also been planned in order to satisfy the mystical imagination of the Eastern crowds in an area that had been conquered by Alexander the Great, follower of Dionysos.

The promotion of Caesarion and the queen's other children

The births of her other children did not stop the Queen from promoting the heir to the Egyptian throne, Caesarion. Images of and inscriptions dedicated to him multiplied. Almost all of these works were eventually destroyed, but fortunately we still have the very famous wall with bas-reliefs from the Temple of Hathor at Dendera showing the queen and Caesarion in profile making offerings to the gods in a purely Egyptian manner (fig. 3.2). At the entrance to the temple of Edfu two giant stone falcons protect a young prince, his face partially destroyed by weathering (fig. 3.3). These works surely depict Caesarion between the ages of eight and eleven. We must go all the way back to the Nineteenth Dynasty to find another work so impressive in size (Rameses II as a boy with Horus).

In 34 BC, when the queen received new territories from Mark Antony, the couple organized a sumptuous feast in Alexandria to celebrate Antony's victory over the king of Armenia, who was clad in golden chains and exhibited to the crowd. This celebration, which is known as 'the ceremony of the Donations', drew on both the so-called 'Ptolemaic' traditional religious celebrations linked to the cult of the sovereigns and on the Roman triumph. It was the first time that such an event was celebrated outside Rome and this fact later angered many Romans. Cleopatra was dressed as Isis, probably completely in black, and received gifts of various territories from Antony for their children. The young Selene was given the rich land of Cyrenaica, and her twin, Alexander Helios, was given the newly conquered Armenia. The description of the ceremony that Plutarch provides (*Life of Antony*, 54, 6–9) has led me to recognize the image of Alexander Helios as a prince of Armenia in two bronze statues now in American museums (cat. no. 270 and another in the Walters Gallery of Art, Baltimore). These may have been commissioned for the procession at the time of the ceremony, conceived as an expression of Romano-Egyptian imperialism linked to the cult of the sovereigns.

The watershed of Actium

On the threshold of war with Octavian, the queen sailed towards Greece with her 200 battleships. From Ephesus, by that time familiar to her, she went to Samos in the spring of 32 BC. She and Antony took part in a celebration where the traditions, theatre and ceremonies of the cult of Dionysos all met and mingled accompanied 'by the sound of flutes and the lyre', as Plutarch wrote. He goes on to describe the scene: 'Every city sent an ox for the sacrifice and the kings (allies) tried to outdo one another with receptions and gifts' (Plutarch, *Life of Antony,* 56, 8 and 9). The kings and princes whom he mentions came from the regions situated between Syria, Palus-Meotis, Armenia and Illyria (*Life of Antony*, 56,7). They did not have a common flag and Mark Antony did not possess either the charisma of Alexander or the Roman soldiers of Caesar. But the Greek language – at least in the form of the dramas of Euripides and Sophocles – and the evocation of Dionysos, of whom the Roman general, now dressed as a Greek, was the incarnation, proved enough to unite the kings in support of him and his divine consort, Cleopatra/Isis/Aphrodite. The project failed due to the numerous defections that occurred before the battle at Actium took place: Cleopatra's divinity was never accepted by some of the kings nor by many of Antony's Roman companions.

When she arrived in Athens in the summer of 32 BC, Cleopatra had her statue, or rather that of Isis, erected on the Acropolis. She repeated the pretensions to divinity with accompanying

propaganda already seen in the Temple of Venus in Rome. But she derived no benefits from an attempt to establish her own cult. Dio Cassius, often pro-Octavian, wrote that the queen, upon her return to Alexandria with her fleet after Actium, 'had decorated the bows with garlands as if she had actually won and flute players accompanied her with songs of triumph' (Dio Cassius, 51,4). Can we really believe that the entire fleet would have accepted such a charade? It is more reasonable to suppose that this scene was one habitually played out for the queen, in her role as Isis Navigans, every time she entered the port.

The death of Cleopatra

As a result of the misinformation disseminated by Augustus, the queen's death on 17 mesore (August) 30 BC is shrouded in mystery. But let's stop for a moment to consider the symbolic, popular interpretation that Spiegelberg (1925) gave Cleopatra's death, maintaining that it had been a religious act, that is to say the bite of the serpent, due to its sacred nature and power, would have 'rendered the queen divine'. In 1961 J.G. Griffiths contested this hypothesis and, indeed, it is not to be considered valid. Let us not forget that Cleopatra was *Thea* (divine) from birth – she was the daughter of the king – a new Isis–Aphrodite! Perhaps she was assassinated in the manner reserved for friends of Stalin, or perhaps she chose to commit suicide as her uncle, the king of Cyprus, had done in 58 BC when he was dethroned and stripped by the Romans of his treasures. The queen was mummified in accordance with the practice of the royal family followed since the time of Ptolemy V (the four previous kings had been cremated).

After the queen's death, Plutarch wrote a rather sybilline phrase *en passant*, which I have decoded at length. In short: 'The statues of Antony were torn down but those of Cleopatra remained standing, a "friend" [*philos*] of the queen, Archibios, had offered Caesar [Octavian] two thousand talents so that her statues did not experience the same fate as those of Antony' (Plutarch, *Life of Antony*, 86,9). Archibios is the Greek name of a 'Hellenized' Egyptian, Hor-em-akh-byt. Philos ('friend') is a courtly title allowing the bearer to carry out high-level functions. Two thousand talents: the amount offered could have maintained Octavian's army for an entire year: J.M. Carter and M. Grant calculated that the cost of a legion during peace time amounted to forty or fifty talents a year. The offer was astronomical! Had Archibios personally been the owner of such a fortune, in a best-case scenario he would have immediately been deprived of it by Octavian, and in the worst of cases he would have been killed for it. Thus the talents must have come from the temples' treasuries. The fact that the queen's death provoked such financial sacrifice shows us just how much she was venerated. The agreement between Archibios and Octavian ensured the continuation of the Egyptian religious tradition. Given that Octavian did not destroy her statues, he became, in the eyes of the priests, Cleopatra's natural successor.

Epilogue

Our chronological review of the world of temples and tabernacle-ships of a patriotic queen – in a papyrus dated 36/35 BC, she is called 'Philopatris' (Brashear, 1980, no. 2376) – who was worried about the future of her first-born has taken us some distance away from the traditional male chauvinistic and Eurocentric view of Cleopatra. She was the companion of a Caesar who, in private, made no bones about his atheism, while in public he sought a divine status that Egyptian queens had enjoyed by right for millennia. They also had a common political and religious model, Alexander. Caesar died too soon for us to be able to judge the impact of his presence as a new Dionysos in the orient.

The meeting between Cleopatra – pharaoh and divinity – and other Romans had a disastrous impact. She could not understand them and they could not understand her. She was unable to win over the Roman followers of Isis, as they did not see the need for a queen to act

as intermediary between them and the goddess. Outside Egypt the cult had freed itself from the old traditions of the Egyptian state. The same schism would happen centuries later between the Vatican and the Protestants. Isis could not be transformed into an imperialistic instrument. Cleopatra was more at home along the Nile, the source of her inspiration when she met Antony on the banks of the River Cydnus. A revolt in the Nile Valley, provoked by the priests, broke out a few months after the queen's death and was put down by the legions. Caesarion had already been assassinated. What remains of the fable of the 'sleeping beauty ?' In 1937 Griffith published a demotic script dating back to AD 373, 403 years after the queen's death: 'I covered the figure of Cleopatra with gold', Petesenoufe, scribe of a book on Isis, proudly states. Even Quaegebeur thought that the figure referred to was Cleopatra VII.

In the Christian world the image of a Jew, the Madonna, was most successful in places where the cult of Isis had been strong. It is enough to recall the churches consecrated to the Black Madonna, the colour of the goddess's dress. *Isis fluctuat nec mergitur.*

Cleopatra's images:
reflections of reality

SUSAN WALKER

The earliest dated image to survive of Cleopatra, remarkably, represents her as a man (cat. no. 154). Though Shakespeare's Octavius was to disparage Antony as

> … not more man-like
> Than Cleopatra; nor the queen of Ptolemy
> More womanly than he (*Antony and Cleopatra, I.iv.5–7*)

this unexpected vision of Cleopatra most probably results from the hasty adaptation of a record of offerings to Isis originally prepared on behalf of her father, Ptolemy XII Auletes ('the flute-player'). Only the Greek text was amended, and Cleopatra was portrayed in relief as a male pharaoh. The limestone stele was dedicated on Cleopatra's behalf on 2 July 51 BC, the year of her accession to the throne at the age of seventeen.

Portraits of Cleopatra in Hellenistic Greek style

A more conventional image of Cleopatra as queen appears on a silver drachm minted in Alexandria in 47/46 BC (cat. no. 178). Cleopatra is here portrayed as an attractive young woman, with a lively, almost smiling expression and large eyes, a strong hooked nose and prominent chin. Her hair is drawn back from the face in the conventional braids termed by modern scholars *Melonenfrisur* (melon hairstyle, after the resemblance of the divided braids to the segments of a melon). Some curls escape behind the ears and a small knot of hair appears to have been coiled above the brow. The braids are confined beneath a broad diadem, and bound into a bun at the nape of the neck.

The queen's portrait also appears on the bronze coinage of Alexandria, for which no more precise dates than her reign (51–30 BC) may be offered. On these larger coins the portrait is more mature and stately than the youthful version on the tiny drachm. Though the portrait is extended below the neck, little is revealed of the queen's dress, which appears to comprise a modest tunic and mantle, sometimes shown with a simple necklace, perhaps of pearls. This image was also used for a fine silver tetradrachm minted in the free city of Ascalon as early as 50/49 BC, and again in 39/38 BC (cat. nos 219–220), most probably in gratitude for the queen's assistance in protecting the status of the city in periods of local conflict. Maturity and regal

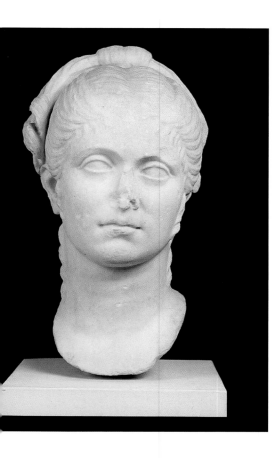

Fig. 4.1 Portrait of a woman resembling Cleopatra, perhaps a queen of Pontus in Asia Minor (Rome, Palazzo Massimo 52875).

bearing were therefore features of some of the earliest Greek-style portraits of Cleopatra; this style of portrait is known to have circulated for at least a decade, but did not exclude a more youthful image, as seen on the Alexandrian tetradrachm.

Visually akin to the coin portraits are two marble portrait heads, both of which can now be associated with findspots near Rome (see pp. 203–7 and cat. nos 196, 198). The sculptured portraits have lost their torsos and offer no sense of Cleopatra's dress and jewellery. Both are carved in Greek marble from Paros, much used to represent flesh in Greek and Roman portraits. These sculptures also suggest Cleopatra's youth, and could date from the early years of her reign, or at least present a portrait evocative of that period. A similar image appears on an engraved glass gem, now very worn, in the collections of the British Museum (cat. no. 153); this could have been used as a seal, indicating allegiance to Cleopatra on the part of an official or a loyal individual. In all these portraits, whatever the medium, Cleopatra presented herself, as might reasonably be expected, as a Hellenistic Greek queen. The gem, however, is remarkable in combining a Greek image with the Egyptian royal symbol of the three uraei (cobras), set atop the queen's head (see p. 154). The evidence of the sculptures shows that Cleopatra was seen in Greek style at Rome, where indeed the marble heads could have been the work of artists from Greece or Alexandria. Both works are likely to have come from the sites of Roman villas located south of Rome. They might even have been occasioned by Cleopatra's extended stay in Rome as Caesar's guest from 46 to 44 BC.

Contemporary portraits in Cleopatra's style

Several portrait heads representing women in a style similar to Cleopatra and with some connection to Rome have survived. In the British Museum is a portrait of a woman carved in Italian travertine (cat. no. 210), acquired in Rome from the collector and dealer Alessandro Castellani. This head has often been identified as Cleopatra, but it lacks the royal diadem, and the shape of the face differs from the two diademed portraits. The head could represent a member of Cleopatra's court, or simply a contemporary who imitated her appearance.

In the collections of the Palazzo Massimo in Rome is a more than life-sized unprovenanced marble head, with long locks of hair tumbling from the crown (fig. 4.1). Its scale suggests a royal subject, and the style of the portrait is Greek. Comparison with a portrait on an engraved gem now in Paris suggests that it might represent a queen of Pontus in north-west Asia Minor.

Among the sculptures from the collections of the Musei Capitolini now exhibited at Montemartini is a marble portrait found built into a gate at the Villa Doria Pamphili (cat. no. 212). This head was finished with added pieces of stone or stucco, now missing; the face is very similar to that of Cleopatra, but again lacks the royal diadem. On the crown of the head extensive traces of the *Melonenfrisur* survive, along with what may be part of a *nodus*, or roll of hair above the brow. In front of the ear is a large curl, not unlike a smaller curled lock of hair appearing on a later coin portrait of Cleopatra minted in the eastern Mediterranean (cat. nos 221–222).

In the same collection is a full-length private funerary portrait of a woman with her young daughter, who sports Cleopatra-style hair (Rome, Musei Capitolini, Centro Montemartini no. 2176).

Discovered on the island of Delos, famous for its community of Roman entrepreneurs, is a remarkable portrait of a woman with a hairstyle like Cleopatra's, a pronounced hooked nose and projecting cheekbones, incongruously combined with Venus rings, representing fat on the neck (fig. 4.2). Though a proposal to identify this head as Cleopatra has not won wide acceptance, it does resemble the portraits on coins from Ascalon minted as early as 50–49 BC (see p. 211), which show the eighteen-year-old queen with a fierce countenance combined with Venus rings (cat. no. 219, fig. 4.3). It is also very close to the British Museum's head

Fig. 4.2 Head of a woman resembling Cleopatra, found in the House of the Diadumenos, Delos (Archaeological Museum, Delos A4196 [DAI Athen I.N. 70/989]).

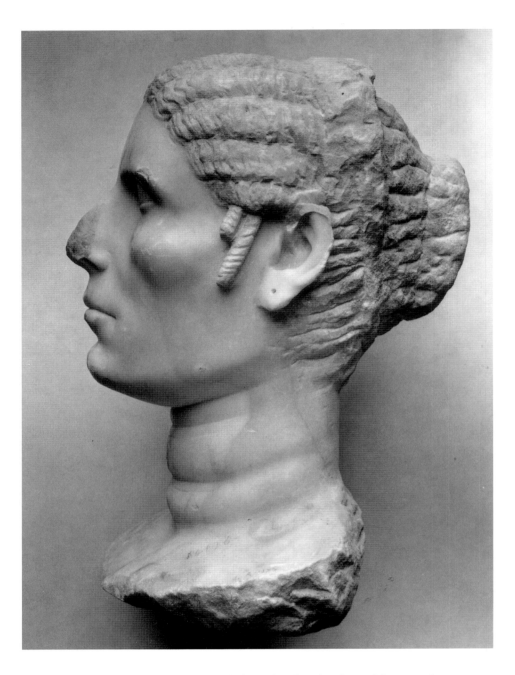

Fig. 4.3 Silver tetradrachm of Ascalon with portrait of Cleopatra (cat. no. 219).

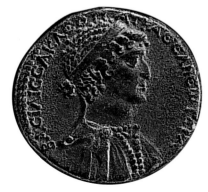

(above and cat. no. 210), and has recently been dated to the close of the second century BC. Neither head bears any trace of a *nodus*.

The larger-than-life head in the Palazzo Massimo indicates that Cleopatra's style could also have been used by other contemporary royal subjects. As a royal style it no doubt proved attractive to private individuals, whose aspirations might have found some resonance in Caesarian Rome, where the dictator Caesar's portrait was said to have been used in kingly fashion. The strong echoes of Cleopatra may reflect a public interest in the queen occasioned by her prolonged stay in Rome as Caesar's mistress, the mother of his son, and a guest in one of his villas.

An Egyptian queen in Rome

Another distinctive image from Rome (cat. no. 194) offers no scope to would-be imitators. This head, like cat. nos 196 and 198, is carved in Parian marble, but in a fashion that speaks strongly (the more so for the exceptional quality of the workmanship) of Alexandria. The

subject, long identified as a Ptolemaic queen, appears in an Egyptian vulture headdress and wig, a sign of divine royal status. The inlaid eyes are now lost from the marble sockets. In the headdress are cuttings for the head of the vulture, and for a crown, these elements also now missing. This head has none of the naturalism of the portraits described above; the only features that suggest an identity as Cleopatra VII are the shape of the face and the evident youth of the subject. Indeed, the portrait has been regarded by many scholars as representing a queen of the second century BC, but it does not compare closely with the surviving mature, even masculine images of queens Cleopatra II and III (d. 116/115 BC and 101 BC respectively: see cat. nos 25, 26). The reason for the Egyptian style of the Rome head lies in the context: the portrait was recovered from the wall of a church in the Via Labicana, Rome, very close to a major sanctuary of Isis, with which it was almost certainly associated. Though different in concept from the portraits found to the south of Rome, this youthful head could also be associated with the early years of Cleopatra's reign. A sense of the appearance of the whole figure is offered by a representation of Cleopatra incised in the wall of the Temple of Hathor at Dendera in Egypt (fig. 3.2). Here Cleopatra wears a vulture headdress and cobra crown. She stands behind her son Caesarion, both offering incense to the deities of the province.

Cleopatra's later portraits

After Caesar's assassination in March 44 BC Cleopatra hastily returned to Alexandria with Caesarion, widely regarded as Caesar's child though not the beneficiary of his will, which favoured his great-nephew Octavian. Famine in Egypt fuelled the political instability that followed, before Cleopatra's legendary meeting with Antony at Tarsus in 42 BC, and the subsequent blow of Antony's politically advantageous marriage to Octavian's sister Octavia in 40 BC, following the Treaty of Brundisium. But Antony was to desert Octavia for Cleopatra, having already fathered the twins Alexander Helios and Cleopatra Selene (b. 40 BC); another son, Ptolemaios, was born in 36 BC. Coins were issued (denarii in Alexandria and tetradrachms elsewhere in the East) with portraits of Antony and Cleopatra celebrating the couple's union (nos 221–222). The images are unattractively 'realistic', the noses, eyes and chins exaggerated. Cleopatra's *Melonenfrisur* was more tightly confined, the diadem thinner, the bun greatly reduced and the curls around the face looser and more prominent. Her clothing became more elaborate, the décolletage of her tunic edged with pearls.

The coin portraits of the 30s BC find some affinity with a marble head of a veiled woman from Cherchel, Algeria (cat. no. 262), who is often identified as Cleopatra or her daughter Cleopatra Selene, who after her mother's downfall was married to Juba II, the pro-Roman king of Numidia. A mass of curls appears in front of the veil. The nose is strongly hooked, the jaw and chin prominent. This style of portrait is often termed 'Roman' by scholars who see in it an interest in *verism*, the republican Roman fashion for recording in almost documentary style all personal features, however unflattering. It is assumed that the change from royal Greek to veristic Roman style was mediated through Antony, described by his biographer Plutarch as Herculean in appearance, with well-grown beard, broad forehead and aquiline nose. It is apparent that Cleopatra and Antony were made to resemble each other in their coin portraits. But why should they wish to adopt a style of portrait associated with the noble families of the Roman republic? Such a move would have run counter to their political ambition to revive the Ptolemaic empire within a context of Roman control of the eastern Mediterranean.

Indeed the features resemble not so much Roman veristic portraiture of the late republican period as the image of Cleopatra's father, Ptolemy XII Auletes (ruled 80–58 BC and 55–51 BC), a model more suited to Antony and Cleopatra's political agenda. The link with Auletes raises interesting questions about realism in first-century-BC portraiture. The currents of influence

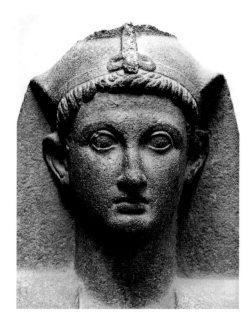

Fig. 4.4 Granite head from a statue of Ptolemy V
(Cairo, Deutsches Archäologisches Institut).
(Photo Dieter Johannes.)

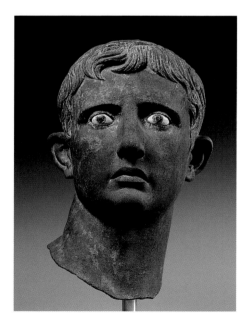

Fig. 4.5 Bronze head from a statue of Augustus
(cat. no. 323).

are complex: Ptolemy XII himself was dependent on Rome for his throne, principally through the agency of Pompey the Great, who had given him refuge at Rome when he was forced to flee Alexandria in 58 BC. Pompey combined in his portraits a homely Roman face with a hairstyle recalling that of Alexander; like Alexander, he commanded huge tracts of land in the East, and was able to appoint kings and create provinces of Rome. Both men were called 'the Great' by those anxious to appease them. It is possible, then, that through his dependency on the known world's most powerful man, Ptolemy XII adopted elements of Roman style for his images. However, signs of individuality had appeared much earlier in Ptolemaic royal portraiture, and were even combined with traditional Egyptian features. As early as the reign of Ptolemy V (205–180 BC), the monarch's hair was shown at the front of the *nemes* (fig. 4.4), a cloth headdress, in mortals a sign of royalty. Indeed, the portraits of Ptolemy V as pharaoh have been confused with those of Augustus (cat. no. 323, fig. 4.5), and it may even be the case that the first dynasty of Roman emperors drew their distinctive hairstyle from Ptolemaic sources. Augustus's consort Livia apparently imitated the Greek portraits of Arsinoe II (cat. no. 8, figs 4.6, 4.7), while Cleopatra herself used the style and attributes of Arsinoe II for her Egyptian portraits (pp. 152–4).

Nostalgia and survival

It was perhaps the Egyptian-style images of Cleopatra that were saved by the wealthy Alexandrian Archibios, who bribed Octavian with 2,000 talents to spare the statues of Cleopatra in Egypt from destruction (Plutarch, *Life of Antony*, 86,5). To a Roman such images would have meant very little; to the Egyptians they were divine, and a demotic graffito at Philae shows that one, at least, was still cared for as late as AD 373.

Astonishingly, a sacred image of Cleopatra survived in the centre of Rome long after her suicide. It was said to have been commissioned by Julius Caesar during Cleopatra's stay in Rome as his guest in 46–44 BC. The statue was set next to a statue of Venus in the Temple of Venus Genetrix (the Divine Mother of the Julian family) at the inauguration of the Forum of Caesar, the first of a series of public spaces later developed to glorify emperors. The opening ceremony coincided with Caesar's spectacular Alexandrian triumph, which featured among other paraded captives Cleopatra's younger sister Arsinoe, later murdered on Antony's command, it was said at Cleopatra's request. We do not know the form of this statue; it is possible that Cleopatra, who had enjoyed divine status since the age of four, was portrayed as the goddess Isis, often worshipped with Venus. Whatever the form of the statue, its dedication was a remarkable development in Rome, where, in contrast to Egypt, no images of individuals, however powerful and distinguished, were set in temples alongside the gods. Caesar was himself quick to follow the extravagant compliment he had paid Cleopatra; his own image was set in the Temple of Quirinus, the divine form of Romulus, legendary founder of Rome. Cleopatra's statue was noted as late as the third century AD by the historian Dio Cassius (51, 22–3), who describes it as if it were part of Octavian's Egyptian spoils; its redefinition by Octavian no doubt accounts for the statue's survival (p. 195).

The butt of satire: the fate of Cleopatra's Greek image

It is said that Octavian, enraged by Cleopatra's suicide preventing him from parading her live in his triumph, commissioned another statue of the dying queen to take her place. Attempts to identify ancient copies of this figure have not proved successful. It does seem, however, that the Greek image of the queen was posthumously subverted for caricature, appearing in a crude pornographic cartoon on a Roman lamp of the mid-first century AD (cat. no. 357). It is perhaps significant that this type of lamp, of Italian manufacture, is well represented among the finds from military sites along the Rhine-Danube frontier: did the

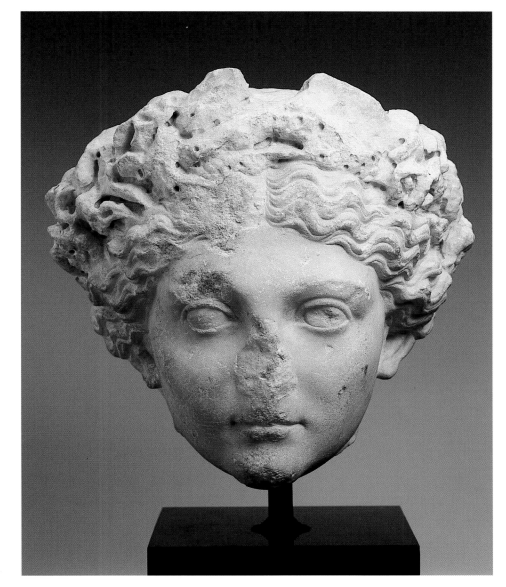

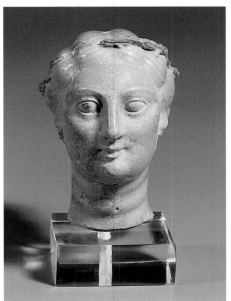

Fig. 4.6 (left) Faience head of Arsinoe II (cat. no. 8).

Fig. 4.7 (right) Marble head from a statue of Livia as the goddess Ceres (London, British Museum GR 2000.8–18.1).

exuberantly erotic Cleopatra serve as a soldier's pin-up, at the same time reminding them of their sacred duty to save the manhood of Rome from the amorous clutches of foreign queens? A similar sexual caricature appears on a marble relief (cat. no. 356), perhaps part of a frieze subverting scenes from the Nilotic mosaic of Palestrina (p. 352). If such images may be identified as Cleopatra, who on the frieze is shown with a male figure, perhaps intended as Antony, then they form a visual counterpoint to the mockery of the couple made by early imperial writers.

Cleopatra's portrait was clearly manipulated by the queen herself, most likely also by Antony, and evidently by her worshippers, her admirers and especially her detractors. Sadly for those who seek the secret of her personal allure, the more we study Cleopatra's surviving images, the less certain we may be of her looks. By the fourteenth century Boccaccio could claim that Cleopatra was 'famous for nothing but her beauty'. We are, perhaps, better advised by Antony's second-century biographer, Plutarch, who observed that Cleopatra's greatest allure lay in the sound of her voice and the charm of her company.

5

Identifying the Egyptian-style Ptolemaic queens

SALLY-ANN ASHTON

The numerous statues in both Greek and Egyptian styles representing Ptolemaic royal women reflect the important role that the queens played in the religious cults of individual rulers and, more generally, of the Ptolemaic dynasty, from the time of Arsinoe II (275–270 BC), wife and sister of Ptolemy II. However, understanding the visual language of these images and consequently identifying the representations of individual Ptolemaic queens is impeded by the lack of inscribed sculptures in the round. Here, the various categories of statue and their function are explained, and a group of statues that will be re-identified as Cleopatra VII is given more detailed consideration.

The Ptolemaic queens and the Egyptian royal cults

Archaeological evidence for the promotion of royal worship is much greater in Egyptian temples than in Greek sanctuaries, largely because of the long-established native tradition of decorating temple walls with representations of rulers and deities. Many of these reliefs, such as figures 5.1 and 5.2, show the worship of Ptolemaic rulers by their successors as part of the dynastic cult, which was subdivided into the deification of royal couples and the promotion of individual queens.

From an early stage the dynastic cult involved the promotion and worship of living rulers. Although Ptolemy II inaugurated the dynastic cult by instigating a cult of his deceased parents as the Theoi Soteres, or saviour gods, from 272/271 BC Ptolemy II and his sister–wife, Arsinoe II, were themselves deified and worshipped as the Theoi Adelphoi, or sibling gods, during their lifetime. Following her death in 270 BC, Arsinoe II was then awarded an individual cult, which was served by priestesses called the Kanephoroi. Documentation for the dynastic cult comes from the names of the eponymous priests and their cult titles (see cat. no. 51); thus the development of the cult and any subsequent changes that were made are recorded in the dating formulae of decrees and documents from the period. Each branch of the dynastic cult had its own priests or priestesses and at Philadelphia in the Fayum and in Alexandria the shrines of the Theoi Adelphoi and Arsinoe were quite distinct. The two temple reliefs showing the deified Arsinoe illustrate these two roles. At the temple of Isis at Philae, Arsinoe, standing behind the goddess Isis, receives offerings from her brother as a deity in her

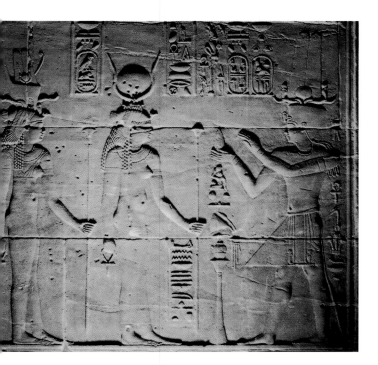

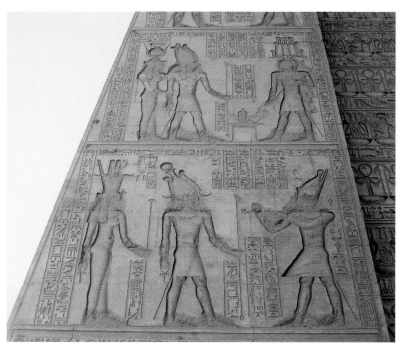

Fig. 5.1 (left) Relief from the Temple of Isis, Philae:
Ptolemy II makes an offering to Isis and Arsinoe II.
(Photo Sally-Ann Ashton.)

Fig. 5.2 (right) Relief from the gateway of Ptolemy III
Euergetes at Karnak: the ruler makes an offering to the
Theoi Adelphoi (Ptolemy II and Arsinoe II).
(Photo John Williams, Red Head.)

own right (fig. 5.1). However, on a relief decoration from the gateway of Ptolemy III at Karnak Temple (fig. 5.2), Arsinoe appears with her brother, and together the Theoi Adelphoi receive an offering from Ptolemy III.

Ptolemy III and Berenike II joined themselves to the existing cult of Alexander the Great in Alexandria, which included those of the Theoi Adelphoi, and Arsinoe II, calling themselves the Theoi Euergetai, again during their lifetime. Then, under Ptolemy IV, Berenike II was deified posthumously, in the same manner as Arsinoe II, but in order to promote his mother Ptolemy IV placed her priestess (the Athlophoros) before that of Arsinoe II in the dating formula. Cleopatra III, wife of Ptolemy VIII, was the first queen to take on the role of priestess of the dynastic cult, and was also the first ruler to refer to herself as an established deity, calling herself Isis. Later, Cleopatra VII called herself Nea (the new) Isis, after her father, Ptolemy XII, who called himself Neos (the new) Dionysos.

The various royal decrees from priestly synods are extremely instructive with regard to the acceptance and promotion of royal cults by the Egyptian priesthood. Images of deceased members of the royal family were worshipped as Sunnaoi Theoi, or temple-sharing gods, in both Greek and Egyptian temples, as described in the text of the Pithom stele, which is concerned with the placing of images of Arsinoe II in all temples. In the Canopus decree of 238 BC the deceased Princess Berenike, child of Ptolemy III and Berenike II, was deified; her individual crown and specific regalia are described in great detail, illustrating that the appearance of royal statuary was regulated and centrally controlled. The uniformity of the appearance of royal images is extremely important for the identification of uninscribed statues and it is with such information that modern scholars are able to identify individual representations.

The three types of Egyptian-style representation

The Egyptian-style statues divide into three distinct sub-groups:
1 Purely Egyptian
2 Egyptian with Greek attributes
3 Egyptian with Greek hairstyles and portrait features

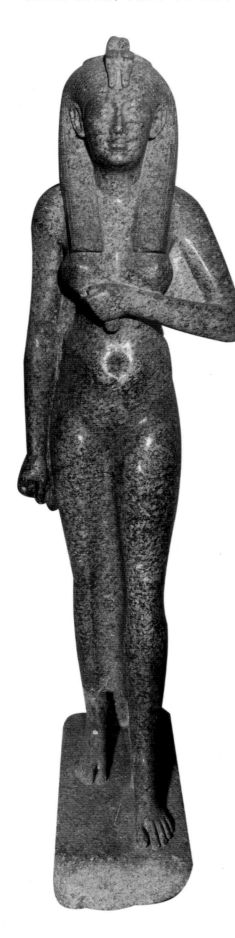

Group 1 is made according to the Egyptian tradition, and includes the earliest images of queens to be manufactured, such as the granite statue of Arsinoe II, now in the Vatican Museum (fig. 5.3). This type of statue, showing the subject striding forward in a sheath-like garment and traditional Egyptian wig, continues into the second century BC, as illustrated by a posthumous statue of Arsinoe II now in the Rijksmuseum, Leiden (fig. 5.4), and includes two first-century-BC images of Cleopatra VII, now in the Rosicrucian Museum, San Jose, California (cat. no. 161) and the Louvre, Paris (cat. no. 162).

Group 2 is often associated with Isis because of the later adoption of the attributes (knotted costume, a corkscrew wig and cornucopia) by the Romans, probably following the association of the later Ptolemaic queens with the goddess. However, an inscribed statue (cat. no. 166) shows that in the Ptolemaic period these attributes were not associated with Isis but with Amun, and that such images probably served as cult statues of the deified, and in the early stages, deceased queens. The corkscrew wig and cornucopia are both Greek in origin, and the costume, although Egyptian, often shows a Hellenized influence on the drapery. This group is represented in its purest form by the colossal statue of a second-century-BC queen from the underwater explorations in Alexandria (cat. no. 24b) and by two very similar images of Cleopatra VII: a complete statue, now in the Metropolitan Museum of Art, New York (cat. no. 164) and a head of the same type, now in the Brooklyn Museum of Art (cat. no. 163).

There are three more statues in this exhibition that show a variation of this type of image and the more traditional Egyptian statue. The first is a bust of a Ptolemaic queen, probably dating to the first century BC and now in the Greco-Roman Museum, Alexandria (cat. no.168), which maintains the knotted garment, but has the more traditional Egyptian tripartite wig found on the purely Egyptian-style statuary. The other two images are slightly later in date. One, a bust of Cleopatra VII, now in the Egyptian Museum, Turin (cat. no. 167), does not immediately appear to belong to this group, since her drapery and wig are of the type found in the first, purely Egyptian group of statues. However, the slightly raised left shoulder shows that this statue once held a cornucopia. The other statue, now in the Hermitage Museum, St Petersburg (cat. no. 160) also wears an Egyptian wig and sheath-like garment, although here the double cornucopia survives.

Group 3 is the smallest, and consists of Egyptian-style statues with Greek portrait features and coiffure, such as cat. no. 17. Such portraits are a direct parallel to those of male rulers, which adopt Greek-style portrait features and have hair showing beneath the *nemes* headdress (cat. no. 19). They may, therefore, represent queens such as Cleopatra I or III who ruled as regents or in their own right.

Thus, particular types of statues served different functions, and the diversity of function explains the continuation of the purely Egyptian and purely Greek styles of image from the third century BC alongside the combined Egyptian with Greek features from the second century BC. The difficulty arises when attempting to relate individual statues to specific queens, since the features are often of a general nature. Because the majority of royal statues are uninscribed, modern scholars must depend on stylistic analysis and the interpretation of visual attributes to date individual pieces. In most cases the iconographic features that were associated with the Ptolemaic queens on their Egyptian-style images are of a very general nature, showing them with a single uraeus, or cobra, as a royal symbol decorating their wig and a single cornucopia or ankh sign; others simply with clenched fists (see fig. 5.5).

Fig. 5.3 Statue of Arsinoe II (Rome, Vatican Museums 22682).

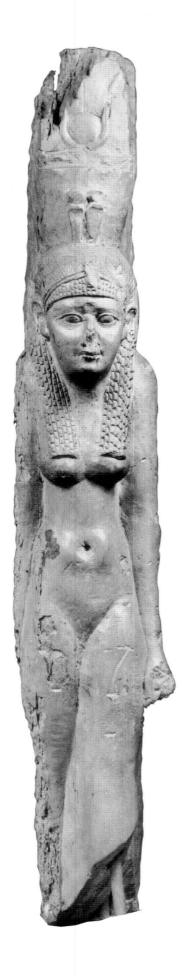

Dating and identifying royal statues: Arsinoe II

The only two inscribed statues representing Arsinoe II are those in the Metropolitan Museum of Art, New York (see cat. no. 164) and in the Vatican Museums (see fig. 5.3). The Vatican statue, as previously mentioned, is purely Egyptian in style, and is part of a pair representing the Theoi Adelphoi, therefore dating to the reign of Ptolemy II. The Metropolitan Arsinoe is later in date and belongs to the second group of images, with Hellenized drapery, corkscrew locks and cornucopia, and was probably associated with Arsinoe's own deification and individual cult. The Metropolitan Arsinoe is an important piece of evidence because it shows, along with the inscribed faience cult vases and coin images, that Arsinoe was associated with the double cornucopia in both Greek and Egyptian contexts.

A third image of the queen, now in the Rijksmuseum, Leiden (fig. 5.4) can be identified by comparison with the two temple reliefs shown in figures 5.1 and 5.2, since Arsinoe wears the same distinctive crown. The attributes of the inscribed images are, therefore, of considerable importance for identifying individual queens and, because of the prominence and the popularity of her individual cult, Arsinoe II is a crucial figure in the understanding of the iconography of the Egyptian representations of royal women. Moreover, statues of the queen made after her death that show the specific features of her image remained unchanged from the third to the first century BC, as can be seen from a comparison of the Vatican Arsinoe, the Leiden statue and the later head of the queen from Canopus, now in the Greco-Roman Museum, Alexandria (cat. no. 165); all three wear a double uraeus.

When Arsinoe was portrayed in the Egyptian style she always wore a double form of the *uraeus*, which is unusual in Egyptian royal representations. The earliest example occurs in the Eighteenth Dynasty, where Queen Tiye, wife of Amenhotep III, frequently appears with the double form of uraeus: one cobra wearing the white crown of Lower Egypt and the other the red crown of Upper Egypt, thus representing the joining of the two lands. Nefertiti, wife of Amenhotep IV (later known as Akhenaten) also wore the double uraeus; however, it is not possible to know whether the double form of the uraeus referred to Upper and Lower Egypt or whether it had, in this period of great artistic and ideological innovation, another meaning. The double uraeus also appears on a Nineteenth Dynasty representation of Meretamun, daughter and consort of Ramesses II, now in the Egyptian Museum, Cairo; the crowns of Upper and Lower Egypt are worn by each cobra, again suggesting that the double form was a reference to the two lands. In the Twenty-fifth Dynasty, the male rulers and their consorts frequently appeared with the double uraeus. These kings were originally from the kingdom of Kush, in modern Sudan, and the use of the double form of uraeus by these rulers may have represented the amalgamation of Egypt and Kush rather than Upper and Lower Egypt.

The double uraeus as worn by Arsinoe II may also refer to the joining of Upper and Lower Egypt; the inscription on the back pillar of the Vatican statue implies that the double form refers to the queen's role of mistress of the two lands:

> The Princess inherent, daughter of Geb, the first, the daughter of the
> bull *mrhw*, the great generosity, the great favour, the daughter of the
> king, sister and spouse (of the king), woman of Upper and Lower
> Egypt, image of Isis, beloved of Hathor, mistress of the two lands,
> Arsinoe, who is beloved to her brother, beloved of Atum, mistress of
> the two lands.

Fig. 5.4 Statue of Arsinoe II (Leiden, Rijksmuseum F 1938/7.20).

However, the cobras of the Ptolemaic period do not wear the crowns of Egypt. The other problem with interpreting the double uraeus simply as a reference to the joining of the two lands is that Arsinoe is the only queen to wear the double form. If the significance was of such a general nature, one might expect subsequent queens to adopt the double uraeus, but that seems not to have been the case. It is possible that the double uraeus was a parallel to the double cornucopia that appears on the coins of Arsinoe II and that it may represent the close relationship between the queen and her brother, Ptolemy II as the Theoi Adelphoi.

Dating and identifying royal statues: Cleopatra VII

The distinctive crown that Arsinoe wore, as seen on the Karnak and Philae reliefs (figs 5.1, 5.2) and the Leiden statue (fig. 5.4), and the characteristic double form of the *uraeus* and cornucopia distinguished her from other queens and deities. Although the later queens did not imitate the double uraeus, Cleopatra III and Cleopatra VII wore Arsinoe's crown on occasion, and Cleopatra VII also adopted the double cornucopia on her coins (cat. no. 186). The close association between the attributes adopted by Arsinoe II and Cleopatra VII has helped to further our understanding of a group of statues of a Ptolemaic queen wearing a triple uraeus for the first time in Egyptian art. The exhibition contains six such images, which until recently have not been recognized as a single group.

The importance of iconography for the identification of individual rulers is illustrated by the statues that are not immediately striking as a group; they are the product of separate artistic trends and also probably served different functions within the royal and dynastic cults. Two statues are purely Egyptian in style and look back to the styles of the third century BC: the Louvre queen (cat. no. 162) with her sculptured make-up lines and the queen now in the Rosicrucian Museum, San Jose (cat. no. 161), who wears drapery that is more typical of the early Ptolemaic period; only the sharp facial features betray her later date. The remaining four statues all have Greek attributes. The inscribed statuette now in the Metropolitan Museum of Art, New York (cat. no. 164) wears a knotted dress and a corkscrew wig, and carries a cornucopia. The head of a queen now in the Brooklyn Museum of Art (cat. no. 163) has hair and dorsal support identical to the Metropolitan Cleopatra, with tight snail-shell curls around the forehead and longer locks falling on to her shoulders and would probably have been very similar in overall appearance when complete. The bust of a queen now in Turin (cat. no. 167) and the statue of a queen now in the Hermitage Museum, St Petersburg (cat. no. 160), however, wear the more traditional dress and wig, but as previously stated, the latter holds a horn of plenty, and the raised shoulder of the Turin bust suggests that she also once held this attribute.

There are stylistic features that help to date this group of statues to the first rather than the second century BC. Several scholars have noted the 'hawk-like' appearance of the San Jose and Hermitage queens, but a comparison with the coin portraits of Cleopatra VII on which this feature appears serves little purpose, since the majority of these statues are Egyptian in style and the coin images are Greek. A more useful comparison can be made with the male statues, since the queens follow the ruler's portrait type very closely during this period. The second-century-BC Cleopatras adopt a masculine appearance, as seen on the Paris and Vienna queens

Fig. 5. 5 Statue of a first-century BC prince, probably Caesarion (New York, the Brooklyn Museum of Art 54.117).

(cat. nos 25, 26), which compare well with the male version (cat. no. 27) and are quite different to the statues from the triple uraeus, on which a more youthful portrait type is adopted.

The San Jose statue was identified in 1983 as an image of Cleopatra VII by the late Dutch Egyptologist Jan Quaegebeur, who compared the profile of the statue with the Greek-style coin portraits of Cleopatra VII. This identification was later disputed on stylistic grounds not only because of the discrepancy in the styles but also because the nose was found to have been restored (and has since been removed), and the type of drapery was considered more typical of an earlier statue. The triple uraeus on this statue was not taken into account in the original identification and so a comparison and discussion encompassing the other statues in the group was not undertaken. However, the argument for the association of the triple uraeus with Cleopatra VII that follows supports the original identification of the San Jose queen on stylistic grounds.

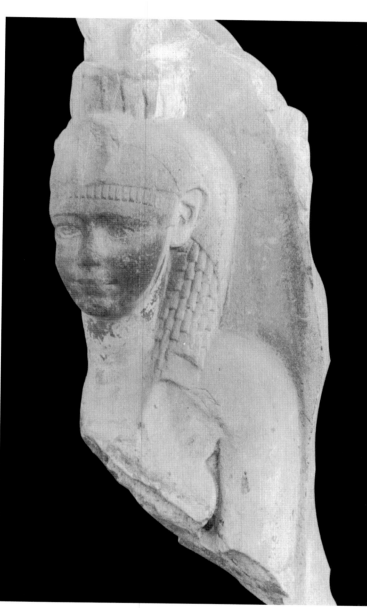

Fig. 5.6 Statue of a goddess or queen (Mariemont Museum E 49).

The Hermitage queen is perhaps the most useful for dating purposes, because she has an added Greek attribute and is stylistically similar to a statue of a first-century-BC prince, now in the Brooklyn Museum of Art (fig. 5.5). The features on both the Hermitage queen and the Brooklyn prince are refined versions of the downturned mouth and square chin that appear on the portraits of the second-century-BC rulers. The prince could represent Ptolemy XIII or XIV, both of whom ruled with their sister, Cleopatra VII, during the early part of her reign; he is, however, more likely to represent Caesarion. The similarity of the portrait features was probably a deliberate association of the two rulers, as seen on the south wall of the Temple of Hathor at Dendera and on the Cypriot coins (see cat. no. 186). The Cypriot coins reveal another interesting iconographic link between the Hermitage queen and Cleopatra VII: the double cornucopia, which appears on the reverse of the coins and on the statue.

The Hermitage and San Jose queens have most recently been allocated a third-century-BC date on account of their sheath-like drapery, which is so typical of this period. However, a late Ptolemaic pair of statues from the Hadra region of Alexandria (the male is now in the Greco-Roman Museum and the female is in the Mariemont Museum) suggest that during the first century BC there was a deliberate return to the pure, Egyptian-style images of the third century BC. The male ruler, although Egyptian in style, has hair, a non-Egyptian feature but one that is common from the time of Ptolemy V and is seen in later Ptolemaic royal portraits and Roman representations of emperors as pharaohs. The female figure, on the other hand, is very similar to the type of representation found in the third century BC (fig. 4.6), and without the obvious date of the male, who is often identified as Mark Antony, the female would be dated to the early Ptolemaic period. The Louvre queen with a triple uraeus and sculptured make-up lines is also reminiscent of early Ptolemaic images, such as the Arsinoe II in the Metropolitan Museum of Art in New York (cat. no. 166), drawing inspiration from portraits dating to the Twenty-sixth and Thirtieth Dynasties. On the Hermitage queen this can be seen in the costume and wig, which returns to the more traditional Egyptian form compared to the Hellenized drapery and wig of the Metropolitan Arsinoe and other such statues with the cornucopia.

The features of the Turin queen are more youthful in appearance than the others and very similar to those of the Brooklyn head. The fleshy lips and fuller face are closer to the Greek-style

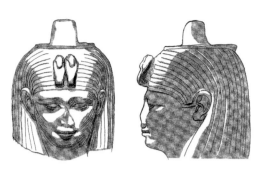

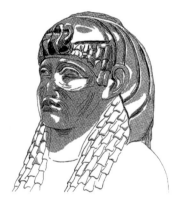

Fig. 5.7 The double uraeus, triple uraeus and questionable Turin queen with a vulture headdress. (Drawings by Candida Lonsdale.)

portraits and may well have been influenced by that style, but unfortunately the noses are missing and so it is not possible to use the coin images for comparison. The portrait of the Turin queen has, like a similar statue probably from the Iseum by the Via Labicana in Rome (cat. no. 194), been compared to that of Berenike II. However, both the Turin and Rome sculptures have the same fleshy features as the late second and first century BC portraits of male rulers. The same features can be seen on a marble head perhaps representing Ptolemy VIII (cat. no. 21), now in a private collection in North America, and, most convincingly, on the Louvre Auletes (cat. no. 154). For this reason the Turin, Rome and Brooklyn images fit more comfortably into the late Ptolemaic period, and a comparison with the hard, masculine, second-century-BC portraits of queens would suggest that the three sculptures are of a first-century-BC date.

Finally, the stone used for the Metropolitan Cleopatra supports a late Ptolemaic or early Roman date. The statue is most likely carved in marble from Proconnesus, in north-west Asia Minor, a stone much used for architecture and funerary sculpture in Roman Alexandria. The position of the Metropolitan queen's hand, which clutches the drapery rather than being clenched in the usual Egyptian fashion also betrays a late first-century-BC date (fig. 5.7). This statue is of further importance because it bears a remarkable resemblance to a portrait of Arsinoe II from Canopus (cat. no. 165), which has a double uraeus and shows that the triple form must have been intended to represent a different queen. This significant distinction is often ignored, and many of the statues in this group have been identified as Arsinoe II despite the iconographic inconsistencies. The stylistic evidence for associating this group of statues with Cleopatra VII is supported by a seventh image, a naturalistic portrait engraved on a small glass gem (cat. no. 153), which shows Cleopatra VII as she is known from her Greek-style images. Remarkably, the portrait includes the triple uraeus, thereby confirming the association of this feature with the queen.

What did the triple uraeus represent?

Not all scholars, however, recognize the triple uraeus, but prefer to see the form as a double uraeus with the central vulture from the headdress worn by queens and goddesses in Egypt (fig. 5.7). Although this is certainly the case in pre-Ptolemaic representations, here that explanation is applicable only to the Turin queen, since she is the only statue from the group to wear a vulture cap. It is also clear from the second century BC that some sculptors forgo such details, showing the legs and feathers of a vulture over the wig but without the bird's head.

One of the earliest discussions of the triple *uraeus* can be found in a catalogue by Bernard V. Bothmer for the exhibition *Egyptian Sculpture of the Late Period* (which was held at the then Brooklyn Museum in 1960) as part of the entry for the Metropolitan Cleopatra (pp. 145–7, no. 113). Bothmer dismisses the possibility that the statuette represents Cleopatra VII on stylistic grounds, preferring to date the piece to the second century BC. He tentatively suggests that the triple *uraeus* represents the triple rule of Cleopatra II, Ptolemy VI and Ptolemy VIII. Bothmer cites the Turin, Hermitage and San Jose queens as comparable examples and stresses the hawk-like appearance of the latter two statues, concluding that they may well represent the same queen. However, which queen?

Although the idea that the triple *uraeus* represents the triple rule of Ptolemy VI, Ptolemy VIII and Cleopatra II is tangible, there are nonetheless historical reasons for refuting it. Ptolemy VI was ten or eleven years of age in 176 BC when his mother, Cleopatra I, died. Two unlikely candidates were chosen as regents: Eulaeus, a eunuch, and Lenaeus, a former slave from Coele-Syria. In order to consolidate royal power Ptolemy VI was married to his sister Cleopatra II, in April 176 BC, although neither was of age. Then in 170 BC, when Ptolemy VI came of age, his younger brother, Ptolemy VIII, was made joint ruler to further strengthen the royal throne and prevent internal rivalry. In reality, however, the reigns of Ptolemy VIII with both his siblings and then

Fig. 5.8 Hand position on the Metropolitan Cleopatra, the Rosicrucian Cleopatra and the Hermitage Cleopatra. (Drawings by Candida Lonsdale.)

later with Cleopatra II and her daughter by Ptolemy VI, Cleopatra III, were dominated by internal power struggles. It seems unlikely therefore that the three would be associated in this way. A triad representing Ptolemy VIII and Cleopatra II and Cleopatra III sometimes appear on temple reliefs and on seal impressions, but a more careful study of the images in question suggests that the triple uraeus represented a more complex, ideological union.

It is possible that the resemblance to images of Arsinoe was quite deliberate and that the triple uraeus was used to distinguish Cleopatra VII from her popular predecessor, whose cult even survived the Roman occupation of Egypt. Carrying the double cornucopia, Cleopatra VII also appears with the crown of Arsinoe on a wall relief at Dendera. Interestingly on another relief at the same temple an image representing Ptolemy XIII, XIV or XV (Caesarion, Cleopatra's son) shows the ruler wearing a crown that is decorated with three cobras rather than the usual single or double forms.

The fragment of a crown from Koptos, now in the Petrie Museum of Egyptology (cat. no. 170, London only) can again be explained as evidence of a deliberate policy of association of Cleopatra VII with Arsinoe II. The crown is in the simple form of two plumes with a sun disc and decorated with three cobras. Its wearer has been identified as Arsinoe II because of the titles that appear in the inscription: '…king's daughter, king's sister, great royal wife, who satisfies the heart of Horus…'. However, the crown is not the usual form worn by this queen (see figs 5.1, 5.2, 5.4). If it is compared with the representations in relief of Arsinoe II, the queen is shown either without cobras on the crown or, on an example from the Temple of Horus at Edfu, with the double cobra, as a parallel to the double uraeus on her statues. The titles in the inscription of the Koptos crown are used by Arsinoe II, but it is also possible that Cleopatra VII adopted a similar titulature, just as she used the double cornucopia and crown of Arsinoe. It seems unlikely, then, that the triple form of uraeus was associated with Arsinoe, and it is often missing from her representations in the round. Instead, the triple form of uraeus is more likely to be linked to Cleopatra VII and there are further reasons to link this form of the uraeus with her, although its meaning must remain conjectural.

As noted above, the double uraeus is most commonly associated with the two lands of Upper and Lower Egypt, and it is possible that the triple form represents an extension of this affinity. The triad may comprise Upper and Lower Egypt and the old Seleucid kingdom, as illustrated by the coins of the queen and Mark Antony that were perhaps minted in Antioch. Returning to the view that the triple uraeus might represent triple rule, it is possible that the emblem represents the union of Cleopatra, Caesarion and the deceased Julius Caesar as Isis, Horus and Osiris. A difficulty here is that Caesar never actually ruled Egypt and so could not be linked to Osiris, an association usually reserved for a dead pharaoh. It is even less likely that the triple form could relate to Cleopatra, Caesarion and Mark Antony, because the latter did not rule Egypt, although he did associate himself with Dionysos, who is linked to Osiris and the underworld.

The third element could also be a reference to Ptolemy XII Auletes, Cleopatra's VII's father, with whom she maintained a strong bond, as shown by her adoption of the title Philopator, or father loving. Finally the triple uraeus may have been used literally, to illustrate Cleopatra's title as 'Queen of Kings', the remaining cobras representing the kings.

Without inscribed statues it is not possible to know for certain why this new and distinctive form of iconography was introduced. That it has received such little attention from scholars illustrates not only how neglected the study of Egyptian Ptolemaic royal portraiture has been, but also the problems of conducting research into a culture that links two of the great civilizations. By considering stylistic features on the Egyptian-style material in conjunction with Greek representations such as the gem showing a recognizable portrait of Cleopatra VII wearing a triple uraeus the pieces of a rather difficult puzzle finally come together.

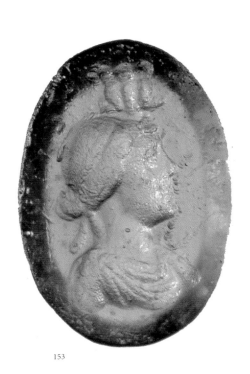

153

153 Blue glass intaglio with a portrait of Cleopatra VII

First century BC

Provenance unknown

Length 1.3 cm

London, British Museum GR 1923.4-1.676 (Gem 3085)

This pale blue glass gem shows a portrait of a royal woman, identified by the broad, knotted diadem. The hair is tied back in a bun in the usual Greek manner and the dress that the queen wears is also Greek in origin, with folds of drapery clearly visible. The headdress, however, is Egyptian in style and in the form of a triple uraeus; the cobras wear sun discs on their heads. The portrait features are relatively clear and show a full face, with straight nose and a strong chin with a downturned mouth. It is, however, the hairstyle and broad diadem in particular that indicate that this representation is of Cleopatra VII. Portrait features are often distorted when produced on such a small scale.

This piece provides important support for the re-identification of several Egyptian-style statues with a triple uraeus as Cleopatra VII.

BIBLIOGRAPHY: H.B. Walters, *Catalogue of the Engraved Gems and Cameos, Greek, Etruscan and Roman, in the British Museum* (London 1926), cat. no. 3085.

S-A.A.

154

154 Limestone stele attributed to the reign of Cleopatra VII

51 BC (?)

Said to be from the Fayum, and according to the text from Hawara

Height 52.4 cm

Paris, Musée du Louvre E 27113

There are remains of red paint on the surface.

The upper part of this stele shows a seated goddess nursing her child, in front of whom a pharaoh wearing the *pschent*, or double crown of Upper and Lower Egypt, presents two globular vases. The inscription of the lower part has been deeply engraved, except for the last lines, and bears remains of red paint. According to the dedication formula, this stele was consecrated by the chief of the association of the devotees of the goddess Isis, who was also the administrator of her temple located in the Fayum oasis, according to the peculiar epithet of the goddess. The reference to Cleopatra Thea Philopator is the main indication that this stele dates from the reign of Cleopatra VII.

The inscribed date (year 1, the first of Epiphi) makes this stele the earliest surviving document of Cleopatra VII's reign. This stele is therefore believed to have been re-carved after Cleopatra's sole leadership, which would explain why the bottom half with the inscription is sunk lower into the background than the scene on the upper part of the stele. It is thought that the scene originally showed Ptolemy XII, whose name would have been engraved before its modification. The scarcity of the queen's representation as a male king and the shift between the preparation grid and the lines of the inscription have been regarded as proofs of this deliberate alteration.

However, this shift could also be explained by a miscalculation by the engraver concerning the size of the inscription that compelled him to cut the lower part of the frame to add an extra line. On the other hand, the French Egyptologist Michel Chauveau has recently suggested an earlier dating of this document on epigraphic grounds, which will be soon thoroughly reconsidered.

BIBLIOGRAPHY: A. Bernand, *Inscriptions grecques d'Egypte et de Nubie au Musée du Louvre* (1992), 62–4, n. 21, pl. 16, R.S. Bianchi, (ed.), *Cleopatra's Egypt: Age of the Ptolemies* (New York 1988), 188, 189, n. 78.

M.É.

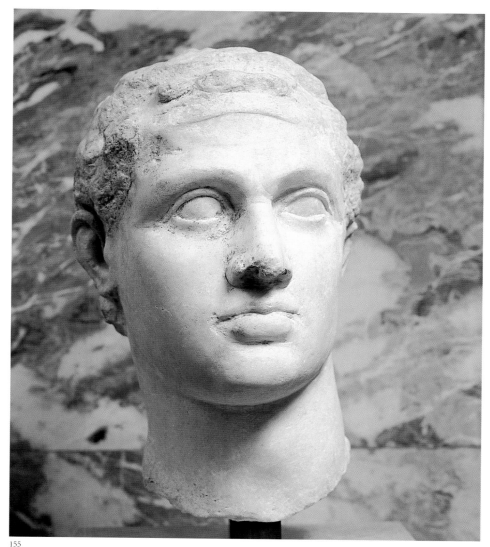

155

155 Marble portrait of Ptolemy XII

80–51 BC

Provenance unknown

Height: 38 cm

Paris, Musée du Louvre Ma 3449

The hair, top of the ears and diadem are roughly worked; the missing pieces were probably finished in stucco. The tip of the nose is damaged and there is further superficial damage to the surface.

This Greek-style portrait was originally inserted into a statue. The rough treatment of the eyebrows, bridge of the nose, and mouth suggests that the piece was reworked from an earlier Ptolemaic portrait. The ruler wears a diadem across the forehead, which originally could have been a *mitra* of Dionysos, although it is possible that the band is the result of the recutting. The nose is prominent and accentuated by the crudely carved bridge. The eyes are large and slightly downturned at the outer corners. These portrait features are similar to those identified as Ptolemy XII on the sealings and coins, but the straight mouth with a fleshy lower lip, suggests that the original portrait represented Ptolemy IX or X.

BIBLIOGRAPHY: G.M.A. Richter, *Portraits of the Greeks*, 3 vols. (London 1965), 261 [Ptolemy II]; H. Kyrieleis, *Bildnisse der Ptolemaer* (Berlin 1975), 76–7, II [Ptolemy XII]; R.R.R. Smith, 'Three Hellenistic Rulers at the Getty', *GMJ* 14 (1986), 67; R.R.R. Smith, *Hellenistic Royal Portraits* (Oxford 1988), 97, 168, no. 62 [Ptolemy XII?]; M. Hamiaux, *Les Sculptures Greques II: La période hellénistique IIIe-Ie siècles avant J.C.* (Paris 1988), 81–2, no. 83 [Ptolemy XII].

S-A.A.

156

156 Clay seal impression with a portrait of Ptolemy XII (?)

80–58 BC

Said to have been found at Edfu

Height 2.1 cm, width 1.8 cm

Toronto, Royal Ontario Museum 906.12.122

The top of the seal impression is damaged but the impression is clearly preserved. The image shows a Ptolemaic ruler wearing the double crown of Upper and Lower Egypt and an Egyptian breastplate. The pointed chin and hooked nose are both features that are found on Greek portraits of Ptolemy XII; here the ruler also has a faint beard. The Greek portrait with Egyptian regalia on this impression echoes the adoption of Greek features on hard-stone statues of the Ptolemies as pharaohs.

BIBLIOGRAPHY: H. Kyrieleis, *Bildnisse der Ptolemäer* (Berlin 1975), pl. 68.5 [Ptolemy XII].

S-A.A.

157

157 Clay seal impression with portraits of Ptolemy XII and Cleopatra V (?)

80–58 BC

Said to have been found at Edfu

Height *c.* 1.8 cm, width *c.* 2 cm

Toronto Royal Ontario Museum 906.12.202

These jugate portraits show a male ruler identified by the broad diadem, typical of the late Ptolemaic period, and his queen, who wears a *stephane* (crown). The features on both rulers are similar: full face, strong chin with a hooked nose and large mouth. The male ruler is shown in the primary position at the front of the image.

BIBLIOGRAPHY: H. Kyrieleis, *Bildnisse der Ptolemäer* (Berlin 1975), pl. 68.5 [Ptolemy XII and Cleopatra V].

S-A.A.

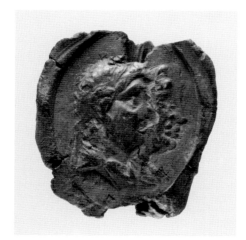

158

158 Clay seal impression with a portrait of two late Ptolemaic rulers

First century BC

Provenance unknown

Length 1.2 cm

London, British Museum GR 1956.5-19.1

The lower section of the seal is damaged and part of the upper edge is missing; there are grains of what appears to be sand embedded in the surface. The jugate pair are shown in the usual position, with the ruler more dominant. The female's features are worn, but the *stephane* (crown) is clear. The ruler, who also appears on cat. no. 65, wears a headdress consisting of a lion's head, the mane clearly visible on his shoulders. His portrait features are distinctive, with a hooked nose and a

strong, pointed chin. The mouth is downturned, a feature typical of late Ptolemaic portraits and which accord with the representations of Ptolemy XII. It is, therefore, possible that this image shows Ptolemy XII and Cleopatra V. On the back of the seal are vertical lines, from the papyrus to which it was originally attached.

UNPUBLISHED.

S-A.A.

159 Painted terracotta bust of Gnaeus Pompeius Magnus (Pompey the Great)

c. 60–50 BC

Provenance unknown

Height 12 cm, width 9 cm, depth 10 cm

Stuttgart, Württemburgisches Landesmuseum, Antikensammlung Arch 65/7 (Acquired in 1964)

The bust is broken in an irregular line at the neck. The clay is pale yellow, with a greenish tinge; deposits of soil are visible on the hair. There are traces of a brown colour wash on the face.

Pompey is portrayed with the characteristic *anastole* (raised lock of hair above the brow), copied from the image of Alexander the Great (see cat. no. 2), whose name was also adopted by Pompey, the most powerful Roman of his day. Scourge of the pirates who had plagued the region, and kingmaker to many would-be monarchs in the lands of the eastern Mediterranean, Pompey invited comparison with Alexander. He was indeed the guarantor of the throne of Cleopatra's father, Ptolemy XII Auletes. Pompey's intervention in Egyptian politics was to prove fatal: on 28 September 48 BC he was murdered by supporters of Cleopatra's brother Ptolemy XIII on the beaches east of Alexandria. The severed head was brought in triumph to Alexandria, to the distress of Pompey's rival, Julius Caesar, who was then in the troubled city securing the throne for Cleopatra.

Apart from the *anastole*, the hair is rendered as a single mass of locks, in simpler fashion than is seen on the surviving marble and coin portraits. The facial features are closer to surviving ancient portraits of Pompey in marble, and on the coins of his son, Sextus Pompey. The brow is lightly furrowed, the small and wide-set eyes are shown with heavy lids, the nose turns up at the tip, with pronounced lines to either side of the thin, downturned mouth. The upper lobes of the ears project markedly. Pompey's large, moon-shaped face is turned to his left.

The antiquity of this terracotta bust has been doubted by Johansen, who notes that terracotta images of famous Romans are rare. While this is true of free-standing images, well-known indi-

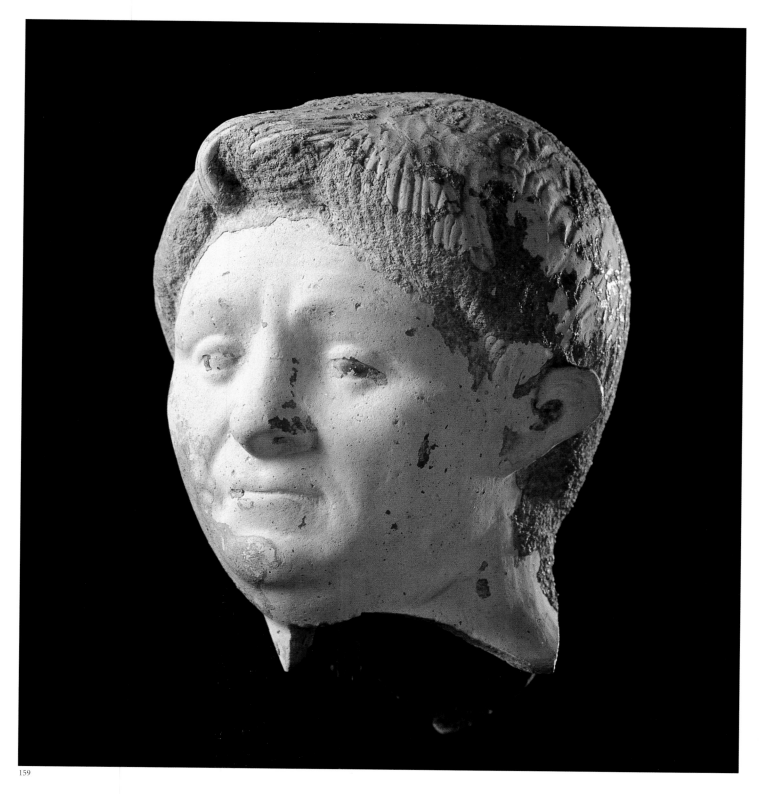

159

viduals of Pompey's day were portrayed at minia-
ture scale in high relief, the portraits forming
raised medallions in the centres of ceramic
dishes. These imitate similar works in silver (such
as cat. no. 324, exhibited in London only), and
there seems every reason to suppose that small
statuettes and busts in bronze or silver could sim-

ilarly have been imitated in terracotta. There
appear to be no other grounds for doubting the
antiquity of the Stuttgart head.

BIBLIOGRAPHY: *Ars Antiqua Auktion* V (Lucerne 7/11/1964),
no. 96, pl. xxi; D. Michel, *Alexander als Vorbild für
Pompeius, Caesar und Marcus Antonius. Collections
Latomus* XCIV (Brussels 1967), 65, pl. XX ; F. Johansen,

'Antike Portraetter af Gnaeus Pompeius Magnus',
Meddelelser fra Ny Carlsberg Glyptotek 30 (1973), 114
(figs 26 and 27 are reversed); M. Bentz, *RM* 99 (1992),
229ff; H.-P. Kuhnen (ed.), *Judäa im Widerstand gegen die
Römer* (Stuttgart 1994), colour pl. 1.

S.W.

160 Black basalt statue of Cleopatra VII

c. 51–30 BC

Provenance unknown

Height 104 cm

St Petersburg, Hermitage Museum 3936

There is some surface damage to the statue, particularly around the uraeus. The crown, earrings and inlays for the eyes are now missing.

This Egyptian-style statue is one of the best-preserved representations of a Ptolemaic queen. The subject strides forward and wears a sheath-like transparent dress, through which the curves of her body are clearly visible. The tripartite wig falls behind the ears, with the lappets resting on the chest. The front of the headdress is decorated with a triple form of the uraeus, the symbol of royalty. Her right arm is held firmly by her side and in her hand she clutches an ankh sign. The left arm supports a double cornucopia, or horn of plenty, a symbol that is commonly associated with the queens worshipped in the Greek ruler cult during the third century BC, but was also used by Egyptian sculptors for royal representations in the second and first centuries BC.

The face is oval in appearance with angular features. The slightly upturned chin and groove beneath the lower lip accentuate the downturned mouth. The eyes, although narrow, dominate the face and are intensified by the non-naturalistic form of the lids and eyebrows.

The statue is traditionally identified as Arsinoe II, wife of Ptolemy II, because of her association with the *dikeras,* or double cornucopia. Arsinoe II, however, usually wears the double form of the uraeus in Egyptian-style representations whereas the Hermitage statue has the triple form. Stylistically, the downturned mouth and angular facial features place this statue in the first century BC, a time when Cleopatra VII also used the double cornucopia on the reverse of her coinage. For this reason and the anomaly of the triple uraeus, the statue is more likely to represent Cleopatra VII than Arsinoe II .

BIBLIOGRAPHY: I.A. Lapis, 'Statue of Arsinoe II' (in Russian) *Bulletin of the Hermitage Museum* 11 (1957), 49–52; B.V. Bothmer, *Egyptian Sculpture of the Late Period* (New York 1960), 192; N. Landa and I. Lapis, *Egyptian Antiquities in the Hermitage* (Leningrad 1974), fig. 131; J. Quaegebeur, 'Trois statues de femme d'époque Ptolémaïque' in H. De Meulenaere and L. Limme (eds), *Artibus Aegypti: Studi in honorem Bernardi V. Bothmer* (Brussels 1983), 116–17; F. Queyrel, catalogue entry, in M. Rausch (ed.), *La gloire d'Alexandrie* (Paris 1998), 80, no. 38; S-A. Ashton, 'Ptolemaic royal sculpture from Egypt: the interaction between Greek and Egyptian traditions', *BAR* (Oxford, forthcoming), no. 62 [Cleopatra VII].

S-A.A.

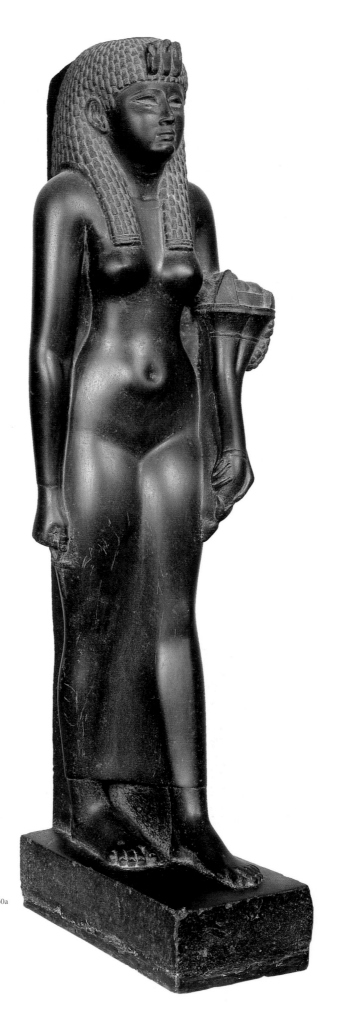

160a

160b ▶

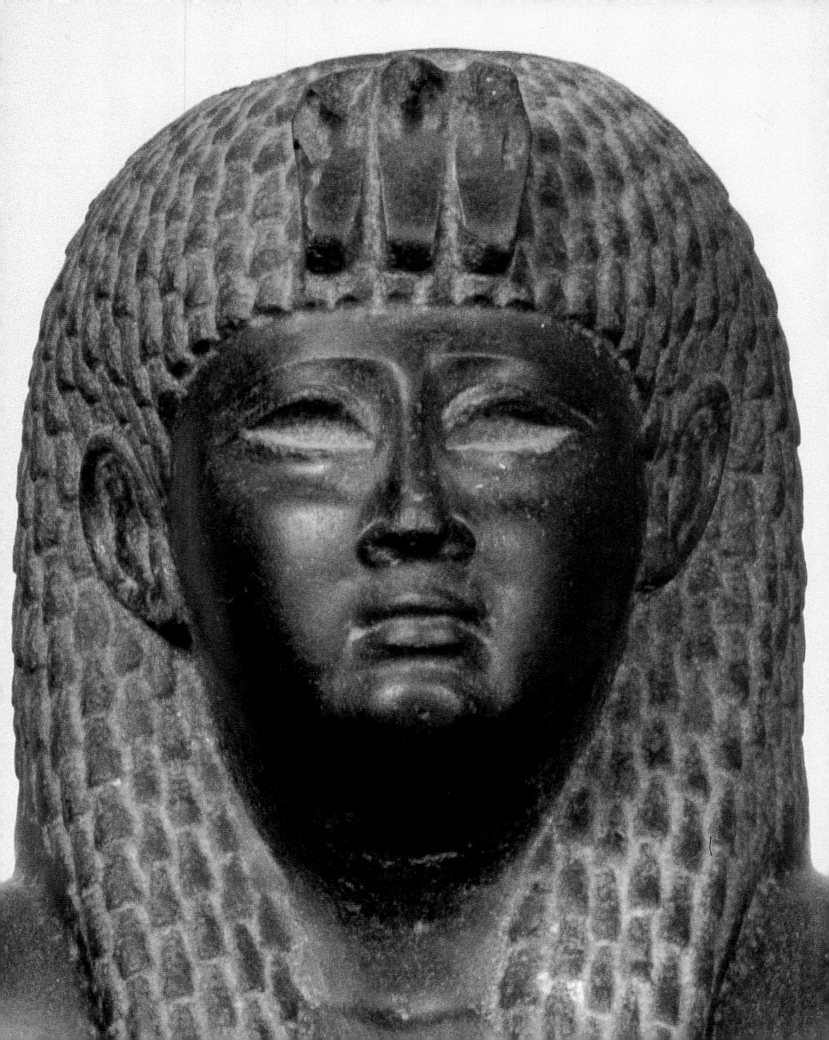

161 Basalt statue of Cleopatra VII

c. 51–30 BC

Provenance unknown

Height 105 cm (113 cm with the modern base)

San Jose, California, Rosicrucian Museum 1586

The lower section, base, feet and nose of the statue are restored, and there is superficial damage to the back pillar.

The subject of this Egyptian-style statue is undoubtedly a queen, although the identity must be determined by the iconography because the back pillar is uninscribed. The queen strides forward with her left leg, holding her arms firmly by her sides and the customary bar in her clenched hands. Her drapery clings tightly to her body and she wears a tripartite wig with a diadem and triple uraeus. The face is very angular. The eyes are wide, with oval-shaped eyebrows, and the mouth is relatively small, with thin, downturned lips. The neck is thick set and, visible above the neckline of her dress, the queen has three rolls of fat, commonly referred to as 'Venus rings' and common on portraits of the Ptolemaic royal women from the second century BC.

The statue was first identified as Cleopatra VII and dated to the first century BC by Quaegebeur, following Kyrieleis. This identification rested largely on the profile of the statue, which, with its

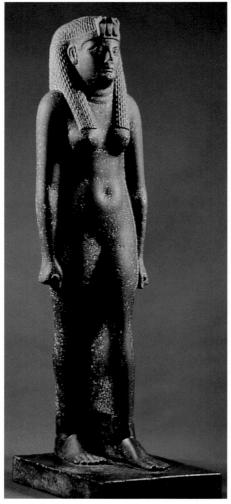

161

restored nose, was described as 'hawk-like'. Following the removal of the restoration, Bianchi and many subsequent scholars have suggested that the statue represents an earlier Cleopatra, although he concludes that the statue dates to the third century BC. Most recently the piece has been identified as Arsinoe II, following Bianchi's third-century-BC date. However, both suggestions seem unlikely because of the triple rather than double uraeus that Arsinoe typically wears, and the strong portrait features of the face, in particular the square chin and downturned mouth are typical of images dating to the first century BC.

BIBLIOGRAPHY: W. Needler, 'Some Ptolemaic Sculptures in the Yale University Art Gallery', *Berytus* 9 (1948–9), 140; B.V. Bothmer, *Egyptian Sculpture of the Late Period* (New York 1960), 147 [Cleopatra II or III]; H. Kyrieleis, *Bildnisse der Ptolemäer* (Berlin 1975), 184, no. M7 [Cleopatra VII]; J. Quaegebeur, 'Trois statues de femme d'époque Ptolémaique' in H. De Meulenaere and L. Limme (eds), *Artibus Aegypti: Studi in honorem Bernardi V. Bothmer.* (Brussels 1983), 114 [Cleopatra VII]; R.S. Bianchi (ed.), *Cleopatra's Egypt: Age of the Ptolemies* (New York 1988), 59, 62, 130, 149, 167, 175–176, 194, 249, no. 69 [third century BC]; M. Rausch ed. *La Gloire d'Alexandrie* (Paris 1998), 175, no.123 [Cleopatra II or III]; J. Freeman et al. *Women of the Nile. Rosicrucian Museum San Jose, California* (San Jose, Calif. 1999), 37 [third century BC, Arsinoe II]; S-A. Ashton, 'Ptolemaic royal sculpture from Egypt: the interaction between Greek and Egyptian traditions', *BAR* (Oxford, forthcoming), no. 39 [Cleopatra VII].

S-A.A.

162 Steatite (?) statue of Cleopatra VII

c. 51–30 BC

Little is known about the origin of the statue. It belonged to the former collection of the Cabinet des Médailles at the Bibliothèque Nationale, but it is difficult to identify this piece with certainty in the registration book of 1862. It might have been part of the former Anastasi collection.

Height 36.5 cm, width 18.3 cm

Paris, Musée du Louvre E 13102

The stone in which the statue has been carved is of a peculiar nature. It is a very soft green stone with pink inclusions and veins, perhaps a kind of steatite, which could originate from the quarries of the Arabian desert. The concretions and traces of earth on the statue and within the grooves of the wig attest its authenticity and preclude any possibility of a modern fake. A portion of the wig and the nose were completed at the time with a stone of a similar hue. The statue is preserved from the abdomen to the base of the crown. There is some damage to the front, around the break, and the inlaid eyes and headdress are missing; the tip of the nose is restored and there is a large hole at the top of the *modius*, where the headdress once fitted.

This Egyptian-style statue of a Ptolemaic queen has an uninscribed back pillar, preserved to the middle of the back. The queen wears a sheath-like garment, a tripartite wig and triple uraeus with a base of a crown in the form of a circle of cobras. Her left arm is drawn across her upper abdomen and holds a lily sceptre, which falls across the top of her right arm; this arm is held firmly by her side. The face is oval in shape, with well-defined eyes and plastic make-up lines around the eyes, which appear first on female statues dating to the early Ptolemaic period, but reappear in the first century BC. The downturned mouth is also characteristic of first-century-BC Egyptian royal portraits, and the triple uraeus suggests that the statue may represent Cleopatra VII.

UNPUBLISHED.

M.É., S-A.A.

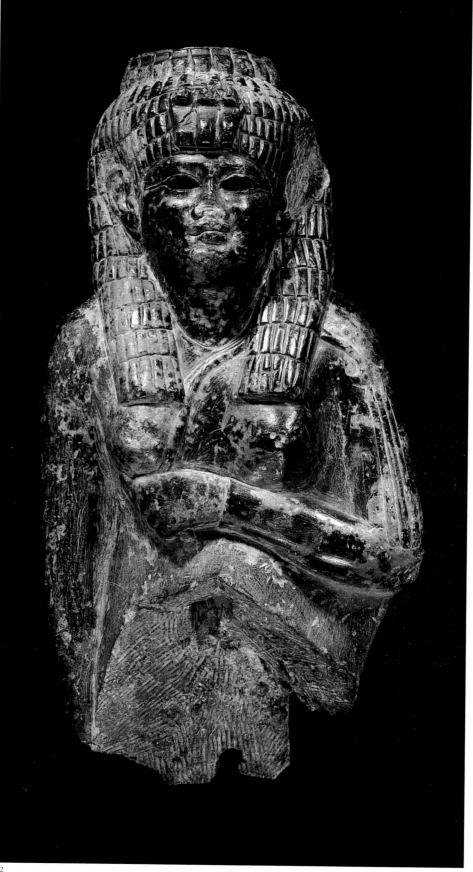

162

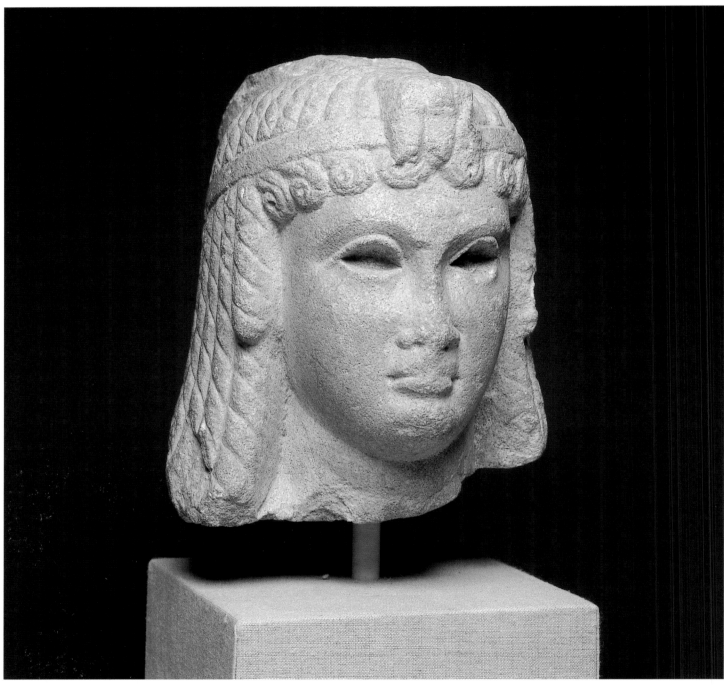

163

163 Limestone head of Cleopatra VII

c. 51–30 BC

Provenance unknown

Height 12.7 cm

New York, loaned by the Brooklyn Museum of Art 71.12

Only the head is preserved and there is superficial damage to the surface of the face, particularly the nose and lower locks, and to the uraei. The inlays for the eyes are missing.

On this Egyptian-style portrait the back pillar, which is uninscribed, extends to the top of the head. Although damaged on the top, there is no hole to support a crown, as on the Metropolitan Museum of Art Cleopatra VII (cat. no. 164). The wig consists of a double layer of locks with archaizing snail-shell curls across the forehead and a diadem with a triple uraeus, which identifies the queen as Cleopatra VII (see pp. 152–5). The face is youthful and rounded with a small nose and mouth, but full fleshy lips, downturned

in profile, a feature also found on the other statues with a triple uraeus. The eyes are almond-shaped and the line of the upper lids follows the strong eyebrows. There are Venus rings on the neck.

BIBLIOGRAPHY: *Bulletin of the Brooklyn Museum* 12 (1971) 20-1.

S-A.A.

164 Marble statue of Cleopatra VII

c. 51–30 BC

Provenance unknown

Height 61.8 cm

New York, The Metropolitan Museum of Art 89.2.660
(Gift of Joseph W. Drexel, 1889)

The statue is preserved to below the knees and there is minor damage to the surface.

The back pillar of this Egyptian-style statue is uninscribed, but a cartouche containing the hieroglyphs spelling 'Cleopatra' are carved on to the upper right arm, although the authenticity of the inscription has been questioned. The right arm is held by the queen's side and the hand rests open on her thigh, rather than the usual clenched fist. In her left arm the Queen holds a single cornucopia, an attribute adopted from the Greek royal statues. The drapery, which is also influenced by Hellenistic styles of dress, is pulled over the right shoulder and knotted above the right breast, forming a central pleat below. The face is broad, the eyes large and the mouth thin and straight. The nose is small and slightly upturned. The queen wears a wig of corkscrew locks with stylized snail-shell curls on the brow, decorated by a thin diadem with a triple uraeus, and originally an Egyptian crown.

The identity of this figure as a sculpture of Cleopatra VII rests on the triple form of the uraeus and certain stylistic features, namely the manner in which the right hand rests on the hip rather than being tightly clenched, and the long, thin locks of hair. The portrait features, in particular the thin mouth and prominent eyes, are also typical of the first century BC (see cat. no. 163). The use of a single rather than double cornucopia for Cleopatra VII does not correspond with the other statues in this group, but can perhaps be explained by an Egyptian borrowing a Greek iconographic feature. The triple uraeus, on the other hand, occurs on all of the other statues that have been identified as the last Ptolemaic queen.

BIBLIOGRAPHY: W. Needler, 'Some Ptolemaic Sculptures in the Yale University Art Gallery', *Berytus* 9 (1948–9), 137, 139–140; B.V. Bothmer *Egyptian Sculpture of the Late Period* (New York 1960), 145–6, no.113 [Cleopatra II or III]; S-A. Ashton, 'Ptolemaic royal sculpture from Egypt: the interaction between Greek and Egyptian traditions', *BAR* (Oxford, forthcoming), no. 64 [Cleopatra VII].

S-A.A.

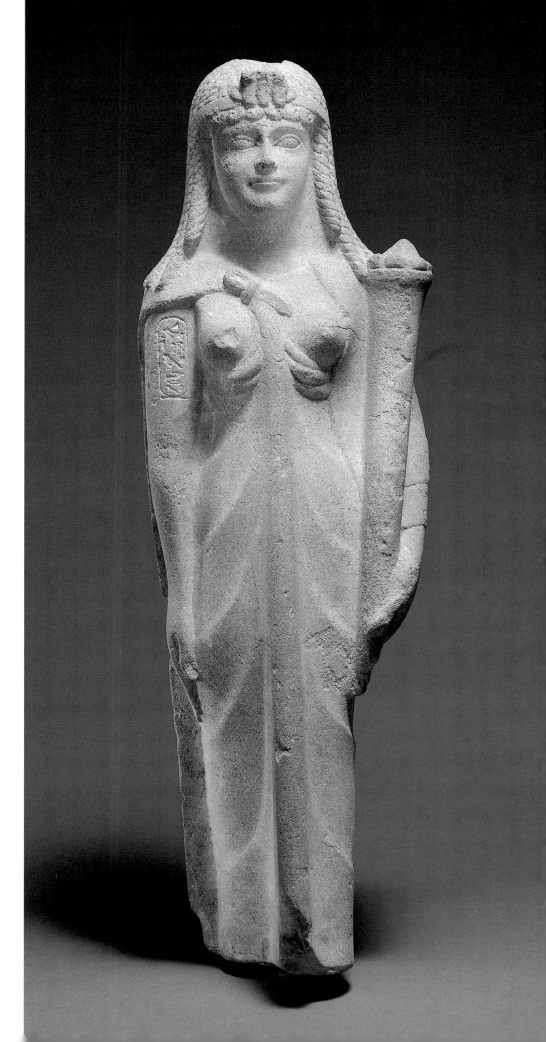

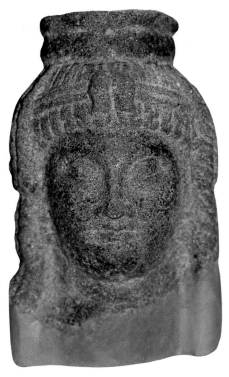

165

165 Granite head of Arsinoe II

First century BC

From Canopus

Height 16 cm.

Alexandria, Greco-Roman Museum 18370

The head is preserved to the neck. The hole in the plain *modius* at the top of her head would have originally supported a crown, now missing.

The queen wears her hair in two rows of corkscrew locks and has ringlets on her forehead. The double uraeus on the narrow diadem identifies the ruler as Arsinoe II, even though the back pillar is uninscribed. The face is round and the eyes have incised lids and rounded eyebrows. The nose is short with flaring nostrils and the mouth is straight with very thin lips. These features are also found on an inscribed statue of Cleopatra VII, now in the Metropolitan Museum, New York

(cat. no. 164). See pp. 152–5 for a full discussion of the identification of both images.

BIBLIOGRAPHY: E. Breccia, *Le rovine e i monumenti di Canopo. Teadelfia e il tempio di Pneferôs.* Monuments de l'Egypte gréco-romaine 1 (1926, Bergamo), 60 f. [Berenike II?]; H. Kyrieleis, *Bildnisse der Ptolemäer* (Berlin 1975), 118, 183, M2 [first century BC]; S-A. Ashton, 'Ptolemaic royal sculpture from Egypt: the interaction between Greek and Egyptian traditions', *BAR* (Oxford, forthcoming), no. 65 [Arsinoe II, first century BC].

S-A.A.

166 Limestone statue of Arsinoe II

Mid-second century BC

Provenance unknown.

Height above modern base: 38.1 cm, height of base 1.7–2.1 cm, width 4.3–7.3 cm, thickness 13.1 cm

New York, Metropolitan Museum of Art 20.2.21 (Purchased, Rogers Fund, 1920)

The crown is missing and the inscription on the back pillar is badly damaged. The top of the coiffure and the nose are also damaged and much of the original paint is missing. Traces of gilding, black paint on the hair and dress, and red and black paint on the cornucopia survive.

This limestone statue represents Arsinoe II and shows the queen striding forward with the left leg advanced in the traditional Late Period Egyptian manner. The queen holds a double cornucopia in her left arm, with her hand wrapped around the base; her right arm, with clenched hand, is held rigidly by her side. On her head she wears a wig of corkscrew locks over a fringe of tightly twisted curls. Her dress consists of a chiton and himation with a fringed edge, which is draped over the right shoulder and tied in a knot above the right breast. The folds of the undergarment show Hellenistic Greek influence and are typical of the second century BC.

Bianchi dated the statuette to a period after the Queen's death but during the reign of Philadelphos (270–246 BC) because of the hieroglyphic inscription, which he compares to a fragmentary statue in Alexandria manufactured at that time. However, the rounded, fleshy face is

very similar to the portrait features of Ptolemy VIII (see cat. no. 22), particularly the close-set, rounded eyes with arched eyebrows that follow the curve of the upper lid. The mouth is also similar to the portraits of Ptolemy VIII, with small, fleshy lips, which are straight rather than downturned in profile. The neck is very short and the shoulders are rounded. The lack of inscribed statues from the Ptolemaic period make their dating and comparison problematic, and although Bianchi quite rightly uses a third-century-BC Alexandrian statue as a parallel for the inscription on the Metropolitan queen, the features suggest a later, second-century-BC date. The continuation of the double form of the cornucopia on a posthumous portrait of Arsinoe II demonstrates that the iconography associated with individual royal cults remained consistent; this was probably to ensure immediate recognition. The back pillar is carved up to the top of the head and probably the crown, if there was one. It is badly damaged and the text is extremely difficult to read and problematic. From what is legible, the following translation is likely: 'King's [daughter], King's [sister], King's [wife], daughter of [Amu]n, mistress of the two lands, Arsinoe, the divine, brother-loving who lives forever.'

BIBLIOGRAPHY: N. Scott, *Egyptian Statuettes* (New York 1946), fig. 36; W. Needler, 'Some Ptolemaic Sculptures in the Yale University Art Gallery', *Berytus* 9 (1948–9), 137, 139–140; B.V.Bothmer, *Egyptian Sculpture of the Late Period* (New York 1960), 159–60, no. 123; M. Bieber, *The Sculpture of the Hellenistic Age*, 2nd edn (New York 1961), 92, n.23 [Cleopatra VII]; J. Frel, 'A Ptolemaic Queen in New York' *AA* 86 (1971), 211–14; H. Kyrieleis, *Bildnisse der Ptolemäer* (Berlin 1975), 82, 178, 188, J1; R.S. Bianchi, 'Not the Isis Knot', *BES* 2 (1980), 12, 17, 19, figs 5–6; J. Quaegebeur, 'Trois statues de femme d'époque ptolémaïque', in H.DeMeulenaere and L.Limme (eds), *Artibus Aegypti: Studia in honorem Bernardi V. Bothmer* (Brussels 1983), 115f.; R.S. Bianchi (ed.), *Cleopatra's Egypt: Age of the Ptolemies* (New York 1988), 47, 67, 69, 73, 84, 165, 170–, 180, 183, 184, 194, 206, 208, 231, 239, 244, no. 66; E.J. Walters, 'Attic grave reliefs that represent women in the dress of Isis', *Hesperia Supplement* 22 (1988), 8 n.20, 9 n.26, 10 n. 33; R.R.R. Smith, *Hellenistic Royal Portraits* (Oxford 1988), 95, n. 51; F. Queyrel in M. Rausch (ed.), *La Gloire d'Alexandrie* (Paris, 1998), 80, cat. no. 39.

S-A.A.

166 ▶

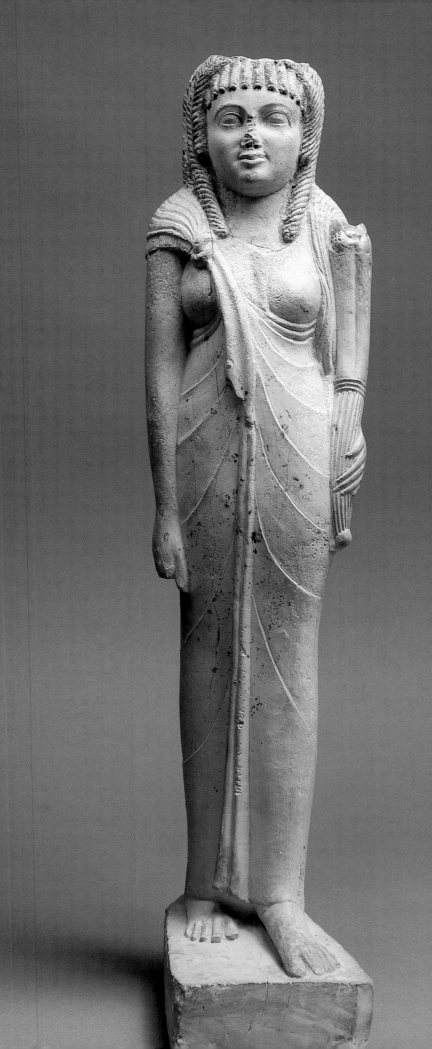

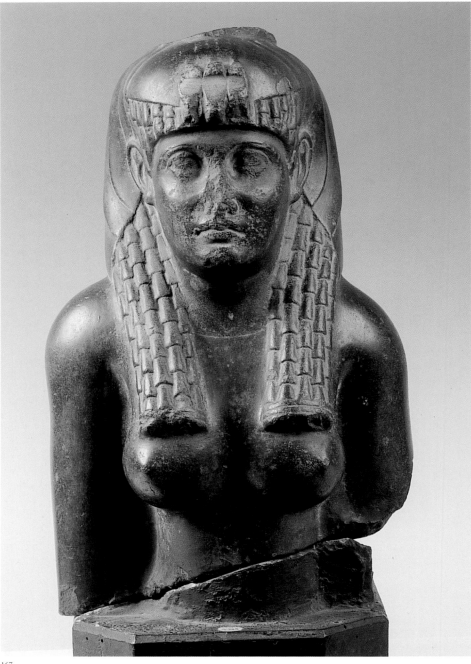

167

167 Basalt bust of a Ptolemaic queen, perhaps Cleopatra VII

Variously dated from the third to the first century BC

From Egypt, formerly in the Drovetti Collection

Height 54 cm

Turin, Egyptian Museum C 1385

The bust, which displays a rather clean oblique cut at the level of the waist, belonged to a statue of a Ptolemaic queen. This much is clear from the physiognomical, iconographic and stylistic features, but the individual subject may not be identified with certainty.

The face is framed by a tripartite wig, whose curls are rendered geometrically; the wig is surmounted by a vulture-shaped headdress, a typical attribute of female divinities with connotations of goddess-mothers (see, for example, Mut), and of queens, a tradition passed down from the Pharaonic era. The headdress is embellished above the forehead by three uraei, a particularly unusual feature, interpreted either as the assimiliation of the head of the vulture within the more familiar double uraeus or as a mark of further territory acquired for Egypt by the soveriegn (Capriotti Vittozzi 1995, 427–31, who with this hypothesis would confirm the attribution of the statue to Berenike II, daughter and heir of Magas of Cyrene, who added Cyrenaica to Egypt, and the wife of Ptolemy III). On the tip of the head there is still the cutting for a crown (now lost), probably a base surmounted by a diadem of the type worn by the goddess Hathor. The face, whose realistic modelling echoes Greek influence, in contrast with the hairstyle and attributes of purely Egyptian origin, is characterized by strong features, such as the accentuated cheekbones that highlight the eyes, and a downturned mouth, resulting in a severe expression. The figure wears a tunic (of which the carved neckline is visible), which rather clings to the body, highlighting the soft forms and full breasts. The shoulders are asymmetrical, the left one slightly lowered, perhaps because the arm was folded to support a cornucopia (Cappriotti

Vittozzi 1995, 431). The backing pilaster, which begins at the base of the wig, is uninscribed.

The sculpture's traits, which combine a peculiar Egyptian iconography with Greek stylistic fashions, show how 'far it is from the stylizations of Saitic statuary and from those of the early Ptolemaic era' (Donadoni 1993, 206, who dates it to the end of the third century BC). Of the various proposed identifications, almost all interpret the 'portrait' as representing either one of the first Cleopatras (I, II, or III) or Berenike II, but S-A. Ashton has recently suggested that Cleopatra VII is the subject (see below).

E.L.

The great attention given to the details of the headgear with the vulture-figured headdress, and to the crafting of the ear, decorated with something akin to a floral motif, illustrate the high quality of this sculpture. It has been suggested that the missing left arm held up a cornucopia, of which no traces remain, but it could also be that the left arm was crossed over the bust in a way similar to the Vatican's Arsinoe (p. 150, fig. 5.3).

Various identifications have been proposed: Cleopatra II or III, if the central motif is interpreted as a triple uraeus; Arsinoe II, with the head of a vulture within a double uraeus; Cleopatra I, for the territories associated with the Syrian princess who married Ptolemy V. Lastly, it has been proposed that the piece represented Berenike II for stylistic reasons. However, the equivalent in Greek style that is closest to the Turin queen is the head of a Ptolemaic sovereign coming from the Esquiline, Rome (cat. no. 194), here identified as Cleopatra VII. As far as the attributes are concerned, the central motif appears to be composed of three similar figures and could therefore be interpreted as a triple uraeus. It is also worth pointing out that, from the second century BC, the head of the bird is sometimes omitted from statues with a vulture headdress.

S-A.A.

BIBLIOGRAPHY: E. Scamuzzi, *Museo Egizio di Torino* (Turin 1965), pls CX – CNI ; B.V. Bothmer, *Egyptian Sculpture of the Late Period* (New York 1960), 134,147; H. Kyrieleis, *Die Bildnisse der Ptolemäer* (Berlin 1975), 184, M6; S. Curto, *L'Antico Egitto nel Museo Egizio di Torino* (Turin 1984), 292, 294 fig.; S. Donadoni, 'L'Immagine e la Forma: L'Esperienza della Scultura', in *Egizio di Torino. Civiltà degli Egizi*, III, *Le Arti della Celebrazioni* (Milan 1989), 182 pl. 275,184; S. Donadoni, 'Egitto, Greco, Romano e Copto', in *L'Antico Egitto nel Museo Egizio di Torino. Guida alla Lettera di Una Civiltà (*Novara 1993, new edn*)*, 206; G. Capriotti Vittozzi, 'Un Busto di Regina Tolemaica al Museo di Torino. Note Sull'Iconografia di Berenice II e di Cleopatra I', in *Atti della Accademia Nazionale dei Lincei, Anno CCCXCII, 1995, Classe di Scienze Morali, Storiche e Filologiche. Rendiconti, serie IX, VI, Fascicolo 2* (Rome 1995), 409–38.

168 Granite statue of a late Ptolemaic queen

First century BC

From Fouah

Height 53 cm

Alexandria, Greco-Roman Museum 3227

The statue is preserved from the waist to the head, and the crown is now missing. The uraeus and nose are damaged, and the back pillar is almost completely eroded, and it is possible that it was once inscribed. The arms have been broken off below the shoulder.

The queen wears a stylized garment with heavy folds around the shoulders, forming a knot between the breasts and with a fringed edge on the section covering the right shoulder. She wears an echeloned, tripartite wig with a diadem and single uraeus (now missing). The face is youthful, with a pointed chin and slightly upturned mouth in profile. The eyes are almond shaped, and the brows accentuate the curve of the upper lids. Such features are typical of the first century BC and the image could, therefore, represent one of Cleopatra VII's immediate predecessors or even the youthful queen herself. Because there are no distinct iconographic features, it is not possible to identify the sculpture more precisely. However, the back pillar, which reaches the head and continues over the top, is identical to several of the images with a triple uraeus that have been identified as Cleopatra VII (cat. nos 160–164).

BIBLIOGRAPHY: B.V. Bothmer, *Egyptian Sculpture of the Late Period* (New York 1960), 135.

S-A.A.

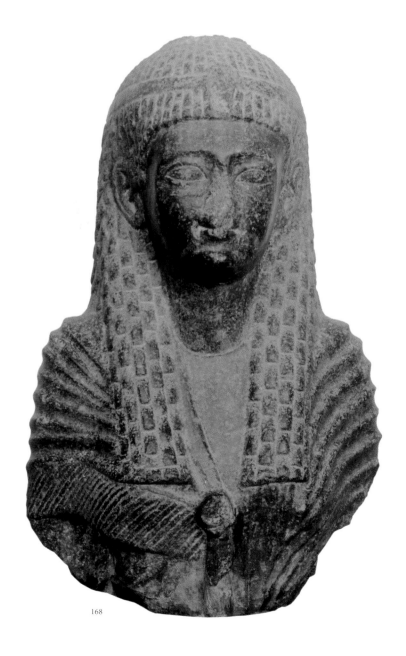

168

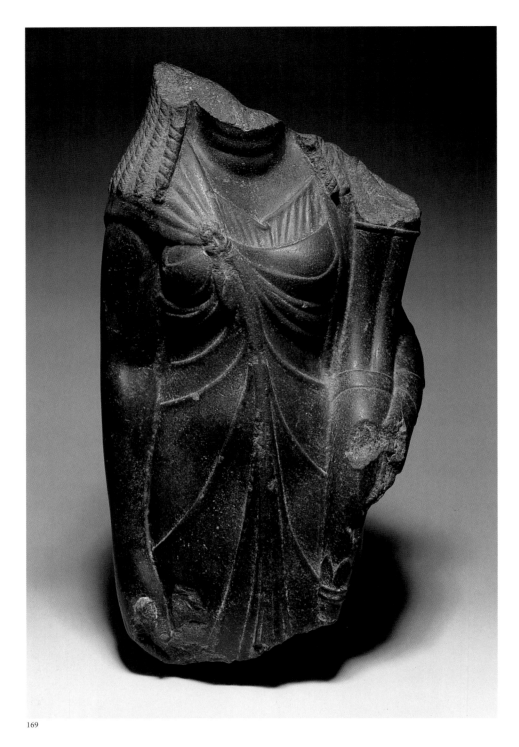

169

169 Basalt statue of Arsinoe II or Cleopatra VII

Mid- to late first century BC

Provenance unknown

Height 42 cm

Cambridge, Fitzwilliam Museum E27.1981

The statue is preserved from the upper thighs to the neck. There is some superficial damage to the top of the cornucopia and left hand.

Although the exact identity of this Egyptian-style torso of a Ptolemaic queen must remain speculative, because the back pillar is uninscribed, the attributes and style of drapery indicate a late Ptolemaic date. This narrows the possibilities for the identification of the subject. The cornucopia is split in two, and for this reason the queen has been identified as a posthumous image of Arsinoe II. However, the double form of this attribute, originally associated with the Greek royal cult, is also found on the reverse of the Cypriot coins of Cleopatra VII. The statue may therefore represent Arsinoe II or Cleopatra VII.

The queen wears a himation, which hangs in heavy folds over the right shoulder and is then secured in a knot over the right breast. This garment is worn over a chiton, which forms more delicate folds around the neckline. There are also three Venus rings on the neck, a feature common on Egyptian representations of the Ptolemaic women from the mid-second century BC. The breasts are not as full as in the typical representations of Ptolemaic women, since the drapery obscures them and the locks of hair are also longer than usual. Like the Metropolitan Cleopatra VII (cat. no. 164), this statue has much in common with a version in the Cairo museum without a back pillar (JE 27473). Uniquely, the right hand of the Cambridge statue also clutches a wreath, which may suggest that the statue represented a deceased queen.

BIBLIOGRAPHY: *Christie's Auction Catalogue* (London 20 May 1981), 47, no. 215; E. Vassilika, *Egyptian Art* (Cambridge 1995), 120, no. 56 [Arsinoe II, mid-second century BC]; S-A. Ashton, 'Ptolemaic royal sculpture from Egypt: the interaction between Greek and Egyptian traditions', *BAR* (Oxford, forthcoming), no. 66.

S-A.A.

170 Limestone crown of Cleopatra VII?

First century BC

Excavated at Koptos

Height 52 cm, width 22 cm, thickness 21 cm

London, Petrie Museum of Egyptology UC 14521

There is superficial damage to the sides of the crown and around the sun disc. The cow's horns are broken at the base and the heads of the right and middle cobras are missing. The top right square edge of the back pillar is missing and there is minor damage to the surface. On the back pillar is a hieroglyphic inscription in two columns, now worn, especially the lower left column; the lower section is missing. The inscription reads: '1. Hereditary noble, great praise, mistress of Upper and Lower Egypt, contented… 2. King's daughter, king's sister, great royal wife, who satisfies the heart of Horus…'.

No cartouche is preserved but it has been suggested that the queen to whom the titles refer is Arsinoe II, sister and wife of Ptolemy II, who was indeed daughter of a king, sister of a king and royal wife. Furthermore, the crown was found between the second and third pylons of Isis at the temple dedicated to Min and Hathor/Isis at Koptos, which was rebuilt by Ptolemy II. The crown consists of a sun disc, decorated with three cobras, and cow's horns with two stylized plumes.

However, the identity of the statue that once supported this crown is questionable because Arsinoe II is not known to have worn this type of crown, nor is she associated with the triple form of uraeus. The titles 'king's daughter, king's sister and royal wife' are applicable to several of the Ptolemaic queens including Cleopatra VII, who was married to both of her siblings and was the daughter of a king. As noted, the site was patronized by Ptolemy II, and there is later evidence of royal patronage by Ptolemy VIII, Ptolemy IX, Ptolemy XII, and Cleopatra VII, who dedicated a barque shrine at the site. Unfortunately, it is not known when Cleopatra made additions to the site, but is often assumed that it was during her trip down the Nile with Julius Caesar. Because the triple uraeus and this more general crown are unusual for Arsinoe II, it seems more likely that this statue represented Cleopatra VII and was perhaps dedicated during the building of the barque shrine at the temple complex.

170a

BIBLIOGRAPHY: W.F. Petrie, *Koptos (London 1896)*, 21 f., pl. 26.3; K. Sethe, *Hieroglyphische Urkunden der griechisch-römischen Zeit*, 2: *Historisch-biographische Urkunden aus den Zeiten der makedonischen Könige und der beiden ersten Ptolemäer* (Leipzig 1904), 73, no. 17; B. Porter and R. Moss, *Topographical Bibliography of Ancient Egyptian Hieroglyphic Texts, Reliefs and Paintings*, no.5, 123; J. Quaegebeur in R.S. Bianchi, *Cleopatra's Egypt: Age of the Ptolemies* (New York 1988), 73–108; M. Gabolde in G. Galliano *et al.* (eds), *L'Egypte antique aux portes du désert.* Exhib. Lyon, Musée des Beaux-Arts (Lyon 2000), 77, no. 41.

S-A.A.

170b

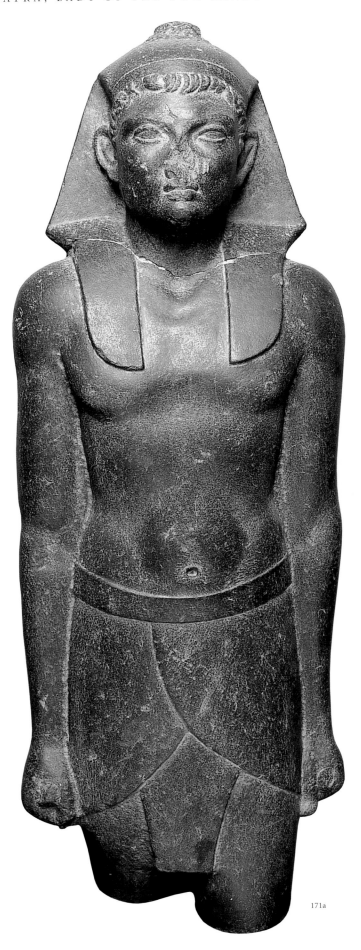

171a

171 Part of a basalt statue, possibly representing Caesarion

c. 35–30 BC

Said to be from Karnak (sent by Barsanti in 1915)

Height 96 cm

Cairo, Egyptian Museum 13/3/15/3

The statue is preserved from the base of the crown to the knees. The nose and back of the headdress are damaged and there is a break at the base of the neck, now repaired.

This Egyptian-style statue represents a ruler supported by a back pillar, originally preserved to shoulder level, but the surface and the inscription of the pillar have been deliberately removed. The ruler wears a plain *nemes* headdress and a kilt with a low waistband; there is a small *modius* on the top of the headdress. The ruler strides forward with the left leg, the arms held firmly by the sides, the hands holding bars. The stomach muscles are well defined and the pectoral muscles are softly modelled; the nipples are shown and the belly button is an incised hole.

The face is rounded, with a small nose and well-defined eyes. The downturned mouth and the slightly squared chin are both features commonly found on first-century-BC portraits, and the statue is often identified as a representation of Mark Antony, despite the fact that he was not crowned pharaoh and Cleopatra VII took Caesarion as her consort. It is, therefore, more likely that the statue represents her son Caesarion. The youthful appearance of the portrait supports this identification and may explain why the inscription was removed. The hair beneath the *nemes* headdress is styled in Greek fashion, with locks falling towards the centre of the head.

BIBLIOGRAPHY: F.W. v. Bissing and F. Bruckmann, *Denkmäler ägyptischer Sculptur* (Munich 1914), 3ff; C. Michalowski, 'Un portrait égyptien d'Auguste au musée du Caire', *Bulletin de l'Institut français d'archéologie orientale* 35 (1935), 73–88, 73ff; B.V. Bothmer, *Egyptian Sculpture of the Late Period* (New York 1960), 177; G. Grimm, 'Zu Marcus Antonius und C.Cornelius Gallus', *Jahrbuch des Deutschen Archäologischen Instituts* 85 (1970), 158–70; H.W. Müller, *Ägyptische Kunst* (Frankfurt 1970), 50, no. 191 ; G. Grimm and D. Johannes, *Kunst der Ptolemäer und Römerzeit in Ägyptischen Museum Kairo* (Mainz 1975), 19, no.14; W.-R. Megow, 'Zu einigen Kameen späthellenistischer und frühaugusteischer Zeit', *Jahrbuch des Deutschen Archäologischen Instituts* 100 (1985), 49,1 no.18, 494; F. Queyrel, catalogue entry, in M. Rausch (ed.), *La Gloire d'Alexandrie. Cat. Exh. Petit Palais* (Paris 1998), 285 no. 229; S-A. Ashton, 'Ptolemaic royal sculpture from Egypt: the interaction between Greek and Egyptian traditions', *BAR* (Oxford, forthcoming), no. 33 [Caesarion].

S-A.A.

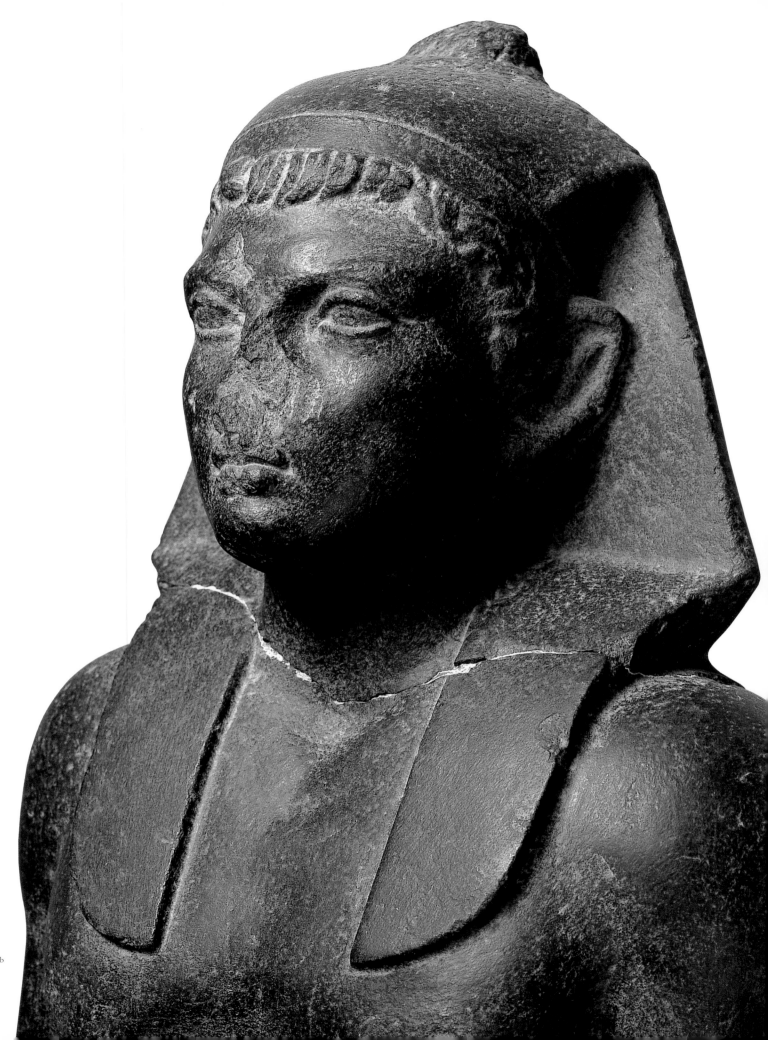

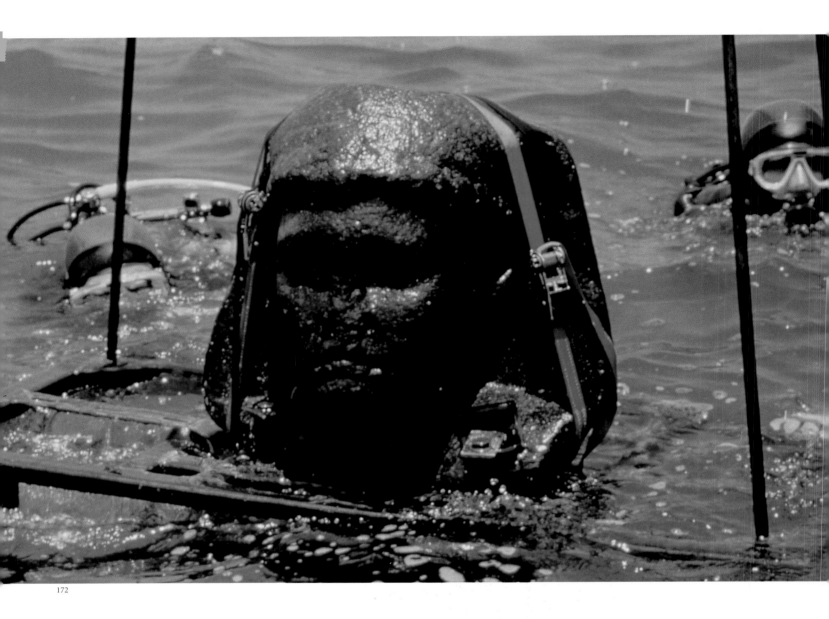

172

172 Fragment of a granite statue of Caesarion (?)

c. 45–30 BC

Excavated in paving on the eastern side of the east harbour at Alexandria

Height 80 cm

Alexandria, Greco-Roman Museum 1015

The surface of the sculpture is worn by water erosion, the nose is damaged and the uraeus is missing. Only the head is preserved. The ruler wears a plain *nemes* headdress with a fringe of hair protruding underneath, a Greek feature. The face is broad and flat; the mouth is full, with downturned lips; and the chin has a prominent line below the lips, a characteristic feature of Ptolemaic royal portraits in the late second and first centuries BC. The eyebrows are rounded and the eyes have well-defined lids, again typical of late Ptolemaic fashion.

The portrait has been identified as Octavian but is very similar to the Turin queen (cat. no. 167), identified here, on stylistic and iconographical grounds, as Cleopatra VII. The head should be reconsidered as an image of Caesarion: the style of the hair in short waves combed towards the centre of the forehead compares well to the other representations of first-century-BC royal princes.

BIBLIOGRAPHY: Z. Kiss in F. Goddio (ed.), *Alexandria: the submerged royal quarters* (London 1998), 175–7; for the findspot, see p. 47.

S-A.A., S.W.

173 Round-topped sandstone stela with Caesarion offering to deities

31 BC

From Coptos, Egypt

Height 74.5 cm, width 53 cm

London, British Museum EA 1325

At the top, below a winged sun disc with pendent uraei, wearing sun-discs and flanking a scarab, symbol of the newly-risen sun, is a double offering scene framed by two *was* sceptres and the sign for 'heaven'. At the right a pharaoh wearing the Double Crown, who is unnamed since the two cartouches are empty, presents two cos lettuces to the ithyphallic fertility god, Min, whose favourite food they were. As usual, Min wears two plumes on his head and a flail floats over his upraised

arm. The hieroglyphs name the god specifically as Min of Coptos, his chief cult site in Upper Egypt at the Nile Valley end of the Wadi Hammamat, the main eastern desert crossing to the Red Sea. Behind him, separated by his cult fetish and the further epithet 'Possessor of Joy', stands his consort at Coptos, Great Isis the divine mother, wearing vulture headdress and cow's horns and disc, and carrying a papyrus sceptre and ankh. In the other scene the unnamed king offers wine to Geb, prince of the gods, who wears the White Crown of Upper Egypt, and to crocodile-headed Sobk, who is specifically said to be a guest in Min's temple; his own chief cult sites were in the Fayum, at Gebelein and at Kom Ombo. Both gods carry *was* sceptres and ankhs.

Empty cartouches are frequently encountered in Ptolemaic royal scenes and the unnamed ruler does display the typical Ptolemaic physiognomy, but a fixed date is provided by the text in demotic, the third and most cursive of the Egyptian scripts, incised in thirty-one red-filled lines beneath the figured scene. It is a legal contract and so is dated exactly as a contract written on a demotic papyrus would be. It begins with the regnal year with month and day: 'Year 22 which is the equivalent of year 7, first month of *akhet*, day 22', which in the Gregorian calendar is 21 September 31 BC. It continues 'of the female pharaoh, the bodily daughter of kings who were on their part kings born of kings, Cleopatra the beneficent father-loving goddess and of pharaoh Ptolemy called Caesar, the father- and mother-loving god'. Thus the unnamed pharaoh is Caesarion.

The contract is an agreement drawn up in perpetuity between a guild of thirty-six linen manufacturers (who are all individually named) and their families and, in the first instance, two high-ranking priestly officials of Coptos, concerning the expenses of the local Apis bull. The sacred animal of Min was also a bull, so assimilation between it and the more famous Apis would not have been difficult. In the second instance the agreement is with the guild of local embalmers and concerns payment for the embalming of the Apis and other local sacred animals, for the training of the embalmers and the cost of clothing their children and wives. The guild of linen manufacturers is to be paid in gold and wine. Just as though the text were written on a papyrus, it is signed by its scribe and there is even a list of witnesses' names at the end. There can be no doubt that this stela was set up in the house used by guild members, where it would have served as a visible reminder of their agreed rights. Thus far similar texts have been found only on papyrus.

It has sometimes been suggested that the double dating of the last seven years of Cleopatra's reign refers not to her co-regency with Caesarion but to the new beginning made with the acquisition of Syrian territories in 37 BC. This would represent a very idiosyncratic Egyptian method of regnal dating, indicating a renaissance of some kind: exactly the same double dating occurred in the latter part of the reign of Ramesses XI of the Twentieth Dynasty over 1,000 years earlier. It is of particular interest that this text was inscribed only nineteen days after the Battle of Actium took place.

BIBLIOGRAPHY: A. Farid, *Fünf demotische Stelen aus Berlin, Chicago, Durham, London und Oxford mit zwei demotischen Turinschriften aus Paris und einer Bibliographie der demotischen Inschriften* (Berlin 1995), 32–76.

C.A.

173

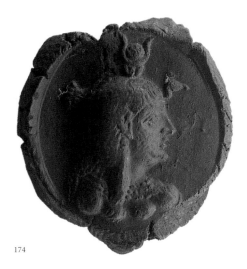

174

175

176

174 Clay seal impression with a portrait of Cleopatra VII

51–30 BC

Said to have been found at Edfu

Height *c.* 2 cm, width *c.* 1.8 cm

Toronto, Royal Ontario Museum 906.12.162

This well-preserved clay seal impression shows the portrait of a female wearing an Egyptian tripartite wig, vulture headdress, with vulture head and a small Egyptianizing crown consisting of a sun disc and cow's horns, as worn by the goddess Isis. The subject has a long, straight nose with flared nostrils, and a large eye. Around her neck is a necklace consisting of three strands, beneath which she wears a sheath-like Egyptian costume. The impression is very similar to that on a gold ring (cat. no. 195) and a marble head (cat. no. 194). Although it has been suggested that the representation is of an early Cleopatra, the obvious association with Isis, the prominent necklace and the overall portrait type mean that it may equally represent Cleopatra VII.

BIBLIOGRAPHY: H. Kyrieleis, *Bildnisse der Ptolemäer* (Berlin 1975), pl. 100.4 [early Cleopatra]; D. Plantzos, 'Female portrait types from the Edfu hoard of clay seal impressions', *Bulletin de Correspondance Hellénique* suppl. 29 (1993), fig. 18 [Isis].

S-A.A.

175 Clay seal impression with a portrait of Cleopatra VII

51–30 BC

Said to have been found at Edfu

Height *c.* 2 cm, width *c.* 2 cm

Toronto, Royal Ontario Museum 906.12.166

This well-preserved seal impression show the portrait of a royal female, as identified by the *stephane* (crown) that she wears and the sceptre behind her shoulders. The style of the image and the attributes are Greek, as is the chiton that the queen wears. The strong, aquiline nose and hair tied back in a bun identify the subject as Cleopatra VII. The earring and necklace, which is partly obscured, accord with the representations of the queen on coinage (cat. nos 221–222).

BIBLIOGRAPHY: Cf. H. Kyrieleis, *Bildnisse der Ptolemäer* (Berlin 1975), pl. 107.1–7 [Cleopatra VII].

S-A.A.

176 Clay seal impression with a portrait of Cleopatra VII

51–30 BC

Said to have been found at Edfu

Height *c.* 1.8 cm, width *c.* 1.8 cm

Toronto, Royal Ontario Museum 906.12.168

There is a small section missing from the lower edge. The portrait on this clay seal impression shows the image of a queen wearing a broad diadem. The portrait features show a strong, hooked nose and compare well with the Ascalon coin issues of Cleopatra VII (cat. nos 219–220).

S-A.A.

177–186 The coinage of Cleopatra VII (cat. nos 177–186)

By the time of Cleopatra's accession to the throne in 51 BC the days of impressive gold and high quality silver coinage were gone. The economic and political demise of the Ptolemaic dynasty in the first century BC is thus well reflected in its coinage. No gold was issued by the queen at all. The basic silver coinage of her kingdom, moreover, was now heavily debased. Whereas silver tetradrachms of the early Ptolemies had contained 98–99 per cent silver, and even those of Ptolemy Auletes had contained 80–90 per cent on average, the silver coins of Cleopatra typically contained less than 40 per cent silver.

Through this radical reform Cleopatra was, in fact, providing the initial impetus for the debasement of Egyptian coinage that would continue in the province under Roman rule. At the same time, it appears that the result of this reform was to make the new debased silver coinage compatible with the Roman denarius. In terms of weight, the silver content of the new royal issues was close to that of the denarius (about 3.5–4g per coin). Moreover, it is clear from later papyrological evidence that the coinage of Cleopatra, which continued to circulate in Egypt after the creation of the Roman province, was later treated as equal in value to the denarius.

Also innovative was her approach to the bronze coinage of the kingdom. The pattern of production of bronze coinage under the Ptolemies to a large degree mirrors that in the precious metals. Large quantities had been produced under the early rulers, but production had gradually declined. Under Cleopatra's two immediate predecessors virtually no bronze had been produced at Alexandria. Cleopatra now recommended the production of bronze in her capital.

BIBLIOGRAPHY: L.C. West and A.C. Johnson, *Currency in Roman and Byzantine Egypt* (Princeton 1944); O. Mørkholm, 'Ptolemaic Coins and Chronology: the Dated Silver

Coinage of Alexandria', *ANSMN* 20 (1975), 7–24; A. Gara, 'Egitto' in A.M. Burnett and M.H. Crawford (eds), *The Coinage of the Roman World in the Late Republic* (Oxford 1987), 153–163; R.A. Hazzard, 'The Composition of Ptolemaic Silver', *JSSEA* 20 (1990), 89–107; R.A. Hazzard, 'Two Hoards of Ptolemaic Silver: *IGCH* 1713 and 1722', *NC* 154 (1994), 53–66; K. Maresch, *Bronze und Silber. Papyrologische Beiträge zur Geschichte der Währung im ptolemäischen und römischen Ägypten bis zum 2. Jahrhundert n. Chr. Papyrologica Coloniensia XXIV* (Opladen 1996).

A.M.

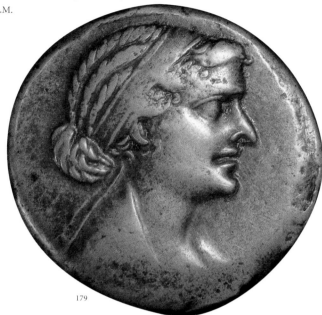

179

177 Silver drachm of Ptolemy XII Auletes

80–51 BC

Mint of Alexandria

London, British Museum BMC Ptolemy XIII 34

177

The coin bears a portrait of Ptolemy XII with a broad diadem and wavy, unkempt hair. The hooked nose and pointed chin are typical of the late Ptolemaic portraits and a similar image can be seen on the seal impression cat. nos 156–158.

UNPUBLISHED.
A.M., S-A.A.

178 Silver drachm of Cleopatra VII (51–30 BC)

47/46 BC

Mint of Alexandria

London, British Museum BMC Cleopatra VII 1

178

Although no silver portrait tetradrachms were produced by Cleopatra, she did follow her father's lead in producing silver drachms with her portrait. They were issued on two occasions, in the sixth and eleventh years of her rule (47/46 and 42/41 BC).

UNPUBLISHED.
A.M.

179–182 Bronze eighty drachma coins of Cleopatra VII

51–30 BC

Mint of Alexandria

Hunterian Museum, University of Glasgow
Cleopatra VII/Macdonald 14; London, British Museum
CM 1857-8-22-46; London, Weill Goudchaux Collection;
London, Weill Goudchaux Collection

180

181

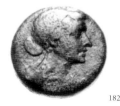

182

183–185 Bronze forty drachma coins of Cleopatra VII

51–30 BC

Mint of Alexandria

London, British Museum BMC Cleopatra VII 9; London, British Museum BMC Cleopatra VII 6; London, Weill Goudchaux Collection

Cleopatra's approach to bronze coinage was innovative in a number of ways. Her production of substantial issues at the mint of Alexandria was in some sense a return to the status quo of a century earlier, after the decline of production there in the interim. A complete innovation on her bronze coinage was the appearance of

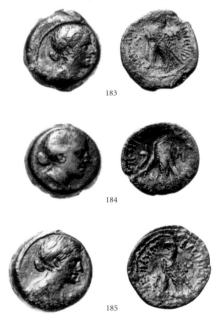

183

184

185

denominational marks. The larger value coins were marked with a Greek letter Pi (Π), the symbol for the number eighty. The lower value coin was marked with a Mu (M), the number forty.

An ancient metrological treatise records a table of weight-standards established by Cleopatra, and the evidence of this bronze coinage certainly points towards a reform of the bronze weights in

use in Egypt during her reign. Since the third century BC constant inflation within Egypt seems to have caused a dislocation between the metal value of bronze used in Ptolemaic coinage and its actual value in monetary transactions. The resulting instability may account for the cessation of production of bronze coinage in Alexandria in the late second and early first centuries. Cleopatra's reform seems to have sought to make explicit for the first time the fiduciary nature of bronze coinage: it took its value not from its weight, but rather from the value she gave it and with which she marked it.

This bold step, together with the debasement of the silver, indicates a clear policy of interventionism in the monetary economy on the part of the Ptolemaic administration during Cleopatra's reign. Whereas the policy under previous kings had, by and large, been to maintain the monetary system they had found in place, Cleopatra's treatment of both bronze and silver issues is indicative of a desire to innovate and adapt to new circumstances.

UNPUBLISHED.

A.M.

186 Bronze coin of Cleopatra VII

51–30 BC

Minted on Cyprus

London, British Museum BMC Cleopatra VII 3

Cleopatra also produced a bronze coinage on the island of Cyprus, which had been restored to her kingdom by Caesar. In contrast to the issues produced in Egypt, the bronze coinage of Cyprus was given no denominational marks. The obverse design also differed in the appearance not just of the queen's head, but also that of her young son Caesarion in front of her. The design could thus perhaps be interpreted as Aphrodite and Eros or Isis and Harpokrates. These differences from the issues of Alexandria (cat. nos 179–185) may perhaps suggest an abnormal, commemorative occasion for the Cypriot issue, possibly connected with the birth of her son in 47 BC.

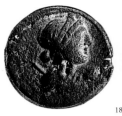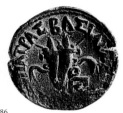

186

On this coin the queen wears a *stephane* (crown) and her hair is arranged in the so-called melon coiffure. To the left of the image is a sceptre, similar to that on the coins of Arsinoe II. On the reverse is a double cornucopia, again as on the coins of Arsinoe II.

UNPUBLISHED.

A.M., S-A.A.

187 Greywacke statue of Panemerit, governor of Tanis

Reign of Ptolemy XII Neos Dionysos, 80–59/58 BC, 55–51 BC

Found in the forecourt of the temple of Amun, Tanis

Height 83.5 cm, width 53 cm

(body) Paris, Musée du Louvre E 15863, (head) Cairo, Egyptian Museum JE 15154 = CG 27493

The head and upper part of the body are preserved, but both forearms have broken away.

This fragmentary statue of the governor of the city of Tanis, identified through an inscription as Panemerit, belongs to a series of monuments placed in a small chapel located at the forecourt of the temple of Amun, the chief deity of the town. The head was unearthed by A. Mariette and is now in Egyptian Museum, in Cairo. In 1937 P. Montet discovered the torso and proved that it belonged to the head in Cairo. Panemerit's statue is of the striding type, and he originally held a statue of the god Horus of Mesen, another senior deity of the Ptolemaic Tanis, to his stomach with his now missing left hand. The other hand was raised in a gesture of worship.

The back pillar bears an biographical inscription giving the titles and filiation of the subject. Unlike the texts of Panemerit's other statues, no

allusion is made here to the work he undertook in the temples of Tanis under the reign of Ptolemy XII Neos Dionysos (Auletes). It is therefore one of the masterpieces of private statuary of the last phase of the Ptolemaic dynasty, and also one of the well-dated examples of the prevailing style of the time. Because of its exceptional quality, this statue has been considered a prime example of Greek influence over the traditional Egyptian sculptural styles. It rather exemplifies the last stylistic phase of an former Egyptian trend rooted in the Thirtieth Dynasty. The Greek-inspired features, such as the hairstyle, have been used to enhance the status of the owner of the statue. It might have been typical for high-ranked Egyptians to use the Greek style as a sign of their social status during the last phase of Greek rule of Egypt.

BIBLIOGRAPHY: C. Zivie Coche , *Cahiers de Tanis* (1984), t. I p. 177; B.V. Bothmer, *Egyptian Sculpture of the Late Period* (New York 1960), 171; P. Montet, *Kemi* VIII (1946), 50, pl. IX, XI; P. Montet, 'Un chef-d'oeuvre de l'art Greco-Egyptien: La statue de Panemerit', *Mon. Piot* (1958), 1– 10.

M.É.

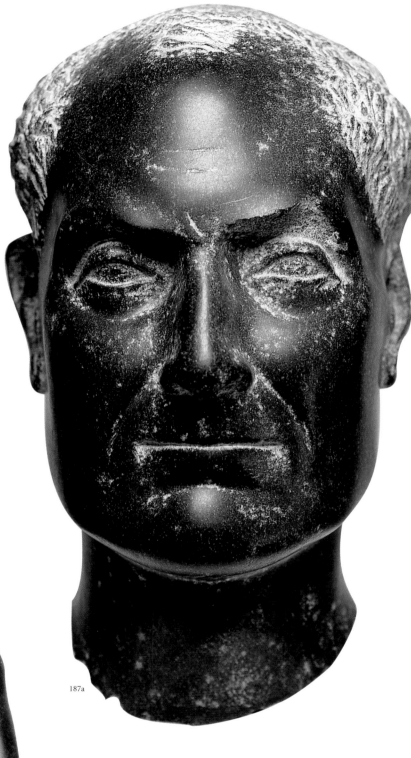

187a

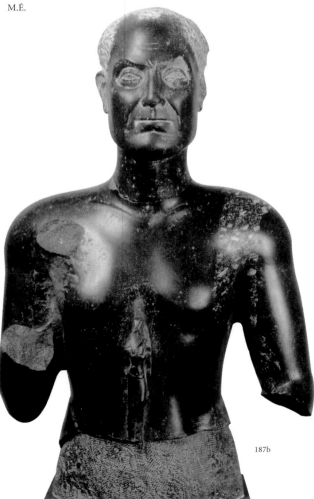

187b

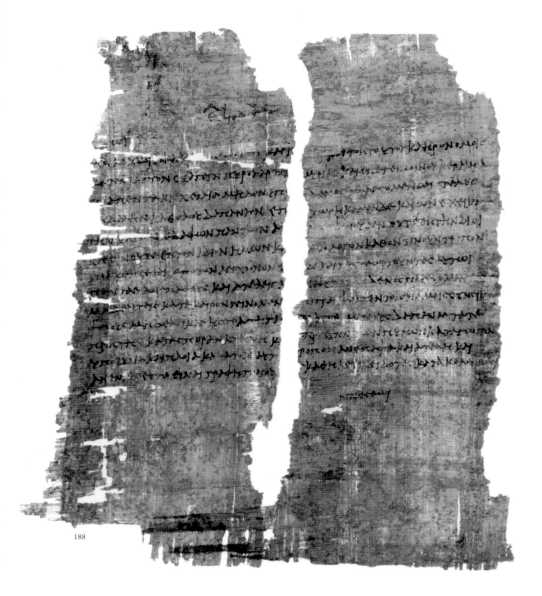

188

188 (detail)

duty on these items and, moreover, in perpetuity from all taxes on his land in Egypt. His tenants were to be free from personal liabilities and taxes, as were Canidius's farm and pack animals, and his ships used for transporting the wheat. By granting such privileges Cleopatra strengthened his commitment to Egypt and to her personally; indeed, two years later Cleopatra's active participation in the Battle of Actium was agreed by a reluctant Antony only after pressure from Canidius, then in command of his land forces.

The text is the original document addressed to a high-ranking Alexandrian official charged with notifying other officials. At the top the date of receipt (23 February 33 BC) has been added in a third hand, presumably by the addressee. After the main text of the royal ordinance, written by a scribe, follows the subscription in a second hand. It contains the authorization of the queen (Greek γινέσθωι, or 'make it happen'), presumably written in her own hand. As the issuing authority, Cleopatra would have had to subscribe the document herself. She does not sign her name nor does she write the title of the addressee, because the text is an internal note passed between the queen and a high-ranking Alexandrian official who would have recognized her subscription. Other officials would have received copies of the text with a forwarding letter explaining what was expected of them.

The Alexandrian state archives of the late Ptolemaic and early Roman period were discarded some time in the first century AD; some papyri ended up in Abusir el-Melek, where they were recycled in mummy casings.

BIBLIOGRAPHY: P. Sarischouli, 'Συγχώρησις-Vertrag in H. Melaerts (ed.), *Papyri in honorem Johannis Bingen octogenarii (P.Bingen)* (Leuven 2000), 214–22. This first edition mistakenly presents the text as a private document. For the new reading, see P. van Minnen, 'An official act of Cleopatra (with a subscription in her own hand)', *Ancient Society* 30 (2000), 29–34.

P. van M.

188 Royal ordinance on papyrus of Cleopatra VII, granting tax privileges to Publius Canidius

33 BC

From the Roman cemeteries at Abusir el-Melek, where it was reused as mummy cartonnage

Height 23.3 cm, width 20.2 cm

Ägyptisches Museum und Papyrussammlung, Berlin. P. Berolinensis 25.239

This papyrus was retrieved from a mummy casing found at Abusir el-Melek in 1903–5, but not taken apart until recently. The papyrus comprises a royal ordinance of Cleopatra VII granting substantial tax privileges in Egypt to Publius Canidius (Crassus), a Roman general known from literary sources as Antony's right-hand man. Canidius was permitted to export 10,000 sacks of wheat from Egypt and to import 5,000 amphoras of wine from Cos each year, and enjoyed exemption from

189 Grey granite statue of Pakhom (Pa-ashem), governor of Dendera

c. 50–30 BC

Provenance unknown; formerly in the collection of Albert Eid, Cairo

Height 69.8 cm, width 18.5 cm

Collection of the Detroit Institute of Art, Detroit, Michigan 51.83 (Founders Society Purchase, William H. Murphy Fund)

The figure is complete down to the ankles. The left leg is advanced in the traditional posture for males in Egyptian sculpture. In contrast, the left arm is bent at the elbow and crossed over the lower abdomen rather than hanging straight at

the left side. The left hand clutches the edge of the garment slightly right of centre. The right arm is at the side and the hand is closed, holding an object usually identified as a cloth but described by Bernard V. Bothmer as 'the traditional emblematic staff'. The figure wears a round necked, short-sleeved shirt, a wraparound skirt, and a scarf or shawl with a serrated edge, which is held by the left hand. This style of dress is attested on a large number of statues and statuettes of the Ptolemaic period. The head is slightly turned to the left, as on many statues of the later phases of Egyptian sculpture. There is a broad fillet encircling the head, which lacks any precise delineation or any decorative device due to its unfinished state. The eye sockets are empty hollows made to receive inlaid eyes, with the upper and lower lids indicated in slight relief.

The back pillar runs the full preserved length of the figure and is topped by a pyramidal plinth at the base of the skull. The inscription on the back pillar is in a rudimentary stage of execution, having been only lightly carved. The statue is unfinished overall; the surface is unpolished and shows the slight pitting of the penultimate stage of work prior to the smoothing of the surface.

The inscription on the back pillar, translated from the French by Herman de Meulenaere, reads:

> The prince and count; royal brother; general in chief; prophet of the statues of the pharaoh; guardian of the treasure of Horus of Edfu, the great god, Lord of the sky; and of Hathor, Lady of Dendera; prophet of Isis who resides at Dendera; prophet of Isis, Lady of Philae; and of the gods(?) of Eileithyiaspolis; prophet of Harsomtous the child, son of Hathor; prophet of Hathor, eye of Re, mistress of the sky, regent of all the gods; prophet of Horus of Edfu, the great god, lord of the sky; prophet of the gods and goddesses (?) who are in Wts-Hr and the gods and goddesses who are in …; Pakhom, son of the general P3-srj,…(?)

This statue of Pakhom, governor of Dendera, stands as one of the few nearly complete examples of a well-known type from the period at the end of Ptolemaic rule and on the eve of the coming of the Romans to Egypt. As such, it exemplifies one of the images that would have been prevalent in the time of Cleopatra VII, or in the reign of her father. There is extensive literature on the type and costume represented by this figure. The work of Bothmer, de Meulenaere, Stricker and Bianchi, each in its own way, has given us a better understanding of Pakhom's place in Ptolemaic history and has contributed to an understanding of this statue's place in the development of late Ptolemaic sculpture in Egypt. There is some debate about the extent of evidence for Egyptian tradition versus foreign

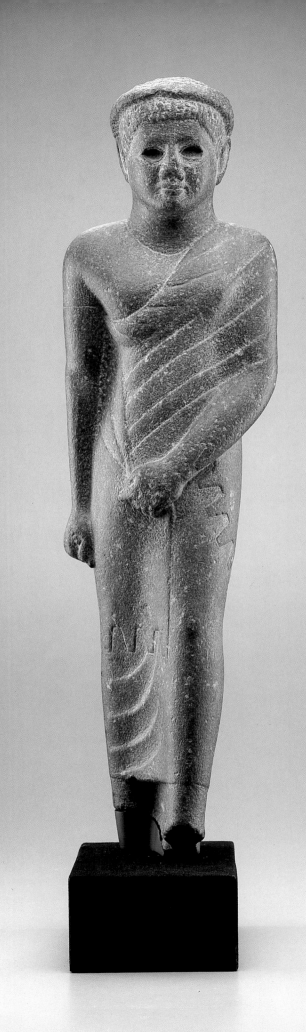

influence represented in figures such as this that will probably not be easily resolved. The obvious disproportionate size of head to body (1:1.5 – one head height in a total of about five and a half head heights) in this example, however, must be indicative of a style that has lost some contact with the standard proportional concepts pervasive in two- and three-dimensional representation throughout the history of Egypt. Other elements, such as the pleated garment and the position of the left arm can be attested in examples of earlier Egyptian sculpture. As Edward L. B. Terrace observed over thirty years ago, concerning a well-known example of the series preserved in the Egyptian Museum, Cairo (cat.no. 190), 'The style of Egyptian sculpture has not changed, only some mannerisms have been introduced to highlight its intrinsic qualities.'

A comment on the unfinished state of this statue is in order. It is possible that the work was not completed simply because the stone was flawed or the lower legs and ankles were too insubstantial to support the weight of the stone, causing a break during the production of the piece. A considerable number of examples from all periods are unfinished and also broken, suggesting that they were discarded as the result of accident in the processes of sculpture.

BIBLIOGRAPHY: *Bulletin of the Detroit Institute of Arts*, Vol. XXXI, no. 2 (1951–2). 49; H.de Meulenaere, 'Les Stratèges Indigènes du Nome Tentyrite a la Fin de l'Epoque Ptolemaique et au Début de l'Occupation Romaine', *Rivista Degli Studi Orientali* Vol. XXXIV (1959), 3, 12–16, Ill; B.V. Bothmer, *Egyptian Sculpture of the Late Period* (New York 1960); B.M. Stricker, 'Graeco-egyptische private sculptuur', *OMRO* 40, 1–16; 41, 18–30; R.S. Bianchi, 'The Striding Draped Male Figure of Ptolemaic Egypt' in H. Maehler and V.M. Strocka (eds), *Das ptolemaische Ägypten* (Mainz 1978), 59–60; R.S. Bianchi, *Cleopatra's Egypt: Age of the Ptolemies* (New York 1988), cat. nos 32, 126–7.

W.H.P.

190 Basalt statue of Hor, priest of Thoth during the reign of Cleopatra VII

c. 40–30 BC

Found in Kôm el-Damas, Alexandria, 1881

Height 83 cm

Cairo, Egyptian Museum JE 38310 (CGC 697)

The statue is preserved from the upper thighs to the top of the head. The surface has suffered only minor damage.

The figure strides forward with his left leg, holding his right arm by his side, with a clenched fist, and the left arm in front, with a clenched hand. The costume can also be found on a statue of a priest (cat.no 138). The high brow, receding hairline and lines around the mouth and chin are

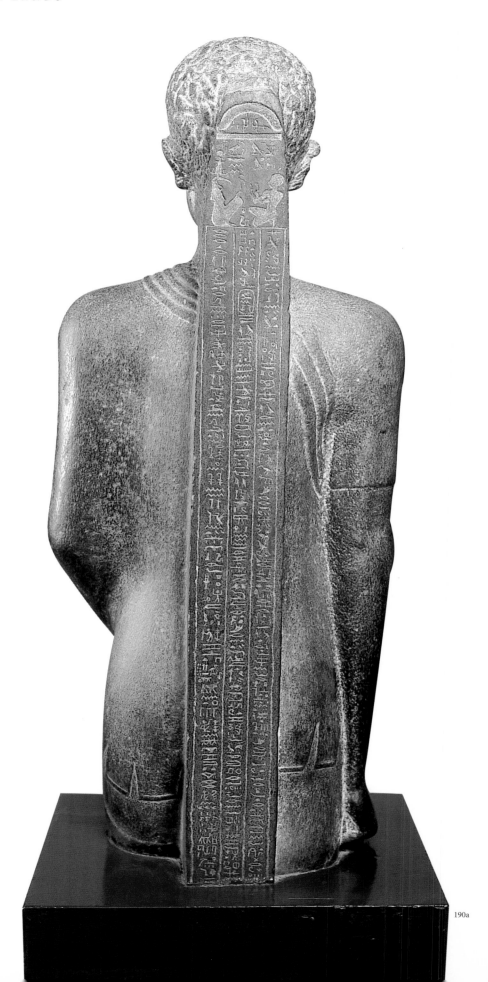

190a

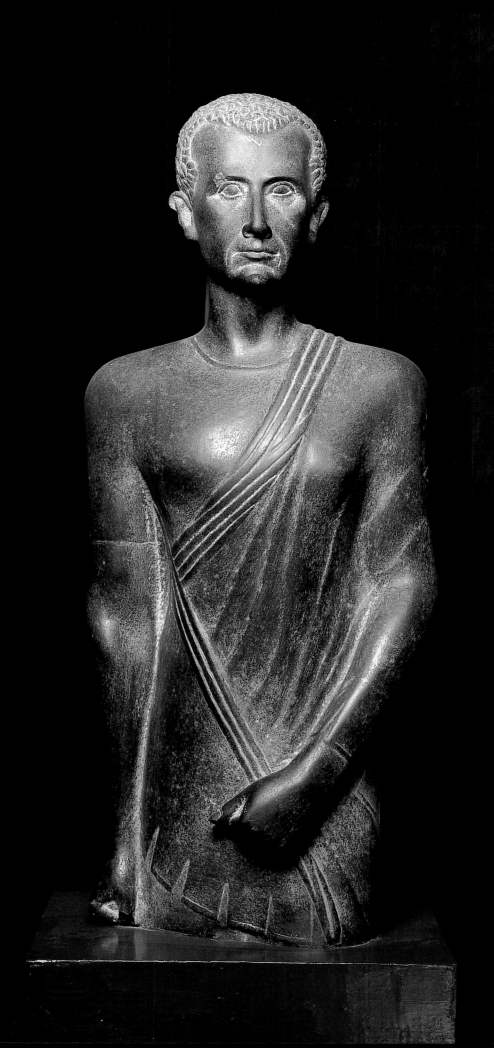

features typical of images dating from the mid-
to late first century BC. The high, rounded back
pillar is also seen by some scholars as characteris-
tic of this period, although variations do occur.

At the top of the back pillar, beneath a protec-
tive winged sun disc and the sign for 'heaven', the
statue's subject, Hor son of Hor, or possibly Hor
son of Hormaakheru, kneels in adoration before
the squatting figure of ibis-headed Thoth, who is
named and provided with the epithets 'Twice
Great' and 'Lord of Ashmunein'.

This scene is part of the evidence for the
assumption that the statue's subject was a priest of
Thoth, although it proves only that he was partic-
ularly devoted to the god, a devotion confirmed by
the text. In fact, the three columns of hieroglyphs
nowhere provide any of the subject's offices. A
number of cryptic writings with hieroglyphic
forms unique to the Ptolemaic period are used,
which sometimes make the sense a little obscure.
The text begins with some stock clauses about
Hor's good deeds upon earth, ending with the
usual wish that he be granted a long life, joy and a
goodly old age with love of contentment. What
follows, however, is autobiographical. An address
to Thoth and a listing of many of his epithets is
interrupted by the break in the figure but the
text continues with the wish that this statue
remain before Thoth so that Hor's name might be
mentioned upon earth for ever because he loved
serving the god, being his adherent and doing
what he loved. This means that the figure must
have been set up in the precincts of a temple to
Thoth. The contents of the third column are
unique to Hor. They record that he renewed the
sacred place, that is the shrine of the god Osiris to
the west of his home city (unfortunately not
named), which had fallen into ruin because its
foundations were of mud brick and had been
affected ever since a canal had been cut into the
area. Hor is also said to have looked after the
divine offerings due to Amen-Re, king of the gods,
when they were brought, which suggests his office
might actually have been in the service of that god
even if he had a personal devotion to Thoth.

BIBLIOGRAPHY: L. Borchhardt, 'Statuen und Statuetten von
Königen und Privatleuten im Museum von Cairo', CGC
1294 I–III (Berlin 1930), 39–40, pl. 128; F. Poulsen,
'Gab es eine alexandrinische Kunst?' From the Collections
of the Ny Carlsberg Glyptothek 2 (1938), 31 ff; P. Graindor,
Bustes et statues-portraits d'Égypte romaine (Cairo 1939),
138, no. 74; G.A.S. Snijder, 'Hellenistisch-römische
Porträts aus Ägypten', Mnemosyne 3 ser. 7 (1939), 262–9;
B.V. Bothmer, Egyptian Sculpture of the Late Period
(New York 1960), 170–3; G. Grimm and D. Johannes,
Kunst der Ptolemäer und Römerzeit in Ägyptischen
Museum Kairo (Mainz 1975), 19, no.16; B. Tkaczow,
Topography of Ancient Alexandria (An Archaeological
Map) (Warsaw 1993) 251, no.179.

C.A., S-A.A.

190a

191 Lapis lazuli amulet of Ptah

c. 600 BC or later

Possibly from Memphis, Egypt

Height 5.6 cm, maximum width 1.9 cm

London, Weill Goudchaux Collection

Ptah, the ancient creator god of Memphis and patron of craftsmen, is depicted with characteristic iconography. He has a skullcap on his head and wears the straight divine beard on his chin. He is mummiform, his body completely enveloped in a tightly-fitting garment from which only his hands emerge to clasp a long multiple sceptre. It comprises a *was* sceptre crowned by a slanting animal head, its characteristic long ears almost hidden by the god's beard, and a *djed* pillar. The shaft of the sceptre ends in its usual bifurcation. On Ptah's chest is a broad collar with an outermost row of drop-shaped pendants; the

individual rows of beads forming the collar are each clearly distinguished. Behind is the trapezoidal counterpoise that helped to keep the heavy collar in position on the chest; it ends above the deep pillar, which provides the figure with magical support. A very narrow hole for suspension is pierced from side to side at the top of the back pillar so that the piece could be worn.

Small amulets made from lapis lazuli, which the Egyptians obtained only from Afghanistan, are a feature of Late Period burials in Egypt. Amulets of Ptah, however, although providing general protection in his capacity as one of the oldest and most powerful of deities, are not usually part of the repertory found on mummies. This piece, moreover, is rather larger than most contemporary examples and the quality of the carving in so hard a material and on such a small scale is superb, suggesting it was made to be worn, and seen, in life. The carefully formed features hint that it might have been made as early as the Twenty-sixth Dynasty but it could well have continued in use as an heirloom. It is not too fanciful to imagine it was worn by no less a person than the high priest of Ptah himself, as a particular sign of personal devotion to his god.

Seven centuries earlier General Wendjebauendjed, who was buried at Tanis in the eastern Delta, owned just such a lapis lazuli figure of Ptah, which was set within a superbly decorated gold shrine with a suspension loop on the roof so that he might wear it as a reliquary. Perhaps that is how this figure was originally worn; the piercing for suspension certainly seems to have been made rather later.

UNPUBLISHED.

C.A.

192 Round-topped limestone stela of the High Priest Pasherenptah III

41 BC

From Saqqara, Egypt

Height 72.5 cm, width 61 cm

London, British Museum EA 886

Below the usual winged sun disc Pasherenptah, wearing the characteristic sidelock of the High Priest of Ptah and the panther skin of an officiat-

ing priest, kneels in obeisance at the left side of the figured scene. Before him is an offering stand stacked with slices of bread and surrounded by hieroglyphs for the invocation-of-offerings formula that will supply him with bread and beer, flesh and fowl, linen garments, incense and unguent in the afterlife. The hieroglyphs before his face supply his titles, name and parentage, and describe the ritual he carries out as 'adoring the god four times'. The deities depicted from left to right, all named and with lengthy epithets, are Osiris, god of the dead; Apis, earthly animal manifestation of the god Ptah of Memphis, shown as a bull-headed man; Isis, sister and wife of Osiris; Nephthys, their sister; falcon-headed Horus-avenger-of-his father; Anubis, jackal-headed god of embalming; Imhotep, deified architect of the first pyramid; and the falcon of the West.

All of them grant Pasherenptah otherworldly blessings. The frame at the left is composed of the palm rib, the hieroglyph for 'a year', with Heh, god of millions, in characteristic pose at its base, the whole symbolically wishing the deceased millions of years in the afterlife. The frame at the right is the *was*-sceptre with long-eared animal's head set aslant a stave with bifurcated end, the whole representing 'dominion' in the Other World.

The fourteen rows of superbly carved hieroglyphs begin with a standard funerary offering formula on behalf of Pasherenptah, whose numerous titles are listed in full, and continue with a conventional address to the living. Then there follows a detailed autobiography. Pasherenptah describes how, immediately after his appointment as high priest of Ptah at the age of fourteen, he performed the coronation of Cleopatra's father, Ptolemy XII Auletes, in 76 BC in accordance with the ancient pharaonic rituals. When Pasherenptah went to Alexandria, the King stopped his chariot en route to the temple of Isis to show him personal favour by rewarding him with a gold chaplet and appointing him priest of the royal cult. The hieroglyph for 'ride in a chariot' occurring twice in line 10 is a particularly fine Ptolemaic example of the graphic nature of the script. Subsequently, Auletes and his family visited Memphis to take part in local festivals in which the High Priest undoubtedly played an important role.

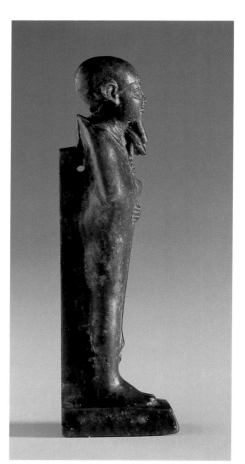

191

192 ▶

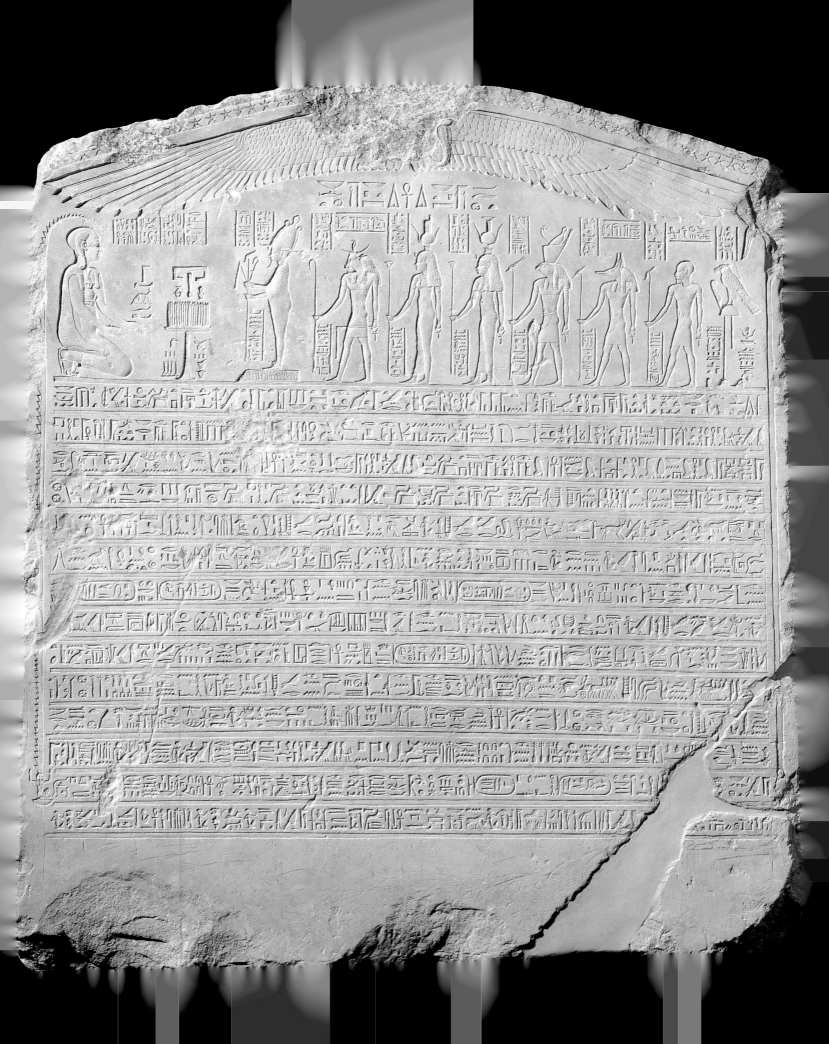

When Pasherenptah had reached the age of forty-three, he and his wife were still without a male child, but Imhotep answered their prayers and the son was named in the god's honour. The intercession of Imhotep presumably explains his appearance among the deities at the top of the stela: although after deification the architect of the first pyramid was made the son of Ptah and so had particular relevance for Ptah's priesthood, Paherenptah obviously looked upon him as a personal god. The High Priest's death took place in year 11 of Cleopatra VII, precisely on 14 July 41 BC, and it is of interest that the embalming process took eighty days rather than the seventy usually considered the optimum time. The inscription also provides the information that the text was composed by Pasherenptah's brother-in-law Horimhotep and carved by the deceased's own nephew Khahap.

This stela is only one in a series made for a family whose members served as high priests of Ptah at Memphis in an unbroken line during the Ptolemaic period and thus belonged to what became the most important of contemporary native priesthoods. Among Egypt's cities Memphis had always been second only to Thebes; now Thebes was poor and no longer the religious capital. Moreover, it had been a hotbed of anti-Ptolemaic intrigue under rebel native pharaohs during the reigns of Ptolemy IV, V and VIII, so the Ptolemies actively cultivated the Memphite god and his priesthood as a means to counteract nationalism.

BIBLIOGRAPHY: E.A.W. Budge, *A Guide to the Egyptian Galleries (Sculpture), British Museum* (London 1909), cat.no. 1026; E.A.E. Reymond, *From the Records of a Priestly Family from Memphis*, vol.1, *Ägyptologische Abhandlungen* 38 (Wiesbaden 1981), cat.no. 18.

C.A.

193 Round-topped limestone stele of Tayimhotep

42 BC

From Saqqara, Egypt

Height 90.2 cm

London, British Museum EA 147

Tayimhotep, daughter of Khahap and Herankh, was the wife of Pasherenptah III, owner of cat. no. 192, and the size of this piece alone indicates the importance in her own right of this particular high priest's wife. In the figured scene, beneath the usual winged sun disc, Tayimhotep herself stands at the right with hands raised in the attitude of prayer. Anatomically correctly, but by Egyptian artistic conventions most unusually, she is depicted with both breasts shown. The hieroglyphs before her provide her title, name and mother's name alone; this is a frequent practice in Egyptian filiation, since often only a mother's name was ascertainable. The signs above the conventionally heaped offering table describe the ritual as 'adoring the god four times', exactly as on Pasherenptah's stele. The row of deities adored from right to left comprise the local Memphite funerary god Sokaris, in the guise of Osiris; bull-headed Apis, Ptah's earthly animal manifestation; Isis and Nephthys, wife and sister of Osiris; falcon-headed Horus, avenger of his father; jackal-headed Anubis, god of embalming; and the falcon of the West. The text with each figure provides the name and epithet and various wishes granted to the deceased. The frame at each side is a *was*-sceptre, conferring Other World dominion.

The main text begins with Tayimhotep's birth in year 9 of Ptolemy XII Auletes, on precisely 17 November 73 BC; she married Pasherenptah in 58 BC, when not yet fifteen. What follows, however, is an unexpectedly personal account of her life; for such a high-ranking woman it might normally be expected to consist of formulaic utterances. It is certainly one of the most intimate documents to survive from antiquity and provides Tayimhotep's version of the events recorded on Pasherenptah's stele. 'My husband rejoiced because I became pregnant by him three times but I did not bear him a male child, only

daughters.' After prayers were addressed to Imhotep, one of whose epithets is 'who gives a son to the one who does not have one', the god appeared in a dream, asking that Pasherenptah arrange for substantial building work to be carried out at the god's shrine in the Memphite necropolis. When everything had been done according to the god's instructions, Tayimhotep became pregnant with a son, who was born in year 6 of Cleopatra VII, around 2 p.m. on 15 July 46 BC. This was the future High Priest of Ptah Imhotep, named for the god but better known as Padibastet III. Tayimhotep lived only another four years: her death occurred at the early age of thirty-one on 15 February 42 BC.

The text ends with a plea to her husband to *carpe diem* because the afterlife is a place of misery. Only its location, on a funerary stele, is surprising: the sentiments of this pessimistic view of the life after death can be traced back nearly two thousand years to the Eleventh Dynasty 'Song of the Harper' and were still current in the fifth century BC as Herodotus records (Book II, 78). Tayimhotep's words are extraordinarily heartfelt:

Oh my brother, my husband, friend, High Priest!
Do not weary of drinking, eating, getting
intoxicated and making love! Make holiday! Follow
your heart day and night! Let not care into your
heart otherwise what use are your years upon
earth? As for the west, it is a land of sleep; darkness
weighs on that place where the dead dwell. Sleeping
as mummies they do not wake to see their brothers,
they are not conscious of fathers or mothers, their
hearts forget their children. The water of life which
is nourishment for all is thirst for me: it only comes
forth to those upon earth.

This remarkable text, like that on Pasherenptah's stele was composed by Tayimhotep's brother Horimhotep but in this instance there is no written evidence that it was carved by her nephew.

BIBLIOGRAPHY: E.A.W. Budge, *A Guide to the Egyptian Galleries (Sculpture), British Museum* (London 1909), cat.no. 1027; E.A.E. Reymond, *From the Records of a Priestly Family from Memphis*, vol 1, *Ägyptologische Abhandlungen* 38 (Wiesbaden 1981), cat.no. 20.

C.A.

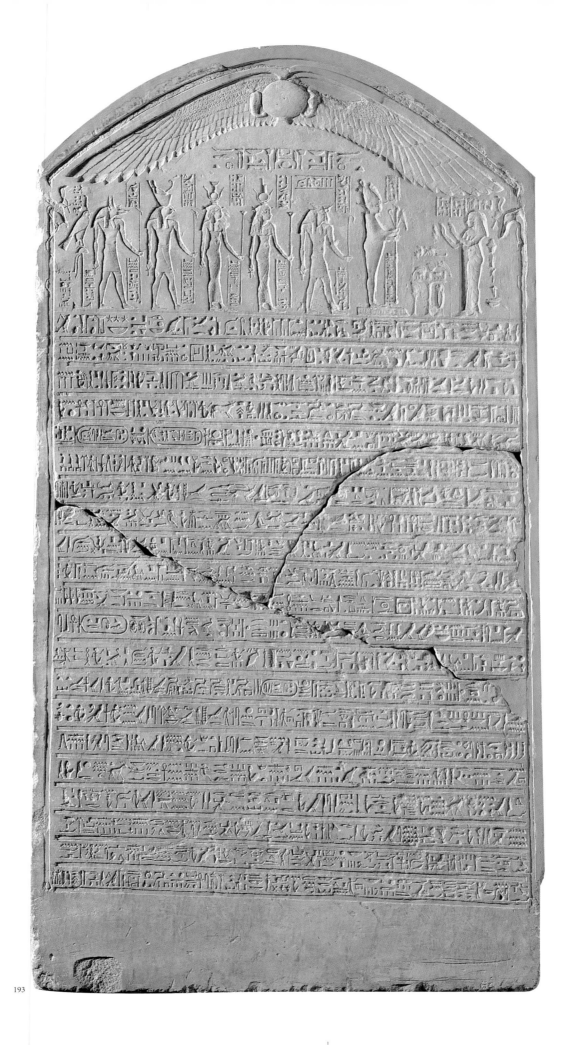

Cleopatra and the Power of Rome

'Spoiling the Egyptians':
Octavian and Cleopatra

J.H.C. WILLIAMS

Fig. 6.1 Forum of Caesar:
recent excavations with
(centre right) the Temple
of Venus Genetrix.
(Photo by courtesy of
Eugenio La Rocca.)

W hat did he make of her? Cleopatra was almost one of the family after all, having had an affair and, she claimed, a son by Octavian's own adoptive father, Julius Caesar, which made her the mother of a child with a significantly more tangible kinship with the great man than was his own. The nature of Octavian's interpretation of what his posthumous adoption meant was anyway rather irregular. Julius Caesar had certainly named Octavian, his great-nephew, as principal heir in his will, and had adopted him into his family. While testamentary adoption of this sort was not unknown in Rome, it did not usually entail that the adopted heir took on the full name of his benefactor, or that he pretended to a real filial relationship with his adoptive father in quite the way that Octavian did. It is often forgotten that Octavian did not usually go by that name in antiquity. Cicero uses it of him in his letters, perhaps slightingly. But, as his early coins reveal, the name he used in the years immediately after Caesar's death was Caius Julius Caesar – he had simply abandoned his original name Caius Octavius in favour of Caesar's own, irresistibly talismanic as it was. 'Julius' seems to have been dropped quite soon thereafter, leaving just Caius Caesar. By 31 BC his name had been finessed into the quite extraordinary form 'Imperator Caesar Divi Filius', meaning 'Commander Caesar Son of the God', more divine appellation than human nomenclature. According to human biology and Roman tradition, this was a highly debatable and unprecedented formulation, and Octavian absolutely had to vindicate it. Without it, he had nothing. Cicero, the great orator, reports Mark Antony as saying, "You, boy, you owe everything to your name" (Cicero *Philippics* 13.24). He was right. In 27 BC, after his final victory, Octavian would receive from the Senate the equally exalted and unparalleled name 'Augustus', a word with profound religious connotations, meaning 'venerable' or 'majestic', almost 'sacred', in recognition of his position of supreme power. But in the 30s BC Octavian had serious competition for the right to claim unchallenged the name and paternity of Caesar.

The existence of another alleged son of Caesar was an awkward reminder of the persistent insecurity of Octavia's own position. On his own, Ptolemy XV, surnamed Caesarion ('Little Caesar'), would probably not be able to supplant Octavian, but he was not alone. Behind him was the more formidable, and convincingly Roman, Mark Antony, scion of a respectable Roman aristocratic family who had been Caesar's right-hand man at his death. As his expan-

sive military exploits of the 30s BC demonstrated, Antony was a man of grand ideas, if not necessarily blessed with constant success, and he was certainly a serious contender for the position of successor to Caesar's mantle.

If there was to be a showdown between the various claimants to the different aspects of Caesar's legacy – political, legal, financial, genetic – to the victor would go the spoils, no matter what his origins. According to the early third-century AD historian Dio Cassius, Caesar had incurred considerable opprobrium during Cleopatra's stay in Rome from 46 to 44 BC when he had consorted with her fairly openly (Dio 43.27.3). He does not mention a source for this information, and he may have been guessing. We know that Cicero had loathed Cleopatra's *superbia*: 'I hate the queen… Her arrogance, when she was living across the Tiber in the gardens… I cannot recall without profound bitterness' – though he was the sensitive type (*Letters to Atticus* 15.15.2). She left Rome fairly quickly after Caesar's murder in March 44 BC, which suggests that she did not exactly feel at home among the Romans on her own. But there is no reason to think that her presence had seriously alienated the people of Rome from Caesar. There was perhaps also no reason to suspect that they would necessarily take the prospect of her return with Mark Antony and Caesarion too much amiss either. Some senators may have had different views on that issue. It was, after all, an important part of the senatorial tradition to be wedded to the idea of the free Roman republic, and hostile to foreign tyranny. Cleopatra was all too easy to characterize as the latest in a long line of unsavoury aliens who had set their sights on capturing the city of Rome. But not everyone necessarily believed that this was either true or the most important point. Other issues, personal and political, were at stake here as well, which tended to divide the senators' views. Not all of them were necessarily persuaded that Cleopatra, rather than Octavian, was the real enemy of the free republic, while many were personal friends of Antony or enemies of Octavian. When the crisis came in 32 BC, a majority of the thousand-strong Senate, bloated beyond its normal size with Caesar's appointees and other accretions of the Triumviral period, stayed in Italy with Octavian. But possibly several hundred of their colleagues and, importantly, both the consuls for the year crossed the Adriatic to join Antony, and many of Octavian's followers were, no doubt, floating voters. It was, in short, by no means a foregone conclusion that Octavian's cause would receive a ringing endorsement from Romans at every, or indeed any, level of society.

Fig. 6.2 The obelisk of Augustus' sundial, Rome, Piazza Montecitorio. (Photo Paolo Monti, Rome.)

This is an important point. Whatever one calls it – propaganda is the most commonly used term to describe what Octavian was up to in Italy in the years before Actium, though it has problematic, and anachronistic, connotations – he was certainly setting out to focus Roman minds on the coming war as one against a foreign power rather than a further bout in the civil war that had begun in 49 BC with Caesar's crossing of the Rubicon into Italy. In 32 BC Octavian personally performed, and perhaps revived, the ancient Roman ritual for the declaration of war, which involved a member of the Roman priestly college known as the *fetiales* hurling a

spear into a small plot of land in Rome located outside the Temple of Bellona, the war goddess, which was designated as enemy territory. The important point about this ritual was that Cleopatra, not Antony, was named as the enemy (Dio 50.4.4–5). Octavian had what purported to be Antony's will read out in the Senate, wherein Caesarion's alleged parentage was declared authentic, great bequests were made to Antony's children by Cleopatra and his body ordered to be buried next to Cleopatra's in Alexandria. This it was, so Dio says, that finally persuaded the Romans – and here he means the Romans of Rome – that all the other stories they had heard about Antony were true, that he was going to give their city to Cleopatra and move the seat of power to Alexandria (Dio 50.4.1). All this was then followed by the orchestration of the famous oath sworn by all Italy, *tota Italia,* to Octavian, of which so much was later made in his inscriptional autobiography, known as the *Res Gestae Divi Augusti* (literally, 'the Achievements of the Divine Augustus'): 'All Italy took a personal oath to me voluntarily, and demanded me as their leader in the war in which I was victorious at Actium. The provinces of Gaul, Spain, Africa, Sicily and Sardinia swore in the same terms….' (*Res Gestae* 25). Compare this with Dio's rather more balanced and plausible account: 'Such was the zeal of both sides equally that the alliances which they made with the two leaders were cemented by oaths of allegiance' (Dio 50.6.6).

Two points are important here. There is no reason to believe all that Dio and others write about the Romans' attitudes towards Antony, or Cleopatra for that matter, or that Octavian's antiquarian performances and publicity coups necessarily made very much of an impact at the time. These acts were anyway aimed as much at posterity as at the present, and to that extent they have succeeded admirably. There is, after all, a serious danger that we might end up falling for Octavian's presentation of other people's views, and particularly those of the Romans towards himself. Even if Dio is right that the reading of the will was what turned the Romans wholeheartedly against Antony, all this took place only in the year before Actium. There is little hard evidence that Italians had long been united in their loathing of the triumvir in the East, or that they looked longingly to their Roman hero Octavian to save them from the awful threat of Cleopatra. All this is myth which Octavian, once victorious, had a long time to create and refashion. We should set it all aside and construct for ourselves a more sceptical and varied conception of what the views of Romans were in the months before Actium. That they were not unanimous was, presumably, precisely why so much effort was invested, both at the time and later, in the public pretence that all Italy was behind Octavian the saviour of Rome, and against Antony, the arch-traitor to his country, who was sexually, morally, and politically enthralled to the monstrous Queen of Egypt.

That there was not much clear blue water between Octavian and Antony was in many ways the reason why Octavian had quickly to create some in 32 BC, and he used Cleopatra to do so. Antony and he had been fellow triumvirs until the end of 33 BC, and thereafter both continued to exercise the powers of that extraordinary office beyond its legal terminus. Antony continued to use the title unlike Octavian, but their positions were not substantially different. Neither was there much difference between the ways in which they had fashioned their public images; during the 30s BC, Antony had indulged in some curious eastern customs suggesting that he was a god. In 41 BC he had been hailed as Dionysos at Ephesus, and Cleopatra appeared in the seductive guise of Aphrodite when she met him in spectacular fashion at Tarsus. The allusions to Dionysos appeared again in 39 BC at Athens while Antony was ensconced there with his wife Octavia, Octavian's sister. On the cistophoric tetradrachms struck for him in Asia in the early 30s BC , his bust, and the whole obverse, are wreathed in Dionysiac ivy. In the months before Actium, according to Dio, what most upset Roman opinion were the rumours alleging that Antony had his picture painted together with Cleopatra, with himself as Osiris and her as Isis (Dio 50.5.3). All very un-Roman, we might think, and

thoroughly unwise of Antony to reveal his apparent infatuation with the oriental queen by dabbling in such suspect notions as divine kingship. But this would be a serious misreading of what it was that might have offended Romans about how he was carrying on. Dio also tells us that Antony allowed Cleopatra to conduct public business with him and rode with him in cities, or at other times he walked behind Cleopatra's carriage *together with her eunuchs*, that he dressed in an untraditional, foreign manner, wearing oriental daggers in his belt, and allowed himself to be seen in public in a gilded couch or chair. What it came down to was not whether or not Antony was posing as a god, but that the rumours circulating about him suggested that he was allowing himself to be subordinated to a foreign woman, who was thus both emasculating and barbarizing him, stripping him of his manhood and his sense of identity as a Roman.

However far Antony may have taken the business of assuming a divine identity in the East, it is not clear that Octavian was doing very much different in Rome. Here again, the name he is given in most modern treatments is deceptive. 'Octavian' sounds very Roman, very traditional, but, as mentioned above, it was not his name. Mark Antony continued plain Marcus Antonius to the end. It was Octavian whose very name asserted divine parentage, it was his coins that depicted him in various divine guises – as Jupiter and Apollo – more explicitly than those of Antony. In a former generation it might have been unusual for Romans to do this kind of thing in public, though there was by no means an explicit rule against it. But, between them, Pompey and Julius Caesar had changed all that for good. The boundaries of the public acceptability of Romans claiming divinity, or allowing divinity to be attributed to them, had plainly shifted in the previous ten years or so just as, for instance, the custom of not depicting living individuals on coins had changed. Romans had avoided this in the past, though perhaps not for any very clear reason. After Julius Caesar, even his murderer and arch-republican Brutus had to show his image on coins made in his name. It became not merely acceptable but necessary for the image of the great man to appear on the coinage, and similarly it became a normal part of being a significant public figure in the years after Caesar's death to assume divine status and have oneself depicted with the attributes of any number of gods, both in the East and in Rome itself.

What differentiated Antony's from Octavian's actions in this direction was, from the Roman point of view, that by adopting the guise of Osiris Antony seemed to be posing as an alien deity and, moreover, an Egyptian one. Romans had an uncertain attitude towards Egyptian religion. Polytheism is often rightly contrasted with monotheism on the grounds that it appears to be more welcoming to foreign cult practices and their presiding deities. Polytheistic belief systems are indeed more flexible in this regard than, say Christianity or Islam, but not infinitely so. The Romans were occasionally suspicious of certain foreign gods and cults, and Egyptian ones sometimes fell within this category. Though symbols related to the worship of the Egyptian goddess Isis – the *sistrum,* or ritual rattle, and her crown – had appeared in Rome as symbols on the coinage alongside, and as alternatives to, traditional Roman cultic objects such as priestly headdresses and sacred shields, shrines of the Egyptian goddess Isis within the city of Rome seem regularly to have come under attack in the 50s and 40s BC. For what particular reason in each case is unclear, but this at least suggests an inconsistent, and occasionally hostile, attitude towards Egyptian religious practices existing among the inhabitants, and the authorities, of Rome before the entry of Cleopatra on to the stage. This was the uncertain boundary of Roman xenophobic insecurity that Antony crossed when appearing to involve himself too closely in identifiably Egyptian practices and with a queen of Egypt. Not that every Roman would automatically have taken against him for doing so. The triumvirs themselves had voted a temple to Isis in 43 BC after all, though it seems never to have been built (Dio 47.15.4). Nonetheless, properly exploited, the latent uncertainty in many

Roman minds about the propriety of Egyptian rites could potentially redound to Antony's considerable discredit. Octavian did not make the same mistake. When visiting Egypt after the conquest, he ostentatiously refused to worship the sacred Apis bull. Egypt's animal deities could present a shocking prospect for Romans used to anthropomorphic gods.

So it was the distasteful and humiliating foreignness of it all, not specifically Antony's pretentions to divinity, that came to be regarded as rather un-Roman, and gave Octavian and his allies much material to create damaging publicity against Antony in Rome through the medium of public speeches. Being on the spot, Octavian's version naturally had much better chances of getting through to the crucial constituency formed by the citizen inhabitants of Rome than Antony's presentation of events in Alexandria. Antony had his friends in Rome and sent letters in justification of his actions, even writing a pamphlet entitled *On His Own Drunkenness* rebutting accusations made against him in that direction. But without the charismatic presence of the man himself, all his pronouncements about the ways in which he had carved up Africa and Asia and distributed lands and kingdoms to Cleopatra, Caesarion and his children by her – Alexander Helios ('Sun'), Cleopatra Selene ('Moon') and Ptolemy Philadelphus ('Sibling-loving') – in the extraordinary ceremony of the 'Donations of Alexandria' of 34 BC, would merely come across as so much oriental posturing. It was not as though other Romans before him had not already made significant moves in that direction – Pompey the Great for instance, adopting Alexander the Great's epithet for a start, and Caesar too of course – but they were both on hand to lend a present focus, and perspective, to their innovative public styles. Romans were well able to allow for outrageous post-triumphal swagger from their military heroes, and they distinguished this carefully from the daily civic persona of the great man concerned. But Antony was not present, and so the myth of his having really 'gone native' took hold. Instead of being the victor who had added the Orient and Egypt to the possessions of the Roman people – a starring role that he could have played convincingly, given the chance – he came to be perceived as a bewitched slave of Cleopatra's demented ambitions for world-conquest, which went so far as to encompass even Rome itself (Dio 50.5.3).

Moreover, the Romans were not used to receiving imperial missives from other cities in the world where events of great moment were taking place. They were the imperial people – Pompey and Caesar had known this – not the Egyptians or the Medes and Armenians and all these other subject aliens with whom Antony was now seen to be getting far too close. Had he done all this and then celebrated a great triumph in Rome, attitudes to his dealings in the east would doubtless have been very different. As it was, in 34 BC he marked his conquest of Armenia and the East with what is portrayed in our sources, and probably also in Rome at the time by Octavian, as a curious parody of a Roman triumph through the streets of Alexandria, news of which, according to Plutarch in his biography of Antony, upset the Romans most of all, "because they felt he had made a present to the Egyptians of the honourable and sacred traditions of his fatherland for the sake of Cleopatra" (Plutarch *Antony* 50). His friends Sosius and Domitius, the consuls of 32 BC, suppressed his despatches to the Senate and people announcing the Donations, rightly divining that they would be damaging to his reputation, while Octavian for his part encouraged their publication and prevented that of the favourable reports concerning Antony's victories in Armenia (Dio 49.41.4–5). It looked as though Antony was abandoning Rome and transferring the seat of power to Alexandria, and the control of world affairs to Cleopatra.

Roman nervousness on this score is interesting and revealing. It suggests that even in Rome people were actually looking to Antony rather than Octavian as the decisive figure of the moment. It was he, after all, who had followed in the footsteps of Alexander and Pompey, not to mention the less glorious attempt of Crassus, and conquered the East, while Octavian had

achieved very little of any consequence apart from defeating Sextus Pompey in 36 and undertaking a rather unimpressive campaign in Illyria. Antony had made all the headline-grabbing moves and done so very much in the style and after the example of Caesar himself – was not Caesar's final plan before his death rumoured to be the conquest of Parthia and all the orient by going north round the Black Sea? To have overcome the orient was one of the indispensable claims for any would-be world ruler, which all aspirant monarchs of the Roman world certainly were. Hence the extraordinary fuss Augustus later made over the return of Crassus' standards in 19 BC – this was his, much more pragmatic, risk-free and cost-effective version of imitating Alexander. In the 30s BC, then, Antony was on the one hand looking much more like the world conqueror than Octavian, which was a good thing. But on the other, he was not around in the city itself, to be seen dressed as a Roman and behaving as one in the Forum. So Octavian could fill the people's ears with complaints about Antony's callous abandonment of Octavia, and their minds with stories of his orientalized effeminate licentiousness and with visions of Rome governed by Cleopatra or of the seat of world-power transferred to Alexandria. Anxious Romans were all too vulnerable to scare stories of this sort, as Octavian no doubt knew.

Antony's involvement in the east and in Egypt was not pure folly on his part. It was the ideal way to keep all eyes on him and marginalize Octavian, for whom after all there was little in the West left to conquer of equal attraction. The late Republican and triumviral period in Rome was a time of grand showmanship, of sumptuous display and absurdly hyperbolic claims to divine power and superhuman achievement. That was how you attracted the people's attention and support. Roman public styles had, in one sense, already been thoroughly 'orientalized' in Roman terms in all sorts of different ways, from the appearance of triumphal processions to the articulation of the public image of prominent individuals. Though Romans were aware that things were changing, they made the necessary adjustments to their notions of what was appropriate and simply enjoyed the spectacle of it all. Watching oriental luxury led in captivity through the city in totally over-the-top triumphal processions persuaded Romans of the continuing superiority of the Roman People, who remained unaffected by, and victorious over, the enfeebling wealth of the East. Antony's weak point was that the Roman People came to believe, not without some assistance, that he was more conquered by, than conqueror of, the Orient. This need not have happened had he been in Rome itself to interpret his oriental dispositions for a Roman audience in Roman terms: of victory, of universal mastery, of world power. That he could have done and, in all probability, he would have been believed. He need not then have been ultimately successful, and no doubt things would have come to a head between him and Octavian at some stage, an inevitable repetition of Caesar's showdown with Pompey. But neither he nor Cleopatra would have been automatically spurned by the Romans. That took some work from Octavian. So much still turned on the versatile opinions of the Romans of Rome.

Having turned Rome against Antony on this point before Actium and the conquest of Egypt, it only made sense that Octavian should use it as the very foundation stone of his new dispensation after the victory. As Dio tells us, Octavian erected a statue of Victory originally from Tarentum as the focus of the new *Curia*, or Senate House, in Rome. This was begun by Julius Caesar and was hence called the Curia Iulia, but it was completed and inaugurated only in August 29 BC. The statue itself was decorated with the spoils of Egypt, as were the new Temple of the Divine Julius and the Capitoline temple of Jupiter, Juno and Minerva. This, the most important temple in Rome, Dio adds, was by decree stripped of all its previous dedications as having been religiously defiled. They were then replaced by the spoils of Egypt. 'Thus', he writes, 'Cleopatra, though defeated and captured, was nevertheless glorified, for her adornments lie dedicated in our temples and she herself is to be seen in gold in the temple of Venus'

(Dio 51.22.3). This golden image, which Dio seems to think was erected as a part of Octavian's Egyptian spoils, was, according to the second-century-AD historian Appian, dedicated in the newly built Temple of Venus by Julius Caesar himself in 46 BC (Appian, *Civil Wars* 2.102: fig. 6.1). If Appian is right, this is a statue with a very interesting history. It began its life as a signal mark of honour for Cleopatra erected in her lifetime and, without moving an inch, was then redefined by later generations as a symbol of her submission to Octavian's triumph. Its survival through at least 250 years down to Dio's lifetime surely says a lot about the enduring fascination that the figure of Cleopatra provoked in antiquity.

A few days before the inauguration of the new Senate House, Octavian had celebrated a triple triumph, consisting of a different procession on each of three days, the first celebrating his victory over an assortment of northern and Illyrian barbarians, the second for the war at Actium, the third and last for the conquest of Egypt, which, of course, far surpassed the other two in magnificence. An image of the dead Cleopatra on her couch was paraded through the city in the absence of her living self, together with Alexander Helios and Cleopatra Selene, her twin children by Antony. There was so much new money in Rome from the plunder of Egypt that the prices of goods rose, while interest rates fell from 12 to 4 per cent (Dio 51.21.5). Though the victory in the civil war at Actium was given its due and not forgotten, the public emphasis was clearly on the victory in the foreign war in Egypt, which also constituted a new conquest, a new subject province of the Roman people. On some of the inscribed religious calendars that survive from the early first century AD, the Kalends (1st) of August, the date on which Octavian captured Alexandria in 30 BC is noted as the day 'on which Imperator Caesar freed the Commonwealth (*rem publicam*) from a most grievous danger'.

Octavian identified the defeat and conquest of Egypt as the revitalizing basis for the new Rome he had in mind. Consequently, Cleopatra became central to many later accounts of Augustus' rise to power, though by no means all, as we shall see. His victory re-established the centrality of Rome within world affairs, as the seat of eternal Victory whose headquarters were on the newly purified Capitol, suitably redecorated in the Egyptian style. It reasserted the proper order of the races and the genders: alien queens conquered by male Roman leaders. This had been a favourite theme with Romans ever since their early brush with Teuta the Illyrian queen in the 220s BC. It continued so at least until the early AD 270s, when they encountered Zenobia of Palmyra, who herself was reputed to be something of a Cleopatra *rediviva*.

The theme of the Egyptian victory as the root and foundation of the new *res publica* ('Commonwealth' or 'State' rather than 'Republic') of the People of Rome was revisited in later years, nowhere more so than in Augustus' great sundial, the Solarium Augusti, erected in 10 BC. Its gnomon, or pointer, was a 30-metre-high Egyptian obelisk (fig. 6.2). The dedicatory inscription, which survives in part, reads, 'Augustus [...] gave this gift to the Sun, having brought Egypt into the power of the Roman People.' Not only was the expropriation of foreign monuments in itself a vivid symbol of conquest and subjection, so was the use to which this particular one was put; for sundials are never merely instruments for time-keeping, they are also, especially when built on such a monumental scale, signs of the cosmic order of the universe, revealed in the heavens by the movement of the sun, moon and planets and mirrored on Earth by the actions of divine men like Augustus. From Augustus' birth to the victory of Egypt to world peace, all was revealed in the movement of the heavens and traced out in the monumental fabric of the city of Rome in the pattern of the sundial.

The conquest of Egypt and the defeat of Cleopatra were clearly fundamental to the stories that Romans told about the origins of Augustus' power. Nevertheless, as the theme of the restoration of order – political, ethnic, sexual, and cosmic – in the life, actions and persona of Augustus began to dominate over the course of his reign, so proportionally, it seems, did the

person of Cleopatra diminish in Roman memories and presentations of what the great founding war of the Augustan commonwealth was all about. At an early stage Egypt as a whole rather than Cleopatra herself came to be figured as the enemy. This trend began in 28 BC soon after the triumph of August 29 BC, Cleopatra's final public appearance as it were, with the production of coins celebrating not Octavian's victory over her personally, but the conquest of Egypt. Of course, emphases vary and it is probably wrong to imagine that there was a consistent official line at any one time on how Actium, Egypt and Cleopatra should be fitted together. In the *Res Gestae*, for instance, things are very different. In its opening paragraphs Augustus is far more explicit about the civil wars of the 40s and 30s BC than about foreign wars; again in section 25 the war 'in which I was victorious at Actium' is quite clearly mentioned; as in section 34, where his extinction of the civil wars is cited as the crucial moment at which 'by universal agreement I had complete power over all things'. By contrast, the conquest of Egypt is mentioned only briefly in section 27 amongst a general catalogue of triumphs, while Cleopatra herself is passed over in complete silence. This is a very different picture from that met in the 20s and 10s BC on the coinage and on the inscription of the Solarium.

It could be argued that this simply represents a chronological progression: first Cleopatra and then Egypt fell out of the picture as time went on, while the civil wars, a subject that had at first been rather taboo, gained in general acceptability until, at the end of Augustus' reign, they were able to be proffered as the respectable cause and source of Augustus' rise to supreme power. This may indeed be true in part. A lot of time had passed since Actium by AD 14, when Augustus died and the inscribed version of the *Res Gestae* was erected, and he had long outlived most of those who were involved. No doubt the civil wars had become a less controversial topic of discussion, and far easier to refer to in public. But there is also a difference in kind, or genre, between the coins, the sundial inscription and the *Res Gestae*. Augustus, though all-powerful, was, unlike Louis XIV, not himself the totality of the state. He may have been its saviour, but the Senate and People remained the substance, however shadowy. Inscriptions on the public coinage and public monuments represent that side of the story in which the whole Roman people took part, the story of their victory over Egypt led by Augustus, in which Egypt was added as a province to their empire. The civil wars, by contrast, were the more personal story of Augustus' vengeance for the death of his father and the indisputable means by which he restored peace to the Commonwealth. It might seem appropriate, then, to adopt a different, more personal, perspective on past events which differed somewhat from their representation in more public contexts – though the original location of the *Res Gestae*, on the monumental Mausoleum of Augustus in Rome, was public enough. It was, nevertheless, a monument to a private individual written in the first person singular, not a public dedication to him by the Senate and the Roman People (SPQR).

Views will not merely have changed with time, they will always have been complex in nature at any one time. Historical, literary and material context must be important in understanding how and why the events of 31 BC are variously presented. Before Actium, Octavian was trying to get the Romans and Italians behind him. That was clearly going to be easier if Cleopatra were the declared public enemy rather than other Roman citizens, particularly Antony, who was still a very popular figure in Rome. Later historians, even useless ones like Velleius Paterculus, attempted to say what really happened and, reasonably enough, admitted that the decisive battle was essentially between Romans, not against Cleopatra, though her presence and influence is correctly registered. Poets, on the other hand, are not committed even to a semblance of truth and consequently found the figure of the Eastern queen, by turns a drunken whore and a formidable fury, too good to resist. Antony, if he appears at all, becomes a barbarized Eastern potentate 'victor from the peoples of the Dawn and the Red Sea, bringing with him Egypt and the strength of the Orient and remote Bactria' – no mention

of his Roman allies or of civil wars in Virgil (*Aeneid* 8.686-8). On the coins the crocodile of Egypt and the lyre-playing Apollo of Actium are the only types that refer explicitly to the great struggle. There is a range of designs including such elements as ships' prows and winged Victories that clearly allude generically to the theme of triumph. But there is certainly no direct reference to Cleopatra or Antony. It would be hard to discern which of these differing viewpoints is the official line; it is doubtless vain to try.

Octavian made a lot of the defeat of Cleopatra and the conquest of Egypt in the immediate aftermath of Actium. Though Suetonius and Dio claim that he tried to have her revived by Africans expert in curing snakebites (Suet. *Augustus* 17.4; Dio 51.14.4–5), in retrospect Octavian was perhaps rather relieved by Cleopatra's timely suicide, which meant that he did not have to drag her in chains through the streets of Rome in his triumphal procession. The Roman people were notoriously sentimental towards defeated enemies and loved to indulge in displays of magnanimous sympathy, as indeed they had towards Arsinoe, Cleopatra's elder sister, when she was led captive in Julius Caesar's triumph of 46 BC (Dio 43.19.3–4). As in the case of Antony in the 30s BC, it was far easier for Octavian as Augustus to shape people's perceptions of Cleopatra in her absence. In the end, he had a lot to thank those asps for.

Searching for Cleopatra's image:
classical portraits in stone

PETER HIGGS

The image of Cleopatra has been a constant source of interest for classical scholars since ancient marble sculptures were first discovered. The search for her portrait has been seen as a challenge by both academics and collectors, but their quest has not been entirely fruitful. Few sculptures could be convincingly identified as the queen – hardly surprising as the majority of her portraits were surely destroyed by Octavian after her death. Moreover only a couple of portraits of Cleopatra are mentioned in the ancient sources. These are the gold statue dedicated by Julius Caesar in the temple of Venus Genetrix in his Roman Forum, and the representation of the dying Cleopatra carried by Octavian in his victory parade through Rome. Finally, no inscribed statue bases of Cleopatra VII survive.

Despite the lack of hard evidence, several attempts have been made to identify the queen amongst the large corpus of surviving classical sculpture and many more identifications have been suggested on gemstones, cameos and other small-scale objects. The most homogenous group of portraits of Cleopatra VII are to be found on coins, but these were not utilized for identifying sculptures carved in the round until relatively recent times. Portraits of the queen also appear on a series of clay sealings from Edfu, many of which are now in the Royal Ontario Museum in Toronto (cat. nos 174–176). These tend to conform to the type found on the Alexandrian coin issues.

Some of Cleopatra's portraits may not have followed the official representation found on coins or sealings. They may, for example, have had a different hairstyle, or shown Cleopatra at different ages, but no portraits showing the queen as a young girl have been identified as yet. Finally, such are the rarity of portraits of Cleopatra that when a new example emerges we are suspicious of its authenticity. Yet the search for Cleopatra's image has yielded some interesting candidates, some of which are outlined below.

Identifications of Cleopatra before and during the Renaissance

Even before Shakespeare in 1607 or Dryden in 1677 had dramatized the life and death of Cleopatra attempts had been made to identify statues of the Egyptian queen. These may well have been influenced by illustrated manuscripts of Plutarch's Life of Antony. One of the earliest known identifications of Cleopatra VII is a statuette of a woman from the Grimani

Collection, now in the Archaeological Museum in Venice (fig. 7.1). The torso of the statuette is of Roman date and shows a woman leaning on a pillar, with a snake armlet carved as if beneath the drapery that covers her upper left arm. Her other hand was raised and held a shallow dish. The head, right forearm, left hand and pillar are restorations, perhaps by the Italian sculptor Tullio Lombardo (1455–1532), and the form of the crown certainly reflects the style of this period. Zanetti, who first published the statue in 1740, believed the statue to represent Cleopatra.

The sculptor who restored the statue dramatically altered the mood of the original work by adding a new head which is thrown back, the eyes rolling upwards. The mouth is slightly opened and her anguished expression may indicate that the poison has already taken effect. The tragic queen steadies herself by resting her right hand on a pillar while clasping a piece of cloth, perhaps used to mop her brow. Furthermore, the significance of what was originally a simple snake armlet was greatly enhanced by the restorer: the snake became the asp that injected its venom into Cleopatra. Apart from the snake bracelet, there was no reason for the owner of the statue or its restorer to identify the piece as Cleopatra. It appears that the owner wanted a statue of the queen, and had an ancient classical torso customized to suit his needs.

Sleeping Beauty with a snake!

This famous statue (p. 304, fig. 11.1) in the Vatican Museums, now known as the Vatican Ariadne, was also traditionally identified as Cleopatra for similar reasons as the Venice figure. A snake armlet, although included by the Roman sculptor as an insignificant piece of jewellery, was interpreted by scholars in the sixteenth century as the asp that bit Cleopatra, and her bared left breast would have been the snake's target. Because the woman's eyes are closed and she is reclining, with one arm poised dramatically over her head and the other raised up to support the cheek, the subject was thought to be the dying Cleopatra. It is not known exactly when the statue was discovered, but it was already in the possession of the Mattei family by the first decade of the sixteenth century. By 1512 it had been acquired by Pope Julius II and placed in the Belvedere of the Vatican as the centrepiece of a fountain. Pope Julius III later installed it in a room that became known as the Stanza della Cleopatra. The statue became extremely famous and was copied widely in a variety of materials (e.g. cat. no. 390). Other versions of the same statue in various museums were also labelled as Cleopatra. One interesting example in Dresden has a snake creeping upwards towards the woman's breast, but this is obviously a restoration to transform the subject into an image of Cleopatra.

The Vatican statue became so renowned that poems were written about it, and one example by Baldassare Castiglione (1478–1539) was so highly praised that it was translated into English by Alexander Pope. The poem associated this statue with the figure of the dead Cleopatra that, according to the Roman writer Dio Cassius, Octavian had made for his parade through Rome after his conquest of Egypt. The identification of the statue as Cleopatra persisted until

Fig. 7.1 Marble statue of a muse restored as a tragic portrait of Cleopatra (Venice, Archaeological Museum inv. 53; Soprintendenza Archeologica per il Veneto, Padova).

the eighteenth century, when Johann Winckelmann, the founding father of classical art history, voiced doubts. Instead he proposed that the statue was a sleeping nymph, or even a Venus, and that the snake was merely, as the sculptor had intended, a piece of jewellery. By the early nineteenth century the statue was no longer believed to represent Cleopatra but rather, as E.Q. Visconti, the cataloguer of the Vatican collections, suggested, a deserted Ariadne.

It is surprising that scholars had not attempted to use coins of Cleopatra to their full potential for making more secure identifications in sculpture. The earlier, tailor-made Cleopatra in Venice and the Ariadne in the Vatican represented a preference to highlight the dramatic death of the tragic queen as represented in Plutarch's Life of Antony and Boccaccio's 'Concerning Famous Women'. Little attention was paid to the facial features of any of the statues: Cleopatra's portrait was virtually ignored.

Cleopatra as a Venus-Aphrodite

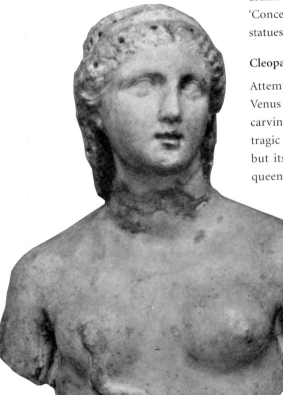

Attempts were also made to identify copies of the statue of Cleopatra in the temple of Venus in Rome. Busts and statues of naked Aphrodites were altered by restorers adding or carving a snake into one of the breasts, thereby transforming the goddess of love into the tragic queen. A particularly lively example (fig. 7.2) was formerly in a collection in Cairo, but its whereabouts today are unknown. The holes drilled in the hair indicate that the queen probably wore a metal diadem. The head and bust had broken and were later rejoined and, if they belong together, originally formed part of a statue of Aphrodite in the so-called *pudicitia* pose. It seems unlikely that this and other similar figures echoed the famous gold statue in the Temple of Venus: we do not know what that statue looked like, and have no reason to presume that Cleopatra was shown in the guise of Venus at all. Furthermore, it seems improbable that the queen would have been shown naked in antiquity.

As classical art historians began to make more discerning observations about ancient sculpture, more attempts were made to use original sources, such as coins, to identify historical characters. Cleopatra could now be looked at as a real person, one who lived, ruled and was an integral part of both Ptolemaic and Roman history. The myth of Cleopatra was beginning to unravel.

Fig. 7.2 Bust of a naked Aphrodite, from Sotheby's auction catalogue, 4 May 1931, no. 82. (Reproduced by kind permission of Sotheby's Ltd.)

Hairstyles and noses: nineteenth-century identifications

During the nineteenth century scholars began to publish monumental studies about ancient iconography. In the mid-nineteenth century F. de Clarac included in his encyclopaedic work the Venice Cleopatra and the various Ariadne types, but no portraits. Later, in 1882, J.J. Bernoulli published a series of volumes about portraits of both Greeks and Romans. There Cleopatra appeared in the Roman section, and most of the monuments cited were coins. A few marble busts were briefly mentioned, but none of them bears any resemblance to Cleopatra as we know her from her coin portraits.

British Museum (Castellani head)

The first identification of Cleopatra VII based on coins concerned a portrait carved from Italian travertine and acquired by the British Museum in 1879 (cat.no. 210). It had formerly been in the collection of Alessandro Castellani, a dealer and collector living in Rome, where the head may have been discovered. On arrival at the British Museum the head was soon labelled Cleopatra, or at least a woman resembling the queen. The identification was based upon the aquiline nose, seen clearly on her coins. The portrait appeared in many subsequent

publications with the label 'Cleopatra VII', and is still frequently included as a portrait of the queen in articles and books today. It is probably a portrait of a woman who closely modelled herself on the queen or one of the members of Cleopatra's entourage from Egypt. Cleopatra's stay in Rome from 46 to 44 BC undoubtedly influenced women's fashions and hairstyles, and added an exotic touch to a somewhat conservative republican ambiance. That this fashion was not restricted to women in Rome, however, is shown by a second private portrait in the Cairo Museum (cat. no. 267), and a portrait of a woman found on the island of Delos (p. 144, fig. 4.2). Like these two heads, Castellani's lacks the expected royal diadem. The hairstyle of Castellani's portrait is similar to that of Cleopatra on her coins, but is more elaborately dressed at the back in a series of twisted braids that form a coil. The facial features echo those of Cleopatra, but do not match exactly.

Desperately seeking Cleopatra: Schliemann's Cleopatra

Further away still from Cleopatra's physiognomy is a head now in Berlin (SK 205). In 1888 the archaeologist Heinrich Schliemann visited Alexandria with the intention of locating and excavating Cleopatra's palace, in which he hoped to discover an image of the queen. So it was with remarkable coincidence that within days of his arrival in Alexandria he claimed to have found a marble head of a woman twelve metres below ground, which he instantly declared was a portrait of Cleopatra VII. This damaged head has the hair arranged in the so-called melon-coiffure fixed into place by two straps that cross over the head. The hair would have originally been secured in a bun, but this has broken away. The hairstyle of Schliemann's head is not unlike that worn by Cleopatra on her coins but the head has no royal diadem. Furthermore, the facial features of Schliemann's head exhibit no similarities to coin portraits of Cleopatra. The nose had been damaged but was restored, and the general bland appearance of the face reveals no portrait characteristics whatsoever. When the head was presented to the museum in Berlin, German scholars quickly challenged the identification and grouped it with a number of similar portraits identified as either one of the Greek poets Korinna or Sappho. The proposed portrait types for both of these women sport a melon hairstyle. As far as we know Cleopatra never publicly identified herself with these Greek poets, and her style appears to follow the tradition of earlier Ptolemaic queens.

It is now doubted whether Schliemann's portrait was even found in Alexandria. His craving for discovering images of famous people of antiquity may have driven him towards deceiving both himself and the archaeological world.

It appears then that during the nineteenth century specialists in ancient portraiture were hard pressed to identify any portraits of Cleopatra. The British Museum head and Schliemann's Cleopatra had been eliminated as possible portraits of the queen almost as soon as they were first declared as such. It was not until the German scholar Ludwig Curtius published his research in 1933 that the first authoritative identification of a marble portrait of Cleopatra VII was proposed, and that is the portrait in the Vatican.

Twentieth-century identifications: the Vatican, Berlin and Cherchel Cleopatras

The Vatican Cleopatra (cat. no. 196)

The head Curtius identified had been placed upon a statue of Ceres to which it did not belong, and then displayed in a gallery in the Museo Pio Clementino. On its alien body, the head was poorly accessible, had been miscatalogued and was virtually ignored for over a century. Since Curtius' discovery the head has been consistently published as a portrait of the queen, but is usually erroneously described as coming from the Tomba di Nerone near the Via Cassia. Both the body and the head were actually found at the site of the Villa dei Quintilii on the Via Appia.

Although the nose had been broken off, and was restored shortly after its discovery, Curtius claimed that enough survived of the bridge to ascertain its original angle, hooked like Cleopatra's on some of her coins. The arrangement of the hair, the broad diadem and the large eyes were also closely comparable to the coins. The second part of Curtius' theory is perhaps less credible. Curtius believed that the marble head was a copy of an earlier portrait of Cleopatra VII, perhaps the gilded statue of Cleopatra placed in the Temple of Venus Genetrix in Caesar's Forum at Rome. He proposed that the Vatican statue showed the queen with Caesarion in the guise of Venus holding Eros, interpreting the small lump on the left cheek of the marble head as the remains of the finger of the boy, who was shown sitting on his mother's shoulder, playfully caressing her cheek. Actual examples survive of statues of Venus and Eros in this intimate pose. This marble lump, however, is more likely to be the remnants of a point on the stone marked out for accurate measuring by the copyist. The damaged nodule of marble above the brow is perhaps the remains of a *nodus* or roll of hair. The theory that the Vatican head showed Cleopatra as Venus is indeed attractive, but must be discounted in view of the lack of evidence for the appearance of the golden statue in the temple.

The origin of the Vatican type of Cleopatra portrait is disputed, with some scholars claiming that it copies an Alexandrian bronze original, while others see the influence of Roman Republican verism within the facial features. The face has a rather harsh expression, but then the portraits of Cleopatra on her coinage are hardly flattering or beautiful. It seems that by the late second and first centuries BC portraits of Greeks and Romans alike were beginning to exhibit a greater realism, which can be clearly detected in portraits of the later Ptolemaic rulers, and in private portraiture at both Alexandria and Rome. However, the Vatican head was found in a Roman context, and it is likely that it was made by a sculptor in Rome, as it is not pieced from separately made marble sections, a technique typical of Alexandrian workshops. Cleopatra may have transported images of herself to Rome when she visited in 46–44 BC, and it is likely that sculptors fashioned her image during her stay there. The Vatican head may be a vestige of one such portrait.

The Berlin Cleopatra (cat. no. 198)

Recent research concerning the finely carved marble portrait of Cleopatra VII now in the Antikensammlung in Berlin augments our knowledge of its history and discovery, as well as fuelling the arguments that surround the authenticity of the portrait. The bust, acquired by the Antikensammlung in 1976, had been offered for sale without much of a history, only a rumour that it had once belonged to a Greek family living in Alexandria and then passed to an American collection. As soon as the head was published and exhibited in Berlin it became a well-known and controversial piece, not only because its history was ambiguous but also because it bore a strong resemblance to the portrait in the Vatican Museums. Out of all the published works concerning the Berlin Cleopatra two principal conclusions have been drawn: firstly, that it is a fake, copying the Vatican portrait, and, secondly, that if the head is authentic, it is the work of an Alexandrian sculptor.

When the head was exhibited in Berlin, its modern bust and the restored left rear section of the hair had been removed. The then director of the museum, Klaus Vierneisel, briefly pub-

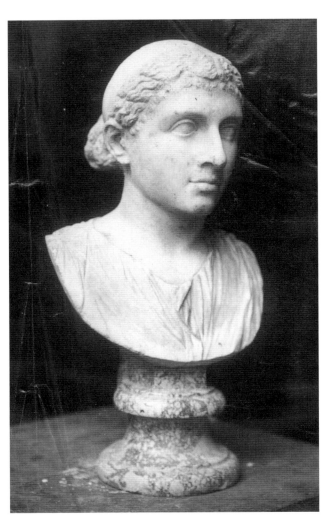

Fig. 7.3 The Despuig 'Cleopatra', from a photograph taken in 1897, with restorations intact. (Photo Greek and Roman Antiquities archive, British Museum, London.)

Fig. 7.4 Marble bust from the Despuig
Collection, no. 76; a neoclassical version of the Berlin
Cleopatra (Castell de Belver, Palma, Majorca).
(Photo Peter Higgs.)

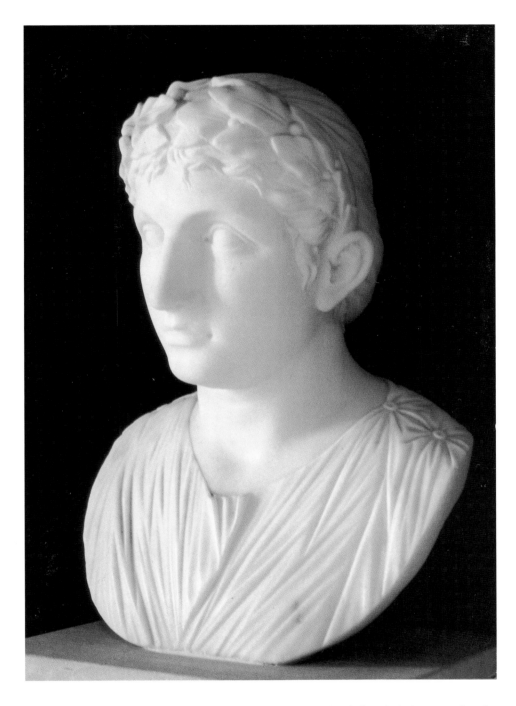

lished the portrait of Cleopatra in 1976, but wrote a more detailed analysis in 1980, after the
portrait had been dismissed as a fake in 1978 by the archaeologist Flemming Johansen. Most
writers since have given the head the benefit of the doubt but were concerned about its lack of
any fixed provenance or history; they nonetheless argue that the head is of Alexandrian work-
manship. Now, however, we know much more about the history of this sculpture from infor-
mation derived from archival sources in the Department of Greek and Roman Antiquities in
the British Museum.

A photograph of the Berlin Cleopatra taken in the late nineteenth century was sent to the
British Museum amongst a series of photographs of sculptures belonging to the Count de
Montenegro of Majorca (fig. 7.3). These sculptures were offered for sale to the British
Museum by the Count's agent, Lorenzo Roselló, a sculptor and dealer based in Paris. The

Count's family name was Despuig, and the collection had originally been displayed in his family home at Raxa, just north of Palma on Majorca. At the time the Despuig portrait was not recognized as that of Cleopatra, but was offered for sale with a tentative identification as the Antonine empress Faustina. The comparable head remained undiscovered in the galleries of the Vatican. The Despuig head therefore passed notice and was not purchased. Despuig's antiquities had been published in 1846 by D. Joaquin Maria Bovér, whose catalogue is illustrated with line drawings of some of the sculptures, but not of the Cleopatra/Faustina. The head is there identified as a portrait of Lucilla.

This information connects the Berlin Cleopatra with a collection catalogued in the middle of the nineteenth century, but what of the acquisition of the Despuig sculptures? From 1786 to 1797 the Cardinal D. Antonio Despuig y Damet undertook excavations in the region of the town of Ariccia on the Via Appia, south of Rome. Some of the sculptures in the collection were discovered in the remains of a Roman villa situated between Genzano and Ariccia, and other pieces may have been found during excavations nearby, but the exact findspot of the Berlin portrait is unknown. We cannot assume that all the sculptures in Despuig's collection were discovered during these excavations, but there is no documentary evidence to suggest that the Cardinal or later members of his family acquired ancient sculptures from elsewhere.

When at the end of the nineteenth century, because of financial difficulties, the Count de Montenegro was forced to sell some of his antiquities, several of the choice pieces of sculpture ended up in Ny Carlsberg Glyptotek in Copenhagen. Others were acquired by different collectors and museums, but the Cleopatra/Lucilla may have been sold privately and did not re-emerge until 1976. Many pieces of sculpture from Despuig's Collection were excluded from the sale and even today remain in Palma. Amongst them is a marble, neoclassical bust of a woman wearing a *sakkos* (a tightly fitting cloth cap) and a laurel wreath, the face of which was copied from the Cleopatra originally in the same collection (fig. 7.4).

This marble portrait bust was catalogued in 1846 as a portrait of the sixth-century-BC poet Sappho of Lesbos. She was so identified because of her laurel crown, the type worn by victors in dramatic and literary competitions. On close inspection, this bust and that restored to the Cleopatra now in Berlin, although not exact duplicates or mirror images, are almost identical in terms of scale, style of carving and form. The marble is also the same. Cardinal Despuig may have held the portrait of his Cleopatra/Lucilla in such great esteem that he commissioned a companion (pendant) piece. It is likely that the Sappho was carved by D. Luis Melis, one of the sculptors hired by Cardinal Despuig to restore his collection of sculpture. Melis worked around 1801, both on the restorations of the ancient bust and on the Sappho. Scholars who are sceptical about the authenticity of the Berlin Cleopatra may now compare a copy with the original.

The relationship between the Berlin and Vatican portraits is of more significant interest now that we know so much more about their history. It has always been a puzzle why the Vatican head has such a distinctive restored nose that in its shape and form is so like Cleopatra's on ancient coins. The head was not identified as Cleopatra VII until 1933, yet shortly after its discovery a new nose was added that looks very similar to that on the Berlin head. If the Berlin head can be associated with the excavations by Cardinal Despuig, then both it and the Vatican portrait may have been known in Rome long enough for someone to have made the connection. It is perfectly reasonable then to assume that the nose of the Vatican head was restored in the manner of the nose on the head found by Cardinal Despuig, which is almost exactly the same shape.

Now that we can trace the Berlin Cleopatra back to a collection that consisted of antiquities collected from Italy, its supposed Alexandrian origin may be questioned. When compared

with other Ptolemaic portraits, the Berlin Cleopatra does not fit comfortably with the style and technique of Alexandrian sculpture as the head was carved from one piece of marble: the cut surface on the left side was prepared to receive the restored section of the hair. The blurred surface and smooth finish have also been compared with the technique known as Alexandrian *sfumato*, a style some scholars consider typical of sculpture produced in Egypt during the Hellenistic period. On close examination, however, the surface of the marble shows signs of having been smoothed down during conservation treatment undertaken prior to its acquisition by the museum in Berlin. Furthermore, the purple staining in the hair may be the base for gilding and is unlikely to be remains of original colour: can we accept a portrait of Queen Cleopatra with a purple rinse in her hair?

We cannot, of course, completely dismiss the idea that the Berlin Cleopatra was the work of an Alexandrian sculptor. As already suggested, Cleopatra may have taken some of her court sculptors to Rome when she visited in 46 BC; she may even have taken finished portraits with her, and the Berlin head may be one such example. Furthermore, this portrait type has always been convincingly compared with the coins issued in Alexandria and Ascalon. The Romanized version of Cleopatra's portrait has usually been considered that found on the Antioch coin issues, on which she appears with Mark Antony in a highly veristic style (but see pp. 145–6, 212–14). It may be concluded that the Berlin head, although loosely inspired by Alexandrian portraits, was made for a Roman context.

These observations are also relevant to a pair of portraits in Cherchel Museum in Algeria identified at various times as Cleopatra VII.

Portraits in the Cherchel museum

One portrait with a melon hairstyle and diadem (cat. no. 197) was discovered in 1856 and the other, a veiled head (cat. no. 262) in 1901. Both were found at the port of Cherchel (ancient Iol Caesarea). When they were first published no mention was made of their resemblance to Cleopatra, even for the diademed head that so meticulously reproduces the queen's physiognomy and hairstyle on coins. Instead, this head was tentatively described as a portrait of Cleopatra Selene, the daughter of Cleopatra VII by Mark Antony. Cherchel was the capital of the ancient kingdom of Mauretania, the region restored by Augustus to Cleopatra Selene's husband, Juba II (25 BC–AD 23), the king of Numidia. Many high-quality portraits of the Mauretanian rulers survive, and Cleopatra Selene is likely to have included posthumous portraits of her famous mother in any family group. The setting up of a statue of the notoriously hated Queen Cleopatra VII during the Roman period would have been almost impossible anywhere except in the semi-autonomous kingdom of Mauretania where one of the members of the royal family was a direct descendant of the last Ptolemaic queen.

The problem with the two female portraits has always been who was who: are they mother and daughter, both Cleopatra VII, both Cleopatra Selene or neither? Scholars have not been able to agree, and over the past few decades the sculptures have been increasingly difficult of access. Nowadays, it is usually the diademed head that is identified as the Cleopatra VII, and the veiled head is rarely mentioned at all. It seems therefore an opportune time to discuss the two portraits in the context of other images of Cleopatra.

In 1954 the French scholar Jean Charbonneaux proposed that the veiled head represented Cleopatra VII, while the head with the melon hairstyle portrayed her daughter. Nevertheless, the diademed head is closest to the Vatican and Berlin portraits in style, hair arrangement and facial features, though there are differences. The modelling of the diademed Cherchel head is much more dynamic than that of the other two portraits. The wrinkled brow with the vibrant locks of hair, the large, staring eyes, the heavy chin and full lips create a remark-

Fig. 7.5 Marble portrait of a woman (Alexandria, Greco-Roman Museum). (Photo Sally-Ann Ashton.)

able portrait with a strong sense of authority. The queen appears older and more matronly than in the other two portraits, although she was only thirty-nine when she died. The marked turn of the neck is a Hellenistic feature. The Berlin and Vatican heads found in Roman contexts betray a slightly different temperament. The Cherchel Cleopatra, although commissioned for a Roman context, was perhaps influenced more by Ptolemaic styles than the other two portraits.

The opposite seems true of the veiled head in Cherchel. This portrait is much more puzzling, as it does not conform to the type shown on coins. When first published, the head was identified as Agrippina the Younger, the mother of the emperor Nero. If it were not for the pierced ears it would be easy to mistake the subject for a man; even the hairstyle, with the short curls deeply drilled to create a sense of volume, appears rather masculine. The head has been associated with Cleopatra VII because of its hooked nose, large eyes and severe expression, perhaps best seen on Cleopatra's coins issued at Antioch (cat. nos 221–222). Both the hair, and the realism of the portrait have prompted scholars to label the head Roman, but the hair is not easily matched amongst portraits of Roman women. The identification of this portrait as Cleopatra VII must remain questionable, but we cannot rule out that portraits existed of the queen that were not paralleled by the images on coins.

The suggestion that the two portraits in the Cherchel museum represent Cleopatra Selene is less appealing. On coins she is shown with a hairstyle reminiscent of Augustan women.

For all these reasons the two portraits in Cherchel should not be eliminated from the modest corpus of Cleopatra portraits. The diademed head is sufficiently close to the Vatican and Berlin heads and the coins that she almost certainly is the same woman, whereas the veiled head shows perhaps a different portrait type of Cleopatra VII.

Late twentieth-century identifications: any woman with a hooked nose will do

By the end of the twentieth century a mere handful of portraits of Cleopatra VII had been convincingly identified. Attempts to recognize the queen's highly distinctive physiognomy in a variety of media, from cameos to sculptures, continued. Few of these identifications have been embraced by classical scholars, and nearly all of them are without the crucial diadem. In his study of Ptolemaic portraits in 1975 Helmut Kyrieleis included only the Vatican portrait of Cleopatra, for the Berlin example had not yet re-emerged. By 1988 R.R.R. Smith included the Vatican head, the diademed Cherchel head and the Berlin portrait in his study of Hellenistic royal portraiture. Two heads in the Alexandria museum are frequently illustrated on the Internet in web sites relating to Cleopatra (figs 7.5 and 7.6). Both of the marble heads are very weathered and, apart from their large noses bear little resemblance to portraits of Cleopatra. One is clearly an Antonine woman (fig. 7.5), the other, with the tall headdress, is probably Trajanic in date (fig. 7.6).

One of the most recent identifications, however, uses criteria reminiscent of those adopted during the sixteenth and seventeenth centuries. This is a marble statue, known as the Esquiline Venus (fig. 7.7), that the Italian scholar Paulo Moreno has claimed is a replica of the famous gold statue of Cleopatra set up by Julius Caesar in his Forum at Rome.

Full circle: Venus with a snake

In 1994 Paolo Moreno argued that this statue was made during the reign of the emperor Claudius, who, as the grandson of Mark Antony, had a great interest in Cleopatra. Moreno compares the facial features with those of the Berlin and Vatican portraits and concludes that they are similar, and that the cobra carved on the vase alludes to the Egyptian origin of

Fig. 7.6 Portrait of a woman

(Alexandria, Greco-Roman Museum).

(Photo Sally-Ann Ashton.)

the subject. This theory is appealing, but on close examination the facial features of the Venus appear idealized as befits a goddess. Moreover, the cold, harsh modelling of the face betrays the so-called Severe style prevalent in Greek sculpture during the 480s to 460s BC, and revived at Rome during the Augustan period. Another difficulty arises from the historical sources, none of which claimed that the queen appeared in the guise of the goddess.

For all we know, Cleopatra may have appeared in the traditional Hellenistic royal form, that is, draped. Whatever the case, the search for the image of Cleopatra will no doubt continue, and produce both matches and mismatches. What is important is that the identifications ought to be based on firm ground, using numismatic evidence and iconographical details, such as those used for identifying the Egyptian-style images of Cleopatra VII (pp. 152–5). A snake, a hooked nose, large eyes and a melon-hairstyle do not a Cleopatra make.

Fig. 7.7 The Esquiline Venus

(Rome, Capitoline Museum, inv. 1141).

(Archivio Fotografico Musei Capitolini.)

Was Cleopatra beautiful?
The conflicting answers of numismatics

GUY WEILL GOUDCHAUX

The absence of a recognized three-dimensional image of Cleopatra has obliged scholars to rely on her portrait on coins to verify statements made by ancient writers regarding her profile. Even the recognition in 1933 of a marble head of the queen in the Vatican Museums (cat. no. 196) did not change matters significantly, as it is missing its nose. But having to refer to the numerous surviving coins to reconstruct the outlines of the queen's face, although it appears the simplest option, is, as we will see, quite complex in practice.

Cleopatra's coins were issued throughout her twenty-one-year reign. There are several places of production: Alexandria and Cyprus (traditional Ptolemaic lands), Ascalon (near Gaza), Beirut, Chalkis and Tripoli in Lebanon, Antioch (or Damascus?), Dora, Ortosia, Ptolemais Ake, probably Athens, Patras and finally, according to a comment by Servius (concerning Virgil, *Aeneid*, VII, 684ff), Anagni near Rome. Michael Grant supposed that the so-called issue of Anagni was produced locally but with imported moulds.

Cleopatra's effigy appears on almost all the coins, but only ten of them have come down to us in very good condition, and even among these none is mint. Even when they are not worn, many coins can transform or deform a face, just as today very good or very bad pictures can modify the reality of a portrait. Usually Cleopatra's silver or bronze coins are worn out and the latter are further deformed as a result of oxidation, and they therefore show a profile of the queen that is not very pleasing. Unlike her famous ancestors, Cleopatra did not issue gold coins.

Many modern historians have illustrated their texts using these coins, though they are in poor condition, and they obviously reached negative conclusions, to the point that they quite often attribute to Plutarch's sentence a meaning it never had:

> As far as they say, her beauty was not in and for itself incomparable, nor such to strike the person who was just looking at her; but her conversation had an irresistible charm; and from the one side her appearance, together with the seduction of her speech, from the other her character, which pervaded her actions in an inexplicable way when meeting people, was utterly spellbinding.
> The sound of her voice was sweet when she talked. (Plutarch, *Life of Antony*, 27)

The 'was not … incomparable' became in their texts 'not beautiful' or, even worse, 'ugly'. And it is true that from almost the totality of her coins, at a first superficial glance, we can discern crude caricature-like outlines, as if she were the model for the witch painted by Goya.

But Plutarch himself falls into a contradiction 'relying on the power of her beauty' (25, 4) and 'she was about to meet Antony at the age [27/28 years] when feminine beauty reaches its peak' (25, 5), while Dio Cassius writes: 'and it is true that she was a woman of incomparable beauty and … it was incredible when she was young, furthermore she had the most seductive voice and she knew how to make herself likeable to everyone' (XLII, 34, 4). These are words that recall those of a contemporary of Baudelaire: in the poet's voice one could hear 'the cursive and the capitals'.

The only three-dimensioned portrait that I am sure is that of Cleopatra – of the others, I do not have any convincing proof that they represent the queen – is then the marble head in the Vatican Museums. As was stated above, the nose is missing, but the bones of the face, the eyes and the lips give an idea of a young, fresh, wilful woman. It is a fine and imposing head although its ears are badly made, a clear sign of Alexandrian manufacture and no reflection of

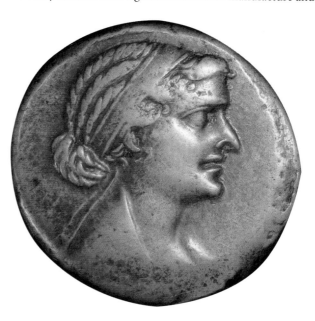

Fig. 8.1 Bronze coin of Cleopatra minted in Alexandria (cat. no. 179).

any ugliness on Cleopatra's part; as a matter of fact, other Alexandrian heads, which are in other respects quite beautiful, characteristically have ugly ears, such as, for example, the head of the young man (possibly Ptolemy Apion) now in Stuttgart (cat. no. 28).

Until now it has been difficult to build a clear relationship between the image of Cleopatra of the Vatican portrait and that presented on the coins. Luckily, this exhibition offers the chance to present a group of coins showing the queen's profile, turned to the right, which are neither deformed by wear and tear nor corroded. In the refined bronze example from the Hunterian Museum, Glasgow (cat. no. 179, fig. 8.1), the queen is attractive – indeed, this is the only coin where she appears radiant. We can further compare an early Alexandrian group of three bronze coins with the queen's youthful profile (cat. nos. 180–182): the first, worn and corroded, shows Cleopatra with a witch-like face; the second, uniformly oxidized, respects the queen's beauty, while the third, completely cleaned with acid in modern times, shows a sac-charine image. Let us leave aside the coins minted in Cyprus around the years 47–44 BC in which Cleopatra is pictured with the child Caesarion, for the examples are so worn that it is impossible to imagine that they represent the same character as the Glasgow coin or the example from the Goudchaux collection.

Let us now compare the two silver tetradachms originating in Ascalon. Both draw their inspiration from the youthful prototype issued in Alexandria. The coin in the British Museum collection (cat. no. 219) dates to 49 BC and portrays a boney and lined face, not that of a

twenty-year-old princess. The Chapman-Adda example (cat. no. 220), minted nine years later, in 38 BC, instead portrays a queen who appears significantly younger than the one on the coin preserved in the British Museum!

Another two images of her, with or without chignon, on coins of smaller diameter were issued in Alexandria at the beginning of her reign: the silver drachma in the British Museum dates to 46 BC; Cleopatra is twenty-four years old, but it is more likely that the minting had occurred some time earlier. The 40-drachm bronze coin of the Goudchaux collection also offers a romantic face of almost modern cast, à la Chanel.

Before examining the coins of the second part of Cleopatra's reign, we will consider those of her rivals. Firstly, a coin of Antony's third wife at the moment of his meeting with the Queen of Egypt: Fulvia, daughter of Marcus Flavius Bambalius, already the widow of Publius Clodius (killed by Milo in 62 BC) and of Gaius Scribonius Curio (who died at the Battle of Utica in 49 BC). In the years 41–40 BC, she was no longer twenty years old. The comparison between Fulvia's royal profile and Cleopatra's completes Plutarch's text:

> She was not a person made to spin wool and run a home: despising the domination of a simple
> citizen, she wanted to dominate a dominator and to command an army commander. Cleopatra was
> in debt to Fulvia for the lessons of submission to women that Antony had learnt from her: she had
> made of him a tamed and trained man when he passed into Cleopatra's hands. (*Life of Antony,* 10, 5-6)

Having herself become a leader of warriors, a 'passionate supporter' of Antony's cause in Italy during his absence between the years 42 and 40 BC , Fulvia was to die in 40 BC at Sicyon in Greece.

Antony, in order to put an end to domestic conflicts in Italy, raced back in the summer of 40 BC and agreed to marry Octavian's sister, Octavia (66–11 BC), the beautiful widow of Gaius Marcellus. We can admire her noble outline and delicate profile in a coin issued at the time of their marriage or just after that date (cat. no. 259) or, better, on a marble bust of that period (fig. 8.2). Despite the young wife's beauty, intelligence and political influence, the union did not last more than two years, just time enough for her to give birth to two daughters, Antonia Maior and Antonia Minor. From the second half of 37 BC Mark Antony would remain with Cleopatra until his death. In that year of Antony's return, when Cleopatra entered the last period of her political life, she was thirty-three years old. From that time onward she would have coins issued, always outside Egypt, with her effigy on the obverse and that of the Roman on the reverse. These coins would be issued mainly in those zones where Cleopatra wanted, by means of monetary policy, to legalize or to promote her political power. It is natural that the queen's profile underwent some changes compared to the first issues of the years 51–38 BC.

The new prototype, most likely made in Antioch, was taken as a model by different moneyers. The queen is portrayed in almost imperial comportment, her clothes are emphasized, as is her coiffure (in the Goudchaux collection's example (cat. no. 222) one can count the exact number of braids and curls), along with her jewels (among which the famous earring with a pearl). One can understand that she is not afraid to be portrayed according to a taste verging on the colossal, despite the smaller size of the tetradrachm: her neck is massive with an unexpected Adam's apple, she wears a mantle that looks like a *chlamys*, more often worn by men, and, unlike other queens of the family, she does not wear a veil. The tendency toward enlarging particular details (the eye in the Goudchaux examples) has a political goal, and indeed almost a religious one: it must impress. Of course, the *ex orbito* eye is not a novelty in Ptolemaic representations on coins. In the Goudchaux burnished silver example (cat. no. 222) the queen's profile is transfigured, it almost looks like a noble bird of prey: there is no further need to add the Ptolemaic eagle to the reverse!

This stylistic change takes us far from the young woman portrayed in the Glasgow,

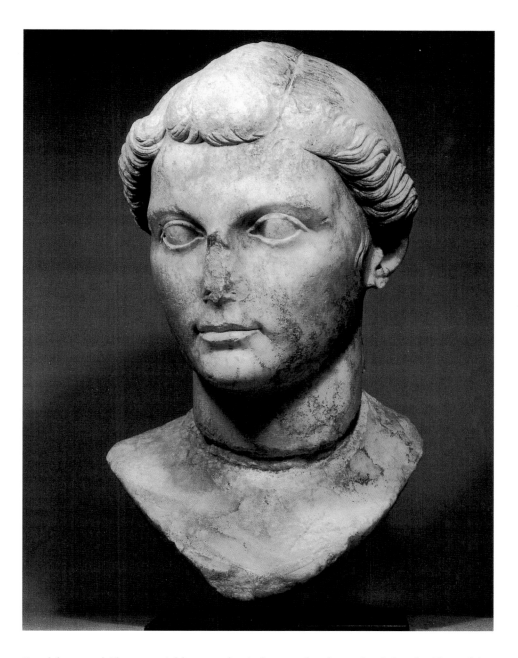

Fig. 8.2 Marble portrait bust of Octavia
(Private collection, France).

Goudchaux and Chapman-Adda examples; it does not involve maintaining the Alexandrian tradition representing the princess's youthful freshness, but emphasizing a symbol, the omnipotent 'Queen of Kings', who has achieved such status thanks to the fruitful union with Mark Antony. Her minters opened the way to a type of portrayal that shows a warlike and dominating Cleopatra on the obverse together with an Herculean Mark Antony on the reverse. In 34 BC, following the ceremony of the 'Donations' – the first Roman triumph out-side the city – Alexandria was in open competition with Rome: the new issues up to that of Actium express this political policy. We will find this more stylized typology again on the late antique coins of the soldier–emperors before and after the foundation of Constantinople in AD 330.

As far as the so-called Athens issue (of which the best example, discovered in Paestum in 1998, is now in the local museum) is concerned, it seems that the minter tried to make the queen's profile resemble the noble perfection of Octavia (fig. 8.2), who had lived in that town with Antony from 40 to 38 BC, where she enjoyed a measure of popularity. But such an obser-

vation does not confirm that this issue, usually deformed by constant use, was certainly minted in Athens.

At the end, on the small format bronze coins issued at Chalkis in Lebanon in 32–31 BC and destined for paying soldiers, the queen is represented in a simplified way (cat. no. 214), the lines inspired by the Antioch examples. The Chalkis coins were issued, as far as it appears, in a mobile mint, which followed the troops that were being assembled in the shadow of the war against Octavian. Can one suppose that among the minters there were some from Gaul, given the marked simplification of the queen's outlines on the obverse and of the triumvir on the reverse of the coin? Antony always had soldiers and followers from Gaul at his disposal. If, with due prudence, one compares this profile to certain statuettes in the Celtic tradition, one has an impression of dejà-vu.

What conclusions may be drawn?

The coins dating back to the second period of her reign portray Cleopatra with an enormous neck and the features of a bird of prey. It may look easy to compare the queen's neck with Mark Antony's massive representation on the reverse, but the observer must remember that such a neck does not exist in reality, it is instead a 'baroque' aberration already found in Rome, especially on Julius Caesar's coins, both those issued when he was alive and those minted after his death (cat. nos 201–205). They differ from each other in the sense that the dictator's wrinkled neck became very long, while those of Cleopatra and her second companion became not only longer but also stockier.

Let us now dwell for a moment on a contradiction that is not easily resolved. The rare fine-quality coins do not show the same nose in profile. In Alexandria the minters portrayed a straight nose with nostrils that are a little over-prominent, in Ascalon the nose is long and pointed, while in Antioch it is boney, almost 'Bourbonic'. How can this be? Let us recall the observation made above: as with pictures, coins transform the model.

Numismatists know that the coins never portray Cleopatra as a whole figure. We may suppose that she was petite from the tale that in 48 BC Apollodorus Siculus, the queen's *philos* (high-ranking confidant), managed to carry her wrapped in a bedroll from a boat up to the room of the palace where Caesar had his general headquarters. She surely had to be a fine healthy woman to give birth without any problems to four children (three boys and one girl). Finally, we should note that from Cicero's correspondence, censured by Octavian, we can infer that the queen had a miscarriage in the month following Caesar's death.

Many know the remark of Pascal, who also had quite a prominent nose: 'If Cleopatra's nose were shorter, the shape of the world would have been different' (*Pensées*, no.180). In the seventeenth century, in Pascal's day, numismatics was a discipline far more taken up than making collections of archaeological pieces. Already in the sixteenth century there were 200 numismatic collections in the Netherlands, 175 in Germany and more than 389 in Italy (Murray, *Museums, Their History and Their Use*, Glasgow 1905, 14–15). The great mathematician Pascal would have not written thus if he had not been concerned with a precisely delineated profile. One has to understand Pascal's warning; that if the queen's nose had been shorter, the queen would have lacked the necessary strength of character – of which this powerful nose was the symbol – to attract and keep in her power two of the most influential men of her time. But the present aesthetic standard requires straight and small-nosed women, with no personality, such as those fashioned by cosmetic surgery. In the period of mannerism and the baroque, an aquiline nose caused no dismay. Laura Battiferri's portrait by Bronzino (fig. 8.3) reminds us that a woman can indeed be beautiful despite her prominent profile.

Long live Cleopatra's nose!

Fig. 8.3 Bronzino, *Portrait of Laura Battiferri*, 1555–6.

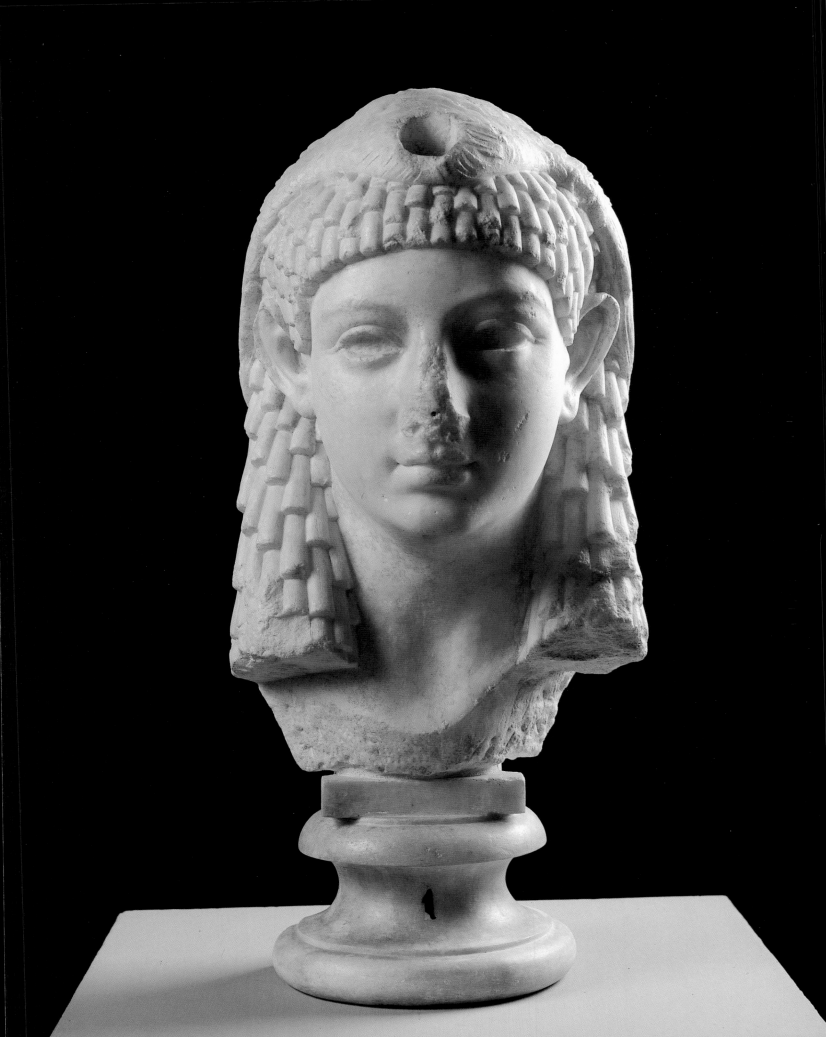

194 Marble head of a Ptolemaic queen with vulture headdress

First century BC

Found rebuilt into the Church of San Pietro e Marcellino in the Via Labicana, near the sanctuary of Isis, Rome

Height 39 cm

Rome, Musei Capitolini 1154

The head is preserved to the neck; the marble was worked to be slotted into a separately made body. The back of the headdress is unfinished and there is superficial damage to the surface of the wig. The tip of the nose is also damaged, and the inlays for the eyes and the original fixtures of a vulture head and crown are missing.

This sculpture is carved in Parian marble according to the Hellenistic tradition, without a back pillar, but the sculptor has used Egyptian attributes for the portrait: the tripartite wig and vulture headdress. The vulture cap has two holes, one at the front for the vulture head, and a second at the top of the head, for a crown. The latter is relatively small and there is no *modius*, as is usual in the Egyptian tradition for a statue of this size. The appearance of the headdress was likely to be Egyptianizing rather than Egyptian, in the form of the crown of Isis, with a sun disc and cow horns (see cat. no. 195).

Both the wig and vulture cap are extremely well carved and comparable to the wig on the Hermitage queen (cat. no. 160); the crown and bird head would probably have been finished in metal and would have contrasted well with the Parian marble surface of the sculpture. The portrait is carved in a style that is typical of Alexandrian sculpture. The fleshy appearance of the cheeks, lip and chin contrasted with the heavy eyes are similar to male portraits of the late second and first half of the first centuries BC. The overall appearance of the piece is youthful. The large ears, set unevenly in front of the wig, are also typical of Ptolemaic portraits from Egypt. It

is, therefore, likely that this statue was either manufactured in Egypt and brought to Rome, or carved by an Alexandrian artist resident in Rome at the time of manufacture.

Previously, the statue has been identified as a portrait of Berenike II, wife of Ptolemy III (246–222 BC). However, portraits dated to the first century BC more closely parallel the rounded cheeks, prominent nose and full lips. It has also been claimed that the image is a generalized representation of the goddess Isis. However, the features are strong enough to suggest that the sculptor used an Alexandrian royal portrait as a model, even if it was not intended to represent an individual queen. The association with the goddess Isis and the similarity to the portraits of Cleopatra VII might suggest that the Queen's Hellenistic portrait was used as a model for this piece. It is even possible that the statue was dedicated during Cleopatra's two-year stay in Rome, 46–44 BC.

BIBLIOGRAPHY: C.L. Visconti, 'Trovamenti di oggetti di arte e di antichità figurata', in *Bull Com* 25 (1887), 133–4; S. Ensoli in E.A. Arslan (ed.), *Iside, il mito, il mistero, la magia* (Milan, 1997), 396–7 for earlier bibliography.

S-A.A.

195 Gold finger ring with an engraved portrait of Cleopatra VII

51–30 BC

Provenance unknown

Length of bezel 1.7 cm

London, Victoria and Albert Museum M38.1963

This well-preserved finger ring with an oval bezel has a carefully engraved portrait of a Ptolemaic queen wearing an Egyptianizing costume. The head, which is in profile, wears a tripartite wig with a vulture headdress, the head of which is

195

clearly visible at the front. On top of the headdress is a circle of cobras supporting a sun disc and cow's horns, a crown worn by the goddess Hathor and, later, Isis. The torso is shown in a frontal position and the subject wears a sheath-like garment and pectoral or several necklaces.

The vulture headdress indicates the subject's divine status, and the portrait features with rounded cheeks, a strong hooked nose and pointed chin are similar to those found on images of Cleopatra VII. One seal impression is very close to that on this ring (cat. no. 174) and both compare well to the marble head possibly representing Cleopatra VII from the Esquiline in Rome (cat. no. 194).

BIBLIOGRAPHY: H. Kyrieleis, *Bildnisse der Ptolemäer* (Berlin 1975), pl. 100.8.

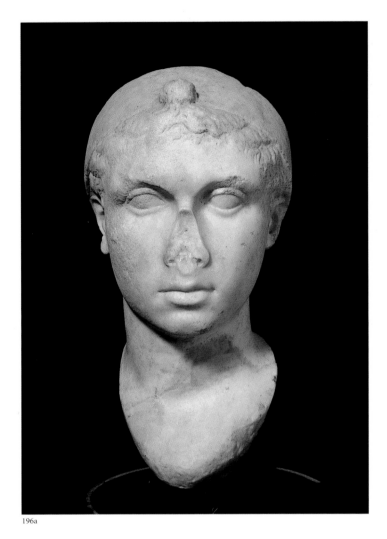

196a

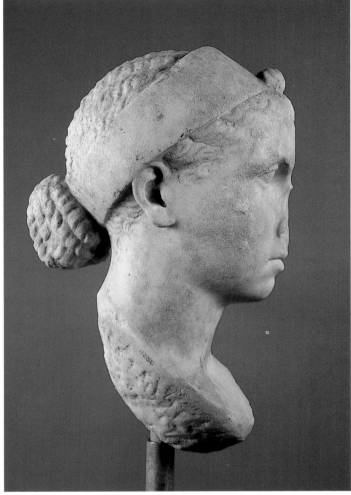

196b

196 Marble portrait of Cleopatra VII

c. 50–30 BC

Found at the Villa of the Quintilii
on the Via Appia in 1784

Height 39 cm

Vatican, Museo Gregoriano Profano,
Vatican Museums 38511

This head in Parian marble is generally well pre-
served, but the surface is more weathered on the
left side than on the right. The hair is damaged at
the front, and the boss of stone projecting from
above the centre of the brow is broken. The nose
had been restored in the late eighteenth century,
but this has now been removed. There is a small
weathered lump of marble protruding from the
left cheek.

This striking portrait was first displayed in the
Vatican Museums on a body that had been dis-
covered in the Villa of the Quintilii at the same
time as the head. It was identified by E.Q.
Visconti as a 'not very pretty' portrait of a priest-
ess of Ceres because of the diadem that he misin-
terpreted as a band, an *infula*.

Ludwig Curtius identified the head as
Cleopatra VII in 1933, and claimed that the body
did not belong. The head closely resembles por-
traits of the queen on coins and, like the Berlin
example, follows the portrait type found on
coins from Ascalon and Alexandria. The hair is
carefully arranged into a melon hairstyle,
around which is tied the royal diadem of the
broad type favoured by late Hellenistic rulers.
The large, widely opened eyes and short mouth
resemble earlier Ptolemaic portraits, but both
the general appearance and the technique of the
sculpture do not correspond with products of
the Alexandrian workshops. It has been sug-
gested that the head copies a bronze original.
The lump of marble on the crown of the head
may be the remnants of an attribute such as a
lotus crown or uraeus, or even the remains of a
large knotted lock of hair. The portrait was
carved to be inserted into a draped body.

The original context of the portrait of
Cleopatra VII is not clear, but it was found in a
Roman villa where many other pieces of sculp-
ture were discovered. Very few of these are por-
traits, and those that are represent Romans.
Curtius proposed that the head comes from a
copy of the famous gold statue of Cleopatra set
up by Julius Caesar in the Temple of Venus
Genetrix in his forum in Rome. Curtius also
claimed that it represented Cleopatra as Venus

with Caesarion as Eros sitting on her shoulder. This theory is appealing, but no ancient sources describe the gold statue or mention that the queen was portrayed as Venus.

BIBLIOGRAPHY: E.Q. Visconti, *Le Musée pie-Clémentin* III (Milan 1820) pls XX, tav.IV; L. Curtius, 'Ikonographische Beiträge zum Porträt der Römischen Republik und der Julisch-Claudischen Familie, IV: Kleopatra VII Philopator', *RM* 48 (1933), 182–92; G. Lippold, *Die Skulpturen des Vaticanisches Museums* Vol. III, 1 (Berlin and Leipzig 1936), Sala a Croce Greca, no.567, pl. 54; C. Pietrangeli, ibid., 543; G.M.A. Richter, *The Portraits of the Greeks* (London 1965), 269, figs 1863–4; H. Kyrieleis, *Bildnisse der Ptolemäer* (Berlin 1975), 185, cat. no. N1, pl. 107; K. Fittschen, 'Zwei Ptolemäerbildnisse in Cherchel', in N. Bonacasa and A. DiVita (eds), *Alessandria e il Mondo Ellenistico-Romano. Studi in onore di A. Adriani 4* (Rome 1983), pl. XXLX, no.7; R.R.R. Smith, *Hellenistic Royal Portraits* (Oxford 1988), 169, cat. no. 67; R.S. Bianchi, *Cleopatra's Egypt: Age of the Ptolemies* (New York 1988), 184–6, cat. no. 76; U. Schädler, in A. Ricci (ed.) *La Villa dei Quintili* (Rome 1998), 95, no. 37, pl.VIII.

P.H.

197 Marble portrait, perhaps of Cleopatra VII's daughter, Cleopatra Selene, Queen of Mauretania

c. 10–1 BC

Found in Cherchel, Algeria, perhaps in 1856
Height: total 31 cm, head 27 cm, face 20 cm
Cherchel, Archaeological Museum S 66(31)

The head is generally well preserved but for some chips of stone lost from the base of the neck, the chin, the tip of the nose and the lobes of the ears. Particularly noteworthy for the reconstruction of the original form of coiffure is the loss of the central tuft of hair above the brow (*nodus*) and the chignon at the back of the head.

The work represents a mature woman, her head leaning to the left and slightly upturned. This position, indicated by the oblique axis of the neck, reveals that the figure was probably shown moving. The portrait, which was found close to Juba II's palace at Cherchel, is of an estimable quality. The refined melon coiffure, quite similar to that adopted by the early Ptolemaic queens and revived by Cleopatra VII, is held in place by a rigid diadem, large and thick, and apparently imitating metal. In front of the diadem the hair is elaborately arranged in several waves of locks drawn out of a central parting to cover the upper brow. The centre of the brow was dominated by the *nodus*. On the forehead a series of small, care-

fully arranged tight curls, pierced by symmetrical holes, completes the elegant coiffure.

Though slightly narrowed at the crown, the head is round. The face is full of realism and its execution has been accomplished with great care. The artist has insisted on details that have been rendered with precision, increasing the individuality of the subject. The flat cheeks give the face greater expression and strength, accentuating its bearing. The almost-round eyes are wide open, the line of the straight and delicate nose drawn above them to frame the arched eyebrows, which are noticeably knitted. The mouth is well delineated, with a slightly prominent lower lip.

As with cat. no. 262, the identification of the subject is disputed. For more than a century the portrait was, for valid reasons, attributed to the queen Cleopatra Selene, the wife of Juba II (21/20–5/4 BC), and twin daughter of Mark Antony and Cleopatra VII. Recently, it has been proposed that we should recognize instead the face of her mother, notwithstanding the considerable differences between this portrait and the head in the Vatican (cat. no. 196), unanimously acknowledged as representing Cleopatra VII. However, the differences are significant, not only in the hairstyle but also in the facial features, both critical to recognition and identification. The Vatican portrait's long

face, with narrow chin, long nose, high brow and wide-set eyes, is not matched by the royal image in Cherchel, which is full-faced and expresses none of the energy and harsh authoritarianism of the Vatican portrait. However, certain images of Cleopatra Selene on coins show a similarly full profile. Thus, though a likeness to Cleopatra VII exists, there is no hesitation in restoring to this portrait the first identification as Cleopatra Selene, Queen of Mauretania. The marks of her devotion and love for her mother country were to be seen in this image, set up in her kingdom's capital city, Cherchel, where Cleopatra Selene revived Ptolemaic Egyptian fashions, infusing them with a Hellenistic Greek quality.

The style of the work, the distinguishing stylistic features of the face, and the age of Cleopatra Selene, who died aged thirty-five or thirty-six in 5–4 BC, allows us to establish the date of this portrait in the last decade of the first century BC.

BIBLIOGRAPHY: P. Gauckler, *Cat. Musée de Cherchel* (1895), 54, 8,no. 4; S. Gsell, *Cherchel, Antique Iol-Caesarea* (1952), 51 n 31; K. Fittschen, 'Zwei Ptolemäerbildnisse in Cherchel', in N. Bonacasa and A. DiVita (eds), *Alessandria e il Mondo Ellenistico-Romano. Studi in onore di A. Adriani 4* (Rome 1983), 168ff., pl. 29; P. Moreno, *Scultura Ellenistica 2* (Rome 1994), 730ff., fig. 921.

M.F.

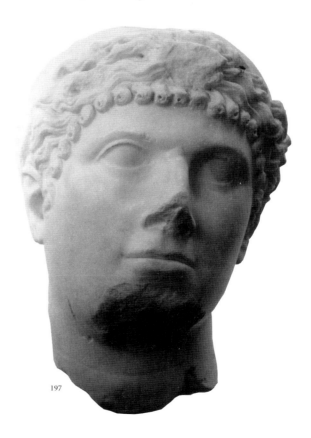

197

198 Marble portrait of Cleopatra VII

c. 50–30 BC

Provenance unknown, but acquired for the Despuig Collection in the late eighteenth century, so likely to be from Italy. It may have come from the region of Ariccia or Genzano, south of Rome

Height 27 cm

Berlin, Staatliche Museen zu Berlin, Antikensammlung 1976.10

The portrait is in fine condition, except for one or two small abrasions. The bun, although broken and reattached, is ancient. The rear left part of the head, including the ear, and the tip of the right ear had been restored, but these restorations have been removed. The head had been placed on a modern bust of variegated marble, now also removed.

This portrait follows the type found on the coins of Alexandria and Ascalon. It is a slightly more flattering portrayal of the queen than the Vatican (cat. no. 196) and Cherchel portraits (cat. no. 197), but some of the softness and delicacy of the features may have been exaggerated by modern treatment with an abrasive chemical, which has blurred the sharpness of the original carving.

Cleopatra is shown with the usual melon hairstyle and a broad diadem. Unlike the Vatican portrait, however, her diadem is set further back on the head, and runs underneath her bun, rather than merging with it. A series of small

coiled curls have escaped from the formal melon arrangement of the hair and frame the brow. These curls have been almost obliterated on the Vatican portrait but do occur on the diademed Cleopatra in Cherchel. The Berlin head's nose has a slightly downturned tip, with curving nostrils that compare favourably with the portraits of Cleopatra VII on coins and clay sealings. The mouth is downturned at the corners, the lower lip somewhat fleshier than the upper. The head originally tilted slightly to the right and turned on the neck in the same direction. This reconstructed pose is based on the asymmetrical carving of the eyes and the mouth.

The most distinctive feature of the portrait is the purple colouring on the hair and diadem. This has been identified as a base for gilding, but it is unlikely that both hair and diadem were covered in gold leaf as they would have merged into one mass. It is possible that the purple colour is the result of a conservation treatment, where some patina has been removed, thereby leaving a purple residue behind.

This portrait has generally been considered an Alexandrian original but, because of its probable Italian provenance, was more likely made for a Roman context, like the Vatican Cleopatra. The technique of the sculpture does not correspond well with Alexandrian portraiture because there is no evidence for piecing: the head and neck were originally made in one piece for insertion into, presumably, a draped body (see pp. 204–7

for further details about collection history and authenticity).

BIBLIOGRAPHY: D. Joaquin Maria Bover, *Noticia Historico-Artistica de los Museos del Eminentismo Senor Cardenal Despuig* (Palma 1845), 100, cat. no 53, described as a portrait of Lucilla; K. Vierneisel, *Jahrbuch der Stiftung preussischer Kulturbesitz 13* (1976), 246–7; F. Johansen, 'Antike portrœtter af Kleopatra VII og Marcus Antonius', *Meddeselser fra Ny Carlsberg Glyptotek 35* (1978), 62, fig.10 (who believes it is a fake. The Cleopatra is shown with restorations); K. Vierneisel, *Jhb.Berl.Mus.22* (1980), 5–33; L. Giuliani, *Bilder von Menschen.* Berlin Exhib.Cat.(1980), cat. no. 44; K. Fittschen, 'Zwei Ptolemäerbildnisse in Cherchel', in N. Bonacasa and A. DiVita (eds), *Alessandria e il Mondo Ellenistico-Romano. Studi in onore di A. Adriani 4* (Rome 1983), pl. XXLX, nos 5–6; R.R.R. Smith, *Hellenistic Royal Portraits* (Oxford 1988), cat. no. 68; R.S. Bianchi, *Cleopatra's Egypt: Age of the Ptolemies* (New York 1988), 187–8, cat. no. 77; G. Ortiz, 'Connoisseurship and Antiquity', *Small Bronze Sculpture from the Ancient World* (Papers given at a symposium, J. Paul Getty Museum, 16–19 March 1989) (Malibu, Calif. 1990), 257–61, figs 3a–b, where the author declares that the portrait is a fake; P. Moreno, *Scultura Ellenistica II* (Rome 1994), 730; G. Grimm, *Alexandria, Die Erste Königsstadt der Hellenistischen Welt* (Mainz 1998), fig.125; B. Andreae, *Schönheit des Realismus* (Mainz 1998), 250; G. Weill Goudchaux, 'Cleopatra', *Archeo* (Dec. 2000), 53–5, revives the view that this portrait is a fake, but omits a discussion of the neoclassical version illustrated here on p. 205, fig. 7.4., which first appeared in S. Walker and P. Higgs, *Cleopatra: Regina d'Egitto* (Milan 2000), 149, fig. 6.

P.H.

198 ▶

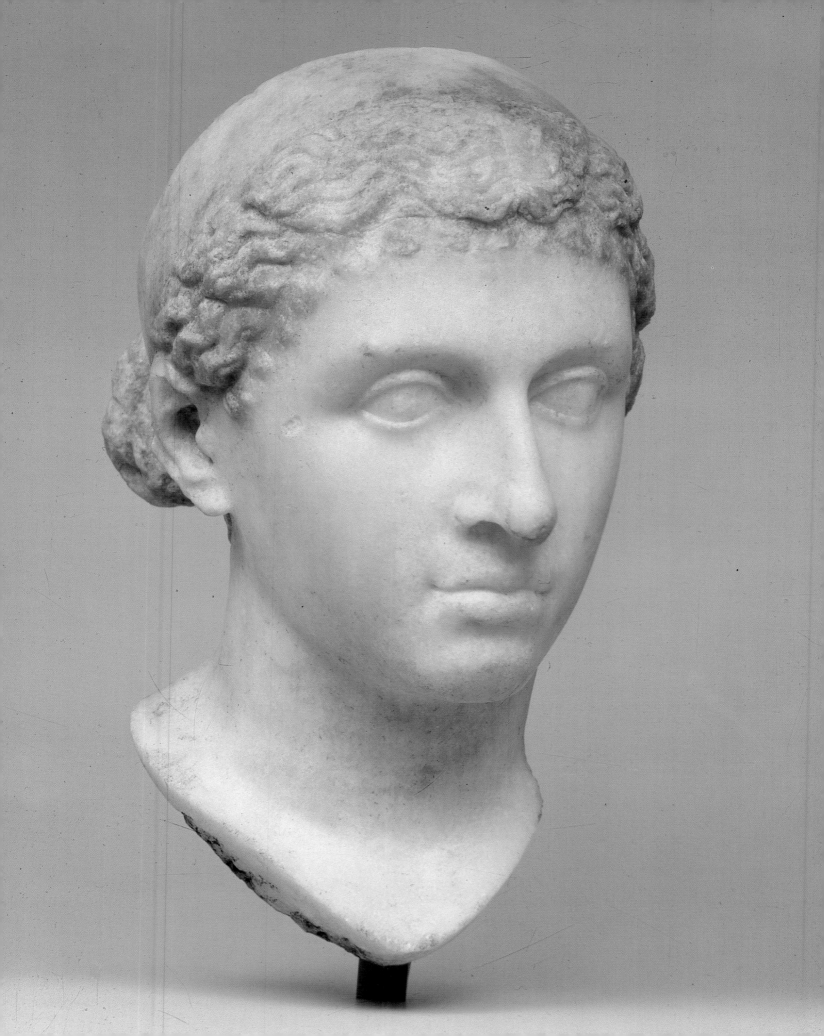

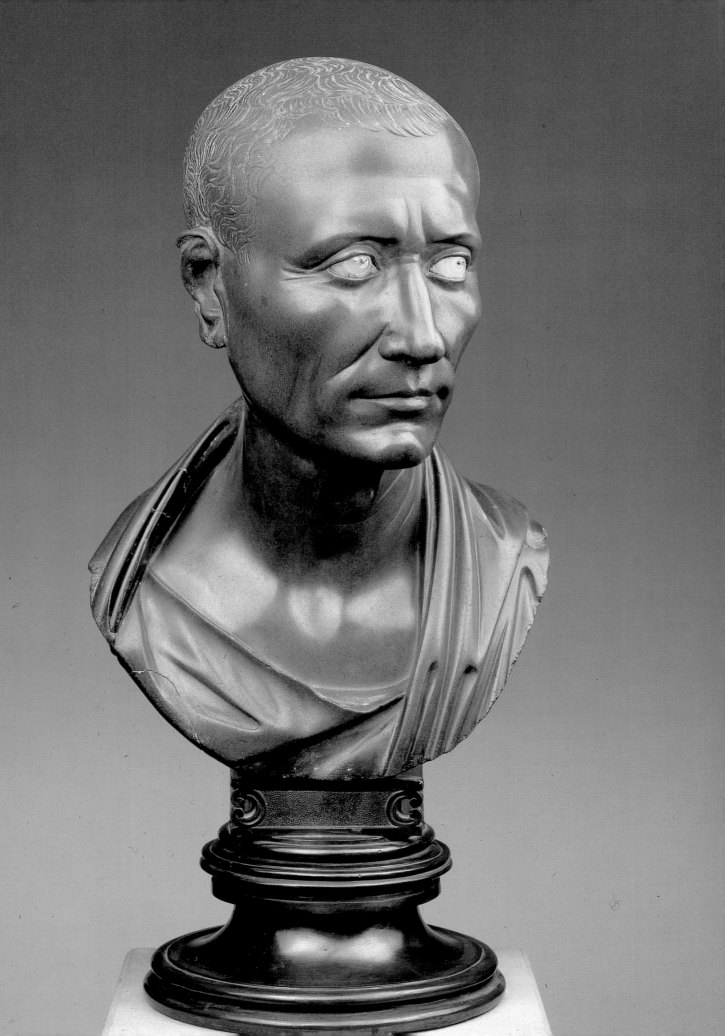

199 Green basanite bust of Julius Caesar

c. AD 1–50

Probably from Italy; acquired in 1767 by Frederick II of Prussia from the Julienne Collection.

Height 41 cm

Berlin, Staatliche Museen zu Berlin, Antikensammlung R9

There are minor restorations to the left ear and drapery. The inlaid marble eyes may be entirely modern; certainly the carving of the pupil and iris is not ancient. The entire surface has been repolished.

The over life-sized portrait shows a man of mature years looking to his left: the thinning hair is almost engraved on the scalp. The brow bulges, with two pronounced lines diving to the bridge of the nose, which is itself marked by two deep horizontal lines. Lines also mark the outer corners of the eyes. The nose is long and slightly hooked, with deeply cut and wide set folds of flesh running from the nostrils to the ends of the mouth. The cheekbones and round chin are prominent.

Though its identity and authenticity have been doubted, this portrait is most likely an image of Julius Caesar made fifty years or more after his murder in 44 BC. The stone is Egyptian, from Wadi Hamamat in Upper Egypt, and the facial structure, with high cheekbones and prominent chin, is reminiscent of many Egyptian portraits. The individual features, particularly the deep folds of flesh from nostrils to the mouth, the lips and the eyes, are very like those of stone portraits recognized as posthumous images of Caesar, while the hair is reminiscent of the type of portrait made during Caesar's lifetime. Such combinations of features are often found in portraits of famous individuals made long after their death.

The form of the bust suggests a date in the first half of the first century AD.

BIBLIOGRAPHY: K. Fittschen in *Pompeji. Leben und Kunst in den Vesuvstädten* Kat. Ausstellung Villa Hügel, (Essen 1973), 29, no. 1(first half of first century AD, probably found in Italy); F. Johansen., 'The Portraits in Marble of Gaius Julius Caesar: a Review' in J. Frel (ed.), *Ancient Portraits in the J. Paul Getty Museum Volume 1* (Malibu, Calif. 1987), 17–40, 33 (bibl.), 37, fig.30 (questionable antiquity); B.V. Bothmer, 'Egyptian antecedents of Roman Republican Verism' in N. Bonacasa and G. Rizza (eds), *II Conferenza Internazionale sul Ritratto Romano: Ritratto Ufficiale e Ritratto Privato* (Rome 1988), 47–66, , esp. 62–3 (Egyptian work of *c.* 48 BC); M. Kunze, *Die Antikensammlung im Pergamonmuseum und in Charlottenburg (Staatliche Museen zu Berlin)* (Berlin 1992), 203–4 (bibl.) (probably found in Italy and made in the first half of the first century AD); S. Klie, 'Zum "Grünen Caesar" in Berlin', *Mousikos Aner. Festschrift M. Wegner* (Bonn 1992), 237–42 (Alexandrian work of the years following Caesar's murder); R. Belli Pasqua, *Sculture di età romana in 'basalto'* (Rome 1995), 65–7, no. 1(bibl.: first century BC).

S.W.

200 Iron ring with a gilded emblem of Julius Caesar

c. 42 BC

Provenance unknown

Diameter 2.6 cm

London, British Museum GR 1873.10-20.4 (Ring 1469)

The iron ring has a thin hoop which broadens towards the shoulder. The ovoid bezel contains a thin inlaid sheet of gold, engraved with a portrait bust of the dictator Julius Caesar, who was assassinated in 44 BC. Caesar is recognizable by his relatively large head and scrawny neck, characteristics that feature on nearly all portraits of him, whether in sculpture or on gems and coins. Caesar wears a wreath, while behind him is engraved a jug, perhaps linked to the pouring of

200

libations and offerings to the gods, amongst whom Caesar was numbered following his deification in 42 BC.

This ring may well have belonged to one of the supporters of the Caesarian side in the bloody civil war that followed his murder. On one side were his assassins, led by Brutus and Casssius and much of the Senate, while on the other was the Triumvirate of Mark Antony, Octavian (later to be the emperor Augustus), and Lepidus. The war culminated in total victory for the Triumvirate at Phillippi in northern Greece in 42 BC and the murder or suicide of many prominent figures among their opponents, including the orator Cicero.

BIBLIOGRAPHY: F.H. Marshall, *Catalogue of the Finger Rings, Greek, Etruscan and Roman, in the department of Antiquities, British Museum* (London 1907), cat. no. 1469; S. Walker and A. Burnett, *Augustus*, British Museum Occasional Papers 16 (London 1981), 16, no.168.

P.R.

Julius Caesar – king in all but name (cat. nos 201–205)

By mid-45 BC Caius Julius Caesar had won the civil war against his opponents, and was effectively the master of the Roman Empire, including adjacent kingdoms like Egypt. Cleopatra claimed that she had conceived a child by him during his stay in Alexandria in the winter of 48/47 BC and she brought this supposed son of Caesar, Ptolemy Caesarion, to Rome in 46 BC. There she stayed until Caesar's murder in March 44 BC.

201–202 Denarii of Julius Caesar

44 BC

Rome mint

London, British Museum BMCRR Rome 4159, 4157
(*RRC* no. 480/6)

Cleopatra was in Rome when these coins were made there, shortly before Caesar's murder on the Ides (15) of March, whereupon she made a swift exit to Alexandria. On the obverse appears Caesar's bust wearing the golden crown with which he concealed his baldness, together with the inscription 'Caesar, perpetual dictator', a title given to him at some point before 15 February. The reverse shows a complex arrangement of Roman symbols of power. Note especially the clasped hands on the left, a sign of trust, in this case between Caesar and his army, and the globe above, representing the Roman claim to world rule.
J.W.

203 Denarius of Julius Caesar.

44 BC

Rome mint

London, British Museum BMCRR Rome 4187
(*RRC* no. 480/19)

Caesar both exploited and flouted Roman traditions and conventions. His dalliance with Cleopatra was carried on with some discretion in Rome – even a man as powerful as he could not be seen consorting too openly with a foreign queen. He was also the first living Roman to have his portrait on coins, which may have caused something of a stir, but it was carefully associated with symbols of traditional Roman religion. Here his head is veiled like a priest, while on the right appears a *lituus*, the curved staff of the *augures*, an important college of Roman priests who read the omens before all public occasions, and on the left an *apex*, the spiked cap worn by the *pontifices*, another important group of priests. Caesar was himself the head of the college, *Pontifex Maximus*. The legend describes him as *Parens Patriae* ('Father of the Fatherland').
J.W.

204–205 Denarii of Julius Caesar, showing Venus and Aeneas

47–45 BC

Mints in Africa and Spain

London, British Museum BMCRR East 31 (*RRC* no. 458), Spain 86 (*RRC* no. 468)

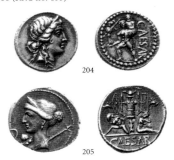

Perhaps drawing on the example of the Hellenistic monarchies of the Greek east, Caesar emphasized the divine ancestry of his family, the Julii. They claimed descent from the goddess Venus and her son, the Trojan hero Aeneas, who saved his father from the fall of Troy and, according to legend, fled to Italy. The Romans traced their history back to him. These claims were duly illustrated on the coins made in Caesar's name. In his lifetime Caesar was also clearly addressed and worshipped as a god in his own right, at least by some. For Greeks and Romans the boundary between humanity and divinity was often quite porous – both Antony and Octavian would follow Caesar in crossing it.
J.W.

206 Marble head from a portrait of a man resembling Julius Caesar

c. 50–30 BC

Found in Egypt in 1898 and purchased in Alexandria for the collection of the Comte de Stroganoff

Height 31.5 cm, width 19.7 cm, depth 19.7 cm

New York, The Metropolitan Museum of Art, 21.88.14
(Rogers Fund, 1921)

Much of the nose is lost, and the folds of the mantle, visible to the left of the neck, have been chiselled off on the right side.

Long known as the 'Stroganoff Caesar', this portrait, carved in calcitic marble from the northern Aegean island of Thasos, more likely represents a contemporary who has adopted some of the dictator's features. The brow is crossed with lightly incised lines; two much deeper lines dive to the bridge of the nose. The almond-shaped eyes are deeply set below the brow, and appear irregular, the proper right larger than the left. The round chin is very pronounced, the face gaunt, with deep curving lines and a pronounced swelling between the nostrils and the lips. The lips are thin, and the mouth downturned. The hair is combed forward in regular locks to fall on the brow. The long, thin neck is deeply lined.

This fine portrait was regarded by many twentieth-century scholars as exemplifying the veristic style in Roman portraiture of the mid-first century BC. Adriani, however, was able to compare the work with other portraits known to be from Alexandria, and concluded that there was no reason to suppose that it had been imported to Egypt from elsewhere. Indeed, the protruding chin and almond-shaped eyes are reminiscent of Egyptian portraits of the period, while the lined face and scraggy neck recall Roman work, and are particularly close to images of Caesar. The subject may have been a Roman resident in Alexandria at the period, or indeed an Alexandrian who had adopted Caesar's style.

BIBLIOGRAPHY: G.M.A. Richter, *Roman Portraits* (New York 1948), no. 3 (bibl.); A. Adriani, *RM* 77 (1970), 77–8, 104, pl.33.2 (bibl. 77–8, n.18.); L. Giuliani (ed.), *Bilder vom Menschen in der Kunst des Abendlandes* Kat. Ausstellung Berlin (Berlin 1980), 72–3 no. 38; E. Milleker (ed.), *The Year One: Art of the Ancient World, East and West* (New Haven, Conn. 2000), cat. no. 9.

S.W.

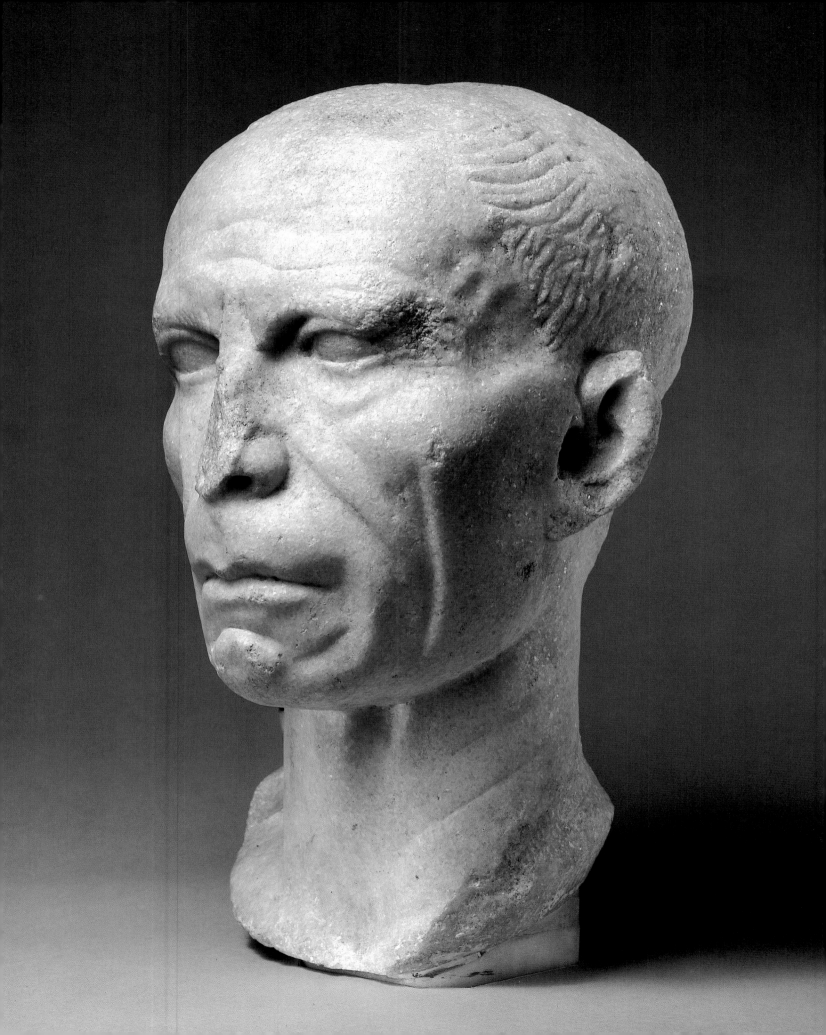

207 Black basanite head from an Egyptian-style statuette of a man

c. 50–30 BC

Said to be from Egypt

Height 16.5 cm, width 10.8 cm, depth 19.5 cm.

London, British Museum GR 1897. 7-29.1
(Sculpture 1871)

There are some scratches on the brow and cheek, and the figure is broken through at the neck and at the top of the back pillar.

The subject, of mature years, has a thin face with prominent cheekbones and deep lines to the sides of the nose and mouth. The brow is furrowed, the nose long and hooked, the mouth turned down and the chin prominent. The large ears are somewhat crudely carved. The hair recedes at the temples in a style popular in late Ptolemaic Egypt (see also cat. nos 208–209). Three rows of locks are differenti-

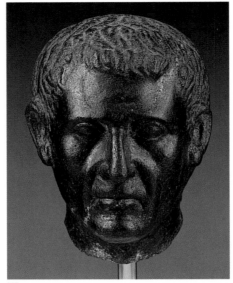

207a

ated; beyond them, the crown of the head is worked with a point.

The outer surface of the back pillar is smooth and uninscribed. The subject has been identified as Caesar; while he does have the appearance of a contemporary of Caesar, he is more likely to have served as a priest or official in Cleopatra's kingdom.

BIBLIOGRAPHY: A.H. Smith, *A Catalogue of Sculpture in the Department of Greek and Roman Antiquities in the British Museum*, Volume III (London 1904), cat. no. 1871.

S.W.

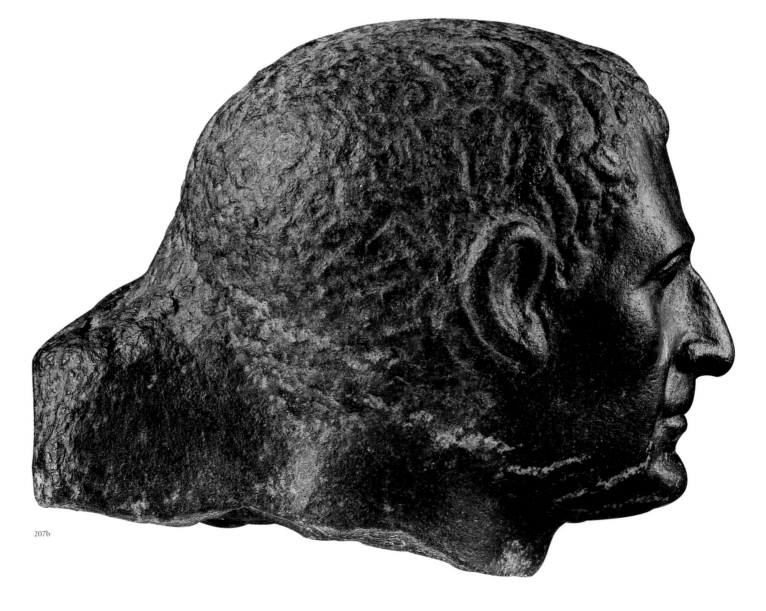

207b

208 Marble head of an elderly man, perhaps a priest, wearing a rolled band

c. 25 BC–AD 10

Provenance unknown

Height 31.25 cm

Alexandria, Greco-Roman Museum 3243

The back of the neck is restored in plaster, but otherwise the head is well preserved. It is almost vertically cut at the back, where the surface was finished with a claw chisel. Originally, the head may have been finished in stucco, or it may have been entirely marble, the back later cut for reuse.

The subject is a thin man with a lined face and sagging cheeks. He has, however, quite a lot of hair, which recedes at the temples in the manner of the official Hor (cat. no. 190). The central hair is carefully modelled, while at the sides and on the crown the treatment is more linear. Three horizontal lines and a vertical slash crease the brow. The protruding almond-shaped eyes lie beneath heavy lids; the brows are straggling near the nose, but then become slightly arched. The nose is very long and hooked, the thin lips are straight and the angular chin is dimpled.

This head has been identified as a portrait of Caesar, but it bears little resemblance to the corpus of Caesar's portraits (cat. nos 199–200) or even to portraits of individuals who copied Caesar's style (cat. no. 206). Instead the features derive from portraits of Egyptian officials such as Panemerit and Hor (cat. nos 187 and 190). However, the straight mouth and the rolled band of cloth suggest a Roman rather than Ptolemaic context.

BIBLIOGRAPHY: E. Breccia, *Alexandria ad Aegyptum* (Bergamo 1922), 178, no. 20a; H. Riad, *Guide aux musées alexandrins* (undated), 114, fig.19; P. Graindor, *Bustes et statues-portraits d'Égypte romaine* (undated), 37; Z. Kiss, *Études sur le portrait impérial romain en Égypte* (Warsaw 1984), 28, figs.12–13; G.L. Steen (ed.), *Alexandria: The site and the history* (New York 1993), 82–3, 100–103.

S.W.

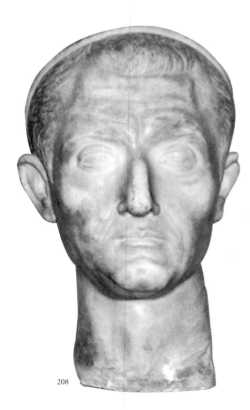

208

209 Sard intaglio: portrait of a Roman with furrowed face and receding hair

c. 50 BC

Provenance unknown (formerly in the Blacas Collection)

Height 1.5 cm, width 1.1 cm

London, British Museum GR 1867. 5-7.492 (Gem 1964)

The subject is portrayed with extraordinary refinement of detail and manipulation of the planes of view. The tightly curled hair recedes at the temple. The brow is deeply lined, bulging above the long, slightly hooked nose. Beside the

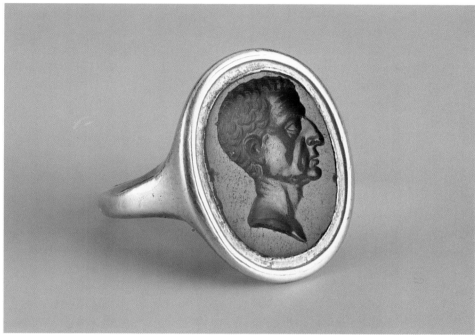

209

hooded eye are crow's feet; the cheeks are deeply lined, the mouth slightly open, and the chin prominent. The neck, creased at the back, is turned at the shoulder. The Adam's apple projects to reflect the turn at the front.

The subject is evidently a Roman of mature years, of the mid-first century BC; the hairstyle may be compared to Egyptian and Roman portraits from Egypt (e.g. cat. nos 206–208). The subject has been identified as Cleopatra's detractor, the orator Marcus Tullius Cicero. The date of the portrait and the carefully recorded age of the subject would fit such an identification, which is not, however, supported by the individual features.

BIBLIOGRAPHY: S. Walker and A. Burnett, *Augustus*, British Museum Occasional Papers 16 (London 1981), 16, no. 162 (bibl.).

S.W.

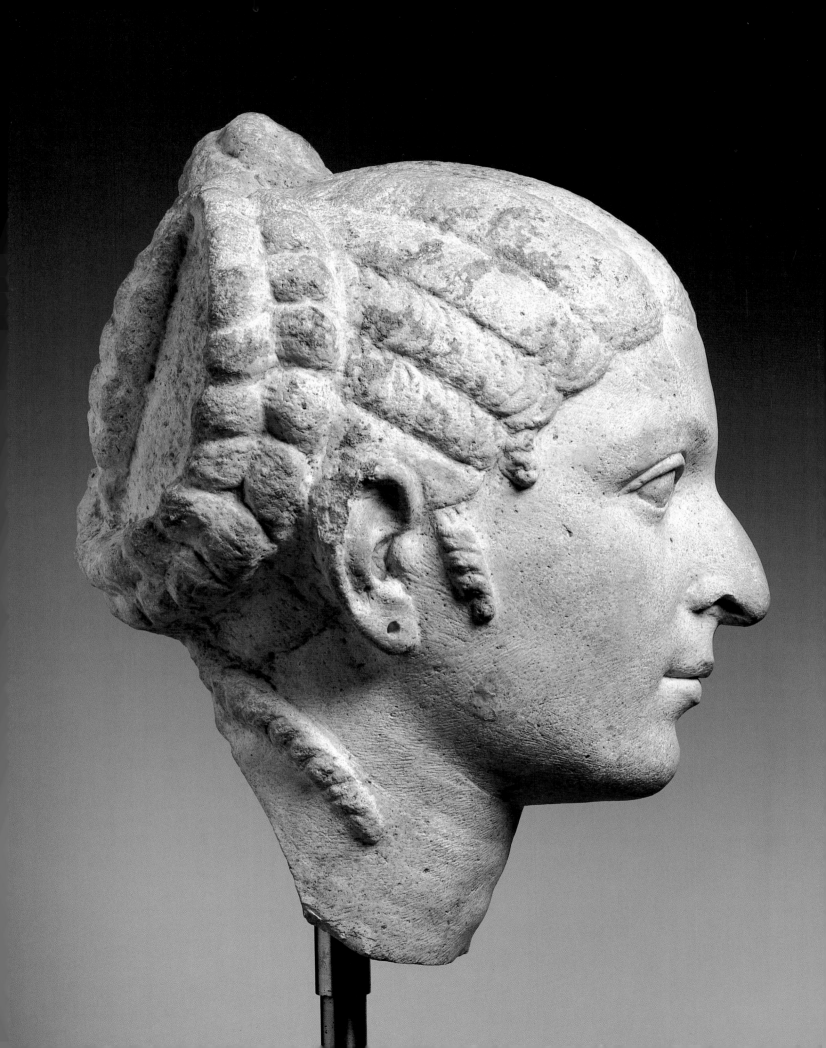

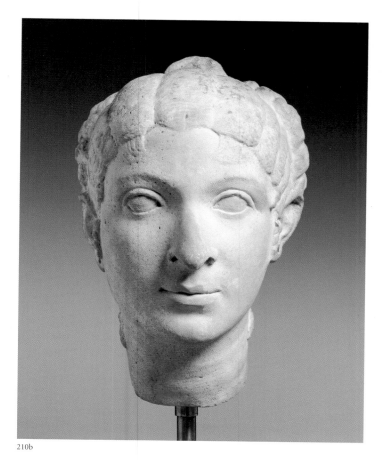

210b

210c

210 Head of a woman resembling Cleopatra VII

c. 50–40 BC

Acquired in Italy (formerly in the collection of Alessandro Castellani)

Height 28 cm

London, British Museum GR 1879.7-12.15 (Sculpture 1873)

The head has been broken from a statue but is in good condition. The surface is a little weathered, with a few chips missing from the hair and the upper lip. Remains of the rasp survive on the surface, particularly under the chin and around the neck. The ears are pierced for metal earrings to be attached.

This head was one of the first portraits to be identified as Cleopatra VII using coins as a comparison. However, there is no royal diadem and it is now widely believed to represent a woman who closely modelled herself on Cleopatra's image, perhaps a member of the queen's entourage who travelled to Rome with her from Egypt. During Cleopatra's stay in Rome between 46 and 44 BC, her notoriety and public appearances would have made her a celebrity, and her style and fashions were also imitated by Roman women. Alterna-

tively, if this head is to be identified as a portrait of Cleopatra VII, it may indicate the queen's desire to be shown in Roman fashion with no royal insignia. This latter idea would, however, be totally at odds with the words of Cicero (*Ad Atticum* 15, 15, 2), who regarded Cleopatra as unacceptably regal and arrogant.

Some of the facial features can be compared with coin portraits of Cleopatra. The hooked nose with curved nostrils follows that on coins minted in Alexandria and Ascalon (cat. nos 179–180) and on clay sealings showing the queen. The shape of the eyes and the pointed chin also compare well with the royal coins. The hairstyle differs, however, from the portrait heads of Cleopatra in the Vatican, Cherchel and Berlin (cat.nos 196–198). A fundamental problem in establishing a comparison is that the different coin issues showing Cleopatra's portrait vary quite considerably, particularly in the rendering of the nose (see p. 214). Furthermore, the coins may not be an accurate reflection of her real face. Sculptured portraits also vary in details of the physiognomy, and it may be that the surviving marble portraits show the queen at different ages, and were made in various locations.

The hairstyle also differs from that shown on coins. At the front it is arranged in the formal melon coiffure, but at the back the locks of hair are coiled upwards and fed through a central knot, while two stray locks curl around the neck. This style is parallelled on another head made of Italian travertine in the National Gallery, Oslo (SK 1015). The sardonyx head of a woman (cat. no. 211) shows another example of the hairstyle. This style seems to have been popular for only a short period during the middle decades of the first century BC.

It cannot be proved that this head is a portrait of Cleopatra VII, but the similarities with some features of her coin images are significant.

BIBLIOGRAPHY: A.H. Smith, *A Catalogue of Sculpture in the Department of Greek and Roman Antiquities in the British Museum*, Volume II (London 1900), no. 1873; H.P. L'Orange, 'Zum Frührömische Frauenporträt', *RM* (1929), 167–79, fig.2, pls 35–6; R.P. Hinks, *Greek and Roman Portrait Sculpture* (London 1935), 15–16, fig 18a; G.M.A. Richter, *The Portraits of the Greeks* (London 1965), fig.1862; B. Lundgreen, 'A Female Portrait from Delos', *Ancient Portraiture: Image and Message*, Acta Hyperborea 4 (Copenhagen 1992), 66, figs.6–7; S. Walker, *Greek and Roman Portraits* (London 1995), 74.

P.H.

◀ 210a

211a

211b

211 Sard cameo portrait bust of a woman of the time of Cleopatra

c. 50–25 BC

Provenance unknown

Length 2.6 cm

London, British Museum GR 1923.4-1,1172, Gem 3960.

The bust is damaged on the lower right edge. It was probably intended to finish the bust in the style of late republican portraits in stone.

There is a pronounced twist to the neck, in the manner of Hellenistic portraits, and a suggestion of Venus rings in the modelling. The straight nose, thick lips, strong brows and eyes are carefully defined within an oval face. The gaze is firmly to the subject's left. The hair is drawn back into a knot at the nape of the neck, which is then taken up in the two plaits around the back of the head to knot at the crown. The central parting extends from the brow to the nape above the knot. There is a narrow fillet behind the waves of hair framing the face.

The hairstyle strongly resembles that worn by some of Cleopatra's contemporaries, notably cat. no. 210.

BIBLIOGRAPHY: H.B.Walters, *Catalogue of the engraved gems and cameos, Greek, Etruscan and Roman, in the British Museum* (London 1926), cat. no. 3960.

S.W.

212 Marble head of a woman resembling Cleopatra

Found built into a gate in the Villa Doria Pamphili, Rome

First century BC

Height 35 cm

Rome, Musei Capitolini 3356

The nose, lips and sections of the bust are damaged. Two flat surfaces on either side of the head were worked to receive separately made attachments (now missing). Two square holes were cut to fix these pieces. The back of the head was also made separately and attached by two marble plugs, for which the holes survive at the back of the head.

This portrait resembles a herm, the draped bust carved in one piece with the head. However, it seems more likely that the bust was inserted into a draped body. The woman has a very unusual hairstyle, but its general pattern is that of the melon coiffure. Two large curls fall in front of the ears, carved in shallow relief. At the front of the head, however, the arrangement must have differed from the norm. The flat surfaces are carved to receive either separately made sections of hair, or some kind of ornament that fell diagonally over the woman's temples, half-covering her ears. A possible form of such an ornament is painted on a mummy portrait of a young woman from Hawara ('The Golden Girl', Cairo, Egyptian

Museum CG33216), where two gold plates are attached to the sides of the head by a chain and pendant that run over the crown. In this example, of early second-century-AD date, the subject was perhaps an initiate in the cult of Isis. This type of headdress has been tentatively restored to other portraits of women with similarly flat surfaces cut into the marble at the sides of the head. Whether the head should be restored with thick locks of hair or a gold ornament is uncertain, but the whole arrangement seems to have been completed over the centre of the brow by another ornament, or a plait of hair. A similar portrait, with comparable piecing techniques on the hair, was found in the Baths at Tivoli (Rome, National Museum 126391). A similarly projecting wing (it is unclear whether this was intended to represent hair or an ornament) is seen on coins celebrating Antony's wife Fulvia as Victory (see cat. no. 224): minted in the 40s BC; these coins are roughly contemporary with this portrait.

The woman's rather severe facial features resemble the portraits of Cleopatra VII, and the large, heavily lidded eyes are particularly close to the Vatican Cleopatra (cat. no. 196). The nose is damaged, but the bridge survives, and suggests a hooked profile like that on the coins of Cleopatra VII. The long, thin lips do not compare quite so well with portraits of the queen. The subject of this portrait should perhaps be interpreted as a contemporary of Cleopatra who imitated the queen's style. The unusual arrangement of hair or head-ornament may reflect the subject's involvement in a religious cult or suggest that she should be compared to a goddess.

BIBLIOGRAPHY: K. Fittschen and P. Zanker, *Katalog der römischen Porträts in den Capitolinischen Museen und der anderen kommunalen Sammlungen der Stadt Rom* Band III (Mainz 1983), 38, cat. no. 40, pl. 52.1–4; for similar portraits, see W. Trillmich, *Das Torlonia-Mädchen* (Göttingen 1976); the Tivoli bust, pl. 6.1–4, and the mummy portrait in Cairo, pl. 5, 4.

P.H., S.W.

212 ▶

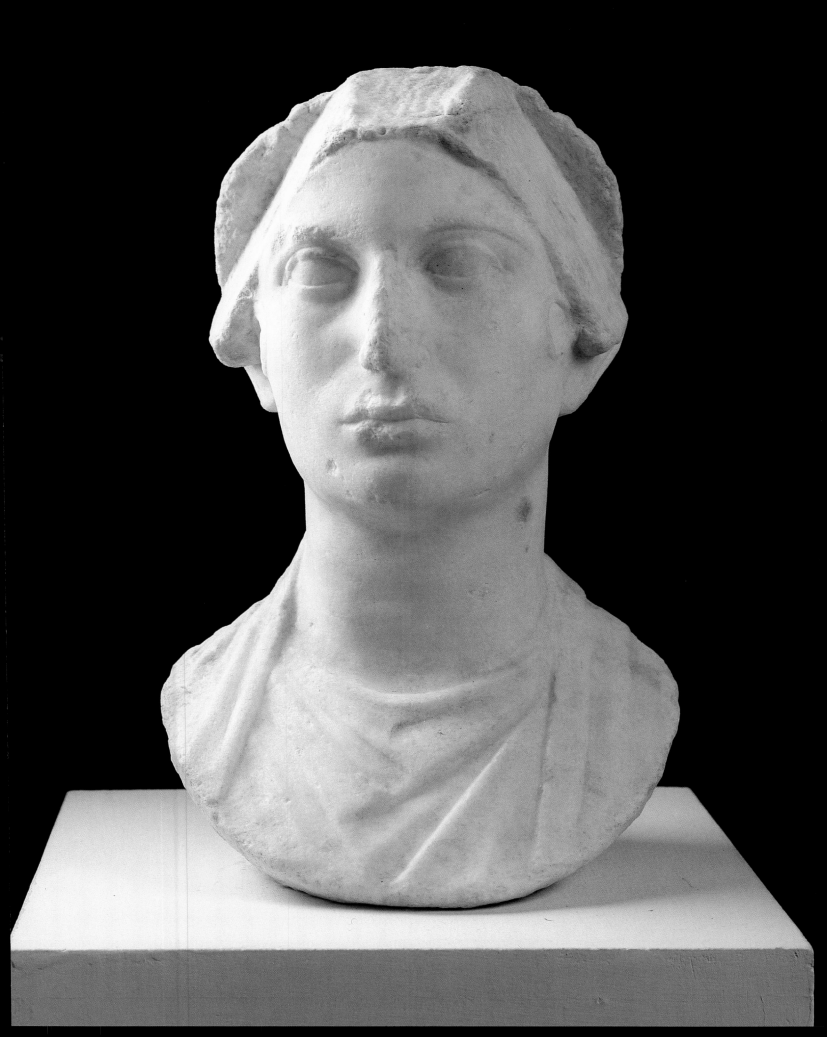

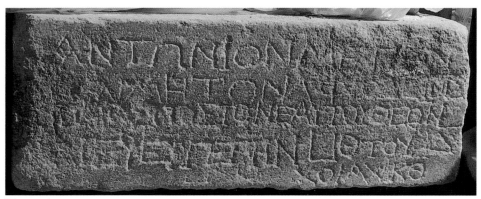

213

213 Basalt statue base with an inscription naming Antony

28 December 34 BC

Found in Alexandria, but the date and circumstances of its discovery are unknown.

Height 28 cm, width 75 cm

Alexandria Greco-Roman Museum 10

The base is chipped around the edges, and damaged at the top right corner. The inscription is worn in places.

This inscription has been published several times, but the poor preservation of many of the letters has led to a variety of translations and interpretations. Its most recent editor, P.M. Fraser, read the text as follows:

Ἀντώνιον μέγαν
ἀμίμητον ἀφροδισίοις
Παράσιτος τον ἑαυτοῦ θεὸν[ε]
καὶ εὐεργέτην L ιδ τοῦ καὶ δ
Χοιὰχ κθ

'Antony, the Great, lover without peer, Parasitos (set this up) to his own god and benefactor, 29th day of Choiack, year 19.'

The word *aphrodisiois* in its plural form as it appears in the second line has been translated in a papyrus text as 'brothels' (*P.Teb.* 6,29). *Parasitos* (l.3) is most likely the name of the dedicant, and could also be a pun on his status as a dependant of Antony or even (using an older meaning of the word) as a priest of his cult. The date is given in local calendar months and translates as 28 December 34 BC.

Plutarch's *Life of Mark Antony* (28.2) describes the establishment by Antony and Cleopatra of the 'Association of Inimitable Livers', and this text suggests a clever and humorous pun on the club, making Antony the Inimitable Lover, whether in the brothels of Alexandria or Cleopatra's bed. The form of the statue that originally stood on the base is unknown; the cuttings in the upper surface suggest that the figure was made of bronze.

BIBLIOGRAPHY: C. Wescher, *Bull Int Arch Rom* 38 (1866), 199–201, no.1; E. Breccia, *Catalogue Général des Antiquités Égyptiennes du Musée d'Alexandrie: Iscrizione Greche e Latine* (Cairo 1911), 24 no. 42, pl. 11, no.30; P. M. Fraser, 'Mark Antony in Alexandria – a note', *Journal of Roman Studies* 47 (1957), 71–3.

P.H., A.M., S-A.A., S.W.

Coinage and the adminstration of Antony's empire (cat. nos 214–260)

Antony's Eastern empire divided essentially into two different types of territory. On the one hand there were the Roman provinces, such as Achaea, Macedonia, Asia and Syria, that had all existed before he arrived and were all subject to Roman governors appointed by him. On the other, there were the client kingdoms established by Antony, with kings directly appointed by him. One aspect that marked out these client kingdoms as different from those used elsewhere or before by Rome was the nature of the kings selected by Antony. Rather than endorsing existing monarchies or dynasties, Antony favoured the imposition of monarchs from outside existing ruling elites. Discontinuity rather than continuity was the rule. Another innovation was the additional layer of monarchy he imposed above these kings through the Donations of Alexandria in 34 BC. In this new layer he fused the concept of dynastic rule in the east with the power that derived from his position as a representative of Roman imperial authority.

The cities

Throughout the eastern Mediterranean, cities within the client kingdoms and the Roman provinces produced coinage as and when the need arose. Increasingly throughout the late first century BC Roman coinage (minted at Rome and at mints in the East) came to circulate in the area. Nonetheless, some city silver coinages continued in production and a plethora of bronze issues were produced.

Under Antony, however, an interesting new development occurred. Some cities within his *imperium* began to place his portrait on their coins. Although coins produced at Roman mints had been using the portraits of living Romans since the dictatorship of Caesar, the images of the great generals Caesar and Pompey had never appeared in their lifetimes on the local coinages of the East. Nor was there any real precedent for this phenomenon in the coinages of the Hellenistic rulers. On the few occasions when royal portraits had appeared on bronze city-issues the name of the king had appeared too, making it clear that such coinages were to a degree royal issues.

The bronze coinages that began from 42/41 BC to carry the portrait of Antony, and sometimes his spouses, bore only the portrait, not Antony's (or Fulvia's or Cleopatra's) name. These were almost certainly not issues 'of Antony', that is commissioned or specifically authorized by him. Rather, in placing these portraits on their coins, the cities were proclaiming their relationship with the individual concerned, for the

relationship of the cities of the East with their rulers underwent a significant change under Antony's rule. They were no longer in a simple one-to-one relationship with a royal house or the Senate and People of Rome. Through his wide-ranging and in some cases revolutionary organization of the territories and rulers of the East, Antony introduced an extra layer of administrative power above the cities, along with the ever-impending prospect of political upheaval. This seems to have been felt most strongly in Antony's easternmost territories, where the new order of client kings, followed in 34 BC by the Donations of Alexandria, had the deepest impact. The safest and perhaps most reassuring relationship for any city thus became, if possible, a personal one with Antony and his family. This aspect of the coinage policy of the eastern cities in fact foreshadowed the much broader phenomenon of provincial coinage throughout the East in the Roman imperial period, from the reign of Augustus onwards. As such, it gives us some hint of what must have been a much more wide-ranging development. No doubt countless statues and honorific inscriptions were also set up in honour of Antony. Of all these, however, next to nothing survives.

Greece and Asia Minor

During the late first century BC the precious metal coinages previously common to so many Greek states in Greece and Asia Minor finally disappeared. They were replaced by the Roman denarius, issued at Rome as well as in mints travelling with the triumvirs Antony and Octavian The principal exception to this decline was the cistophorus, the old coinage of the Attalid kingdom of Pergamum. This denomination continued to be issued at Ephesus under Antony and, subsequently, Octavian.

Syria

The picture further east is slightly different. As the mints of the Seleucid empire had declined during the first century BC, so several city coinages had sprung up to fill the gap in available silver coinage in the area. The principal producers were Antioch, Laodicea, Sidon, Tyre and Ascalon. The appearance of dates on these coinages allows us to form a fairly accurate impression of patterns of production. Interestingly, while several of the mints, notably Antioch, Sidon and Tyre, had produced a fluent stream of annual issues until 39 BC, all subsequently stuttered in the years that followed until Actium.

A.M.

214

215

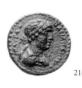
216

217

214–217 Bronze coins of Cleopatra as tetrarch of Chalcis

32/31 BC

214–215: London, Weill Goudchaux Collection; 216: London; British Museum BMC Berytus 14; 217: London; British Museum CM 1969-9-1-1 (Presented by H.C. Lindgren)

As part of his settlement of 36 BC, Antony made over to Cleopatra the area in Ituraea known as the tetrarchy of Chalcis. Previous tetrarchs had issued

bronze coins, and Cleopatra continued this tradition with a series of three denominations. All had a bust of Cleopatra on the obverse; the largest (cat. nos 214–215) had a bust of Antony on the reverse, the middle (cat. no. 217) a figure of Nike, and the smallest (cat. no. 216) a figure of Athena. The legends were the same on all three denominations: 'of Queen Cleopatra' on the obverse and 'year 21 and 6, Thea II' on the reverse. The silver tetradrachms of Antioch with their similar legends aside (cat.

nos 221–222), these bronze coins of Chalcis were the only issues produced in Cleopatra's name outside of Egypt, Cyprus and Cyrene.

A.M.

218 Silver drachm of Antioch

c. 40–31 BC

London, British Museum BMC Antioch 52

The mint of Antioch also produced a drachm coinage in its own name, but with a portrait of Antony on the obverse. On the reverse appeared the head of Tyche with the legend 'of the metropolis of the people of Antioch'. The date of the issue cannot be determined with precision. In concept, this coinage is analogous to, though of higher value than, the city bronze coinages with Antony and Cleopatra's portraits.

A.M.

219–220 Silver tetradrachms of Ascalon

50/49 and 39/38 BC

London, British Museum BMC Ascalon 20; London, Fan Museum Trust

Ascalon achieved its freedom from the Seleucid empire in 104/103 BC and began the production of silver tetradrachms with the types of head of Seleucid king and Ptolemaic eagle on thunderbolt shortly thereafter. Later in the first century BC the mint seems to have switched to the depiction of living Ptolemaic monarchs rather than dead Seleucid ones on the obverse of the silver.

Quite why Ascalon should have been placing the portraits of Ptolemaic monarchs on its coinage in 64/63 and 50/49 BC is not immediately clear, since the city was not within the Ptolemaic realm at this point. It has been suggested that the issue of 50/49 BC (cat. no. 219) was produced by the city to aid the campaign of the young Cleopatra during her period of exile at this time, before her restoration by Julius Caesar.

A.M.

221–222 Silver tetradrachms of Antony and Cleopatra

c. 37–32 BC

London, Weill Goudchaux Collection

These tetradrachms present something of a numismatic puzzle. On the obverse, the usual place for a monarch to appear on her coinage, is the portrait of Cleopatra with the legend 'Queen Cleopatra Thea II'. On the reverse, where one

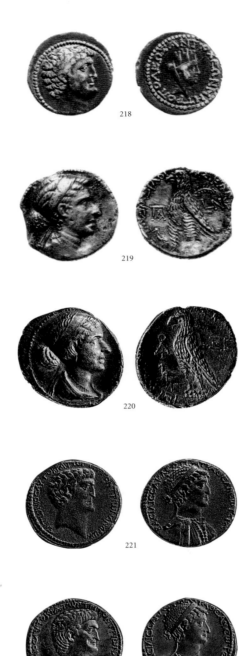

218

219

220

221

222

would normally find the name of the issuer of a coin, appears the portrait of Antony with the legend 'Antonius Imperator for the third time and triumvir'. It is not immediately clear then who the issuer of the coins is; the fact that the legends are in the nominative case, as they generally are on Roman coins of the period, rather than the genitive, as they always are on Greek coins, suggests that the inspiration for these coins is Roman rather than Greek. Yet it is clear that some attention has been paid in the construction of both legends on the coin to the official titulature of both Cleopatra and Antony. Cleopatra's title reflects the queen's desire to be seen as the new Cleopatra Thea, ruler of both Egypt and Syria. As such, it is of a piece with the coinage issued by Cleopatra as tetrarch of Chalcis, and the bronze issues of Cyrene in the name of Cleopatra and Antony (cf. cat. nos 214–217 and 232–234). The inscription of Antony translates the title IMP TERTIO IIIVIR, familiar from his Roman coinage.

The place of production is also uncertain. Preliminary die-studies indicate that huge numbers of these coins were originally produced. The long gap in production of city issues at the mint of Antioch has suggested to some scholars that this may have been the mint. If so, then Antony probably intended them to be used elsewhere, since Antioch was never within the realm of Cleopatra. Given the size of the issues, and the appearance of different control marks on some issues, however, it is quite possible that more than one mint was in production.

Date of production is also unclear. The portrait seems to have been copied at Damascus in 37/36 BC (cat. no. 230), suggesting that issue may have begun in 37 BC or a little before. If that is the case, these coins perhaps offer the earliest evidence of Antony's plans for Cleopatra, which mature in 34 BC in the Donations of Alexandria. On the other hand, the similarity of portrait at Damascus may be coincidental or derived from a third, shared source. In this case, the tetradrachms may be closer in date to the Antony and Cleopatra denarii, to which they are certainly close in conception.

BIBLIOGRAPHY: T.V. Buttrey, 'THEA NEOTERA on coins of Antony and Cleopatra', ANSMN 6 (1954), 95–109, pl. XV.

A.M.

223–224 Bronze coins of the city of Fulvia

40s BC

London, Weill Goudchaux Collection (*RPC* no. 3139);
London, British Museum CM 1979-1-1.672
(*RPC* no. 3140/1)

In the late 40s BC a city in western Asia Minor, perhaps Eumeneia in Phrygia, briefly changed its name to Fulvia in honour of Antony's then wife of the same name. It is probably her bust, in the guise of winged Nike, that appears on the obverse. Similarly, the city of the same region later called Tripolis adopted the name of Antoniopolis ('Antony-ville').

BIBLIOGRAPHY: C. Habicht, 'New Evidence on the Province of Asia', *JRS* 65 (1975), 64–91.

A.M.

225–226 Bronze coins of Orthosia

35/34 BC

Formerly in the collection of Henri Seyrig
Paris, Bibliothèque Nationale (*RPC* nos 4501/1, 4502/1)

In addition to bearing the queen's portrait, the coins of Orthosia were also dated by a regnal era of Cleopatra in Phoenicia, which began in 37/36 BC. Issues of years 2 and 3 are known.

A.M.

227 Bronze coin of Tripolis

36/35 BC

London, British Museum BMC Tripolis 19

Where once Fulvia had appeared on the coinage, Cleopatra took her place on the coinage of Tripolis after the area had been granted to her in 37/36 BC. Here too the coins were dated by the 'Phoenician' era.

A.M.

228–229 Bronze coins of Berytus

36/35 and 32/31 BC

Paris, Bibliothèque Nationale (*RPC* nos 4529/1, 4530/1)

Berytus also began to place Cleopatra's portraits on its coinage from the second year of her 'Phoenician' era. The coins dated to year 6 of this era are also dated by her Egyptian regnal era, perhaps indicating a change in status of the city in the interim.

A.M.

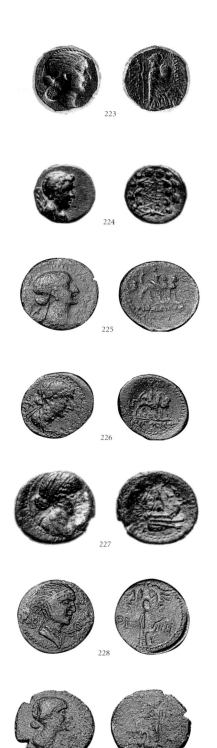

223

224

225

226

227

228

229

230

230 Bronze coin of Damascus

37/36 BC

New York, American Numismatic Society 1944.100.79323
(*RPC* no. 4781/1)

There exists no evidence for Damascus ever having formed part of the territories granted to Cleopatra by Antony. Indeed, the coins are dated by the old Seleucid era rather than by an era of the queen. The appearance of her portrait on the coinage issued by the city may therefore attest some other form of personal connection between the queen and the city. Issues of 37/36 and 33/32 BC are known. In both years other denominations were produced with different obverse designs.

A.M.

231

231 Bronze coin of Ptolemais

35/34 BC

New York, American Numismatic Society 1965.181.1
(*RPC* no. 4742/2)

Only two cities employed the portraits of both Antony and Cleopatra on their coinage. Ptolemais, which had earlier used the portrait of Antony alone placed the pair on obverse and reverse. The city of Dora seems to have taken the unique step of placing their portraits together on the same side of the coin on a now extremely rare issue of bronzes from 34/33 BC. The coins of Dora, like those of Berytus and Chalcis, were dated by the era of Cleopatra's rule in Egypt, perhaps suggesting that all three cities were under the direct rule of Cleopatra.

A.M.

The Actium campaign

Antony, descendant of Herakles

As Antony and Cleopatra moved gradually westwards in 32–31 BC towards their showdown with Octavian at Actium, a number of cities responded in their coinages to their presence. Coinage was in this respect simply one element in a whole array of honours that could be granted to powerful individuals, and in these cases the only ones physically to survive.

Antony is an elusive figure in many ways. Overshadowed by Caesar, Cleopatra and Octavian, he has perhaps not received the attention he deserves from historians. Few contemporary portraits survive. The coins made in his name are the best source we have for his public image during the triumviral period from the death of Caesar to the Battle of Actium (44–31 BC), when he ruled the eastern half of the Roman Empire effectively as a monarch.

Antony's portrait appeared on coins in a range of styles over thirteen years. Coins were made for him at Rome, in Gaul (which he governed as triumvir, 43–40 BC) and in his Eastern domain. The 'Rome' style is characterized by finely engraved heads, the 'Gaul' style produces small, misshapen busts, while his Eastern coins tend towards a more massive, square style (attribution of styles to places of production is not always certain). Antony was said to look like Herakles: 'He had a very good and noble appearance; his beard was not unsightly, his forehead broad, and his nose aquiline, giving him altogether a bold masculine look that reminded people of Herakles in paintings and sculptures' (Plutarch, *Life of Antony* 4).

232–234 Bronze dupondii and semis in the names of Antony and Cleopatra

c. 31 BC

Cyrenaican mint

London, British Museum CM 1844-4-25-1200 (Presented by the Duke of Devonshire); E.H. p.691,6; 1952-6-2-1 (Presented by W. Broomfield)

Although there is no indication on these coins of where they were produced, the only known find-spot for them is Cyrene, which suggests that they were produced there. Their design consists only of abbreviated legends. On one side this reads 'The queen the new goddess (*Thea*)'; on the other 'Antony consul for the third time'. This description of Antony dates the coin to 31 BC, and thus to the period of Scarpus of Cyrene, who changed his allegiance from Mark Antony to Octavian, and issued coins for both of them. The title given to Cleopatra may be an echo of that which appeared earlier on the silver tetradrachms produced in the name of Antony and Cleopatra (cat. nos 221–222).

A.M.

235 Denarius with bust of Antony

44 BC

Rome mint

London, British Museum BMCRR Rome 4128 (*RRC* no. 480/22)

Antony was Caesar's right-hand man at the time of his death. It made sense, therefore, that he should try to succeed to Caesar's legacy. This coin, made soon after the Ides of March, bears the earliest extant portrait of Antony. It shows his bust veiled, associated with priestly symbols, and bearded as a sign of mourning – the whole stressing *pietas*, his dutiful, religious devotion towards Caesar and the Commonwealth. His bust is also unnamed, suggesting that his image was meant to be recognizable instantly, perhaps like that of a god.

J.W.

236–238 Denarii with busts of Antony

42 BC

Rome mint

London, British Museum BMCRR Rome 4278 (*RRC* no. 494/17), 4293, 4294 (*RRC* no. 494/32)

Also produced at Rome, these portraits of Antony are in a fine, monumental style. The legend on 236 gives him his official title 'IIIVIR R[*ei*] P[*ublicae*] C[*onstituendae*]' (Member of the Board of Three for Establishing the Commonwealth). The Three, Antony, Octavian, and Lepidus, were by law effectively given supreme authority over the Roman state.

J.W.

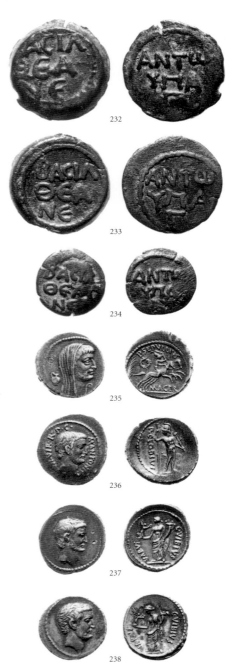

232

233

234

235

236

237

238

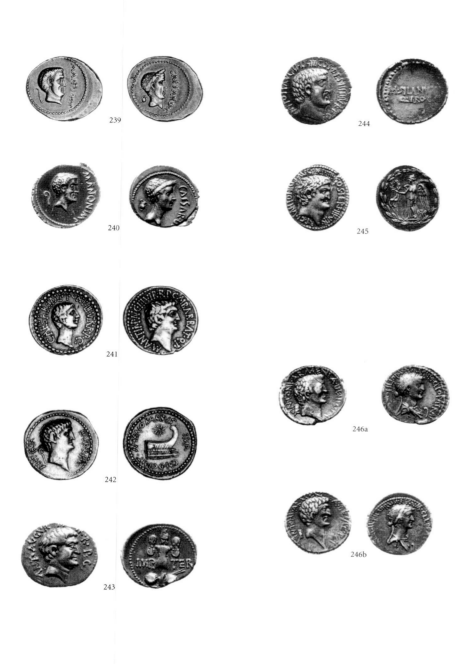

239

240

241

242

243

244

245

246a

246b

239–240 Aureus and denarius of Antony

43–42 BC

Mint in Gaul

London, British Museum BMCRR Gaul 52, 54
(*RRC* no. 488)

The head of Antony on his coins attributed to Gaul is still recognizable, but rendered in a much cruder style.

J.W.

241–245 Aurei and denarii of Antony

40–31 BC

Eastern mints

London, British Museum BMCRR East 99
(*RRC* no. 517/1a), 111 (*RRC* no. 521), 147 (*RRC* no. 536),
175 (*RRC* no. 542), 227 (*RRC* no. 545)

The common theme to all these Eastern representations of Antony is the size of the bust on the coin and the impression of a large, broad head that it creates (compare Plutarch's description of him above). This was an important part of Antony's Heraklean image (see also cat. nos 247–248).

J.W.

246a–246b Denarii of Cleopatra and Antony

32 BC

Eastern mint

London, British Museum BMCRR East 179 and East 181
(*RRC* no. 543; both)

These extraordinary coins show Cleopatra and Antony looking remarkably alike. But who is being assimilated to whom? The decisive point is that both have the strong projecting chin of Ptolemy I, the founder of Cleopatra's dynasty. Antony's Heraklean portrait here seems to have picked up Ptolemaic features. Recent research has revealed that Cleopatra is on the obverse of these coins, not Antony as used to be thought. Through his protection, she was securing the future of her kingdom and aiming at the restoration of the Ptolemaic empire. These coins raise the question of just who was using whom during the 30s BC.

J.W.

Antony, godlike ruler of the East

Antony's affinity with Herakles was not merely physical. It was claimed that he was actually descended from the famous god-man of Greek myth. Dionysos too was adduced as a divine patron and model. Antony was acclaimed as the New Dionysos at Ephesus and Athens. Not coincidentally, these were also the two favourite gods of Alexander the Great, the prototype conqueror of the East. They were both regarded as civilizers of the barbarian world and victors over the hordes of the Orient, a historical persona that Antony also wished to acquire or have ascribed to him.

247–248 Aurei of Antony showing Herakles

42 BC

Rome mint

London, British Museum BMCRR Rome 4255 (*RRC* no. 494/2a), 4256 (*RRC* no. 494/2b)

Antony claimed that his family, the Antonii, were descended from Anton, a son of Herakles invented for the purpose.

J.W.

249–250 Cistophori showing Antony and Octavia

c. 39 BC

Mint in western Asia Minor

London, British Museum BMCRR East 134 (*RPC* no. 2201), BMCRR East 135 (*RPC* no. 2202)

Dionysiac ivy decorates the border of cat. no. 249 and adorns Antony's bust on both coins. On cat. no. 250 he is shown side by side ('jugate') with Octavia, Octavian's sister, whom he married in 40 BC in a dynastic alliance intended to seal a pact between the two triumvirs concluded in the same year at Brundisium in southern Italy.

J.W.

251 Denarius of Antony showing Armenian tiara

c. 36 BC

Eastern mint

London, British Museum BMCRR East 172 (*RRC* no. 539)

On the front of this coin Antony's bust is shown with eyes raised heavenwards like Alexander. The reverse design represents the headgear of the kings of Parthia, against whom Antony campaigned with little success in 36 BC, and of Armenia, where in 34 BC his armies met with better fortune. It is superimposed on a crossed bow and arrow, a Roman symbol of Eastern warfare. The tiara also appears as a small symbol behind Antony's bust on other coins, where the legend reads 'Marcus Antonius, upon the conquest of Armenia'.

J.W.

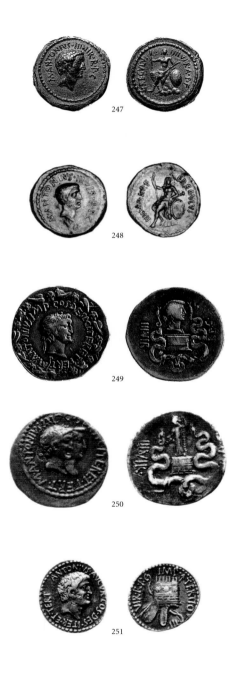

247

248

249

250

251

The dynasty and legacy of Antony

Antony clearly intended to create a dynasty. In this, he was both following and departing from Roman tradition. Roman nobles were proud of their ancestry and many claimed divine origins for their families. But, like Julius Caesar and Augustus, who both stressed the descent of their clan, the Julii, from the goddess Venus, Antony went a step beyond custom, allowing his supposed ancestor Herakles to impute the aura of divinity to himself. Also like them, he allowed his own image and the images of his immediate family to appear on coins and presumably in other more prominent media as well. Three of his wives, Fulvia, Octavia and Cleopatra, made an appearance on coins. Antony's direct descendants were plentiful, unlike those of Augustus. Ironically, he was the ancestor of three of his opponent's successors as emperor: Gaius (Caligula), Claudius and Nero.

252–254 Aureus and quinarii possibly with bust of Fulvia.

Late 40s BC

Rome and Lyons mints

London, British Museum BMCRR Rome 4215 (*RRC* no. 514); CM 1919.2-13.821 (Presented by Sir A.J. Evans) (*RRC* no. 489/5); BMCRR Gaul 49 (*RRC* no. 489/6)

Fulvia was Antony's third wife and by all accounts a remarkable woman. Together with Antony's brother, Lucius Antonius (see cat. nos 255–256), she was involved in a political dispute and eventual armed uprising against Octavian in 41–40 BC. She fled to Greece upon its failure and died there, rejected by Antony. Her bust, adorned with the wings of the goddess Victory, has been plausibly identified on these coins (see also cat. nos 223–224). She was the mother of two sons by Antony, Marcus Antonius Antyllus (see cat. no. 258) and Iullus Antonius.
J.W.

255–256 Aureus and denarius with bust of Lucius Antonius

41 BC

Eastern mint

London, British Museum BMCRR East 106 (*RRC* no. 517/4a), BMCRR East 108 (*RRC* no. 517/5c)

Lucius Antonius, Antony's younger brother, was consul in 41 BC (see cat. no. 257). His obvious lack of hair is also mentioned on inscribed sling-bullets found at Perusia, where his attempted armed uprising against Octavian came to an inglorious end ('Lucius Antonius, you're dead, baldy. Victory of Caius Caesar' [i.e. Octavian]).
J.W.

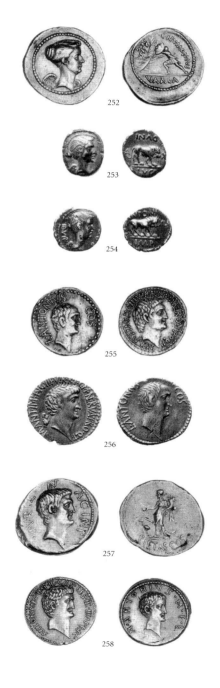

252
253
254
255
256
257
258

257 Aureus of Mark Antony.

41 BC

Eastern mint

London, British Museum BMCRR Gaul 69 (*RRC* no. 516/1)

The legend of this coin reads 'PIETAS COS' (The Righteousness of the consul), celebrating the consulship of Antony's brother, Lucius Antonius, in 41 BC. He took 'Pietas' as a surname during his futile showdown with Octavian.
J.W.

258 Aureus with bust of Marcus Antonius Antyllus

34 BC

Eastern mint

London, British Museum BMCRR East 174 (*RRC* 541/2)

Antony's elder son by Fulvia was surnamed Antyllus, recalling Anton, the mythical progenitor of the Antonian line. Antyllus was betrothed in 37 BC to Julia, Octavian's daughter but later executed by him after the Battle of Actium. His younger brother, Iullus Antonius, named after Iulus, son of Aeneas and mythical founder of Julius Caesar's family, survived until 2 BC when he was accused of treason (and of having had an affair with Julia, his late brother's former fiancée) and committed suicide. His son, Lucius Antonius, who rose to become consul in AD 25, was the last of the male line.
J.W.

259 Aureus with bust of Octavia.

38 BC

Eastern mint

London, British Museum BMCRR East 144
(*RRC* no. 533/3a)

Antony married Octavia, sister of Octavian, in
40 BC as a seal on their reconciliation pact con-
cluded at Brundisium after the war involving
Lucius Antonius and Fulvia. She was effectively
abandoned by Antony but remained publicly
loyal to him until their divorce in 32 BC. She bore
him two daughters, Antonia the Elder, grand-
mother of the emperor Nero (AD 54–68), and
Antonia the Younger (Augusta), mother of the
emperor Claudius (AD 41–54), grandmother of
the emperor Caligula (AD 37–41) and great-
grandmother of Nero.

J.W.

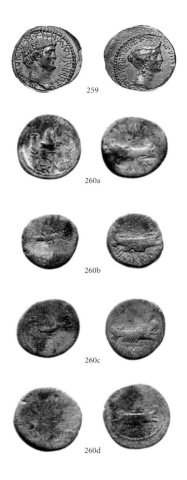

259

260a

260b

260c

260d

260a–d Denarii of Antony

30s BC

Eastern mint; from the Howe, Norfolk, hoard, buried AD 80s

London, British Museum CM 1993.3-22.5-8 (*RRC* no. 544)

Another important aspect of Antony's legacy was
the silver denarius coinage produced for him in
the 30s BC. It continued in use for over 250 years
into the third century AD. By then the coins were
worn flat, but they still formed about 3 per cent
of all denarii in circulation. Partly because of
their lower silver content, they long outlived
Augustus' purer silver coins, which had already
disappeared from circulation by the late first
century AD.

J.W.

261 Green basalt bust probably representing Mark Antony

c. 40–30 BC

Purchased at auction by William John Bankes in 1828. A letter of the 1840s states that the bust was found near Canopus and was previously in the collection of George Baldwin, who served as British Consul for Egypt 1785–96.

Height 42 cm

Kingston Lacy, The Bankes Collection
(The National Trust)

The ears and the lower edge of the bust are damaged, but the facial features, even the nose, are intact.

The subject of this refined portrait is a mature man, with a high, lightly lined brow, a long nose, slightly downturned at the tip, with clearly indicated lines running beyond the thin, slightly downturned mouth. The bone structure of the face is prominent, with little spare flesh. The tendons and muscles of the neck are clearly shown, with a prominent Adam's apple. The hair falls on the high brow in a straight fringe, lightly swept to each side above the nose. The crown of the head and the hair behind the ear follow the conventional arrangement of hair in early imperial male portraits.

The perceived difficulty in identifying the subject as Antony arises largely from the interpretation of character in this portrait, which appears high-minded, reflective and intellectual quite the reverse of the image of Antony we have from surviving literature as a bluff and burly soldier of impulsive nature, much given to soldierly camaraderie. On these grounds the subject has alternatively been identified as Julius Caesar, but the individual features do not match Caesar's known portraits.

In favour of the identification as Antony are the form of the tip of the nose, and the slope of the upper lip, features that appear in all of Antony's coin portraits, no matter how greatly the other features vary. As with cat. no. 277, the known provenance is encouraging: Antony and Cleopatra were widely (and to Roman eyes, notoriously) associated with Canopus. It is likely that this portrait was designed to fit into a niche or possibly a herm.

BIBLIOGRAPHY: A. Michaelis, *Ancient Marbles in Great Britain* (Cambridge 1882), 416, no. 2; C. Vermeule and D. von Bothmer, 'Notes on a new edition of Michaelis', *AJA* 60 (1956), 330–1; G. Grimm, 'Zu Marcus Antonius und Cornelius Gallus', *JdI* (1970), 164–5 (bibl.); J.M.C.Toynbee, *Roman Historical Portraits* (Oxford 1978), 45 and pl. 52 p. 47, and cover; F. Johansen, 'Antike Portraetter af Kleopatra VII og Marcus Antonius', *Meddeleser fra Ny Carlsberg Glyptotek* 35 (1978), 76 and fig. 22, p. 69; B. Holtzmann and F. Salviat, 'Les portraits sculptés de Marc-Antoine', *BCH* CV (1981), 276; C. Picon in *The Treasure Houses of Britain, exh. National Gallery of Art* (Washington DC 1985), 321, no. 246.

S.W.

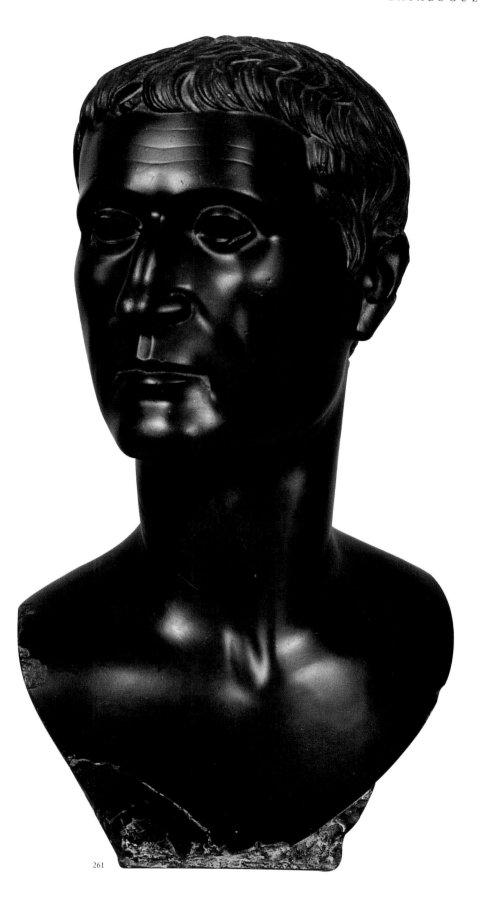

261

262 Veiled head from a marble portrait statue

Perhaps made *c.* AD 1–50

Found in Cherchel, Algeria, 1901

Height 41 cm

Cherchel, Archaeological Museum S65 (28)

The state of the preservation of this head is good despite the hammering suffered on the left side. The tip of the nose and the lips are damaged. In some areas the fine-grained white marble has become reddish due to oxidation from iron used for a modern mount. The portrait, apparently part of a colossal draped statue, comprises a head covered by a thick veil slightly folded back above the forehead, leaving exposed a fringe of thick curly hair. The soft locks are short, mostly fluted, with holes drilled at the curved ends. The oval face has an aquiline nose, with prominent cheekbones and a strong jaw. The ears stand out from the head and are pierced for earrings (now lost).

Initially, the face was thought to be that of Agrippina, Nero's wife, then that of Cleopatra VII, Selene's mother; this last identification is, however, uncertain. The scholars who identify this portrait as Cleopatra VII draw into their arguments her masculine character; but they also note the lack of resemblance to Cleopatra VII's profile as it is preserved on coins, and to the marble portrait preserved in the Vatican (cat. no. 196). The other head from Cherchel with a melon coiffure (cat. no. 197) is even further removed from the veiled portrait, with its masculine and idealized appearance.

It is true that the perforated ear lobes and the form of the fringe can cause confusion, but it must be recalled that this hairstyle can also be used for portraits of men. We cannot see the length of the hair at the back of the head, and this portrait does resemble others originating from Iol Caesarea, the capital of the Mauritanian kingdom. If we accept the perforation of the ear lobes as contemporaneous with the making of the statue, the identification of the character's sex takes a new dimension. The power of the neck muscles, the strong chin, the haughty expression and the coiffure only viewable from the forehead show the artist's intention to portray a masculine face. In the Cherchel figure the manner of wearing the toga is most unusual, covering only two-thirds of the head and intentionally drawn back behind the ears in order to show the earrings. Wearing rings on the ears was part of the costume of Numidian men, notably high-ranking personalities or priests. We cannot, therefore,

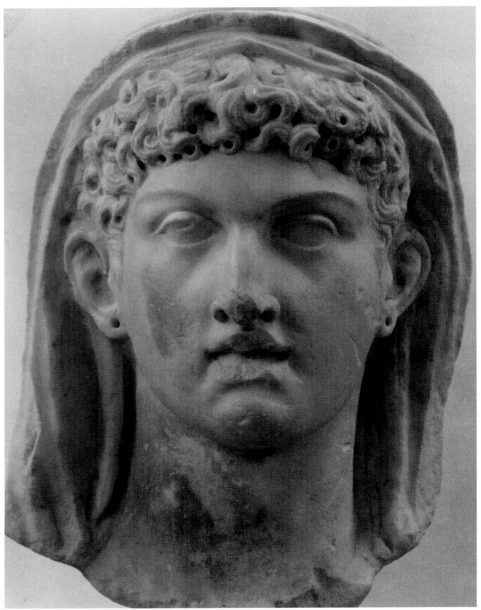

262

exclude that the portrait could represent a *togatus* (man dressed in a toga) with elements of North African dress, according to the custom of King Juba II and his son Ptolemy (25 BC–AD 40)

BIBLIOGRAPHY: M. Durry, *Musée de Cherchel* (Paris 1924), 87–89,pl..IX, 3–4; J. Charbonneaux, 'Un portrait de Cléopâtre VII au Musée de Cherchel', *Libyca* 2 (1954), 49–63; K. Fittschen, 'Zwei Ptolemäerbildnisse in Cherchel' in N. Bonacasa and A. DiVita (eds), *Alessandria e il mondo ellenistico. Studi in onore di A. Adriani* 4 (Rome 1983), 170, n.46.

M.F.

263 Green schist portrait bust of a man, perhaps Mark Antony

c. AD 40–70

Provenance unknown

Height 23.5 cm

Lent by the Brooklyn Museum of Art, Charles Edwin Wilbour Fund 54.51.

The lower part of the nose is lost. There are substantial chips of stone missing from the undraped proper right shoulder, and minor chips from the drapery.

The subject of the portrait is a man with a squarish face and a strong, projecting chin. The short hair falls high on the brow in a fringe, lightly swept to either side above the proper left eye. The brow is lightly furrowed. The eyes are smallish, with heavy lower lids. The surviving part of the nose is hooked. The upper lip slants inward. In the manner of Hellenistic Greek kings, the subject turns to look beyond his naked right shoulder, his thick neck creased by the movement. His left shoulder is draped with a folded mantle.

The diagnostic downturned tip of the nose is lost, but the form of the upper lip compares well with other portraits of Mark Antony, and the overall appearance of the head and hair led Brendel to propose such an identification. The identity of the subject has been doubted, but this small-scale portrait has rightly been compared with the grander bust of Caesar now in Berlin (cat. no. 199), and, like the Caesar, is to be dated to the first century AD. If the identification is correct, the bust was most likely commissioned when one of Antony's descendants became emperor, thus in the reigns of Gaius (Caligula, AD 37–41), Claudius (AD 41–54) or Nero (AD 54–68). As in the case of the Berlin Caesar, the much posthumous date would account for the divergence in detail from contemporary portraits on coins and gems.

BIBLIOGRAPHY: O. J. Brendel, 'The Iconography of Mark Antony', in M. Renard (ed.), *Hommages à Albert Grenier* (Brussels 1962), 366 with pl. LXXXI; F. Johansen, 'Antike Portraetter af Kleopatra VII og Marcus Antonius', *Meddeleser fra Ny Carlsberg Glyptotek* 35 (1978), 76 and fig.23, p. 70; B. Holtzmann and F. Salviat, 'Les portraits sculptés de Marc-Antoine', *BCH* CV (1981), 276.

S.W.

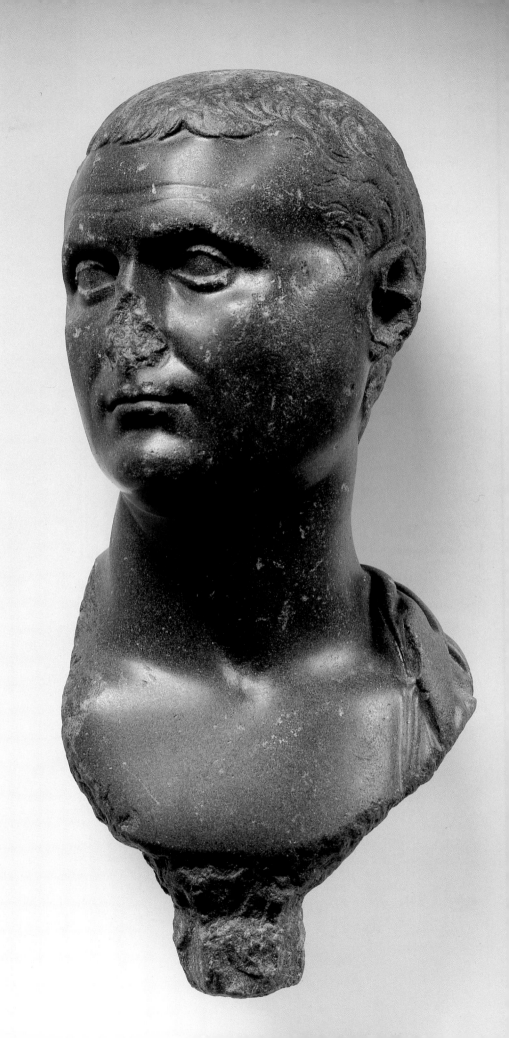

264 Red jasper intaglio: portrait bust of Mark Antony

c. 40–30 BC

Provenance unknown

Length 1.4 cm, width 1 cm

London, British Museum GR 1867. 5-7.724

BM Gem 1966 (Blacas Collection)

The engraver has cut an exceptionally clear pro-file portrait, with long, tousled hair, the locks carefully delineated, and no beard. The nose is hooked, the slightly open mouth downturned, and the chin prominent. The features resemble those of Antony on some of his coin portraits, and the bust ends at the neck. Sydenham 1528, a *denarius* issued in 39 BC and now in the collec-tions of the Musei Capitolini, Rome, is particu-larly close to this intaglio.

BIBLIOGRAPHY: S. Walker and A. Burnett, *Augustus*, British Museum Occasional Papers 16 (London 1981), 16–17, no. 174 (bibl.).

S.W.

265 Bone counter with a portrait of a woman wearing a *sakkos*

First century BC

From Egypt

Diameter 2.8 cm

London, British Museum GR 1927. 3-18.5

The subject wears a large *sakkos*, the folds of which are clearly shown. In front of the head-dress and above the brow are a mass of small curls reminiscent of the later portraits of Cleopatra VII or her daughter, Cleopatra Selene. Also of late Ptolemaic appearance is the nose (compare the marble portrait of Cleopatra VII in Berlin, cat. no. 198), the full cheek, the thick, slightly downturned lips and the prominent chin. The portrait is not continued below the chin. On the reverse is inscribed the numeral VI and per-haps the demotic '*tay*', meaning 'she of', a conven-tional start to an Egyptian woman's name.

UNPUBLISHED.

S.W.

266 Marble portrait head of a man with a hooked nose

c. 40–30 BC

Said to be from Alexandria

Height 22 cm, width 17.5 cm, depth 18 cm

London, British Museum GR 1872.5-15.3 (Sculpture 1972)

This head, broken through the neck, was origi-nally pieced across the crown. At each side are cuttings where the ears should be; while the proper right cutting is approximately ear-shaped, the left is more geometric. This feature and the presence of a slight ridge above the brow, with no

264

265

trace of hair, suggest that the subject might have worn a helmet.

The subject is a man of mature years, with fur-rowed brow and carefully modelled winged eye-brows. Beneath these, the fleshy sockets and upper brows are prominent. The tear-ducts are hardly apparent and the lower lids lost in a bag of flesh. The nose is clearly aquiline; the mouth, with thin upper lip, downturned. Unexpectedly, there are no deep naso-labial lines. The chin is very prominent, the jowls fleshy but unlined.

The subject has been identified as Mark Antony (Walker 1981). The work is evidently of the period (not late first century AD as Jucker proposed), and in profile the head compares well with coin portraits of Antony. However, surviv-ing portraits of Antony are notably inconsistent, and it is difficult to sustain an individual identifi-cation without hair. A helmeted head recently sold on the art market is markedly similar, though made in one block of marble and appar-ently of Augustan date (Christie's New York, sale of 9 December 1999, lot 352).

BIBLIOGRAPHY: H. Jucker, 'Römische Herrscherbildnisse aus Ägypten', *ANRW* II, 12(1979), 34–6, pl.28 a–b (Vespasian); S. Walker and A. Burnett, *Augustus* (London 1981), 37–41 (Antony?).

S.W.

267 Marble portrait of a woman resembling Cleopatra

c. 50–30 BC

Provenance unknown

Life-sized

Cairo, Egyptian Museum 43268

The surface of the bust is in excellent condition, with superficial damage to the surface of the hair, and breaks around the tenon which was inserted into a draped body. The top of the head was made from a separate piece of marble and attached to a sloping joining surface worked with a point to aid the bonding with an adhesive.

This striking portrait represents an unidenti-fied woman whose hair is centrally parted, then pulled backwards, forming thick strands over the ears. The hair is then rolled upwards and secured in a bun. Above this the hair lies close to the skull, with the missing upper section having completed the arrangement. A few locks of hair hang free from this formal style over the brow and on the nape of the neck. The whole arrange-ment is close to that of Arsinoe III on her coins (cat. no. 75), but her facial features betray a later date. This woman has a large, hooked nose with nostrils flaring in the manner of Cleopatra VII on her coinage, and similar to that on the Vatican and Berlin portraits (cat. nos 198 and 196). The lips are full, slightly parted, baring the teeth. The heavily lidded eyes are assymetrical, with the left eyelid rounded and arched compared to the flat-ter, right one. The neck has pronounced fleshy wrinkles, known as Venus rings, and the bust is naked to the point where it would have been inserted into the, presumably draped, body.

This head belongs with a series of late-first-century-BC portraits that, despite their subtle dif-ferences in hairstyles and details of their physiog-nomies, still bear a considerable resemblance both to each other and to Cleopatra VII's por-traits on coins and in sculpture (cat. nos 210 and 212). While the woman represented in this por-trait is unknown, the high quality carving and the use of Parian marble indicates that the sub-ject was a woman of some considerable wealth. The lack of a diadem makes it unlikely that she is royal, but she may have been a high-ranking member of the Ptolemaic court who modelled her portrait type closely on that of her queen.

BIBLIOGRAPHY: H. Kyrieleis, *Die Bildnisse der Ptolemäer*, AF2 (Berlin 1975), 133 pl. 108, 3–4.

P.H.

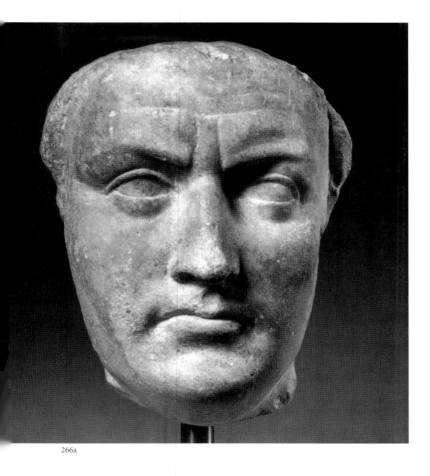

266a

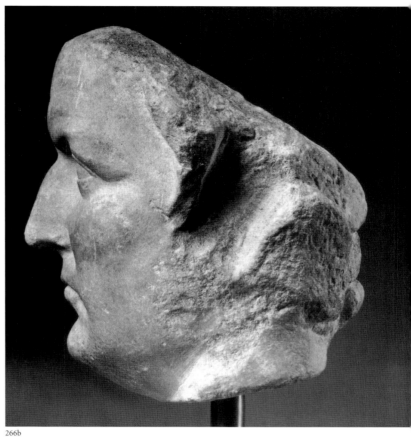

266b

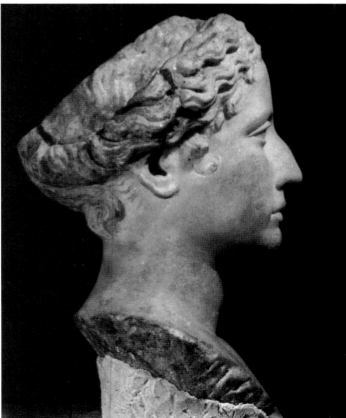

267a

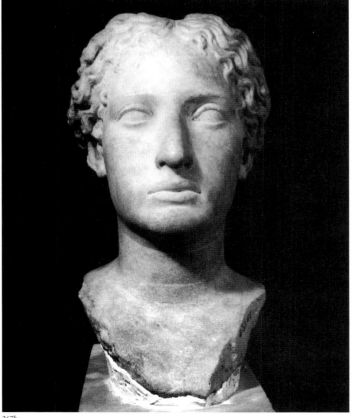

267b

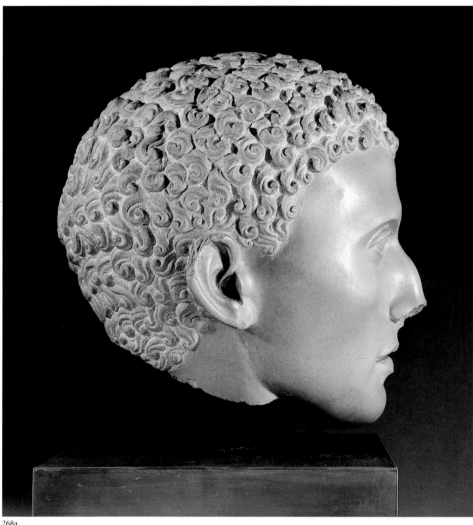

268a

268 Green basanite head from a statue of a youth

First century BC

From Alexandria; formerly in the collection of Anthony Charles Harris

Height 23 cm

London, British Museum EA 55253
(formerly GR. 1928.1-23.1)

The head is broken below the chin. The upper lobe of the proper right ear is lost, as is the tip of the nose. The figure was free-standing, with no evidence of any supporting back-pillar.

The portrait represents a youth of African appearance, with prominent cheekbones and chin, his curly hair strongly contrasted with the smoothly polished flesh. The chiselled curls of hair cross the brow in a slightly irregular line. The brow itself is lightly contoured, the lids of the almond-shaped eyes are delineated with great delicacy; the nose is hooked, and the full lips barely parted.

The subject is unknown, but from the refinement of the portrait appears to be an individual of southern Egyptian origin and high social rank. The style of the portrait combines the Egyptian taste for contrasting rough and smooth surfaces with a soft, almost pathetic expression associated with Hellenistic Greek royal portraits.

BIBLIOGRAPHY: R.P. Hinks, *Greek and Roman Portrait Sculpture*, 2nd edn (London 1976), 35, no. 25; T.G.H. James and W.V. Davies, *Egyptian Sculpture* (London 1973), 56, fig. 63; S. Walker and A. Burnett, *Augustus*, British Museum Occasional Papers 16 (London 1981), 13, no. 132; R. Belli Pasqua, *Sculture d'età romana in 'basalto'* (Rome 1995), 40–1, no.8, fig.12.

S.W.

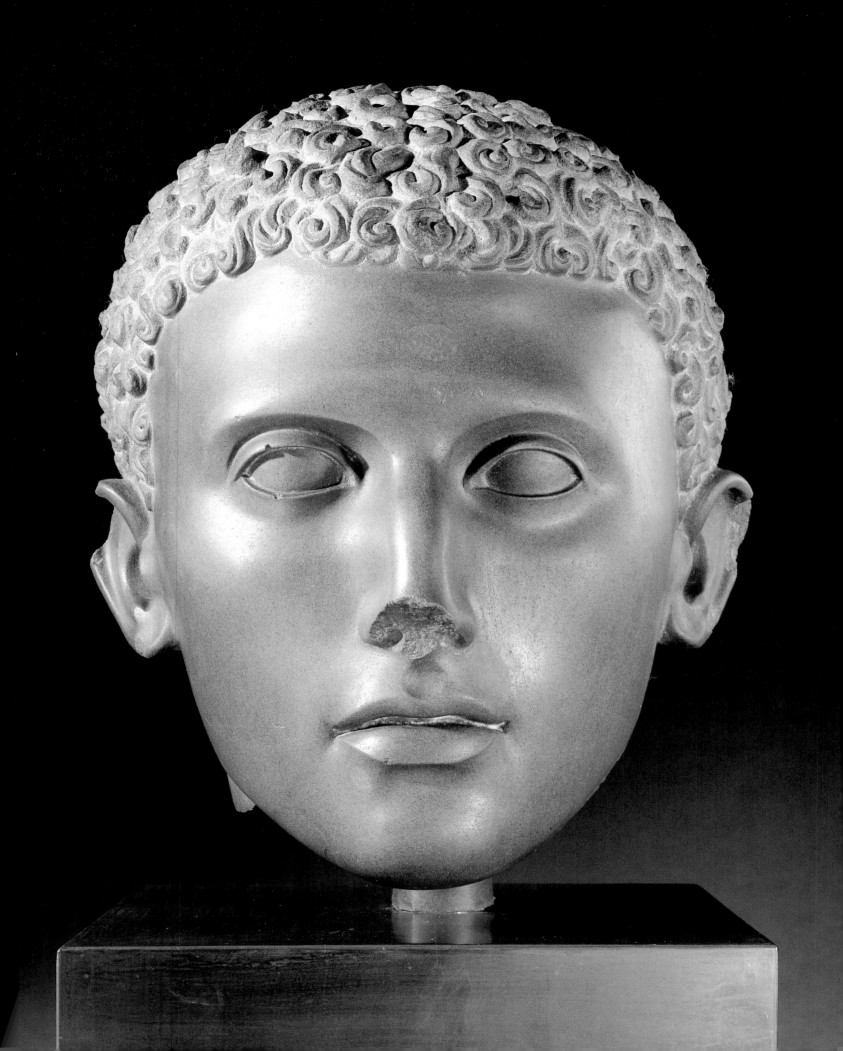

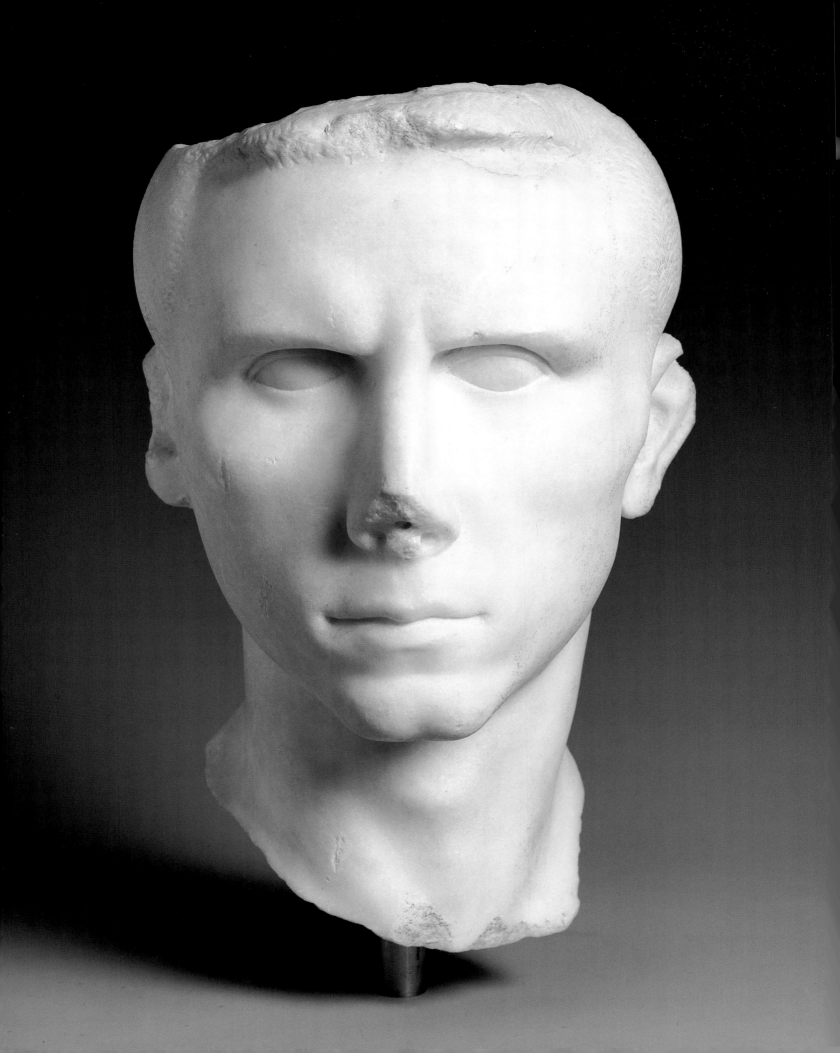

269 Parian marble portrait head from a statue of a Roman

c. 40 BC

From Cyprus

Height 31 cm, width 20.5 cm, depth 20 cm

London, British Museum GR 1902. 10-11.1
(Sculpture 1879*)

The head is broken through at the base of the neck. The tip of the nose and part of the nostrils are lost. The proper right ear is mostly lost, and the tip of the subject's left ear is damaged. Originally, the head was pieced, with an L-shaped block (now lost) forming the crown and the back of the head. The close-cropped hair stands up above the brow. It recedes at the temples in a fashion seen on contemporary portraits from Egypt. However, like cat. no. 207, the subject's features are of Roman appearance. The brow is furrowed, the deep-set almond-shaped eyes are long and hooded, the nose hooked, the lips thin and unsmiling, the chin and Adam's apple prominent.

This portrait, in Parian marble, is of exceptional quality. It has been identified as Octavian, but the face lacks Octavian's broad cheekbones and jaw. The subject is more likely a contemporary senior official of considerable authority. The treatment of the eyes recalls some Hellenistic royal portraits (e.g. cat. no. 23), despite the Roman features.

BIBLIOGRAPHY: S. Walker and A.Burnett, *Augustus*, British Museum Occasional Papers 16 (London 1981), 15, no. 154 (bibl.).

S.W.

269b

◀ 269a

270 Bronze statuette perhaps representing Alexander Helios as Prince of Armenia

34–30 BC

Provenance unknown

Height 64 cm

New York, The Metropolitan Museum of Art, Department of Greek and Roman Art, no. 49.11.3

This bronze, one of a pair, has often been discussed since its first publication in 1917. Each figure represents the same youth standing in regal attitude, wearing an oriental costume and a complex tiara, which may be identified as Armenian. Their alleged discovery was in 1912, 'either just east of the Suez Canal or else in Alexandria' (Hermann 1988). The pairing figure (62 cm high) is now in the Walters Art Gallery, Baltimore.

The young 'sitter' has not been identified. A date for the bronzes in the second half of the first century BC has been generally accepted, as has their most probable origin, a workshop in Alexandria. The question of their function remains open, with other factors that do not appear to have been previously taken into consideration.

The age of the youth is about five or six years and no more. If he was intended to be not an abstract entity but an identifiable person, then the precise representation of his age must be a first step towards the resolution of the enigma. Who could already be so important at that age to be represented twice in such a regal manner and with oriental attire, in an Alexandrian workshop?

After his victorious campaign of 34 BC in Armenia, Antony had taken a 'great mass of booty' and the Armenian King Artavasdes 'with his wife and children', writes Dio Cassius.

> Sending them with the captives ahead of him
> into Alexandria in a kind of triumphal procession,
> Antony himself drove into the city upon a chariot
> and he not only presented to Cleopatra all the
> other spoils but brought her the Armenian
> and his family in gold bonds (XLIX, 40, 3).

The clothes and headdress of the two bronze figures could have been inspired by these events and even skilfully copied from some of the royal spoils. But if their royal attire had been the model, the captive royal children themselves were not; they were in gold chains and by no means allowed to express such a regal attitude. Dio Cassius goes on to write that 'much coercion was

brought to bear upon them [the Armenian royal family] and many hopes were held out to them to win their compliance, but they merely addressed Cleopatra by her name' (XLIX, 40, 4).

A second clue is offered by Plutarch in his life of Antony:

> Antony then gave the title of kings to the sons he
> had by Cleopatra, assigning to Alexander Armenia,
> Media, and the Parthian Empire, once submitted,
> and to Ptolemy Phoenicia, Syria and Cilicia. At the
> same time, he presented both of them to the
> people, Alexander wearing the Median costume
> with the tiara (and the straight *kidaris*), Ptolemy
> with the sandals, the *chlamys* and Macedonian hat
> complete with diadem. The latter suited one of the
> kings, heirs of Alexander (the Great), and the
> former was the clothed appearance of the Medians
> and Armenians. When the two children had kissed
> their parents (Antony and Cleopatra), they were
> surrounded one by Armenian bodyguards, and the
> other by Macedonian bodyguards. (Ant. LIV, 7,8,9)

Despite slight differences in the names of the territories distributed to them by Antony during this Alexandrian event of 34 BC, in a ceremony known as the Donations, the information reported by Dio Cassius does not diminish the authority of Plutarch's text (Cas. Dio. XLIX, 41, 3). In contrast to their complex oriental dress, the figures have an occidental profile, which makes them children in disguise. We know, of course, that several oriental dynasts were represented with Western features at the time of Antony, mainly on coins, so that they could be presented within the idealized Hellenistic tradition begun with the portraits of Alexander the Great. But these are always of adults.

The faces are marked by two shadows under the eyes and thick lips, which help to individualize the two heads. John Herrmann has rightly remarked: 'The figures – thick neck and the deep backs of their heads, as well as their fleshy chins – even recall numismatic portraits of Nero' (Herrmann 1988, 292). Although it is risky to compare portraits of young children to those of adults, in view of the baby fat with which the features of the former are still imbued, we must admit that the two bronzes also display a certain fatness that is more than the usual baby fat: the boy is not two or three years old, but in his late fifth or sixth year. Could this cow-like neck be a genetic characteristic of some of the male descendants of Antony, between 40 BC and Nero,

who, as Plutarch recalls, 'was the fifth descendant in line from Antony' (Ant. LXXXVII, 9)?

We must now consider the postures of these almost twin bronzes. The right arm, although at a slightly different level for each, shows an expression of power, a sense of domination over the crowd viewing them. Were they made to be seen also from a stand carried by bearers? They appear at the same time both imposing and peaceful, as benefactors should be. Treated in the manner of colossi, their heads have been in no way enlarged, and only the necks appear bloated. The left hand also gives the impression of being larger than life. The style seems to us almost a caricature, but it only underlines the features of the young prince, as make-up does for actors, and is directly linked to the representation of Cleopatra and Antony on coins struck in Damascus or Antioch. But the two bronze figures remain in the tradition of the representations of a Hellenistic ruler. What is indeed exceptional is, first, that they wear a specifically non-Hellenistic Armenian costume, secondly, that they are not of an age to adopt naturally the dominant attitude of adult Hellenistic kings, since they still bear the features of *putti* (cupids).

These observations, with the text of Dio Cassius recalling the fate of Artavasdes and his family, and, with the description by Plutarch of the ceremony of the Donations in 34 BC in the great gymnasium of Alexandria, can only lead us to recognize in the two bronzes a contemporary representation of Alexander Helios, aged about six, son of Antony and Cleopatra VII, and twin of Cleopatra Selene, born in Egypt in 40 BC.

It remains to determine the circumstances of their creation. If they were found in Alexandria, there is every chance that the figures had been commissioned by Cleopatra and Antony, in view of the ceremony of the Donations, which was considered by Antony himself as a 'Roman' triumph outside Rome (the first of its kind) after his Armenian campaign started in the spring of 34 BC. The latter had produced, it seems, enough booty to cover, perhaps, the considerable expenses of the unfortunate preceding Parthian expedition of 36 BC. Such statues could easily have been introduced in the triumph, following the Alexandrian tradition of Ptolemy II Philadelphos in the third century BC, when he created the regular festival of the Ptolemaia in the Stadium, a ceremony that we know through

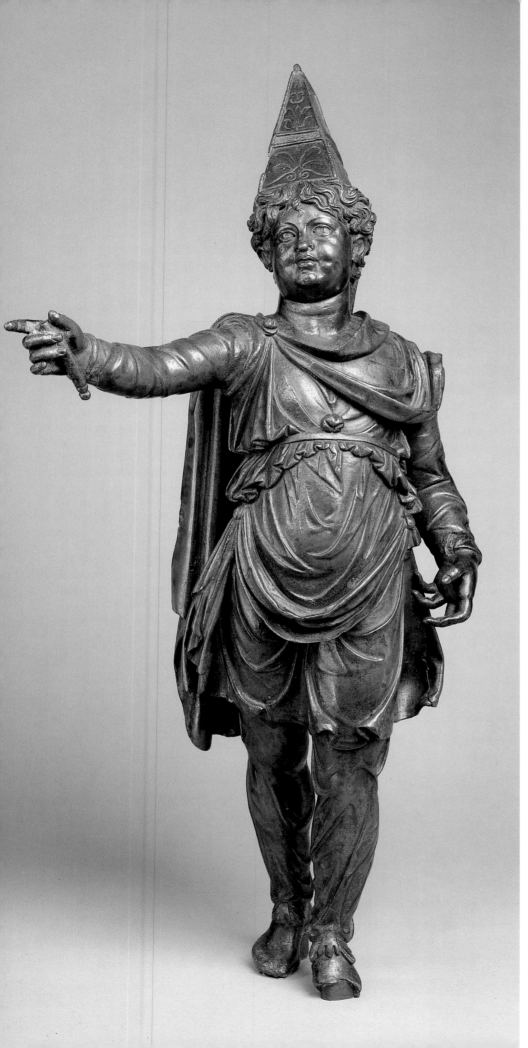

the barely credible lengthy description by Kallixenos of Rhodes reported by Athenaeus (*Deipnesophists* 11 392-419; Loeb ed. 1928). Thereafter the bronzes could have adorned for a while sanctuaries devoted to the cult of the royal house, which Cleopatra had always encouraged.

Had they been discovered 'just east of the Suez Canal', might it mean that, after the ceremony of the 'Donations', they were on their way to the East for dynastic reasons, and that an accident interrupted their trip to Armenia, Lesser Armenia or even Media? In considering the possibility that the two statues might personify the territory in question, John Herrmann writes: 'Armenia Major, moreover, adjoined Armenia Minor, a situation that could also have led to a double representation' (1988, 291).

Alexander Helios was not fortunate. In August 30 BC he was taken prisoner in Alexandria after the 'suicides' of his parents, and sent to Rome less than a month later with his twin sister, Selene, and, it seems, little Ptolemy Philadelphos. They were looked after by Octavia – the fourth wife of Antony and his official Roman widow – who also had to look after Jullus Antonius, the younger son of Antony and Fulvia – his third wife – now dead.

Octavia, half sister of Octavian, had herself to educate her two daughters by Antony, Antonia Maior and Antonia Minor. Yet, in 29 BC, Alexander Helios and Selene had to follow the infamous procession along the Via Sacra, in the triumph of Octavian over Cleopatra. Fate made him discover in his turn the deprivations that the family of Artavasdes had suffered in 34 BC in Alexandria. We know nothing more about Alexander, and all we are left with are the two baroque bronze figures in the American museums.

BIBLIOGRAPHY: J. Herrmann in *The Gods Delight* (Cleveland 1988), 288–93 with n. 51, 294–5 with n. 52; R.R.R. Smith, *Hellenistic Royal Portraits* (Oxford 1988), 169, n. 69; cf. Dorothy J. Thompson, *Memphis under the Ptolemies* (Princeton 1988), ch. IV, 127, 131, 136; G.W. Goudchaux, 'Archibios, sauveur des effigies de Cléopatre VII', in *VI Congresso Internazionale di Egittologia*, (Turin 1991), I.651-656; G.W. Goudchaux, 'Bronze Statuettes of a Prince of Armenia', in *The International Congress of Egyptology, Cairo 2001* (Cairo, forthcoming)

G.W.G.

Cleopatra's children (cat. nos 271–275)

After Cleopatra's death in 30 BC, her three children by Antony were spared by Octavian. Cleopatra Selene was taken to Rome to be paraded before the Roman people in Octavian's triumph. She was subsequently married by Octavian to King Juba II of Numidia, to whom she bore a son, Ptolemy. Her brothers, the grandly named kings Alexander Helios and Ptolemy Philadelphus, were sent with their sister to live out their lives in complete obscurity in Africa.

271–274 Silver coins of Juba II and Cleopatra Selene of Numidia

25 BC–AD 23

London, British Museum CM RPK p.218,1 (Bequeathed by Richard Payne Knight); CM1938-5-10-167; CM1850-8-7-1; CM1964-13-3-66 (Bequeathed by Sir A.G. Clark)

J.W.

275 Silver coin of Ptolemy of Numidia (AD 20–40)

AD 20–1

London, British Museum CM TC p. 241, 2

The kings of Numidia issued silver coins, initially on the same weight standard as denarii, though their weight was subsequently reduced. The coinage of Juba II and his wife Cleopatra Selene was remarkable for the different use made of the obverse and reverse sides of the coins. On the obverse appeared the portrait of the king with the Latin legend 'REX IVBA'. On the reverse by contrast the legend was in Greek and read 'Queen Cleopatra', accompanied sometimes by the portrait of the queen and sometimes by symbols recalling her Egyptian origins, such as the crown of Isis, sistrum or crocodile. On Juba's death the pair were succeeded by their son, Cleopatra and Antony's grandson, Ptolemy.

J.W.

271

272

273

274

275

276 Marble portrait head from a statue of Octavian

Probably made *c.* 30–25 BC

Acquired in Rome

Height 35.5 cm, chin to crown 22 cm, width 20.5 cm, depth 21.5 cm

London, British Museum GR1888.10-12.1 (Sculpture 1878)

The lower edge of the neck, fashioned as a tenon to fit into a draped torso (the join then concealed by drapery), is lost. The proper left ear is chipped. The surface is damaged at the outer end of the proper left eyebrow, to the left of the mouth, and at the left edge of the neck. The nose has been replaced, the glued join concealed. The restoration necessitated some superficial reworking of the lips and chin. In general the head, which is carved in Carrara marble with some mineral inclusions, has the appearance of an ancient piece cleaned and reworked for the antiquities market.

Octavian appears pensive, his abundant thick locks of hair kept well clear of the high brow and broad face. The expression and hairstyle, which may be compared with two other portraits in Italian collections, have none of the emotional agitation suggested in other marble portraits of Octavian. The serenity prefigures that of portraits of the Roman leader after he assumed the name Augustus in 27 BC, and may date close to that time. Alternatively, the portrait may be retrospective; indeed, some scholars have suggested that the head was made long after Augustus' death in AD 14. Others have believed it to be a nineteenth-century fake, but, as Boschung notes, the one head of this type with a secure archaeological context was discovered at Lucus Feroniae (Capena, Etruria) only in 1959, making forgery less likely than the reworking described above. The Lucus Feroniae head formed part of a group of imperial statues including a portrait of Agrippa (see cat. no. 313). It has been convincingly argued by Sgubini Moretti that these were a single project, completed in the earlier years of Augustus' reign.

BIBLIOGRAPHY: D. Boschung, *Die Bildnisse des Augustus* (Berlin 1993), 108, no. 3 (bibl.); A.M. Sgubini Moretti, 'Statue e ritratti onorari da Lucus Feroniae', *RendPontAccad* LV–LVI (1983–4), 71–110.

S.W.

276 ▶

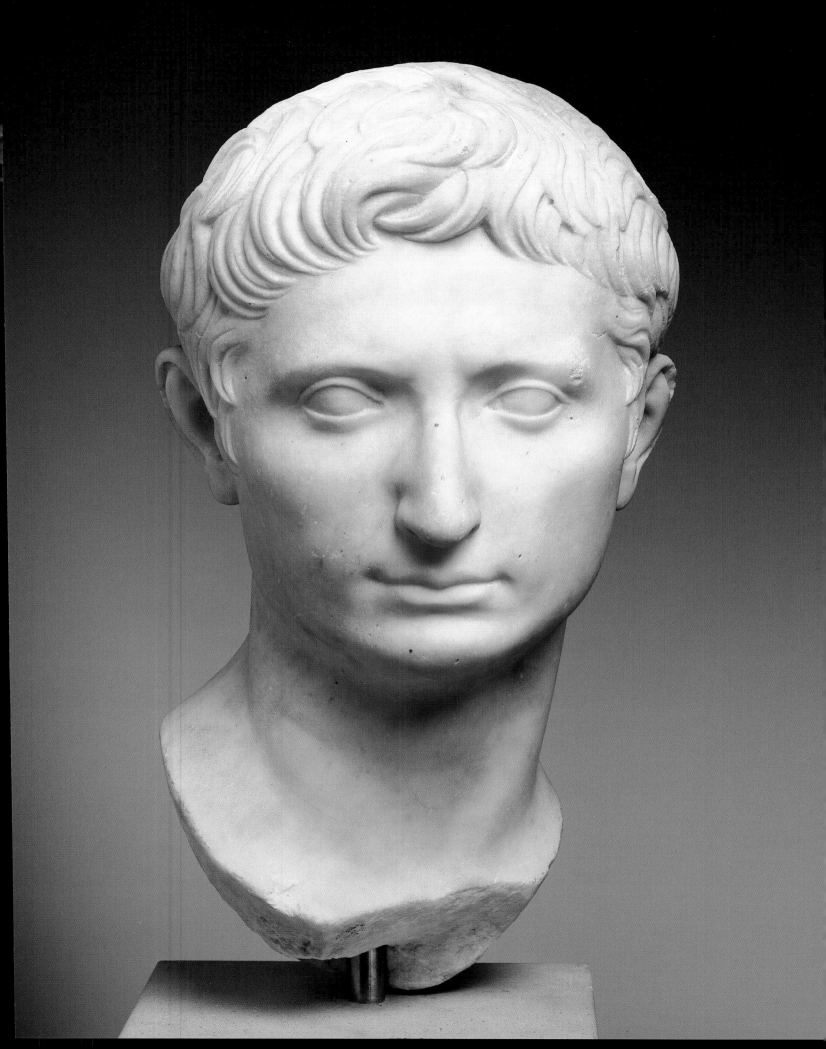

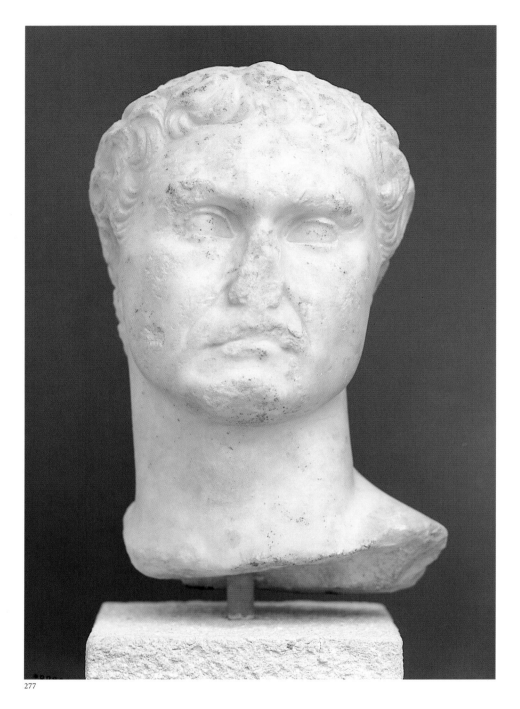

277

bottom line running the length of the entire fore-head, and the two top ones barely visible on the right side. The eyebrows are set close together and the eyes are deep set and relatively small; two furrows appear above the eyelids and grow deeper near the nose area; there are wrinkles ('crow's feet', sculpted rather than chiselled) around the left eye. Labionasal furrows are accentuated on the right side and the mouth is closed and turned downward. The neck is thick, with marked lateral muscles.

Paul Arndt (1912) and Anton Hekler (1929) thought that the sculpture was a private work dating back to the age of Claudius. The idea that the Budapest bust could possibly portray Mark Antony was first put forward by Helga von Heintze (1966), and then further considered by Berhard Holtzmann and François Salviat (1981), who sustained the dating of the head to the second half of the first century BC. However, Walter Megow rightly called attention to the fact that the presumed correlation between the Budapest bust and the portraits from Cos and Mytilene identified as Antony by Holtzmann and Salviat was not fully convincing: they cannot be traced back to the same prototypes (1985, 493). Megow considered the busts of Budapest and Thasos (the later also discussed by Holtzmann and Salviat) only as replicas of the same original. However, the chipped and worn surface of the latter does not allow verification of this hypothesis – and thus the Budapest bust remains in a category of its own. The fact that it was found in Patras, the last headquarters of the triumvir, does not provide a sufficient basis for a positive identification. Therefore, the hypothesis that the head is a portrait of Mark Antony has yet to be proven.

The findspot and the type of marble (Parian) suggest that the head was the work of a Greek studio. There are only a few objective points of reference available to determine the date of the bust. The realism of the facial features and the intense expressiveness of the eyes betray the roots of the portrait in Hellenistic art, still current among the plurality of styles adopted in the early years of the Roman Empire. The date put forward by Holtzmann and Salviat on the basis of two stylistic comparisons is not entirely convincing: the bust from Cos (see Hafner 1954) seems to be very different from the Budapest head, while the one found in Mytilene (see Schmaltz 1978) has actually been dated to the time of Claudius (ibid., 164; cf. Salzmann 1985). The hairstyle sculpted on the Budapest head is characterized by a series of short locks, which appear on imperial busts from the age of Tiberius (see Boschung 1993, 58 nr Lf, fig. 35, 'Copenhagen 624' type;); it is well documented in portraits created during the reign of Caligula (compare

277 Head from a statue of a man (so-called Mark Antony)

From Patras, Greece; previously in the P. Arndt Collection, Munich, and purchased by the Budapest Museum of Fine Arts in 1980

Height 35 cm

Budapest, Museum of Fine Art 4807

A large part of the mouth and nose are missing. The work is chipped in several places, especially around the left eyebrow and the mouth.

The fact that the square head is turned towards the right explains the noticeable asymmetry of the face, especially in the arch of the eyebrow, the eyes and the mouth. The face is wide, with a marked bone structure, high cheekbones and a square, short chin. The hair is styled in tidy locks only on the front of the head while on the back of the head the locks fall from a cowlick. On the left side of the head the very short locks are arranged in three tidy rows, while on the right side they overlap one another. In front the locks seem combed in the opposite direction; those on the temple are combed forward and upward. There are three thin facial lines on the brow, with the

Boschung 1989) and also appears in the portraits of Claudius sculpted before his investiture (Boschung 1993, 70, nr VA, fig. 56). The frontal hairstyle of the Budapest head, a significant element in any type of portraiture, is more easily compared to some of the pieces belonging to the above-mentioned 'Copenhagen 624' type of Tiberius (Polacco 1955; Balty and Cazes 1995). Moreover, the hairstyle of the 'l.Nebentypus' of Caligula is characterized by locks brushed forward over the temples. These comparisons seem to constitute a possible starting point for the dating of the Budapest head and suggest a date within the second quarter of the first century AD. However, a precise chronological and stylistic framework can be established only on the basis of a reconstruction of the artistic production of the studio.

BIBLIOGRAPHY: P. Arndt in J. Wollanka (ed.), *Az antik szoborgy-jtemény magyarázo katalògusa* (*Catalogue of the Collection of Sculptures*) (Budapest 1912), 120, nr 102; A. Hekler, *Sammlung antiker Skulpturen* (Wien 1929), 127, nr 116 and photograph; H. von Heintze in W. Helbig and H. Speier (eds), *Führer durch die offentlichen Sammlungen klassischer Altertümer in Rom II* (Tübingen 1966), 414–16; B.Holtzmann and F. Salviat, 'Les portraits sculptés de Marc-Antoine', *BCH* 105 (1981), 265–88, esp. 278–84, with ample photographic documentation; W.-R. Megow, 'Zu einigen Kameen späthellenistischer und frühaugustischer Zeit', *Jdl* 100, (1985), 445–96, esp. 492–3; J. Gy.Szilágyi, *Antik müvészet* (*Ancient art. Guide to the antique collection*) (Budapest 1988), 82–3, fig. 75; G. Hafner, *Späthellenistische Bildnisplastik* (Berlin 1954), 26–7, nr R 24, ill. 9; B. Schmaltz, 'Zu einem Porträt in Mytilene', *AM* 93 (1978), 161–70; D. Boschung, 'Die Bildnisstypen der iulisch-claudischen Kaiserfamilie', *JRA* 6 (1993), 58, nr Lf, fig. 35 – for an iconographic analysis, see also A.K. Massner, *Bildnisangleichung* (Berlin 1982), 79–80, 89–91; D. Boschung, *Die Bildnisse des Caligula* (Berlin 1989), 58–60, 86; L. Polacco, *Il volto di Tiberio* (Rome 1955), 128–30, ills 22, 23, 25; J.C. Balty and D. Cazes, *Portraits impériaux de Béziers* (Toulouse 1995), 72–6.

A.N.

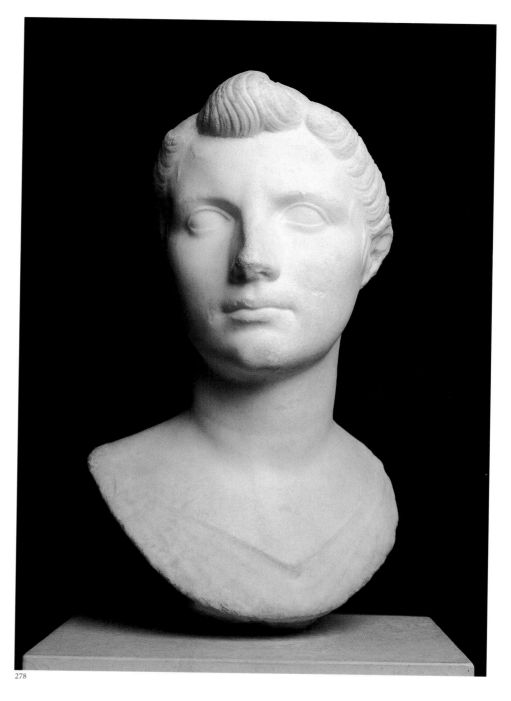
278

278 Marble Bust of Octavia

c. 40 BC

Colle Lante, Velletri

Height 25.5 cm

Rome, Museo Nazionale Romano 121221

The head, which is turned and slightly raised towards the left, represents a young woman with slightly sunken eyes, a thin nose, a small mouth and a round chin. Her hair is styled in the manner first seen on the gold coins of Mussicius Longus and Numonius Vaale (Vessberg 1941, pl. XIII, 6, 8) and later on a gold coin not preceding 40 BC and now in Berlin (ibid, pl. XIII, no. 9). The style is characterized by a thick tuft of hair (*nodus*) lying on the forehead, from which a thin braid is drawn back along the central parting, coming together with two side braids to form a bun on her neck.

Given the similarity with the gold coin of Berlin that portrays the younger Octavia (the sister of Octavian, later Augustus), one possibility is that the young woman may indeed be Octavia. However, doubts remain as to the exact identification of the portrait, especially as a result of the inconsistency that the iconography of Octavia and of Livia still present today.

BIBLIOGRAPHY: V. Picciotti Giornetti, *Museo Nazionale Romano* 1,1 (1979), 203; E. Bartman, *Portraits of Livia: Imaging the Imperial Woman in Augustan Rome* (Cambridge 1999), 214–15, figs 191–2.

L.N.

Rome and Egypt (cat. nos 279–280)

Since first expanding into the eastern Mediterranean in the late third century BC, the Romans came into increasingly close contact with the Ptolemaic kings of Egypt and with Egyptian culture. Their victories over Macedonia and the Seleucid empire in the early second century BC turned them into one of the great powers in the Greek-speaking Hellenistic world. The Ptolemies successfully maintained their independence from the Romans longer than any other Hellenistic dynasty by avoiding conflict, in wise acknowledgement of their own inferior status as a military power.

279–280 Denarii of M. Lepidus.

61 BC

Rome mint

London, British Museum BMCRR Rome 3648, 3649
(*RRC* no. 419/12)

279

 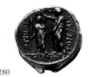

280

The designs of this coin-issue comprise the most explicit, and intriguing, reference to Egyptian affairs on the Roman coinage. The obverse shows a bust of the personification of the Ptolemies' capital, Alexandria (the legend below reads 'ALEXANDREA'). On the reverse are shown a Roman male in a toga who is crowning a smaller male figure in Greek dress. The legend reveals the identity of the Roman: Marcus Aemilius Lepidus, a distinguished Roman statesman of the early second century BC as well as namesake and ancestor of the *moneyer* (the future triumvir). It also calls him 'TVTOR REG[*is*]' ('guardian of the king'). This relates to a story of uncertain historicity recounted by various ancient sources, namely that this Lepidus was dispatched by the Senate to Egypt in 201 BC to act as guardian to King Ptolemy V.

In 65 BC, shortly before these coins were struck, the Roman statesman Crassus had tried to have Egypt annexed, a scheme in which he was foiled by Cicero. This clear evidence for a positively acquisitive stance towards Egypt on the part of a powerful Roman provides a plausible contemporary context for the invention of the story depicted on the coins, namely that Ptolemy V actually received his crown from Lepidus. The implication of, and motivation behind, this historical myth is clearly that Egypt had already been a Roman dependency for generations, and maintained its autonomy only on Roman sufferance. After all, some alleged, Egypt had been bequeathed to the Roman people by King Ptolemy Alexander, so it was legally theirs anyway. The sources that mention this supposed bequest do not specify whether the king in question was Ptolemy X Alexander I, who died in 88 BC, or his son Ptolemy XI Alexander II, who reigned briefly in 80 BC. A copy of the will was never produced and this story may well have been fabricated by those at Rome keen to annexe Egypt.

UNPUBLISHED.

J.W.

Octavian: 'Commander Caesar Son of the God' (cat. nos 281–306)

Octavian was only eighteen years old when Caesar, his great uncle, died. He inherited his posthumously adoptive father's name, and succeeded in claiming his share in Caesar's political legacy together with Antony and Marcus Lepidus in the triumvirate. Three soon became two as Lepidus was squeezed out of the picture.

281–282 Bronze coins with busts of Octavian and Julius Caesar

c. 38 BC

Italian mint

London, British Museum BMCRR Gaul 106, CM 1872.7-9.438 (*RRC* no. 535/1)

The connection between 'father' and 'son' is conveyed by the legends. Caesar is called 'Julius the god', Octavian 'Caesar son of the god'.

The 'Actium' coin issues

In the late 30s and early 20s BC Octavian issued a series of inventive coin-types. His bust is beautifully modelled and divinely anonymous. His image is assimilated to a variety of gods very much as Antony's was (cf. cat. nos 235–246). The frequent use of symbols of victory on these coins might suggest that they were made after Actium in 31 BC. But in 36 BC Agrippa, Octavian's principal general, won a great sea victory off Sicily against Sextus Pompey, son of Pompey the Great and another major player in the power politics of the early 30s BC. All these victory symbols could thus refer to this earlier victory, allowing all these coins to pre-date Actium. The debate continues.

J.W.

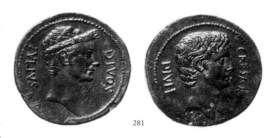

281

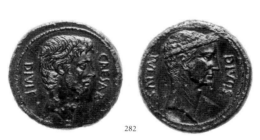

282

283

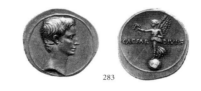

284

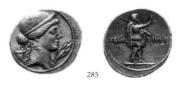

285

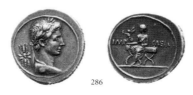

286

283 Denarius showing bust of Octavian

c. 34–28 BC

Probably Italian mint

London, British Museum BMC Augustus 602 (*RIC* Augustus no. 254a)

By this stage Octavian has lost his beard and appears unnamed on the obverse, like a god.

J.W.

284–286 Denarii showing Octavian in various poses

c. 34–28 BC

Probably Italian mint

London, British Museum BMC Augustus 609 (*RIC* Augustus no. 251), 612 (*RIC* Augustus no. 253), 637 (*RIC* Augustus no. 270)

Octavian is shown as the military man of action and the civilian magistrate seated on his official chair, but still holding a small figure of Victory. He held one of the two yearly consulships, the highest republican magistracy, almost continually from 33 to 23 BC (with a break in 32 BC).

J.W.

287–291 Aureus and denarii of Octavian with symbols of victory

c. 34–28 BC

Probably Italian mint

London, British Museum BMC Augustus 622
(*RIC* Augustus no. 268), 603 (*RIC* Augustus no. 254b),
617 (*RIC* Augustus no. 264), 631 (*RIC* Augustus no. 266),
625 (*RIC* Augustus no. 265a)

Victory stands on a globe on cat. nos 287 and 288, on a ship's prow (a reference to either Naulochus or Actium, or both) on cat. no. 289, and on cat. no. 290 perched on the the roof of a building, which is probably to be identified as the restored Senate House dedicated in August 29 BC. This identification is possibly also a means of dating these coins, though buildings do not actually have to have been built in order to appear on coins. Some scholars think that the Victory-on-globe design may be a representation of the statue of Victory dedicated by Octavian in the Senate House (see pp. 195–6). Octavian rides in a triumphal chariot on cat. no. 289 (he celebrated three triumphs in as many days also in August 29 BC) and a trophy of arms appears on cat. no. 291, consisting of both naval and military spoils.

J.W.

292–294 Denarii showing Octavian with divine attributes

c. 34–28 BC

Probably Italian mint

London, British Museum BMC Augustus 633
(*RIC* Augustus no. 271), 615 (*RIC* Augustus no. 256),
636 (*RIC* Augustus no. 271)

Octavian appears with the laurel wreath of Apollo, and the ship's prow-stem (*aplustre*) of the sea-god Neptune. Cat. no. 292 shows a statue of a naked male figure, probably Octavian, on top of a column decorated with symbols of naval victory. The nude pose resembles similar representations of gods and heroes. Octavian's divine pretensions were no less audacious than Antony's (see cat. nos 235–246).

J.W.

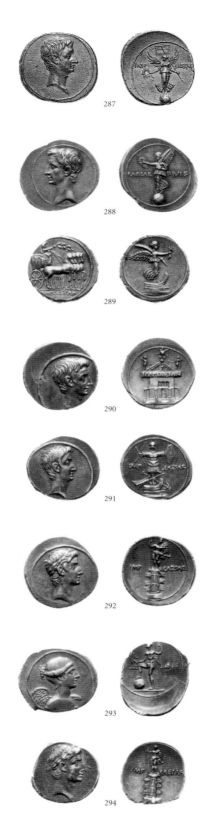

287

288

289

290

291

292

293

294

The victory of Actium and the salvation of the Commonwealth

The first datable coins to celebrate Octavian's victory explicitly were made in his sixth consulship, 28 BC, by which time he had returned to Rome in triumph. The recapture of Asia and the conquest of Egypt were commemorated specifically. More generally, Octavian's heroic achievement in having saved the state and his fellow-citizens from peril became the constant theme of the symbolism associated with him from then on.

295–296 Denarii of Octavian with crocodile

28 BC

Perhaps Rome mint

London, British Museum BMC Augustus 650, 651
(*RIC* Augustus no. 275)

The crocodile was the symbol par excellence of Egypt in Greek and Roman minds. The legend reads 'Upon the conquest of Egypt' (cf. cat. nos 305–306).

J.W.

297 Quinarius celebrating recapture of Asia

c. 30–35 BC

Perhaps Rome mint

London, British Museum BMC Augustus 647
(*RIC* Augustus no. 276)

This half-denarius coin shows Victory standing on a sacred snake-box (*cista mystica*), a symbol used on the coinage of the Roman province of Asia. The legend reads 'For the recapture of Asia'.

J.W.

298–299 Cistophori showing Octavian and Pax

28 BC

Mint in western Asia Minor

London, British Museum BMC Augustus 692, 693
(*RIC* Augustus no. 476)

Octavian's bust is shown wearing the laurel-wreath of the triumphal general as is the whole reverse side. The legend on the obverse calls him 'The Champion of the Liberty of the People of Rome' (LIBERTATIS P R VINDEX), meaning internal political liberty but also freedom from external aggression from Cleopatra. The standing figure is that of the goddess Pax, representing peace gained through military victory, in this case over Egypt and Cleopatra.

J.W.

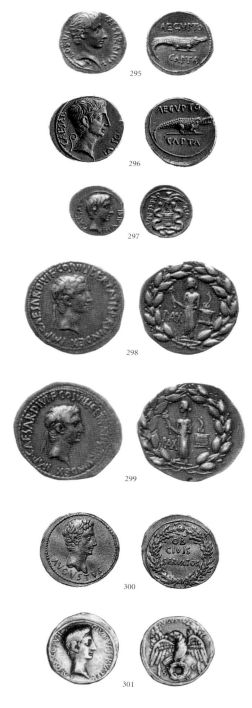

295

296

297

298

299

300

301

300 Aureus celebrating Augustus' victory

c. 28 BC

Probably Spanish mint

London, British Museum BMC Augustus 314
(*RIC* Augustus no. 29a)

Augustus was honoured for 'having saved his fellow citizens' (OB CIVES SERVATOS). The oak-wreath that forms the border was a decoration awarded to a Roman soldier who saved the life of a fellow citizen. Augustus was honoured as having saved them all.

J.W.

301 Aureus celebrating Augustus' victory

27 BC

Probably Rome mint

London, British Museum BMC Augustus 657
(*RIC* Augustus no. 277)

The reverse of this coin shows the eagle of Jupiter with Augustus' oak-wreath crown in its talons and two laurel-branches behind. Above we read the new name 'AVGVSTVS', granted to Octavian in January 27 BC by decree of the Senate (hence 'S C' below, for *Senatus Consulto*). He was also allowed to have two laurel trees growing outside his door in honour of Apollo, the god whom he regarded as the patron of his victory at Actium. Such trees were also positioned outside the offices of priests in Rome. They lent an aura of divinity and religiosity to the emperor's earthly home.

J.W.

302 Aureus celebrating Augustus' victory

c. 27 BC

Probably Spanish mint

London, British Museum BMC Augustus 351
(*RIC* Augustus no. 50a)

In the centre of this coin appears the 'Shield of Courage' (*clupeus virtutis*), a representation of the honorific golden shield voted to Augustus in 27 BC and hung in the Senate. According to a marble copy from Arles, the inscription on it read: 'The Senate and People of Rome gave to Commander Caesar Son of the God Augustus, when consul for the eighth time, this shield for his courage, clemency, justice and righteousness towards the gods and the fatherland.' Either side of the shield are the laurel trees again (see previous coin), and above and below the abbreviated form of the emperor's new name, CAESAR AVGVSTVS.

J.W.

303–304 Aurei showing Apollo of Actium

15–9 BC

Lyon mint

London, British Museum BMC Augustus 460
(*RIC* Augustus no. 170), 481 (*RIC* Augustus no. 192a)

The god Apollo was nominated as the patron of Augustus' victory at Actium. The god had a temple overlooking the scene of the battle. Augustus built a temple in his honour on the Palatine Hill in Rome adjoining his own house. The face of the statue of the god reportedly had the features of Augustus himself.

J.W.

305–306 Bronze coins of Nemausus celebrating Actium

30 BC–AD 14

London, British Museum CM 1866.12-1.3963
(*RPC* no. 523), 1935.11-2.9 (*RPC* no.524)

The Roman city of Nemausus (modern Nîmes) in southern Gaul issued a large coinage throughout Augustus' reign with the standard reverse design of a crocodile chained to a palm branch and the ties of a laurel wreath flying above. The crocodile clearly stands for Egypt or more specifically Cleopatra, tied like a dog to the two classic symbols of Roman victory. It may also refer to the presence of veterans of the Actium campaign

302

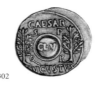

303

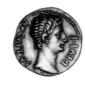

304

305

306

settled in Nîmes by Octavian. These coins circulated widely in Gaul and on the northern frontier of the empire. The obverse shows the busts of Augustus (right) and his great friend and chief lieutenant, Marcus Vipsanius Agrippa (left).

J.W.

307 Clay impression from a seal with a portrait, perhaps of Gaius Cornelius Gallus

Probably made *c.* 30–27 BC

Said to be from Edfu, Egypt

Height 1.2 cm, width 9 mm

Toronto, Royal Ontario Museum 906.12.156

The clay impression is cracked around the rim, but the portrait is intact. The seal is one of a group of 330 said to have been found in a jar at Edfu and, from the evidence of adhering fibres, used to seal papyri.

The subject is a bust of a man with hunched

307

shoulders and an anxious expression. He has a full head of hair, an aquiline nose, huge eyes (these in the style of much larger scale Alexandrian royal and imperial portraits of the 30s and early 20s BC; cf. the colossal head of Octavian, cat. no. 318), curled lips and a prominent chin. His shoulders are draped with a mantle, and the portrait has been identified as that of a philosopher, but alternatively as an image of the first Roman *praefectus* (governor) of Egypt, Gaius Cornelius Gallus.

Indeed, Gallus was something of a romantic intellectual, the author of four books of love elegies addressed to the freedwoman actress Volumnia Cytheris, a mistress of Mark Antony. Gallus was probably born in 70/69 BC at Forum Julii (modern Fréjus, France). By 43 BC he was acquainted with the philosopher Cicero (cat. no. 209), and in the proscriptions of the following years was involved with the confiscation of farmland belonging to the poet Virgil. He played a leading role in Octavian's capture of Alexandria in 30 BC after the battle of Actium, and was subse-

quently appointed to the governorship. Gallus had an eventful tenure, suppressing a rebellion near Thebes, and marching his army beyond the first cataract of the Nile, where he brought the king of Ethiopia under Roman protection, and established a buffer zone between Ethiopia and Egypt. He celebrated his success in inscriptions on the pyramids and at Philae, and had statues of himself set up all over Egypt. This was too much for Octavian, who had him recalled to Rome, where he was banned from the Emperor's house and provinces. Indicted by the Senate, Gallus committed suicide in 27/26 BC.

BIBLIOGRAPHY: J.G. Milne, *JHS* 36 (1916), 94, no. 183; 100 (philosopher), pl. 5, row 5, no. 3; G. Grimm 'Zu Marcus Antonius und C. Cornelius Gallus', *JdI* LXXXV (1970), 170 and fig. 3, p. 160. E. Courtney, 'Life of Gallus' in S. Hornblower and A. Spawforth (eds), *Oxford Classical Dictionary 3* (Oxford and New York 1996), 394–5 s.v. Cornelius Gallus, Gaius (bibl.).

S.W.

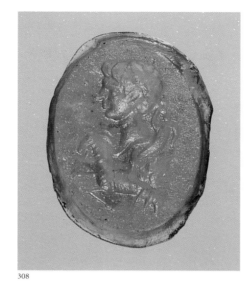

308

308 Glass intaglio: bust of a youth, perhaps Octavian, with a cornucopia, capricorn and mask

c. 35–30 BC

Probably from the Blacas Collection

Height 14 cm, width 11 cm

London, British Museum GR 1923. 4-1. 928. (Gem 3396)

The head, in profile to the left, shows abundant hair falling on the brow in the style of Hellenistic royal portraits. Behind the fringe is a fillet tied at the nape of the neck. The bust is cropped just below the neck, in the fashion of contemporary portraits in stone. Immediately below the bust is a capricorn; balanced on its back is a theatrical mask and above that a cornucopia. These features led Vollenweider to identify the subject as Octavian. The regal fillet also appears on a carnelian intaglio, now in Vienna, representing Octavian with a lance. The portrait probably dates from the later 30s or early 20s BC, by which time Octavian had abandoned the beard worn as a sign of mourning or vengeance for Caesar's murder, and adopted a style reminiscent of Hellenistic Greek monarchs.

BIBLIOGRAPHY: M- L. Vollenweider, *Die Porträtgemmen der römischen Republik* (Mainz 1974), 151,18; 151,1 (Vienna gem); S. Walker and A. Burnett, *Augustus*, British Museum Occasional Papers 16 (London 1981), 3, no. 26.

S.W.

309 Blue glass intaglio: portrait of a youth, perhaps Octavian, with cornucopia below

c. 30 BC

Provenance unknown

Height 1.4 cm, width 1.1 cm

Unprovenanced

London, British Museum GR 1923. 4-1.813. BM Gem 3236

The youth is shown with a prominent fringe of hair falling across the brow and temple; a long, straight nose; small, angular chin; and the broad jaw and cheekbones that were to be such a strong feature of the portraits of Augustus. Beneath him is a cornucopia overflowing with fruit.

BIBLIOGRAPHY: M-L. Vollenweider, *Die Porträtgemmen der römischen Republik* (Mainz 1974),148, no. 3; S. Walker and A. Burnett, *Augustus*, British Museum Occasional Papers 16 (London 1981), 3, no. 25.

S.W.

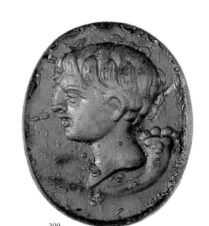

309

310 Sard intaglio portrait of Livia

c. 35–25 BC

Height 1.4 cm, width 1 cm

Blacas Collection

London, British Museum GR 1867. 5-7. 491. BM Gem 1975

This lively portrait has the face upturned, giving a pert expression often found in early portraits of Livia. The hairstyle with double plait drawn back from the *nodus* above the brow, the double bun at the nape of the neck, and the curls escaping from the bands of hair at the side of the face, are also features of Livia's early portraits of the so-called Marbury Hall type. Folds of drapery are shown at the base of the neck, beneath which are inscribed the Greek letters ΛEY (LEU), presumably part of a gem-cutter's signature.

BIBLIOGRAPHY: On portraits of Livia, see recently R. Winkes, *Livia, Octavia, Julia. Porträts und Darstellungen* (Providence, RI and Leuven, 1995), and E. Bartman, *Portraits of Livia. Imaging the Imperial Woman in Augustan Rome* (Cambridge 1999).

S.W.

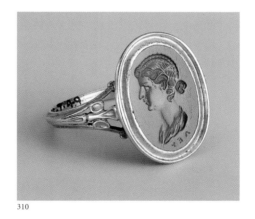

310

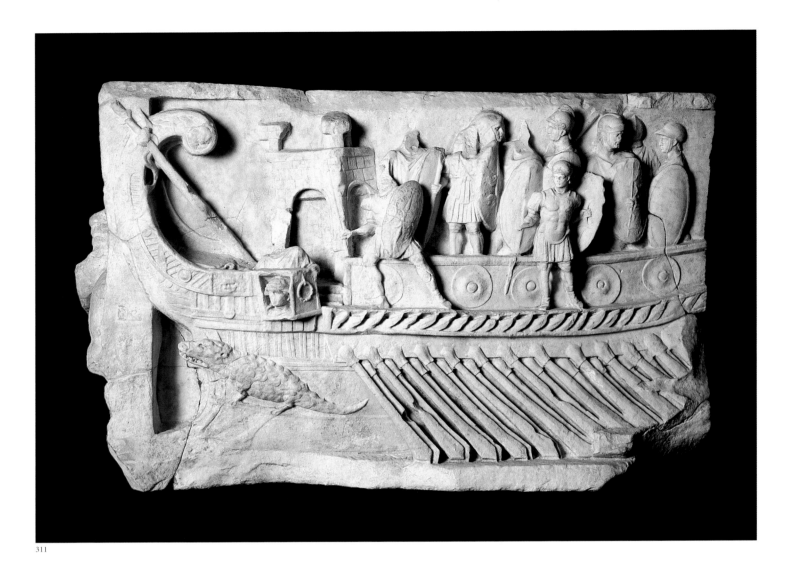

311

311 Marble frieze with a scene depicting warships and the march of the cavalry

c. 40–30 BC

Found in the 17th century at Praeneste (Palestrina) in the necropolis of Colombella.

Height 74 cm, length 110 cm, thickness 40 cm

Vatican, Gregoriano Profano Museum, Vatican Museums 31680

The block is an angular piece of marble forming part of a frieze of a monument. The most important side of the frieze depicts a bireme warship turned towards the left with eleven soldiers armed with shields and spears (the last two soldiers on the right and all of the heads except for the soldier in the background have been restored). It must have been the first in a row of ships as along the right edge traces of a second, similar ship can be made out, although only the rostrum, or prow, has survived. The smaller side

of the marble bears the image of a soldier on horseback armed with shield and javelins.

One interesting detail is the presence of a crocodile above the ship's rostrum, as, following Miltner (1929), the animal has always been interpreted as an allusion to Egypt. It was commonly thought that the frieze came from the area of the sanctuary of Fortuna Primigenia, the main sanctuary of Praeneste, a Roman city partial to Antony. On the basis of these elements Hölscher (1979, 1988) proposed that the monument had been dedicated by Antony to Fortuna Primigenia between 37 and 32 BC.

From the point of view of both type and style, the relief fits very well with the last years of the Roman Republic; however, any interpretation must be based on a document that provides us with a more exact origin of the frieze. An unknown drawing of the seventeenth century with a miscellaneous code from the Vatican

Library (*Barb. lat.* 4333, fol. 58) depicts the warship in this frieze with the caption '*Praeneste/ In anaglypho marmoreo/ a Colombella*'. Colombella was the pre-Roman and Republican Roman necropolis of the city: thus the block was part of a funeral monument and not a dedication inside the sanctuary.

In the light of the above information, the monument is more easily identifiable and can be grouped with friezes coming from other Roman and Italian funeral monuments all dating to the same years. Included amongst these are: the fragment of the frieze from Isernia (Felletti Maj 1977, 223, Fig. 93), the two reliefs from Pozzuoli, the relief of the two biremes full of soldiers from the National Museum of Naples, the Doric frieze found in Rome in the anonymous catacomb on Via Anapo and, finally, the frieze from the tomb of C. Cartilius Poplicola in the necropolis of Porta Marina in Ostia (Floriani Squarciapino

1958, 192–207, illustrations 39–43). The last amongst these is especially interesting as, in addition to the warship, foot soldiers and at least one horse are also present, perhaps originally forming part of the left side of the tomb.

In conclusion, the frieze represents a decorative element from a tomb dating back to the end of the Roman Republic built for a person who was most probably a member of the army under the command of Antony.

BIBLIOGRAPHY: W. Amelung, *Die Sculpturen des Vaticanischen Museums II* (Berlin 1908), 65–72, no. 22, ill. 5; F. Miltner, 'Das Praenistinische Biremenrelief', *Jahreshefte Österr. Arch. Inst.* 24 (1929), 88 ss.; R. Heidenreich, 'Zum Biremenrelief aus Praeneste', *RömMitt* 51 (1936), 337–46; M. Floriani Squarciapino, *Scavi di Ostia III* (Rome 1958), ill. 43.1; E. Simon, in W. Helbig, *Führer durch die öffentlichen Sammlungen klassischer Altertümer in Rom I* 4th edn (Tübingen 1963), 385–7, no. 48 ; B.M. Felletti Maj, *La tradizione italica nell'arte romana* (Rome 1977), 226–9; T. Hölscher, *Arch. Anzeiger* 24 (1979), 342–8; Id., in *Kaiser Augustus und die Verlorene Republik* (Mainz 1988), 363, cat. no. 198; C. Pietrangeli, *Bollettino Monumenti Musei Gallerie Pontificie* VIII (1988), 147–8, no. 8; L. Basch, *Le musée imaginaire de la marine antique* (Athens 1987), 24, 424 ss., ill. 22, 913, 914, 916; P. Kränzle, *Die zeitliche und ikonographische Stellung des Frieses der Basilica Aemilia* (Hamburg 1991), 165, no. 4; I. Pekàry, *Repertorium der hellenistischen und römischen Schiffsdarstellungen*, Boreas Beiheft 8 (1999), 390, Vat. 1.

P.L.

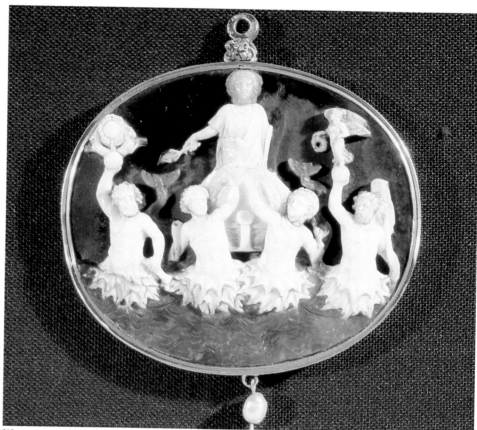

312

312 Sardonyx cameo: Augustus in a chariot drawn by Tritons

Made after 27 BC

Provenance unknown; known to have been in the Austro-Hungarian imperial collections since the early seventeenth century (Matthias inventory of 1619, no. 2230)

Height 6 cm, width 6.6 cm

Vienna, Kunsthistorisches Museum Antikensammlung IX A 56

The cameo is made of two layers of sardonyx. The heads are restored. The enamelled gold setting was made about AD 1600.

The naval battle at Actium (the point of Acarnania on the Ambracian Gulf) was the last act of the Roman civil war. On 2 September 31 BC Octavian routed Mark Antony's fleet. The way to Alexandria was free. Antony, together with Cleopatra, 'Queen of Kings', committed suicide. The victory was crucial to the later career of Octavian and, indeed, for the empire itself.

Octavian would be emperor, with the honorary name Augustus; he laid the foundations for peace within the lands he controlled, for the most powerful empire within secure borders and for economic development.

The cameo shows the central significance of the victory at Actium, in terms not only of global politics and social development but also, with hindsight, of artistic representation, as Augustus, clad in a toga – the heads of the figures were later restored – stands in a chariot facing the viewer, drawn over the sea by Tritons. The victor of the naval battle holds an oar in his right hand and a sceptre in his left. On the chariot wall is attached a wreath of oak leaves, while on the end of the prow is a seashell. The two central Tritons, one of whom holds a horn in his right hand, the other a dolphin in his left, symmetrically raise aloft their other arms as if to point at Augustus. The other two Tritons show the symbols of Augustus' rule:

the one on the left holds a globe on which two capricorns support the *clipeus virtutis* (the shield awarded to Augustus for his personal virtue) surrounded by the oak wreath, while the Triton on the right holds a figure of Victory on a globe.

The cameo was probably made immediately after Augustus was awarded the oak wreath in 27 BC, which, with the capricorn, was engraved on the back of the stone in the seventeenth century.

BIBLIOGRAPHY: H. Möbius, 'Zweck und Typen der römischen Kaiserkameen' in *Aufstieg und Niedergang der römischen Welt* (Tübingen 1975), 39–40; W. Oberleitner, *Geschnittene Steine. Die Prunkkameen der Wiener Antikensammlung* (Vienna 1985), 35–6, fig. 17; P. Zanker, *Augustus und die Macht der Bilder* (Munich 1987), 102 fig. 81.

A.B-W.

313 Head from a portrait statue of Marcus Agrippa, veiled with part of his toga

c. 25–10 BC

Found on Capri

Height43 cm, width 34 cm, thickness 23 cm.

London, British Museum GR 1873.8-20.730
(Sculpture 1881)

The head is broken through the neck and at the back; the veil is preserved only on the figure's right side. The head is joined horizontally through the eyes and across the bridge of the nose; the veil has been reattached to the head in modern times but, from the crude finish at the extreme right side and the tooling of the back of the head, does appear to belong. Recent conservation has made it apparent that the head and veil are carved of different marbles: the head appears to be of a fine-grained stone with greyish tinges, most likely quarried at Carrara (Tuscany), while the veil is coarser, perhaps Proconnesian. Over the subject's left ear and the adjoining area of hair and cheek is a heavy iron stain, perhaps arising from a dowel used to join the fragments of the head.

The brow-line of the broad face is broken by a distinctive central lock of hair falling in four strands. Beneath, the brow is crudely creased with two incised lines; more subtle folds of skin appear above the nose. The large almond-shaped eyes – the tear duct and lower lid of the proper left eye were damaged in the break – are lined with crow's feet beneath broadly arched brows. The naso-labial creases are accentuated either side of the broad mouth; the chin is heavily jowlled.

Once believed to represent Tiberius or Domitius Ahenobarbus, the portrait has now been convincingly identified as Antony's opponent at Actium, Octavian's naval commander Marcus Agrippa. Indeed, the head compares well with other images of Agrippa, notably the portrait carved in relief on the Altar of Augustan Peace in Rome, and a statue excavated at Lucus Feroniae, part of a group including an image of Octavian similar to cat. no. 276.

BIBLIOGRAPHY: Ilaria Romeo, *Ingenuus Leo. L'Immagine di Agrippa* (Rome 1998), 184 no.R16, figs 143–4.

S.W.

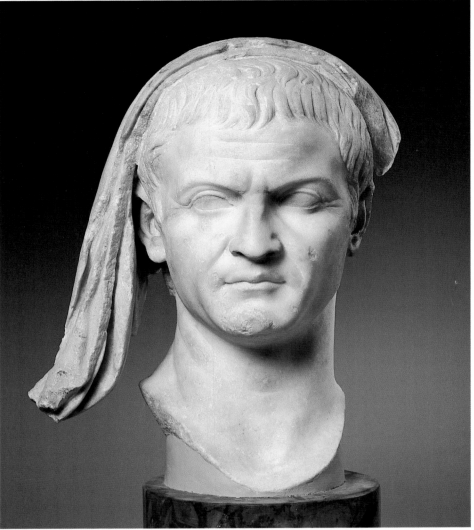

313

314 Bronze prow from a boat or small ship

First century BC

Dredged up from the outer bay at Actium, Greece

Length 47.5 cm

London, British Museum GR 1872.12-14.1 (Presented by HM Queen Victoria)

The prow is heavily corroded, and encrusted with remains of sea creatures. The medallion bust has damage to the breasts of the female figure, and the sides of the prow are torn. The sides have rivet holes for attaching the object to the ship, and there are remains of wood on the inner sides.

From a tondo at the tip of the prow emerges a bust of a figure wearing a helmet and an aegis strapped under the arms and over the shoulders. Both the sex and the identity of the subject are unclear, but it is usually thought to be female and either Athena or Roma. Athena is more likely to wear the aegis than Roma, and the latter is usually represented like an Amazon, in a short tunic with one breast exposed. The goddess turns slightly to her left, and raises her hands upwards. Her eyes are particularly large, similar to portraits from Egypt dating to the late Hellenistic period (compare the colossal head of Octavian, cat. no. 318). The helmet is also a Greek type from the Hellenistic period, with a broad peak and a rudimentary cheek piece on either side, and a bronze fitting on the top for the plume,

presumably separately made and attached. It seems likely that the piece was Greek rather than Roman, and perhaps Ptolemaic.

It has always been assumed that the prow comes from a sunken ship that participated in the battle of Actium. Its date is perhaps applicable, but there are few prows to compare with it. One in Trier was not actually used on a boat, but was made as a dedication, presumably after a victory in a sea battle. This example probably comes from a relatively minor vessel because the medallion bust and figure are small, and would not have made a major visual impact on a large warship.

BIBLIOGRAPHY: H.B. Walters, *Catalogue of the Bronzes, Greek, Etruscan and Roman in the Department of Greek and Roman Antiquities, British Museum* (London 1899), no. 830; A. Göttlicher, *Materialien für ein Corpus der Schiffsmodelle im Altertum* (Mainz 1978), 82, cat. no. 490 (the example in Trier is cat. no. 491).

P.H.

314 ▶

315

ing neck and a sharply carinated shoulder. The body is full and rounded, tapering gently to a low ring foot. Above the shoulder rise two large horizontal handles with striated shafts, decorated with female masks at the terminals and at the mid-points. The lid has a conical knob and a shallow body with a small everted rim. The vessel has been reconstructed from many fragments and the black surface has been overpainted in several areas.

The lid is decorated in relief, with ten olive leaves forming a wreath. The body of the *stamnos* is also covered with relief decoration. Below the shoulder is a band of double ovolos and at the base of the body is a band of acanthus leaves. Between these are two zones of relief decoration, separated by a band of concentric bulbs. The upper zone features seven olive trees, from which are suspended heavy festoons. Above each festoon is a cupid playing the syrinx and flanked by two light festoons of vine leaves. Above one of the cupids is a maker's name, BASSU(S), in cursive script. The lower, larger zone contains five representations of the same scene. A male figure, perhaps Neptune, bearded and with his lower body draped, sits on a rock and looks back over his right shoulder. In his left hand he holds a long, arched palm branch, while below his feet is a squared masonry altar. To his left, Victory offers him the prow of a ship, decorated with the head of a sea monster. Above the figure of Neptune in three of the five scenes is a small four-columned (tetrastyle) temple. Another temple appears above Victory in three scenes. In one scene Neptune's head is flanked by two small panels, each inscribed 'BASSI'.

The vessel and lid bear traces of polychrome decoration, namely gilding on the knob and leaves on the lid, and on the wings of the figures of Victory; pinkish paint on the exposed parts of the bodies of the cupids, Neptune and Victory; and blue paint on the bands of border motifs, ovolos, bulbs and acanthus leaves. Recent scientific analysis by the Department of Scientific Research at the British Museum has revealed the blue colouring to be lapis lazuli, and the pink to be madder, both in a medium of hydrocerussite (white lead) and gypsum.

Ever since it first came to the attention of Froehner and other scholars in the 1860s it has been suggested that the decoration is an allegory of Octavian's victory over the naval forces of Antony and Cleopatra at the Battle of Actium.

315 Handle ornament broken from a terracotta lamp, decorated with a warship

c. 10 BC–AD 50

Made in Egypt; said to be from the Fayum

Height 6.4 cm

London, British Museum GR 1926.9-30.54 (Lamp Q 1936). (Purchased from the Rev. Greville Chester in 1883)

This fragmentary triangular handle-ornament from a lamp shows a warship with a triple ram at the prow, a centaur figurehead, and a bank of oars. A decorative gunwale is adorned with a crested helmet and a circular shield. On deck are soldiers, helmeted, with swords and oval 'Celtic' shields. Behind them rise either groups of spears or shrouds of the ship's rigging, between which is a military standard. The centaur is shown as about to throw a rock and this may refer to the menacing centaurs on the prows of Antony's ships at Actium to which the Roman poet Propertius refers (Propertius iv.6). It would perhaps be odd to depict a ship of Antony's on an

Imperial-period lamp, but residual sympathy in Egypt for the defeated royal couple is possible.

BIBLIOGRAPHY: E.H. Williams, 'Centaurica Saxa: a new Actium Representation in the British Museum', in J.N. Coldstream and M.A.R. Colledge (eds), *Greece and Italy in the Classical World* (Acta of the XI International Congress of Classical Archaeology) (London 1979), 239; E.H. Williams, 'A Ship of Actium on a Roman Lamp', in *The International Journal of Nautical Archaeology* 10 (1981) 23–7.

D.M.B.

316 Black-glazed lidded *stamnos* with relief decoration, 'The Actium Vase'

c. 30 BC–AD 25

Said to be from Capua

Height (with lid) 35.2 cm

London, British Museum GR 1873.2–8.3 (Vase G 28) (Formerly in the collection of Prince Louis Napoleon (Napoleon III))

The *stamnos* (jar) has a sharply offset rim, a slop-

On the vase, however, in a gesture of Augustan piety, it is Neptune, the ruler of the seas who is presented with the true honours of battle. The vase is often described as 'black Arretine', yet although it was most likely made in Italy at the height of production of relief-decorated Italian sigillata, it is almost certainly not true Arretine ware (i.e. it was not made in Arezzo itself). The form, decorative motifs and applied colour are completely removed from the traditions of Arezzo, while the lack of care with which the vessel has been removed from its mould, causing figures to be smudged and cut, tell against an Arretine provenance. The dark, micaceous fabric and the dark finish (the latter very unusual for a relief-decorated piece of this period) suggest rather that the piece may have been made in Campania, an area with a long tradition of black-glaze relief-decorated wares, for example Calenian ware, and interestingly, Hellenistic gilded black-glaze wares from Capua itself. It is possible that the vessel belongs to a final phase of this local production. The vase was probably used as a cinerary urn and, in spite of its rather clumsy manufacture, it was probably a high-status piece.

BIBLIOGRAPHY: W. Fröhner, *Choix de vases Grecs inedits de la collection de son altesse imperiale le Prince Napoleon* (Paris 1867), 43–46; H.B. Walters, *Catalogue of the Greek and Etruscan Vases in the British Museum. IV Vases of the Latest Period* (London 1896), 242, cat. no. G28; H.B. Walters, *History of Ancient Pottery* Vol.I (London 1905), 503; J.W. Hayes, *Handbook of Mediterranean Roman Pottery* (London 1997), 39, pl.12.

P.R.

317 Sardonyx cameo: the emperor Caligula with the goddess Roma

Made in AD 37–41

Provenance unknown; known to have been in the Hapsburgs' possession since 1724 (Inventory of the Treasury of 1750, 12, no.64); transferred from the Treasury in 1779.

Vienna, Kunsthistorisches Museum, Antikensammlung IX A 59

An emperor with a laurel wreath in his hair sits on the left on a double high-backed throne with a side panel in the form of a sphinx. He wears a mantle covering his lower body and drawn over his left shoulder. The raised right arm holds a double conucopia; with his left hand he gently steadies a long sceptre, which rests against his leg and is crowned with a flower.

The emperor had a close-cut beard on his cheeks and upper lip, pricked as small holes in the stone. He gazes to his left, where the goddess Roma is seated next to him. She wears a belted, sleeveles tunic and mantle, while on her head is a helmet with a triple plume. With her right hand she holds an oval shield and points an extended index finger to show that she is engaged in conversation with the emperor, towards whom she turns.

The portrait of the enthroned emperor was earlier linked with Augustus. More recently, the pair have been interpreted as the emperor Caligula (AD 37–41) and his deified sister Drusilla; the Ptolemaic Egyptian double cornucopia would then refer to their sibling union, the beard a sign of mourning, grown by Caligula after the death of his sister in AD 38. It is clear from the irregular shape of the stone that this is a fragment of a larger cameo, which in the seventeenth century was given an ornate setting that in its style recalls the insignia of the Hapsburgs. A.B-W.

Though the identification of the figures as Caligula and Drusilla has won wide acceptance, it is worth noting that the double cornucopia was also used on the Egyptian-style portraits and-coinage of Cleopatra VII (see cat. nos 160 and 186). To portray a Roman ruler bearing such a cornucopia while seated on a throne supported by a sphinx strongly recalls the Roman conquest of Egypt. The cameo, which is far from complete, is of exceptional quality, finer than the more famous Gemma Augustea (also in the Kunsthistorisches Museum), with which it is often compared. It is indeed very similar in composition, the relaxed poses of the principal figures on both cameos recalling the images of the gods conversing on the east frieze of the Parthenon. Given the classical and Egyptian allusions, could it be that the male figure might represent Octavian, portrayed as conqueror of Egypt and of godlike status? And, if so, why should he be bearded? In his early portraits Octavian did wear a beard in mourning for Caesar, but this had long since been abandoned by the time of the Egyptian conquest in 30 BC. Perhaps the artist simply wanted to give his subject more of the features of Jupiter, whose pose and style of dress is here adopted by the emperor. S.W.

BIBLIOGRAPHY: F. Eichler, E. Kris, *Die Kameen im Kunsthistorischen Museum Wien* (Vienna 1927), 51, no. 6, pl. 3; W. Oberleitner, *Geschnittene Steine. Die Prunkkameen der Wiener Sammlung* (Vienna 1985), 46, pl. 25, 28; W-R. Megow, *Kameen von Augustus bis Alexander Severus* (Berlin 1987), 185, no. A 60, pl. 15.3; *Schätze des Österreichischen Kaiserhauses. Meisterwerke aus der Antikensammlung des Kunsthistorisches Museum Wien*, cat. exh. (Mainz 1994–5), 97, no. 131, pl. 116.

317 ▶

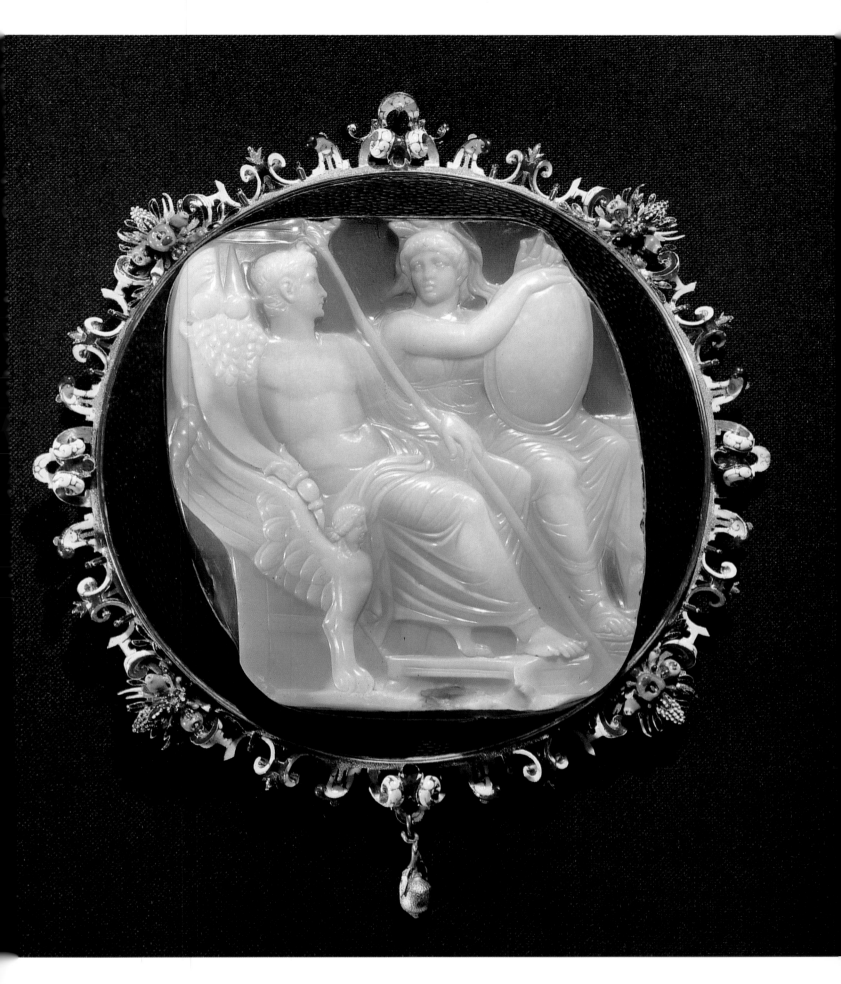

318 Marble portrait head from a colossal acrolithic statue of Octavian

c. 30–25 BC

From Athribis; acquired in Cairo 1935

Height 79 cm

Alexandria, Greco-Roman Museum 24043

Only the face, the surrounding hair and the neck survive from this colossal figure, of which only the fleshy extremities were made in stone. The rear surface is roughly finished, with a central cutting to attach the separately made back of the head. A cutting 34 cm long was evidently intended to join the head to the body, now lost. Both ears are damaged, indeed the proper left ear was largely cut away, and was left unfinished. There are traces of red paint surviving on the hair, the brows and the eyes.

As has been noted by Boschung, the hair differs from the normal arrangement used for portraits of Augustus, and the head is turned to the left, again a departure from the standard pose. Indeed, the locks of hair frame the face in a lively fashion recalling images of Octavian (though in Roman portraits the locks are straighter; see cat. no. 276) .

The face is dominated by the huge round eyes, set within projecting and sharply defined lids beneath long straight brows. The nose is very long, with a prominent bridge. The downturned mouth is slightly opened. Octavian's broad face is clearly represented, but here with thick lips and a prominent chin.

This head has long been thought to belong to a posthumous representation of the emperor Augustus. Boschung proposed that it was Flavian work of the late first century AD, recut from a statue of the emperor Nero. However, it is difficult to see any evidence of recutting, and the overall appearance of the head is late Ptolemaic, differing in several respects from the repertoire of images of Augustus. Indeed, the eyes, ears, mouth and even the hair compare well with a colossal male portrait, one of a dyad of which the male is in the Greco-Roman Museum in Alexandria (inventory 11275) and the female in Mariemont. These have been identified as Mark Antony and Cleopatra, but, since the male wears a hm-hm crown, are perhaps better understood as their

318

twin children, Alexander Helios and Cleopatra Selene. The so-called colossal head of Augustus should then be interpreted as one of the earliest representations of the new ruler of Egypt, commissioned shortly after the conquest in 30 BC.

BIBLIOGRAPHY: P. Graindor, *Bustes et statues-portraits d'Égypte romaine* (Cairo 1937), 44f, no.3, pl.3; P. Zanker, *Studien zu den Augustus-Porträts I. Der Actium-Typus.* Abh. Göttingen 3 Nr 85 (1978), 29 n.36; U. Hausmann, 'Zur Typologie und Ideologie des Augustusporträts', *Aufstieg und Niedergang der Römischen Welt II, 12, 2* (Tübingen 1981), 588; H. Jucker, 'Römische Herrscherbildnisse aus Ägypten', *Aufstieg und Niedergang der Römischen Welt II, 12, 2* (Tübingen 1981), 667–725; Z. Kiss, *Études sur le portrait impérial romain en Égypte* (Warsaw 1984), 37f, 132 figs. 46,47; D. Boschung, *Die Bildnisse des Augustus* (Berlin 1993), 81f, nn. 136, 172, 457, 501, 139 no.65, pl. 144, 194,7; G.L. Steen (ed.), *Alexandria: The site and the history* (New York 1993), 81.

S.W.

319 Marble head from a statue of Augustus, reworked from a portrait of a Ptolemy

c. 25–1 BC

From Sakha, near Damanhur (western Delta, Egypt); formerly in the Reinhardt Collection

Height 31 cm

Stuttgart, Württembergisches Landesmuseum, Antikensammlung, 1.35

The head was made for insertion in a torso: part of the proper right shoulder is preserved. The tip of the nose is restored in plaster. The right and left sides of the back of the head were apparently finished in stucco (now lost). There is some minor superficial damage to the hair and the ears.

Originally the head was turned to the right and perhaps up. Perhaps the Ptolemaic diadem, of which substantial traces remain, and the back and sides of the hair, in which the hair is summarily finished, were not visible. However, the hair above the brow is very carefully worked in the arrangement used for most surviving portraits of Augustus. As Boschung notes, the realization of the angular planes of the Emperor's face from the original rounded image of the Ptolemy provided a substantial challenge to the sculptor, which was not entirely met. Although none of the features is entirely typical of Augustus, the portrait conveys enough of the Emperor for easy recognition, while the identity of the original subject may no longer be recovered. This is one of at least three, possibly four, portraits of Augustus from Egypt that have been recut from images of Ptolemies. Given that unrecut portraits were also commissioned (cat. nos 318 and 320–321), it is uncertain whether a deliberate comparison of the Emperor with his Ptolemaic predecessors was intended, or whether these portraits represent some economy on the part of those who commissioned them. The recutting is almost certainly Augustan, and perhaps to be dated in the earlier years of the reign, when motives of economy or political expediency are more likely to have had some validity.

BIBLIOGRAPHY: R.S. Bianchi, catalogue entry in *Cleopatra's Egypt: Age of the Ptolemies* (New York 1988), no. 81; D. Boschung, *Die Bildnisse des Augustus* (Berlin 1993), 187–8, no.92.

S.W.

319

320 Miniature head from a statuette of Augustus carved in obsidian

27 BC–AD 14

Provenance unknown

Height 3 cm

Alexandria, Greco-Roman Museum 3536

The figure is broken at the shoulders, with the neck and part of the shoulders preserved. The nose is broken, and flakes of obsidian have broken off around the base of the neck and shoulders.

320

Even at miniature scale the hairstyle reproduces with great fidelity the so-called 'Prima Porta' portrait associated with the Emperor's constitutional settlement of 27 BC, his assumption of the name Augustus and the dissemination of his image throughout his reign. The image is, however, interpreted in Hellenistic Greek fashion: the Emperor's head is turned to the right and up, with considerable torsion in the figure (compare the large-scale head of Augustus from Meroe, cat. no. 323). The facial features recall earlier images of the Emperor as Octavian, suggesting a date early in Augustus' reign.

BIBLIOGRAPHY: P. Graindor, *Bustes et statues-portraits de l'Égypte romaine* (Cairo 1937), 45 n.185; D. Boschung, *Die Bildnisse des Augustus* (Berlin1993), 139 no. 64, pl. 202 (bibl.); M-D. Nenna in M. Rausch (ed.), *La Gloire d'Alexandrie,* Cat. Exh. Petit Palais, (Paris 1998), 287 no. 236.

S.W.

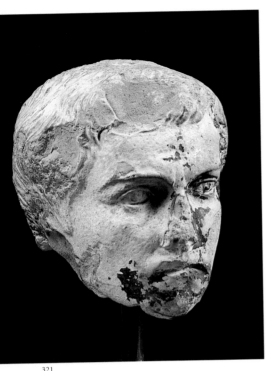

321

321 Miniature faience head of the emperor Augustus

c. 30–10 BC

Probably from Memphis

Height 6.8 cm, width 6 cm, thickness 7.2 cm

New York, The Metropolitan Museum of Art 1926. 26. 7. 1428 (Gift of Edward S. Harkness.)

The head is broken through at the chin. The surface has suffered considerable damage; the nose is lost from the bridge down and large patches of hair have been lost from the crown and proper right side. The surviving hair and features are plastically modelled with considerable refinement. Two vertical lines furrow the brow above the bridge of the nose, a feature of the Emperor's portraits in the years preceding Actium. The eyebrows are fashioned in Egyptian style, and indeed the facial structure appears more Egyptian than Roman, the Emperor's broad face developing prominent cheekbones, the planes of flesh hollowed from behind. On these grounds the identification of the figure was questioned by Cooney, but the arrangement of hair in the better-preserved areas at the back and sides of the head does appear close to Roman prototypes, and the portrait, though usually dated within the reign of Augustus, is comparable with images of Octavian made about the time of the Battle of Actium. Most likely a early product of Kom Heleul, a Roman kiln at Memphis, this head is a remarkable Egyptian interpretation of a Roman imperial portrait type.

BIBLIOGRAPHY: M. Stuart, 'A Faience Head of Augustus', *AJA* XLVIII (1944), 171–5, figs 1–5; G.M.A. Richter, *Roman Portraits* (New York 1948), fig.21; J.D. Cooney, 'Glass Sculpture in Ancient Egypt', *Journal of Glass Studies* II (1960), 39; D. Boschung, *Die Bildnisse des Augustus* (Berlin 1993), 116–17, no. 19 (bibl.); R.S. Bianchi in Florence Dunn Friedman (ed.), *Gifts of the Nile* (London and Providence RI 1998), 200 no. 63, with appendix on the fabric by M. Wypyski, p.265. G. Grimm, *Alexandria* (Mainz 1998), 148, fig. 135 e, f.

S.W.

322 Gold finger-ring with a carnelian intaglio with a portrait of the emperor Augustus

First century AD

Said to have been found near Rome

London, Victoria and Albert Museum 461-1871

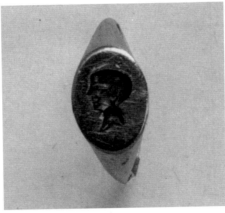

322

The gold bezel surrounding the gemstone is slightly scratched, but the ring is otherwise in good condition. The carnelian setting has been cut to the shape of the subject's head. The portrait is sketchy but resembles the 'Prima Porta' portrait type of the emperor Augustus.

UNPUBLISHED.

P.H.

323 Bronze head from an over-life-sized statue of Augustus

c. 27–25 BC

Excavated beneath the steps leading into a shrine of Victory at Meroe (Sudan) in 1910 by L. Garstang

Height 43 cm, height of head 29.6 cm

London, British Museum GR 1911.9-1.1

The head is broken through the neck but is otherwise in an excellent state of preservation. The eyes are inlaid, with glass pupils set in metal rings, the irises of alabaster. The eyebrows are plastically rendered.

The emperor's head is turned to his right, with the pronounced twist to the neck typical of Hellenistic work. The hair falls on the brow in the divided and curving cut that marked most of Augustus's portraits as emperor. Indeed, it seems clear from the archaeological context that this head must be one of the earliest examples of the type, known to scholars as the 'Prima Porta', from the famous statue of the emperor found at Livia's villa on the outskirts of Rome and now in the Vatican Museums. The development of the type, a substantial change from the portraits of Octavian associated with the period leading up to and immediately after the Battle of Actium in 31 BC, may be linked by the issue at Pergamum of silver cistophoroi in 27/6 BC to the constitutional settlement of 27 BC in which Octavian took the name Augustus offered to him by the Senate.

In the bronze head the facial planes are even broader than in marble versions. The mouth is slightly downturned, a feature of late Hellenistic portraiture. The ears project markedly, the upper lobes bending forwards; this was to become a standard feature in portraits of the first dynasty of Roman emperors.

The context strongly suggests that the head was captured in one of the raids upon Roman forts and settlements in Upper Egypt carried out by Meroitic tribesmen and recorded by Strabo. Haynes has suggested that the raid in question was mostly likely that on Syene, which took place in 25 BC, after which statues torn from their bases were mostly returned in the course of negotiations between the Meroitic queen Candace and the Roman general Petronius (Strabo, XVII 82). However, the decoration of the temple, which includes a painting of a Roman legionary humiliatingly bent double beneath the young king's footstool, and the discovery of other fragments of this statue on site suggest that the burial of the head was no oversight, but was intended as an insult to the Emperor, for whoever walked up the steps into the shrine would step on Augustus' head.

The other unpublished fragments recovered in Garstang's excavation indicate that this was a cuirassed statue. The scale is imposing, and it is of interest to note that, wherever the figure was made (Alexandria has often been proposed), the height of the head is precisely one Roman foot. Its fate is a graphic illustration of resistance to the imposition of Roman rule in Egypt from strongly independent tribes beyond the southern frontier.

BIBLIOGRAPHY: R.C. Bosanquet, *Liv.AAA* IV (1912), 66ff; D.E.L. Haynes, 'The Date of the Bronze Head of Augustus from Meroe' in N. Bonacasa and A. Di Vita (eds), *Alessandria e il mondo ellenistico-romano: studi in onore di Achille Adriani* (Rome 1983), 177–81 (bibl.); D. Boschung, *Die Bildnisse des Augustus* (Berlin 1993), 160–1, no.122 (bibl.).

S.W.

323 ▶

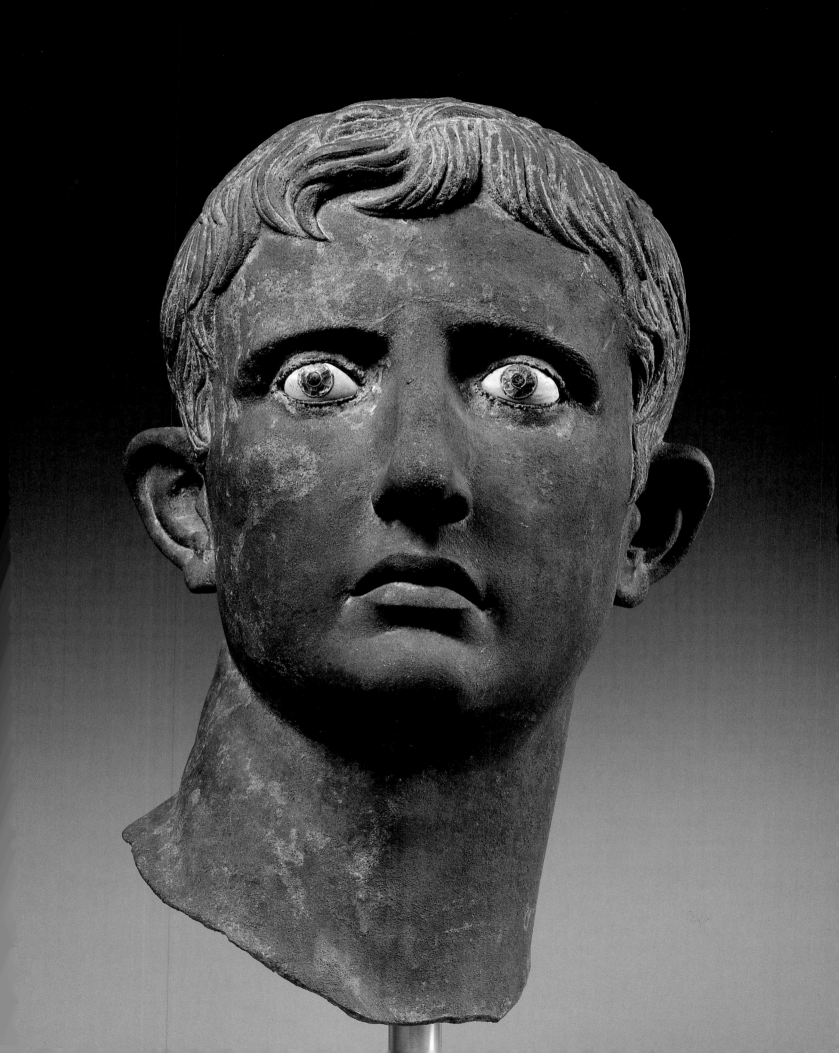

Egypt in Rome / The Myth of Cleopatra

Egyptian influences in Italy

CARLA ALFANO

Cleopatra came to Rome in 46 BC, in one of the greatest moments of Julius Caesar's personal power and glory, precisely when the city was celebrating a series of triumphs for his conquest of Gaul, his victory in Egypt, and his successful campaigns against the Pharnaces and Juba. Particular emphasis was given to the triumph for the Alexandrian War, which included statues of the god of the Nile and representations of the pyramids and the Sphinx. But Cleopatra did not come to Rome as a trophy of conquest. On the contrary, she came as a queen, bringing her son Ptolemy Caesar, called Caesarion (Little Caesar), Julius Caesar's child. She was hosted in the dictator's villa in the gardens of Trastevere, where all honours befitting a queen were bestowed upon her with the particular attention reserved for a beloved bride.

Cleopatra became acquainted with many important Romans during her residence in Trastevere – among them even Cicero – who were intrigued by her fame and flattered to be admitted into her company. Rome, at that time rather provincial and simple in its customs, was both curious and surprised by the splendour of an oriental monarchy, even if reproduced within a small court, and was astonished by the grandiosity and luxury of Cleopatra's world. It was impossible not to acknowledge – albeit grudgingly – the intelligence, culture and witty irony of this young queen, who was only in her early twenties at the time. She was not yet the goddess-queen who ten years later in Alexandria would appear alongside Mark Antony dressed as Isis, and who would receive her subjects as a goddess. However, already in Rome Cleopatra presented herself with that royal stature and those distinctive features of undeniable sovereignty that made her unique and unattainable. There was no lack of envy and incomprehension of the extremely refined and cultured queen, to the point that a love–hate relationship began to take root, with the latter feeling tending to be the stronger of the two. In her long and intense stay in Rome (lasting about two years until shortly after Caesar's death), the queen and her fascinating, exotic world remained essentially alien to the sensitivities and hearts and minds of the Romans.

Her presence in Rome, however, proved not to be without cultural and political consequences, beginning with the not insignificant fact that it provided an ongoing occasion for

the Romans to become acquainted with Egyptian customs. Her presence had significant repercussions and, though not always in an immediate and direct way, she managed to influence, inspire and guide some of Caesar's choices, the latter most likely drawing upon Egyptian learning.

The reform of the calendar desired by Caesar was evidently a product of the studies and experience of Egyptian astronomers such as Sosigenes of Alexandria, just as the reform of the public libraries in Rome unquestionably drew its inspiration from the organization, structure and, more importantly, the influence of Alexandria's culture and scholarship. Hydraulic projects – the attempt to determine the shortest routes between the Ionian and Aegean seas (anticipating the construction of the canal through the Isthmus of Corinth) and the search for alternative waterways in Italy (canals from Rome to Terracina and so forth) – most probably made use of the experience of the Egyptian geographers and experts present in Cleopatra's small court or who later joined the Queen's retinue.

Egyptian cultural influence in Rome

One event marking Cleopatra's presence in Rome occurred during the inauguration of the Forum Iulium (the Forum of Julius Caesar), Caesar had a gold or gilded bronze statue of Cleopatra placed in the Temple of Venus Genetrix, which had only shortly before been built along the Via Sacra (Sacred Way). Many interpreted that decision as an open acknowledgment of marriage between a descendant of a prestigious dynasty and the daughter of a god. This event was a decisive turning point, which in any case clearly illustrated Caesar's new orientation towards the oriental world and its customs, giving them an official stamp of approval in Roman circles.

Cleopatra's long stay and, more importantly, the political and cultural relations that Caesar built with Egypt certainly opened the doors to Egyptian cults and gods, some of which were already established, with greater or lesser success and by various means, in several

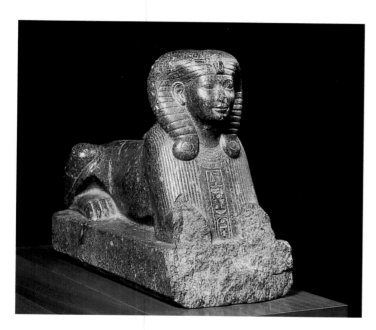

Fig. 9.1 Basalt figure of a sphinx with the features of Queen Hatshepsut (Rome, Museo Baracco 13).

parts of Italy, even in Rome itself. Caesar's opening up to that world led to the development and diffusion in Rome of an Egyptianizing tendency, which could be construed from certain points of view of as a 'fashion'.

Cultural elements of the Egyptian world, other than specifically religious rites, were adopted by the Romans. They tended to reproduce the expressive elements of Egyptian religion in the Roman world of art, architecture and decorative ornamental painting. This was a cultural trend, which developed parallel to and tightly linked with the practice of the cults and which, from the time of Augustus, rapidly spread throughout the entire empire to reach a peak in the second century AD. The taste for things Egyptian died only in the fourth century (the closing of all Egyptian temples was finally ordered in AD 384 by Theodosius), when the religious cults, which traced their origins to such cultural fashions, were inexorably overwhelmed by Christianity, another winning oriental religion.

What happened after Augustus is well known and much in evidence. In fact, there are many literary and epigraphic sources and much archaeological documentation that confirm both the devotion of many emperors to Egyptian gods, seen in the construction of great temples dedicated to Isis and Serapis in Rome (fig. 9.1) and all over the empire, and the production of Egyptian art in Rome, along with the importation from the land of the Nile of statues, obelisks and reliefs of pharaonic date for decorating temples, villas, tombs and stadiums.

'The divinities that were once Egyptian are now Roman' (Minucius Felix 22, 2) and 'The

Fig. 9.2 Marble statue of Isis (Naples, Museo Nazionale Archeologico 976; Soprintendenza Archeologica delle Provincie di Napoli e Caserta, Archivio dell' Arte Pedicini).

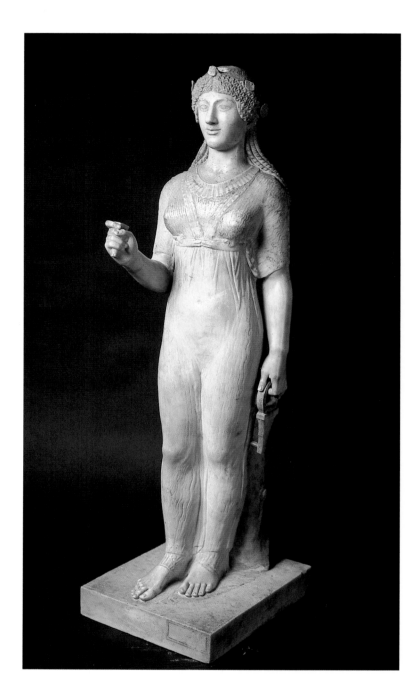

whole world swears today before Serapis' (Tertullian, *Ad Nationes*, 2,8), lamented the Christian writers of the second century AD, confirming the spread of devotion to the Egyptian gods (fig. 9.2).

Trade and the cults of Isis

Cleopatra did not introduce the pharaonic world to Rome, even if her presence was decisive in boosting its spread. Indeed, for more than a century, the cults of Isis had been widespread in Italy, and were not restricted to trading zones, harbours and places with high levels of immigration. Numerous Egyptians (merchants, slaves, doctors, members of the cultural and

scientific community of Alexandria, entertainers, craftsmen, sailors and athletes) had already settled in Italy and their arrival gave a strong boost to the spread of Egyptian cults.

In the second and first centuries BC trade between Italians and Greeks via the Aegean islands and Asia Minor was particularly intense. The Greek island of Delos, where the cult of Isis had taken root, was a significant factor in the religion's spread throughout Italy. In much the same way that Aquileia in northern Italy was the doorway to Gaul, the ports of Puteoli (modern Pozzuoli) and Pompeii proved to be the pathway for the spread of Egyptian cults throughout Italy. Prior to construction of the port of Ostia, these ports in Campania represented for central Italy and Rome the privileged route for trade with oriental and African countries and were the first to be swayed by the cultural and religious influences emanating from these areas.

The construction of the temples in Campania was a result of Rome's contacts with the Aegean island of Delos, which became particularly intense in the wake of the defeat of the kingdom of Macedonia in 166 BC, with the return of Delos to the Athenians and the development of the island as a trade centre, a warehousing area for Greeks and Italians, and a focus for religious cults of many different cultures.

In Italy, two of the earliest sites of worship of the Egyptian gods are the Temple of Isis (Iseum) in Pompeii and the Temple of Serapis (Sarapeum) in Puteoli, constructions that may date from as early as the second century BC.

In Puteoli, Campania's main port throughout the early Roman Empire, numerous surviving inscriptions confirm the presence not only of sailors but merchants (*mercatores*) from Alexandria, Asia Minor and Syria (*C.I.L* X, 1797), who set up markets in the city complete with lodgings, store rooms and shrines dedicated to their own gods. The establishment of shrines (*sacraria*) was evidently linked to the arrival of Egyptian trading vessels.

Egyptian cults were especially influential in the cosmopolitan city of Puteoli, being well documented as flourishing from the second century BC, with some evidence that could push the date of a Temple of Isis and Serapis back to the fourth century BC. Particularly well established was the cult of Isis Pelagia (Isis of the Sea), the goddess of sailors and navigation, who was honoured both on the coast of Asia Minor and in the Aegean islands as well as in the ports of southern Italy, as recent discoveries in Cumae have confirmed. The city of Puteoli, like Pompeii, was greatly influenced by Alexandria in the construction of some of its sacred buildings and in the urban layout of the port areas.

In Cumae, a former Greek colony (the ports of Misenum and Puteoli were part of the territory of Cumae), archaeologists recently found three small, finely crafted Egyptian figures of Isis, a sphinx and a *naophoros*, or shrine-bearer (fig. 9.6), only 300 metres from the Acropolis in a small temple dedicated to Isis Pelagia, demonstrating the presence of Isiac cults of Hellenistic Greek origin and inspiration along the coast of Campania.

During the first years of Augustus's reign, direct commercial trading with Alexandria increased enormously in the ports of Puteoli and Pompeii, without the trade centres of Delos or the Aegean acting as intermediaries. The ports of Campania, from Puteoli to Lacus Lucrinus across the Phlegraean Fields, became the principal centres for the import of all goods flowing to Rome from the provinces of Asia and Africa.

The geographical position of Pompeii, linked to the sea via the River Sarno by a canal harbour and also well connected to the people of the hinterland of Campania and central Italy, favoured a concentration of foreign influences, which were quickly assimilated and transformed into local fashions and cultural habits. Much surviving evidence testifies to the strong sway of Alexandria over the cultural, artistic and religious life of the people of Pompeii.

The great importance given to the Temple of Isis at Pompeii can be deduced by its rapid rebuilding after it was partially destroyed by an earthquake in AD 62; it was among the few

sacred and public buildings completely restored before the cataclysmic eruption of Vesuvius in AD 79, while other important buildings of the forum, even the basilica itself, were still in a state of ruin. In the urban layout of the second century BC, the temple was situated in a central area, dedicated to ancient cults, near the temples of Athena and of the other god of salvation, Aesculapius, with whom the temples of Isis and Sarapis were often associated. Aesculapius, like Isis and Serapis, was a divinity brought to the Italic pantheon by the merchants of the Aegean world.

Along with its cults, Egyptian culture arrived in its least esoteric form, permitting the painters of Pompeii to be inspired by scenes of Egyptian mythology, simple objects and sacred subjects, all used for purely ornamental and decorative purposes. There was a vast production of interior decoration: frescos and mosaics of Nilotic landscapes of clear Alexandrian inspiration spread outward from Pompeii and other centres of Magna Grecia (the former Greek colonies of southern Italy and Sicily) to the rest of the Roman world during the early empire. Such works, which suggested an Egyptianized setting, were used both in buildings consecrated to Egyptian cults as for example in Praeneste (modern Palestrina; see pp. 332–4), and in buildings for civilian use (both public and private).

Links between Egypt and Rome

Contacts between Ptolemaic Egypt and Rome, destined to become very intense after Actium, had been consolidated over a long period. The history of the Ptolemies, or at least that of the later sovereigns, is interwoven with that of Rome's many political factions, their intrigues and eventually the civil wars that were to shake the Republic and herald its downfall. In Rome, Egyptian politics often found a strong and secure ally, if not a direct protector. Contacts became especially intense during the third and second centuries BC, when ten diplomatic missions occurred between Rome and Egypt, and political as well as commercial relationships with the Ptolemies became a constant phenomenon. Indeed, a form of psychological dependence developed, a feature of Egypt's relationship with a power that, though younger, was progressively and inexorably rising, to the point at which Ptolemy XI bequeathed Egypt to Rome. A notable Alexandrian influence on Rome can be seen in Ptolemy XII's (Auletes) reinstallation on the throne, which took place only thanks to the determined involvement of Rome.

It was during the Ptolemaic period that there was the largest influx of Egyptians to Rome, in contrast to the numerous restrictions imposed by Augustus, in whose reign Egypt, reduced to an imperial province, was strictly controlled by military authorities and thus isolated for a period of time. Trade between Africa (Egypt) and Italy until the first century BC was sparked by several intertwined interests, which allowed Egypt to export wheat, linen, papyrus, hemp, stone; luxury products such as glass, silverware, perfumes, spices, and precious objects made with raw materials that came from India and the Far East (figs 9.5, 9.7). The Italic peoples at that time, first and especially in Campania, exported oil, wine, dyed wool, ceramic vases and commercial products such as glass objects and more commercial silverware to Egypt.

After Octavian's victory over Cleopatra, Egypt, which had become an imperial province, was transformed into the most important source of wheat for Rome, to the point that imposing commercial fleets of almost 500 ships at a time were sailing across the Mediterranean Sea to bring wheat from the port of Alexandria to Puteoli, at that time the principal port for Rome before it was gradually replaced by the port at Ostia, planned by Claudius and completed during the reign of Trajan. Conquered Egypt began to be plundered of its most valuable resources, including precious stones like the imperial porphyry of Mons Porphyrites, the granite of Mons Claudianus and alabaster, papyrus and foodstuffs from Aswan. All these goods found their way to Rome and intensified the contacts which during the Ptolemaic era had been largely filtered through Greece and Magna Grecia.

Under Caesar and, later, during the reign of Augustus contacts with the Egyptian world became closer and more continuous. They then became more stable with the conquest of Egypt and Roman military penetration into Nubia. This led to a greater spread of the cult of Isis, with a direct impact on culture and customs. Egyptian features came to be represented in the mosaics and paintings found in houses and public buildings as well as on temples and in areas of the imperial court. Pyramid-shaped tombs, pillars and other exotic extravagances were introduced and became accepted in Rome, regardless of any religious belief that their owners might hold.

The wide acceptance and the popularity of the Egyptian cults was still not accompanied by tolerance on the part of the political authorities, which often intervened with prohibitions, convictions and, from time to time, persecutions. The story of Egyptian cults in Rome was long marked by these two opposing attitudes: on the one hand the widespread popular accep-

Fig. 9.3 Mosaic with Nilotic scene, from the Casa del Fauno, Pompeii (Naples, Museo Nazionale Archeologico 9990; Soprintendenza Archeologica delle Provincie di Napoli e Caserta, Archivio dell' Arte Pedicini).

tance of a cult based on rituals and on simplified access, and, on the other hand, fear on the part of the authorities that those cults and practices could cause political instability, arising from noted excesses and immoral behaviour. Condemnation of the Egyptian cults, in some cases part of a political strategy with quite a different objective (for example, action of the conservatives against the populists), even took the form of deportations of believers, the destruction of temples and sanctuaries, the crucifixion of priests, the destruction of images of the divinity, censure and mockery by writers close to the emperor, and negative propaganda.

The cult of Isis, founded, sustained and propagated by the Ptolemies, came from Alexandria, at that time the more cultured and sophisticated of the two cities. Rome felt and feared such superiority, that model of a perfect capital, more civilized and refined, which the Latin West admired and tried to emulate. The scholars of Alexandria were translated everywhere, and particularly in Rome; Alexandria's men of letters were imitated; its artists were asked to embellish Italic and Roman residences; its institutions were considered a model; their astronomers contributed to the reform of the calendar of the Roman pontiffs, introducing within it the feasts of Isis. We can therefore reasonably presume that Egyptian religion exercised an important influence on the customs and behaviour of the higher social classes, even in Rome, to the point that the religious fervour of the believers, despite numerous prohibitions, even managed to maintain the sanctuaries on the Capitoline Hill, where the educated matrons of the Roman aristocracy consulted Petosiris's ephemera before fixing their most important appointments.

Egyptian religion

Egyptian religion lacked a speculative foundation that could spawn dogmas or revelatory truths structured in coherent form for acceptance by the faithful. It did not have any unifying principle, but survived on a fluid aggregation of myths and legends, superimposed one on another for centuries and made alive by a rigorous respect for tradition and, most importantly, by ritual, which was a structural element and the real essence of the religion. The actual

obsequious repetition of the rite guaranteed the function of the pact established between the divinity and his or her followers in order to maintain cosmic order.

The absence of a unifying theological system was certainly one of the reasons why the Egyptian cults had so much success outside Egypt: it was easy and natural to find aspects of local divinities within the various Egyptian deities, thereby proceeding to the process of syncretism that made Isis and Serapis universal, allowing philosophical and mystical theories to find some confirmation and identity in the magma of Egyptian theological tradition. The ritual as practised in Rome seemed to maintain only some characteristics of the pharaonic cult (the purification ceremonies of the priests, the ritual of waking and clothing the statue of the god, the processions), while it introduced completely new and strange elements (the presence of believers inside the temple, the female priest, original cult objects, clothes and masks).

Fig. 9.4 Wall painting with Nilotic scene, from Herculaneum (Naples, Museo Nazionale Archeologico 8561; Soprintendenza Archeologica delle Provincie di Napoli e Caserta, Archivio dell' Arte Pedicini).

Egyptian religion permitted access on various social levels, welcoming on one hand the common people, believers of humble origin who for different reasons had come in contact with a more gratifying faith than was offered them by the Greco-Roman pantheon, and on the other hand, an elite of powerful and educated followers who sought greater theological depth and the discovery in those mystical cults of both a palpable religious aura and a strong instrument of power and political influence. Due to their appeal across significant sectors of the population, together with their capacity to meet a variety of needs, the Egyptian cults enjoyed overwhelming success.

However, it should be observed that, before their arrival in Rome and during their 500-year stay in the empire, the Egyptian cults underwent various contaminations. It would then be an oversimplification to think that the Serapeum of Alexandria was the only source from which these cults emanated. Nubia, well known to the numerous garrisons placed in that area, along with the complex relations between Meroe and Rome, seems to have been a second and important channel of contact and influence.

Isis' followers

Epigraphic sources show that, among the followers of Isis, foreigners did not form the majority. There was a homogeneous distribution, with pockets of density in Latium, Venice and obviously in Rome. Apart from Egyptians and Greeks from Egypt, there were also many Ethiopians engaged in the cults, as a fresco in Herculaneum shows, in which may be distinguished a number of officials with unmistakable dark skin.

The surviving epigraphic sources, though numerous, are insufficiently homogeneous to make the data statistically credible, though we can cautiously deduce that believers were mostly slaves and freedmen (even if the number of *ingenui*, or free-born, remains rather high); that the majority of Greeks from Egypt and from the Orient resident in Italy had a servile origin, with the largest populations being in Rome and in the ports (Aquileia, Ostia, Puteoli); and that

a considerable proportion of the followers of Isis belonged to the lower middle class (imperial officials and local magistrates) in addition to the world of the freedmen.

The Egyptian divinities – as mediated by Greek culture – had a non-exotic, reassuring aspect, and above all they expressed a different and deeper spirituality, with an unshakeable faith in life after death, the real winning key of all the oriental religions over Roman paganism and widespread atheism.

It is now clear that the success of the Egyptian deities did not derive from political opportunism, but from sincere religious needs – a consequence of the fact that already in the second century BC Roman religion went through an apparent crisis, intensified by the ease of introduction of the cults of the Bacchanalia and of Cybele. The average man found himself faced with cults lacking profundity and philosophical introspection, with scant consideration of spiritual need, whereas the cults of Isis contained innovative elements that were definitely able to fill the gap.

Egyptian religion, which was based on the preservation of all myths and theories, and on the absence of the principle of excluding whatever had been sacred for the forefathers, permitted all cultures with which it came into contact to find something of their own in which they could recognize themselves. It also accepted the assimilation of a multitude of foreign gods, just as had happened in the pharaonic period with the assimilation of numerous local divinities into the principal pantheon.

Probably the first and oldest Roman *interpretatio* (assimilation) of Isis was with the goddess Fortuna in Praeneste. A merging of the cults of Isis and Tyche appeared in the second century BC. To them was dedicated an enormous temple in Palestrina, restored by Sulla and decorated with – among other elements – the famous mosaic representing the Egyptian landscape (see cat. nos 352–355).

In Rome the goddess was assimilated with other local divinities and thus emerged as Isis Pelagia or Pharia, the protector of navigation, and Isis Demeter, arriving finally at the recognition of Isis as the lady of the sky and of the earth, who in a pantheistic vision became *una quae est omnia* (one who is everything – *C.I.L.X*, 3800).

The figure of Isis, in more than 500 years of existence in the Western world, grew in theological and mystical depth, until the goddess took on characteristics of absolute maternal and universal purity. Isis was then used, at least in her iconographical form, to represent the Virgin Mary, mother of Christ, while the pagan classical world had so thoroughly assimilated Isis that Latin and Greek writers gave her, as Zeus's daughter, a Hellenic origin.

In Rome, the cult of Isis had certainly been introduced at least by the beginning of the first century BC, as we know from a literary source (Apuleius, *Metamorphoses*, 11, 30) of a Sullan college of *pastophoroi*, a priesthood of elders, whose establishment implies a cult that was also practised outside the so-called private devotions of many distinguished members of the Roman aristocracy. In fact, the Scipios (the two Cornelii Scipiones Nasicae Serapiones, one of them the killer of Tiberius Gracchus) and Quintus Caecilius Metellus Pius, of the distinguished family of the Caecilii Metelli, consul in 80 BC with Sulla and founder, between 72 and 64 BC, of the Iseum Metellinum, the sanctuary of Isis at the foot of the Caelian Hill, all displayed a marked interest in the Egyptian cults. This confirms the diffusion of the cult even among members of the Roman aristocracy as early as the late republican era.

Some inscriptions prove that Isis was given the epithet 'Capitolina', utterly unexpected for a divinity other than Jupiter, and prove the existence of her cult – although archaeological evidence for the construction of a sanctuary has never emerged – as early as the first half of the first century BC. In 59/58 BC a decree forbade the cult on the Capitoline Hill (Tertullian, *Ad nat.* 1,10,17) despite popular support.

The Senate, the popular political faction, the *curule aediles* (magistrates with responsibility

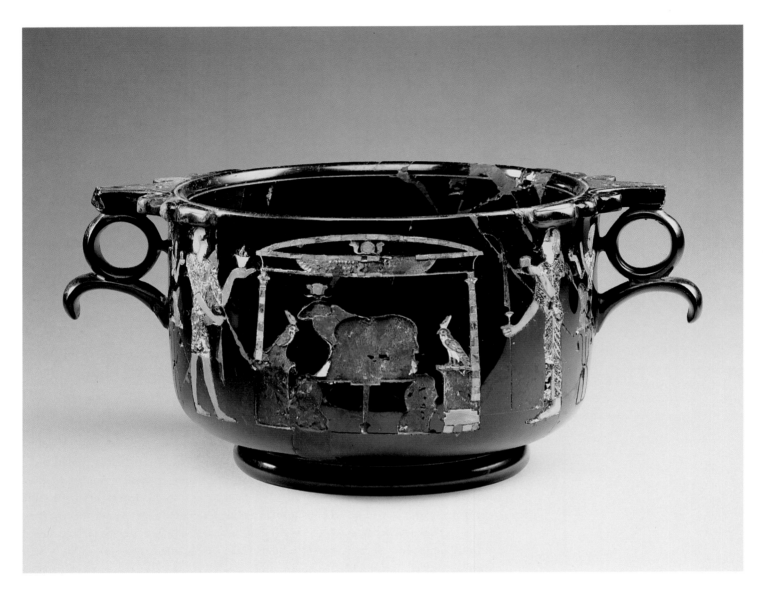

Fig. 9.5 Obsidian cup with ritual scenes
in an Egyptianizing style, from Stabiai
(Naples, Museo Archeological 312; Soprintendenza
Archeologica delle Provincie di Napoli e Caserta,
Archivio dell' Arte Pedicini).

for the urban fabric of Rome) and the *tresviri monetales* (official moneyers and the authors of a form of propaganda for Isis on coins) played a very important role in the destiny of the Isiac cult throughout the first century BC, further proof that political conflicts determined the favours from which certain cults profited; they were also the cause of later persecutions.

A Senate decree issued in 58 BC sought to prohibit the worship of Isis, Serapis, Harpocrates and Anubis, the four Egyptian divinities established in Delos and the Aegean area. This would confirm the view that the first and oldest phase of diffusion of Egyptian cults occurred through the intermediary of the Aegean world. Direct contact between the Egyptian and Roman worlds would come about only later with Caesar and Augustus.

A decree of 53 BC that ordered the destruction of all private temples to Isis was probably also directed at the Isium Metellinum as well as a sanctuary that had been illegally rebuilt on the Capitoline Hill. All the other temples in Rome dedicated to Isis and Serapis (the Sarapeum on the Quirinale, the Iseum in the Campus Martius and another in the Regio III district; the Temples of Isis at Castra Praetoria and the Horti Sallustiani; the sanctuaries at St Martin on the mountains in Regio V, of the Forum Boarium in Regio XI , of Trastevere and the Vatican in Regio XIV, of Isis Athenodoria in Regio XIII and another in Regio III) were undoubtedly built in later periods. The grand Temple of Isis in Regio III 'Isis et Serapis', a district which

even got its name from the temple, was one of the biggest, second only to the Campus Martius, and surely one of the oldest.

A decree issued in 48 BC ordered the destruction of all areas dedicated to Isis and Serapis. These repeated decrees, some of which were very late in being applied, are indirect proof of the vitality and illegal survival of Egyptian cults.

In 43 BC Mark Antony, Octavian and Lepidus authorized the construction of an Iseum known as 'Campense' in the Campus Martius, outside the Pomerium (the area next to the sacred wall of the city of Rome), to win Queen Cleopatra's favour, as many suspect, and to have her support against Caesar's murderers.

After Actium, the cults of the four Egyptian divinities Isis, Serapis, Harpokrates and Anubis, by then very popular outside Egypt, seem to have experienced a lull and sources tell us that divinities with more Egyptian characteristics appeared: Isis and her husband, Osiris, less prominently Anubis, and then Apis, Harpokrates and Bastet. The substitution of a cult of Hellenic origin with one more typically Egyptian became evident.

The close contact and definitive Roman occupation of Egypt threw open the doors to direct relations without the mediation of the Greek ports. The rapid spread of the cult of gods coming directly from the Nile Valley in many cases was not really approval of Egyptian cults but a fashionable interest in matters Egyptian, a kind of 'Egyptomania', which conquered the Roman world very quickly and mingled with religious piety in an often indistinguishable way.

Augustus, between the cults and Egyptian culture

Augustus was openly hostile towards these divinities, like Serapis, which acquired in Roman propaganda ever fewer humanized connotations, and ever more negative bestial aspects. Octavian, unlike Germanicus (Pliny, 8,46) and later the Flavians, flatly refused to render homage to the bull Apis (Dio Cassius 51,16) and favoured the execration of Anubis, ridiculed because of his doglike form, in the work of Virgil, who restored an element of mysticism to the Western gods of the Pantheon against the ridiculous *monstra* from the Orient.

The rejection of, accompanied at the same time by an attraction for, Anubis was already strong during the persecutions of the first century BC, but it became more bitter with Augustus and it lasted until the fourth century AD. This hostility was mixed with the unquestionable favour with which Anubis was received in the Western world, first and foremost in Greece, documented by the innumerable representations of him in the form of a statue that was the object of public and private cult, even bizarrely dressed as a Roman soldier.

In his very own way, Augustus regulated the veneration of the *deos Alexandrinos* (gods of Alexandria), condemned animal worship and its degenerations but safeguarded the cult of Isis.

Born of an evolution of primitive totemism, zoolatry had developed such that it appeared one of the principal characteristics of Egyptian religion, so much so that sacred animals became protectors of cities and were combined with other divinities in the shape of a human being, assuming the hybrid form of half-animal, half-human. It was not until the Late Period that every district of Egypt consolidated the adoration of a specific divinity in the form of an animal, true incarnations of the divinity. The enormous animal cemeteries in Lower Egypt, also of the Late Period, are examples of the invasion of superstition in the old cults.

As a result of Augustus' decrees, from 28 to 21 BC the exclusion of the cults from the Capitoline Hill and the Pomerium was confirmed, the wording of the ban comprehensive, including the Egyptian cults. In this ban, which did not name the divinities Isis and Serapis, one can see the desire to strike at the origin of the cults in Egypt, thus affirming Roman sovereignty over the conquered country. From this we can conclude that the ban

had not only a religious nature but also a political purpose, without immediate and direct oppressive intentions.

Augustus' regulation worked. In fact, a true persecution of the Isiac cults took place only many years later, under Tiberius in AD 19, when more than 4,000 Isiac and Jewish believers and their cult communities (*collegia*) were outlawed.

The aversion of Augustus towards the protective gods of his enemies Mark Antony and Cleopatra revealed an open hostility at their diffusion and official legitimation, a hatred that poets and writers supported, giving vent to their fury against the Egyptian gods and denigrating them in any possible way. But the official behaviour of Augustus towards the Egyptian cults and Egyptian culture was clearly contradictory, even if it was the expression of a policy designed to soothe the republican political wing that identified itself with the defenders of the *mos maiorum* (the customs of the forefathers).

Dio Cassius claimed that Augustus – who in the year 10 BC had erected two obelisks taken from Heliopolis (one in the Campus Martius, the other in the Circus Maximus) and adorned his mausoleum with two uninscribed obelisks (the tomb itself having much Egyptian ornament) – had erected sanctuaries for the Alexandrian gods whom he had excluded from the Pomerium.

As far as Egyptian cults and culture in Rome were concerned, the public Augustus was quite different from the private Augustus, who, in turn, was quite unlike the Augustus, conqueror of Egypt, where he was pharaoh, with all the iconographical characteristics and comportment of a god–king. Though this was the only comprehensible language of power in the land of the Nile, Augustus did not disdain that 'Egyptianized fashion' that became especially widespread following Egypt's occupation by Roman armies. His apparently contradictory behaviour shows that he, with great political intelligence, knew how to bridge the social, political, religious and cultural transformations that, with the encounter between East and West, had led to the end of the Republic and to the beginning of a new historic era.

Caesar, on the other hand, who had foreseen such an important change, probably became a victim of his own attitude, which was too open towards the Orient and inclined to introduce these novelties to Roman society too quickly. The 'restoration' sought by Augustus in Rome and well represented by the work of Virgil, by the design of the Altar of Augustan Peace, and by political attitudes towards the Senate, was an operation constructed for the purpose of calming Rome. Augustus, the oriental sovereign, the patron of 'Egyptianizing' works in Rome, the sponsor of a new city with Hellenistic Greek layout implemented by Agrippa, was first and foremost the refined politician who had understood that the oriental 'wave' that was about to spread in the Roman world should not be stopped but supported and guided in order to maintain Roman culture and customs without excessive force.

Egyptian fashions and tastes in Rome

Augustus' conquest of Egypt stimulated massive imports to Italy of pharaonic works of art, but not all of them were destined for sacred settings and many ended up with collectors or in villas, town houses, baths, public areas or stadiums.

The frescos of the Isiac Hall on the Palatine Hill, almost certainly from the Augustan era, appear to be refined and educated expressions of that Egyptian fashion whose influences were felt throughout Roman artistic production, but above all in painting, in the period after the Battle of Actium. The significance of the decoration of the hall has been discussed at length. If it is to be understood as a religious site, it is difficult to ascribe it to the Augustan period; with such a function it would be more credible to think of this structure as an expression of Caligulan favour towards orientals. But none of the paintings seems to have any sacred value. They may be clearly recognized as exclusively decorative, drawn from Alexandrian Greek

Fig. 9.6 Basalt statue of a *naophoros* (shrine-bearer) (Naples, Museo Archeological; Soprintendenza Archeologica delle Provincie di Napoli e Caserta, Archivio dell' Arte Pedicini).

repertory and taste (vegetal elements such as the lotus flower and the water plantain – very common in Egypt – architectonic elements, Isiac symbols, Egyptian statues and female priests, sacred-idyllic landscapes and mythological scenes). The fantasies of the modern viewer are stimulated and we are impressed by the mythological painting of Paris and Helen's disembarkation, which suggests the disembarkation of two other famous lovers, Mark Antony and Cleopatra, still too dangerous and hated to be recalled in Augustus' palace. The entire decorative programme with its 'Egyptianized' triumphal imprint bears witness to the 'contamination' of the Roman world by Ptolemaic Egypt.

It is often difficult to understand by which criteria the bas-reliefs, the sculptures and the architectural elements were selected, even if we have tried to find justification in the resemblance or in the comparison of some characteristics. We have tried to find a thread, a logic that could explain the choice of pieces transported to Rome, but such a thread, which could be linked to a profound understanding of the material, does not seem to exist. A statue of a queen could be used to represent Isis, just as statues of priests or portraits of functionaries drawn in the statue-cube position were used to represent the mummiform Osiris.

Often, a statue of a pharaoh could be placed in a temple and revered as Osiris (as happened, for example in the Syrian sanctuary on the Janiculum Hill or in the Campense). Regal sphinxes (like those of Hatshepsut or Amasis) and obelisks were snatched from their context and brought to make the atmosphere of the Roman and Italian temples of Isis and the Sarapea appear 'Nilotic' . There was no grasp of any artistic or religious meaning behind the choice of a statue of a priest from Egypt for decorating a temple in a Roman ambience. There was also no logic behind the texts of the hieroglyphs carved in beautiful monumental style, like the ones, for example, engraved on the slab that adorned the pillar of the grand staircase to the cella of the Iseum in Pompeii, and which recounted personal biographies or were extracts of absolutely illogical inscriptions with no connection to the sacred place in which they were put.

The same goes for the use of the obelisks as triumphal spires in the Iseum Campense, which spanned the *dromos* (access route) to the sacred area and were thus deprived of any sacred and religious connection that in Egypt linked them to Heliopolitan cosmogenies and to the solar destiny of the pharaoh.

Many works were brought only to embellish public places with no cult connotations. The numerous obelisks brought from Egypt, apart from serving as triumphal spires, were basically used as sundials for enormous meridians (such as the solar clock of Augustus in the Campus Martius) or for decorating tombs (such as the mausoleum of Augustus) or for stadia.

The sphinx perhaps became the most common decorative element, also far removed from its real significance. In the Roman world it was only considered a magnificent and majestic ornament, with a strong exotic connotation, which, however, did not disturb Roman aesthetic taste. Also for this reason sphinxes were brought to Rome in large quantities without selective criteria, based on casual collection, which included indiscriminately anonymous sphinxes and historically important sphinxes representing pharaohs from different epochs – from that of Queen Hatshepsut (Eighteenth Dynasty) to that of Amasis (Twenty-sixth Dynasty) – which, in some cases, became associated with sphinxes produced locally (see fig. 9.1).

The decorations and the paintings in Roman residences were characterized by landscape (especially Nilotic landscapes) and pharaonic themes. Nilotic scenes embellished sacred places and also civil buildings; and Nilotic landscapes became quite widespread, executed in floor mosaics (see fig. 9.3), stone reliefs, terracotta panels or painted on the walls (see fig. 9.4). Often there were small and elegant groups of Nilotic scenes and animals, set within views of gardens or still-life paintings.

The small paintings in pharaonic style showed figures distanced from each other in order

or in symmetrical groups, with an idol or an object in the centre, predominantly representing scenes of animal worship that reflected the specific interest of Ptolemaic Egypt (see fig. 9.8). The lay character of these paintings, which were purely ornamental in the context of the Roman house, was justified by the desire to form collections and by a cosmopolitan spirit, stimulated by direct contacts with the newly conquered province. It also satisfied the need to disenfranchise the Isiac cults.

The development of gardens followed Alexandrian fashion, and the Egyptianizing garden could not exist with less than a broad mirror of water, a channel and aquatic vegetation. Cicero's friends made fun of the 'Niles' artificially created in Rome and in Roman villas, in imitation of Egyptian landscapes (Cicero, *De leg.* II, 2), where, through channelling the water supply, they tried so hard to recreate the exotic landscapes that several tiny streams were renamed the Nile and Euphrates!

There was also an intense trade in minor works of art (scarab beetles, small statues, amulets, *ushabti* – figures substituting for servants in the after-life) aimed expressly at satisfying a widespread and fashionable taste, but not without references to the religious, magical and mysterious world of the Orient. The *ushabtis* and other small objects (statuettes, amulets) were easy to transport from Egypt and in any case easily associated with the deeds of the god Osiris and with magical rituals.

Tiberius took the Egyptian cults hostage and decided upon their elimination, or at least the persecution of some cult communities, but all his attempts at eradication, like those of other authorities, were followed by reconstruction of the sanctuaries, often accompanied by suspension of the destruction decrees, and embellishments and favours from emperors better disposed towards the fascination of oriental religion and style. It is certain that throughout the imperial period until the time of Constantine, Egyptian cults were one of the major outlets of religious feeling, with liturgical displays that were among the most popular and most extravagant. Caligula openly favoured Isiac cults, owing to his policies, which, following oriental models, were strongly absolutist, by such means also acceding to numerous requests that had been made for a long time by the army and the common people.

During Domitian's reign, there was a massive importation of pharaonic works (sphinxes, statues, fragments of frescos, obelisks and so on) mostly taken from the sacred buildings of the pharaohs of the Thirtieth Dynasty (Nectanebo), of the Twenty-sixth Dynasty (Amasis) and even of the Nineteenth Dynasty (Rameses II). Such objects together with Egyptianized products made in Rome were used to decorate the Temples of Isis, the Sarapea and many civil buildings. During Hadrian's reign a second massive importation of pharaonic works took place.

Burials in Rome

Through the form of tombs, documentation from cemeteries, inscriptions, burial techniques and decoration inside the tombs, scholars have tried to grasp the ethical, social and cultural identity of the followers of Isis. In this way we can distinguish the tombs of Egyptians, Nubians and Greeks in Egypt; tombs of Roman citizens who were followers of the Isiac cults or of different oriental religions; and tombs of Romans with Egyptian elements or Egyptianized simply to follow fashion (like the pyramid of Caius Cestius).

There were no substantial differences regarding burial methods, and embalming was not in common usage. (Although embalming was known at Rome, it was hardly ever used; the traditional Roman rite of cremation and the inhumation of human remains of oriental origin were the norm.) Unlike the Jews and the Christians, the followers of Isis had no cemetery areas reserved for them. Neither were there cemeteries for other oriental cults, and it has been impossible to identify reserved areas. On the other hand, a concentration of tombs has been

observed near the areas reserved for residence, for example in Regio XIV, Transtiberim, or in areas outside the city such as the Vatican Hills, where there arose sanctuaries dedicated to the divinities of Alexandria, to Mithras, Attis and Cybele.

The tombs of Egyptians and followers of Isis did not differ from those of the Romans. There were only a few names of obvious Egyptian origin: Cleopatra, Claudia of Meroe, Appia Pyramis, Alessandria. The worshippers of Isis had names that belonged to the Latin corpus, with some names in Latinized Greek. The inscriptions concerned both sexes; tombs for very

Fig. 9.7 Gold bracelets or armlets in the form of coiled serpents (Naples, Museo Nazionale Archeologico 24824–5; Soprintendenza Archeologica delle Provincie di Napoli e Caserta, Archivio dell' Arte Pedicini).

young children were numerous, a further proof of the universal character of the Egyptian cults, which, unlike Mithraism, were not restricted to a particular category of followers.

The social status that may be inferred from the funeral inscriptions is mostly that of the imperial freedman. Sometimes the professions are indicated: an actor, a painter, a sailor, *procurator Fari Alexandriae ad Hegyptum* (keeper of the Alexandria lighthouse), a guard in Serapis's temple, a servant, a priest, and even a female priest (*pastophorus, melanephori*). Many declared themselves priests not only in the cults of Isis and Serapis, but also of Mithras or the Roman divinities. The most common burial was the *ossuarium* (a burial urn) or urns for ashes; there were only a few sarcophagi indicating inhumation. Some cemeteries of the Augustan era have paintings referring to the membership of Isiac cults (for example, the dead person draped in the Isiac mantle with fringe and carrying the sistrum, or rattle, or Nilotic scenes).

From studies of funerary practices it seems clear that there was an absence of rituals that might distinguish the worshippers of Isis from others. Embalming was used for some of the bodies of followers of Isis buried in the Vatican necropolies: mummies of Augustan date treated with a typical Egyptian gilding have been found in tombs by the Via Cassia and on the Appian Way. The spread of exotic funeral practices, apart from those belonging to the Isiac faith, seems to emerge from some fifty cases of proven embalming studied in the area of Rome (examples outside the city are very rare).

It is evident that the Egyptian cults practised in Rome were very different from those of pharaonic Egypt and even from Alexandrian ritual. Even the concept of a life after death, the

basis of the entire Egyptian world, of which Rome kept a weak memory, seemed to be missing: in fact, in funerary inscriptions there appears no prospect of a life after death, but instead the sad and miserable acceptance of the end of life, a typical sentiment for the Roman pagan.

Numerous pyramids were built in Rome along the consular roads as early as the reign of Augustus. Inspired by Egyptian models, they had an exclusively funerary function. The choice of this form of burial appears to have been particularly popular in the late Republican era and the reign of Augustus. It was not unusual for Romans to choose alternatives to the traditional form of burial, and they often drew their inspiration from the various cultures with which they came into contact.

The pyramids of Rome can be ascribed to the fashion for things Egyptian, and do not imply adherence to the cult of Isis or other Alexandrian cults. The tombs of the followers of Isis and of Serapis do not differ significantly from those of Roman tradition, and they display only a few signs (inscriptions, details of the clothing, details of the hairstyle, ritual objects, funeral masks) that could indicate membership of oriental cults.

We can distinguish various types of pyramid, which evolved chronologically, responding both to changing needs and to practical difficulties. The first were imposing buildings of precious materials, such as marble from Luna, which followed the tradition of the pyramids of Memphis, even if the acute angle of the surfaces, about 68°, would indicate the pyramids of Deir el Medina and Meroe as the models for inspiration.

The later structures were made of bricks and took as their models architectural prototypes that were discovered during the Roman penetration of Egypt and Nubia. These later tombs, far less imposing than the first Roman pyramids, comprised a chapel or a podium surmounted by a pyramid of small dimensions.

Conclusion

The time span of the widespread and stable presence of the Egyptian cults in Italy and in Rome was at least half a millennium, an ample period, which cannot be ignored in the formation of Italic and Roman customs and culture. For many more reasons than the wealth of surviving material evidence, the Egyptian and especially the Isiac cults made significant contributions to the evolution of the culture and customs of that period.

The strong spirituality emanating from these cults and their defining rituals helped people to have a fuller sense of life, also (though this concept was weakened at Rome) through the prospect of a life after death. The victory over death and the sense of passing to another life, which offered acknowledgment of any merit acquired during one's life on earth, did not yet have either all the transcendental strength of Christianity nor the boost of the new Gospel brought by Christ, but it certainly anticipated its most 'revolutionary' and alternative aspects. And because many substantial aspects of the Egyptian cults did not conflict with the new cult of Christianity, the eventual religious transition was less painful.

What survived, restricted to the remote areas of the cultures that were not directly and profoundly pervaded by the new religion, was some residue of magical, mystical and symbolic ritual, imbued with polytheistic elements, which passed through the succeeding centuries in different forms.

Anything truth can do, we can do better: the Cleopatra legend

CHRISTOPHER PELLING

Cleopatra's story has glamour; it has menace; it has sex; it has power. It can be made tawdry or witty or tragic. She can be a coquettish temptress, or a guileless victim, or a subtle and worldly manipulator of susceptible men. She can be the immoral ruination of her kingdom, casting all aside for love; or the great leader who, but for bad luck, might have shared rule of a unified Mediterranean world; or at least the shrewd political manager, steering a complex path and staving off Roman domination for one final generation. The glamour can be seen as the self-indulgence of a libertine, insensitive to her people's sufferings; or as a variation on a traditional way of articulating power, fostering a sense of joy and self-belief in which her subjects could share. Perhaps she was a threat and a disgrace; perhaps it is all simply fun, on the grandest scale; perhaps she is an inspiration, a figure whom one is proud to have as a role model for one's race or sex. No wonder she has generated such varied treatments in literature, art, and film, variations that are traced in two fascinating recent books, Lucy Hughes-Hallett's *Cleopatra: Histories, Dreams and Distortions* (1990) and Mary Hamer's *Signs of Cleopatra: History, Politics, Representation* (1993). And several of those variations – though not the last, that inspirational Cleopatra – are already there in antiquity, as she became the Cleopatra of myth and fantasy as well as of history.

She built her own legend, of course. She built it in Egypt, presenting herself as the massive ruler of a willing people, close to the gods and divine herself: that is clear from the great relief at Dendera (p. 138, fig. 3.2). Above all, she was a virtuoso of spectacle. At the so-called 'donations of Alexandria' in 34 BC Cleopatra herself appeared as Isis; she and Antony took their places on high thrones; their children were paraded in the national dress of the kingdoms they were marked out to rule, Alexander Helios in the costume and headdress of Media, Cleopatra Selene in that of Cyrene, Ptolemy Philadelphus in the cloak and cap of Macedonia. It was all show; it did not affect the administration of the countries at all. But, as show, it was marvellous. It was perhaps on that same occasion that the defeated Armenian king Artavasdes was paraded in a Dionysiac procession, and that too had to be done properly: he was led in gold or silver chains.

Antony and Cleopatra's riotous lifestyle was not an embarrassment, but a central part of that image (fig. 10.1). They had a club called 'The Inimitable Livers', perhaps a religious association devoted to Dionysos, but if so one that carried through that worship in exuberant

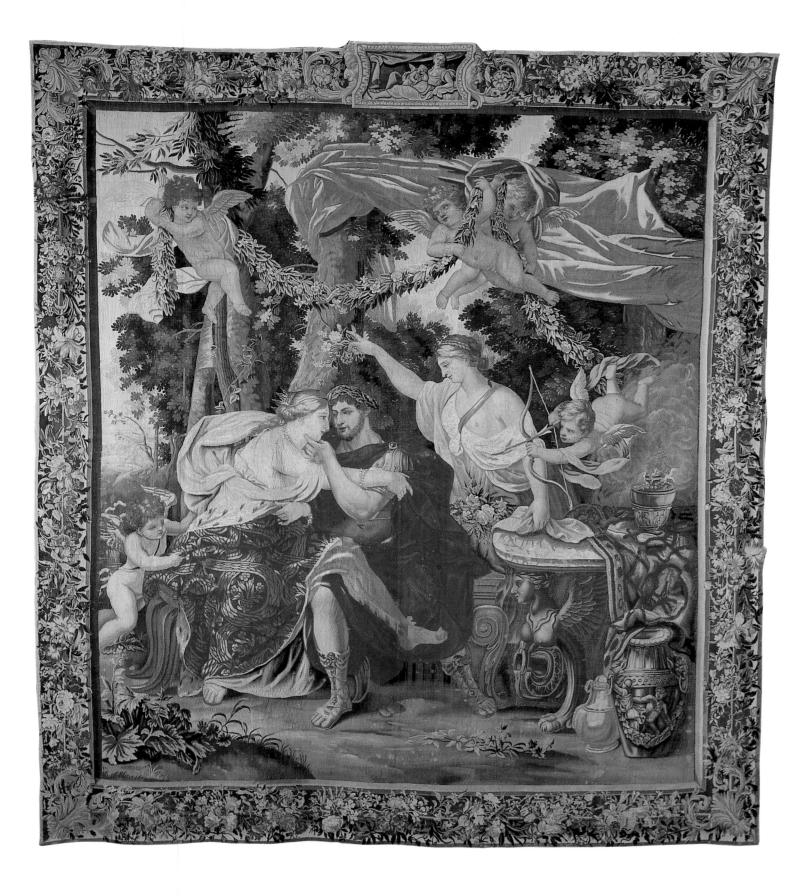

style. At the end, so it was said, they changed its name to 'The Partners in Death'. Antony built a glamorous image too. 'Inimitable' recurs. We have an Alexandrian inscription of 34 BC set up by a certain 'Parasitus', celebrating 'the great Antonius, the god, inimitable in *aphrodisia*' (cat. no. 213). Perhaps this reflects a serious cultic association with Aphrodite as well as Dionysos, perhaps it was just a joke on stone (Antony, who's so very good – and big – in bed). Either way it shows an Alexandrian entering into the spirit of the genial leadership that the couple gave.

Naturally, Cleopatra became a legend for Romans too, with that fabulous glamour and style. That scene of her arrival at Tarsus in 41 BC, as told by Plutarch and Shakespeare – 'the barge she sat in, like a burnish'd throne, /burn'd on the water…' (*Antony and Cleopatra* II.v.196–7) – may well be historical, at least in part: the details have much in common with attested features of Alexandrian processions and royal barges. This was a woman who knew how to make an entrance. But here, as in many cases, it is hard to pick out truth from fantasy, for she swiftly became the stuff of Roman propaganda. Octavian worked sedulously on Italian misogyny and xenophobia: Antony became caricatured as the man sinking into Eastern excess, while Octavian himself was champion of the traditional values of home. That Dionysiac celebration of the Armenian victory was portrayed as a Roman triumph sacrilegiously transferred to Alexandria; the 'Donations' were taken as the abandonment of Rome's conquests to be a lover's gift. The riotous living went down less well in Italy, too. A sense of fun is hard to share when one is just hearing enviable stories of it all, hundreds of kilometres away. The contrast between Octavia, the sober Roman wife, and Cleopatra, the languorous foreign mistress, proved irresistible to later writers, and it was probably exploited by Octavian himself. Antony was firmly on the defensive. He had to write a pamphlet, *On his own Drunkenness*, presumably explaining that he was not really as drunken as all that. But for nearly all the 30s BC he was far away in the East, and from mid-decade onward he was firmly with Cleopatra.

Unsurprisingly, she was demonized, and so was their affair. Her favourite oath, it was said, ran 'So may I give my judgements on the Capitol.' Antony, they claimed, was planning to move the centre of the empire to Alexandria. Tales were told of his reading love letters as he delivered judgements, or springing from his tribunal to cling to her litter as she passed. When war was declared, it was on Cleopatra alone; that did not mean Antony was ignored – far from it – but the best way of attacking him was to present him as enthralled to a foreigner, a woman, and an enemy. Horace's ninth *Epode*, written soon after the battle of Actium in 31 BC, is a dramatic re-creation of the battle, and captures the spectators' horror at what the other side threatened:

> Future generations will not believe it – a Roman soldier,
> bought and sold, bears stakes and arms for a woman,
> serves under withered eunuchs! Amid the standards
> the sun gains sight of a shameful mosquito net!

(A weak climax, for modern tastes, but a Roman soldier should take his insect bites like a man.) Could anything be more appalling, more effete, more un-Roman?

Then Actium was won, and a year later Alexandria. Rome never saw Cleopatra walking in Octavian's triumph: her death pre-empted that. But victory changed the style of the legend. Her forces could still be demonized, but could not be so effete: Octavian needed to have defeated a genuinely formidable enemy. It was also the Roman style to express pity for the defeated foe. Scipio Aemilianus had wept for the captured Carthage; Caesar had wept for Pompey; Octavian's tears, however crocodile, now flowed for Antony. The suggestion is one of human vulnerability, as the victor might one day be the vanquished. Roman poetry too begins to show something more subtle towards the defeated Cleopatra. A year or so later Horace treated her in *Odes* 1.37, and the tone is different. It is right to celebrate her defeat, of

course – 'now is the time to drink…' and her mind is 'crazed' by her own wine. But Octavian swoops on her like a hawk on a dove or a hunter on a hare, both images that focus more sympathy on the victim.

> She sought to die more nobly; she did not fear
> the sword, woman-like, nor sought to hurry
> her fleet to secret shores; she brought herself
> to view her fallen palace with tranquil face,
> to handle the fierce serpents bravely, to drain
> the black poison in her body, fierce in her calculated death,
> grudging to be led by the cruel galleys
> of the Liburnians, a queen no more,
> to a proud triumph. No humble woman, she.

She is still for Horace a *fatale monstrum*, but *monstrum* is a 'miraculous portent' as much as a 'monster', and *fatale* is sent by destiny as well as 'death-threatening'. This is something beyond nature. There is an eery respect here, even admiration, as well as fear.

Above all, Cleopatra is fascinating; and she was a lover as well as a queen, which made her more fascinating still. Now she was dead she could become the subject of wit as well as fear. Propertius writes of the lover's subjection: 'Why be surprised, if a woman tosses my life about, and drags me as slave to her judgement…?' (3.11). There are many such dominating women in myth – Medea and Jason, Omphale and Herakles – but the greatest example of all is Cleopatra. What a threat she poses, this 'harlot queen', and how wonderful that Augustus drove it all away! How thankful we must be! As so often, and as in his celebration of Actium in another poem (4.6), Propertius' tone is elusive: he, of course, is the Antony figure in this equation, though that need not make his praise of Octavian ironic or the poem 'subversive'. But this does take its place in a sequence of poems that take favourite Augustan moral platitudes and give them a teasing twist, appropriate to the lover-poet's alternative lifestyle. Yes, greed is everywhere – it costs so much these days to get a girl for the night (3.13)! Yes, we need more fighting backbone – militarist Sparta had it right, where you could see naked girls exercising all the time (3.14)! Cleopatra is becoming a figure a poet can do things with. You think of her, and you think about how to love and live. And it is fun.

In a graver register Virgil makes her thought-provoking too. The *Aeneid* was written in the eleven years after Cleopatra's death. In that poem past, present, and future often fuse: Aeneas is fighting Turnus over a thousand years in the past, but he is also fighting a people who ought to be his own, devastating his own country, and playing out in anticipation the civil wars of Virgil's own generation. Dido is Dido; she is also the Carthage that will be Rome's greatest enemy; and she is also, in part, Cleopatra. There is probably a sense of that even in the first book, when Dido entertains Aeneas sumptuously, and the description strongly recalls Cleopatra's first banquets for Antony. Then, in Book 8, Aeneas is given a shield depicting scenes of Rome's future, particularly its fighting future and particularly its Italian and civil wars; the centrepiece is Octavian's victory at Actium, and Cleopatra is there. The great moment is, as it was for many later writers, that of her flight:

> Vulcan had placed her there amid the slaughter,
> pale at her coming death, borne by the waves and wind;
> before her the Nile, all its great length mourning,
> throwing open its folds, calling the conquered host,
> with all its garb, to its dark bosom and its hidden streams.
> (*Aeneid* 8.709-13.)

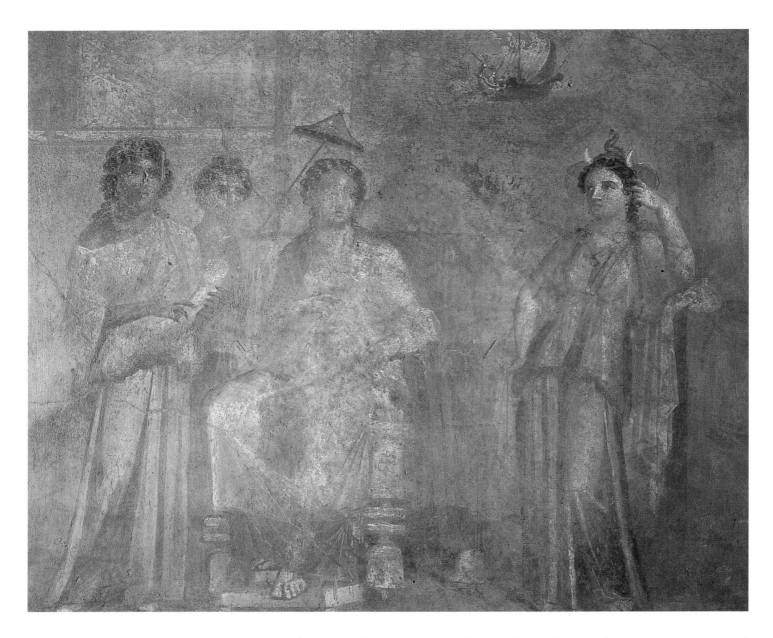

Fig. 10.2 Wall painting showing Dido,
from the Casa di Meleagro VI
(Naples, Museo Nazionale Archeologico 8898;
Soprintendenza Archeologica delle Provincie
di Napoli e Caserta, Archivio dell' Arte Pedicini).

This is more than Roman triumphalism. There is harmony here of queen, country, and
people, and a stress on the nation's mourning and their queen's fear. The phrase 'pale at her
coming death' also echoes an earlier passage where it was Dido who showed 'pallor at her
coming death' (4.643), and once again we have that blurring of past into present: Cleopatra
blurs into Dido, another beautiful queen from Africa, another challenge to a Roman hero and
another alternative to a Roman path of fighting and achievement. In that case Cleopatra's
suggestions inevitably colour Dido, and Dido's colour Cleopatra (fig. 10.2). The present and
Cleopatra point Dido's threat to Rome's future: had Aeneas been an Antony, he might have
stayed with Dido, and Rome would never have happened. The past and Dido affect the way
Cleopatra is seen too. Dido's point of view has been felt as well as Aeneas': this is what defeat
means. Doubtless it had to be so, but the victims' story matters as well, even if they are
women, foreigners, lovers.

These hints of involvement prefigure some of the lines the myth will later take, but the
underlying menace remains. None of the Augustan poets actually *name* Cleopatra; the various
phrases are all dismissive – 'the Egyptian woman', 'the harlot queen of impious [or incestuous]

Canopus', even 'the woman whom her own servants used to grind' – and any frissons of engagement or admiration are only fleeting. Nor do any of these poets tell the tale in a direct narrative form. Others did. We have sixty lines surviving from an early-Empire poem usually called 'The Actian War' – probably miscalled, because all we have deals with the fighting in Alexandria. There is no doubt what the climax is to be. We have an extract from a monologue of Cleopatra where she is summoning her own courage to die, and there is a gruesome scene in which she tries out various modes of death on condemned prisoners before deciding for the asp (the Egyptian cobra). A few lines give a description of the gentle, serene, sleepy death that the cobra brings. That is a little misleading: death by cobra bite can be quite unpleasant. But that too becomes a traditional part of the myth.

Then we have Lucan, writing under Nero. In his tenth book he has a tour de force describing Cleopatra's rich entertainment of Julius Caesar. Dido's banqueting lurks in the back of author's and audience's mind, but in Virgil Cleopatra was only a suggestion; now Cleopatra claims back Dido's feasting for her own. Cleopatra herself is (with another Virgilian echo) the Helen of the West, Italy's destructive Fury; she is beautiful, shameless, and very sexy indeed, in a rather obvious way – how very different from Pompey's wife, Cornelia, who had been so noble and so Roman! Sex is now in the air, but elusively so. The price Cleopatra agrees for Caesar's support is an 'unspeakable night', so unspeakable, indeed, that it is left undescribed, and it is not even clear if it has happened by the time of the feasting itself. Various touches then bring out the surreal quality. Jewels serve not just as adornment but also as floor, as furniture, even as military defence (the reinforced door is made of ebony); an unnatural mix of servants stand by, some dark, some oddly fair-haired and Germanic, some eunuchs, some older men who are strangely beardless. One paradox is explicit: why show off your wealth to the man who has the power to take it? Worldly wise, we think we know the answer: seduction, of course, and that seems to be where the narrative is leading. And so the meal ends. It is late. The scent of exotic spices fills the air. Caesar is flushed with wine. He duly turns to – an elderly male intellectual who is conveniently placed nearby, and the two pass the night in learned conversation about the Nile's flooding, course, and exploration. Cleopatra has no further role to play in the action, and silently disappears. Caesar, yet again in this text, has turned everything natural upside down – even lust, and even in an unnatural world. In his own way Lucan has played with the reader's expectations with just as much wry wit as Propertius.

The Caesar affair is only a part of Cleopatra's story: her fuller, later years with Antony were treated by prose historians very soon after the events. Those close to her wasted little time in telling the world. A certain Quintus Dellius had played a part in setting up that meeting of Antony and Cleopatra at Tarsus, and he wrote his memoirs; we also hear, intriguingly, of his 'sexy letters to Cleopatra'. Cleopatra's doctor published a version of her final days. And those writing full histories of Rome naturally dwelt on these momentous events. Livy on the whole told an ungenerous tale, it seems. That part of his *History* does not survive, but we can reconstruct some of its content, and he clearly made a good deal of Antony's sacrificing public duty 'for the love of Cleopatra'. He also made a great set piece of her final days. Apparently he made her exclaim in Greek 'I will not be led in triumph', and, if so, it was a breathtaking moment, breaking a fundamental rule of the genre: in Latin histories people do not speak Greek words. The scene must surely have conveyed the dignity and the resolve that those words highlight, and here it does not sound as if Livy was simply dismissive.

Then there is the brief and exuberant version of Velleius Paterculus, writing under Tiberius: 'Who can hope to express, in the compass of so abbreviated a work, what that day meant for the world, what condition the fortune of the nation gained as a result?' (2.86.1). There are a few tales of the excesses at the court, notably the picture of the senior politician

Plancus dancing as a sea-god, naked, painted, and dragging his tail; there is a hint of Horace's portrayal of her death – 'as the snake bit, she had no womanly fear…'. More interesting is Josephus, who wrote in the second half of the first century AD and drew on Jewish as well as Greco-Roman historical traditions. He describes in some detail the exchanges of Cleopatra with King Herod of Judaea (the Herod of the Gospels). Cleopatra had coveted Herod's territory and got from Antony some, though by no means all, of what she wanted: and Josephus is unenthusiastic. His Cleopatra is a robber of her own temples, a witch, a murderess. Propertius' 'harlot queen' is shifted into the narrative register, as Cleopatra tries to seduce Herod himself, only to be rejected in contempt (*Jewish Antiquities* 15.97–8). Such meetings were far too juicy topics for writers to leave alone: similar stories, we shall see, were told about Cleopatra's encounter with Octavian a day or so before she died.

Josephus' narrative, like Lucan's, covers only part of Cleopatra's story, in his case the times when it intersected with that of the Jews. It is only at the beginning of the second century AD that we find a fully extended narrative, with Plutarch's *Lives*. Plutarch mentions Cleopatra briefly in his *Caesar*, including the famous arrival wrapped in a carpet: this woman, at least the woman of myth, really did do entrances well. But his principal treatment of Cleopatra is in the *Antony*, the main source for Shakespeare's *Antony and Cleopatra*, and the work, more than any other, that created the Cleopatra whom the world knows.

Plutarch immediately avoids the predictable:

> In itself her beauty, they say, was not of that particularly outstanding kind which would astonish those who saw her. It was when a man was with her that he felt her irresistible hold over him. Her looks combined with her powerful conversation and the charm which surrounded her whole manner, and the effect was extraordinarily attractive. There was delight even in the sound of her voice… (27.3–4)

It is this beguiling charm that Plutarch points out in story after story. There is the tale, for instance, of Antony fishing in the Great Harbour of Alexandria and seeking to impress by having a slave swim underwater and fix fish on to his line. Cleopatra noticed. The next day she sent a slave of her own to attach a salted fish from the Black Sea, evidently dead for months. Antony is discountenanced and sheepish. 'My lord,' says Cleopatra, 'leave the rod to us, the monarchs of the Nile. Your prey is kingdoms, and emperors, and continents.' Suddenly humiliation has become a majestic compliment: that is style. And that is tragedy too, for that playful lovers' scene is recalled at the end of the *Life*, when Cleopatra and her maids toil to reel in the dying Antony, hoisting him to the 'monument' where they have sought refuge.

Antony is for Plutarch marked by his 'simplicity', literally 'oneness'. He cannot be other than the man he is, a bluff and genial soldier. Cleopatra is in contrast 'one who will do anything', someone who can change her style to suit her victim: and victim, at first, is indeed the impression we have. Take the description of the banqueting after Cleopatra's barge-borne arrival. Others had dwelt simply on the expenditure and the luxury. Plutarch dwells more on the psychology of the two, as they take one another's measure and Cleopatra gauges her tactics:

> So Antony sent to invite Cleopatra to dinner; she said it was more appropriate for him to come to her. Wishing to begin by showing some courtesy and kindness, he accepted and went.
> The entertainment that awaited him was beyond words, but he was particularly astonished by the number of lights. There were so many there, hanging from the ceiling, shining out on every side at once, ordered and arranged in such intricate interrelations and patterns, some in squares, some in circles, that it was one of the most remarkable and beautiful sights ever to meet the eye…(26.6–7)

That is very like Virgil's scene in which Dido first entertains Aeneas, with the lurid gleam of the torches and the smoke circling to the ceiling: the sensuous atmosphere is beautifully caught.

> The next day he entertained her in return, and tried hard to outdo her in splendour and lavishness, but he fell short and was defeated on both counts. He was the first to make fun of the squalid and

coarse quality of his own arrangements. Cleopatra could see that there was a lot of the vulgar
soldier about Antony's humour, and so she began to use the same tones herself, in a free and
confident way…(27.1–2)

This is a tale of two personalities, meshing closely together, and Cleopatra is mistress of her art.

There were stories of the expense as well. Plutarch's grandfather had known a doctor who
was in Alexandria at the time, and he told of an evening in the kitchens when eight wild boars
were being prepared. 'You must have a vast number dining,' he had said. 'No,' he was told,
'only about twelve. But everything must be served at its best, and we never know when
Antony will call for the meal, so we prepare not one, but many dinners.' There were stories too
of the couple riotously stalking the streets of Alexandria in disguise; and Alexandria becomes,
as for Shakespeare, a world of languor and pleasure, the opposite of cold, political, militarist
Rome and of the man who sums up all those values, the young Octavian.

Antony may be simple, but he too is not a caricature. He finds Cleopatra fascinating, but he
also knows other claims, those of his wife Octavia, Rome, and duty. He is torn, but Cleopatra
knows how to guide his choice:

She would make her face light up as he approached, and made sure that he would glimpse how
it dropped and darkened as he left; she took care that she was often seen weeping, but then would
wipe away and try to hide a tear, as if she were hoping he would not notice. … Her flatterers told
Antony what a hard, insensitive man he was, destroying a woman who was devoted to him.
Octavia had married him for politics and her brother's sake, and she enjoyed the title of wife;
Cleopatra, queen of so many nations, was content to be called his mistress, and did not shun
that name as unworthy of her, just as long as she could see him and share his life. If he left,
it would kill her. (53.6–10)

The thought is there: what must it be like for her? That question was intimated by Virgil, but
indirectly through his Dido; even here matters are not straightforward, as this is all a counter-
feit adopted by Cleopatra, 'pretending' to be in love with Antony, and the reproaches come
from her 'flatterers'. But the question is still raised, and we have that rare thing in ancient litera-
ture – an attempt, and not an unmoving one, to capture the woman's point of view.

All ends in defeat and Antony dies. Octavian and Cleopatra now have to meet. Other writ-
ers would turn this into a failed seduction attempt by Cleopatra; Plutarch just has her lying on
a simple mat, her face and breasts torn by her lamenting, though 'something in the move-
ments of her face' still showed that old vitality and grace. They talk, and Octavian is per-
suaded that she plans to live on; he leaves delighted, convinced that he will parade her in his
triumph at Rome. But it is she who will win the final victory, and it will be by her death.

First, though, she comes to Antony's grave (cat. no. 363):

'Antony, my love,' she said, 'I buried you a few days ago, and then my hands were those of a free
woman; now I am a slave as I pour libations to you, guarded so that I may not even disfigure this
slave's body with beating or lamenting, kept for the triumphs to be celebrated over your defeat.
Expect no other libations than these; they are the last which Cleopatra will bring. Nothing separated
us when we were living, but it seems that in death we may exchange places, you the Roman lying here,
I wretchedly in Italy. That alone will be my share of your land. But if there is any force and power of
the gods of hereafter, for those here have betrayed us, do not foresake your wife while she lives, do not
ignore it when you are triumphed over in my person, but hide me and bury me here with you. I have
ten thousand woes, but none so great and dreadful as these few days I have lived without you.' (84)

Much of Hollywood is already here, and it is more than sentimentality. Now she is his 'wife',
no mere mistress; she had been accused of wanting Italy, but now her only portion of Italian
soil may be her grave. They should really be bonded together, perhaps in the Roman triumph
where Antony will be 'triumphed over in my person', but how much better if it could be in
death, and in Egypt! Octavian's propaganda had accused Antony of wanting to be buried with

Cleopatra, and made that the height of his degradation; now this *Liebestod* is not a disgrace but a culmination. And, crucially, now the love is real. The counterfeits are over.

Her death is a culmination too. She bathes and puts on regal dress: these were features of real funerals, where the corpse was bathed and robed before the ceremony. In Aeschylus' play Agamemnon had met his death wrapped in a regal robe in his bath, and it had seemed chillingly unnatural; here a different sort of living funeral seems magnificently appropriate. The Romans burst in, and ask the maids indignantly if this is 'well done'. The tone is almost colloquial, for these are words one would often use to a slave. Shakespeare takes the maid's reply directly from Plutarch:

> It is well done, and fitting for a princess
> Descended of so many royal kings.
> (*Antony and Cleopatra* V.ii.325-6, from *Antony* 85.8)

And the moral? Plutarch is a highly ethical writer, intent on extracting lessons from the past. For much of the *Antony* he shows disapproval of the lovers: indeed, the Parallel Lives *Demetrius and Antony* explicitly form a deterrent pair, showing his readers how not to behave, rather as the Spartans used to parade drunken serfs before their young men as a warning against over-indulgence (*Demetr.* 1). But it is hard to find such simple disapproval and rejection in the final scenes: the involvement with the principal characters is too great for that. If there is moralism here, it is of a different kind, more concerned to trace the fragility of human nature before the force of love. If two figures as great as this can be destroyed, how much more vulnerable the rest of us must be, humbler people as we are.

Not all treatments were as nuanced as this. Florus, writing a brief history of Rome a little later than Plutarch, regards Antony as 'the torch and whirlwind of the century that followed'. Just as the changes of season are marked by storms and thunder, so the transformation of Rome had to be marked by turbulence, but Fortune ensured that the right man won (2.14). So comfortable a picture left little space for any engagement with Cleopatra:

> This Egyptian woman demanded from that drunken general the domination of Rome as
> the price of her favours: and Antony promised it. ... He forgot his nation, his name, the toga,
> the axes of power, and degenerated wholly into the style of that monster, in mind, in dress,
> in all his manner of life…(2.21.2–3)

Cleopatra is a *monstrum* again, and now Antony comes to share the style: Florus allusively borrows Horace's word for her, but this time it really does mean little more than 'monster'. Within a few sentences Florus gives a list of the forces on 'our' side; Cleopatra and Antony are most definitely 'them' not 'us'. A few sentences more and we have reached the final scenes, and for the first time we have the defeated Cleopatra's attempt to seduce Octavian. She falls at Octavian's feet, she gazes hopefully into his eyes, but her beauty was no match for the chastity of the great man – and that is all. The scene is doubtless fiction, just as that seduction of Herod was fiction; but, even within Florus' abbreviated scope, it might have got a more imaginative treatment than that.

Dio Cassius, writing a hundred years after Plutarch, has space for much more detail; he cuts a little deeper, but only a little. His Cleopatra is not merely charming but also 'the most beautiful woman alive'. First Julius Caesar and then Antony are utterly infatuated. Antony in particular is her 'slave' and he is 'bewitched'. At Actium she cannot bear the suspense, 'being a woman and an Egyptian', and takes to flight prematurely. There is something of those themes in Plutarch too, but in Plutarch they are overlaid in the final scenes; in Dio the emphasis comes to rest rather on Cleopatra's attempts to save her own life and her confidence that she will be able to captivate Octavian as well. Dio does a little better than Florus with that scene with Octavian: Cleopatra prepares herself with an affected negligence, she tearfully reads to

Octavian extracts from Julius Caesar's love letters, she gives him smouldering looks and melting words; Octavian is not insensible to it all, but replies carefully, his eyes fixed firmly on the ground (cat. no. 368). Cleopatra finally realizes that it is hopeless, and pleads to be buried with Antony; Octavian leaves without answering. A few days later she is dead. The obituary notice is not generous:

> Cleopatra was insatiate for love and insatiate for wealth. Her ambition and love of glory
> was great, and so was her audacious arrogance. She gained the throne of Egypt through love,
> and through love she hoped to gain monarchy at Rome; she failed to get the second and also lost
> the first. She conquered two of the three greatest Romans of her time, and because of the third
> she killed herself. (50.15.4)

Other aspects of Cleopatra could stir the imagination. Stray anecdotes talk of her as a gifted linguist, as the leader of an intellectual circle, as a magnificent builder (she was sometimes, quite wrongly, regarded as the builder of the Great Lighthouse of Alexandria), as the author of works on cosmetics, weights and measures, coinage, chemistry, and gynaecology – several different types of stereotyping are detectable there. But it is the memorable scenes that keep coming back: the seduction of Caesar, the banquets with Antony, the arrival at Tarsus, the flight from Actium, the meeting with Octavian, the snakebites and the death. After Plutarch the tradition tends to make her looks stereotypically good and her morals stereotypically bad. The murders are often emphasized, especially her early elimination of inconvenient brothers. And even more stress falls on the body and the erotic. 'She was so insatiable that she often played the prostitute', says one writer in late antiquity, 'and so beautiful that many men paid for a single night with their lives' (*De viris illustribus* 86.2). Those devoted clients indeed gave all for love.

That is male fantasy at its tackiest. Yet a more elevated 'all for love' is the recurrent theme of the best as well as the worst ancient writing about Cleopatra, with the focus usually on Antony's 'all' rather than Cleopatra's. Is, then, the world well lost or ill lost? For most, clearly 'ill'. Even Plutarch, whose telling of the end is so moving and beautiful, has spent much of the *Life* in disapproval. But the notion that the love might be transcendent is there in embryo in the Plutarch narrative, one possible response to the final scenes: might there not after all be more to life than these Roman, masculine values of politics and war? So Cleopatra's story becomes not merely fascinating but also a way of thinking about life, love, and sacrifice, as in different ways it had already been for Propertius and Virgil. The material is already available for Shakespeare to make it so great a love, with Cleopatra losing so much as she bids the dead Antony farewell:

> ... the odds is gone,
> And there is nothing left remarkable
> Beneath the visiting moon.
> *Antony and Cleopatra* IV.xiii.67–9

The myth of Cleopatra since the Renaissance

MARY HAMER

'Cleopatra was an Egyptian woman who became an object of gossip for the whole world… She gained glory for almost nothing else than her beauty, while on the other hand she became known throughout the world for her greed, cruelty and lustfulness.' So Boccaccio opened the 'Life of Cleopatra' that he was writing for *De Mulieribus Claris*, his collection of the lives of famous women from the past. As a scholar and poet, an intellectual, as we might describe him today, working early in the Renaissance, Boccaccio was not inventing the attitude to Cleopatra adopted here but merely transmitting one that had been set up by Roman propaganda fourteen hundred years before. Reading his words today, it may come as a surprise to register how precisely Boccaccio was setting terms and laying down categories that Europe would use for thinking about Cleopatra over the centuries that followed, right down to our own day.

The name of Cleopatra speaks of pleasure. For many people nowadays it brings to mind the image of Elizabeth Taylor, who played her in the 1963 film. Try reading Boccaccio's words over again, this time with the name of Elizabeth Taylor substituted at the start: 'Elizabeth Taylor was a woman who became an object of gossip for the whole world…' Uncannily, Boccaccio's words can stand almost unchanged, as if they had been written yesterday. Attacks on Hollywood and its morals are often linked with an assault on pleasure, or at least on popular pleasures, those that are shared very widely, the ones that people don't need to be educated to enjoy. As an actress and as one of the great Hollywood stars, Taylor offered herself to the public gaze and presented herself to be looked at, almost as evidence, just as Cleopatra did when she took the pharaoh's part in public ritual before her people in Egypt.

For Boccaccio and for the way of thinking that he passed on, allowing a woman to put herself on display and to do it on her own terms was not to be encouraged, perhaps because it might lead to spectators deciding about women for themselves. Instead, following the precedent set by Rome, Boccacio set out to shame Cleopatra and to isolate her, inviting readers to dismiss her along with all that she stood for, her achievements and her world. In making this move he was also inviting them to judge the women of their own time and offering them a language in which to do it.

Boccaccio was working, like other Renaissance humanists, to bring the classical tradition

and the Christian one into alignment. Both tended to discourage questions concerning women and concerning what women felt for men. It is in this context that Boccaccio makes his attempt to shut down enquiries about Cleopatra and about the relationships she had with men, refusing to accept this interest as intellectually respectable and writing it off as 'gossip'. In the figure of Cleopatra and in her story Renaissance Europe found itself confronted with a woman who stood outside both its moral and intellectual traditions. Most important of all, Cleopatra stood outside marriage, the institution that was supposed to symbolize the relationship between women and men. For the men of Greece and Rome, as for early modern Europe under Christianity, a good woman was a wife. But by the way she had lived her own life Cleopatra brought into question the notion of the good woman and, with it, the carefully organized asymmetries of marriage.

If Cleopatra was the wrong kind of woman, as both Christian and pagan traditions seem to paint her, that would leave us today with a question. We might want to ask why it was that Julius Caesar represented her differently, Caesar, whom we have learned to admire as the triumphant general and politician, model of good judgement and sound reason in a public man. Cleopatra had borne Caesar a son, who was named Caesarion; the child was with Cleopatra living in Rome at the time when Caesar was assassinated. Caesar honoured Cleopatra by setting up in his forum a statue of her covered in gold in the Temple of Venus Genetrix, who was regarded as the mother of the Roman people and the tutelary deity of his own family. Situating Cleopatra in relation to this goddess, the image of a woman who did not have to choose between being a mother and a lover, this statue also acknowledged the relationship between Caesar and herself.

Caesar's perception of Cleopatra is not one that has been handed down to us with quite the same enthusiasm that his own reputation and his works have been. When Julius II, the pope who liked to represent himself as a second Julius Caesar, set up a statue in the Vatican in Cleopatra's name (fig. 11.1), it was not as the confident spectacle of a living woman and the giver of life that he chose to view her. Instead, the statue that he bought early in the sixteenth century, when it was dug up in a Roman garden, and had installed in the Vatican as Cleopatra offered viewers the sight of a woman who had taken her own life, a woman isolated in death. This was the legacy not of Caesar but of Augustus, a figure who is more often linked with a heritage and a culture of which modern Europe is proud. But there is another aspect to the Augustan model, one that also has implications for the way life is organized in the West today. Augustus represented Cleopatra as the enemy of Rome and he dated his own reign from the day of Cleopatra's death. In order to celebrate his own triumph Augustus had an image made of the dead Cleopatra with the snake at her breast.

When Pope Julius passed on the notion of Cleopatra as an enemy, a deeper understanding of women and of their link with men was displaced and trivialized as myth. Myths of its own, which involved suffering rather than pleasure and separated women from each other and from men, were substituted by the Church. Today we may be inclined to use the term myth lightly and in dismissal, but the example of Caesar's statue might give us pause. In the form of stories, myth speaks of the relations between women and men and of their place in the world of nature. When Cleopatra used to dress as the goddess Isis to appear before her people, it was the language of myth as much as the language of politics that she was speaking. In Egypt there was less of a gap between the two than there was in Rome. In Europe the language of myth, as it spoke of connection and of symmetry between women and men went underground at the point where Cleopatra, the last pharaoh of Egypt, could be described only as a whore.

It is hardly too much to say that for centuries Europe's image of Cleopatra was manipulated by the Church, for the Pope's statue became famous and was reproduced and circulated widely. But from the first, the Vatican Cleopatra embodied a misrecognition, for though it was

bought and installed as an image of Cleopatra, some wishful thinking must have been involved. Otherwise it would have been recognized that the piece belonged in the tradition of the Sleeping Ariadne, the title by which the statue is known today. Even when the German archaeologist J.J.Winckelmann had pointed out the misidentification in 1756, the name of Cleopatra was still associated with this image in people's minds. Name and image together seem to have had resonance, to have chimed perhaps with shared perceptions, ones that oth-

Fig.11.1 The Vatican 'Ariadne',

formerly identified as Cleopatra

(Vatican Museums, Vatican City, Galleria delle Statue).

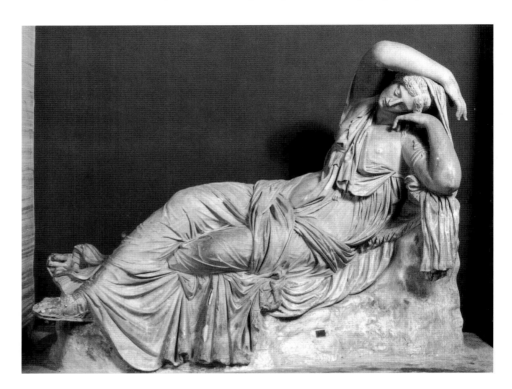

erwise remained unvoiced. These concerned the hostile attitude to women that had been enshrined in the name of religion and morals, one that would reinforce an estrangement between the sexes (see fig. 11.2). The name of Cleopatra might not be separated from the thought of pleasure but in this sculpture love and pleasure became fused with abandonment and death.

As one of the first works to be placed in the Belvedere, the gallery set up by Pope Julius in the Vatican to provide a teaching place for artists, this statue defined Cleopatra, or provided the baseline for meditating on her as a subject, throughout Europe and for many centuries. I would link the countless representations of Cleopatra's death – some of them erotic, others striking in their sense of anguish – with the intuitions of disturbance, the fears and longings that were stirred by the threat of alienation from women, a threat that was captured in the image of this one particular death. We might consider all attempts to imagine Cleopatra that have been made in Europe and in art since the time of the Renaissance, including vernacular attempts, and not forgetting the presentation of the self as Cleopatra by individual women, as a sequence of revolutionary acts, or acts of resistance, attempts to restore perceptions, perceptions about women that had been overthrown. That might help to explain why her name has endured so long in popular as well as elite culture and her image has been constantly reworked.

If the imagination of Europe had a voice at the turn of the seventeenth century, we might say that it spoke through Shakespeare. When Shakespeare wrote his play about Julius Caesar, he left out Cleopatra: a blank had been created in the European mind. The means of imagining Cleopatra on the same scale with Caesar, getting them into dialogue with each other, as it

were, had been destroyed. With that went the ability to envisage a passion that was both viable and worthy of respect: when Shakespeare did come to write about Cleopatra it was in the context of her relationship with Mark Antony and he wrote about a love that was doomed. Yet at the end of *Antony and Cleopatra* audiences are left with a sense not of defeat but of triumph. 'Dost thou not see the baby at my breast /That sucks the nurse asleep?' Cleopatra asks as she is dying (V.ii.308–9). Finding Cleopatra's own voice and working as an artist, Shakespeare made his way back to presenting her as both mother and lover, the knowledge that emperor and pope had closed down.

In counterpoint with attempts to imagine Cleopatra was a voice that spoke about men. His intimacy with Cleopatra forgotten, Caesar, the public man, continued to be held up in Europe as an ideal while it was Mark Antony, the failure, the Roman who experienced public humiliation and defeat, whose relationship with Cleopatra became emblematic. The reports of Antony flying from the Battle of Actium and botching his own suicide underlined his failure as a military leader, yet they could not remove all glamour from his name. His connection with Cleopatra kept Antony's memory bright. Offering a different model of masculinity, one that did not isolate men, by his intimacy with her Antony narrowed the space that was supposed to keep women and men apart. The relationship between Antony and Cleopatra is Europe's most enduring symbol of intimacy between lovers who, unlike Romeo and Juliet, have lived as adults in the world. At the heart of the European tradition, almost singlehandedly, it keeps alive the promise of a human fulfilment that depends neither on winning nor on achieving flawlessness, but it implies that the price of this fulfilment is death.

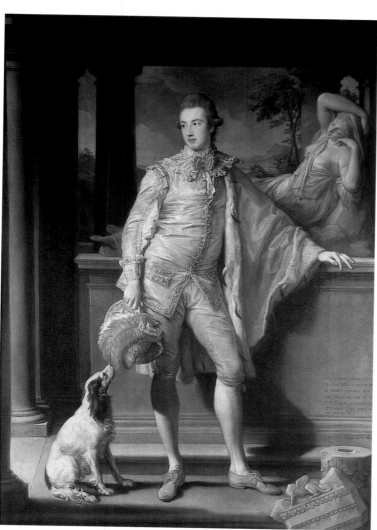

Fig. 11.2 Pompeo Girolamo Batoni's portrait of Thomas William Coke (1774), oil on canvas. The reclining Cleopatra in the background, based on the Vatican sculpture, was said to resemble Princess Louise of Brunswick, unhappily married to the Young Pretender and much enamoured of Thomas Coke (Collection of the Earl of Leicester, Holkham Hall, Norfolk). (Photo Bridgeman Art Library.)

For visual artists, the enigma, the warning and the lure that had become linked with the figure of Cleopatra crystallized around the motif known as Cleopatra's Banquet; several versions are included in the exhibition. As the story goes, Cleopatra invited Antony to compete with her in providing a banquet, boasting that whatever he spent she would outdo him. When the time came and it was her turn, Cleopatra merely loosened one of her earrings, a splendid pearl, and tossed it into the goblet of wine in front of her. Pliny claims that it dissolved there, though he might have had his tongue in his cheek. Cleopatra proceeded to drink the contents of the goblet and if it were not for the protests of the onlookers, including Antony's, so the story goes, she would have followed with the remaining earring, which, like the first, was worth 100,000 sesterces.

The story, which Boccaccio repeats, is first found in Pliny, suggesting that less than a century after Augustus had died an ambiguous note, one that was less hostile both to Cleopatra and to other women, was already daring to make itself heard, for although it was sometimes presented as a symbol of the folly of riches in early emblem books of the Renaissance, this story refuses to be reduced to a simple moral. More than one attitude is expressed: there is wonder as well as hostility; it might almost be called a new myth. Dissolving a pearl in wine is not an experimental result that others have been able to repeat, it is a piece of magic. In the notion of the wager between the lovers an echo of their commensurability is struck; putting a

figure on the cost of the pearl seems to connect Cleopatra with value. But it is the panache of her gesture and its theatrical power, with her ability to act before onlookers, that speak of the charisma that we still connect with Caesar.

Produced out of a deep resistance, the image of Cleopatra, hand extended over a goblet or raised to her ear, is a provocative one. It invites the viewer to think again about women and truth, women and their desires. In the middle of the seventeenth century Jan de Braij, a painter from Catholic Haarlem, chose to play on this when he created a memorial portrait of his family, the parents and siblings of his who had died in the plague a year or two before. He showed his mother as Cleopatra fingering the pearl at her ear, and his father as Antony seated at the banquet, while in one version he is said to have included himself among the other children of the marriage, who also look on. In painting his own mother in the likeness of Cleopatra, de Braij repeated the act of recognition that was made by Caesar when he caused mother and lover to be registered in one woman.

What happens to the desire of such a woman inside marriage, the painting prompts us to ask. The contemporary theologian Francis de Sales had a story of his own about pearls, a story that for a woman cancelled all rights in herself. De Sales taught that 'this jewel signifies spiritually that the first part that a man must have from his wife and which the wife must faithfully preserve is the ear so that no speech or sound may enter it other than the sweet sound of chaste words which are oriental pearls of the gospel.' De Braij expects his viewers to remember this ideal, which is represented in the portrait by the submissive – or is it the mock submissive? – look offered by his mother, and perhaps to compare it with the woman of whom Pliny writes. In choosing to compare his mother with Cleopatra in what seems to have been an act of public mourning de Braij moves the viewer to wonder about the cost of being seen as a good woman.

It was to the image of Cleopatra's banquet that Tiepolo turned, in Venice in the 1740s, when he was moved to challenge a new orthodoxy in Europe, the claim made by Newton that the truth that underlies human experience consists in mathematical equations that can be revealed or demonstrated by using the experimental method. The version included in this exhibition is one of a series that he worked on. In the National Gallery painting (cat. no. 373) he shows Cleopatra as a test case, a small central figure, the cynosure of attention, watched even from the roofs of remote buildings as she sits posed holding the pearl out over a goblet like a demonstrator in an experiment at the Royal Society. As a painter Tiepolo had reason to be sceptical about claims concerning vision and truth, while as a man he may well have felt there was more to life than mathematics. He himself had been trained in the art of kindling the imagination through the eye, an art that he flaunts here by creating extravagantly three-dimensional space, reminding viewers of a more expansive looking that is linked with pleasure.

In painting the actress Kitty Fisher in a pose taken from Francisco Trevisani's earlier banquet, Joshua Reynolds raised the stakes. Trevisani had shown a scene with onlookers and Antony lunging forward in an effort to bring Cleopatra under control. In Reynolds' composition only the figure of Cleopatra remains, taking up all the canvas. Linked by repute with prostitution, actresses were not good women but nor were they easily placed. In choosing a famous actress to model a well-known pose of Cleopatra's, Reynolds compelled viewers to face that they did not know quite who they were looking at in this woman and to hold in tension the desire to control women and the wish to know and be known by them.

Meanwhile, at the level of imagination, Octavian and his authority continued to be recognized as the symbol of all that opposed Cleopatra and what she stood for, including the place of intimacy and pleasure. The image of Cleopatra surrounded by Roman soldiers says it all. Versions of the confrontation between Cleopatra and Octavian are as central to the tradition as images of Cleopatra's banquet and of her death. Yet the story that was told about that meet-

Fig. 11.3 Eugène Delacroix (1798–1863),

Cleopatra and the Peasant Carrying the Basket of Figs,

1838, oil on canvas (Ackland Art Museum,

The University of North Carolina at Chapel Hill).

(Ackland Fund.)

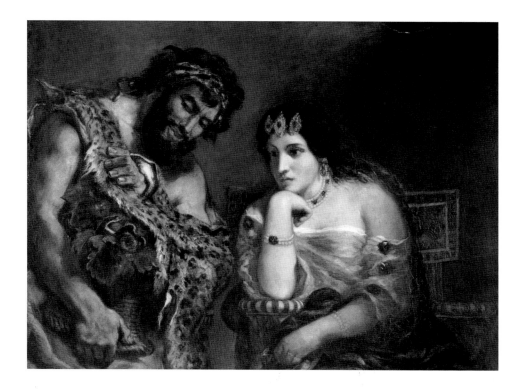

ing changed. Shakespeare had shown it as an occasion on which Cleopatra pitted her intelligence against Octavian's as she tried to find out what he meant to do now she was in his power. But around the mid-eighteenth century Charles Rollin, the French historian and educationalist, revived a version from antiquity that made the emphasis fall differently.

According to Dio Cassius, Cleopatra received Octavian in a room furnished with portraits of Caesar, then attempted to seduce him by reading extracts from Caesar's old love letters. This scenario could sound rather comic, but the graphic images that Rollin's account inspired, from Gravelot, who first engraved it, and from the contemporary painters who took it up, speak of a cynicism that was becoming entrenched (see cat. no. 368). These images deal with the destruction of respect for relationship, a destruction that is carried out in the name of acuity and of clear perception. They put men resolutely on one side of a divide – Octavian is as unmoved as the busts of Caesar – and shame women by putting them, with their rejected invitation, to reach across it on the other. What is more, the story identifies Cleopatra and her invitation with all that is histrionic, manipulative and false: in resisting her Octavian is supposed to demonstrate a penetration that is all the better for being entirely abstract.

At the French Revolution the Augustan contract – that is, the set of political and social arrangements imitated from Rome with which Europe's images of Cleopatra are so closely linked – came under attack. Divorce was introduced and by a unanimous vote slavery was abolished. Though these reforms did not survive, from this moment on the premises that had underpinned Europe's political order were exposed. The link between images of Cleopatra and the order under which contemporary people were living their own lives became more explicit. In his Salon picture of 1838 (fig. 11.3) Delacroix shows a Cleopatra who is in the company of a dark-skinned man wearing a leopard-skin, a figure who would have been instantly recognized as a political symbol from the days of the Revolution.

The slave trade was in operation from the time of Pope Julius but it is a rare image of Cleopatra that engages with the question of her race or asks whether, as the ruler of an African nation, she was herself black. Only late in the nineteenth century did the need to justify Europe's treatment of Africans, in the light of the violence that was associated with colo-

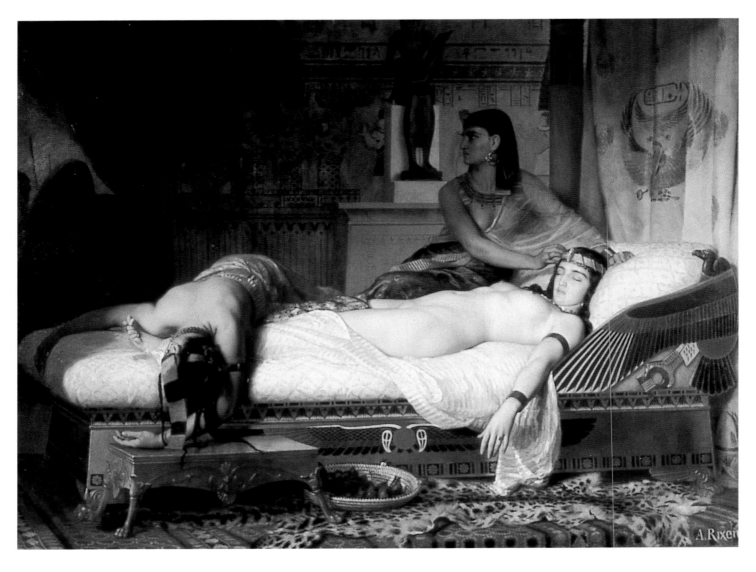

Fig. 11.4 A. Rixens, *The Death of Cleopatra*
(Toulouse, Musée des Augustins).

nialism and the arguments around slavery, bring this issue to the fore. In Europe there followed images of Cleopatra in exotic settings, poisoning slaves, parading in luxury, taking her own life or otherwise demonstrating her distance from the moral values said to be shared in Europe (fig. 11.4). But there is a campy feeling to many of these pictures, a believe-it-if-you-can quality, as if the invitation to scepticism that the figure posed could not be shaken off.

It has been said that it is in America that the implications of European culture are played out. When Thomas Jefferson obtained a copy of the Vatican Cleopatra for his entrance hall at Monticello, well after Winckelmann had pointed out that the piece should not go by that name, he was aligning himself, and the new polity that he played such a large part in founding, with that culture and with the contract that in condemning Cleopatra also invited contempt for the alien culture of Egypt. The American sculptor William Wetmore Story was taking his cue from Rollin when he made a statue of Cleopatra that showed her in humiliation following her rejection by Octavian, but as an American he had an enterprise of his own, one that turned on the question of race. It was 1862 the year in which Abraham Lincoln had promised the end of slavery. Even though it was made out of white marble, the piece that Story created was widely admired as a very 'accurate' and 'daring' portrait of a black woman, a likeness that is by no means obvious to viewers today (fig. 11.5). As Nathaniel Hawthorne's appreciation of the statue in his novel *The Marble Faun* indicates, the image was picked up as

Fig. 11.5 William Wetmore Story (1819–95),

marble statue of Cleopatra, *c.* 1858

(Los Angeles County Museum of Art).

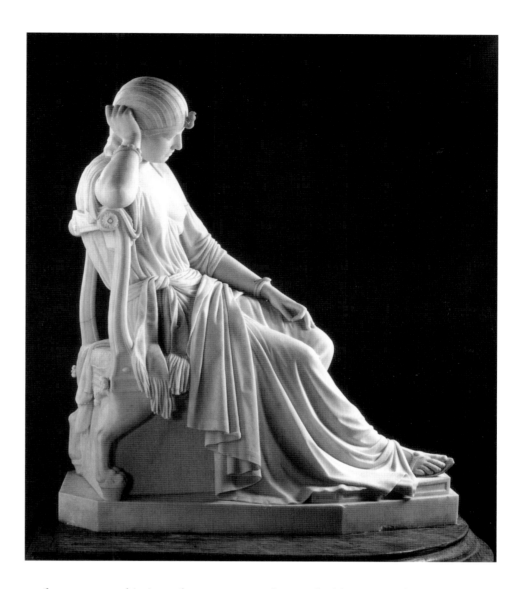

a reference to sexual intimacy between women slaves and white men. In showing Cleopatra both as black and as rejected by Octavian the statue was designed to model a white master's disdain for the advances of a black slave and to repudiate the abolitionist claim that women slaves were taken as mistresses or used for breeding by their white masters.

It is towards the close of the nineteenth century, as some women began to get access to an education more like the one offered to men, that the relation between Caesar and Cleopatra began to move back into view, as though once the structures that underpinned the social order began to shift, new images were thrown up in the minds of artists. It was the story of the twenty-year-old Cleopatra who had herself smuggled into Caesar's presence in a carpet that became a symbol of that relationship, as in the picture by Jean Gérome. The image was taken up by George Bernard Shaw in his play *Caesar and Cleopatra*, and by Cecil B. DeMille in his movie of 1934. In a world in which young women were increasingly pressing to share the lives lived by men outside the home the story of the bold girl who forces her way into the world of men came as a reminder that Octavian's disdainful withdrawal might not be the last word: Caesar may register surprise and alarm at the arrival of Cleopatra, but he is also intrigued. Despite himself, he takes pleasure in Cleopatra, in her refusal to be left out and in her courage.

In the twentieth century it was the medium of film that brought together the stories about Cleopatra with the reality of contemporary lives. When the repressed returned, it was on the

grand scale. Hollywood Cleopatras have always been European (see cat. no. 384): when the question 'Is Cleopatra black?' was asked in DeMille's film, it was raised by an ingenue and she was laughed to scorn. There were very many films about Cleopatra in the early days of cinema, most of them now lost, just as back in the Renaissance, when tragedy was new, playwrights had turned to Cleopatra. The architecture associated with cinema and the conditions in which films were shown, in darkness as if after entry to a tomb, in themselves suggested Egypt. Film images were compared with a pictographic writing, like Egyptian hieroglyphs. Hollywood itself stood in for pleasure and for dreams in a way that made it close to Egypt, close, at least, to all that Europe had repudiated in the name of Egypt, when pleasure became linked with sin. At that time a divorce was made between pleasure and knowledge, a divorce that made it easy for Europe and its philosophers to give precedence to ways of knowing that were intellectual and abstract.

> History has many cunning passages, contrived corridors
> And issues, deceives with whispering ambitions
> Guides us by vanities. Think now
> She gives when our attention is distracted

wrote T.S. Eliot ('Gerontion'), the most scholarly of poets, a man who has often been said to speak for the twentieth century. For Eliot, history itself is a woman, one who is linked with a knowledge that in the end is confusing and disappointing. Under his complaint about ambition and vanity was he also moved by a fugitive longing for an intimacy that been poisoned when in the name of Cleopatra women were framed as aliens and captives within Europe and within its culture?

When they were making *Cleopatra* together in the early 1960s Elizabeth Taylor and Richard Burton, who was married at the time to another woman, began a love affair. The passion that marriage often seemed to defeat in contemporary lives was restored with a flowering of eroticism that took place in full public view. In my youth, as a good Catholic girl who was destined for marriage, I viewed this movie the first time around with great unease. At the time I would have said that I felt offended by its refusal to take Cleopatra and Roman history seriously. Today I would read that unease differently. Beneath the surface, all that was passionate and bold in me was stirred. Unknowingly, I was angry at the fool that had been made of me by my education as a woman, and this movie, with its story of another way of living a woman's life, made me know my own rage.

It has taken the research that led to my book *Signs of Cleopatra* to make me know why the figure of Cleopatra should be an invitation to scepticism as well as a reminder of pleasure. When Elizabeth Taylor in the guise of Cleopatra gave Caesar a great wink on her arrival in Rome, that, too, was an invitation, a vernacular one, that unsettled the decorum of official history, just as those gigantic sets mocked its pretensions.

At the start of the third millennium the figure of Cleopatra is once more under public scrutiny. Today controversy rages again over the body of Cleopatra and, in particular, over her race. When black nationalists in the United States lay claim to Cleopatra, as they do, that attempt is surely made in pursuit of a dignity and a respect that have been denied to black families and their way of life. Countering them are mainly white scholars, who, in defence of 'civilization' and of 'scientific knowledge', as they put it, insist that Cleopatra could not have been black. I find myself asking about this passion for certainty, for a knowledge that is absolute and final, one that cuts off further debate. It is a demand for orthodoxy of belief, a demand more often made in the name of religion than of science.

The figure of Cleopatra cannot be prevented from generating questions for the West, particularly questions about the hidden structures that underpin our present world. In this new

argument over Cleopatra it might be social order itself and the place that it gives to black people that is at stake. About Cleopatra's own family we know both too little and too much. For some people it is too much to know that her parents, Cleopatra V and Ptolemy XII, were brother and sister, for often at the mention of incest minds shut down. On the other hand, we don't know enough: the grandmother who bore both her parents is said to have been 'a concubine' and so goes unnamed and unknown.

There is nothing to tell us what Cleopatra's grandmother looked like, nor from what stock she herself had sprung. What information we do have seems to throw some of our fundamental assumptions into disarray. All those tidy systems for tracking descent and inheritance, for defining families and keeping wealth and power together, fall apart in the face of incest and of sex outside marriage, practices that are by no means confined to the house of Ptolemy, but are found, as we are learning today, all round the world.

It has been one of the fantasies of Europe to dissociate its own culture from such practices, ascribing them instead to those of African descent, just as under Augustus an entire nation and its culture were denigrated when Cleopatra was described as 'the wanton daughter of the Ptolemies'. This tradition of discrediting other cultures and silencing dissident voices, of violence 'in the service of the truth', as Pope John Paul II called it in March 2000, seems to be one that it is not easy for Europe to give up.

324 Gilded silver dish, decorated with a bust perhaps representing Cleopatra Selene

c. AD 1–50

One of 109 silver vessels and toilet articles found
in a villa at Boscoreale, near Pompeii, in 1895

Height 6 cm, diameter 22.5 cm, weight 634.7 g

Paris, Musée du Louvre, Bj 1969

The dish rests on a low ring foot. On the back are
inscriptions giving the weight of the vessel. The
emblema (raised central figure in the bowl of the
dish) is surrounded by two pairs of knotted
branches of olive and myrtle. Depicted in high
relief repoussé (hammered from the back of the
dish, the details being subsequently engraved and
gilded) is a figure of a woman so burdened with
religious and political symbols that her identity
has been the subject of much scholarly dispute.

The woman has a mass of curly hair, arranged
in no recognizable coiffure, framing a face with
strong features suggesting a portrait of a mortal
rather than a personification of, say, Africa or
Alexandria: the nose is long and slightly hooked,
the eyes large and the lower lip and jaw promi-
nent. The ears are pierced for earrings added to
the original and now lost. In this respect, in the
coiffure and in the nose and eyes the representa-
tion recalls the veiled head from Cherchel some-
times identified as Cleopatra VII (cat. no. 262).

On her head the woman wears an elephant
scalp, a symbol of Africa. She wears a tunic with
buttoned sleeves (chiton) which slips from her
left shoulder, recalling the dress of Aphrodite. In
her right hand she holds an asp, and in her left a
single cornucopia. The asp rears against her right
breast, while on her left breast a pantheress con-
fronts it. A lion protects her right shoulder.
Around the bust in lower relief appear (from left
to right as seen by the viewer) the quiver and the
club of Hercules or Omphale, the sistrum (rattle)
of Isis, the dolphin of Poseidon, the pliers of
Hephaistos, the staff of Asklepios, the sword of
Ares and the lyre of Apollo.

Conspicuously mounted on the cornucopia is
a gilded crescent moon set on a pine cone.
Around it are piled pomegranates and bunches
of grapes. Engraved on the horn are images of
Helios (the sun), in the form of a youth dressed
in a short cloak, with the hairstyle of Alexander
the Great, the head surrounded by rays. Below, an
eagle perches on a rock above two stars and
pointed helmets representing the Dioscuri, the
twins Castor and Pollux.

It has been proposed to recognize Cleopatra
Selene (40–4 BC), daughter of Cleopatra VII and
Mark Antony, as the subject of the medallion
portrait (Linfert 1984). The symbols on the cor-
nucopia can indeed be read as references to the
Ptolemaic royal house and specifically to
Cleopatra Selene, represented in the crescent
moon, and to her twin brother, Alexander Helios,
whose eventual fate after the conquest of Egypt is
unknown. The viper seems to be linked with the
pantheress and the intervening symbols of fecun-
dity rather than the suicide of Cleopatra VII. The
elephant scalp could refer to Cleopatra Selene's
status as ruler, with Juba II, of Mauretania. The
visual correspondence with the veiled head from
Cherchel encourages this identification, and
many of the symbols used on the dish also
appear on the coinage of Juba II.

Indeed, the dish appears celebratory, lacking
the negative or amusing references to Ptolemaic
Egypt seen in other media (e.g. cat. nos 356–60).
Other silver vessels from the villa at Boscoreale
suggest a clear allegiance to and interest in the
Roman imperial family, of whom Juba II and
Cleopatra Selene and their son Ptolemaeus were
client monarchs. If the identification is correct, it
is likely that the vessel was commissioned after
Cleopatra Selene's death in 4 BC, most likely
during the reign of Ptolemaeus (AD 23–40).

BIBLIOGRAPHY: A. Heron de Villefosse, 'Le trésor de
Boscoreale', *MonPiot* V (1899), 39ff, no. 1, pl.1; A. Linfert,
'Die Tochter, nicht die Mutter. Nochmals zur "Afrika"-
Schale von Boscoreale', in N. Bonacasa and A. DiVita
(eds), *Alessandria e il mondo ellenistico- romano. Studi in
onore di Achille Adriani* (Rome 1984), 351–8 (bibl.);
F. Baratte, *Le trésor d'orfèvrerie romaine de Boscoreale*
(Paris 1986) esp. 77–81, 90.

S.W.

324 ▶

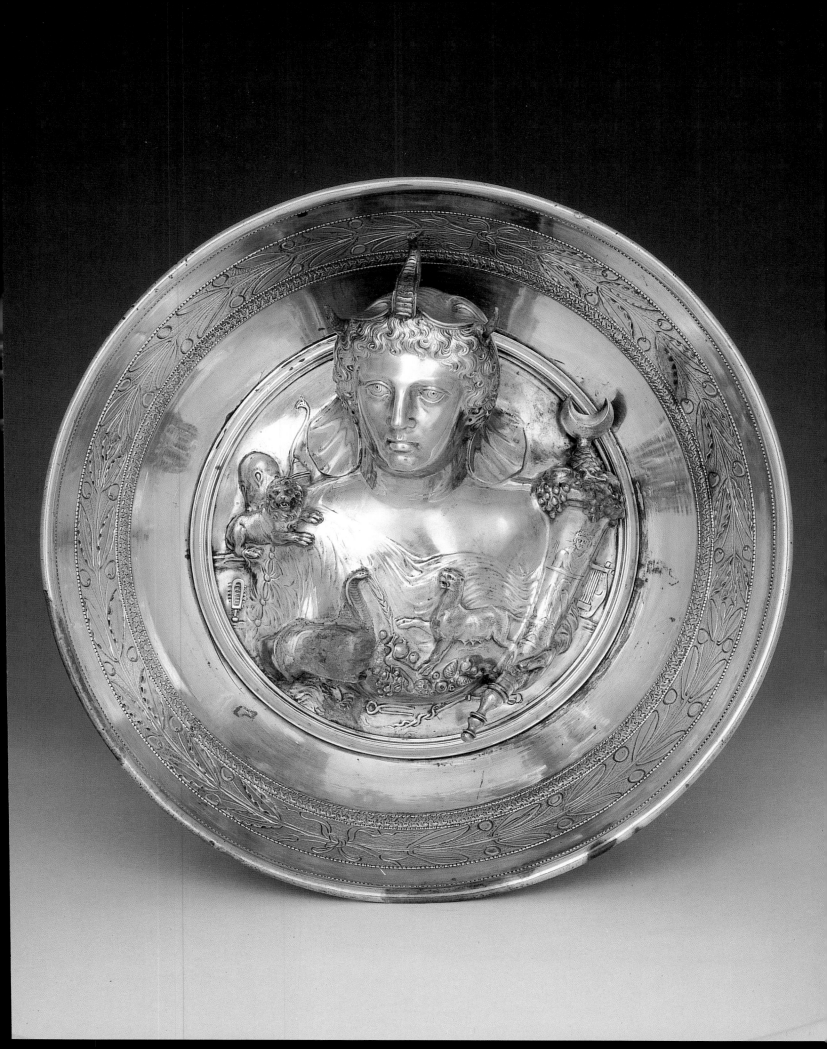

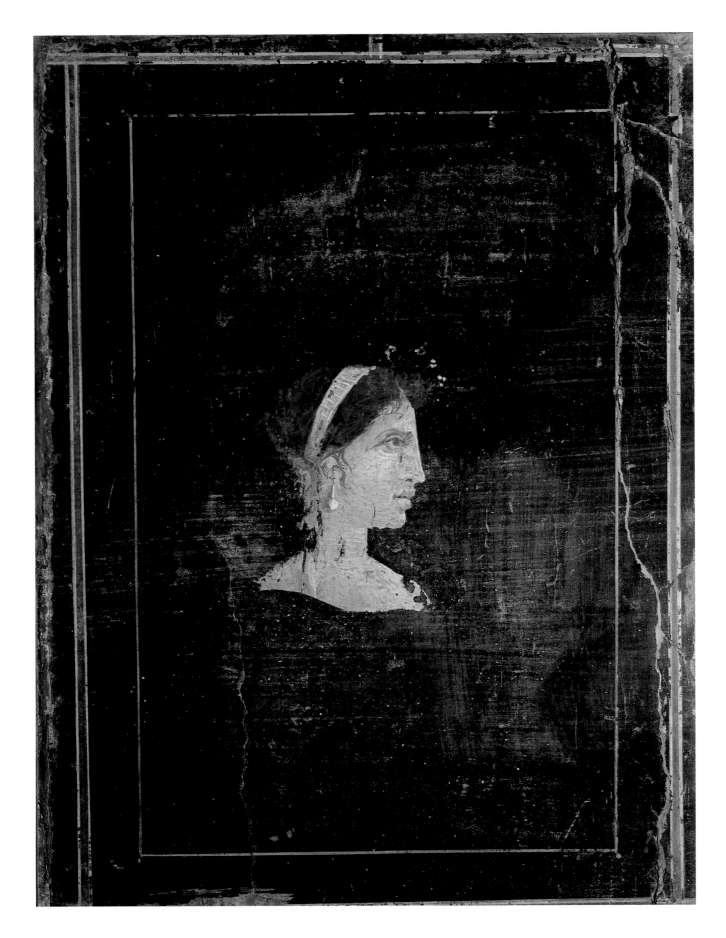

325 Painting with a portrait of a woman in profile

First century AD

Found at Herculaneum

Height 50 cm

Naples, Museo Nazionale Archeologico 90778

The panel comes from a larger decorative scheme from the interior of an unknown building. There are cracks around the edges of the frame, and a large crack running upwards on the left side of the painting.

The large frame with black painted background contains a small bust of a woman in profile. Her face and neck are painted white and her hair reddish-brown, and the rather stark effect is not unlike a cameo, as Reinhard Herbig proposed. She wears a diadem, painted white with a geometric design, and an earring with a ball-shaped pendant. The woman's hair is parted at the centre and then swept back and secured in a bun: a few locks hang loosely in front of her ear. Over the brow a large tuft of hair is painted, rather like the *nodus* found on portraits of women of the later first century BC, and perhaps originally on the marble portraits of Cleopatra from Berlin (cat. no. 198) and in the Vatican (cat. no. 196). The large eye (a late Ptolemaic feature), long nose and full lips are also comparable to the features of Cleopatra as seen on her marble portraits and some of her coins. The effect is somewhat more idealized than for instance, the Antioch coin portraits, but there are similarities. The diadem suggests that this woman is royal.

A close comparison to this painted portrait is to be found on the walls of the House of the Orchard at Pompeii. This house contained several Egyptianizing scenes, and the comparable bust is painted in a frame, not unlike this one, next to a Greek-style sphinx. The woman in the Pompeian painting has a blue crossed-band around her head, not quite a royal diadem, but

the form of the bust is identical. The paintings from the House of the Orchard have been classified within the Third Style of Pompeian Painting, and the room in question has been identified as a Vespasianic (AD 69–79) addition to an Augustan suite, its style following that of the earlier rooms. This portrait from Herculaneum is so like the bust in the House of the Orchard that the two works, though from different sites, may even be by the same painter. Who exactly this woman represents is a mystery, and her resemblance to Cleopatra VII may be coincidental, but it is not completely out of the question that a posthumous image of the famous queen (perhaps derived from a cameo) would have been painted in a Roman house, and possibly in a room with Egyptianizing decoration, like that in the House of the Orchard at Pompeii.

BIBLIOGRAPHY: R. Herbig, *Nugae Pompeianorum* (Tübingen 1962), 19–20 (bibl.), no.17, pl. 31; F.Johansen, 'Antike portraetter af Kleopatra VII og Marcus Antonius', *Meddeselser fra Ny Carlsberg Glyptotek 35* 1(978), 63, fig. 11 (here stated as coming from Stabiae, following the erroneous text of the label in Naples Museum); K. Schefold, 'House of the Orchard', in M. Cerulli Irelli *et al.* (eds), *Pompejanische Wandmalerei* (Stuttgart 1990), 22 with pl. 29. I, 9,5.

P.H., S.W.

326 Glass cameo with a female head

First century BC

Provenance unknown

Height 3.8 cm

London, British Museum, GR 1923.4-1.1062 (Gem 3811)

A chip has broken away, but is repaired. There is some iridescence on the surface, resulting in the loss of some fine detail. The bust of the woman has lost most of its original surface, but the tip of the nose preserves the white polished appearance of the original: the background is brown.

326

The woman faces left and is shown in profile. She wears a vulture headdress over short corkscrew locks that fall almost to her shoulders. She is draped and wears a necklace of oval beads. Her eye is large, the pupil strongly marked, and the nose is pointed, with a distinctly upturned and curved nostril, rather like that found on portraits of the later Ptolemies. Her lips curl upwards slightly, forming a delicate smile. Her chin is short and pointed. The woman's facial features are distinct enough to suggest a portrait, but of whom is unclear. The similarities with Ptolemaic portraits are distinct. It may be an Egyptianizing image, made for a priestess of Isis, or perhaps an early example of Isis wearing the corkscrew locks, formerly reserved for portraits of Ptolemaic queens.

BIBLIOGRAPHY: H.B. Walters, *Catalogue of the Engraved Gems and Cameos, Greek, Etruscan and Roman, in the British Museum* (London 1926), cat.no. 3811.

P.H.

Gaming counters with portraits (cat. nos 327–333)

Counters numbered on the reverse I–XV and with specific images on the obverse were used for a game that apparently originated in Alexandria soon after the Roman conquest in 30 BC. The counters continued to be made at least until the reign of the emperor Nero (AD 54–68), and have been found at various sites in the eastern Mediterranean, in Italy and on the Rhine frontier. The rules of the game are unknown. Some of the obverses were portraits of rulers, named on the reverse.

BIBLIOGRAPHY: On the game, see E. Alföldi-Rosenbaum in *Eikones. Festschrift Hans Jucker* (Bern 1980), 29–39.

S.W.

327 Inscribed ivory game counter with a portrait of Cleopatra's brother

c. 30 BC–AD 70

Provenance unknown

Diameter 2.7 cm

Paris, Bibliothèque Nationale, Cabinet des Médailles (Formerly Dutuit Collection)

327

328

The counter has a suspension hole cut near the upper border; the surface is weathered and there is a crack through the nose of the portrait. The reverse is inscribed in Latin numerals and Greek letters: XIII ΑΔΕΛΦΟΣ ΚΛΕΟΠΑΤΡΑΣ ΙΔ.

The subject, described in the Greek inscription on the reverse as Cleopatra's brother, is portrayed in three-quarter view, his head turned to the right. The flat diadem worn around the head and tied at the nape of the neck is clearly shown. The young king wears a tunic and cloak (*himation*) in civic Greek style, although the large eye shown as if in frontal pose gives the image an Egyptian air. The pose and the prominent ear recall a portrait on an ivory counter in the same collection, identified as the immortal Caesar. Although the formula 'Cleopatra's brother' is known from descriptions of Ptolemy VIII, the subject is likely to be Cleopatra VII's younger brother, Ptolemy XIV, installed in 48 BC as her consort after Caesar's successful defeat of Ptolemy XIII but killed by Cleopatra in 44 BC, following her return from Rome to Egypt in the aftermath of Caesar's murder. A path was thereby cleared for Caesarion, Cleopatra's son by Caesar, to rule jointly with her. The omission of the king's name suggests that it was politically risky to name the subject at the time the counter was made.

BIBLIOGRAPHY: W. Froehner, *Collection Dutuit* (1901), 151; M. Rostovzeff, *Revue Archéologique* V (1905), 110–24, esp. 121; E. Alföldi-Rosenbaum, 'Ruler portraits on Roman Game Counters from Alexandria', *Eikones. Festschrift Hans Jucker* (1980), 29 no. 1 with pl. 7.1, p.35.

S.W.

328 Inscribed ivory game counter with a portrait of Augustus or Julius Caesar

c. 30 BC–AD 70

Provenance unknown

Diameter 2.7 cm

Paris, Bibliothèque Nationale, Cabinet des Médailles

The counter is cracked vertically and obliquely; the reverse is very weathered. This side is inscribed with the Roman numeral I and, in Greek, ΚΑΙϹΑΡ (Caesar)

However, the portrait on the obverse, a head of a man facing left, bears little resemblance to images of Caesar. He has a good head of hair, albeit receding at the temples, with the front locks brushed to one side, the rear in towards the ear. The forehead is lined and the nose very long,

the tip overhanging (compare the portrait of a woman resembling Cleopatra, cat. no. 210). Other facial features and the broad structure of the jaw recall portraits of Augustus. It is not out of the question that the Emperor was intended as the subject, and on Alexandrian coins he is sometimes described as Caesar. However on game counters he is usually called 'Sebastos' (Greek 'Augustus'), and an alternative interpretation would see this as a portrait of Julius Caesar updated to early imperial style. The portrait finishes abruptly at the base of the neck.

BIBLIOGRAPHY: E. Alfoeldi-Rosenbaum, 'Ruler portraits on Roman game counters from Alexandria', *Eikones. Festschrift Jucker* (1980), 29 no. 2 (bibl.), 33–4, pl. 7, 2.

S.W.

329–330 Two bone counters with a male and female portrait

c. 30 BC–AD 70

Provenance unknown

Diameter of 329 2.8 cm, diameter of 330 2.7 cm

London, British Museum GR 1814.7-4.1532; 1974.10-9.99

The surface of no. 329 is generally scratched. Part of the right side of cat. no. 330 has broken away and been repaired. A piece is missing from the

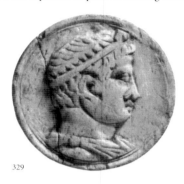

329

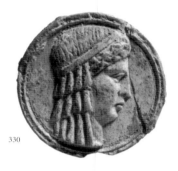

330

bottom of this disc. This counter has a bluish tinge compared with others of its type.

These counters bear heads in profile, and both of the subjects wear the Hellenistic royal diadem. The male figure (cat. no. 329) is shown in bust form wearing a *chlamys* (cloak) secured by a circular fibula on his right shoulder. He wears a diadem, tied at the front, over short locks of hair. His features are summarily rendered, but he has a large eye, a long nose with curling nostril and a short, full-lipped mouth. His chin is square and strong. On the reverse of this counter are the Roman numerals VIII, and below the Greek letter H. The king represented is difficult to identify, and the inscription is of no help. The portrait characteristics best fit one of the earlier Ptolemaic kings.

The female portrait (cat. no. 330) is more carefully executed, with the hair arranged into corkscrew locks that fall in three tiers. The eye is large with sharply defined eyelids, the nose long and pointed with a curling nostril, the upper lip thin but the lower lip fuller, and the chin small and pointed. The cheek is full. On the reverse are inscribed the numeral IIII, the letters CIC (SIS),

and an illegible character. The inscription suggests that Isis is the subject.

BIBLIOGRAPHY: E. Alföldi-Rosenbaum, 'Ruler portraits on Roman Game Counters from Alexandria' in *Eikones Festschrift Hans Jucker* (1980), for the male portrait, see no.13, 30, pl.10.1; for the female portrait, see 38, pl. 11,7.

P.H.

331 Bone counter with a caricatured portrait of a man

First century BC

Provenance unknown

Diameter 2.8 cm

London, British Museum GR 1772. 3-11.86, Sloane Collection

The man has a bulging brow, long pointed nose and a balding crown with a plait of hair hanging at the back. On the reverse is lightly incised the numeral VIIII and a reversed C with a dot in the centre.

UNPUBLISHED.

S.W.

332 Bone counter with a caricatured portrait, perhaps of the empress Livia

First century BC–first century AD

Provenance unknown

Diameter 2.8 cm

London, British Museum GR 1814. 7-4.1531.2, Townley Collection

The subject has her hair dressed in a wide, flat *nodus*. The hair is drawn back over the ear to form an elongated bun at the nape of the neck. The brow is furrowed, the nose strongly hooked, the lips thick, and the chin and neck angular. On the reverse is inscribed the numeral XII, and beneath, in Greek, (Λ)IB[IA], (L)IV[IA].

UNPUBLISHED.

S.W.

333 Bone counter with a portrait of a North African man

First century BC–first century AD

Provenance unknown

Diameter 2.8 cm

London, British Museum GR 1890.6-1.167

The counter is intact, but the surface is slightly scratched and discoloured.

The counter bears a portrait of a balding man, the hair clinging to the back of his skull rendered in tight, short curls. The man has a prominent brow, pronounced cheekbones and a bony face. These features contrast with his large, fleshy nose and lips. The advanced age of the subject is indi-

331

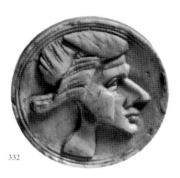

332

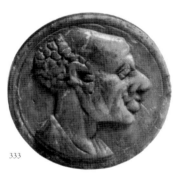

333

cated by his scrawny neck and slightly sagging flesh. The bust shows traces of drapery over his shoulders. The facial features appear to represent a man of North African descent.

On the reverse, are the Roman numerals XIII then, in Greek, the name ΠΑΡΑΙΤΟΝΙΝ and beneath that the letters IΓ. The Greek word does not translate easily but is a form of the verb 'to beg'; the image may then have been intended to represent a beggar.

UNPUBLISHED.

S.W.

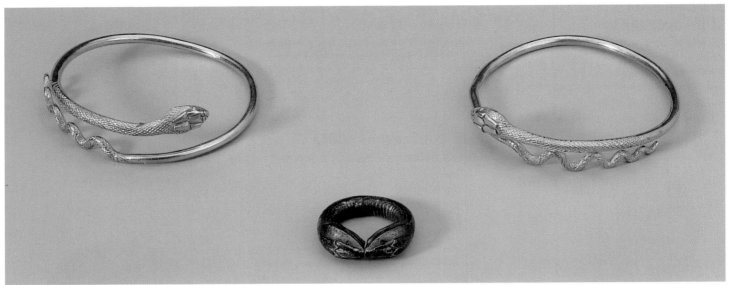

334 (top left and right), 335 (centre)

334 Pair of gold spiral bracelets in the form of serpents

First century BC–first century AD

Provenance unknown

Diameter 6.6 cm.

London, British Museum GR 1917.6-1.2780-2781
(Jewellery 2780-2781).

Each bracelet consists of a solid gold rod that has been twisted into a coil that forms the body of the snake. Only the scales of the forepart and tail of each snake have been indicated by chasing, and even then, only on the top surface. The snake's mouth is slightly opened, showing the lightly indicated teeth. Similar spiral bracelets have been found in Egypt and at Pompeii and Boscoreale in Italy.

Spiral bracelets in the form of twisting snakes were popular throughout the Hellenistic and Roman periods. It was thought both that the snake was a potent symbol of fertility and that it had healing powers. The snake played an important role in the cult of Asklepios, the Greek healing god, because, as the snake lived underground in the dark, then emerged as the sun rose, it designated the transition from the underworld to the upper world. This, then, was a symbol of life and death, sickness and health, fertility and infertility.

Snakes were also connected with several other religious cults. The Egyptian goddess Isis and Dionysos Sabazios, a god whose image and cult assimilated Dionysos with the Phrygian god Sabazios, were worshipped primarily with mysterious rites connected with the afterlife, and snakes often play a major role in the iconography of the representation of these deities.

BIBLIOGRAPHY: F.H. Marshall, *Catalogue of Jewellery, Greek, Etruscan and Roman in the Department of Antiquities, British Museum* (London 1911), nos 2780–1; R. Blurton (ed.), *The Enduring Image: Treasures from the British Museum* (London 1997), cat.no.98; C. Johns, discussion of snake bracelets in S. Walker (ed.), *Ancient Faces* (exh. cat., The Metropolitan Museum of Art, New York) (New York 2000), 151–2.

P.H.

335 Silver snake ring

First century BC–first century AD

Obtained in Rome

Diameter 3 cm

London, British Museum GR 1917.5-1.1136 (Ring 1136)

This intact two-headed snake ring is an unusual type, with the heads almost meeting at the top. The scales are carefully engraved, with those on the upper part of the snakes' bodies small and overlapping, and those underneath broad and ribbed. The heads are particularly fierce in appearance, with the mouths opened to reveal a strip of metal forming the tongue. The beady eyes are placed beneath a heavy hood of skin, and are picked out with tiny carnelian stones.

BIBLIOGRAPHY: F.H. Marshall, *Catalogue of the Finger Rings, Greek, Etruscan and Roman in the British Museum* (London 1907), no. 1136.

P.H.

336 Roman terracotta lamp with an Egyptianizing scene

c. AD 40–90

Made in Italy

Restored length 35.3 cm

London, British Museum, GR 1836.2-24.455
(Lamp Q 1021) (Purchased from the Durand Collection)

Only the rear and upper part of the body are ancient: the nozzles are restored (but wrongly angled) in fired clay; the underside is completed with the base of an ancient pot.

The handle-ornament of this very large lamp shows an obelisk with indications of hieroglyphs, including a royal cartouche. It is flanked by Seshat, the Egyptian goddess of writing and the recording of history, and the ever popular child god, Harpokrates. Seshat wears a long tunic (chiton) and shawl (himation), and a headdress, partially restored, apparently of bird form. She holds a looped garland or perhaps a pen in her right hand and a palm-branch in her left; from her left wrist hangs an inkwell. Harpokrates is naked, with his right hand to his mouth, and has the sidelock of male childhood. In his left hand he holds the royal crook and flail, and perhaps a feather; he wears a crown of horizontal ram's horns surmounted by a sun disc flanked by leaves. Behind him is a tall basket containing ring-shaped objects. Directly below the plinth of the obelisk is a hawk with wings displayed but drooping; on the stem of the handle-ornament are three lotus flowers. This scene is incongruously matched with a representation of Herakles and the Nemean Lion on the top of the lamp.

BIBLIOGRAPHY: J. de Witte, *Description des antiquités et objets d'art qui composent le cabinet de feu M.Le Chevalier E. Durand* (Paris 1836), Lot 1778; H.B. Walters, *History of Ancient Pottery, ii* (London 1905), pl. LXIII; H.B. Walters, *Catalogue of the Greek and Roman Lamps in the British Museum* (London 1914), cat. no. 832; D.M. Bailey, 'A Giant Roman Lamp', *Museums Journal* 59 (1960), 265–7; D.M. Bailey, *A Catalogue of the Lamps in the British Museum ii, Roman Lamps Made in Italy* (London 1980), cat. no. Q 1021; Tram Tan Tinh, 'Harpokrates', in Tram Tan Tinh *et al.*, *Lexicon Iconographicum Mythologiae Classicae iv*, 1 (Zürich 1988), 374, 439.

D.M.B.

336 ▶

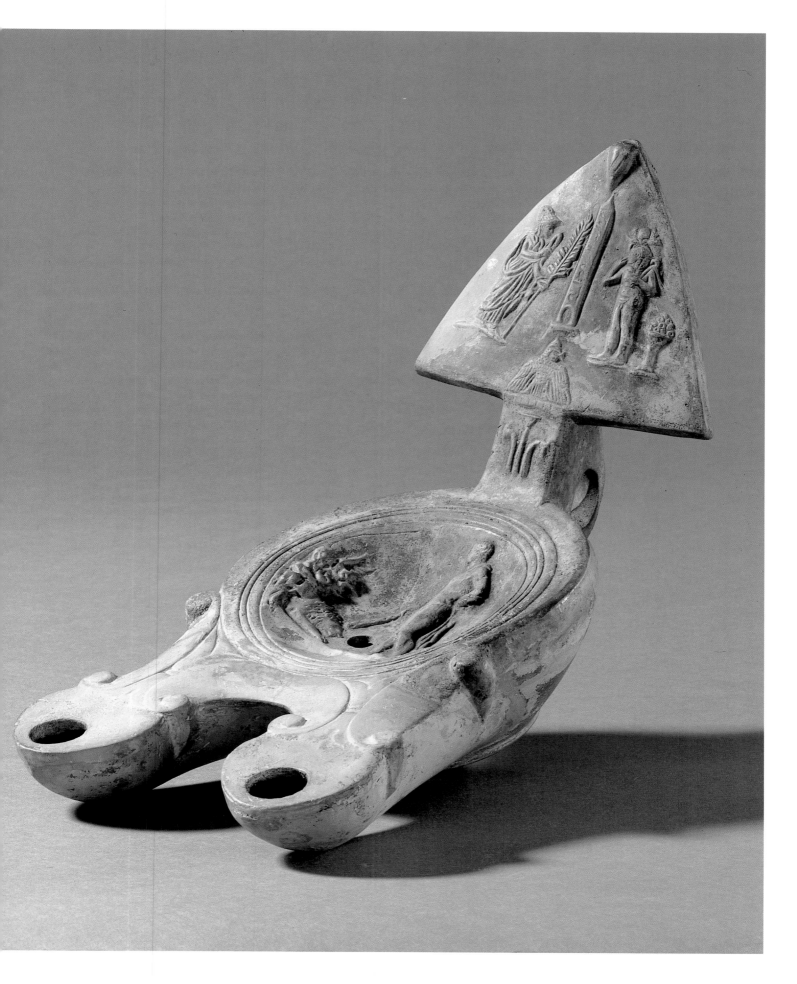

337 Marble head from a statue of a woman

First century BC–first century AD

Found in the Temple of Isis, Pompeii

Height 30 cm

Naples, Museo Nazionale Archeologico 6290

Only the head survives of a figure that may have been acrolithic, the body made of wood or another material. A metal pin is preserved on the

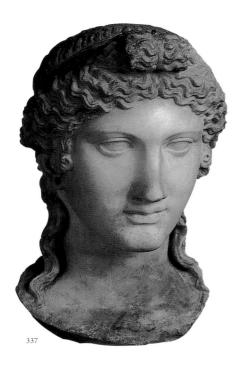

337

top of the head, behind the *lampadion* (top-knot of hair), and the ears are pierced to receive earrings. The head is remarkably well preserved, and the surface of the marble is in good condition.

The head turns slightly to the subject's left and gently bows down. The hair is parted centrally, then is waved in thick locks, which are confined at the top by a fillet, behind which the hair lies close to the crown, while in front the locks are fuller. The hair is secured at the back in a bun, but a few locks escape this formal arrangement and hang freely down the sides of the neck and fall on to her shoulders. Two short and curly locks of hair hang in front of the pierced ears.

The woman has a long, oval-shaped face, almond-shaped eyes, a long, slender nose and slightly parted narrow lips, the upturned corners of which almost form a smile. These characteristics can be found on a series of similar heads also found in the sanctuary of Isis at Pompeii. All of them survive as heads and necks only, carved to be inserted into bodies, and are also well preserved. The subtle smile is a feature of semi-archaizing works of the late Hellenistic period, but in general the heads of these statues tend to be more or less fully up to date in style. The bodies of archaizing statues, however, are often draped in garments arranged in a manner looking back to Attic Greek works of the sixth century BC: the poses are also stiff and frontal. In fact, the only full-length statue to survive from the Isis sanctuary is a fully archaizing statue of the goddess Isis, identified by the sistrum that she carries. This figure was in all likelihood the cult statue of the temple. The individual heads are of larger scale but follow a similar style. The head in this exhibition and the others from the sanctuary, some of which have archaizing hairstyles, may have been statues of devotees of Isis or even priestesses.

BIBLIOGRAPHY: S. Adamo Muscettola, 'La decorazione architettonica e l'arredo', in *Alla ricerca di Iside: Analisi, studi e restauri dell'Iseo pompeiano nel Museo di Napoli* (Rome 1992), 68, cat. no. 3.3; for the complete statue of Isis see above, p. 278, fig. 9.2; L.A. Scatozza Höricht, 'La scultura greco-romana' in *La Collezioni del Museo Nazionale di Napoli* (Rome 1989), 96, cat. no. 10.

P.H., S-A.A.

338 Bronze figure of Isis

First century BC

Said to have been found near Mount Vesuvius

Height 9.7 cm without base

London, British Museum GR 1824.4-51.3 (Bronze 1467) (Bequeathed by Richard Payne Knight)

The figure has been mounted on a new base. Her right arm with the hand holding the patera is restored. The original arm would not have been raised so high as this, but was probably outstretched. Traces of gilding survive on the goddess's face, neck and on the situla.

The subject wears a chiton over which a himation is draped and secured in a knot between the breasts. This costume, the tripartite wig, vulture headdress and striding stance are all features that are influenced by earlier Egyptian-style representations of Ptolemaic queens (see cat. nos 164–169). In her left hand she holds a situla, while the other hand may originally have held a sistrum, as seen on similar examples of the type.

BIBLIOGRAPHY: H.B. Walters, *Catalogue of the Bronzes, Greek, Etruscan and Roman in the Department of Greek and Roman Antiquities, British Museum* (London 1899), no. 1467.

P.H., S-A.A.

338 ▶

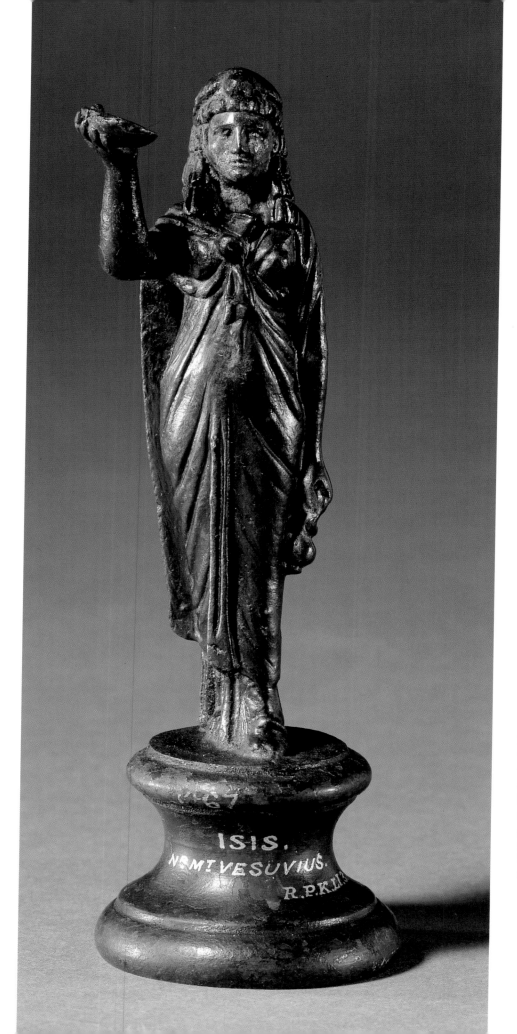

339

339 Gold finger-ring with a figure of Isis

Second–first century BC

Probably from Italy; formerly in the Hamilton Collection

Length 1.9 cm

London, British Museum GR 1772.3-14.25 (Ring 240)

This ring shows a standing figure of a draped female wearing a high-girdled chiton and himation; a sash is draped across the body diagonally. In her right hand she is carrying a sistrum, in her left a situla. Her hair is styled in corkscrew locks that fall on to her shoulders, and on her head she wears an Egyptianizing crown consisting of a double plume and a sun disc. This type of crown is commonly associated with the goddess Isis, and is also worn by Ptolemaic queens.

BIBLIOGRAPHY: F.H. Marshall, *Catalogue of the Finger Rings, Greek, Etruscan and Roman in the British Museum* (London 1907), no. 240.

P.H., S-A.A.

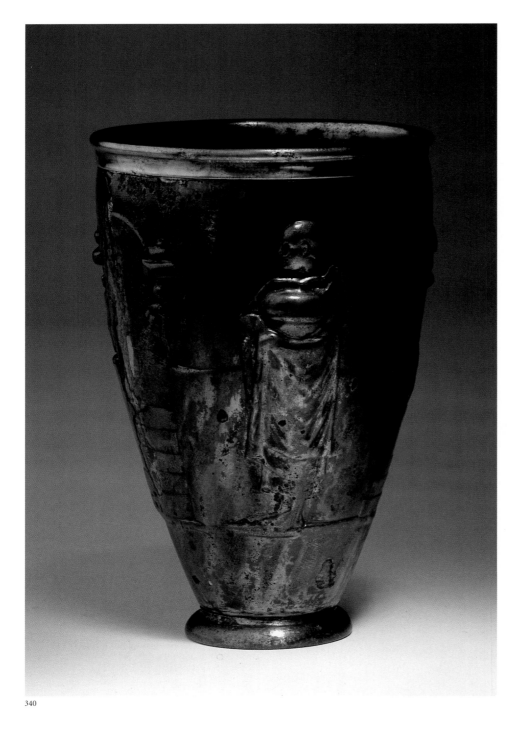

340

her head is decorated with a headdress in the form of a bird that echoes the vulture-like crowns of Egyptian queens. She holds on a small altar base in her right hand a small statue of a god, perhaps Sokar.

The priest, with a traditionally shaved head, is wearing a tunic and mantle covering his hands as a mark of respect while he carries a sacred rounded vase. The clothing and position of the covered hands have been observed in other portraits and images (compare the reliefs of the sculptured columns from the Sanctuary of Isis in the Campus Martius, now in the courtyard of the Capitoline Museums and the Egyptian Museum in Florence), and suggest that the figure is a high-ranking priest who was authorized to carry images of the gods and the most sacred objects during processions.

The cup, like its pair, was used in religious rites celebrated in the cult of Isis and was made by craftsmen based in the region of Campania.

BIBLIOGRAPHY: A. Maiuri, *Notizie degli scavi di antichitá communicate all (Reale) Academia dei Lincei* 1939, 223 ff, no. 2, ill. 12 ; M. De Vos, 'Egittomania nelle case di Pompei e di Ercolano', in *Civiltà dell'antico Egitto in Campania* (Naples 1983); E. Pozzi, *Le Collezioni del Museo Nazionale di Napoli* I,1 (Rome 1989), 210 no. 38; E.A. Arslan (ed.), *Iside: il mito, il mistero, la magia* (Milan 1997), 432.

C.Al.

341 Painted Fourth Style fresco: the ceremonies of the cult of Isis before a temple

First century AD

From Herculaneum

Height 74 cm, width 52 cm

Naples, Museo Nazionale Archeologico 8919

Numerous priests and some followers of the cult participate in the ceremony, which takes place in a *temenos* (enclosed sanctuary), at the foot of a stairway to a small temple, or more probably a sacred cloister, perhaps dedicated to Isis. The compound is surrounded by a high battlemented wall, beyond which we can glimpse a palm tree; some branches, also of palm, hang from the columns of the temple.

Around the marble altar, made ready for the sacrifice at the foot of the stairway, two ibises are foraging. These birds, sacred to the god Thot, are constantly included in Nile river scenes or images of Egyptian rites, perhaps to convey a sense of exoticism to the setting (in the relief from Ariccia (cat. no. 346), for example, a long line of ibises decorates the precinct of Isis). Some officials are dressed in long white gowns, typical of Egyptian priests, while others wear skirts and white mantles, and have shaven heads. The cult followers,

340 Embossed silver cup with Isiac procession

c. 30 BC–AD 14

Large Palaestra, Pompeii

Height 11.5 cm, diameter 7.8 cm.

Naples, Museo Nazionale Archeologico 640 (=6045)

The cup, found along with another depicting an analogous Isiac scene (Naples, Museo Nazionale Archeologico 6044), is finely embossed with figures taking part in an Egyptian ritualistic procession, as fully described by both iconographic and written sources.

The two figures, a priest and a woman in the dress of Isis, move forward towards a sacred area where there are palms and high steps leading to a building with a semicircular arched façade supported by small pillars, each flanked by two nude female figures acting as caryatids. On the arch situated at the top of the stairs there is a vase with a statue of the falcon-god Horus on top.

The priestess is dressed in a long tunic and

including women and some children, are wearing tunics of different colours.

The principal act of the ceremony takes place at the top of the steps, where an individual dressed as a Roman centurion, whose head is embellished with fronds, perhaps palm leaves arranged as a halo (Apuleius, *Metamorphosis,* XI, 24), performs a ritual dance. The rhythm is beaten out by the clapping hands of the priests and the sistra, along with other musical instruments. Within the temple, we can glimpse other priests and adherents of the cult, one of whom is wearing a blue tunic. Some priests, at the foot of the stairway, kneel with arms raised in a sign of adoration.

BIBLIOGRAPHY: V. Tran Tam Tinh, *Le Culte des Divinités Orientales à Herculanum. EPRO* XVII (Leiden 1971), fig. 41, cat. nos 59, 85–86; *Le Collezioni del Museo Nazionale di Napoli,* I.1 (Rome 1989), 160, n. 270; E. Arslan (ed.), *Iside: il mito, il mistero, la magia* (Milan 1997), 447.

C.Al.

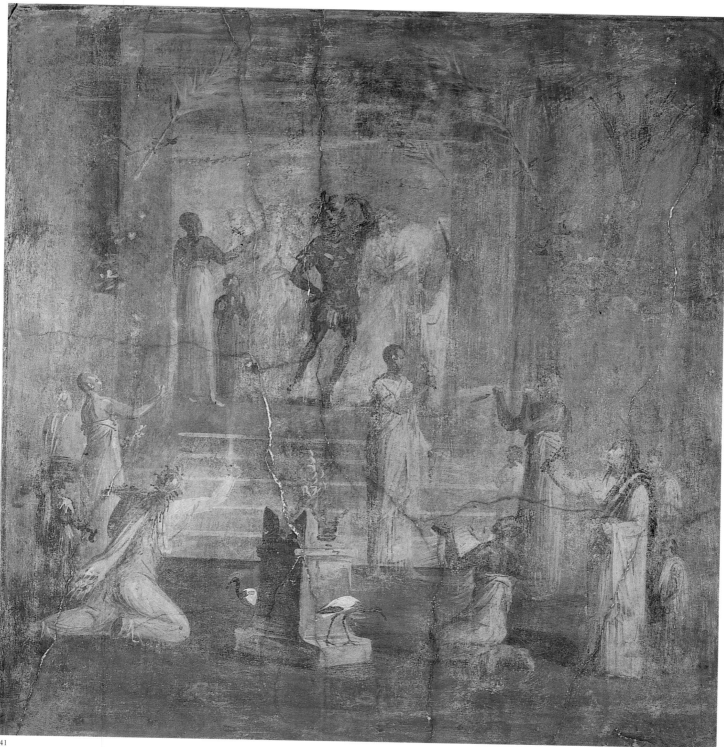

341

342

342 Fresco painting of a priest of Isis with an oil lamp

First century AD, Fourth Style

Temple of Isis, Pompeii

Height 44 cm, width 30.5 cm

Naples, Museo Nazionale Archeologico 8969

Along with similar vignettes depicting priests of Isis with various sacred objects, this fresco decorated the western side of the south portico of the Temple of Isis in Pompei.

The vignettes were painted in the centre of monochrome panels intended for a religious context.

Against a background of architectural elements, we see a priest wearing a long fringed dress knot-ted slightly below his armpits, and white ritualistic sandals; his head is shaved in accordance with Egyptian custom. In one hand he carries an oil lamp with two separate golden spouts, a liturgical instrument associated with the cult of Isis. The clothing and the oil lamp are well-documented in written sources such as Apuleius, *Metamorphosis*.

BIBLIOGRAPHY: O. Elia, *Le pittura del tempio di Isis. Monumenti della Pittura Antica scoperti in Italia* (Rome 1941), 1; E. Pozzi, *Le Collezioni del Museo Nazionale di Napoli* I, 1 (Rome 1989), 162, no. 274 ; E.A. Arslan (ed.), *Iside: il mito, il mistero, la magia* (Milan 1997), 425; V. Sampaolo, in *Alla ricerca di Iside. Analisi, studi e restauri dell' Iseo pompeiano nel Museo di Napoli* (Rome 1992), 48 no. 1.30.

C.Al.

343 Fresco painting of a priest wearing a mask of Anubis

First century AD, Fourth Style

Temple of Isis, Pompeii

Height 38.7 cm, width 29.8 cm.

Naples, Museo Nazionale Archeologico 8920

This fresco depicting a priest of Isis comes from the southern side of the west portico of the Temple of Isis and thus served both as decoration and as a narrative of sacred elements of the cult.

Against a background of architectural elements, the priest stands dressed in a long red mantle, white sandals, and a mask in the form of a dog's head that completely covers his head. Priests were frequently dressed in such a manner during ritual celebrations in the sanctuaries of Isis and Serapis in Italy.

Anubis was amongst the most important Egyptian gods, including Isis, Osiris, and Horus, with followings in Rome. Although opposed and derided for its excessively wild and animal nature, his cult survived for more than three centuries. Opposition to Anubis grew increasingly harsh after Octavian's victory at Actium, when it was easier for the anti-Egyptian propagandists to single out the barking Anubis as a barbarous and monstrous divinity (as portrayed in the writings of Virgil, Propertius, Ovid and Lucan). Nevertheless, Anubis remained extremely popular: priests wearing masks depicting the god were a common sight even in the streets of Rome. In the proscriptions of the civil wars following Caesar's murder in 44 BC the magistrate Marcus Volusius escaped from a building dressed in an Anubis mask, a story recounted by Appian and Valerius Maximus. Repeated scandals linked to devotion to the god depicted with a dog's head provided the pretext for severe persecutions against Egyptian gods and their priests – for example, the incident involving the cavalry officer Decius Mundus and the matron Paulina that took place near the Tiber and was recorded by Flavius Josephus.

BIBLIOGRAPHY: O. Elia, *Le pitture del tempio di Isis. Monumenti della Pittura Antica scoperti in Italia* (Rome 1941), 16; *Le Collezioni del Museo Nazionale di Napoli, I, 1* (Rome 1989), 162 n. 276; V. Sampaolo in *Alla ricerca di Iside. Analisi, studi e restauri dell'Iseo pompeiano nel Museo di Napoli* (Rome 1992), 49 n. 1.36; E.A. Arslan (ed.), *Iside: il mito, il mistero, la magia* (Milan 1997), 426.

C.Al.

343 ▶

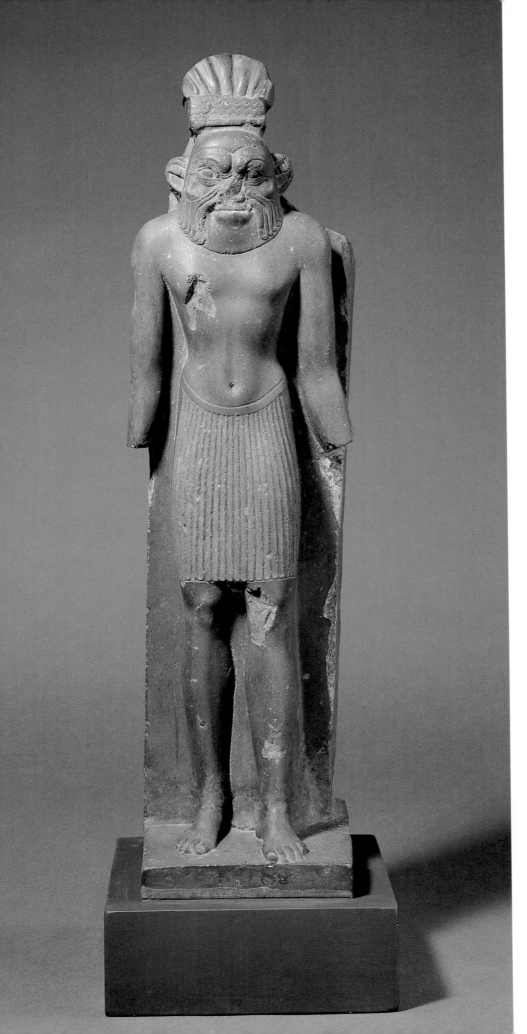

344 Schist figure of a man wearing a mask of Bes

First century BC–first century AD

Bought in Rome by the first Earl Cawdor, afterwards in the Townley Collection

Height 63 cm

London, British Museum EA 47973

Damage has occurred to the nose, right cheek, the left pectoral muscle and the right arm. Both hands have broken away, and the crown has been repaired. The figure has been left unfinished at the back and the sides, where a back pillar was intended, but only partly worked on the proper right side of the figure.

This unusual representation of what appears to be Bes is unlikely to be the god, because of the human form of the body: Bes is usually shown with a flabby, animal-like physique, with stumpy legs, and a hugely distended head (see cat. no. 119). Here the figure is designed according to the ideal Egyptian canon of human form, with square shoulders, arms held out to the sides, a narrow waist, with a well-defined navel, and one leg placed in front of the other, but both feet flat on the ground. The figure wears a kilt, not seen in representations of Bes. It seems probable, therefore, that the subject is human, perhaps a priest of Bes, wearing a mask and crown, for ceremonial activities. This supposition may account also for the flat appearance of the face. A wall painting from the Iseum at Pompeii (cat. no. 343) shows a robed priest with a mask of the jackal-headed god Anubis.

UNPUBLISHED.

P.H.

345 Sestertius of the emperor Vespasian (AD 69–79) depicting a Temple of Isis

AD 71

Spanish mint

London, British Museum BMC Vespasian 780 (*RIC* 453)

The worship of the Egyptian goddess Isis became popular in Rome and throughout the empire during the imperial period. The temple shown on this coin of the late first century AD reveals the cult statue of the goddess standing between its four frontal columns.

UNPUBLISHED.

J.W.

345

346 Marble relief: scenes in an Egyptian temple

First century AD

Ariccia, near Rome

Lenght 111 cm, height 50 cm, thickness 6 cm

Rome, Museo Nazionale Romano, Palazzo Altemps 77255

While some works were being carried out in Pratolungo, in the vicinity of the Church of Santa Maria della Stella near Ariccia, a grave was uncovered, without any external structure, about 15 metres from the side of the Via Appia. The simple grave was edged by two marble fragments and covered with a marble slab decorated with reliefs depicting Egyptian scenes, the whole covered with a tile.

Given the quality of the marble, and the size, style and subject matter of the reliefs, it is probable that a decorated fragment, previously in the Staatliche Museum in Berlin (no. 16777-10a) and lost during the Second World War, came from the same tomb. The marble fragments, reused to regularize the second-century grave, originally formed part of another monument dating no later than the first century AD.

The two reliefs are examples of superior Roman craftsmanship. All of the motifs and pharaonic elements were produced by means of classical, not Egyptian, techniques and rules of design. The scene depicted in the relief is carved in perspective in two registers and shows the interior of a temple dedicated to an Egyptian god.

It is easy to make out one of the long sides of the massive external wall that enclosed all of the sacred area, and some side chapels outlined by the intercolumniations of a portico that surrounded the right and left sides of a large courtyard. The largest chapel is dedicated to a female divinity seated on a throne surrounded by fountains spouting water. The six identical chapels flanking the larger chapel are dedicated to Bes (in the centre of each group) and to Thoth, in the form of a baboon, flanking Bes.

Thoth is also present in the form of numerous ibis, which are represented scratching about in a basin in a long ornamental line, placed as a frieze beneath the central register of dancers. Here, the ibis has a decorative rather than a sacred significance. It was a typical Egyptian bird, useful in confirming the exotic air of the entire scene. Some other birds of prey are crouched down as a sacred motif decorating the peristyle. The portico is formed by spiral and smooth columns, all with ionic or composite capitals.

A statue of the bull Apis is set on a high pedestal, while a circular temple-shrine dedicated to a female divinity and another shrine dedicated to a divinity fill the courtyard, in accordance with information provided in paintings from Pompei, inscriptions, and other archaeological finds. The tall palm trees found in the empty spaces between the chapels suggest a pleasant, lush envi-

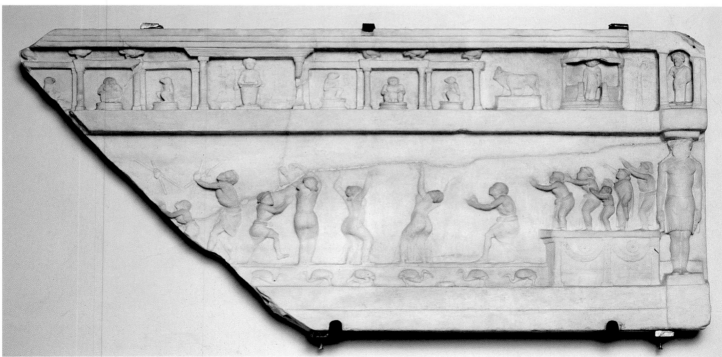

346

ronment, again confirming information provided in literary sources (for example, Strabo, *Geogr.* V, 3,8; Juvenal, *Satires* VI, 488–489; Ovid, *The Art of Love* I, 77–78).

On the fragment formerly in Berlin it is possible to make out two chapels with a sitting male sphinx with a human head and a standing female statue; a statue of Apis on a podium with a tall palm tree is in the background.

On the Rome relief the courtyard is flanked by a impressive telamon in Egyptian dress, and its centre is filled with men and women taking part in a dance with lively and vivacious movements performed to a rhythm provided by people placed on a monumental podium decorated with festoons. Some dancers, amongst them dwarfs, accompany the dance with rods and sticks. The men are wearing short skirts, knotted in the front, while others have long skirts reaching down to their ankles, typical of the clothing worn by priests. The female dancers have gathered hairstyles and are wearing very light, pleated tunics. The dance is most probably part of a sacred ritual performed for the goddess Isis and its movements as well as the presence of the dwarfs remind us of many works of art with an Egyptian flavour typical of the early years of the Roman empire.

The two reliefs are enormously valuable, as they describe the structure of a Roman temple dedicated to Egyptian divinities, probably the Iseum in the Campus Martius, about which we know very little.

BIBLIOGRAPHY: R. Paribeni, 'Ariccia. Rilievo con scene egizie', *NSc* (1919), 106–12; J. Roullet, 'The Egyptian and Egyptianizing Monuments of Imperial Rome', *EPRO* 20 (1972), 27–8, fig. 20; K. Lembke, *Das Iseum Campense in Rom, Archäologie und Geschichte* 3 (Heidelberg 1994), 174–6, n. 1 tav. 31; K. Lembke, 'Ein Relief aus Ariccia und seine Geschichte', *RM* 101 (1994), 97–102; E.A. Arslan (ed.), *Iside: il mito, il mistero, la magia* (Milan 1997), 664.

C.Al.

347 Torso from a basanite statue of a priest

Ptolemaic era

Iseum Campense (Temple of Isis, Campus Martius), Rome

Height 81.5 cm

Rome, Museo Nazionale Romano, Palazzo Altemps 362623

The statue is slightly less than life sized; the head, collar and both legs are missing from just above the knee as a result of ancient fractures. The dorsal pillar is uninscribed.

The torso is easily identifiable as belonging to a statue of an Egyptian from the characteristic dress of a half-sleeved tunic and a mantle with fringes, draped against the body, where it is held in place by a hand, the shoulder bared. The cloth-

347

ing and the posture of the body and arms are of a type quite widespread in the Ptolemaic era.

The sculpture was found by chance in 1987, together with a statue of a headless sphinx and the rear part of a recumbent lion, during excavations for the installation of an underground generator for Palazzo del Seminario, acquired to serve as the official library and office of the Camera dei Deputati (House of Representatives of the Italian Parliament). The excavations took place in the Great Courtyard and its garden within the Palazzo complex, which had formally been a Dominican monastery. It was in this area that the Iseum Campense (Temple of Isis of the Campus Martius) was located. The three sculptures of Ptolemaic era lay together with other fill from the same area at a depth of nearly three metres, piled there to strengthen the foundations of Palazzo del Seminario.

Following the statue's lucky discovery, excavation campaigns were undertaken from 1991 to 1993 by the Archeological Superintendency of Rome.

The priest's torso was one of a number of works from the Saitic and Ptolemaic eras, the most consistent group within the large number of works of art brought from Egypt in imperial times to decorate the Temple of Isis in Rome.

BIBLIOGRAPHY: K. Lembke, 'Das Iseum Campense in Rom, Studien über den Isiskult unter Domitian', *Archäologie und Geschichte* 3 (1994), 236, pl. 41, 8, 4; E.A. Arslan (ed.), *Iside: il mito, il mistero, la magia* (Milan 1997), 390.
C.Al.

348 Head from a statue of a priest of Isis

50 BC–AD 50

Rome, recovered from works carried out along the river bed of the Tiber

Height 33 cm

Rome, Museo Nazionale Romano 1184

The thin, elongated and completely shaved head together with the vertical scar suggest that the subject is a priest of Isis as portrayed in the painting of the lamp-bearing priest from the Iseum at Pompei (cat. no. 342), or on the embossed silver cup bearing a religious scene pertaining to the cult of Isis found in Pompei and which today is displayed in Naples (cat. no. 340).

The sculpture belongs to the so-called Egyptian type of shaven head, dating between the middle of the first century BC and the middle of the first century AD, and attesting to the influence Egypt had on the Roman world and the diffusion of the cult of Isis.

An exact dating of the sculpture housed by the Museo Nazionale Romano has proven difficult (Cellini 1979), and oscillates between the second half of the first century BC, the Julio-Claudian

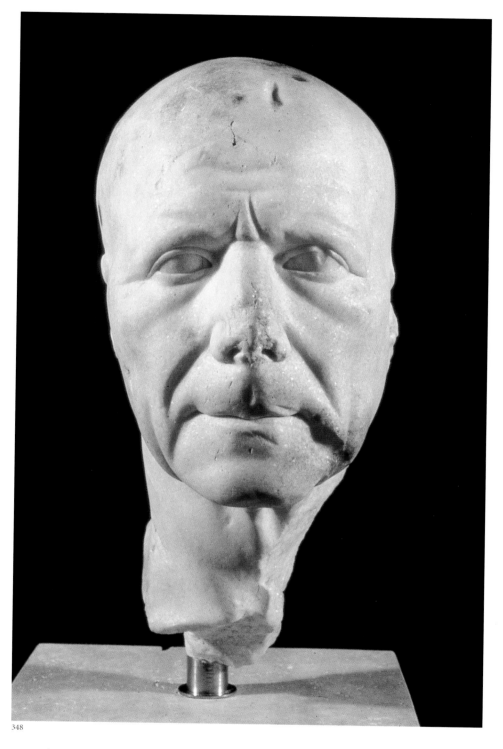

348

age, and even the Flavian-Trajanic era, the later date perhaps being the more probable, given the comparison that can be made with the bust of Vilanius Varrus as well as a that of a man from Cadiz (Poulsen 1933).

BIBLIOGRAPHY: F. Poulsen, *Sculptures antiques des Musées de Provinces Espagnoles* (Copenhagen 1933), 11, figs 3–6; G. A. Cellini, *Museo Nazionale Romano* 1,9,1 (1979), 84–7, R. 52.

L.N.

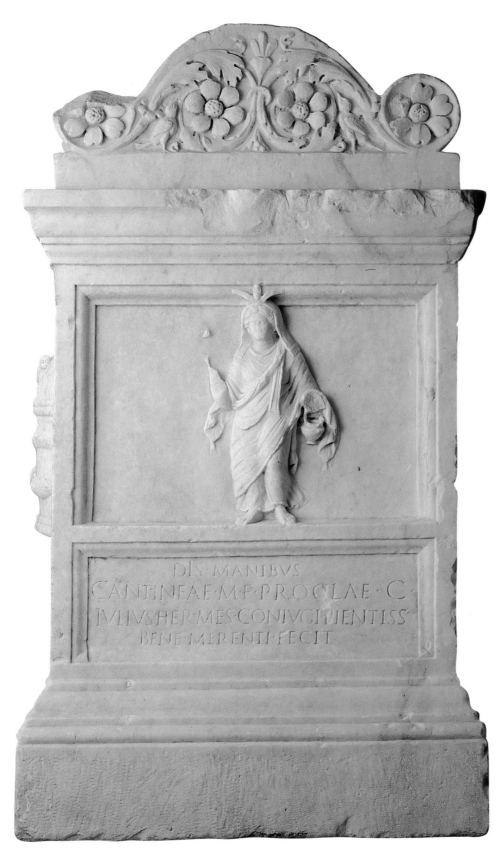

349 Marble memorial altar

First century AD

Discovered during work on the Church of San Paolo fuori le Mura, Rome

Height 121 cm, width 45 cm, thickness 64 cm

Rome, Museo Nazionale Romano (Diocletian's baths) 125406

This Roman funeral monument is topped by a pediment with decorated bolsters, and on the front panel presents the figure of a priestess of Isis standing with her left leg slightly bent. On her head, which is veiled with her mantle, is a *basileion* between two stalks. In her left hand she holds a lustral vase; her right arm is raised, but the hand is missing. Sculpted on the two sides of the monument is the mystical basket with the serpent. The funeral inscription is carved on three sides: 'Dis manibus/Cantinae M(arci). f(iliae). Proclae. C(aius)./Iulius. Hermes. coniuci pientiss(imae)./bene. merenti. Fecit.' (To the departed spirits of Cantina Procla, daughter of Marcius. Gaius Julius Hermes made (this) for his well-deserving and most dutiful wife.)

BIBLIOGRAPHY: *CIL*, VI, 34726; W. Altmann, *Die römischen Grabältare der Kaiserzeit* (Berlin 1905), 239; E. Paribeni, *Le Terme di Diocleziano e il Museo Nazionale Romano* II ed.(Rome 1932), no. 86; S. Aurigemma, *Le Terme di Diocleziano e il Museo Nazionale Romano*, VI ed. (Rome 1970), no. 21; E.A. Arslan (ed.), *Iside: il mito, il mistero, la magia* (Milan 1997), 161, IV 3.

C.M.

349

350 Green steatite statuette of Isis

Ptolemaic period

From Rome, Esquiline Hill

Height 22 cm

Rome, Musei Capitolini 2157

The goddess is portrayed standing, the body fashioned with remarkable plasticity. On the wig, decorated with the vulture typical of the queens of the New Kingdom, there should originally have been placed a headdress that included the horns flanking a solar disc. The goddess wears a large *usekh* (broad collared) necklace.

The most characteristic trait of the figure is, however, the presence, along the sides and legs, of a small network of holes, which originally held polychrome tesserae: this particular detail shows the goddess in her funerary aspect, linking her in a special way to the resurrection of her brother–spouse, Osiris. According to the myth, after Osiris was killed by his brother Seth, his body was cut into pieces and scattered throughout Egypt. The dismayed Isis reconstructed the fragments of her husband's body and, having transformed herself into a hawk, was able to infuse within it the breath of life, thanks to the wind stirred by the beating of her wings.

This iconographical characterization of Isis was also applied to other funerary divinities (Nefti, Selquet, Neith, Nut), giving them a specific character, which has been copiously documented from the New Kingdom: for example, the four funerary goddesses (Isis, Nefti, Selquet, and Neith), who with open wings decorate the corners of royal sarcophagi of the New Kingdom, or the series of analogous representations inside Tutankhamun's tomb. This evidently protective character makes the figure from the Esquiline clearly apotropaic in function: its presence in a sacred context (tomb or cult chapel) provided the necessary guarantee for regeneration and for the constant presence of a divine force, which, especially during the imperial era, was increasingly valued for its magical powers and capacity to save the deceased.

BIBLIOGRAPHY: H. Stuart Jones, *A Catalogue of Ancient Sculptures Preserved in the Municipal Collections of Rome: the Sculptures of the Palazzo dei Conservatori* (Oxford 1926), 305, n. 21, pl.119; S. Bosticco, *Musei Capitolini, i monumenti egizi ed egittizzanti* (Rome 1952), 33ff, n. 175, pl. IV; M. Malaise, 'Inventaire préliminaire des documents Égyptiens découverts en Italie', *EPRO* 21 (1972),175, n. 321; A.M. Roullet, 'The Egyptian and Egyptianizing Monuments of Imperial Rome', *EPRO* 20 (1972), 90, n. 114, fig. 7.

E.M.C.

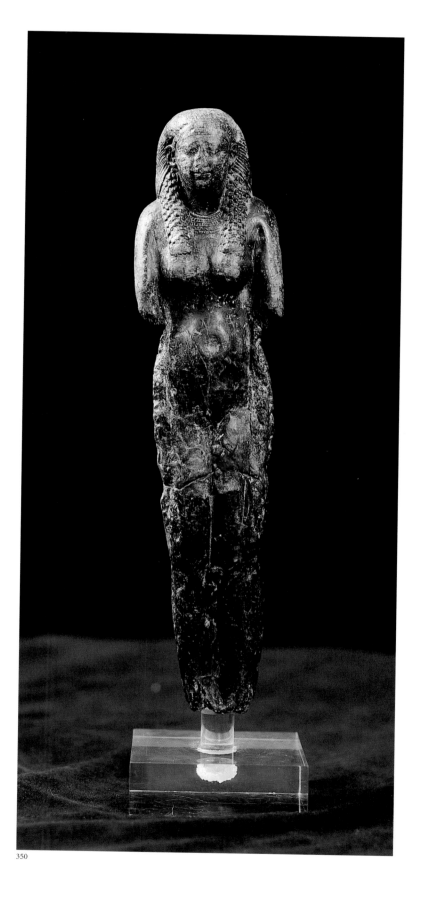

350

351

351 Two bronze sistra (rattles)

First century BC or first century AD

From Rome, recovered from the River Tiber near Ponte Sisto

Height 19 cm and 17.3 cm

Rome, Museo Nazionale Romano, Palazzo Massimo alle Terme, 5148, 5150

Sistrum no. 5148 has an arched frame, and is of rather simple construction without rich decoration: the columnar handle has a small turned pommel at the end, while at the top of the frame is a figure of a cat nursing her kittens.

The tips of the slender transverse rods, intended to support jingling discs that produced the sound (now lost), are in this example ornamented with ducks' heads.

The naturalistic figured decoration of the handle of no. 5150 reproduces the deformed figure of Bes in the act of releasing a lotus flower. Higher up is a two-faced mask of Hathor, whose head supports two small pilasters which form the base of the frame, while two uraei (sacred asps) emerge on the two sides of the frame.

Only two of the three original rods remain; their ends are undecorated.

BIBLIOGRAPHY: F.W. Bissing, 'Sul tipo dei sistri trovati nel Tevere', BSAA 31 (1937), 212 fig. 2 (5148), fig. 4 (5150); M. Malaise, 'Inventaire Préliminaire des Documents Egyptiens Decouverts en Italie', EPRO 21 (Leiden 1972), 232, n.427; E.A. Arslan (ed.), Iside: il mito, il mistero, la magia (Milan 1997), 177–8, IV. 30, 32.

C.M.

352 Nilotic Mosaic of Palestrina (photographic reproduction)

Late first century BC

Height (original as now restored) 4.31 m., length 5.85 m.

Palestrina, Museo Nazionale Archeologico

If we travel 40 kilometres east of Rome to Palestrina (ancient Praeneste), we find a large Nilotic mosaic that served originally as a semicircular floor. In Roman times it was washed by a stream of water from a spring in Monte Ginestro. Though the mosaic was recognized by Fernique as early as 1880 as 'an Alexandrian-style work of art', it has not previously been related to Cleopatra's stay in Italy.

The mosaic of Palestrina remains one of the most enigmatic survivals of ancient times, in a class with the four gilded bronze horses of St Mark's in Venice and the Farnese cup – the latter also, perhaps, commissioned by Cleopatra, according to Eugenio La Rocca. The mosaic has been diversely dated from the third century BC to the fourth century AD. Its interpretation is difficult: the landscapes, the figures of animals and monsters, the genre scenes mixed with anecdotal details are not very clear. This has not held back

artists from drawing inspiration from the mosaic, starting in the eleventh century with the anonymous fresco-painter of St Clement in Rome for the *Miracle of the Azov Sea*, as Jacques Chamay pointed out to me. Maurizio Calvesi demonstrated that in the late fifteenth century Pietro da Cosimo was inspired by the mosaic for his work *The Fire in The Forest* (now in the Ashmolean Museum, Oxford) and Giorgione for some details in his painting *The Tempest* (now in the Museo dell'Academia, Venice).

Understanding of this work was further complicated by an accident in 1640 during the mosaic's return trip to Palestrina after a fifteen-year stay in Rome: 'The transport cases were placed upside down so that the entire mosaic ended up by being smashed and broken into pieces; but thanks to the drawings already commissioned by Cavaliere Cassiano Del Pozzo, who cannot be praised enough, and thanks to the long and painstaking skill of Calandra everything was put all together again' (Pieralisi 1858; see cat. nos 353–355).

The work of art was greatly admired by Poussin, who was inspired by it for three paintings (today in the Louvre, the National Gallery, London, and the Hermitage, St Petersburg), and by Bernini for his fountain placed at the centre of Piazza Navona in Rome. For Claude Lorrain the mosaic was a source of inspiration in the way he represented some of the characters and animals in his work. Poussin, writing about his Holy Family in Egypt (now in the Hermitage) stated: 'I designed it drawing inspiration from the Famous temple of Fortuna in Palestrina, where there is a floor with a most excellent mosaic representing very vividly the natural history of Egypt and Ethiopia and executed by a masterly hand' (letter to Chantelou, 1657). This is one of the first historical comments on the mosaic. Through these artists, the mosaic had an indirect but lasting influence on the vision of the European landscape up to the young Corot.

The mosaic has been restored several times, most recently at the time of the Second World War, when the pavement was dismantled in order to avoid bomb damage. In these circumstances Gullini had the opportunity to examine the mortar and therefore to establish which parts were original and which had been restored. This analysis, published in 1956, shows how incautious it is to draw conclusions about the work of art from its current state. According to Gullini (1956, 15–16), some parts have disappeared, others were wrongly allocated, the filling of the seventeenth century substituted for the missing sections in a rather approximate way, and almost half the work is by various restorers. The mortar needs to be analysed again, especially the ancient

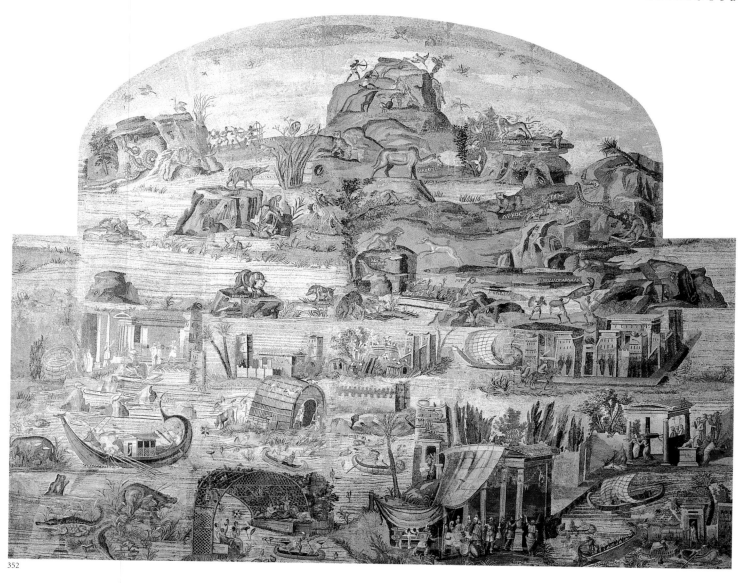

352

mortar. At the end of 1999, during the examination of an enlargement of details, certainly not restored in the seventeenth century, the discovery of an anomaly made me think that the mosaic had already undergone restoration in antiquity. It is therefore premature to insist upon scenes or details that are not quite clear.

The mosaic has long been considered a work of art that is 'historically inexplicable', from Fernique in 1880 to Champeaux in 1982, who wrote: 'We recognize … in the mosaic a solely decorative function, excluding either any ritual meaning and any religious symbolism.' The difficulty of explaining certain anecdotal details – such as foreground scenes in front of the portico, the profile of the man wearing a toga in the tower on the east side, and the standing figure in the bireme on the right of the portico – should not prevent us from finding a way out and a research direction for setting a date for the work's execution. Indeed, a recent substantial attempt to explain the narrative of the mosaic has been

made by Paul Meyboom (1995). My own choice has been to try to connect the mosaic with the movements of at least ten prominent Egyptian travellers to Italy or of more than fifteen Romans visiting Egypt (Goudchaux 1998).

Apart from Abbot Barthelemy in the seventeenth century and Marucchi at the beginning of the twentieth, who believed that the mosaic chronicled the emperor Hadrian's trip, and Mme Shareika, writing in 1978, who thought it the record of a diplomatic mission of Ptolemy II's time, no one else has considered these movements an explanation. Today at Palestrina the mosaic is explained in a label as the commission of local businessmen with interests in Egypt at the turn of the second and first centuries BC.

Whoever he or she was – a Greek-Egyptian who came to Rome, or a Roman who returned from Egypt – the patron ordered an artist of Alexandrian origin to execute the work. The inscriptions identifying the chimeras or those animals of the African fauna unknown to

Alexandrians (such as giraffes, lynxes and rhinoceroses) are in Greek, not Latin. Crocodiles and hippopotamuses have no inscriptions, as they were familiar to the Greek-Egyptians as animals of prey to be hunted, or especially as gods. This difference in treatment clearly shows the Alexandrian origin of the mosaic cartoon. The fact that it was not made accessible to a Latin-speaking public allows us to think that the patron was used to affirming his or her own identity even to Romans and Prenestines.

The mosaic's complexity and its place of discovery – not in a villa or in a brothel, but in the Temple of Fortuna Primigenia itself, or at least in an adjacent consecrated place – make it an exception. The other Nilotic mosaics, when compared to it, appear reductive simplifications. The Palestrina pavement may be judged a prototype in Italy both from a stylistic point of view and in some particularities of the represented scenes. It dates no later the second half of the first century BC, while the others date to later epochs.

The Palestrina mosaic: drawings (cat. nos 353–355)

An important and rich traveller who wanted to leave such a trace of his or her passage in the Temple of Fortuna Primigenia had to know that this divinity was worshipped by the women of the entire Italian peninsula and was linked to Isis. The fact that the goddess received visits by women who were sterile, pregnant or recent mothers leads me to think that the mosaic was likely to have been commissioned by a woman. Who was she? Cleopatra? At the time she arrived in Italy, in September 46 BC, Cleopatra was the mother of a one-year-old child, born in dramatic circumstances, almost an *enfant du miracle*, presented by the queen herself as being the son of Caesar.

The mosaic tells anecdotes of events that occurred in different places and times, as well as presenting the spectacular topographical environment of Egypt, almost a preview of the *Description de l'Egypte*. This permits us to think that whoever was the patron, he or she had to be a person who had travelled along the Nile and who wanted that trip to be remembered in the Temple of Fortuna Primigenia and not somewhere else. If Caesarion was indeed the son of Caesar, Cleopatra was likely already pregnant with this child during the cruise along the Nile or it had been conceived on that occasion, just before the general had left Egypt.

If we put together these elements, we are able to transform a vague hypothesis into a more consistent form: with the approval of Caesar, Cleopatra could have commissioned the famous mosaic. Her goal would have been to thank Primigenia for the birth of Caesarion, but also to achieve in the temple of Palestrina that which she had already accomplished in the Temple of Venus in Rome – in one way or another to introduce her presence as a Hellenistic queen. Let us remember that Cleopatra had a statue of herself placed in the Temple of Caesarian Venus, considering herself to be a new Aphrodite. If we follow this train of thought, the mosaic should have been accompanied by a statue of the queen dressed like Isis, ensuring the introduction of the cult of the queen.

BIBLIOGRAPHY: E. Fernique, 'Etude sur Préneste', *BEFAR* XVII (1880), 70; O. Marucchi, 'Il tempio della Fortuna Prenestina, secondo il risultato di nuove indagini e di recentissime scoperte', *B.Comm* 315 (1907, 275–324); G. Gullini, *I Mosaici di Palestrina* (Rome 1956); A. Steinmayer-Shareika, *Das Nilmosaik ven Palestrin und Eine Ptolemäische Expedition Nach Ethiopen* (Bonn 1978); J. Champeaux, *Le culte de Fortune à Rome et dans le monde romain* (Rome, 1982); F. Coarelli, 'Iside Capitolina, Claudio e i mercanti di schiavi', in *Alessandria e Il Mondo Ellenistico, Studi in Onore di A. Adriani*, 3 (Rome 1984), 461–75; P. Meyboom, *The Nile Mosaic of Palestrina* (Leiden 1995); G.W. Goudchaux, 'Divagations autour de la mosaïque de Palestrina' in *L'Egitto in Italia dall' Antichità al Medioevo* (Rome 1998), 525–34.

G.W.G.

The following three entries describe three of nineteen surviving copies of parts of the Palestrina mosaic, which were made, at varying scales, by an unknown artist working after much of the pavement had been cut into fragments and taken to Rome in 1626. The medium is watercolour and bodycolour over pen, and dark brown ink over chalk. The drawings were owned by the distinguished antiquary Cassiano Dal Pozzo, secretary and curator to Cardinal Francesco Barberini, who had been given pieces of the dismantled mosaic. In 1640 the mosaic was returned to Palestrina (then owned by the Barberini family), and, after a damaging journey, was again restored by Giovanni Battista Calandra, conservator of mosaics at St Peter's. For this work Calandra used the evidence of Dal Pozzo's drawings, which formed part of an encyclopaedic library covering many branches of learning. After Dal Pozzo's death in 1657 the collection passed to members of his family; in the following century it was acquired by the Albani family and in 1762 by King George III. Now owned by HM Queen Elizabeth II, the collection is cared for today in the Royal Library at Windsor Castle.

In the following entries another association of the Palestrina Mosaic with Cleopatra is proposed.

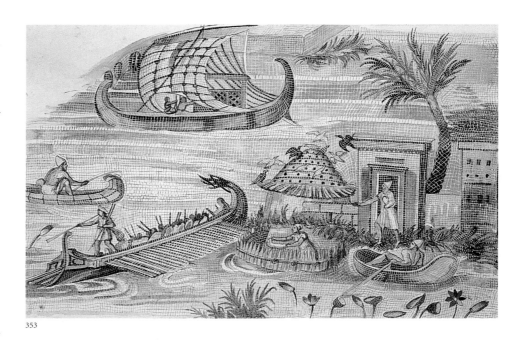

353

353 *The Naval Escort to the Royal Party*

Height 30.5 cm, width 47.5 cm

Windsor, Royal Library Portfolio Pf.Z 19217
(Lent by HM Queen Elizabeth II)

In the foreground a galley rests, filled with armed sailors, while at the prow stands a man in a *kausia* (Macedonian cap) blowing a long trumpet. To the right the scene is watched by a family of fishermen and women: one man emerges from a gate, behind which is a palm tree, a tower house and a dovecot laden with birds; another sits back in a small boat moored before the gate, and a woman drying fish in an open-air enclosure stops her work to gaze. Immediately behind the galley a man fishes from a papyrus canoe, and above him another sails a large boat with a cabin and an elaborately rigged sail. Beyond this appears the edge of the quay, which defines the central scene of the mosaic.

The trumpeter is clearly identified as a member of the Ptolemaic royal guard. He is surely announcing the arrival of the royal party at the festivities (see cat. no. 354), the bireme providing the naval escort for their journey.

In the mosaic the upper part of this scene has been awkwardly manoeuvred out of line, perhaps to compensate for the fact that the fragmentary scene of the royal party (cat. no. 354) was not reincorporated in the original. The trumpeter has also been disfigured in the course of restoration.

BIBLIOGRAPHY: H. Whitehouse, *The Dal Pozzo Copies of the Palestrina Mosaic* BAR Supplementary Series 12 (Oxford 1976), 22 no.17; P. Meyboom, *The Nile Mosaic of Palestrina* (Leiden 1995), 69 (interpretation of the original scene),193–4, n.5 (Dal Pozzo drawings).

S.W.

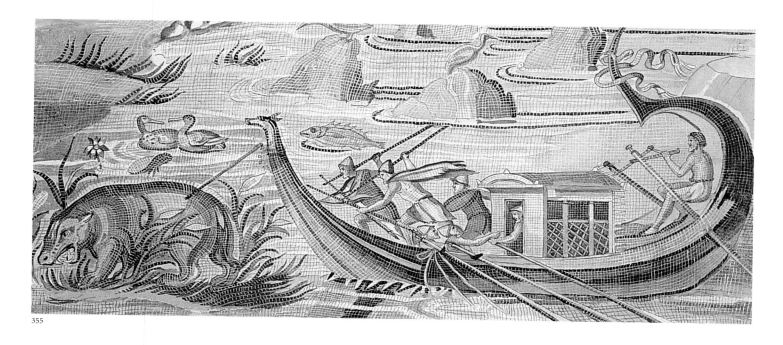

355

354 *A Parasol beside a Quay*

Height 28.5 cm, width 48.3 cm

Windsor, Royal Library Portfolio Pf.Z 19214
(Lent by HM Queen Elizabeth II)

In the foreground is a red parasol, adorned by long golden tassels, supported on a pole and casting a dark shadow on to greenish water. Beyond the parasol is the edge of a quay, with two steps at the left. On the quay are the lower legs of two barefoot men, the nearer clad in a white tunic.

This drawing is the only surviving evidence for a scene lost from the original mosaic, which apparently showed royal patrons of the festival that forms the mosaic's principal theme. The figures on the quay await the landing of the royal party; they are surely colleagues of the priests bearing the coffin of Osiris through the propylon to the right of the quay on the original mosaic. The artist has (rightly) tried to link this scene with the temple in the centre of the front of the mosaic. The moulded wall of the temple appears in outline, and to the left is sketched the figure of the priestess restored in the mosaic as holding the ladle from which wine is given to the celebrating soldiers.

The parasol was not reincorporated in the original mosaic, as the figures beneath it had apparently disappeared, and the seventeenth-century restorer Giuseppe Calandra presumably did not know whom to place beneath the parasol. Accepting Meyboom's location of the festival at Canopus, it is here suggested that the monarch missing from beneath the parasol could have been Cleopatra herself. In Augustan literature and in caricatures of early imperial date Cleopatra was strongly associated with Canopus

(see cat. nos 356–359); moreover, Palestrina is known to have supported Antony (see cat. no. 311). Had the mosaic been commissioned by an associate of Antony and Cleopatra, then its principal protagonists could have been excised in the wake of their defeat. However, such an association challenges the widely accepted view of the date of the mosaic in the late second or early first century BC, and it may be the case that the subversion of the scenes on the Palestrina mosaic represents a more generic Roman distaste for the excesses of Egyptian religious celebration.

BIBLIOGRAPHY: H. Whitehouse, *The Dal Pozzo Copies of the Palestrina Mosaic*, BAR Supplementary Series 12 (Oxford 1976), 19–20, no.14; 'Copies of Roman Paintings and Mosaics in the Paper Museum', in Ian Jenkins *et al.*, *Cassiano dal Pozzo's Paper Museum I* (Milan 1992),

118–21, fig. 9, p. 119; P. Meyboom, *The Nile Mosaic of Palestrina* (Leiden 1995), 37, 65ff, 272 nn 170–72, 312–5 nn 138–47 with pl. 23.

S.W.

355 *The Hippopotamus Hunt*

Height 21.3 cm, width 48.3 cm (scale about 1/3 life-size)

Windsor, Royal Library Portfolio Pf.Z 19112
(Lent by HM Queen Elizabeth II)

This drawing reproduces the scene almost exactly as it appears in the original mosaic. Three helmeted and bearded huntsmen emerge from the cabin of a boat to spear a hippopotamus, howling with pain on land to the left. Two oarsmen sit beneath them, and a third emerges from the cabin. At the stern sits a helmsman. The boat is

354

elaborately decorated with an animal head at the prow and pink ribbons at the stern. The cabin reproduces in miniature the features of Ptolemaic architecture on land; apparently designed to hold precious goods, it is protected at the rear by protruding spikes.

The appearance of the boat indicates a royal connection, the hunt itself not casual sport but part of an elaborate ritual enacted at the celebration of the inundation of the Nile, in which the pharaoh assumed the role of the god Horus, who killed Seth, murderer of his brother Osiris. The hunt scene may thus be linked with the arrival of the Ptolemaic royal family at the quayside, where they were met by priests whose colleagues carried the coffin of Osiris through the adjacent portal (cat. no. 354). The hippopotamus hunt is recalled in an obscene caricature on a Roman marble relief (cat. no. 356).

BIBLIOGRAPHY: H. Whitehouse, *The Dal Pozzo Copies of the Palestrina Mosaic,* BAR Supplementary Series 12 (Oxford 1976), 18, no. 12. On the scene in the mosaic, see P. Meyboom, *The Nile Mosaic of Palestrina* (Leiden 1995), 31–2 with 255–6, nn.114–6; 70–1 with 325–6, nn.169–70 and 329 n.
S.W.

356 Marble relief with an erotic scene in a boat

First century BC to first century AD

Provenance unknown; formerly in the Witt Collection and likely to be from Italy

Height 36 cm, width 40 cm

London, British Museum GR 1865.11-18.252

Preserved is a fragment of a longer relief broken at both ends, but surviving to its original depth of 5.5 cm. The mouldings at the upper and lower level are damaged, as is a large area on the upper left corner. The faces of the figures are almost worn away, and there is some damage to the rest of the surface of the fine-grained marble. Much of the surface, however, retains its original polish.

This comical scene features part of a boat, its sail billowing out above the main characters. A boatman wears a pointed hat, of a type commonly worn by marsh dwellers in representations of life on the river Nile. He steers the boat with a paddle, while behind him a man and a woman are shown performing a sexual act. The woman leans on an indistinct object, probably a cushion. In front of the boat is the rump of a hippopotamus and swimming alongside the boat are two dolphins. Above the hippopotamus two vertical lines in relief may indicate a building on land nearby while the stylized flower, seemingly floating in the waves, may also be an indication that the boat is approaching the shore. Scenes of this

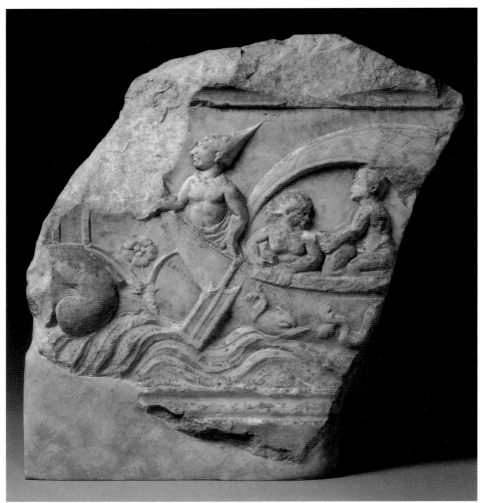

356

kind usually portray pygmies involved in various sexual acts or in hunting scenes, but the figures shown here are not necessarily pygmies. Comparable figures can be seen on mosaics and paintings found in Roman contexts, with several good examples from Pompeii. The original context of this relief is unknown, but there are similar scenes on the base of a statue (now in the Vatican Museums) personifying the Nile, where pygmies in boats cheekily point their backsides towards attacking hippopotami and crocodiles.

The boat is very similar to one featured on the mosaic from Palestrina, which has been interpreted as the celebration of the inundation of the Nile at Canopus (see cat. nos 352–355). Also reminiscent of the Palestrina mosaic is the conjunction of the boat and the rump of the hippopotamus, which in the mosaic is being speared by two huntsmen in an elaborate, perhaps royal boat (cat. no. 355).

This relief may be a parody of the more sober Nilotic scenes found on mosaics and wall paint-

ings. Could the relief even be a savage caricature of the relationship between Cleopatra and Mark Antony? This idea is supported by the presence of both a hippopotamus, suggestive of the Nile, and the dolphins, which symbolize the Mediterranean: the merging of the Mediterranean and the Nile recalling the alliance between Cleopatra VII and Mark Antony. The energetic sexual congress of the couple in the boat also brings to mind the condemnation of the couple by Roman authors such as Propertius, who described Cleopatra as 'the harlot of the Canopus', and Dio Cassius, who as late as the third century AD dismissed Antony as Cleopatra's tambourine player at Canopus.

BIBLIOGRAPHY: unpublished, but comparisons are illustrated in J.P. Cèbe, *La caricature et la parodie dans le monde romaine antique* (Paris 1966); I. Pékary, *Repertorium der Hellenistischen und Römischen Schiffsdarstellungen* (Münster 1999), particularly cat. nos I-N 39 and I-N 40.

P.H., S.W.

357 Roman terracotta lamp with a caricatured scene

c. AD 40–80

Italy

Length 9.2 cm

London, British Museum, GR 1865.11-18.249 (Lamp Q 900) (Given by George Witt)

357

Mould-made lamp with a voluted nozzle, mostly lost. The top is decorated with a crocodile; rising from its tail is a huge human phallus on which sits a naked woman with her hair drawn back in a bun. She holds a palm branch in her left hand; behind her plants, probably intended to be Nilotic, rise up. Although made many decades later than than her death, this may be an obscene caricature of Cleopatra VII.

BIBLIOGRAPHY: A.W. Franks, *ms Register of the Museum Secretum*, W. 249; D.M. Bailey, *A Catalogue of the Lamps in the British Museum ii, Roman Lamps made in Italy*

(London 1980), cat. no. Q 900; C.M. Johns, *Sex and Symbol, Erotic Images of Greece and Rome* (London 1982, 1989, 1999), 110, fig. 91; For a similar lamp, see G. Grimm, 'Regina meretrix oder Kleopatra als königliche Hure ?', *Antike Welt* (2000), 2, 129, fig. 3.

D.M.B.

358 Terracotta 'Campana' relief with a Nilotic scene

First century AD

Provenance unknown

Height 47.5 cm, width 60 cm, thickness 3.5 cm

London, British Museum GR 1805. 7-3.317 (BM Terracotta D 633), Townley Collection

The panel is divided in two, as if the scene were witnessed through an arcade. The upper left part of each scene, the upper part of the central column, and the lower right corner of the panel are restored,

358

359

along with the right central section of the left scene with the base of the plant lower right.

The left side of the panel has a fluted pilaster supporting the upper moulding of the panel; the upper shaft and capital are restored. The arcade is supported on double columns standing on low plinths; those at the sides have twisted flutes, while the plain central column has a twisted moulding to the base. The capital to the right and one profile of the central capital are preserved; these are of Tuscan type. The arches are decorated with miniature modillions.

Though divided by the arcade, the scenes should probably be read continuously, starting from the fluted pilaster on the left. Although the right side of the panel is not framed with a pilaster, a very similar panel now in the Palazzo dei Conservatori, Rome, does have both framing pilasters preserved, which suggests that the scene was intended as a complete episode of narrative.

In the upper left panel is a hut thatched with reeds; a stork (mostly restored) is perched on its roof, and to the left of the hut is a low wall of brick or stone on which another stork, again largely restored, struts. A ground line is indicated beneath both structures. In the lower part of the panel a crocodile crouches perilously on a branch over turbulent waters. Next to the branch is a lotus with curling stem, and, baying at the base of the panel, a hippopotamus. To the right of the central pillar

the riverine scene is continued with a second crocodile, moulded as the first but set at a different angle on a sandbank in the water. Above, two men pole and paddle a boat. The man wielding the paddle on the left has shaggy hair, a long caricatured nose, and exaggerated musculature; he wears a mantle over his left shoulder. The older man with the pole to the right was intended as a pygmy, naked and again with exaggerated musculature. They sail past a small building set on a groundline, probably a shrine, built of stone or brick with a triangular pediment; a third bird, like the others much restored, is perched on the roof.

The plaque is one of a number decorated with very similar scenes; the example in Rome cited above is the closest. Three other surviving examples, now in Copenhagen, Leiden and Frankfurt, show walls or fences with arched entrances beyond the two structures, which are both intended as Egyptian reed huts. On the reliefs in Copenhagen and Leiden, the fence to the left of the round hut has been transformed into a bed, on which reclines a woman, partially draped, with her buttocks exposed and hair tumbling on her shoulders, looking at a statuette of Priapus. This and other elements of the scene recall the genre and symposium scenes on the Nilotic mosaic from Palestrina (cat. no. 352). Though dwarfs and pygmies appear associated with Egypt in classical and Hellenistic Greek art, the Campana panels

represent a lighthearted Roman interpretation of an Egyptian scene, the elements of mockery and sexual titillation perhaps recalling the defeat of Cleopatra (see also cat. nos 356–357).

BIBLIOGRAPHY: M. Moltesen, 'Hvor Nilen vander aegypterens jord…', *Meddelelser fra Ny Carlsberg Glyptotek* (1997), 102–15 (bibl. and English summary).

S.W.

359 Painted plaster panel: caricatured pygmies hunting on the Nile

c. AD 50–75

From the parapet of a colonnaded garden in the 'House of the Doctor' at Pompeii (VIII, 5, 24)

Height 43cm, length 126 cm

Naples, Museo Nazionale Archeologico 113195

This panel is one of a series depicting almost in cartoon fashion the adventures of pygmies hunting and banqueting, the scenes and landscape recalling those depicted in serious fashion on the mosaic at Palestrina (see cat. no. 352). Here, on the right of the panel, a hippopotamus reminiscent of the hunted beast of the Palestrina mosaic takes his revenge by gobbling a pygmy from a boat while another pygmy stands on his back, fruitlessly trying to spear him. The pygmies' boat has been overturned, with two thrown in the water, one trying to save himself by grabbing a branch of the

large tree in the centre of the painting. In the foreground pygmies tackle crocodiles: on the left a single huntsman attacks a menacing beast with improvised weapons, while on the right a pygmy rides on a crocodile's back while three others pull the creature on to the shore. The single huntsman stands on a platform on which is built an elaborate shrine or tomb, evoking the sacred buildings on the Palestrina mosaic: indeed, Meyboom identifies it as the Tomb of Osiris, the focus of the central scene of the Palestrina pavement. In the background of the painting is a rustic structure with a reed roof and a tiered tower. An ibis flies awkwardly from the left. Shown faintly in the upper right is a porticoed building, away from which sails a large galley manned by pygmies, a rare feature of Roman imperial Nilotic scenes, and again reminiscent of the boat escorting the missing royal patrons of the festival shown in the Palestrina mosaic.

Pygmies had long been the subject of ridicule in Greek and Roman art and literature. Here the references to scenes on the mosaic from Palestrina seem very clear and were perhaps deliberately intended. Could it be that such specific caricatures had the mosaic as a target (see also cat. nos 356–357)? The painting was commissioned during or following the reigns of the last Julio-Claudian emperors Claudius and Nero, both descended from Antony, and the latter especially notorious for decadence and unseemly behaviour.

BIBLIOGRAPHY: K. Schefold, *Die Wände Pompejis* (Berlin 1957), 227 (bibl.); W. B. McDaniel, 'A Fresco Picturing Pygmies', *AJA* 36 (1932), 260–61, pl. 9; V. Sampaulo, 'Le Pitture', in *Le Collezioni del Museo Nazionale di Napoli* (Naples 1986), 69, and catalogue, pp.172–3; R. Ling, *Roman Painting* (Cambridge 1991), 165–5, fig. 178; V. Dasen, 'Pygmaioi', *LIMC* VII, 1 (1994), 594–601, esp. 598, no. 46a (bibl.); P. Meyboom, *The Nile Mosaic of Palestrina* (Leiden 1995), 309 n. 124 (bibl.); I. Pekáry, *Repertorium der Hellenistischen und Römischen Schiffsdarstellungen* (Münster 1999), 182 I-N (bibl.).

S.W.

360 Marble group of an acrobat on a crocodile

First century BC–first century AD

Bought in Rome by the first Earl Cawdor, then in the Townley Collection

Height 75 cm, length 38 cm

London, British Museum GR 1805. 7-3.6 (Sculpture 1768)

The surface is in good condition. Restored are the head, tail and front paws of the crocodile; the right leg, left knee, left foot, and elbows of the acrobat; and part of the plinth. The figure of the boy has been repaired at waist level.

The young boy is precariously balanced on top of the back of a crocodile. His hands grasp the rear end of the crocodile, and he appears to be pushing himself up using his shoulder muscles. His back and legs are almost perfectly straight,

and his head faces outwards, mouth open and the features contorted with effort. The boy has corkscrew locks and African features. The crocodile's head is restored with an open mouth, baring his sharp teeth, but how the original appeared we cannot know.

Pliny (*Natural History* 8, 38, 92-3) tells us that the Tentyritae, a tribe of people living on the Nile, were adept at diving on to the backs of crocodiles in the river. Crocodiles were first exhibited in Rome by Marcus Scaurus in 58 BC, and may have been attended by the Tentyritae, famous for their control over these wild, Nilotic creatures. This group may represent one of these dare-devil tribesmen performing either in his native landscape or, because it was likely to have been found in Rome, in an amphitheatre. A similarly posed statue of an acrobat, but without the crocodile, was found in the area of the Villa Patrizi in Rome.

BIBLIOGRAPHY: A.H. Smith, *A Catalogue of Sculpture in the Department of Greek and Roman antiquities, British Museum Volume III* (London 1904), cat. no. 1768; G.H. Beardsley, *The Negro in Greek and Roman Civilization* (Baltimore 1929), 104, cat. no. 229; F.M. Snowden Jr., *Blacks in Antiquity*, (Cambridge, Mass. 1970), 166, fig.107.

P.H.

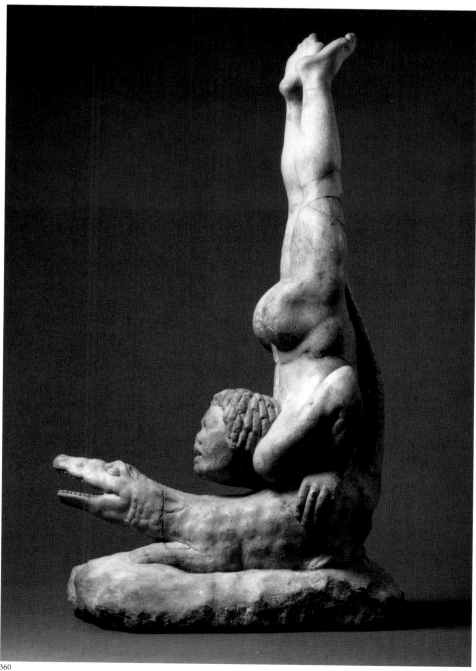

360

361

361 Glazed terracotta statuette of a crocodile

First century AD

Casa delle nozze d'argento, Pompeii

Length 40 cm

Naples, Museo Nazionale Archeologico 121324

The crocodile is in a crouched position with its stomach on the ground; unfortunately, the jutting snout is almost completely missing. ,The eyes are large and round. Special attention was paid to the skin, rendered with large scales along the back and tail which become much smaller along the crocodile's underbelly; the tail is slightly curved and the feet are shown as if moving.

The reptile is positioned on a long, rimmed oval base, smaller than the figure itself. The statue is covered with a coloured glaze which is reduced to a slight covering in the protruding areas while in other areas the glaze accumulates to deeper effect. The figure was made in a mould, using a light nut-coloured terracotta covered with what is probably an alkaline substance coloured with copper oxide. Generally, blue colouring was obtained with cobalt oxide, although research carried out on original Egyptian glass windows has revealed that 'Egyptian blue' was obtained by using copper oxide and an alkaline base, consisting mainly of calcite, which, after being baked, did not take on the typical green of copper oxide, but rather a greenish-blue (turquoise blue) colour.

Given that this Egyptian crocodile was made in a mould, it is logical to presume that a number of statuettes was produced in similar fashion; probably some, at least, were placed along the rims of garden ponds or decorated the houses of Pompei. Other statues of aquatic animals and extravagant-looking gods, such as Bes and Ptah-Pateco, always used for decorative and non-religious purposes, were rather common in Pompei and in Rome and in the region of Campania.

BIBLIOGRAPHY: G. Ballardini, L'eredità ceramistica dell'antico mondo romano (Rome 1964), 86, fig. 104; M. De Vos, L'egittomania in pitture e mosaici romano-campani della prima metà imperiale. EPRO LXXXIV (Leiden 1980), 62–3; E. Rozzi, Le Collezioni del Museo Nazionale di Napoli I, 1 (Rome 1989), 202, n. 6.

C.Al.

362 Bronze statue of Cleopatra

Hubert le Sueur (*c.* 1585–*c.* 1658)

c. 1636

Height 170 cm

London, Hampton Court Palace, Royal Collection
No. 39714 (Lent by HM Queen Elizabeth II)

This sculpture, which may have been made in London, is probably to be identified with the *Statua of Cleopatra in brasse deliv^d to his Majestie*, for which Le Sueur was to be paid £200 by a warrant to the Exchequer of 7 May 1636 (*Calendar of State Papers Domestic Charles I* 1635, 409). Another possible reference appears on 23 October 1651, when the *Cleopatria* was sold to 'Stone' (Millar, 139 no.72), and a third in 1659, when the 'brasse statue of Cleopatra' was listed among the possessions of Oliver Cromwell in the Privy Garden at Hampton Court Palace (Law, 302).

Le Sueur, a bronze founder with little sense of invention, seems to have reversed the pose of the Venus, with which this figure was paired.. The Queen's head is upturned in a gesture of pathos, her right hand holding her mantle, which is draped over an ornately decorated urn.

The composition shows a remarkable interest in historical accuracy. The head appears to have been copied from Ptolemaic Greek portraits; it resembles not Cleopatra VII but her mentor and model in many respects, Arsinoe II. The pathetic appearance is in keeping with early Ptolemaic portraiture. A likely inspiration for the figure was a statue of Cleopatra displayed in the seventeenth century at Versailles, published as an ancient work in an illustrated catalogue of ornamental sculpture in the chateau and the park, compiled in 1695 by the engraver Simon Thomassin. Again, the pose is reversed and in the engraving the urn is left plain. Though doubtless based upon Roman decorative vases in marble, the urn of the Hampton Court statue uncannily resembles their Ptolemaic prototypes (compare cat. no. 147). These scholarly references stand in contrast to representations of Cleopatra in other media of seventeenth century or earlier date, which portray her either with a contemporary hairstyle (e.g. cat. nos 378–80), or in less specific fashion as a romantic heroine (cat. no. 369).

BIBLIOGRAPHY: S. Thomassin, *Recueil des figures, groupes, thermes, fontaines, vases, statues et autre ornemens de Versailles…* (Amsterdam 1695), no. 29; E. Law, *The History of Hampton Court Palace II* (1888), 302; F. Boyer, 'Un inventaire inédit des antiques de la Villa Médici', *Revue Archéologique XXX* (1929), 256–70; O. Millar, 'The Inventories and Valuations of the King's Goods 1649–51', *Walpole Society XLIII* (1972), 139, no. 32; C. Avery, 'Hubert le Sueur, the "unworthy Praxiteles" of King Charles I', *Walpole Society XLVIII* (1982), 135–209, esp. p. 180, no. 25.

J.M., S.W.

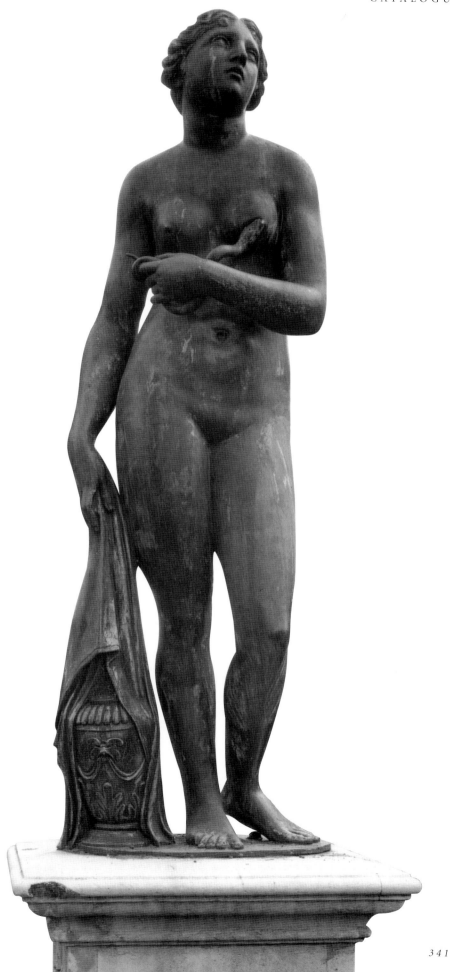

362

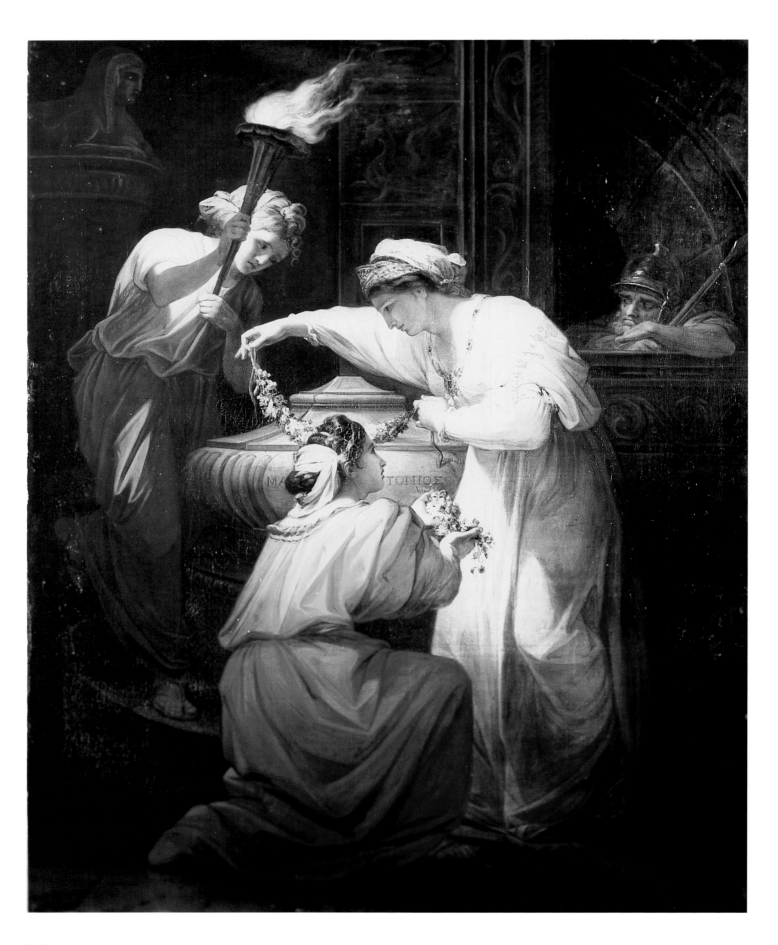

363 *Cleopatra Decorating the Tomb of Mark Antony*

Angelica Kauffmann (1741–1807)

1769/70

Oil on canvas

125.5 × 105 cm

The Burghley House Collection PIC286

Maria Anna Angelica Catharina Kauffmann, always known as Angelica, was born in Switzerland, but her fame and influence were established in Rome and England. Throughout her time in Italy, where she travelled from 1757 to 1766, she was admired as a beautiful young artist and as something of a prodigy. In Rome in 1764 she established her reputation with a portrait (now in Zurich) of Johann Winckelmann, whose thought so inspired and informed attitudes to ancient art and contemporary Neoclassicism. One of her early admirers was Brownlow Cecil, 9th Earl of Exeter (1725–93), who eventually amassed some thirteen of her pictures for his home at Burghley House in Lincolnshire, where this painting still hangs. Lord Exeter, an avid collector of Italian art, sat to Angelica for his portrait in Naples in the 1760s.

In 1766 Lady Wentworth, wife of the British Ambassador, brought Angelica to London. Angelica became a founder member of the Royal Academy of Arts, London, in 1768, a real feat for a female artist at that time. Lord Exeter had introduced her to Joshua Reynolds, who was to become the Academy's founding president; Reynolds became enamoured with her and her painting. Her work as a decorative painter may be seen today on the ceiling of the entrance hall of Burlington House in London, the home of the Academy.

From her time in the circle of Reynolds, Angelica fostered an interest in history painting, for which there was a prevailing taste. *Cleopatra Decorating the Tomb of Mark Antony*, completed in 1769/70, when it was exhibited at the Royal Academy, is regarded as an outstanding example of her work in this category.

This painting illustrates Cleopatra, attended by Iras and Charmian, adorning Mark Antony's tomb with garlands, watched by a Roman soldier. Possibly, the soldier is Proculeius or just the Guard, (if Angelica was recalling Shakespeare's *Antony and Cleopatra*, Act V) or perhaps Epaphroditus (if the artist was thinking of Plutarch's *Life of Antony*, LXXIX). Cleopatra adorns Antony's finished, stone sarcophagus, in a way that is not specifically mentioned in either major text: the scene seems to be the artist's invention.

364

It is interesting to find this painting in the collection at Burghley, where the subject complements Stothard's grand mural of *The Banquet of Cleopatra* on the Painted Staircase, created for the 1st Marquess of Exeter between 1799 and 1803, and Laguerre's great painting of the banquet, completed in 1697 and displayed in the Bow Room.

BIBLIOGRAPHY: The Marchioness of Exeter, MSS *Catalogue of Pictures at Burghley House, Northants* 1954; J. Ingamells, *A Dictionary of British & Irish Travellers in Italy 1701–1800* (New Haven, Conn. 1997), 343–4; Peter Walch in J. Shoaf Turner (ed.), *The Dictionary of Art*, vol. 17 (London 1996), 850–53; B. Baumgärtel (ed.), *Angelika Kauffmann. Retrospective.* (Düsseldorf 1999), 27–8.

H.W.

364 *The Suicide of Antony*

from Giovanni Boccaccio, *De casibus illustrium virorum et feminarum*, translated into French by Laurent du Premierfait

c. 1420

Paris; first recorded in the English Royal Library at Westminster in 1542

Manuscript on vellum

Folio 390 × 285 mm

London, British Library, Royal MS 20 C IV, folio 239v (Presented by H.M. George II in 1757)

Antony, pierced through the heart by his sword, staggers forward in dramatic pose. Blood gushes from the wound on to the paved floor beside his discarded scabbard. Bearded and with fair hair, Antony is of almost regal appearance, dressed in a royal blue tunic with huge ermine-trimmed sleeves and a gold belt, and an ermine-trimmed red hat with matching red hose. His companions, though well-dressed, do not have his air of authority. They gather to the right, the figures in the foreground gesticulating in dismay. In the background are the pink walls of the palace, the doors conspicuously bolted and the windows closed. To the right is a grilled structure with coloured panels.

BIBLIOGRAPHY: Sir G.F. Warner and J.P. Gilson, *Catalogue of Western Manuscripts in the Old Royal and King's Collections in the British Museum* (London 1921), II, 371–2; C. Bozzolo, *Manuscrits des traductions françaises d'oeuvres de Boccace, XV e siècle* (Padua 1973), 138–40; C. Reynolds, 'Illustrated Boccaccio manuscripts in the British Library, London', *Studi sul Boccaccio* 17 (1988), 168–70.

S.McK., S. W.

365

365 *The Suicide of Cleopatra*

from Giovanni Boccaccio, *De mulieribus claris*,
translated into French

c. 1405

Paris; possibly owned by Lady Margaret Beaufort.
First recorded in the English Royal Library at Westminster
in 1542

Manuscript on vellum

Folio 390 × 270 mm

London, British Library Royal MS 20 C.V, folio 131v
(Presented by H.M. George II in 1757)

In this image the scene is transposed to a
meadow with blossoming flowers and trees, the
latter growing from a high rocky outcrop against
a deep blue sky. Cleopatra stands with the sleeves
of her tunic rolled up to show blood pouring
from the veins at her elbows into the mouths of
two griffins posed heraldically to either side.
There is no sign of the asps, and the need to show
her exposed breast has been avoided. The
Queen's fair hair is hidden by golden hairpieces
and she wears contemporary clothes: a golden
crown and a long dress with a brown bodice and
red skirt, both extensively trimmed in white.

BIBLIOGRAPHY: Sir G.F. Warner and J.P. Gilson, *Catalogue of
Western Manuscripts in the Old Royal and King's Collection
in the British Museum* (London 1921) II, 372; C. Bozzolo,
*Manuscrits des traductions françaises d'oeuvres de Boccace,
XV ᵉ siècle* (Padua 1973), 153–4; C. Reynolds, 'Illustrated
Boccaccio Manuscripts in the British Library (London)',
Studi sul Boccaccio 17 (1988), 171–80.

S.McK., S.W.

366a

366b

366a *The Murder of Antyllus, Antony's Son by Fulvia*

from Giovanni Boccaccio, *De casibus illustrium virorum et feminarum*, translated into French by Laurent du Premierfait

c. 1480

Bruges

Produced for Edward IV and first recorded in the English Royal Library at Richmond Palace in 1535

Manuscript on vellum

Folio 480 × 345 mm

London, British Library Royal MS 14 E.V, folio 348v (Presented by H.M. George II in 1757)

Antyllus clings to a gilded statue of a king (Octavian?), who stands on a pedestal, holding aloft a sword and, in his left hand, a globe. Antyllus' blue, fur-edged cloak is pulled back by one of the soldiers, who makes ready to stab him with his sword, brandished in his right hand. Meanwhile, another soldier moves in with a spear aimed at Antyllus' abdomen. A third soldier spears him in the back. All protagonists are shown in contemporary dress.

The scene is set in a court within grandiose palatial architecture. Empty arcades of cold grey stone disappear into the distance, creating a menacing ambiance.

FROM THE SAME SOURCE BUT NOT EXHIBITED

366b *The Suicides of Antony and Cleopatra*

In this image the suicides are conflated (compare cat. no. 367), but the scene is moved outdoors, where Antony and Cleopatra stand together, apparently on a decorated grey cloth laid in a hilly landscape. A river runs behind them and, beyond it a wood with an open glade at the foot of a grassy hill. Higher, rockier hills with sparse trees are more faintly shown in the background.

Cleopatra, to the right, watches anxiously as Antony prepares to strike himself in the heart with a mighty sword, while she herself applies the asps to both breasts. Cleopatra has slipped her fur-trimmed reddish gown to the waist, exposing her upper body. Her long, black hair flows down behind her shoulders, unconfined by the high horned headdress, which has at its base a golden crown and, flowing from it, a fine transparent veil. Antony, with thick, dark hair and beard, and strong features, wears a long blue coat, the cuffs and hem embroidered in gold, the garment edged with gilded fur. Around his waist is knotted a thick white sheet of cloth, which billows out behind him. On his head is a golden crown.

BIBLIOGRAPHY: Sir G.F. Warner and J.P. Gilson, *Catalogue of Western Manuscripts in the Old Royal and King's Collections in the British Museum* (London 1921), II, 141; C. Bozzolo, *Manuscrits des traductions françaises d'oeuvres de Boccace, XV^e siècle* (Padua 1973), 136–7; C. Reynolds, 'Illustrated Boccaccio Manuscripts in the British Library (London)', *Studi sul Boccaccio* 17 (1988), 153–9. *Flemish Art 1300–1700*, Royal Academy Exhibition Catalogue (London, 1953–4), no. 586; *Giovanni Boccaccio*, British Library Exhibition Catalogue (London 1975), no. 34.

S.McK., S.W.

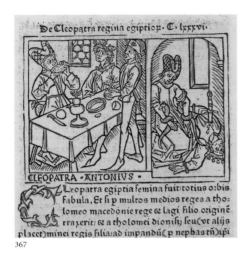

367

367 Cleopatra's Banquet and the Suicides of Antony and Cleopatra

Giovanni Boccaccio, *De mulieribus claris*
(On the Lives of Famous Women), Folio LXXXIXV

1473

Printed in Ulm, Germany, by Johann Zainer

Folio lxxxixv, 285 × 193 mm, woodcut 76 × 105 mm

London, British Library G. 1449

The image is one of eighty or so woodcuts made for
this text. In this copy the rubricator, whose work
was to colour the principal letters in red, has also
highlighted the picture. The woodcuts were copied
in other editions of Boccaccio's work, including a
Latin version published in Louvain in 1487 and a
Spanish translation printed in Saragossa in 1494.

The scene on the left shows Cleopatra in a con-
temporary headdress and an edged robe, drinking
from the cup in which she had dissolved the pearl
from her earring. Antony, also wearing contempo-
rary robes and a crown, watches with an expression
of astonishment and concern from a seat beside
her at the table. Standing to face them is a third
figure, who could be a servant but should perhaps
be identified as Lucius Plautus, who was called to
adjudicate the challenge between the two lovers.
The two principal figures are named in Latin below
the picture, the names appearing as if on a Roman
memorial beneath the appropriate images.

On the right, a second scene is set within an
arched frame, this feature, the undecorated window
and the positioning of the image slightly below the
banquet scene perhaps indicating that the setting is
a subterranean vault. Antony falls prostrate and
almost inverted on the ground, a long sword stuck
into his breast. Immediately beside him stands
Cleopatra, the sleeves of her robe rolled up to allow
the asps to bite into the veins at the elbows. Both
figures are clearly identified by their headdresses.

The printer Johann Zainer was active in Ulm
from 1473 until at least 1493. Among his books
figure Heinrich Steinhöwel's German translation of

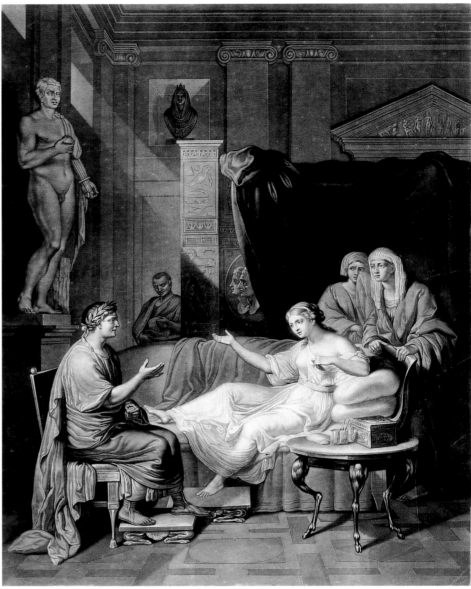

368

Boccaccio's Decameron, and an illustrated edition of
De mulieribus claris, also translated by Steinhöwel.

BIBLIOGRAPHY: *Catalogue of books printed in the XVth century
now in the British Museum* (London 1912), Part II, 521;
A.M. Hind, *An Introduction to the History of Woodcuts*
(London 1935), II, 305–6, 593; Giovanni Boccaccio,
Concerning Famous Women, trs, with an introduction and
notes, by G. A. Guarino (London 1964); R. Müller, *Ein
Frauenbuch des frühen Humanismus: Untersuchungen zu
Boccaccios De mulieribus claris* (Stuttgart 1992).
B.T., S.W.

368 *The Interview of Augustus and Cleopatra*

Richard Earlom (1743–1822) after Anton Raphael Mengs
(1728–1779)

1784

Mezzotint engraving

63 × 45.8 cm

London, British Museum PD 1872-5-11-427 (Purchased
from Mr Love)

Anton Raphael Mengs spent much of his life in
Italy, where he enjoyed the friendship of the great
scholar of classical art Johann Winckelmann,
with whom he debated the relative merits of
Greek, Roman and Etruscan sculpture. Mengs'
interest in the classical world seemed to guide the
choice of his subject matter when approaching
the life of Cleopatra in his painting of about
1760. He, like many other neoclassical artists,
chose a dramatic moment from the Egyptian
Queen's life, which allowed for a very clear-cut,
crisply lit, composition with strong Roman links.

The scene shown is taken from Plutarch's *Life
of Mark Antony*, LXXXIII. Octavian refutes
Cleopatra's justification for her actions.
Cleopatra, reclining on 'a mean pallet-bed', as

Plutarch calls it, points to the statue of Caesar in the background. A medallion of Cleopatra, shown with Antony in Ptolemaic royal style, is partially exposed by the drape behind her. While trying to conceal her possessions from Octavian, her ploys flounder as Seleucus, her steward, emerges from the background with the inventory of them.

This print, after a painting by Mengs, shows the artist's knowledge of recently published engravings of antiquities. The composition, in Cleopatra's gesture and in the curious zoomorphic form of the table, relates closely to an engraving of a *Feasting Scene* after an antique painting that was illustrated in *Le pitture antiche d'Ercolano*, I (1757, pl. XIV). This publication was the main vehicle for spreading visual information about discoveries at Herculaneum, a site that Mengs had visited. The pseudo-hieroglyphs do not make sense in the sequence in which they are shown and probably derive from inscriptions on Egyptian obelisks observed in Rome.

In the eighteenth century mezzotint prints became one of the most popular methods of reproducing famous paintings. There was a particularly large market in Germany for these prints, at which English engravers like Richard Earlom excelled and from which publishers like John Boydell made vast fortunes. It was not always necessary to have the original oil painting in front of him for an engraver to make a print; in this case, Anton Raphael Mengs's painting hung in a collection in Dresden, where he was court painter, and his pupil Seydelmann recorded it in a careful drawing, which was sent to Earlom. The painting in Dresden was not Mengs's first of Cleopatra and Octavian. Two years earlier the wealthy banker Henry Hoare had commissioned one for Stourhead House in Wiltshire, and two other closely related versions are now in Vienna and Augsburg.

BIBLIOGRAPHY: T. Pelzel, *Anton Raphael Mengs and Neoclassicism* (New York and London 1979); S. Roettgen, *Anton Raphael Mengs 1728–1779 & his British Patrons* (London 1993).
H.W., K.S.

369 *Cleopatra*

Giovanni Francesco Barbieri (1591–1666),
called Guercino

Late 1630s

Casa Gennari; J. Bouverie (L.325); C. Hervey;
1st Earl of Gainsborough; J.C. Robinson; J. Malcolm

Red chalk

29.2 × 21.5 cm

London, British Museum PD 1895-9-15-709

This handsome red chalk drawing by the Bolognese Baroque painter Guercino shows the moment just prior to the asp's fatal bite. The beautiful young queen appears here as a paradigm of stoicism, calmly turning her head so as not to look

at the writhing snake held up to her breast with her right hand. The reticence Guercino displays in his depiction of this episode is deliberate, as it encourages the viewer to imagine what is just about to happen: the terrible moment of the snake's strike, and the ensuing agonizing death of Cleopatra.

The dramatic possibilities of the subject made it a favoured theme of Baroque painters, especially as it provided an ideal opportunity to show a voluptuous young woman with her breasts bared. Guercino is known to have painted at least three representations of this subject during the 1630s, only one of which survives, and the present drawing probably relates to one of these lost works. The rise in popularity of paintings of this subject during the seventeenth century is connected to the growing number of collectors who commissioned works specifically for their private galleries. Depictions of Cleopatra's death, like mythological themes related to Diana and Venus, were ideally suited to this expanding market because the subject matter was sophisticated and learned, thereby flattering the erudition of the patron, while the allusions to classical history and mythology sanctioned the creation of sensuous, erotically charged images.

BIBLIOGRAPHY: N. Turner and C. Plazzotta, *Drawings by Guercino from British Collections* (London 1991), 145–6; M. Royalton-Kisch, H. Chapman and S. Coppel, *Old Master Drawings from the Malcolm Collection* (London, 1996), 98, 99.

H.C., H.W.

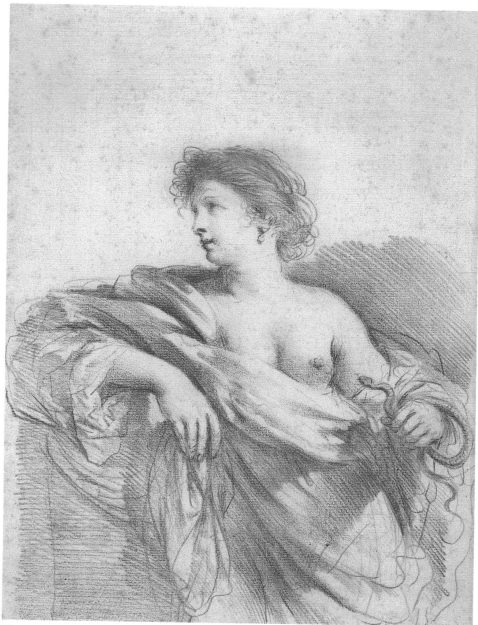

369

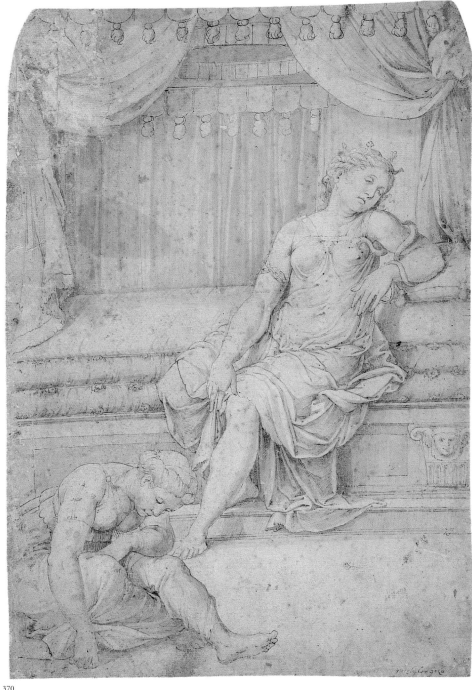

370

370 *The Death of Cleopatra*

Bartolomeo Neroni, called Riccio (*c.*1500–*c.*1571–3)

Pen, brown ink and grey wash, blue crayon and
black chalk

40.5 × 26.9 cm

London, British Museum PD 1943-11-13-53
(Presented by Eric Rose)

Despite the old attribution at the lower right
corner to Michelangelo, added later by an opti-
mistic collector, the lumpish figures and the
rather pedantic penmanship are typical features
of drawings by the little-known Sienese painter
and architect Neroni. The artist has set the scene
in a lavish sixteenth-century interior with a
richly canopied bed, on the edge of which
Cleopatra sits precariously in an ungainly pose,
leaning her weight unconvincingly on the
unyielding form of a pillow on the right.

The monumental forms and draperies of the
Queen and her maid Iras, seated at her feet, delib-
erately evoke classical sculpture, and Neroni's
depiction of Cleopatra with her head leaning to

one side and her eyes closed echoes the pose of
the famous Roman sculpture of the *Sleeping
Ariadne*, then as now displayed in the Vatican
(p.304, fig. 11.2). This discrete reference would
have had an added resonance because the sculp-
ture was believed, on account of Ariadne's snake
bracelet, to represent the dying Cleopatra. Neroni
is not known to have visited Rome, and his
knowledge of its classical works may have been
based on the antiquarian drawings made by his
Sienese contemporary Baldassare Peruzzi. The
lack of any changes to the outline and the precise,
if now sadly faded, wash suggest that this drawing
was intended as a finished work of art, or as a
means of showing a patron the intended form of
a painting.

BIBLIOGRAPHY: N. Adams in J. Shoaf Turner (ed.),
The Dictionary of Art 22 (London 1996), 804–5.
H.C., H.W.

371 *The Funeral of Cleopatra*

Charles Michel-Ange Challe (or Challes; 1718–78)

1760s

Pen and black ink with grey wash

42.2 × 55.4 cm

London, British Museum PD 1991-10-5-79

Challe, a Parisian, was the pupil of Boucher and
of Andre Lemoine. He won the Prix de Rome and
was at the French Academy in Rome from 1742
to 1749. During this long sojourn he made an
excursion to visit the recently excavated ruins
around Naples, Herculaneum and Vesuvius. On
his return to France, he was graced with royal
favour, being appointed, in 1765, Dessinateur de
la Chambre et du Cabinet du Roi to Louis XV,
who eventually ennobled him in 1770.

While in Rome Challe had contributed to the
design of carnival festivities and particularly to the
masquerade, or *farandole,* staged at the French
Academy just before Lent. This seems to have been
ideal experience for the major role that became his
especial strength after his return to France, when
he designed the *menus plaisirs,* grandiose enter-
tainments, for the crown, including the lavish illu-
minations at Versailles to celebrate the birth of the
Dauphin, and, later, the funerals of the Dauphin,
the King of Poland, the Queen of Spain, and even-
tually of Louis XV in 1774.

The sculptor and engraver Giovanni Battista
Piranesi (1720–78) was closely associated with
students at the French Academy in Rome, and
in 1746 he designed a fireworks festival in
honour of the French sculptor Saly at the
French Academy. Piranesi printed his etchings
on the Corso opposite the French Academy and
he sold his prints through the Frenchman Jean
Bouchard.

The sheer grandiosity of this robust drawing is

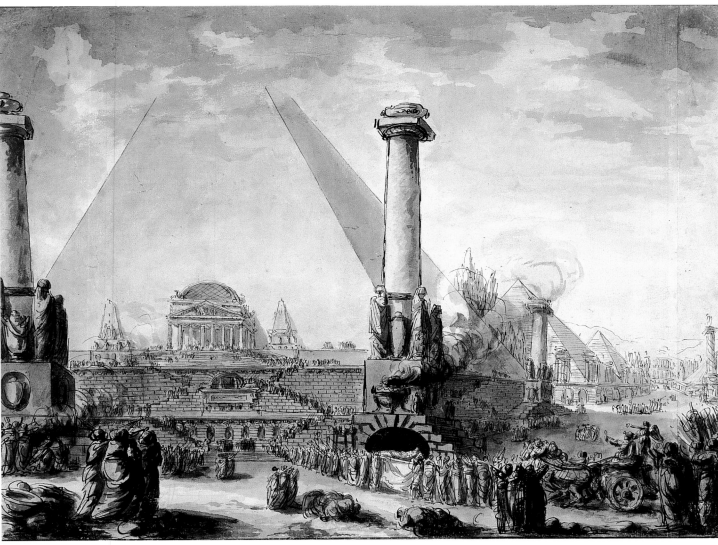

371

symptomatic of a new artistic era heavily inspired by the grandeur of ancient Rome. It echos the designs in Piranesi's etched series *Prima Parte di Architetture e Prospettive*, published in 1743, and anticipates the work of the neoclassical architects E-L. Boullée (1728–99) and C-N. Ledoux (1736–1806), and the festival designs made by the great French artist J.L. David (1748–1825) for enactment on the Champ de Mars in Paris during the Revolutionary years.

The massive scale of the scene represented by this drawing is shown by the three enormous pyramids, one of which has its apex in the clouds. The procession winds through the foreground, leading towards a neoclassical temple on one side of the foremost pyramid: the whole scene is almost like a stage-set for an opera. In the procession we see a draped body lying on a bier, followed by an emperor in a quadriga. Presumably, the body is Cleopatra's and the emperor is Octavian, accompanied by the goddess Victory, who offers him a wreath. The funeral of Cleopatra was thus made a Roman triumph, for which there is no historical evidence. This design may have been intended for a festival, a sort of tableau to be enacted on an official or royal occasion, but it could equally relate to a grandiose painted composition. It is one of over 800 drawings that Challe made throughout his career.

The works that Challe sent to the Salon in the 1760s were predominantly themes taken from history, mythology or the Bible. In 1761 Challe sent to the Salon *Cleopatra Expiring* (now apparently lost). Diderot 'questioned the choice of the moment of the episode. If the serpent were removed, we should not be able to recognise Cleopatra; she should gloatingly smile at the serpent, instead of being merely shown as dying, in order to demonstrate disdainful triumph over those who would lead her captive to Rome' (Wunder 1967): this eloquently tells us the way in which an informed eighteenth-century critic expected Cleopatra to be represented.

BIBLIOGRAPHY: R.P. Wunder: *Charles Michel-Ange Challe, a Study of his Life and Work* (London 1967), *passim*.

H.W.

372 Marble bust of Catherine, Lady Stepney as Cleopatra

Richard Cockle Lucas (1800–1883)

Made before April 1836

Height 67.3 cm

London, Victoria and Albert Museum A8-1964
(Bequeathed by Miss Dorothy Manners, a descendant
of Lady Stepney)

Lady Stepney is portrayed turned to her left, in three-quarter view. Her hands are crossed, and a snake encircles her right wrist. She wears a low-cut gown, and a ring on the fourth finger of her left hand. Ringlets escape from beneath her cap.

The uninscribed bust was exhibited at the Royal Academy, London, where it was seen by Sir David Wilkie, who commented favourably on its position in a letter to Lady Stepney of 27 April 1836. In a letter written to Albert Dürer Lucas (son of the sculptor) on 14 December 1909, Lady Stepney's grandson Stepney Manners recalled as a boy seeing a replica of the bust, which was then displayed in the entrance to the Coliseum in Regents Park.

Richard Cockle Lucas, best known for his work in wax and ivory, also produced a full-length wax portrait of Lady Stepney; this too was exhibited at the Royal Academy.

Catherine, Lady Stepney (d. 1845) was a novelist, the daughter of Thomas Pollock, rector of Grittleton, Wiltshire. She was first married to Russell Manners. After the death of her second husband, Sir Thomas Stepney, in 1825, she became the noted hostess of a London literary salon. Attractive and accomplished, she perhaps took the part of Cleopatra in a dramatic or literary reading; the occasion for the portrait is not recorded.

BIBLIOGRAPHY: V. Graves, *RA Exhibitors V* (London 1836), 106, nos 1145, 1128 (wax portrait); R. Gunnis, *Dictionary of British Sculptors 1660–1851* (London, 1968), 245; *Royal Academy Bicentenary Exhibition 1768–1968* (London 1968), 105 no. 232; L. Stephen and S. Lee (eds), *Dictionary of National Biography* Vol. XVIII (Oxford 1998), 1077, s.v. Stepney, Lady Catherine.

S.W.

372

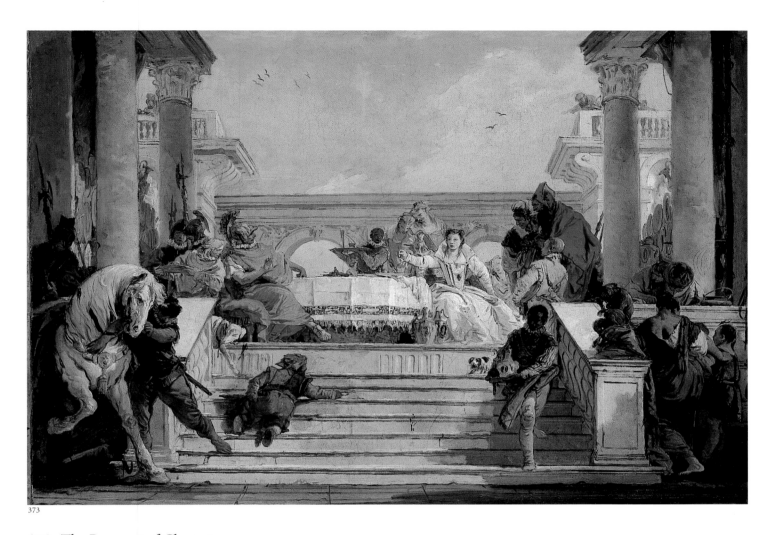

373

373 *The Banquet of Cleopatra*

Giovanni Battista Tiepolo

1740s

Oil on canvas

46.3 × 66.7 cm

London, The National Gallery 6409

This oil sketch, made in preparation for a larger work, depicts the famous episode related in Book IX of Pliny's *Natural History*. Contemptuous of the lavish banquets hosted by Mark Antony, Cleopatra wagered that she could provide a costlier feast. During the meal she dropped one of her largest, most expensive pearls into a vessel containing vinegar. The pearl dissolved, the queen drank the liquid and declared herself the victor. The painting captures the moment when Cleopatra is about to release the pearl from her grasp, and Mark Antony starts back in amazement.

Tiepolo painted this subject on several occasions. The most celebrated version forms part of an elaborate scheme of frescoes for the ballroom of the Palazzo Labia in Venice. The present work may represent an early idea for this scene; alternatively, it may be connected with a canvas of 1747 now at Archangelskoye near Moscow.

The costumes and setting recall the fashionable balls and *divertimenti* of eighteenth-century Venice. A staircase in the foreground leads the spectator's eye into a bright, sunlit space framed by monumental architecture. Rapid, brilliant brushstrokes offset the calculated stillness of Cleopatra's gesture: the pearl hangs at the very centre of the composition.

BIBLIOGRAPHY: M. Levey, Giambatista Tiepolo: *His Life and Art* (New Haven, Conn. 1986), 143–66; B.L. Brown (ed.), *Giambattista Tiepolo, Master of the Oil Sketch*, exh. cat., Kimbell Art Museum (Fort Worth, Texas 1993), 250–55, cat. no. 35, ill. p.115; C. Baker and T. Henry, *The National Gallery Complete Illustrated Catalogue* (London 1995), 660; *Giambattista Tiepolo 1696–1770*, exh. cat., Museé du Petit Palais, (Paris,1998–9), 180–82.

S.K.

374 *Cleopatra Dropping the Pearl into the Wine*

William Kent (1684/5–1748) after Carlo Maratta
(1625–1713); inscribed, possibly in a later hand, 'W.Kent'

*c.*1710–1720 H.S. Reitlinger (Lugt Suppl, 2274a);
Sotheby's, London, 27 January 1954, lot 159

Two shades of red chalk with use of stylus

36.4 × 25.7 cm

London, British Museum PD 1954-2-13-5
(Purchased with assistance from the H.L. Florence Fund)

Kent, a Yorkshireman, travelled to Italy in 1709,
where he studied with Benedetto Luti in Rome
and was influenced by artists who, in turn, were
inspired by Maratta. He travelled widely around
the country between 1709 and 1719, spending
most time in Rome, Florence, Parma and Venice.
In 1714 on the Brenta, in the Villa Giovanelli,
Kent encountered the decorative scheme repre-
senting *Antony and Cleopatra,* by Ricci and
Pellegrini. It was here that Kent met Lord
Burlington, with whom he returned to England
in 1719 and who was the mentor of much of
Kent's career, which encompassed painting,
architecture, furniture and garden design.

In Italy Kent's sponsors expected him to pur-
chase or copy works of art for them; this red
chalk drawing may fit into the latter category, as
it includes, in the lower right corner, for example,
many hatched and cross-hatched lines, which
often appear in drawings made by printmakers
or from which prints are made. This drawing
relates to a print made by Jacob Frey, who left his
native Switzerland in 1702 for Rome, where he
took lessons from Carlo Maratta. Frey's engrav-
ing of 1720 of this composition differs slightly in
details from this drawing. The fact that faint
stylus lines are perceptible around the main lines
of the drapery suggests that this drawing was
intended for transfer.

The composition seems most closely based on
an original painting by Maratta, now in the
Palazzo Venezia, Rome. Cleopatra holds an enor-
mous pearl towards a classical drinking cup,
opening her hand so that we may see its great
size. The scene concerns the banquet of
Cleopatra, a feast given in a bid to outdo
Antony's pretensions to extravagance, exempli-
fied in the moment when the Queen removed a
precious pearl earring and dissolved it in a cup
of wine, which she then consumed. The episode
is meant as the epitome of ostentatious con-
sumption, a mood captured here in Cleopatra's
luxurious clothes and the voluminously draped

374

setting. Beside the throne a voluptuous female
figure, apparently a statuette, evokes Cleopatra's
sensuality.

BIBLIOGRAPHY: J. Ingamells, *A Dictionary of British & Irish
Travellers in Italy 1701–1800* (New Haven, Conn. 1997),
569–71; N. Turner and C. Plazzotta, *Drawings by Guercino
from British Collections* (London 1991), 256, no. 38.

H.W.

375 The Meeting of Cleopatra and Antony

Tommaso Costa (d. 1773)

c. 1750–1770

Pen and grey ink, grey wash, black chalk, watercolour, squared up with red crayon

27.7 × 36.1 cm

London, British Museum PD 1947-5-10-1; purchased at Sotheby's, 30 April 1947, lot 16

This and the following drawing are designs by the obscure Venetian stage designer Costa for an unknown theatrical production centred around the doomed romance of Cleopatra and Mark Antony. The first of these shows the meeting of the lovers at a port, an episode that does not have a specific historical source. Costa may well have had in mind Giovanni Battista Tiepolo's celebrated fresco of the subject painted in the 1740s in the Palazzo Labia in Venice. His depiction shares with the fresco the device of differentiating the two parties: Cleopatra is dressed in a sumptuous sixteenth-century manner, inspired by the richly decorated brocades found in paintings by the Venetian painter Paolo Veronese, while the Romans wear a more historically accurate, if somewhat florid, style of Roman armour. As in Tiepolo's fresco, the contrasting natures of the two cultures are underlined in the figures' costumes, the opulence and luxuriance of Egypt as against the martial austerity of Rome.

Costa's attention to the drawing is largely concentrated on the colours and details of costume, and on the elaborately decorated prows of the ships in the harbour. The building on the right, reached by two flights of steps, is only lightly sketched in with black chalk. The red chalk squaring laid over the entire drawing would have facilitated the copying of certain areas for further elaboration, and the enlargement of the design for the production of the finished stage scenery.

BIBLIOGRAPHY: U. Thieme and E. Becker, *Allgemeines Kunstler-Lexikon*, revd by K.G. Sauer, 21 (Munich and Leipzig 1999) 456, *s.v.* Tommaso Costa.

H.C., H.W.

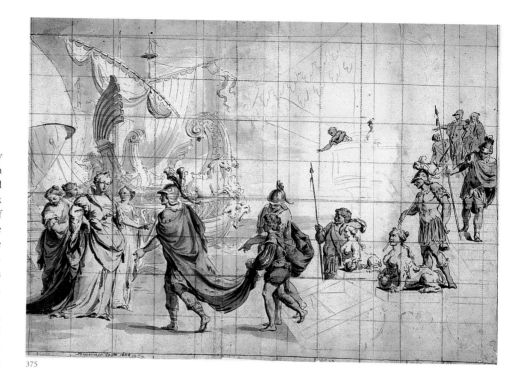

375

376 The Feast of Cleopatra

Tommaso Costa (d. 1773)

c. 1750–1770

Pen and grey ink, grey wash and watercolour

Image 22.9 × 27.9 cm; sheet 24.5 × 29.7 cm

London, British Museum PD 1947-5-10-3
(Purchased at Sotheby's, 30 April 1947, lot 16)

Like cat. no. 375, this version of the banquet of Cleopatra is probably a stage design for a theatrical or operatic production. As in the previous drawing, Costa has sought inspiration from Tiepolo's fresco of the subject in the Palazzo Labia (see also cat. no. 373). From this source Costa has

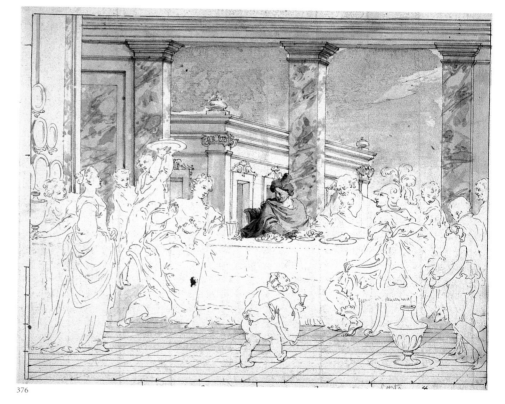

376

borrowed the richly attired dwarf seen from behind in the foreground, and the screen of columns in the background. In contrast to the previous drawing, Cleopatra is shown in contemporary eighteenth-century costume, while the other figures, save Antony, are dressed in a theatrical mixture of Renaissance and eastern styles. This

drawing is once again unfinished, with only the background architecture and one of the figures coloured in watercolour.

BIBLIOGRAPHY: U. Thieme and E. Becker, *Allgemeines Kunstler-Lexikon*, revd by K.G. Sauer, 21 (Munich and Leipzig 1999) 456, *s.v.* Tommaso Costa.

H.C., H.W.

377

377 *Antony Taking Leave of Cleopatra*

Francis Philip Stephanoff (1789–1860)

c. 1838–45

Watercolour and bodycolour

24.8 x 19.7 cm

London, British Museum PD 1977-11-5-6

Francis Philip Stephanoff was born in London, the son of a Russian painter who had emigrated to England. He exhibited widely in London, from 1807 to 1845, at the Royal Academy, the British Institution, Suffolk Street and at the Old Watercolour Society. He became known for genre scenes and historical subjects, drawing the costume portraits for Nayler's *Coronation of George IV* and a profusion of illustrations for other works. This drawing might be a study for one such illustration.

The scene shows Antony preparing to take leave of Cleopatra in a room in her palace in Alexandria. His attendant, Eros, helps him on with his footwear while the fair-skinned Cleopatra fastens his epaulette. It is likely that the drawing evokes Shakespeare's *Antony and Cleopatra*, Act IV, Scene iv, when Cleopatra, assisting Antony to put on his armour, asks 'Is not this buckled well?', and Antony goes on to castigate his servant, crying 'Thou fumblest, Eros.'

The drawing includes two other attendants and the whole group is gathered in front of pseudo-Egyptian columns on which hangs a grandiose drape, in a manner that owes much to Van Dyck or J.L. David. The standards of Rome are visible in the background, to the left, and imply Antony's forces waiting to attend his departure. The artist has attempted historical accuracy in the portrayal of Antony's sword and shield but such historicism jars with the portrayal of the face of Antony, whose swashbuckling moustache shows him every inch a Victorian. Cleopatra, too, looks very contemporary and the appearance of the main protagonists suggests a date of *c.* 1838–45 for the drawing.

BIBLIOGRAPHY: E. Bénézit, *Dictionnaire des peintres, sculpteurs, dessinateurs et graveurs*, 13 (Paris 1999), 227–8.

H.W.

378 *Head of Cleopatra*

c. 1533 or later

Copy of a work by Michelangelo Buonarroti

W.Y. Ottley; Sir Thomas Lawrence (L.2445); S. Woodburn (Christie's, London, 4 June 1860, lot 140)

Black chalk

24.6 × 17 cm

London, British Museum PD 1887-5-2-120 (Wilde 91) (Presented by H. Vaughan)

The drawing is inscribed in ink in the lower right corner 'Mic: Angelo Buonaroti' (*sic*).

This is one of many copies after a black chalk drawing by Michelangelo, which we know from his sixteenth-century biographer Giorgio Vasari was made as a present for his close friend, the Florentine aristocrat Tommaso de'Cavalieri in 1533–4. The custom of giving drawings as gifts to his intimate friends was not unique to Michelangelo, but we are better informed about his activities because his works were so highly treasured by his contemporaries.

The original drawing after which this was copied is generally believed to be that in the Casa Buonarotti in Florence. Michelangelo intended this drawing as a showpiece of his own creative genius, manifested in the imaginative transformation of Cleopatra's tresses into a snake, and in the extraordinary refinement of the black chalk shading (the latter quality only dimly visible in the present drawing).

This type of study belongs to an established Florentine tradition, stretching back to Leonardo and Verrocchio in the 1470s, of making highly finished studies of heads. Michelangelo is not remotely concerned in the drawing with the historical figure of Cleopatra, whose tragic death is instead emptied of pathos and turned into a beautiful play of sinuous curving forms ending in the snake's head fastened on her bosom. Every detail of the figure is artfully contrived to emphasize its elegant grace, an abstracted quality made plain in the manner in which the pose is truncated below the shoulder. This detail, in conjunction with the polished brilliance of Michelangelo's chalk, was doubtless intended to bring to mind exquisitely refined small-scale bronzes, an antique form revived in the sixteenth

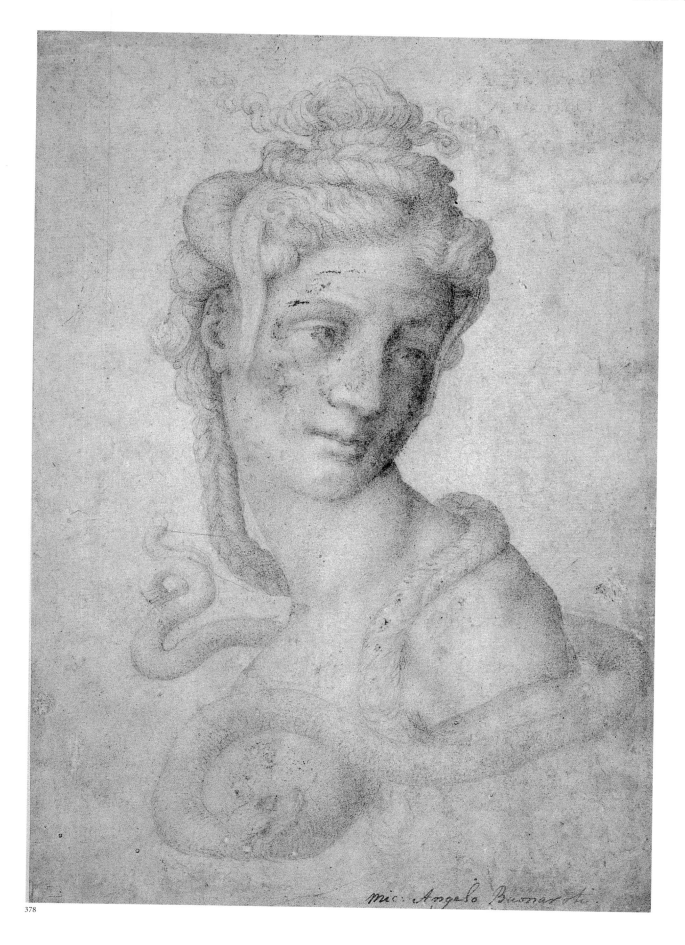

378

century, which, like the drawing itself, were intended for private contemplation and study. Drawings such as this may have inspired later sixteenth-century representations of Cleopatra, such as cat. no. 379, a cameo in which Cleopatra appears both as a tragic heroine of antiquity and as a fashionable contemporary woman.

BIBLIOGRAPHY: J. Wilde, *Italian Drawings in the Department of Prints & Drawings in the British Museum* (London 1953), 125–6.

H.C.

379 Sardonyx cameo: the suicide of Cleopatra

Late sixteenth century

Northern Italian, from Lombardy or Emilia

Height 3.5 cm, width 2 cm

London, British Museum Sloane Bequest 86; Dalton 472

The gem is cut in very high relief out of a single piece of sardonyx, showing Cleopatra in profile facing to her left. Her profile is deeply undercut so that it projects out over the base layer, adding definition to her features. She is presented as a vision of contemporary beauty and fashion in a fanciful combination of antique and modern details. Her hair is elaborately dressed in what would have been considered an *all'antica* style, and she wears contemporary drop earrings. Her flimsy shift is cut away to reveal her breasts: the asp, twined around her right arm and hand, reaches out to bite her right nipple.

The presentation of Cleopatra as both ancient heroine and fashionable contemporary woman is closely allied to late sixteenth-century medals of the Emilian and Lombard schools, such as those made by Jacopo da Trezzo, Bombarda, Ruspagiari and Pastorino. Named women – such as Bombarda's wife, Leonora Cambi – are treated in similar ways to Cleopatra here, with elaborately dressed hair and clinging, light draperies revealing one breast. The representation therefore plays on the idea of Cleopatra as both seductress and moral exemplar, in a way that could be flattering, as in the medals of named women, with reference to a specific contemporary woman. Female heads are treated in a very similar way on sixteenth-century Italian majolica (tin-glazed earthenware), where they are often accompanied by moralizing inscriptions or praising labels, such as 'Divine and beautiful Lucia'.

This gem would originally have had an elaborate enamelled gold and gem-set mount, making it into a superb and dramatic pendant. As a jewel, it is as likely to have been worn by a man as by a woman.

Very different in style and technique to cat. no. 380, this high-quality cameo came to the British Museum as part of the Sloane Bequest at the

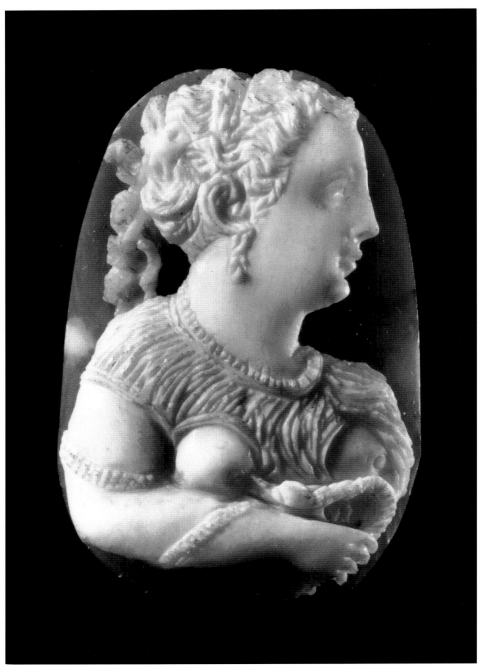

379

foundation of the museum in 1753. It is correctly identified as showing Cleopatra and the asp in the manuscript catalogue of Sloane's collection.

BIBLIOGRAPHY: MS catalogue, Sloane Collection, British Museum, Department of Medieval and Modern Europe, cat. no. 86; O. Dalton, *Catalogue of Gems in the British Museum* (London 1915), 472; S.K. Scher (ed.), *The Currency of Fame, Portrait Medals of the Renaissance* (New York 1994), no. 75; M. Ajmar and D. Thornton, 'When is a portrait not a portrait? *Belle donne* on maiolica and the Renaissance praise of local beauties', in N. Mann and L. Syson (eds), *The Image of the Individual, Portraits in the Renaissance* (London 1998),138–53.

D.T.

380 Sardonyx cameo: the suicide of Cleopatra

Late sixteenth century

Northern Italian, perhaps from Milan

Height 4.3 cm, width 3.3 cm

London, British Museum, MME 1772, 3-14.188;
Gem Cat.319

Cleopatra is shown frontal, bare-breasted and with drapery (cut in the brown layer of the stone) around her head and shoulders. The asp, which is to give her a fatal bite, is coiled around her left wrist. Cleopatra's form is cut out of the white layer of the sardonyx, sensuously modelled in high relief, and polished to give a smooth reflective surface. Differences in texture between skin, draperies, hair and the asp are skilfully accentuated. Cleopatra's pupils are drilled into the stone to give a sense of expression, as are the corners of her mouth. Her neck has also been drilled so as to hold a jewelled choker (now removed) in place; perhaps to disguise a break in the cameo, which must have occurred before 1915, when it was recorded by Dalton. The bust has been glued to a separate backing plate, perhaps also part of a later repair which must have been done before Sir William Hamilton sold the cameo to the British Museum in 1772.

One of the very few cameos in Hamilton's first collection to be sold to the British Museum, it was then considered to be Roman, of the first or second century AD. Hamilton's adviser d'Hancarville described it as antique but retouched in his manuscript catalogue of Hamilton's collection. Even now, the cameo is difficult to place. The theme of Cleopatra was popular with sixteenth-century gem engravers and goldsmiths owing to the opportunity it presented for the erotic depiction of a female nude. In addition, Cleopatra, like Lucretia, could be presented as an exemplary figure; as a model of feminine courage and integrity. The confident handling and the overt classicism of the head in this cameo can be compared with Milanese gems of the mid- to late sixteenth century, showing female heads. Some of these use the differently coloured layers within sardonyx in a similar way to model and frame the form represented. Milanese gems are also drilled in a similar way to the present example. However, sixteenth-century female heads with drapery are rarely presented frontally as here, but are usually shown in twisting (*contraposto*) movement, often three-quarter face or in profile as in cat. no. 379. Similarly, draperies on most sixteenth-century examples tend to be arranged in a more fluid manner. These discrepancies may even suggest that the gem is later than the sixteenth century, and could have been produced closer to Hamilton's lifetime, and certainly before its sale

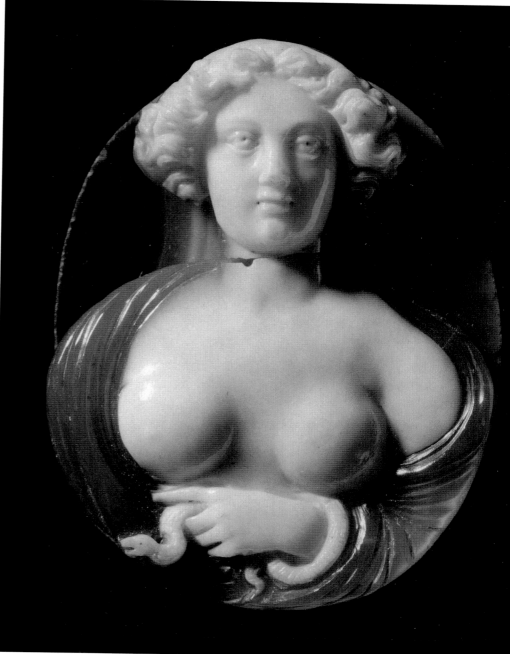

380

to the Museum in 1772, as an exercise in the classical manner.

BIBLIOGRAPHY: O. Dalton, *Catalogue of Gems in the British Museum* (London 1915), no. 319; I. Jenkins and K. Sloan, *Vases and Volcanoes* (London 1996), no. 66; D'Hancarville, MS catalogue of the Hamilton collection, Vol. II (1778, now in the British Museum, Department of Greek and Roman Antiquities), 503–4; E. Babelon, *Catalogue des camées antiques et moderne de la Bibliothèque Nationale* (Paris 1897), pl. 60, no. 671; A. Furtwängler, *Die antiken Gemmen*, 3 vols. (Leipzig and Berlin 1900), I, pl. 67, no.16; P. Venturelli, *Gioielli e gioiellieri milanesi* (Milan 1996), 56, 119.

D.T.

381 Silver pair-cased verge watch: *Cleopatra before Octavian*

1790

London; formerly in the Ilbert Collection

Diameter 5.07 cm

London, British Museum MME CAI.642.1958

The movement is of standard Geneva pattern with fusee, four-wheel train and verge escapement. The three-arm balance, oscillating beneath a pierced foliate balance bridge, has a spiral balance spring and geared regulator. The polychrome enamel dial has an inner white chapter ring with Roman hours and arcaded minutes. Around the outside is a border of coloured enamel depicting a young sailor departing from his sweetheart on the left and a sailing ship on the right. The gilt hour and minute hands are pierced.

Of the silver pair cases, the inner is plain with rubbed London hallmarks for 1790, the outer repoussé with a depiction of *Cleopatra before Octavian* within a rocaille border. Cleopatra, seated to the left, gestures with her raised left arm to Octavian, standing to the right in military dress. Immediately behind him is a bust of Caesar, while an attendant peers from a curtain behind Cleopatra. Between the two major protagonists is Antony's burial urn on a decorated stand.

The movement is signed 'May London 811' and the dial 'May London'. The name May is likely to be fictitious. During the eighteenth century, particularly in the second half, there was a flourishing industry in Geneva making poorer-quality watches with spurious London names on the movements. They typically have silver repoussé outer cases and are now thought to have been sold either in Europe or perhaps as second-quality merchandise by the London watchmaker-retailers, although the practice was at the time illegal. In this instance, the existence of London hallmarks in the inner case of this watch suggests the latter circumstance.

UNPUBLISHED

Dd.T.

382 Silver pair-cased verge watch: *Cleopatra Receiving the Basket of Figs*

Formerly in the Ilbert Collection 1798

Diameter 5 cm (repoussé case)

London, British Museum MME CAI.842. 1958

The movement has square baluster pillars, fusee, four-wheel train and verge escapement. A pierced and engraved foliate balance cock provides bearing for a steel three-arm balance with spiral balance spring and geared regulator. The white enamel dial has hours marked I–XII and minutes 5–60. The gold hands are not original.

Of the silver pair cases, the inner is plain with the maker's mark TC with an axe above, for Thomas Carpenter, and the London hallmark for 1778. The silver repoussé outer case has a depiction of *Cleopatra Receiving the Basket of Figs* within a border of volutes and flowers. Here Cleopatra sits to the right, plucking the asp from the basket of figs, which is proffered by a kneeling attendant. Between the two principal figures stands a distraught maid. In the background is an elaborate arrangement of baroque columns and arcades, as it happens very appropriate to the evocation of Hellenistic Alexandria. A third tortoise-shell covered outer case with silver rims is a later association.

The movement is signed 'B. Bennett London 6497'. B. Bennett is otherwise unknown. The watch case-maker Thomas Carpenter had his business in Islington Road, Clerkenwell, London and his mark was registered at Goldsmiths' Hall London on 20 July 1797.

The origins of this watch are rather similar to those of cat. no. 381 in that it appears to be a London watch with an imported outer case but with a London–made inner case hallmarked and with an established case-maker's mark. The movement itself might be of English origin but, equally, could have been made in Switzerland.

UNPUBLISHED

Dd.T.

383 Gold and enamel cased verge watch: *The Death of Cleopatra*

c. 1690

Pieter Paulus of Amsterdam and Pierre Huaud the younger of Geneva; formerly in the Ilbert Collection, purchased 1958

Diameter 3.98 cm

London, British Museum MME CAI.2360

The movement has pierced foliate pillars, fusee, four-wheel train of gears and a verge escapement. The three-arm balance is fitted with a spiral balance spring and a geared regulator to

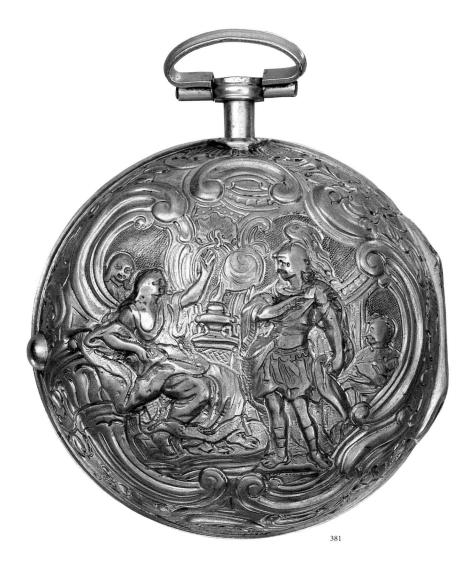

381

adjust the rate of the watch, which goes for a day on one wind.

The polychrome enamel dial has a white chapter-ring surrounding a depiction of *The Death of Cleopatra*. The Queen, of contemporary appearance, wears a golden crown, and crimson and blue drapes over a white shift. She pulls the asp from the basket of figs beside her. The fixing for the missing hands discreetly covers her exposed breast. The dying Cleopatra is posed in front of purple drapes, to the left of which is part of a wooden frame. The tone of the image is theatrical.

The gold case, with hinged gold bezel and gold pendant, is enamelled in colours with a depiction on the back of *Roman Charity* after an engraving by Claude Mellan based on a painting by Claude Vouet. In a series of vignettes around the band are rustic landscapes with buildings, probably after engravings by Gabriel Perelle and Nicholas Cochin.

The watch movement is signed 'Pieter Paulus Amsterdam' and in a cartouche on the case band is inscribed 'P HUAUD P. GENIIUS F.GENEVA'. Pieter Paulus, who flourished from 1690 to 1710, had his business in Hartenstraat, Amsterdam. The case was made and enamelled by Pierre Huaud the younger who worked periodically at

the Brandenburg Court between 1685 and 1689. In 1691 he became artist-miniaturist to the elector Frederick of Brandenburg but also maintained a studio in Geneva. While no positive attribution has been made, the similarity in style and composition of *The Death of Cleopatra* to that of the *Roman Charity* depiction would strongly suggest that this too is based on a painting by Claude Vouet.

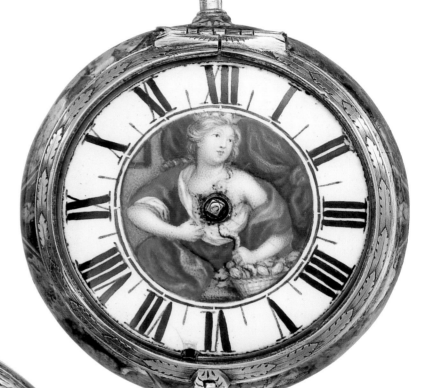

383

A very similar watch exists in the collections at the Hermitage Museum, St Petersburg, also depicting *Roman Charity* and *The Death of Cleopatra*, and decorated with similar vignettes around the band. The watch movement is inscribed '*Huaud le puisne fecit*'. The movement is signed 'Cld Lerisinime Genin 416'.

At the end of the seventeenth century the Huaud family in Geneva were perhaps the foremost exponents of the art of painting in enamel and they achieved their greatest popularity in the Netherlands, where their cases and dials were used by a number of different watchmakers in the period 1685–1710.

UNPUBLISHED. For the St. Petersburg watch, see L. Yakovleva, 'Swiss Watches and Snuff-Boxes 17th–20th Centuries', *Artistic Enamels from the Hermitage Collection* (St Petersburg 1997), 20.

Dd.T.

382

384 Pressbook for the film *Cleopatra*, directed by Cecil B. DeMille

1934
Paramount Studio
Height 47 cm, width 31 cm
London, British Film Institute

The film starred Claudette Colbert as Cleopatra, Warren William as Julius Caesar, and Henry Wilcoxon as Mark Antony, and was produced by the Paramount Studio. Pressbooks (or press campaign books, as they are also known) were a marketing tool devised by studio publicity departments for the exhibition arm of the industry. They instructed cinema managers in ways in which the film might be exploited and marketed to potential audiences, and included information about publicity aids such as posters, production stills and lobby cards that were available for hire or purchase from the distributing company. They included a variety of promotional ideas such as competitions, recipes, and links with local shops, as well as suggested copy for local newspapers.

This is a particularly fine example of the lavish publicity campaign that accompanied the release of one of the sumptuous costume spectacles for which DeMille was famous. The pages are displayed to show the ways in which female cinemagoers were encouraged to acquire the 'Cleopatra look', and they illustrate the influence that cinema has always had on current fashion trends.

BIBLIOGRAPHY: M. Hamer, *Signs of Cleopatra* (London 1993), 122–3 with n. 50, pls 5.3–4 (bibl.).

Jt.M.

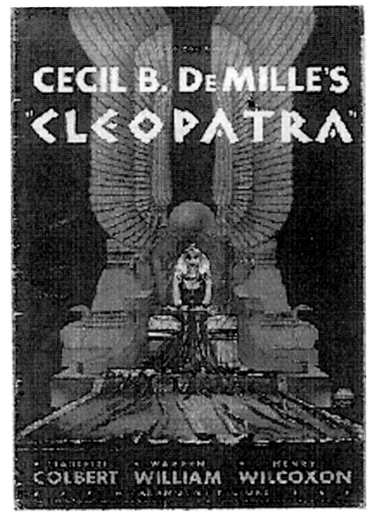

384

385 Cleopatra's Marriage Contract III

Barbara Chase-Riboud (b. 1939)
2000
Rome
Drawing on handmade paper in pencil, charcoal and ink with cord, sealing wax and silk additions
Height 116 cm, width 120 cm
Baltimore, Maryland, Walter Gomez Gallery and Jacqueline Rothschild Fine Art

This is one of a series of images of Cleopatra's marriage contract, of which the first, made in 1973, was exhibited in Paris at the Musée d'Art Moderne in 1974. The artist, of American origin, works in Paris and Rome, and for some years has explored the theme of Cleopatra through poetry (see below) and the creation of objects associated with the Queen: Cleopatra's bed, her throne, her cape (also first made in 1973) and her door.

No ancient evidence has been recovered for the legal status of the marriage of Cleopatra and Antony. However, the creation of this image acquires added poignancy in the light of the recent recognition of a document that is claimed to be the first to show the Queen's personal authorization in her own handwriting (cat. no. 188).

CLEOPATRA XXVI

Beneath the weight of angry pride
My Pharaohian breasts glisten through Sidonian
fabric
Wrought in fine texture by the sley of the Chinese:
My bridal gown woven by Egyptian needles.

Which separate the warp-web of the legally
Wedded,
Touching a map of the world with a peacock
feather,
Murmuring quietly, this…and this…and this…
Sinai, Arabia, Cyprus, Jericho, Galilee, Lebanon,
Crete.

You're not the only man to pay for my Egyptian
Nights.
My Royal Prostitution mortgaged the lives of
countless men:
Death at dawn was the price of phallic rapture

So don't wonder that your Tariff is my Territory
Shimmering through Nile-dyed muslin
Murmuring this…and this…and this…

©Barbara Chase-Riboud, from *Portrait of a Nude Woman as Cleopatra* (New York 1987), winner of the Carl Sandberg Poetry Prize for the best American poet 1987–8

BIBLIOGRAPHY: P. Selz, *Barbara Chase-Riboud: sculptor* (New York 1999), 84 (fig.); Musée d'Art Moderne, *Catalogue 'Chase-Riboud'* (Paris 1974).

S.W., B.C.R.

385 ▶

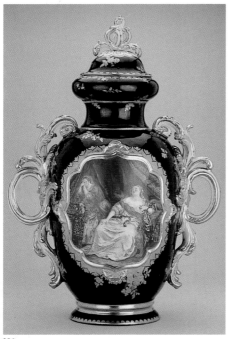

386

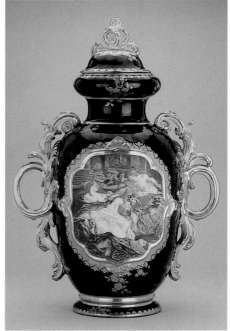

387

386–387 Soft-paste porcelain pair of vases: the *Death of Cleopatra* and the *Death of Harmonia*

c. 1760

Chelsea porcelain factory, London

Height 19.7 cm

London, British Museum MME 1763,4–15, 1 and 2
(Presented by an anonymous donor through Mr Empson
in 1763)

The vases are painted over the glaze in enamel
colours against a dark blue ground. One (cat. no.
386) shows the *Death of Cleopatra* after a paint-
ing by Gaspar Netscher (1639–84) engraved by
J.G. Wille (1715–1808). The scene on the other
vase is based on the *Death of Harmonia* after
Jean-Baptiste-Marie Pierre (1713–89). Pierre's

painting was exhibited at the Paris Salon in 1751.
Harmony is the child of Mars (a patron of Mark
Antony) and Venus (Cleopatra's patron goddess),
and so stands for Cleopatra, and is shown here
in the act of killing herself. The other vase (cat.
no. 387) depicts the discovery of the dead
Cleopatra by Octavian and Dolabella. The dead
woman at her feet is her maid Iras. The scene is
based on Shakespeare's *Antony and Cleopatra*, Act
V, scene ii. It is depicted in an oil-on-paper paint-
ing by John Parker painted in Rome around
1748–9 (cat. no. 388).

On the reverse of these expensively decorated
and lavishly gilded vases, no doubt destined for
an aristocratic client, are panels of exotic birds.
Bird-painting was extremely popular on all kinds
of porcelain. Figure scenes of dramatic events,
such as the death of Cleopatra, are exceptional.

In 1759 David Garrick presented an adapted
version of Shakespeare's play at Drury Lane, but it
was not a success. Performances were given
throughout the eighteenth century of John
Dryden's *All for Love* (1678), and this may have
been how the English public absorbed the story of
Cleopatra. That it was popular is not in doubt, as
there are various medallions and figures of the
Egyptian queen made by Josiah Wedgwood from
the early 1770s. Around 1785–90 an enamelled
pottery figure of Cleopatra reclining was made by
James Neale and Co. of Hanley, Staffordshire. It is
based on an ancient marble in the Vatican collec-
tion, which was much admired and copied in
many different media almost from the time it was
first recorded in the early sixteenth century (see
also cat. no 370). Various lead-glazed pottery ver-
sions of the figure were made in the late eighteenth
century by other Staffordshire firms, in particular
by Enoch Wood, who produced a companion
figure of Mark Antony (cat. nos 393–4). By the end
of the eighteenth century there was a market in
Britain for relatively inexpensive ceramic represen-
tations of Cleopatra, and it is probable that some
of these were exported to North America.

BIBLIOGRAPHY: A.W. Franks, 'Notes on the manufacture of
porcelain at Chelsea', *Archaeological Journal*, XIX (1862),
347; A. Demmin, *Guide de l'Amateur de Faïence et
Porcelaines, Poteries, Terres Cuites, Emaux, Pierres
Précieuses Artificielles, Vitraux et Verreries* (Paris 1867),
Pt 2, 924; R.L. Hobson, *Catalogue of English Porcelain in
the British Museum* (London 1905), no. II.28; A.J. Toppin,
'The origin of some ceramic designs', *Transactions of the
English Ceramic Circle*, 10, no. 2 (1948), 272–3, pl. XCIX,
a, b; G.H. Tait, 'Outstanding pieces in the English ceramic
collections of the British Museum', *Transactions of the
English Ceramic Circle* 4, pt 3 (1957), 45; J.V.G. Mallet,
'Two Documented Chelsea Gold-Anchor Vases', *Victoria
and Albert Museum Bulletin* (January 1965), vol. 1, no. 1,
19, 33, figs 7, 8; A. Dawson, 'Franks and European
Ceramics, Glass and Enamels' in J. Cherry and M. Caygill
(eds), *A.W. Franks, Nineteenth-Century Collecting and the
British Museum* (London, 1997), 201.

A.D.

387 (detail) ▶

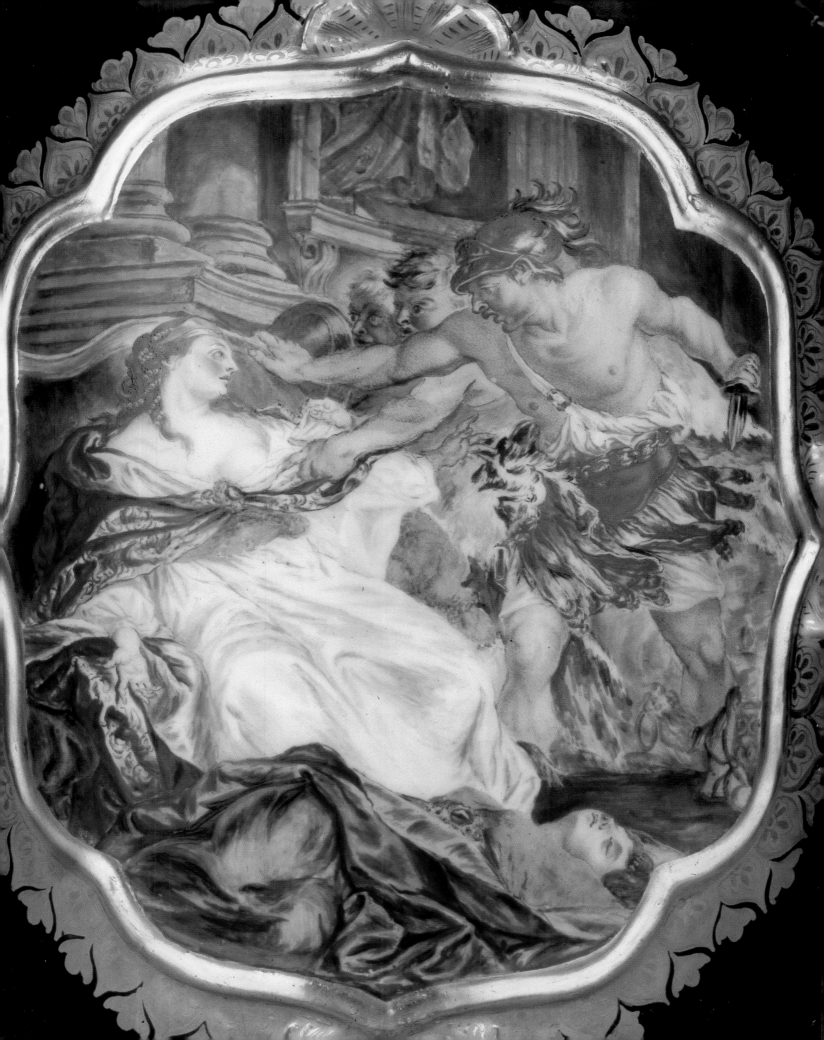

388

388 *The Death of Cleopatra*

John Parker (fl. 1740–1765)

1748/9

Oil on paper

21.6 × 28.3 cm

London, British Museum PD 1949-10-8-1

The inscriptions in Parker's handwriting on the verso are, in ink, 'Death of Cleopatra, J. Parker Invenit. Roma 1748/9' and, in pencil, 'John Parker a native of England resided several years in Rome returning to England about the year 1762 – Died at Paddington 1765'.

The scene illustrated is a fusion of two episodes within Shakespeare's *Antony and Cleopatra*, Act V, scene ii, with which the play ends. Strictly speaking, the 'rural fellow' or 'Clown', who had brought the asp in a basket of figs to Cleopatra, has made his exit by the time the Queen uses the asp to end her life but he is included here as part of the narrative. Iras, the first to take her life, is seen in the lower right, with Charmian, who died after Cleopatra, at the moment when Shakespeare's First and Second Guards enter. Parker includes the next stage, when Dolabella has appeared with Octavius Caesar and they 'see perform'd the dreaded act' which they had sought 'to hinder'. Very similar scenes appear on the Chelsea vases (cat. nos 386–7) made within a decade of this drawing.

John Parker, who studied under Marco Benefial, spent most of his working life in Rome (*c*.1740–*c*.1762), with a sojourn in Naples (May 1754–5) before travelling to London, where he died in Paddington. In 1752 Parker became the first and only Director of the British Academy in Rome, a tenure that ended when the institution was closed by its sponsor, Lord Charlemont. Parker acted as agent for Charlemont, purchasing works by Tintoretto, Caravaggio, Honthorst and others on his behalf. A rift opened between them, apparently due to Parker's interference with correspondence between Charlemont and the artist with whom the latter is most usually connected, G.B. Piranesi. Piranesi intended to dedicate the *Antichità Romanae* (1756) to Charlemont but then withdrew this honour. It is curious that none of Piranesi's brilliant vision and influential representation of antiquity, especially the decline and fall of Rome, inspired Parker's work. Indeed, in this drawing Parker chooses to represent a scene from a turning point in the power of Rome, but does not capitalize on the high drama of the occasion.

BIBLIOGRAPHY: J. Ingamells, *A Dictionary of British and Irish Travellers in Italy 1701–1800* (New Haven, Conn. 1997), 738–9.

H.W.

389 Earthenware tile with *Antony and Cleopatra*

John Moyr-Smith

c. 1875

Minton's China Works, Stoke-on-Trent

15 × 15 cm

London, British Museum MME 2000.11-2.1
(Given by Judy Rudoe)

389

The scene, transfer-printed in black on a cream ground, is one of a series of twenty-four subjects from Shakespeare, which included two scenes from *Antony and Cleopatra*: Act IV, scene iv, and this one, Act V, scene ii. The scene depicts Cleopatra being given the asp with which she kills herself at the end of the play after Antony's death. The asp was brought in a basket and this is faithfully reproduced on the tile. The artist's initials, MS, appear on the steps of the dais.

John Moyr-Smith (1839–1912) trained as an architect in Glasgow, but settled in London in 1867 and is best known as a prolific illustrator; his other tiles series include illustrations to the Bible and the works of contemporary authors such as Walter Scott and Tennyson. His Shakespeare series was made at a time when there was much interest in the revival of Shakespeare's plays in authentic costume. Building on the tradition of antiquarian research in stage design established by J.P. Kemble in the 1820s and Charles Kean in the 1850s, the architect E.W. Godwin designed costumes for Shakespeare's plays throughout the 1870s and 1880s; his designs were based on meticulous sketches in the British Museum and from scholarly publications, and were made for the actress Ellen Terry, with whom he lived from 1868, and the actor-manager Henry Irving.

The industrial production of tiles in the second half of the nineteenth century made them available for a wide range of domestic interiors. They became especially popular for the fireplace, where they would be set into a cast-iron frame forming a fireproof wall lining as well as a miniature picture gallery around the fire. The Victorian hearth was the focal point of the home and so printed tiles with literary subjects such as this were considered the most appropriate, being both morally improving and educational.

BIBLIOGRAPHY: T.A. Lockett, *Collecting Victorian Tiles* (Woodbridge 1982), 121–68; T. Herbert and K. Huggins, *The Decorative Tile in Architecture and Interiors* (London 1995), 118–22; A. Stapleton, 'John Moyr-Smith 1829–1912', *Journal of the Decorative Arts Society*, 20 (1996), 18–28; F. Baldwin, 'E.W. Godwin and Design for the Theater', in S. Weber Soros (ed.), *E. W. Godwin: Aesthetic Movement Architect and Designer* (New York 1999), 313–52.

J.R.

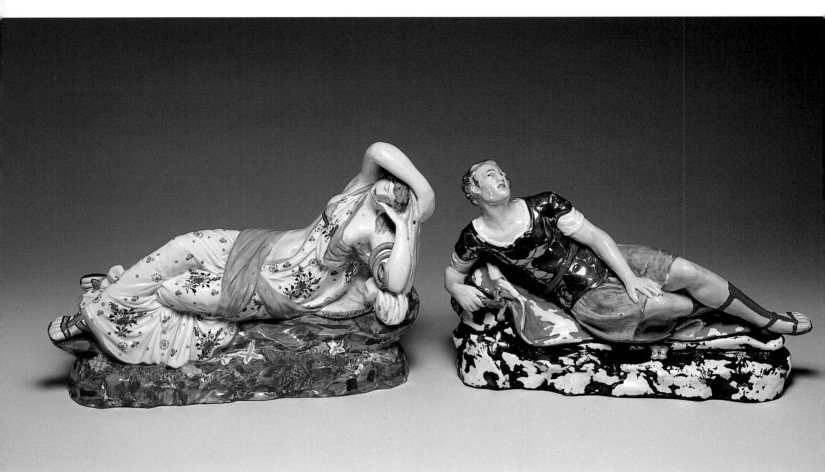

390 and 391

390–391 Two pearl-ware reclining figures: Cleopatra and Antony

c. 1810–18 or 1820

England

Cleopatra: height 21.6 cm, length 31.5 cm;
Antony: height 19.5 cm, length 31.5 cm

Cambridge, Fitzwilliam Museum C.908–1928,
C.909–1928

The figure of Cleopatra is based on the so-called Vatican Cleopatra, which had been the model for Europe's image of the dying Cleopatra since the sixteenth century, despite the fact that it was later identified as Ariadne (see p. 304 and cat. nos 370, 386–7, 395). By the nineteenth century, reproductions were circulating in Britain in various forms, including small bronzes or reproductions in plaster or lead, like the one located in the gardens at Stourhead. In the present example the upper part of the body reclines more than the Vatican marble, suggesting that it was derived from a bronze cast in Rome for François I of France, which also differs from the original in this respect.

This miniaturized vernacular version, perhaps likely to have found a place on the mantelpiece in a country rectory, is a playful one. Turning its back on the solemnity of its remote source, it re-emphasizes the link between Cleopatra and the living world. The coloured enamels make her into a figure of pastoral, giving a yellow lining to her dress and picking out a pink sash – an impression that is reinforced by the painted flowers used to link her gown with the rock on which she lies. The snake in brilliant green is unambiguously alive, unlike the flattened bracelet of the original marble.

There was no such classical model for Antony. His complementary pose, with its romantic tone, was achieved by borrowing that of Rinaldo, the hero who loved the Saracen maiden, in a group made by Paul-Louis Cyfflé for Luneville. The effect tends to the subversive, marking the connection between Cleopatra as an image of innocence and Antony as one of heroic aspiration in defeat. But what was the effect of the pairs that were made in black basalt at the same period?

These two, bought together in 1928, were probably not originally a pair, nor even from the same factory.

BIBLIOGRAPHY: M. Grant, *The Makers of Black Basaltes* (London 1910, reprinted 1967), 354–5 and pl. xcv, figs 1–2; B. Rackham, *Catalogue of the Glaisher Collection of Pottery and Porcelain in the Fitzwilliam Museum, Cambridge* (Cambridge 1935, reprinted 1987) I, 120, no. 908, II, pl. 70F; B. Watney, 'The king, the nun, and other figures', *Transactions of the English Ceramic Circle* 7, Pt I (1968), 49 and pl. 52c; F. Haskell and N. Penny, *Taste and the Antique* (New Haven, Conn 1981), 81, fig. 42 and 184–7 no 24 and fig. 96; J. Poole, *Plagiarism personified? Pottery and Porcelain Figures* (Cambridge 1986), 65, J6; P. Halfpenny, *English Earthenware Figures 1740–1840* (Woodbridge 1991), 148, pl. 37; D. Edwards, *Black Basalt, Wedgwood and Contemporary Manufacturers* (Woodbridge 1994), 208, fig. 314.

M.H.

392 Lead-glazed cream-coloured earthenware figure of Cleopatra

c. 1790–1800

Italy, perhaps Naples; factory unknown, mark:
fleur-de-lys in blue

Height 32 cm, length of base 8 cm

London, British Museum, MME Franks Bequest,
1897 AF 3316

Cleopatra is shown in a loose robe belted below
her breast, over which is a cloak with a clasp on
the left shoulder. The asp, which she is applying
to her left breast, is wound around her left wrist.
The figure, complete with an elaborate support,
imitates a full-scale statue, and is probably
loosely based on the Farnese Flora, a marble
statue now in the Museo Nazionale Archeologico,
Naples, thought to be a Roman copy of a Greek
statue of Aphrodite carved in the fourth century
BC. This statue was in Rome from the sixteenth
century until 1800, when it was sent to Naples.

Little is known about Italian cream-coloured
earthenware and it is not possible at present to
determine where this figure was made. Although
classical scenes were often painted on Italian pot-
tery from the Renaissance onwards and on porce-
lain from the eighteenth century, and classical
figures were created in both pottery and porce-
lain, the subject in this medium at least appears
to be a rare one.

UNPUBLISHED.
A.D.

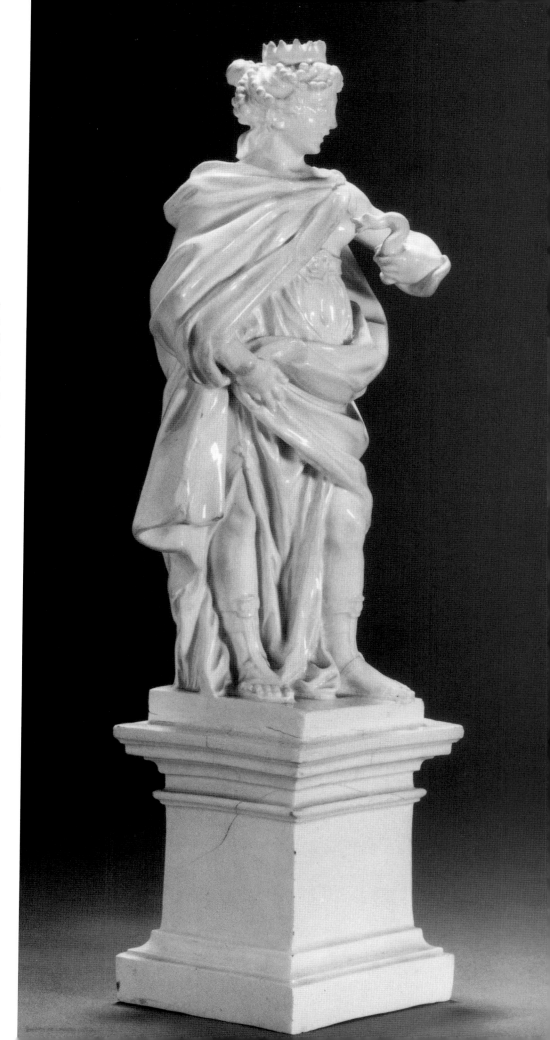

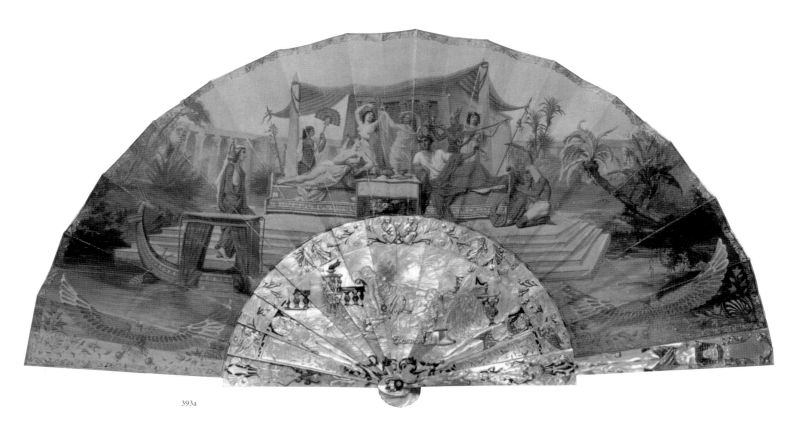

393a

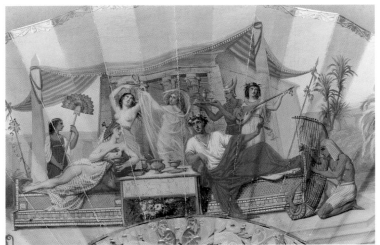

393b

393c

393 Mother-of-pearl fan: *Cleopatra's Banquet*, and *The Suicide of Cleopatra*

J.L. Viger

c. 1870

France; sold by Duvelleroy Ltd, Bond Street, London, 1955

Height 28 cm, span 52 cm

London, Hélène Alexander Collection, The Fan Museum Trust

The mother-of-pearl fan is carved and gilded. The fine skin leaf is double, and is painted on the obverse in gouache with a lively scene of Cleopatra's banquet. Cleopatra reclines opposite Antony; naked but for a patterned cloth knotted at the waist, she drops the pearl into her wine cup, vainly trying to capture Antony's attention. He, meanwhile, gazes into the distance, garlanded and dressed in a white tunic and red mantle. On the table between them is his wine cup, a mixing bowl with a ladle and a covered goblet. Behind them dance a devotee of Isis, naked to the waist and holding a sistrum (the rattle used in the cult of Isis), and a woman wrapped in a transparent veil. The pair are entertained by a Greek lute-player, and an Egyptian harpist; they are served by two men, one with a fan, the other bearing a tray with a second covered goblet, a small cup or dish and a bowl of fruit.

The scene takes place on hard couches standing on a stepped platform; in the background an awning is supported on obelisks before an Egyptian shrine, set in a colonnaded garden. The pose of the figures and the architectural setting suggest an orientalized version of the principal drinking scene and the banqueting bower on the mosaic from Palestrina (cat. nos 352–5).

The style of the painting suggests a date earlier than 1870, but the date coincides well with the opening in 1869 of the Suez Canal, engineered by Ferdinand de Lesseps.

Equally remarkable is the gorge of the fan, which is delicately carved with a scene of the death of Cleopatra. Unusually, the scene shows the interval between the death of the Queen and her attendants Charmian and Iras, and their discovery by Octavian's officers. The asp may be glimpsed slithering over the tiled floor, away from Cleopatra, who reclines with fallen head on a bed set on a terrace, with palms beyond; like the painted banquet scene, this is an interesting reversal of the indoor setting of earlier representations, perhaps reflecting the orientalist design

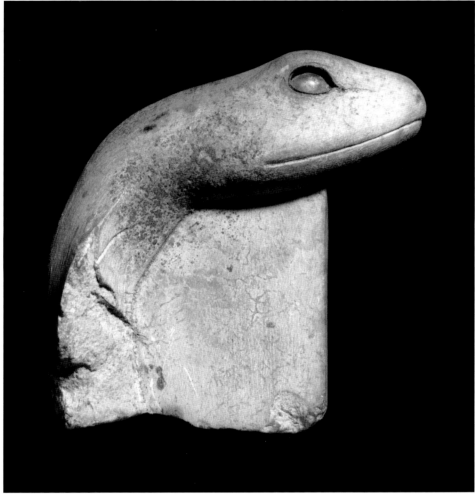

394

of the fan. The furniture is partially gilded, as are the Egyptian figures, hieroglyphs and other decorative elements framing the scene.

BIBLIOGRAPHY: E. Bénézit, *Dictionnaire critique des Peintres...*vol. 12 (Paris 1976), s.v. 'Viger du Vigneau (Jean Louis Victor) dit Viger'.

H.A., S.W.

394 Limestone sculpture of a cobra

Ptolemaic period

Said to be from Egypt

Height 11.5 cm, length 10.5 cm

Cambridge, Fitzwilliam Museum EGA 4536 1943

There is some surface damage and the lower section of the sculpture is missing. One of the glass paste eyes is preserved. Emblematic of Cleopatra's end and her royal status, this sculpture is a representation of the cobra goddess Wadjet. Together with the vulture goddess, Nekhbet, the pair were known as *nebty*, or the two ladies, and are often used to represent Upper and Lower Egypt, wearing the two crowns. They are also associated with divine kingship and were worn as symbols by male and female rulers alike.

This particular piece probably functioned as an ex-voto. Although it is similar in appearance to some of the so-called sculptors' models, the glass eye would suggest that this was its finished form.

UNPUBLISHED.

S-A.A.

CHRONOLOGY

(see also the family tree on p. 16)

I The Ptolemies of Egypt

332 BC Alexander the Great enters Egypt, ousting the Persian administration.

323 BC Death of Alexander the Great

323 BC Ptolemy I, one of Alexander's generals, takes control of Egypt but does not officially become king until 305 BC. Rules as Ptolemy I Soter with his sister–wife, Berenike I, until his death in 283 BC

Ptolemy II Philadelphus	sole reign 283–246 BC
Arsinoe II	278–270 BC
Ptolemy III Euergetes I	246–221 BC
Berenike II	246–221 BC
Ptolemy IV Philopator	221–204 BC
Arsinoe III	217?–204 BC
Ptolemy V Epiphanes	204–180 BC
Cleopatra I	
Ptolemy VI Philometor	180–164 BC and 163–145 BC
Cleopatra II, sister– wife of Ptolemy VI	rules jointly 164/163 BC
Ptolemy VII Neos Philopator	145 BC
Ptolemy VIII Euergetes II	170–164 BC and 145–116 BC
Ptolemy IX Soter II	116–107 BC and 88–80 BC
Cleopatra III	reigns with Ptolemy IX and dies 107 BC
Ptolemy X Alexander I	107–88 BC
Cleopatra Berenike III	reigns with Ptolemy X 107 BC. In 80 BC she rules alone until late that year, when Ptolemy X rules with her.
Ptolemy XI Alexander II	80 BC
Ptolemy XII Neos Dionysos	80–58 BC and 55–51 BC
Berenike IV and Cleopatra VI	58–55 BC
Tryphaena	rules jointly in 57 BC during Ptolemy XII's absence from Egypt, dies that year
Cleopatra VII	51–30 BC; rules with Ptolemy XII and Ptolemy XIII in 51 BC
Ptolemy XIII	dies 47 BC and is replaced by his younger brother, Ptolemy XIV, who dies in 44 BC when Ptolemy XV Caesarion is made king at the age of three; effectively Cleopatra VII is sole ruler.
Caesarion (Ptolemy XV)	rules with his mother, Cleopatra VII, from 36–30 BC
Cleopatra VII	dies 12 August 30 BC; her children reign for eighteen days

II Events of the first century BC relevant to the story of Cleopatra VII

100 BC Birth of Julius Caesar

83 BC Birth of Mark Antony

69 BC Birth of Cleopatra VII

68–59 BC Birth of Arsinoe IV, Ptolemy XIII and Ptolemy XIV, sister and brothers of Cleopatra VII

63 BC Birth of Octavian

49 BC Civil war between Caesar and Pompey

48 BC Cleopatra supports Pompey.

Revolt of Alexandrians against Cleopatra, who flees Alexandria.

Alexandrine war: Arsinoe IV and Ptolemy XIII ally against Caesar

Murder of Pompey under instigation of Ptolemy

Caesar enters Alexandria; Cleopatra returns and is made joint ruler with Ptolemy XIII

47 BC Ptolemy XIII is found drowned in the Nile and Ptolemy XIV made joint ruler with his half-sister Cleopatra

Birth of Ptolemy XV Caesarion

46 BC Arsinoe IV is declared a traitor. Sent to Rome as Caesar's prisoner, she takes part in the dictator's triumphal procession in honour of his conquest of Egypt.

Cleopatra visits Rome with Ptolemy XIV and Caesarion as Caesar's guest

44 BC Assassination of Caesar

Presumed assassination of Ptolemy XIV

Cleopatra rules jointly with her son, Ptolemy XV Caesarion

43 BC First triumvirate of Octavian, Mark Antony and Lepidus

42 BC Antony is victorious at Philippi against Brutus and Cassius, the assassins of Caesar

41 BC Antony summons Cleopatra to meet him at Tarsus on the pretext of discussing the erroneous charge that she had supported Brutus and Cassius. Antony travels to Alexandria with the Queen.

40 BC Antony marries Octavia, sister of Octavian

Cleopatra Selene and Alexander Helios born to Cleopatra by Mark Antony.

39–37 BC Antony and Octavia travel to Athens

Second triumvirate of Antony, Octavian and Lepidus

37 BC Cleopatra joins Antony in Antioch, with their two children

36 BC Birth of Ptolemy Philadelphus, the son of Cleopatra and Mark Antony

34 BC Conquest of Armenia by Mark Antony; his triumph is celebrated in Alexandria

'Donations of Alexandria'

LATE 33–32 BC War between Octavian and Antony

32 BC Antony divorces Octavia

Octavian declares war on Cleopatra

31 BC Naval battle at Actium; Antony and Cleopatra flee the battle and return to Egypt

30 BC Octavian conquers Egypt.

Antony and Cleopatra commit suicide

Caesarion is murdered on Octavian's command.

GLOSSARY

agoranomos (Gr.) senior magistrate responsible for regulating commerce

atef-crown (Eg.) headdress worn by Egyptian gods, comprising a tall crown flanked by ostrich feathers and topped by a feather disc.

athlophoros (Gr.) Alexandrian priest of royal cult (literally, bearer of victory)

anastole (Gr.) locks of hair brushed to either side high above the brow, worn by Alexander the Great of Macedon and much imitated by Hellenistic Greek kings

ankh (Eg.) hierolgyphic symbol for 'life'

aplustre ship's prow-stem

askos (Gr.) vessel imitating a wineskin

baitulos (Gr.) sacred stone or pillar

chiton (Gr.) tunic with buttoned sleeves

chlamys (Gr.) short cloak pinned on one shoulder, usually worn by men

dikaras (Gr.) double cornucopia

djed (Eg.) pillar used in Egyptian art to symbolize stability, also representing Osiris

fillet narrow fabric head band

filtrum fold or channel of skin above the upper lip

heb seb (Eg.) jubilee of reign, originally thirty years

henhemet (*hm-hm, hem-hem*) (Eg.) complex headdress worn by the king or Osiris, consisting of three bundles of reeds flanked by ostrich feathers and rams' horns

himation (Gr.) long cloak, often worn over another garment, sometimes referred to as a mantle

hydria (Gr.) water vase, used in Alexandria as a cinerary urn

kanephoros (Gr.) priest (literally, basket-carrier)

kantharos (Gr.) two-handled drinking cup

kausia (Gr.) Macedonian brimmed beret associated with the empire of Alexander the Great; in modern times worn by, for example, mujaheddin in Afghanistan

kerukeion (Gr.) staff often held by Hermes

kherep (Gr.) sceptre

krater (Gr.) large vessel used for mixing wine

lampadion (Gr.) top-knot of hair

lappet small flap or fold, here of Egyptian headdress as it falls on the shoulder

loculus (Lat.) burial niche, normally cut in rock and closed by a stone slab

melanephore (pl. *melanephorai*) (Gr.) female priests of Isis

Melonenfrisur (Ger.) literally, melon hairstyle, after the resemblance of the divided braids to segments of a melon

mitra (Gr.) head band worn low across the brow, often an attribute of the wine-god Dionysos and his female followers, the Maenads

modius (Lat.) cylindrical vessel used for measuring corn

naophoros (Gr.) shrine-bearer

nemes (Eg.) cloth headdress worn beneath the wig; in mortals, a sign of royalty

nodus (Lat.) roll or lock of hair above the brow

nomen (Lat.) birth name of a pharaoh

oinochoe (Gr.) a type of jug

ossuarium (Lat.) urn used for the burial of bones

pastophoros (pl. *pastophoroi*) (Gr.) priest (literally, shrine-bearer)

petasos (Gr.) wide-brimmed hat often worn by Hermes

polos (Gr.) high cylindrical crown

pschent (Eg.) double crown of Upper and Lower Egypt

quadriga (Lat.) chariot drawn by four horses

rinceau (Fr.) foliated scroll

rhyton (Gr.) drinking vessel in the human or animal-headed form

sacrarium (pl. sacraria) (Lat.) shrine

sakkos (Gr.) a tightly fitting cloth cap usually confining hair secured in a bun

satrap governor

sistrum (pl. *sistra*) (Lat.) rattle used in the cult of Isis

situla (Lat.) bucket or pail used in the cult of Isis

stamnos (Gr.) jar

stephane (Gr.) raised diadem or crown

temenos (Gr.) enclosed sanctuary

thyrsos (Gr.) staff, usually carried by the wine-god, Dionysos

uraeus (pl. uraei) (Lat.) cobra identified with the goddess Wadjit, patroness of Lower Egypt, worn on the brow of the Egyptian royal headdress

usekh (Eg.) broad-collared necklace

Venus rings representation of rolls of fat on the neck

BIBLIOGRAPHY

Part I The Ptolemies and Alexandria

CHAPTER 1 SINS OF THE FATHERS:
THE INHERITANCE OF CLEOPATRA.
LAST QUEEN OF EGYPT

Bagnall, R.S. (1976), *The Administration of the Ptolemaic Possessions Overseas*, Leiden.

Bowman, A.K. (1996), *Egypt after the Pharaohs*, 2nd edn, London.

Grant, M. (1972), *Cleopatra*, London.

Lampela, A. (1998), *Rome and the Ptolemies of Egypt: the development of their political relations 273–80 BC*, Helsinki.

Martin, P.M. (1990), *Antoine et Cléopatre. La fin d'un rêve*, Paris.

Sherwin-White, A.N. (1984), *Roman Foreign Policy in the East 168 BC to AD 1*, London.

CHAPTER 2 ALEXANDRIA

Bernand, A. (1998), *Alexandrie la Grande*, Paris.

Empereur, J-Y. (1998), *Alexandria Rediscovered*, London.

Forster, E.M. (1961), *Alexandria: A History and a Guide*, New York.

Fraser, P.M. (1972), *Ptolemaic Alexandria*, Oxford.

Goddio, F. et al. (1998), *Alexandria: The Submerged Royal Quarters*, London.

La Riche, W. (1997), *Alexandria: The Sunken City*, London.

Thompson, D.J. (1998), *Memphis under the Ptolemies*, Princeton.

Part II Cleopatra, Lady of the Two Lands

CHAPTER 3 CLEOPATRA'S SUBTLE
RELIGIOUS STRATEGY

Bernard, A. (1992), *La prose sur pierre dans l'Egypte hellénistique et romaine*, 2 vols, Paris.

Brashear, W.M. (1980), *Ptolemäische Urkunden aus Mumienkartonnage. Ägyptische Urkunden aus den Staatlichen Museen Berlin. Griechische Urkunden 14*, Berlin.

Carter, J.M. (1970), *The Battle of Actium*, London.

Coarelli, F. (1984), 'Iside Capitolina, Clodio e i mercanti di schiavi' in N. Bonacasa and A. de Vita (eds) *Alessandria e il mondo ellenistico. Studi in onore di A. Adriani III*, Rome, 461–7.

Grant, M. (1972), *Cleopatra*, London.

Griffith, J.G. (1937), *Catalogue of the Demotic Graffiti of the Dodecaschoenus II*, Oxford.

Kokkinos, N. (1992), *Antonia Augusta*, London, 28, 194, no.183.

Lichtheim, M. (1980), *Ancient Egyptian Literature: A Book of Readings of the Late Period*, Berkeley.

Quaegebeur, J. (1988), 'Cleopatra VII and the Cults of Ptolemaic Queens', in R. Bianchi (ed.), *Cleopatra's Egypt: The Age of the Ptolemies*, New York, 41–54.

Volkmann, H. (1958), *Cleopatra*, London.

Weill Goudchaux, G. (1992), 'Archibios sauveur des effigies de Kléopatre VII', *Atti i idel VI Congresso di egittologia*, Turin, I, 651–6.

Wilhelm, A. (1934), *Mélanges Bidez*, Brussels.

CHAPTER 4 CLEOPATRA'S IMAGES:
REFLECTIONS OF REALITY

Bartman, E. (1999), *Portraits of Livia: Imaging the Imperial Woman in Augustan Rome*, Cambridge.

Germini, B. (1999), in A. La Regina (ed.) *Palazzzo Massimo alle Terme*, Rome, 32.

Lundgreen, B. (1992), 'A Female Portrait from Delos', *Acta Hyperborea*, 4, 59–71.

Michalowski, C. (1932), *Les portraits hellénistiques et romaines. Exploration archéologique de Délos*, Paris, 46–9, pls 31–5.

Moltesen, M. (1997), 'Hvor Nilen Vander Aegypterens Jord', *Meddelesler fra Ny Carlsberg Glyptotek*, 102–25.

Plamtzos, D. (1999), *Hellenistic Engraved Gems*, Oxford, no. 96, pl. 17.

CHAPTER 5 IDENTIFYING
THE EGYPTIAN-STYLE PTOLEMAIC QUEENS

Bianchi, R. (1988), 'The Pharaonic Art of Ptolemaic Egypt', in R. Bianchi (ed.), *Cleopatra's Egypt: The Age of the Ptolemies*, New York, 55–80.

Faider-Feytmans, G. (1952), *Les Antiquités du Musée de Mariemont*, Brussels.

Griffiths, J.G. (1961), 'The Death of Cleopatra', *Journal of Egyptian Archaeology* VII, 7, 113–18.

Quaegebeur, J. (1983), 'Trois statues de femme d'époque ptolémaique', in H. De Meulenaere and L. Limme (eds), *Artibus Aegypti: Studia in honorem Bernardi V. Bothmer*, Brussels, 109–27.

Quaegebeur, J. (1988), 'Cleopatra VII and the Cults of Ptolemaic Queens', in R. Bianchi (ed.), *Cleopatra's Egypt: The Age of the Ptolemies*, New York, 41–54.

Part III Cleopatra and the Power of Rome

CHAPTER 6 'SPOILING THE EGYPTIANS':
OCTAVIAN AND CLEOPATRA

Clauss, M. (1995), *Kleopatra*, Munich.

Flamarion, E. (1997), *Cleopatra: From History to Legend*, London.

Gelzer, M. (1939), *Caesar: Politician and Statesman*, Oxford.

Green, P. (1990), *Alexander to Actium: The Hellenistic Age*, London.

Martin, P-M. (1990), *Antoine et Cléopâtre. La fin d'un rêve*, Paris.

Martin, P-M. (1993), 'L'autre' héritier de César' in *Marc Antoine, son idéologie et sa descendance*, Lyon.

Pelling, C.B.R. (1996), 'The Triumviral Period' in A. K. Bowman, E. Champlin, A. Lintott (eds), *The Cambridge Ancient History*, vol. X, *The Augustan Empire, 43 B.C.–A.D. 69*, Cambridge, 1–69.

Rice, E.E. (1999), *Cleopatra*, Stroud, Glos.

Syme, R. (1939), *The Roman Revolution*, Oxford.

Wallace-Hadrill, A. (1993), *Augustan Rome*, London.

Zanker, P. (1988), *The Power of Images in the Age of Augustus*, Ann Arbor, Mich.

CHAPTER 7 SEARCHING FOR CLEOPATRA'S
IMAGE: CLASSICAL PORTRAITS IN STONE

Andreae, B. (1998), *Schönheit des Realismus*, Mainz.

Bernoulli, J.J. (1882), *Römische Ikonographie: Die Bildnisse Berühmter Römer*, Stuttgart.

de Clarac, F. (1850), *Musée de Sculpture IV. Antique et Moderne*, Paris.

di Girolami, A.M. and di Alessandro Zanetti, A.M. (1740), *Delle antiche statue greche e romane che nell'Antisala della Libreria di S.Marco e in altri luoghi pubblici di Venezia si trovano I, II*, Venice.

Joaquin Maria Bover, D. (1845), *Noticia Historico-Artistica de los Museos del Eminentismo Senor Cardenal Despuig*, Palma.

Kyrieleis, H. (1975), *Bildnisse der Ptolemäer*, Berlin.

Moreno, P. (1994), *Scultura Ellenistica II*, Rome.

Schindler, W. (1986), 'Schliemann's Cleopatra' in W.M. Calder III and D.A. Trail (eds), *Myth, Scandal and History*, Detroit, 81–94.

Traversari, G. (1986), *La statua ellenistica del museo archeologico di Venezia*, Rome.

Traversari, G. (1997),'Nuovo ritratto di Cleopatra VII Philopator e rivistazione critica dell'iconografia dell'ultima regina d'Egitto', *RdA*, 21, 44–8.

See bibliographies for catalogue entries 196–198, 210 for further reading about these particular sculptures

CHAPTER 8 WAS CLEOPATRA BEAUTIFUL? THE CONFLICTING ANSWERS OF NUMISMATICS

Hazzard, R.A. (1973), 'Two Hoards of Ptolemaic Silver' in M. Thompson, O. Markholm, C.M. Kraay (eds), *An Inventory of Greek Coin Hoards*, no.1913, New York.

Hazzard, R.A. (1990), 'The Composition of Ptolemaic Silver', *Journal of the Society for the Study of Egyptian Artefacts*, 89–107.

Part IV Egypt in Rome / The Myth of Cleopatra

CHAPTER 9 EGYPTIAN INFLUENCES IN ITALY

Adriani, A. (1966), *Repertorio d'arte dell'Egitto greco-romano*, Serie C, I, Palermo.

Adriani, A. (1970), *Lezioni sull'arte alessandrina*, Naples.

Alfano, C. (1993), 'Piramidi a Roma', *Geo-Archeologia* 1, 33–81.

Alfano, C. (1998),'L'Iseo Campense in Roma: relazione preliminare sui nuovi ritrovamenti', in N. Bonacasa (ed.), *L'Egitto e l'Italia dall'Antichità al Medioevo. Atti del III Congresso Internazionale Italo-Egiziano, Roma-Pompeii 1995*, Rome, 177–206.

Arslan, E.A. (ed.) (1997), *Iside, il mito, il mistero, la magia*, Exhibition Catalogue Milan, Palazzo Reale, Milan.

Bianchi, R. (ed.) (1988), *Cleopatra's Egypt: The Age of the Ptolemies*, New York.

Bonacasa, N. (1960), 'Segnalazioni alessandrine, vol. II', *Archeologia Classica*, 12, 170–88.

Bonacasa, N. and de Vita (eds)(1983–4), *Alessandria e il mondo ellenistico. Studi in onore di Achille Adriani*, I–III, Rome.

Bonacasa, N. and de Vita (eds) (1995), *A. Alessandria e il mondo ellenistico-romano. Atti del III Congresso internazionale Italo-Egiziano*, Alessandria 23–27 novembre 1992, Rome.

Bonacasa, N., Naro, M.C., Portale, E.C. et al. (1998), 'L'Egitto in Italia, dall'Antichità al Medioevo', *Atti III congresso internazionale Italo-Egiziano*, Rome-Pompei 1995, Rome.

Cantilena, R. and Prisco, G. (eds) (1992), *Alla ricerca di Iside. Analisi, studi e restauri dell'Iseo pompeiano nel Museo di Napoli*, Rome.

Caputo, P. (1991), 'Cuma. Rinvenimento di un tempio di Iside', *BdA* 11–12.

Castagnoli, F. (1984), 'Influenze alessandrine nell'urbanistica della Roma auguste', in N. Bonacasa and A. de Vita (eds), *Alessandria e il mondo ellenistico. Studi in onore di Achille Adriani*, III, Rome, 520–26.

Coarelli, F. (1982), 'I monumenti dei culti orientali in Roma: Questioni topografiche e cronologiche', *La soteriologia dei culti orientali nell'Impero romano*, Leiden, 36–66.

De Caro, S. (1994), *La villa rustica in località Villa Regina a Boscoreale*, Rome.

De Caro, S. (1992), 'Novità isiache dalla Campania' in R. Cantileno and G.Prisco (eds), *Alla ricerca di Iside*, Rome.

De Vos, M. (1980), 'L'Egittomania in pitture e mosaici romano-campani della prima età imperiale', *EPRO* 84, Leiden.

De Vos, M. (1994), 'Aegyptiaca Romana', *La parola del passato* 49, Bologna, 130–59.

Donadoni, S. (1981), *L'Egitto*, Turin.

Dunand, F. (1973), 'Le culte d'Isis dans le bassin oriental de la Méditerranée I–III', *EPRO* 26, Leiden.

Eck, W. (2000), *Augusto e il suo tempo*, Bologna.

Fraschetti, A. (1990), *Roma e il Principe*, Rome-Bari.

Gagé, J.(1977), *Res gestae divi Augusti*, 3rd edn, Paris.

Geraci, G. (1983), *Genesi della provincia romana d'Egitto*, Bologna.

Grimal, P. (1990), *I giardini di Roma antica*, Rome.

Iacopi, I. (1997), *La decorazione pittorica dell' Aula isiaca*, Rome.

Kater-Sibbes, G.J.F. (1973), *Preliminary Catalogue of Serapis Monuments*, *EPRO* 36, Leiden.

La Rocca, E. (1984), *L'età d'oro di Cleopatra. Indagine sulla Tazza Farnese*, Rome.

Leclant, J. (1979), 'Les sanctuaires isiaques. Un aspect de l'exotisme gréco-romain', *Le Rêve égyptien*, 13.

Le Glay, M. (1987), 'Sur l'implantantion des sanctuaires orientaux à Rome', *URBS*, 545–62.

Lollio Barerig, O., Parola, G., Toti, M.P. (1995), *Le antichità egiziane di Roma imperiale*, Rome.

Malaise, M. (1972), *Inventaire préliminaire des documents égyptiens découverts en Italie*, *EPRO* 21, Leiden.

Malaise, M. (1978), *Documents nouveaux et points de vue récents sur les cultes isiaques en Italie*, *EPRO* 68, II, Leiden.

Mora, F. (1990), *Prosopografia isiaca*, *EPRO* 113, Leiden.

Muller, H.W. (1971), *Il culto di Iside nell'antica Benevento*, Benevento.

Roullet, A.M. (1972), *The Egyptian and Egyptianizing monuments of Imperial Rome*, *EPRO* 20, Leiden.

Tran Tam Tinh, V. (1964), *Essai sur le culte d'Isis à Pompéi*, Paris.

Tram Tan Tinh, V. (1971), *Le culte des divinités orientales à Herculanum*, *EPRO* 17, Leiden.

Zanker, P. (1989), *Augusto e il potere delle immagini*, Turin.

CHAPTER 10 ANYTHING TRUTH CAN DO, WE CAN DO BETTER: THE CLEOPATRA LEGEND

Becher, I. (1966), *Das Bild der Kleopatra in der griechischen und lateinischen Literatur*, Berlin.

Gowing, A.M. (1992), *The Triumviral Narratives of Appian and Cassius Dio*, Ann Arbor, Mich.

Griffin, J. (1985), *Latin Poets and Roman Life*, London, esp. 32–47.

Gurval, R.A. (1995), *Actium and Augustus: The Politics and Emotions of Civil War*, Ann Arbor, Mich.

Hamer, M. (1993), *Signs of Cleopatra*, London.

Hose, M. (1994), *Erneuerung der Vergangenheit: Die Historiker im Imperium Romanum von Florus bis Cassius Dio*, Stuttgart and Leipzig.

Hughes-Hallett, L. (1990), *Cleopatra: Histories, Dreams and Distortions*, London.

Pelling, C.B.R. (1988), *Plutarch: Life of Antony*, Cambridge.

Pelling, C.B.R. (1996), 'The Triumviral Period' in A.K. Bowman, E. Champlin, A. Lintott (eds), *The Cambridge Ancient History*, vol. X, *The Augustan Empire, 43 B.C.–A.D. 69*, Cambridge, 1–69.

Syme, R. (1939), *The Roman Revolution*, Oxford.

Woodman, A.J. (1983), *Velleius Paterculus: the Caesarian and Augustan Narrative*, Cambridge.

CHAPTER 11 THE MYTH OF CLEOPATRA SINCE THE RENAISSANCE

Haskell, F. and Penny, N. (1981), *Taste and the Antique*, New Haven, Conn. and London.

Rice, M. (1991), *Egypt's Making* , London and New York.

Lant, A. (1992), 'The Curse of the Pharaoh, or How Cinema Contracted Egyptomania', *October* 59, 86–112.

Berstein, M. and Studlar, G. (eds) (1997), *Visions of the East: Orientalism in Film*, New Brunswick, NJ.

Hamer, M. (1993), *Signs of Cleopatra: History, Politics, Representation*, London and New York.

Hamer, M. (1996),'Black and White? Viewing Cleopatra in 1862', in S. West (ed.), *The Victorians and Race*, Aldershot, Hants.

Rice, E.E. (1999), *Cleopatra*, Stroud, Glos.

AUTHORS

| | | | | |
|---|---|---|---|
| H.A. | Hélène Alexander | S.Mck. | Scott McKendrick |
| C.Al. | Carla Alfano | J.Ma. | Jonathan Marsden |
| C.A. | Carol Andrews | C.M. | Claudia Mazza |
| S-A.A. | Sally-Ann Ashton | A.M. | Andrew Meadows |
| D.M.B. | Donald Bailey | J.M. | Janet Moat |
| A.B.W. | Alfred Bernhard-Walcher | A.N. | Arpád Nagy |
| H.C. | Hugo Chapman | L.N. | Leila Nista |
| B.C.R. | Barbara Chase-Riboud | C.P.P. | Claudio Parisi Presicce |
| E.M.C. | Emanuele M. Ciampini | W.H.P. | William H. Peck |
| A.D. | Aileen Dawson | P.R. | Paul Roberts |
| A.E. | Arnold Enklaar | J.R. | Judy Rudoe |
| M.E. | Marc Étienne | K.S. | Kim Sloan |
| M.F. | Mafoud Ferroukhi | B.T. | Barry Taylor |
| M.H. | Mary Hamer | Dd.T. | David Thompson |
| P.H. | Peter Higgs | D.T. | Dora Thornton |
| S.K. | Sally Korner | S.W. | Susan Walker |
| E.L. | Enrichetta Leospo | G.W.G. | Guy Weill Goudchaux |
| C.L. | Christopher S. Lightfoot | H.W. | Hilary Williams |
| L.J.H.L. | Luc J.H. Limme | J.W. | Jonathan Williams |
| P.L. | Paolo Liverani | | |

CONCORDANCE

CAT. No.	MUSEUM	INVENTORY NUMBER
001	London, British Museum EA	EA 933
002	London, British Museum GRA	GR 1872.5-15.1 (Sc.1857)
003	London, British Museum EA	EA 1641
004	Alexandria, Graeco-Roman Museum	24345
005	London, British Museum EA	EA 941
006	New York, The Metropolitan Museum of Art, EA	38.10 006
007	Paris, Musée du Louvre G E & R	Ma 3261
008	London, British Museum GRA	GR 1888.6-1.38 (Vase K7)
009	London, British Museum GRA	GR 1824.4-46.13 (Bronze 1247)
010	Cairo, Egyptian Museum	JE 39520
011	Cairo, Egyptian Museum	JE 39517
012	London, British Museum GRA	GR 1856.8-26.160 (Sc 1741)
013	Cairo, Egyptian Museum	JE 35334
014	Berlin, Ägyptisches Museum und Papyrussammlung	14568
015	London, British Museum EA	EA 68860
016	London, British Museum GRA	GR 1926.4-15.15
017	Alexandria, Graeco-Roman Museum	21992
018	Alexandria, Graeco-Roman Museum	24092
019	Alexandria, Graeco-Roman Museum	3357
020	Paris, Musée du Louvre E	A.28
021	New York, The Metropolitan Museum of Art G R	L 1992.27
022	Brussels, Musées Royaux d'Art et d'Histoire	E 1839
023	London, British Museum GRA	GR 1861.11-27.55 (Sc.1394)
024a	Alexandria, Greco-Roman Museum	1001
024b	Alexandria, Greco-Roman Museum	106
025	Paris, Musée du Louvre G E & R	Ma 3546
026	Vienna, Kunsthistorisches Museum Antikensammlung	AS I 406
027	Alexandria, Greco-Roman Museum	12072
028	Stuttgart, Württembergisches Landesmuseum Antikensammlung	SS.17
029	Stuttgart, Württembergisches Landesmuseum Antikensammlung	SS.176
030	Paris, Musée du Louvre E	E 8061
031	London, British Museum GRA	GR 1917.5-1.1619 (Ring 1619)
032	London, Petrie Museum of Egyptian Archaeology	UC 322
033	London, British Museum GRA	GR 1917.5-1.1267 (Ring 1267)
034	London, British Museum GRA	GR 1930.7-15.3
035	London, British Museum GRA	GR 1865.7-12.55 (Ring 95)
036	London, British Museum EA	EA 36468
037	London, Petrie Museum of Egyptian Archaeology	UC 47632
038	London, Petrie Museum of Egyptian Archaeology	UC 2457
039	London, Petrie Museum of Egyptian Archaeology	UC 47952
040	London, Petrie Museum of Egyptian Archaeology	UC 2462
041	London, British Museum GRA	GR 1917.5-1.97 (Ring 97)

CAT. No.	MUSEUM	INVENTORY NUMBER
042	London, British Museum GRA	GR 1877.8-25.1 (Gem 1196)
043	London, British Museum GRA	GR 1917.5-1.96 (Ring 96)
044	Paris, Musée du Louvre G E & R	Bj 1092
045	Paris, Musée du Louvre G E & R	Bj 1093
046	London, British Museum EA	EA 14371
047	London, British Museum EA	EA 57348
048	London, British Museum GRA	GR 1873.8-20.389 (Vase K 77)
049	London, British Museum GRA	GR 1999.3-29.1
050	Paris, Musée du Louvre E	N 2456
051	London, British Library	2191
052	Alexandria, Greco-Roman Museum	3912
053	Paris, Musée du Louvre G E & R	Ma 3168
054	Alexandria, Greco-Roman Museum	3908
055	Alexandria, Greco-Roman Museum	8357
056	London, British Museum EA	EA 1054
057	Cairo, The Egyptian Museum	JE 54313
058	London, British Museum EA	EA 612
059	Toronto, Royal Ontario Museum	906.12.66
060	Toronto, Royal Ontario Museum	906.12.83
061	Toronto, Royal Ontario Museum	906.12.207
062	London, British Museum GRA	GR 1956.5-19.2
063	Toronto, Royal Ontario Museum	906.12.113
064	Toronto, Royal Ontario Museum	906.12.125
065	Toronto, Royal Ontario Museum	906.12.140
066	Toronto, Royal Ontario Museum	906.12.97
067	London, British Museum CM	CM 1987.6-49.131
068	London, British Museum CM	CM 1964.13-3.3
069	London, British Museum CM	BMC Arsinoe II 3
070	London, British Museum CM	CM 1923.11-8.1
071	London, British Museum CM	BMC Berenike II 3
072	London, British Museum CM	BMC Ptolemy III 104
073	London, British Museum CM	BMC Ptolemy V 51
074	London, British Museum CM	BMC Ptolemy IV 34
075	London, British Museum CM	BMC Arsinoe III 1
076	London, British Museum CM	BMC Ptolemy V 62
077	London, British Museum CM	CM 1978.10-21.1
078	London, British Museum CM	BMC Arsinoe II 36
079	London, British Museum CM	CM 1897.2-1.4
080	London, British Museum CM	CM 1987.6-49.281
081	London, British Museum CM	CM 1987.6-49.514
082	London, British Museum CM	BMC Ptolemy III 101
083	London, British Museum CM	BMC Berenike II/Ptolemy III 16
084	London, British Museum CM	BMC Cyrenaica Regal Issues 39
085	London, British Museum CM	BMC Ptolemy IV 16
086	London, British Museum CM	BMC Ptolemy IV 20
087	London, British Museum CM	BMC Ptolemy V 66
088	London, British Museum CM	BMC Ptolemy VIII 11
089	London, British Museum CM	CM 1926.1-16.951
090	Paris, Cabinet des Medailles, Bibliothèque Nationale de France Fonds Gen.	368
091	New York, American Numismatic Society	1944-100-75452
092	London, British Museum CM	BMC Alexander I/Cleopatra 1
093	London, British Museum CM	BMC Cleopatra Thea 1

CAT. No.	MUSEUM	INVENTORY NUMBER	CAT. No.	MUSEUM	INVENTORY NUMBER
094	London, British Museum CM	BMC Cleo Thea/Anti VIII 6	148	London, British Museum GRA	GR 1926.9-30.39
095	Alexandria, Greco-Roman Museum	32044	149	London, British Museum GRA	GR 1981.2-10.9
096	London, Petrie Museum of Egyptian Archaeology	UC 47634	150	Alexandria, Greco-Roman Museum	GAM 97.1019.23
097	Cairo, The Egyptian Museum	JE 6102	151	London, British Museum EA	EA 1539
098	London, British Museum EA	EA 37561	152	London, British Museum GRA	GR 1922.1-17.1
099	Alexandria, Greco-Roman Museum	24201	153	London, British Museum GRA	GR 1923.4.1.676 (Gem 3085)
100	Cairo, The Egyptian Museum	JE 55034	154	Paris, Musée du Louvre E	E 27113
101	Cairo, The Egyptian Museum	JE 55035	155	Paris, Musée du Louvre G E & R	Ma 3449*
102	Cairo, The Egyptian Museum	JE 55038	156	Toronto, Royal Ontario Museum	906.12.122
103	Cairo, The Egyptian Museum	JE 36460	157	Toronto, Royal Ontario Museum	906.12.202
104	London, British Museum GRA	GR 1906.4-11.1 (Jew 2331)	158	London, British Museum GRA	GR 1956.5-19.1
105	London, British Museum GRA	GR 1904.7-6.1 (Jew 2332-3)	159	Stuttgart, Württembergisches Landesmuseum Antikensammlung	Arch 55/7
106	London, British Museum GRA	GR 1917.5-1.770 (Ring 770)	160	St Petersburg, Hermitage Museum.	39.36
107	London, British Museum GRA	GR 1917.5-1.771 (Ring 771)	161	San Jose, Rosicrucian Egyptian Museum	1582
108	London, British Museum GRA	GR1917.5-1.950 (Ring 950)	162	Paris, Musée du Louvre E	E13102
109	London, British Museum EA	EA 29499	163	New York, Brooklyn Museum of Art E C A M E	71.12
110	London, British Museum EA	EA 65405-6	164	New York, The Metropolitan Museum of Art, EA	89.2.660
111	London, British Museum EA	EA 15715	165	Alexandria, Greco-Roman Museum	18370
112	London, British Museum GRA	GR 1917.5-1.844 (Ring 844)	166	New York, The Metropolitan Museum of Art, EA	1920 (20.2.21)
113	London, British Museum GRA	GR 1872.6-4.1105 (Jew 2442-3)	167	Turin, Museo delle Antichità Egizie	1385
114	London, British Museum GRA	GR 1872.6-4.532 (Jew 2608)	168	Alexandria, Greco-Roman Museum	3222
115	London, Victoria & Albert Museum	M 31-1963	169	Cambridge, Fitzwilliam Museum	E. 27.1981
116	London, Victoria & Albert Museum	M 32/32a-1963	170	London, Petrie Museum of Egyptian Archaeology	UC 14521
117	London, Victoria & Albert Museum	M 34-1963	171	Cairo, The Egyptian Museum	13/3/15/3
118	London, British Museum GRA	GR 1917.5-1.1615 (Ring 1615)	172	Alexandria, Greco-Roman Museum	1015
119	London, British Museum EA	EA 22378	173	London, British Museum EA	EA 1325
120	London, British Museum GRA	GR 1997.10-05.1	174	Toronto, Royal Ontario Museum	906.12.162
121	Alexandria, Greco-Roman Museum	19462	175	Toronto, Royal Ontario Museum	906.12.166
122	Alexandria, Greco-Roman Museum	25066	176	Toronto, Royal Ontario Museum	906.12.168
123	London, British Museum GRA	GR 1809.11-11.1 (Sc.2163)	177	London, British Museum CM	BMC Ptolemy XIII 34
124	London, British Museum EA	EA 37562	178	London, British Museum CM	BMC Cleopatra VII 1
125	Cairo, The Egyptian Museum	CG 27567	179	Hunterian Museum, University of Glasgow	Cleo VII/Macdonald 14
126	London, British Museum EA	EA 20649	180	London, British Museum CM	CM 1857.8-22.46
127	London, British Museum EA	EA 60756	181	London, Weill Goudchaux Collection	No number
128	London, British Museum GRA	GR 1938.3-14.1	182	London, Weill Goudchaux Collection	No number
129	London, British Museum GRA	GR 1936.9-3.3	183	London, British Museum CM	BMC Cleopatra VII 9
130	London, British Museum EA	EA 30458	184	London, British Museum CM	BMC Cleopatra VII 6
131	London, British Museum EA	EA 35417	185	London, Weill Goudchaux Collection	No number
132	Alexandria, Greco-Roman Museum	CRI 96.2088.1.2 31,32,38,39,43	186	London, British Museum CM	BMC Cleopatra VII 3
133	London, British Museum EA	EA 26265-6	187	Cairo, The Egyptian Museum	JE 15154
134	London, British Museum GRA	GR 1884.6-14.12 (Jew 2883)	187	Paris, Musée du Louvre E	E 15863
135	London, British Museum GRA	GR 1888.10-12.1	188	Berlin, Ägyptisches Museum und Papyrussamlung	PBorol 25239
136	London, British Museum GRA	GR 1917.5-1.384 (Ring 384)	189	Detroit, The Detroit Institute of Arts	51.83
137	London, British Museum GRA	GR 1902.12-13.1 (Gems 2068)	190	Cairo, The Egyptian Museum	JE 38310
138	London, British Museum EA	EA 34270	191	London, Weill Goudchaux Collection	No number
139	London, British Museum EA	EA 38214	192	London, British Museum EA	EA 886
140	Paris, Musée du Louvre GE & R	Br 4165	193	London, British Museum EA	EA 147
141	Cairo, The Egyptian Museum	JE 90702	194	Rome, Musei Capitolini (Monte Martini)	1154
142	Alexandria, Greco-Roman Museum	32047	195	London, Victoria & Albert Museum	M 38.1963
143	Alexandria, Greco-Roman Museum	32053	196	The Vatican, Musei Vaticani	38511
144	New York, The Metropolitan Museum of Art G R	90.9.13	197	Algiers, Musée de Cherchel	S66(31)
145	New York, The Metropolitan Museum of Art G R	90.9.29			
146	New York, The Metropolitan Museum of Art G R	90.9.37			
147	Alexandria, Greco-Roman Museum	7306			

CAT. No.	MUSEUM	INVENTORY NUMBER
198	Berlin, Staatliche Museen zu Berlin Antikensammlung	1976.10
199	Berlin, Staatliche Museen zu Berlin Antikensammlung	342
200	London, British Museum GRA	GR 1873.10-20.4 (Ring 1469)
201	London, British Museum CM	BMCRR Rome 4159
202	London, British Museum CM	BMCRR Rome 4157
203	London, British Museum CM	BMCRR Rome 4187
204	London, British Museum CM	BMCRR East 31
205	London, British Museum CM	BMCRR Spain 86
206	New York, The Metropolitan Museum of Art G R	1921.21.88.14
207	London, British Museum GRA	GR 1897.7-29.1 (Sc.1871)
208	Alexandria, Greco-Roman Museum	3243
209	London, British Museum GRA	GR 1867.5-7.492 (Gems 1964)
210	London, British Museum GRA	GR 1879.7-12.15 (Sc.1873)
211	London, British Museum GRA	GR 1923.4-1.1172 (Gem 3960)
212	Rome, Musei Capitolini (Monte Martini)	3356
213	Alexandria, Greco-Roman Museum	10
214	London, Weill Goudchaux Collection	No number
215	London, Weill Goudchaux Collection	No number
216	London, British Museum CM	BMC Berytus 14
217	London, British Museum CM	CM 1969.9-1.1
218	London, British Museum CM	BMC Antioch 52
219	London, British Museum CM	BMC Askalon 20
220	London, The Fan Museum Trust, H. Alexander Collection	No number
221	London, Weill Goudchaux Collection	No number
222	London, Weill Goudchaux Collection	No number
223	London, Weill Goudchaux Collection	No number
224	London, British Museum CM	CM 1979.1-1.672
225	Paris, Cabinet des Medailles, Bibliothèque Nationale	RPC I 4501
226	Paris, Cabinet des Medailles, Bibliothèque Nationale	RPC I 4502
227	London, British Museum CM	BMC Tripolis 19
228	Paris, Cabinet des Medailles, Bibliothèque Nationale	RPC I 4529
229	Paris, Cabinet des Medailles, Bibliothèque Nationale	RPC I 4530
230	New York, American Numismatic Society	RPC I 4781
231	New York, American Numismatic Society	RPC I 4742/2
232	London, British Museum CM	CM 1844.4-25.1200
233	London, British Museum CM	CM E.H. p691, 6
234	London, British Museum CM	CM 1952.6-2.1
235	London, British Museum CM	BMCRR Rome 4128
236	London, British Museum CM	BMCRR Rome 4278
237	London, British Museum CM	BMCRR Rome 4293
238	London, British Museum CM	BMCRR Rome 4294
239	London, British Museum CM	BMCRR Gaul 52
240	London, British Museum CM	BMCRR Gaul 54
241	London, British Museum CM	BMCRR East 99
242	London, British Museum CM	BMCRR East 111
243	London, British Museum CM	BMCRR East 147
244	London, British Museum CM	BMCRR East 175
245	London, British Museum CM	BMCRR East 227
246	London, British Museum CM	BMCRR East 131/181
247	London, British Museum CM	BMCRR Rome 4255
248	London, British Museum CM	BMCRR Rome 4256
249	London, British Museum CM	BMCRR East 134
250	London, British Museum CM	BMCRR East 135
251	London, British Museum CM	BMCRR East 172
252	London, British Museum CM	BMCRR Rome 4215
253	London, British Museum CM	CM 1919.2-13.821
254	London, British Museum CM	BMCRR Gaul 49
255	London, British Museum CM	BMCRR East 106
256	London, British Museum CM	BMCRR East 108
257	London, British Museum CM	BMCRR Gaul 69
258	London, British Museum CM	BMCRR East 174
259	London, British Museum CM	BMCRR East 144
260	London, British Museum CM	CM 1993.3-22.5-80
261	Kingston Lacy, The National Trust	No number
262	Musée de Cherchel	28
263	New York, Brooklyn Museum of Art E C A M E	54.51
264	London, British Museum GRA	GR 1867.5-7.724 (Gems 1966)
265	London, British Museum GRA	GR 1927.3-18.5
266	London, British Museum GRA	GR 1872.5-15.3 (Sc.1972)
267	Cairo, The Egyptian Museum	JE 43268
268	London, British Museum EA	EA 55253
269	London, British Museum GRA	GR 1902.10-11.1 (Sc.1879*)
270	New York, The Metropolitan Museum of Art G R	49.11.3
271	London, British Museum CM	CM RPK Page 218, 1
272	London, British Museum CM	CM 1938.5-10.167
273	London, British Museum CM	CM 1850.8-7.1
274	London, British Museum CM	CM 1964.13-3.66
275	London, British Museum CM	CM TC p241, 2
276	London, British Museum GRA	GR 1888.12-10.1 (Sc.1878)
277	Budapest, Museum of Fine Arts	4807
278	Rome, Museo Nazionale, Museo alle Terme	121221
279	London, British Museum CM	BMCRR Rome 3648
280	London, British Museum CM	BMCRR Rome 3649
281	London, British Museum CM	BMCRR Gaul 106
282	London, British Museum CM	CM 1872.7-9.438
283	London, British Museum CM	BMC Augustus 602
284	London, British Museum CM	BMC Augustus 609
285	London, British Museum CM	BMC Augustus 612
286	London, British Museum CM	BMC Augustus 637
287	London, British Museum CM	BMC Augustus 622
288	London, British Museum CM	BMC Augustus 603
289	London, British Museum CM	BMC Augustus 617
290	London, British Museum CM	BMC Augustus 631
291	London, British Museum CM	BMC Augustus 625
292	London, British Museum CM	BMC Augustus 633
293	London, British Museum CM	BMC Augustus 615
294	London, British Museum CM	BMC Augustus 636
295	London, British Museum CM	BMC Augustus 650
296	London, British Museum CM	BMC Augustus 651
297	London, British Museum CM	BMC Augustus 647
298	London, British Museum CM	BMC Augustus 692
299	London, British Museum CM	BMC Augustus 693
300	London, British Museum CM	BMC Augustus 314
301	London, British Museum CM	BMC Augustus 657
302	London, British Museum CM	BMC Augustus 351
303	London, British Museum CM	BMC Augustus 460

CAT. No.	MUSEUM	INVENTORY NUMBER	CAT. No.	MUSEUM	INVENTORY NUMBER
304	London, British Museum CM	BMC Augustus 481	348	Rome, Museo Nazionale Romano, Palazzo Massimo	1184
305	London, British Museum CM	CM 1866.12-1.3963	349	Rome, Museo Nazionale Romano, Museo delle Terme	125406
306	London, British Museum CM	CM 1935.11-2.9	350	Rome, Musei Capitolini (Monte Martini)	2157
307	Toronto, Royal Ontario Museum	906.12.156	351	Rome, Museo Nazionale Romano	5149-50
308	London, British Museum GRA	GR 1923.4-1.928 (Gems 3396)	352	Palestrina, Museo Nazionale Archeologico	No number
309	London, British Museum GRA	GR 1923.4-1.813 (Gems 3236)	353	Windsor, The Royal Collection Trust	PfZ 19217
310	London, British Museum GRA	GR 1867.5-7.491 (Gem 1975)	354	Windsor, The Royal Collection Trust	PfZ 19214
311	Vatican City, Musei Vaticani	31680	355	Windsor, The Royal Collection Trust	PfZ 19112
312	Vienna, Kunsthistorisches Museum Antikensammlung	IXA 56	356	London, British Museum GRA	GR 1865.11-18.252
313	London, British Museum GRA	GR 1873.8-20.730 (Sc.1881)	357	London, British Museum GRA	GR 1865.11-18.249 (Lamp Q900)
314	London, British Museum GRA	GR 1872.12-14.1 (Br.830)	358	London, British Museum GRA	GR 1805.7-3.317 (TC D 633)
315	London, British Museum GRA	GR 1926.9-30.54 (Lamp Q 1936)	359	Naples, Museo Archeologico Nazionale di Napoli	113195
316	London, British Museum GRA	GR 1873.2-8.3 (Vase G 28)	360	London, British Museum GRA	GR 1805.7-3.6 (Sc.1768)
317	Vienna, Kunsthistorisches Museum Antikensammlung	IXA 59	361	Naples, Museo Archeologico Nazionale di Napoli	121324
318	Alexandria, Greco-Roman Museum	24043	362	Hampton Court, The Royal Collection Trust	39714
319	Stuttgart, Württembergisches Landesmuseum Antikensammlung	1.35	363	Stamford, The Burghley House Collection	PIC 286
320	Alexandria, Greco-Roman Museum	3536	364	London, British Library	20C4
321	New York, The Metropolitan Museum of Art, EA	26.7.1428	365	London, British Library	2OC5
322	London, Victoria & Albert Museum	461-1871	366	London, British Library	2.7 Royal14 E.V.
323	London, British Museum GRA	GR 1911.9-1.1	367	London, British Library	G1449
324	Paris, Musée du Louvre G E & R	MNC 1960	368	London, British Museum P & D	1872-5-12-427
325	Naples, Museo Archeologico Nazionale di Napoli	9077	369	London, British Museum P & D	1895-9-15-709
326	London, British Museum GRA	GR 1923.4-1.1062 (Gem 3811)	370	London, British Museum P & D	1943-11-13-53
327	Paris, Cabinet des Medailles, Bibliothèque Nationale	No number	371	London, British Museum P & D	1991-10-5-79
328	Paris, Cabinet des Medailles, Bibliothèque Nationale	No number	372	London, Victoria & Albert Museum	A8-1964
329	London, British Museum GRA	GR 1814.7-4.1532	373	London, National Gallery	6409
330	London, British Museum GRA	GR 1974.10-9.99	374	London, British Museum P & D	1954-2-13-5
331	London, British Museum GRA	GR 1772.3-11.0085	375	London, British Museum P & D	1947-5-10-1
332	London, British Museum GRA	GR 1814.7-4.1531.2	376	London, British Museum P & D	1947-5-10-3
333	London, British Museum GRA	GR 1890.6-1.167	377	London, British Museum P & D	1977-11-5-6
334	London, British Museum GRA	GR 1917.6-1.2780-1 (Jew 2780-1)	378	London, British Museum P & D	1887-5-2-120
335	London, British Museum GRA	GR 1917.5-1.1136 (Ring 1136)	379	London, British Museum M & E E	SL, B.86
336	London, British Museum GRA	GR 1836.2-24.455 (Lamp Q1021)	380	London, British Museum M & E E	1772.3-14.188
337	Naples, Museo Archeologico Nazionale di Napoli	6290	381	London, British Museum M & E E	1958.1201.642
338	London, British Museum GRA	GR 1824.4-51.3 (Bronze 1467)	382	London, British Museum M & E E	1958.1201.842
339	London, British Museum GRA	GR 1772.3-14.25 (Ring 240)	383	London, British Museum M & E E	1958.1201.2360
340	Naples, Museo Archeologico Nazionale di Napoli	640	384	London, British Film Institute	No number
341	Naples, Museo Archeologico Nazionale di Napoli	8919	385	Paris, The Barbara Chase-Riboud Collection	No number
342	Naples, Museo Archeologico Nazionale di Napoli	8969	386	London, British Museum M & E E	1763.4-15.2
343	Naples, Museo Archeologico Nazionale di Napoli	8920	387	London, British Museum M & E E	1763.4-15.1
344	London, British Museum EA	EA 47973	388	London, British Museum P & D	1949-10-8-1
345	London, British Museum CM	BMC Vespasian 780	389	London, British Museum M & E E	1909.12-1.215
346	Rome, Museo Nazionale Romano, Palazzo Altemps	77255	390	Cambridge, Fitzwilliam Museum	C908.1928
347	Rome, Museo Nazionale Romano, Palazzo Altemps	362623	391	Cambridge, Fitzwilliam Museum	C909.1928
			392	London, British Museum M & E E	AF. 3316
			393	London, The Fan Museum, H. Alexander Collection	No number
			394	Cambridge, Fitzwilliam Museum	EGA 4536.1943

PHOTOGRAPHIC ACKNOWLEDGEMENTS

All photographs are reprinted by courtesy of the Trustees of the British Museum, except the following (numbers in brackets refer to catalogue entries).

The American Numismatic Society, New York (91, 230–231).

Donald M. Bailey (24b)

The Bankes Collection (The National Trust), Kingston Lacy (261); photographs by Paul Mulcahy ©The National Trust Photographic Library.

Barbara Chase-Riboud (385).

British Film Institute, London (384).

The British Library, London (51, 364–367); photographs reproduced by permission of the British Library.

The Burghley House Collection, Stamford (363).

Cabinet des Medailles, Bibliothèque Nationale de France, Paris (90, 225–226, 228–229, 327–328); Cliché Bibliothèque Nationale de France.

Département des Antiquités Grècques, Etrusques at Romaines, Musée du Louvre, Paris (7, 25, 44, 45, 53, 155, 324); ©Photo RMN – Hervé Lewandowski.

Département des Antiquités Egyptiennes, Musée du Louvre, Paris (20, 30, 50, 140, 154, 162, 187); ©Photo RMN – Hervé Lewandowski.

Department of Egyptian, Classical and Ancient Middle Eastern Art, Brooklyn Museum of Art, New York (163, 263) and fig.5.5, p. 152.

The Detroit Institute of Arts, Detroit (189).

Jean-Yves Empereur (17, 19, 95, 132, 142–143, 150, 213).

By courtesy of The Fan Museum, H. Alexander Collection, London (393, 220).

Mahfoud Ferroukhi (197, 262).

Fitzwilliam Museum, Cambridge (169, 390–391, 394); reproduced by permission of the Syndics of the Fitzwilliam Museum.

Jane Foley (18, 27, 52, 54, 122, 165, 168, 208, 318).

Hunterian Museum, Glasgow University (179).

Günter Grimm (55, 100–102).

Kunsthistorisches Museum, Antikensammlung, Vienna (26, 312, 317).

Alain Lecler (4, 10–11, 13, 57, 97, 99, 100–103, 121, 125, 141, 147, 171, 187, 190, 320).

The Metropolitan Museum of Art, New York (6, 21,144–146, 164, 166, 206, 270, 321); photographs ©2000 The Metropolitan Museum of Art.

Musées Royaux d'Art et d'Histoire, Brussels (22).

Musei Vaticani (196, 311).

Museo Archeologico Nazionale di Napoli, Naples (325, 337, 340–343, 359, 361).

Museo delle Antichità Egizie, Turin (167).

Museo Nazionale Archeologico, Palestrina (352).

Museum of Fine Arts, Budapest (277).

National Gallery, London (373); photograph ©National Gallery, London.

Petrie Museum of Egyptian Archaeology, University College, London (32, 37–40, 96, 170).

Roma Musei Capitolini; Archivio Fotografico dei Musei Capitolini (194, 212, 350).

Rosicrucian Egyptian Museum, San José (161).

The Royal Collection Trust, Hampton Court (362) (Conway Library, Courtauld Institute of Art); photographs reproduced by permission of The Royal Collection Trust ©2001 Her Majesty Queen Elizabeth II.

The Royal Collection Trust, Windsor (353–355); photographs reproduced by permission of The Royal Collection Trust ©2001, Her Majesty Queen Elizabeth II.

Royal Ontario Museum, Toronto (59–61, 63–6, 156–157, 174–176, 307); photographs courtesy of the Royal Ontario Museum, Toronto.

St. Petersburg, Courtesy of the State Hermitage Museum (160).

Salaction Public Relations GmbH, Hamburg (172).

Soprintendenza Archeologica di Roma, Museo Nazionale Romano (278, 346–349, 351).

Staatliche Museen zu Berlin Ägyptisches Museum und Papyrussammlung, Berlin (14, 188).

Staatliche Museen zu Berlin Antikensammlung, Berlin (198–199).

Victoria & Albert Museum, London (115–117, 195, 322, 372); photographs ©V & A Picture Library.

Susan Walker (24a)

Guy Weill Goudchaux, London (267).

The Worshipful Company of Goldsmiths, fig.10.1, p. 293 ©The Worshipful Company of Goldsmiths.

Württembergisches Landesmuseum, Antikensammlung, Stuttgart (28–29, 159, 319).

INDEX